BRONZE

NZE

Edited by
David Ekserdjian

Royal
Academy
of Arts

First published on the
occasion of the exhibition
Bronze
Royal Academy of Arts, London
15 September – 9 December 2012

Supported by

Christian Levett and Mougins Museum
of Classical Art

Daniel Katz Gallery

Baron Lorne Thyssen-Bornemisza

John and Fausta Eskenazi

The Ruddock Foundation for the Arts

Tomasso Brothers Fine Art

Jon and Barbara Landau

Janine and J. Tomilson Hill

Embassy of the Kingdom of the
Netherlands

Eskenazi Limited

Lisson Gallery

Alexis Gregory

Alan and Mary Hobart

Richard de Unger and Adeela Qureshi

Rossi & Rossi Ltd

Embassy of Israel

This exhibition has been made possible by
the provision of insurance through the
Government Indemnity Scheme. The
Royal Academy of Arts would like to
thank HM Government for providing
Government Indemnity, and the
Department for Culture, Media and Sport
and Arts Council England for arranging
the indemnity.

British Library Cataloguing-in-
Publication Data
A catalogue record for this book
is available from the British Library

ISBN 978-1-907533-29-7 (paperback)
ISBN 978-1-907533-28-0 (hardback)

Distributed outside the
United States and Canada
by Thames & Hudson Ltd, London

Distributed in the
United States and Canada
by Harry N. Abrams, Inc., New York

EXHIBITION CURATORS
David Ekserdjian
Cecilia Treves
Assisted by Katia Pisvin

EXHIBITION MANAGEMENT
Jane Knowles
Assisted by Elana Woodgate

PHOTOGRAPHIC AND COPYRIGHT
CO-ORDINATION
Katharine Oakes

CATALOGUE
Royal Academy Publications
Beatrice Gullström
Alison Hissey
Elizabeth Horne
Carola Krueger
Peter Sawbridge
Nick Tite

DESIGN
Isambard Thomas, London

PICTURE RESEARCH
Sara Ayad

COLOUR ORIGINATION
DawkinsColour

Printed in Italy by Graphicom

ILLUSTRATIONS
Pages 2–3: detail of cat. 125
Pages 6–7: detail of cat. 22
Page 9: detail of cat. 76
Page 10: detail of cat. 143
Page 281: detail of cat. 66

President's Foreword

Bronze, like no other artistic material, has been used all over the world, from the earliest times to the present, to make works of art and artefacts of extraordinary beauty. Highly prized and durable, it is an age-old medium associated with great historical epochs. When Professor David Ekserdjian first presented the idea of a bronze exhibition to us, the potential richness and diversity of such an undertaking – historical, geographical and stylistic – instantly appealed. The Royal Academy is delighted to see these ambitions realised in this unique exploration of bronze sculpture's most remarkable achievements.

We are deeply indebted to our lenders, who have agreed to part with hugely significant works. Chief among them are those who have lent such treasures as the *Chimaera of Arezzo* and the *Dancing Satyr* from Mazara del Vallo; or, in order that they may be seen together, the Trundholm *Chariot of the Sun* and the *Cult Chariot of Strettweg*. Not only do these loans make the exhibition all the more sumptuous, but their presence also enables us to look at works in a new way: archaeological discoveries challenge our view of classical antiquity; figures from Renaissance Florence stand alongside life-like heads from Ife that are contemporary with them; remarkable bronzes from Southeast Asia, such as the *Avalokiteshvara* from Jakarta, reveal the superb skill of makers in the Far East; and the *Krodo Altar* from Goslar in Saxony can be seen in the context of other rare medieval survivals. The exhibition abounds with such intriguing parallels.

The works selected cause us to wonder at how such masterpieces were made. The technical challenges posed by casting bronzes often require close collaboration between artist, maker, founder and chaser. Bronze responds like no other material to the rendering of varied textures, to different finishes and to the fall of light. Surface colour and texture can vary greatly from, for example, the polished abstractions of Brancusi to the spontaneous sketchiness and deliberate roughness of Giacometti's sculptures. The medium's strength and ductility, its adaptability to the sculptor's vision, also permits compositional boldness unmatched by other materials.

I vividly remember my own first experience of making sculpture in bronze. To see the touch of my hand recorded in the metal with such enduring permanence, a permanence bound to extend far beyond my lifetime, was to encounter the force of the death-defying trope that has been not only a consolation to human frailty, but central to art's meaning for millennia.

The Royal Academy wishes to express its sincere thanks to Professor David Ekserdjian for his unstinting commitment to the realisation of this project. Cecilia Treves, Exhibitions Curator, has worked alongside him with energy and enthusiasm. Special thanks go to Jane Knowles, Exhibitions Manager, who has overseen the organisation of the exhibition. We are also grateful to Kathleen Soriano, Director of Exhibitions; Andrea Tarsia, Head of Exhibitions Management; Katia Pisvin, Curatorial Assistant; Helen Swift, Curatorial Volunteer; Elana Woodgate, Assistant Exhibition Manager; and Katharine Oakes, Rights and Reproductions Manager. The expertise and dedication of the Royal Academy's publications department have resulted in this magnificent catalogue. We would also like to thank Stanton Williams for their beautiful exhibition design.

The exhibition would not have been possible without the support of a number of galleries and individuals, foremost among them the Daniel Katz Gallery and Christian Levett. Their generosity has enabled us to present this remarkable exhibition and we thank them all.

Christopher Le Brun PRA
President, Royal Academy of Arts

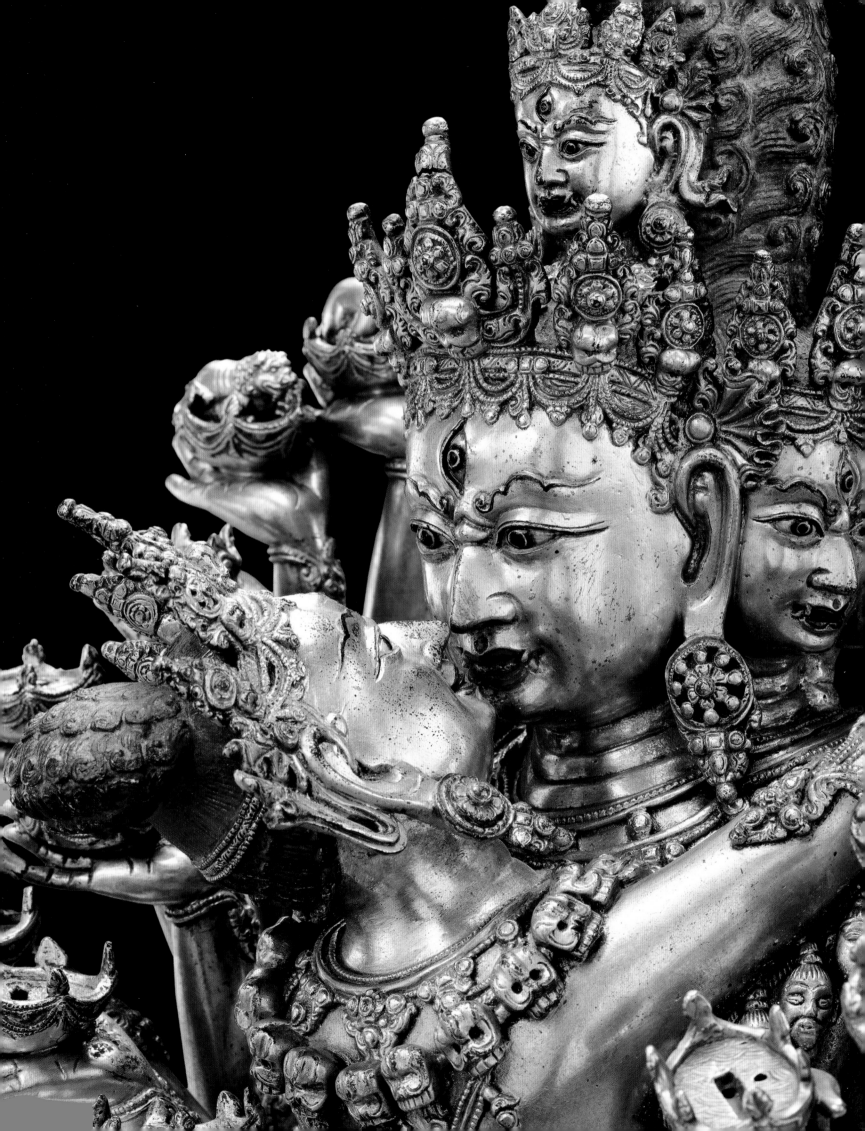

Acknowledgements

The curators of the exhibition and the publishers of this catalogue would like to express their gratitude to the following individuals for their invaluable assistance:

Cristina Acidini, Polyxeni Adam-Veleni, Georgiana Aitken, Patrizia Amico, Yanti Amran, David Anfam, Mark Gregory D'Apuzzo, Mathilde Avisseau-Broustet, Victoria Avery, Sylvia Bandi, Stephanie Barron, Johannes Beltz, Jadranka Beresford-Peirse, Sara Bernesjö, Madeleine Bessborough, Francesca G. Bewer, Stefano Biondo, Anna Bisceglia, Dirk Booms, Antonia Bostrom, Simonetta Brandolini d'Adda, Xavier Bray, Jorrit Britschgi, Sandra van den Broek, Claire E. Brown, Herbert Butz, Richard Calvocoressi, Richard Camber, Pierre Cambon, Gesualdo Campo, Edmund Capon, Sarah Cash, Rita Cassano, Stephen Chambers RA, Tao-Tao Chang, Julien Chapuis, Xuan Chen, Catherine Chevillot, Alan Chong, Frances Christie, Ann Christopher RA, John Clarke, Sarah Collins, Anna Contadini, John Curtis, Stephanie Dalley, Julie Dawson, Michal Dayagi-Mendels, Richard Deacon RA, Catherine Delacour, Marinella De Lucia, Edith Devaney, Lloyd DeWitt, Taco Dibbits, Jo Dillon, Cristina Drake, Ann Dumas, Diana Eccles, Renate Eikelmann, Alain Elkann, Patrick Elliott, Jás Elsner, Daniel Eskenazi, Giuseppe Eskenazi, John Eskenazi, Katherine Eustace, Rupert Faulkner, Stephen Feeke, Anita Feldman, Kiersten Fellrath, Michel Feugère, Elisabeth Fontan, Martina Field Klisovic, Gabriele Finaldi, Jacqueline Finnegan, Kjeld von Folsach, Laura A. Foster, Helen Fothergill, Mark Francis, David Franklin, Simonetta Fraquelli, Raffael Gadebusch, Gabriella Garzella, Davide Gasparotto, Lisa Gaunt, Xenia Geroulanos, Melanie Gibson, Annamaria Giusti, Antonio Godoli, Catherine Gorget, Antony Gormley RA, Anthony Green RA, Paul Greenhalgh, Eric Gubel, Irene Gunston, Christoph Gutmann, John Guy, Melissa Hamnett, Sabrina Handler, Rupert Harris, Maxwell K. Hearn, Matthias Henkel, Greg Hilty, Tom Hodgson, Edward Horswell, Julie Hudson, Jerry Hughes, Cyril Humphris, Despina Ignatiadou, Mario Iozzo, Gregory Irvine, Anna Jackson, Paul Jett, Donald Johnston, Peter Junge, Alexander Kader, Diana Kamin, Iskra Karniš Vidovic, Andrew Keelan, Mervyn King, Rungwe Kingdon, Hiromi Kinoshita, Volker Krahn, Andrew Lacey, Brigitte Leal, Oliver Letwin MP, Valeria Li Vigni, Clare Lilley, James Lin, Stuart Lochhead, Adrian Locke, Jona Lueddeckens, Albert Lutz, Trish Lyons, Shane McCausland, John Mack, Ian McKeever RA, Liam McNamara, John Maine RA, Karen Manchester, J. Patrice Marandel, Jonathan Marsden, Irene Martin, Caroline Mathieu, Carol C. Mattusch, Mariella Maxia, Alessandra Merra, Mark Merrony, Marco Edoardo Minoja, Susan Moore, Peta Motture, Peter Murray, Emily Neff, Antonella Nesi, Anne-Marie Nielsen, Poul Otto Nielsen, Hiroko Nishida, Anne Nishimura Morse, Seiyon Oh, Magnus Olausson, Bruno Overlaet, Peter Pakesch, Orazio Paoletti, Beatrice Paolozzi Strozzi, Edouard Papet, Claudio Parisi Presicce, Eric Parry RA, Virginie Perdrisot, John Picton, Christine Pinault, Jane Portal, Timothy Potts, Sascha Priewe, Adriana Proser, Marc Quinn, Nicola Raspollini, Jessica Rawson, Martin Rees, Maria Reho, Giuseppe Rizzo, William Robinson, Malcolm Rogers, Michael Rogers, Miria Roghi, Petra Rösch, Andrea Rose, Nicole Ruegsegger, Klaas Ruitenbeek, Xavier Salmon, Michael Sandle RA, Maurizio Sannibale, Nick Savage, Eike D. Schmidt, Frits Scholten, Klaus Albrecht Schröder, Karsten Schubert, Piers Secunda, Nicholas Serota, St John Simpson, Michael Spink, MaryAnne Stevens, Peter Stevens, Jan Stuart, Helen Swift, Sarah Taggart, David Tang, Aso Tavitian, Keith Taylor, Elisabet Tebelius Murén, Isambard Thomas, Nicola Todaro Marescotti, Hab Touch, Noriko Tsuchiya, Sebastiano Tusa, Helen Valentine, Maria Vassilaki, Eleni Vassilika, Timothy Verdon, Imrat Verhoeven, Agata Villa, Rupert Wace, Michael Walker, Stefano Weinberger, Ittai Weinryb, Patricia Wengraf, Diana Widmaier Picasso, Alison Wilding RA, Jonathan Williams, Paul Williamson, Peter Wilson, Richard Wilson RA, Rindy P. Zhang, Rainer Zietz, Ann Ziff.

Bronze: An Introduction

David Ekserdjian

Sculpture, and above all sculpture in metal, is both the most universal and the most durable of art forms. Equally, there can be no doubt that – within the larger category of sculpture in metal – bronze sculpture, above all of people and animals, has proved to be not only the most representative but also the most inspirational of media. Since their first appearance over five and a half thousand years ago, bronzes have been made virtually everywhere, with the exception – prior to contacts with western civilisation – of the Americas, Australia and the Pacific islands, all of which had remarkable sculptural traditions in other media.

The principal purpose of our selection is therefore to celebrate the extraordinary historical, geographical and stylistic range of bronze from around 3700 BCE in the ancient near east to the present. At the same time, however, such a display is bound to offer suggestive parallels and correspondences across time and space, as well as a more general richness and diversity.

Although the reference above to sculpture in metal may seem unhelpfully vague, it is rather intended to reflect an element of genuine uncertainty. The fundamental point is that while some metal artefacts – and most notably those made of gold and silver – only comprise naturally occurring single elements, others are man-made compounds of a number of metallic elements, and can only come into being as the result of a chemical process. In the context of

sculpture, the majority of these combinations of elements are copper alloys, which simply means that the predominant element within the works in question is copper. Copper alloy, moreover, is the term now favoured in the most scientifically minded analyses of the composition of particular pieces. By tradition, bronze is the term employed to refer to those copper alloys in which tin is the largest additional component, whereas brass is the term for those copper alloys in which zinc is the largest additional component (the earliest alloys involved arsenic). However, the exact proportion of the various elements within such compounds is far from uniform, and as a matter of fact it is not possible to be certain of the material composition of copper alloys simply by looking at them, even before – as is so often the case – their natural colour is overlaid by some species of lacquer or patina. In the Italian Renaissance, what we refer to as 'bronze' was often simply called 'metallo', while in eighteenth-century England 'brass' was the favoured term.

As more and more pieces are analysed, it is becoming clear which recipes and formulae were being used at particular times and in particular places, or even in specific workshops and foundries, and there will no doubt be many surprises along the way. Thus, it used to be believed that up to and during the Renaissance, brass (or 'latten' as it is termed in the English documents of the period) was almost exclusively employed for sculpture in northern Europe, and

Fig. 1
Head of Constantine, fourth century. Bronze, height 177 cm (including neck)
Musei Capitolini, Rome

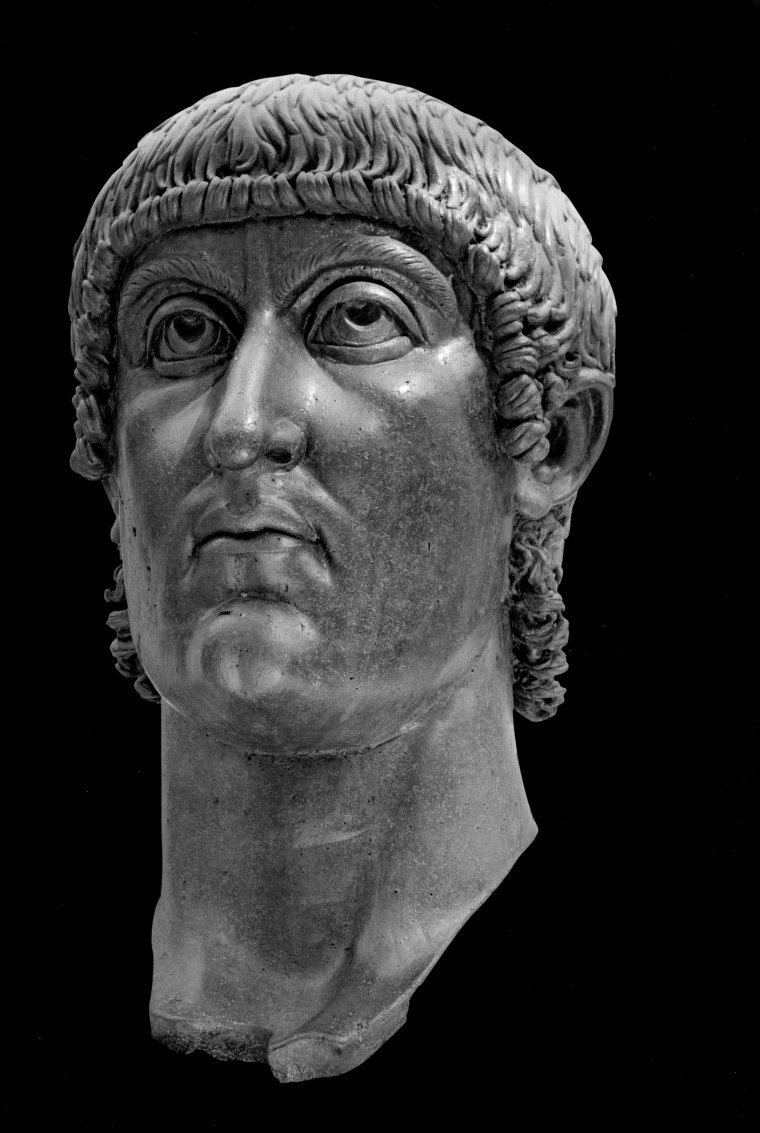

Fig. 2
The Buddha Vairocana, mid-eighth
century. Bronze, height 14.98 m
Eastern Great Temple, Nara, Japan

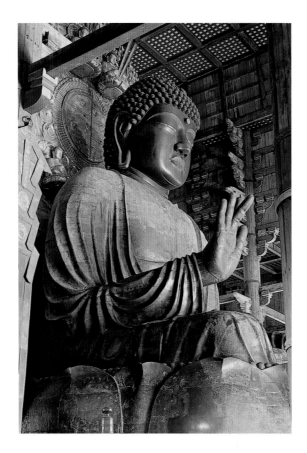

that the Italians worked in bronze. It now transpires that many Venetian Renaissance 'bronzes' are actually made of brass. Given all this confusion, and the inelegance of the term copper alloy, in the present context – as indeed in our title – the word bronze will be used to stand for all forms of copper alloy unless there is a specific need to discuss their composition.

The next essay in this catalogue is devoted to a more detailed consideration of the various techniques that have been employed over the millennia in order to create bronzes, but here the fact needs to be underlined that the manufacture of bronzes – especially those on a large scale – was frequently a difficult and expensive business. Most such pieces were cast by means of the so-called lost-wax technique, which required the sculptor to create a full-scale model of the work in question, usually out of clay, but sometimes of wood. As this mode of production was refined over time, sculptors learnt how to avoid destroying their models during the casting process – by means of what is called the indirect lost-wax method – and it became possible to think of making multiple versions of the same basic model, or indeed to combine different elements in a species of 'cut and paste'. It is widely assumed that these techniques

were already being employed by sculptors in the ancient world, and they were gradually revived during the Middle Ages and the Renaissance, but the question of their survival across the intervening centuries after the fall of the Roman empire continues to be hotly debated.

The sheer quantity of metal required to make a life-size bronze statue meant that the raw materials were extremely costly, and – at least until techniques of casting had evolved to become all but foolproof – the casting of major bronzes must invariably have been a nerve-wracking business. That is no doubt the reason why in the second decade of the fifteenth century, Lorenzo Ghiberti's patrons for his statue of St John the Baptist for the church of Orsanmichele in Florence prudently burdened him with the financial responsibility for any disaster that might ensue. In the same vein, and around a century and a half later, Benvenuto Cellini gives a legendarily nail-biting account in his autobiography of the casting of his monumental statue of *Perseus* (which is 3.2 metres high), and although it is universally acknowledged that he has a tendency to exaggerate or embellish at various points in his story, what he has to say about this episode is usually agreed to be in the main reliable.

The huge scale of the *Perseus* means that it could not possibly be borrowed (cat. 99 is a bronze *modello* for it, however, and cat. 132 a fine nineteenth-century copy), and more generally there are many other works whose size, fragility or iconic status make it inconceivable that they could or should ever be lent. These include pieces from all over the globe, some of which only survive in fragmentary form. One particularly telling example is a monumental reclining *Vishnu* in the National Museum in Phnom Penh in Cambodia (figs 56, 57), which is over two metres long, indicating that the complete statue would have measured around six. Similarly, the Musei Capitolini in Rome house the remains of a gigantic statue of the Emperor Constantine (fig. 1), whose head alone is 125 cm high. Written sources from antiquity refer to a gilt-bronze statue of the Emperor Nero, which was claimed to be 30 metres tall. Such Ozymandian fragments also serve as a reminder of the seemingly all but universal enthusiasm for bronze of authoritarian régimes. Seen in perspective, the recent dismantling of statues in eastern Europe after the fall of the Berlin Wall and in Iraq following the toppling of Saddam Hussein is only the latest chapter of an old, old story. Happily, in other contexts, as with the 14.98-metre-high *Buddha Vairocana* or *Daibutsu* (Great Buddha) in the Todai-ji (Eastern Great Temple) at Nara in Japan (fig. 2), which has periodically been restored but originally dates from the mid-eighth century, mighty works of sculpture in bronze of real artistic distinction remain intact.

Accepting such inevitable limitations, the intention here has been to assemble a range of outstanding objects from a whole variety of different times and places in an attempt to give an overview of this extraordinarily rich body of material. As will become apparent in connection with individual items, they represent a combination of the justly celebrated and the less familiar or newly discovered, although the latter have earned their places only by virtue of their aesthetic distinction.

In this connection, it might seem to be reasonable to assume that by this time there would be no major bronzes left waiting to be identified, but this is not the case. Even in the area of Renaissance and baroque sculpture, important works by artists of the stature of Riccio, Pierino da Vinci and Adriaen de Vries have been rediscovered in the past decade, but the real source of extraordinary new material has been in the field of antiquities, both in Europe and in Asia.

The most spectacular of all such finds have been the bronzes of Riace (figs 18, 43), which were discovered by a diver off the Calabrian coast in 1972, and are presumed to have been jettisoned in antiquity from a ship taking them from Greece to Italy that got into trouble in those waters. They were then painstakingly restored, and were first exhibited in Florence and Rome in 1981 before reaching their final resting place in the Museo Nazionale della Magna Grecia in Reggio Calabria later that year. Arguments rage over precisely when they were made and by whom, with almost all the most illustrious names having been associated with them, but it is uncontroversially agreed that they are among the most stupendous works of art in existence, and that their only rival among ancient Greek bronzes is the figure of *Zeus* in the National Archaeological Museum in Athens (fig. 46). If they are indeed later versions of works by the most celebrated of Greek sculptors, then the mind boggles at the thought of what their finest achievements may have looked like.

Amazingly enough, since their reappearance, there have been a number of other almost equally impressive finds of ancient Greek sculpture, the overwhelming majority of which have been underwater, and it does not seem in the least unreasonable to suppose that there will be further discoveries in the future. Of these, the three most spectacular have been the Croatian *Apoxyomenos* (a man using a strigil; fig. 44), the *Lady of Kalymnos* (fig. 3) and the *Dancing Satyr* of Mazara del Vallo (cat. 28), all of which likewise testify to the avidity of the Roman passion for ancient Greek statuary, which it is tempting to compare with the despoiling American taste for European works of art since the late nineteenth century. Almost all the Greek bronzes that actually made it to Rome, like the ones that

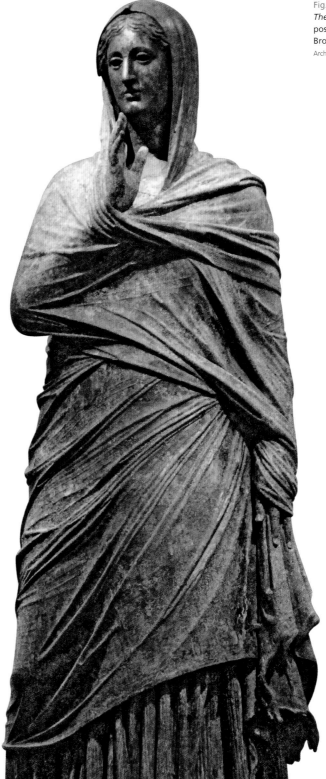

Fig. 3
The Lady of Kalymnos (detail), possibly second century BCE. Bronze, over life-size
Archaeological Museum of Kalymnos

remained in Greece, no longer exist, whereas those that met a watery grave were encrusted with a protective layer of marine fauna and are often miraculously well preserved. Indeed, the only significant damage to the *Apoxyomenos* – which affected the right leg – was demonstrably inflicted prior to its removal from its original location, since the remains of a mouse's nest were discovered within the cavity. To these submarine discoveries should be added the stunning Hellenistic head (cat. 26) found during the excavation of a tomb in Bulgaria believed to be that of King Seuthes III, which is now unarguably the finest treasure of the National Museum in Bulgaria, not to mention such finds as the Nahal Mishmar Hoard (cats 1–5), the *Sky Disc of Nebra* (fig. 4) and the *Crosby Garrett Helmet* (cat. 42).

Turning to the Far East, many remarkable pieces have been excavated in recent decades in China. By no means all are made of bronze, as the spectacular Terracotta Army and various superb jade pieces demonstrate, but bronze has certainly figured prominently. Arguably the most stunning of these finds have been those at Sanxingdui in Sichuan (see fig. 41). A selection of pieces from these excavations was shown at the British Museum in 1996 in an exhibition entitled 'Mysteries of Ancient China', which presented the artistic achievements of a number of hitherto wholly unknown ancient civilisations. In addition to these works, there have also been numerous other stunning finds in the region over the past several decades, which range from an extraordinary Gandharan *Buddha* to arguably the finest of all Cambodian bronze statues, believed to represent a deified king, both of which are in the Metropolitan Museum of Art in New York.

All the great traditions of sculpture in bronze find their place here, and this perhaps serves as a reminder both of where bronze never held sway and of those artists who had almost nothing

to do with it. In the European context, Michelangelo – whose *Bacchus* is present in the form of a same-size replica in gilt bronze by Massimiliano Soldani Benzi (cat. 127) – and Canova are the outstanding absentees. They are joined by the great northern wood sculptors of the Renaissance, such as Tilman Riemenschneider and Veit Stoss, not to mention Franz Xaver Messerschmidt, who almost always worked in metal, but employed lead and tin.

Having determined the exceptionally wide scope of our selection, we needed to decide how to arrange the various pieces. One possibility would have been to organise the material along a combination of regional and geographical lines, with sections devoted, for instance, to the Igbo-Ukwu, Ife and Benin cultures of Nigeria, or to the Renaissance in Europe. The obvious disadvantage of such an arrangement, however, would have been that it would have resulted in a multiplicity of discrete displays, which would have been necessarily uneven both in quantitative and in qualitative terms, and within which an inevitably diverse array of various types of objects would have been juxtaposed. Visitors and readers would have been tempted to concentrate upon the civilisations with which they were most familiar, and at worst to have ignored the unknown. Instead we settled on a thematic arrangement for the galleries and for this introduction, and a chronological arrangement of the plates in the catalogue.

Our themes – Figures, Gods, Heads, Animals, Groups, Objects, and Reliefs – permit us to consider works of the same 'species' from different times and places together. The main danger here was that the juxtaposition of works of vastly different sizes runs the risk of disadvantaging those on a more intimate scale. This would indeed have been disastrous, since for most of its history sculpture in bronze has managed to succeed both on a grand scale and on a determinedly modest one. In antiquity – whether in the Middle East, in the Greek, Etruscan and Roman civilisations, or in the Far East – small figure sculptures, which have come to be known as statuettes, were extremely popular. In the European Renaissance, the taste for them was re-established, and as a rule they were meant to be kept in the home and held in the hand. Only by turning them round and by feeling their surfaces was it deemed possible to gain a full sense of their qualities. Inevitably, some of this magic is lost in a museum context where they have to be shown within glass cases, but at the very least every effort should be made to allow them to be seen in the round. Not for nothing was arguably the most memorable exhibition of European bronzes of recent times, which was held in Berlin in 1995–96, entitled *Von allen Seiten schön* ('Beautiful from every side').

Fig. 4
The Sky Disc of Nebra, 1600 BCE. Bronze inlaid with gold, diameter 32 cm
Landesmuseum für Vorgeschichte, Halle

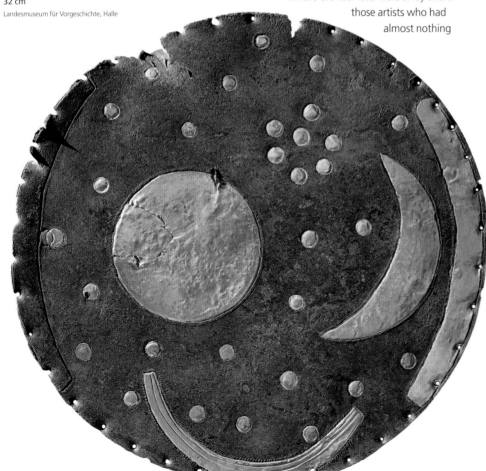

The circumstance of individual works by the select handful of artists who are represented on more than one occasion being found in different sections seems altogether less of a problem, while the fact that occasional pieces – such as functional objects in the shape of animals – might qualify for more than one setting is a positive advantage.

The chronological arrangement of the plates in the catalogue acts as a counterbalance to the thematic presentation of the exhibition and this introduction, creating different and equally intriguing juxtapositions and giving the reader a new appreciation of the many unexpected links that exist between works produced in different regions and under different circumstances.

Seen from a global perspective, the human figure in isolation is without question the subject *par excellence* of bronze sculpture, and clearly merits more extensive representation even than such sub-categories as heads and groups. The earliest figure sculptures in bronze to have survived date from around 3000–2800 BCE and come from ancient Sumer. At the outset, they were finely made but small in scale, but in due course monumental pieces were produced. A case in point is the immensely ambitious if now fragmentary life-size statue in the Louvre of a standing figure of Queen Napirasu from Susa in Iran (fig. 29), which dates from c. 1250 BCE. Since that time, the human figure has been a staple of bronze sculpture, and continues to be so to the present day. In consequence, whereas an ancient Mesopotamian might have been perplexed by certain aspects of Willem de Kooning's *Clam Digger* (cat. 150), there is no doubt that he or she would have instantly recognised it as a representation of a human being.

Any such selection is bound to be a personal one, but it is not by chance that so many of the figures are nude as opposed to draped, and standing as opposed to seated or reclining, nor indeed that the vast majority of them are male. The wholly or predominantly nude figure has proved to be a constant within many visual traditions – from the *Apollo Belvedere* to Donatello's *David* (fig. 74) – and was commonly favoured by a number of religious faiths, which explains the preponderance of nude figures in the section devoted to gods. The principal exception is Christianity, but even here Christ is virtually nude in a whole range of episodes from the Passion, of which the most prominent is the Crucifixion (cat. 64). In the same vein, Adriaen de Vries shows Christ seated in distress, with his hands joined in prayer, meditating on his future death on the cross (cat. 114).

In a sense, what might be described as the default position for the human figure is standing upright, examples of which range in character from the hieratic rigidity of an Egyptian statuette of Ptah (cat. 19) and a Parthian prince

(fig. 36) to the swaying stance of the so-called Dancer of Mohenjo-Daro (fig. 30). For all their diversity, they represent both a standard and a challenge, which many sculptors were delighted to oppose by imagining figures in energetic motion of a kind that cannot be attempted in stone for purely practical reasons. Within the European Renaissance tradition, such explorations took deliberately extreme forms, as in Barthélemy Prieur's *Acrobat Performing a Handstand* (cat. 115) and Giambologna's *Mercury* (cat. 107), but it is perhaps no coincidence if Donatello's *Putto with Tambourine* (cat. 82) from Berlin, which originally belonged to the font of the Baptistery of Siena Cathedral, is at the same time a kind of semi-independent statuette, moving to the sound of the music he and his erstwhile companions are making. In the twentieth century, in their very different ways both Boccioni (cat. 145) and Giacometti carried on this tradition.

It is a striking tribute to the power of the nude in art that statues of naked figures have continued to be made long after the original motivations behind their presentation in this manner were a matter of history. For Rodin, often hailed as the great reviver of the whole western sculptural tradition, it seemed entirely fitting to portray the aptly named *Age of Bronze* (cat. 134) as a male nude. Even Antony Gormley's *Angel of the North*, which is twenty metres tall, regardless of the fact that it is made of steel and not bronze, plainly belongs to this same centuries-old lineage.

As stated above, in bronze the draped figure is a comparative rarity, but there were contexts in which it came naturally. In ancient Greece and Rome, some full-length portraiture involved showing the figure in the nude, but in a case such as the imposing presence of *Lucius Mammius Maximus* from Herculaneum (cat. 35), the richly delineated folds of the drapery are very much part of the overall effect. The revival of the artistic language of classical antiquity in the European Renaissance allowed Lorenzo Ghiberti to explore similar sweeping effects in his *St Stephen* (cat. 81), although detailed comparison only brings out the differences between the two approaches adopted. Moreover, in many Hindu and Buddhist contexts, it was customary to show the figure draped from the waist down, and to stylise the folds of the garments into gorgeous calligraphic patterns.

As is evident from the example of *Lucius Mammius Maximus*, full-length portraiture was always an option (and some heads are all that remain of what were once more complete figures), but – and so too later on with painting – another approach was to concentrate upon the head and bust to the exclusion of all else. In this section, the works involve a combination of portraits, often of famous men and women, with supposedly imaginary heads. It hardly needs to be pointed out that some portraits are doubtless

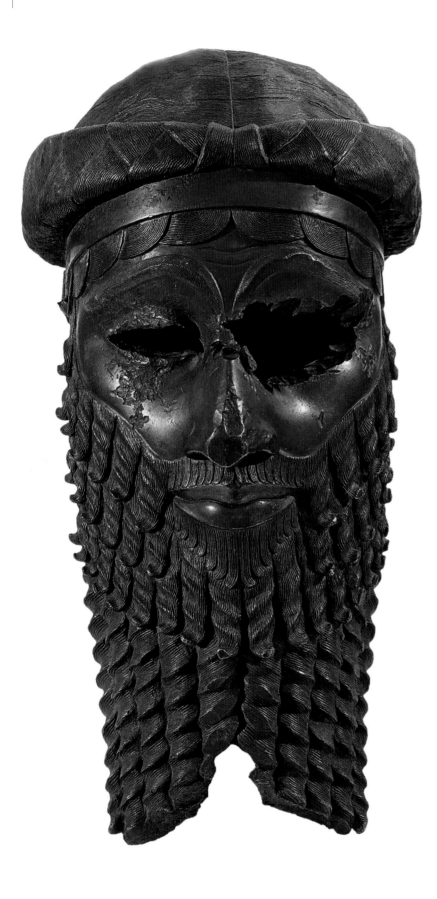

considerably improved versions of actual appearances, while many 'imaginary' heads must have been based upon unflinching observation of real if nameless sitters. In the case of Bernini's arresting *Damned Soul*, which he carved in marble, but which is here included in the form of a gilt-bronze cast by Massimiliano Soldani Benzi (cat. 128), it would appear that the sculptor observed his own features in a mirror in order to capture the tormented expression.

The astonishing Akkadian head in the National Museum of Iraq in Baghdad (fig. 5) conveys such a sense of a living presence that it has traditionally been assumed to be a representation of King Sargon, although there is no evidence to support this. Conversely, by the time of the ancient Greeks and Romans, when the recording of the likenesses of great men and women was commonplace, that sense of observation which captures the lineaments of a Hellenistic king who is believed to be Seuthes III (cat. 26), is equally skilfully applied to the so-called *'Tolomeo Apione'* (cat. 40) from the Villa dei Papiri at Herculaneum, where the corkscrew curls are a glorious added extra.

Moreover, one of the more general oddities about the history of portraiture, which appears to apply *a fortiori* to busts, is that even the mightiest individuals are prisoners of their time, compelled to succumb to the surely largely unconscious imperatives that governed their recording angels. Thus, Germain Pilon's almost terrifyingly austere and stern *Catherine de' Medici* (cat. 108) and Georg Petel's robotically immobile *Gustavus Adolphus* (cat. 122) are both unavoidably children of their ages. Perhaps it is the unexpected intimacy of Francesco Fanelli's melancholy, introspective *Charles I* (cat. 123) that makes him the only one of these rulers who seems to exist beyond time.

Comparatively rare in the Asian traditions, the head is the supreme expression of the genius of both Ife and Benin sculpture. The latter are better known, perhaps simply because more of them have reached Europe, but it is the cicatrised surfaces of the former that impress even more (cat. 73). Here again, it is impossible not to think in terms of likeness, if not of portraiture.

By the nineteenth century, the standard representational portrait had all but run its course, which is why Medardo Rosso sought to revitalise it by melting the forms into a bizarre approximation (cat. 141), or equally why at a later juncture Brancusi (cat. 143) and Moore (cat. 152) reformulated the head in the direction of abstraction. At the same time, some of the most radical artists of the twentieth century, and not least Picasso and Matisse, found it immensely hard to break with tradition in this domain.

The relationship between – to borrow the title of Keith Thomas's classic study – man and the natural world is the

Fig. 5
Head of a Ruler, Akkadian,
c. 2300–2159 BCE. Bronze,
height 30.7 cm
National Museum of Iraq, Bagdhad

subject of the earliest known sculptures in bronze, which were found in a cave at Nahal Mishmar as recently as 1961. The most evolved of these pieces (cats 1–5) – which are included in the section devoted to objects – is referred to as a mace head, but nothing concrete is known about its intended function. Yet it is clear that – for all their stylisation – the creatures that adorn it have been lovingly observed, and are in a sense the distant cousins of the even earlier images of deer and other animals found in European cave paintings.

Over time, a considerable technical advance led to the striking realism of the representations of animals found in the ancient Near East. Such early pieces are perhaps unsurprisingly concerned with the emblematic, quasi-divine nobility of the animal kingdom, and here as elsewhere animals were of course worshipped as gods, a fine later example being the Chola *Nandi* from the Asia Society in New York (cat. 57). The original context of the *Chimaera of Arezzo* (cat. 23), arguably the greatest of all Etruscan bronzes, is unknowable, but the fact that it bears a

dedicatory inscription to Tinia, the Etruscan equivalent of Jupiter, suggests that it served some kind of religious function.

In classical antiquity, however, the grandeur of nature could also be celebrated in the same way, and that is how such major pieces as the Capitoline *She-wolf* (fig. 6) and the *Ram* of Syracuse (cat. 45) came to be made. These in their turn ultimately led to the great medieval bronze animals, such as the Braunschweig *Lion* (fig. 70) and the *Lion* and *Griffin* in Perugia, in which heraldic dignity and a spirit of observation – since even the griffin is an amalgam of actual animals – are magically combined.

The most important and enduring of all the relationships between humans and animals has been with the horse, as is exemplified by the Medici Riccardi equine head (cat. 46). Here, as in the sculptural tradition more generally, it is predominantly represented by groups of horses with riders, although there are also superb bronzes of horses alone, notably by such masters as Giambologna and Adriaen de Vries. It is perhaps a mark of the intensity of this special

Fig. 6
She-wolf, Etruscan, probably early fifth century BCE, with figures by Antonio Pollaiuolo, c. 1470–75.
Bronze, length 75 cm
Palazzo dei Conservatori, Musei Capitolini, Rome

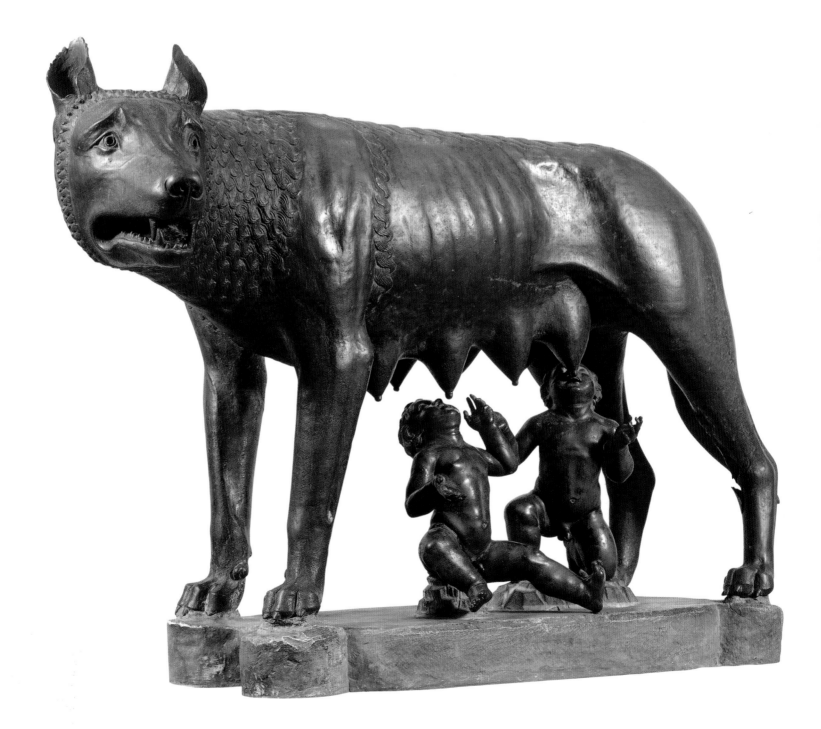

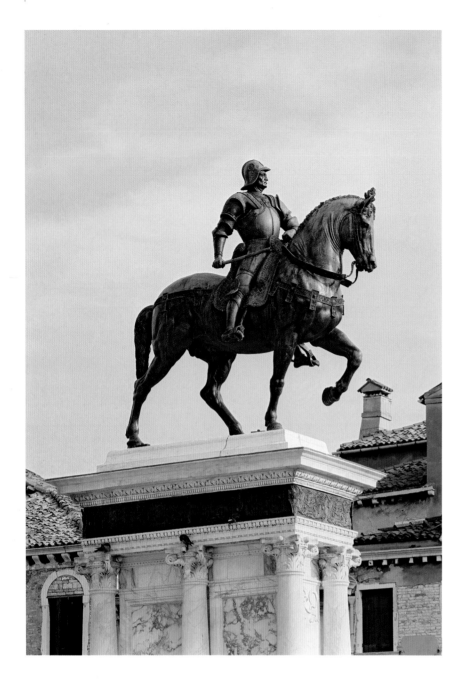

Fig. 7
Andrea del Verrocchio, *Equestrian Statue of Bartolomeo Colleoni*, commissioned 1479, completed by Alessandro Leopardi, 1495. Bronze, height 395 cm
Campo SS. Giovanni e Paolo, Venice

relationship that in Giambologna's paired groups of a *Lion Attacking a Bull* and a *Lion Attacking a Horse* (cat. 117), it is the plight of the horse that moves us more. The gilt-bronze horses of San Marco in Venice, which date from late classical antiquity and originally drew a chariot or *quadriga*, were seized from the Hippodrome at Constantinople by the crusaders in the thirteenth century and thus came to enjoy a new life on the façade of the basilica. Only since the early 1980s, like so many other large-scale outdoor bronzes of the greatest importance, have they been obliged to beat a necessary but regrettable retreat indoors.

Giambologna added an irresistibly wattled and bobbly *Turkey* (cat. 111), at the time an outlandish bird – it had first reached Europe as recently as 1511. Exotic creatures were the stock-in-trade of the greatest of all nineteenth-century *animalier* sculptors, Antoine-Louis Barye, whose *Tiger Devouring a Gavial* (cat. 131) was both the group that made his name and the ultimate in zoo-inspired fictionalisation. Later still, when Picasso created his *Baboon and Young* (cat. 146), he consciously distanced our simian cousin by incorporating a child's toy car for its head. At much the same time, Germaine Richier's monstrous enlargement of an insect in her *Praying Mantis* (cat. 148) is at once a balletic and ominous presence that foreshadows Louise Bourgeois's even more magnified and devouring spiders (cat. 155).

As mentioned above, the section devoted to groups contains a number of variations on the theme of the horse and rider, from ancient Greece (cat. 20) to the Italian fifteenth century (cat. 83). This last, which represents Filarete's signed Hector, a Homeric hero portrayed in classical style, is in addition dated 1456, which makes it arguably the earliest securely dated bronze statuette of the Renaissance. At the other end of the scale, among the first monumental Renaissance bronzes were the equestrian statues of Gattamelata by Donatello (3.4 metres high; fig. 76) and of Colleoni by Verrocchio (3.95 metres high; fig. 7), although even they did not surpass the colossal 4.24-metre-high gilt-bronze *Marcus Aurelius* on the Capitol (fig. 8).

Substantial narrative bronze groups from classical antiquity are not unknown – a much regretted absentee is the Roman *Artemis and the Deer*, formerly in the Albright-Knox Art Gallery in Buffalo, and currently on loan to the Metropolitan Museum of Art, New York, from a private collection – but they are extremely rare. By way of compensation, we include a full-size bronze replica by François Girardon of unquestionably the most celebrated of all ancient marble groups, the *Laocoön and His Sons* (cat. 124). The *Laocoön* was rediscovered in Rome in 1506, and both its turmoil and its intricacy inspired any number of subsequent artists, an obvious example being the *Hercules,*

Fig. 8
Equestrian Statue of Marcus Aurelius, c. 161–180 CE.
Gilt bronze, height 424 cm
Palazzo dei Conservatori, Musei Capitolini, Rome

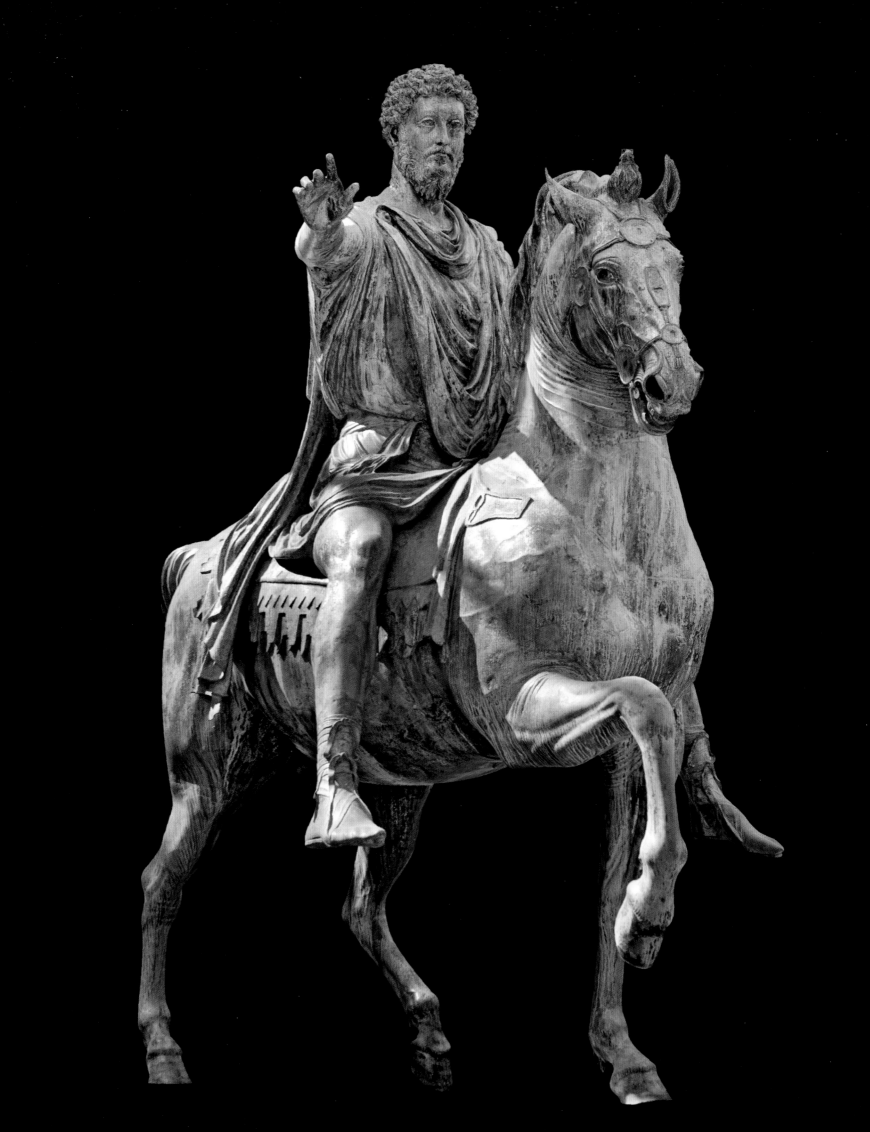

Nessus and Deianira by Adriaen de Vries (cat. 119), who also devised his own *Laocoön* as part of the same series of bronze groups now at Drottningholm. In the case of the flowing forms and conjoined bodies of Gian Francesco Susini's *Abduction of Helen by Paris* (cat. 120) and Alessandro Algardi's *St Michael Overcoming the Devil* (cat. 121), there are no such specific links, but they too are probably ultimately indebted to it. The same violent complexity is also found elsewhere, of course, and not least in such Himalayan groups as *Kapâla-Hevajra and Nairâtmya* (cat. 76).

In the oriental tradition, groups of gods were more commonly assembled in states of meditative tranquility, which almost seem to imply that they are unaware of one another's presence. A different kind of intimacy is represented by the Chola group of *Yashoda Nursing the Infant Krishna* (cat. 69), which cannot fail to remind a western viewer of the Christian subject of the Madonna del Latte, in which the Christ Child is seen suckling at the Virgin's breast (oddly enough, the Madonna and Child in whatever guise are uncannily rare in three-dimensional bronze sculpture). The fact that the various moods of love and lust between couples were deemed peculiarly appropriate for the intimate scale of the small bronze is graphically demonstrated by the affectionate closeness of Riccio's *Satyr and Satyress* (cat. 94) and the gymnastic engagement of Desiderio da Firenze's *Satyr and Satyress* (cat. 93).

Arguably the most weird and wonderful groups are those that assemble a whole host of figures, as opposed to two or three. They existed in distant antiquity, as is demonstrated both by the Etruscan chariot from Bisenzio now in the Museo di Villa Giulia in Rome and by the *Cult Chariot of Strettweg* (cat. 22) in Graz, whose figures occupy the lower tier of the ensemble. A totally different and deeply eccentric variation on the theme involving loosely connected towers of figures became the trademark of Francesco Bertos (cat. 129), certainly not the greatest sculptor who ever lived, but one of the most compellingly distinctive.

Up to this point we have been almost exclusively concerned with figure and animal sculpture, but now it is time to turn to objects. Given the value and delicacy of so many of them, it seems plausible to suppose that virtually from the outset not all of these items were intended for everyday use, but that on the contrary some of them were

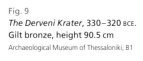

Fig. 9
The Derveni Krater, 330–320 BCE.
Gilt bronze, height 90.5 cm
Archaeological Museum of Thessaloniki, B1

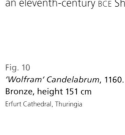

reserved for display. In other cases, what began life as a straightforwardly functional object has metamorphosed over time into a luxury work of art, such as the extraordinary *Derveni Krater* (fig. 9). Inevitably, space constraints have meant that a decision had to be taken about whether it was more important to represent as many types of object or as many civilisations as possible, and in the end the latter won out.

As a result, we have included a number of vessels designed to contain liquid, ranging in time and place from an eleventh-century BCE Shang ritual vessel (cat. 12) to the

Fig. 10
'Wolfram' Candelabrum, 1160.
Bronze, height 151 cm
Erfurt Cathedral, Thuringia

late fourteenth-century ewer brought to Asante from England at some point after its manufacture in the reign of Richard II (cat. 67). Conversely, there are whole categories of objects, such as musical instruments – in southeast Asian countries such as Vietnam some of the most spectacular bronzes are bells and drums – and mortars that have had to be all but excluded (cat. 24 is an exception). Likewise, within the European tradition, bronze candlesticks have been a perennial favourite (fig. 10), inspiring the likes of Verrocchio and Riccio (fig. 80).

Turning to those categories of objects that are present, they include weapons and armour, such as shields (cat. 27), helmets (cat. 42) and even a pair of gilded stirrups made for King François Premier of France (cat. 95), which appear to have been employed during his funeral ceremony, to which ceremonial swords might have been added.

Objects which ostensibly perform similar functions can also be of dramatically different sizes: the most striking case in point brings together a sinuous Cambodian oil lamp (cat. 59), which is a mere 30.5 cm long, and Suzuki Chōkichi's *Incense Burner* (cat. 135), which is composed of a number of separately cast elements, and measures a daunting 2.8 metres in height. The latter appears to have been designed as a display piece for an international art fair, but the former was surely too precious for everyday use either. By the twentieth century, what are in effect bronze still-lifes – such as Jasper Johns's *Painted Bronze (Ale Cans)* (cat. 153) and Jeff Koons's *Basketball* (cat. 154) – have entered the fray.

A final section is devoted to sculpture in relief. Seen globally, this is without question the most problematic category, for the simple reason that the near-universality of relief is not matched by a comparably ubiquitous enthusiasm for reliefs in bronze. Although ancient Egypt can offer a single example here (cat. 39), there is nothing on show from classical Greece and the Etruscan or the Roman civilisations. Similarly, the arts of Asia are extremely erratically represented, which means that the focus is above all on European art.

Both in the later Middle Ages and on into the Renaissance, monumental bronze doors for cathedrals and their baptisteries were among the most ambitious works of art being produced both north and south of the Alps, from Hildesheim and Novgorod to Pisa and Florence, where Lorenzo Ghiberti's two sets of doors for the Baptistery were the ultimate apotheosis of this extraordinary tradition (fig. 73). Alas, such massive items cannot be moved, but by way of compensation Ghiberti's tomb slab for the General of the Dominican order, Leonardo Dati, is included (cat. 80). In an ideal world, it would have been joined by the *Battle Between Romans and Barbarians* by Bertoldo di Giovanni – who was the pupil of Donatello and the teacher of Michelangelo – from the Bargello (fig. 11), arguably the definitive Renaissance homage to the classical past. However, even without this remarkable piece, it is possible to trace a whole sequence of development as sculpture sets out to rival both the precision of painting and later on its fluidity and surface excitement, as demonstrated by Germain Pilon's *Lamentation Over the Dead Christ* (cat. 97) and Adriaen de Vries's emblematic *Forge of Vulcan* (cat. 113). Medals and plaquettes might have been added to this array, but have been omitted principally because too many of them would have been required to make a real difference.

The banally mimetic attraction of relief sculpture was bound to limit its appeal in the nineteenth and twentieth centuries, and new ways of thinking about relief were explored in such works as Matisse's heroic and monumental *Backs* (cats 142.1–4). Confronted by abstracting works such as these, which nevertheless take the human body as their point of departure, it is hard not to be struck by the bond that can unite works of sculpture in defiance of time and space. For all their cultural specificity, the best individual bronzes do as a rule seem to be uniquely capable of speaking a common language.

Fig. 11
Bertoldo di Giovanni, *Battle Between Romans and Barbarians*, 1491.
Bronze, 43 x 99 cm
Museo Nazionale del Bargello, Florence

Bronze Casting:
The Art of Translation

Francesca G. Bewer

Gazing at the many exquisitely wrought bronze sculptures here, one might imagine them springing forth, perfectly formed and finished, much as Athena is said to have emerged from Zeus' head. However, just as Athena's birth was only made possible by the mighty blow of Hephaistos' axe to his brother's cranium, every bronze work is born via the wielding of tools by able artists and artisans – people who manipulate wax, clay and metal through intense heat, the rhythmic din of hammers and chisels, noxious fumes, and always with some uncertainty of what will happen when the molten metal penetrates the voids it is to fill, out of sight, in the belly of the mould.

Bronzes are the fruit of a complex process of translation, the conversion of a form from one medium to another. Indeed, the material is inherently reproductive and versatile. It offers the artist the opportunity to capture the textures and forms of models made of any material while altering their tactile qualities. Its tensile strength frees a form that was originally carved in marble from the constraints of the block, eliminating the need for cumbersome structural supports: Frederic Remington's *Off the Range (Coming through the Rye)* (cat.139) or the dizzying acrobatics of Francesco Bertos's *Sculpture, Arithmetic and Architecture* (cat.129) are unthinkable in stone. Bronze has also been greatly appreciated for its ability to imitate the human form. And in the Renaissance, life casts were seen as a way of imitating not only nature, but nature's creative power. In the course of their existence, sculptures in bronze may also undergo further alterations, whether through exposure to the elements, centuries of burial, restoration, repurposing, or wear.

Knowledge of the materials and processes involved in the making of bronzes contributes to a greater appreciation of the technical feats and artistic choices that are embodied in these works, as well as to an understanding of their original appearance. Since antiquity the most common method of making a bronze sculpture has been casting, and in particular, the 'lost-wax' process. The principles of this process have not changed throughout the ages, although of course the sculptors' and founders' knowledge, tools, and materials have varied. It is helpful to think of casting in terms of a series of alternating positive and negative steps. A model (positive) is used to create an impression (negative) in a refractory material. The resulting mould becomes the receptacle for the molten metal that solidifies into a bronze replica (positive) of the model.

The sculptor or skilled craftsman may fashion a wax model in different ways. When a one-off model is designed to be cast – and thus destroyed in the process of becoming a unique bronze – the work is referred to as a 'direct' cast. Adriaen de Vries's *Hercules, Nessus and Deianira* (cat.119) or the *Roped Pot on a Stand* from Igbo-Ukwu (cat.58) are both examples of this. Small or slim figures, such as the Etruscan

figure from Volterra (cat. 32), can be modelled in solid wax and thus translated into solid metal forms. But most bronzes are cast hollow to economise on the metal. Bronze is a dense and heavy material, and large volumes of liquefied metal tend to shrink in unforeseeable ways as they cool, thereby compromising the outcome of the cast. Furthermore, bronze is expensive. To create hollow casts craftsmen and artists through the millennia have constructed their wax models over a refractory (fire-resistant) core. In this way only the outermost wax layer of the model is replaced by metal. Adriaen de Vries, for instance, modelled a smaller, simplified shape of the *Hercules, Nessus and Deianira* in clay and then fleshed out the figures in wax in all their detail over that core.[1] For forms such as this, which require structural support, the core is built on an iron armature (fig. 12.1–3). As armatures are not always easy to remove, they may remain inside the bronze, as can be seen in an X-ray image of François Girardon's *Equestrian Statue of Louis XIV* (fig. 14).

Throughout the centuries the wax most commonly used for modelling has been that of bees, which might be mixed with other materials such as tallow and turpentine to make it more malleable, or rosin or paraffin to make it harder. The artist may form the wax into a malleable putty that he can shape with fingers and modelling tools (fig. 12.4–5). Or he may apply it in sheets to ensure a thin, even overall thickness of the metal (fig. 15), much as is still done with Benin and Thai bronzes to this day.

In some instances a model is made in a material, such as stone, that is unsuitable for direct lost-wax casting: the models for the *Weepers* attributed to Jan Borman the Younger (cat. 84), for instance, were carved in wood. Or the sculptor may want to preserve his wax model as a back-up or to produce replicas. In such cases the process is called 'indirect', since it involves making an intermediary mould to produce an 'inter-model' in wax, which can then in turn be used for casting (fig. 13.1–4).

Moulds made of non-refractory materials serve solely to produce the wax inter-model. They are reusable, which has the advantage that it allows the artist to delegate the production of replicas. Making such a mould requires great skill. Before flexible moulding materials such as gelatin or synthetic rubber were available, moulds were often made out of multiple pieces of plaster. A piece-mould is made of two or more sections that fit together like a three-dimensional jigsaw puzzle (fig. 13.2). Flexible materials simplify the moulding process as they can be peeled back in larger sections from the surface of the original model while preserving the undercuts. Because flexible moulds are easier to make and use than plaster piece-moulds, they have replaced the latter in modern foundries.

Fig. 12
Diagram of the direct lost-wax casting process

Fig. 13
Diagram of the first steps of the indirect lost-wax casting process, showing the creation of the wax inter-model

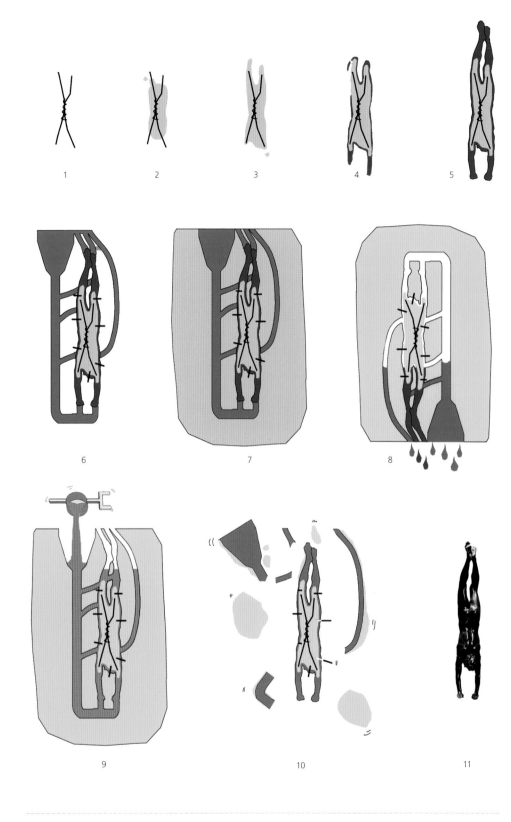

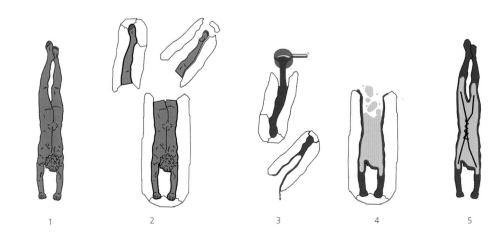

In the indirect process the wax replica is created from the outside in. In other words the liquefied wax is brushed, poured or pressed into the piece-mould until it forms a shell of the desired thickness (fig. 13.3). This hollow wax is then filled with refractory core material (fig. 13.4) and, if necessary, equipped with an armature and assembled (fig. 13.5).

From this point, the casting steps are identical for direct and indirect casts. Before coating the wax model with refractory mould material it is necessary to ensure that the core is anchored in place in the outer mould once the wax is melted out. To this end the founder will insert core pins or 'chaplets' made of bronze or iron through the wax into the core, leaving the ends standing slightly proud so that they will be encased in the outer mould (fig. 12.6). It is also important to create access and pathways for the molten metal to flow efficiently, filling the cavities in the mould while allowing air and gases to escape. A series of strategically placed wax rods (known as sprues) capped with a wax funnel (pouring cup) is attached to the model (fig. 12.6). These rods serve as place-holders for a network of channels that will ensure the efficient flow of metal through all parts of the mould. A technically aware artist might subtly incorporate figural elements into the design of a bronze to promote the flow of the metal. The interlocking limbs of Riccio's *Satyr and Satyress* (cat. 94) and the disposition of the bow and the animal's legs in the African *Huntsman Carrying an Antelope* (cat. 79) are good examples of this.

The sprued wax is now ready to be cloaked in refractory material (fig. 12.7). Clay mixtures have been used for millennia. A slurry of crushed ceramic powder or sand bound with plaster was developed as an alternative, and since the 1960s lighter, form-hugging 'ceramic-shell' moulds have been adapted from industry. The first layer of the outer mould must be very fine in order to pick up the minutest detail on the model; subsequent layers are coarser. Since the refinement of a newly cast bronze surface determines the amount of labour needed to finish it, the quality of the outer mould is crucial. The exact composition of the refractory material was often guarded as a secret because it afforded a founder a competitive edge.

Once the mould containing the sprued model has been built up and given a chance to dry, it is heated to melt away the wax (hence the term 'lost wax'), drive out any moisture, and warm the mould to ensure that the molten metal will not solidify too quickly (fig. 12.8). Devoid of wax, the hot, hollow mould is placed with the casting cup face up ready to receive the liquid bronze.

Most smiths have an empirical knowledge of their metals. Various factors influence their choice of alloys; these include the availability of materials, the suitability of an alloy for a particular task, and symbolic associations. The term 'bronze' popularly refers to a broad range of copper alloys – mixtures of copper and other metallic elements such as tin, lead and zinc combined through melting. These mixtures usually also contain much smaller amounts of other elements, perhaps impurities from the ores or intentional additions. Only since the nineteenth century has the term 'bronze' been used more specifically for alloys of copper and tin as distinct from brass, which comprises primarily copper and zinc. In fact, many so-called bronze sculptures are technically made of brass. Until the eighteenth century

Fig. 14
Numerous X-ray films were needed to cover the large bronze group of François Girardon's *Louis XIV on Horseback*, 1685–87 (Musée du Louvre, Paris). This composite image reveals the complex armature made of iron rods and wires that is preserved inside the sculpture. The rods appear clearly as lighter, linear features inside the limbs, body and neck of the horse

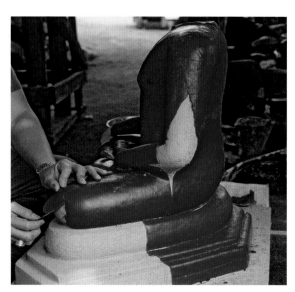

Fig. 15
A Thai sculptor lays thin sheets of wax over a preformed clay core of a Seated Buddha

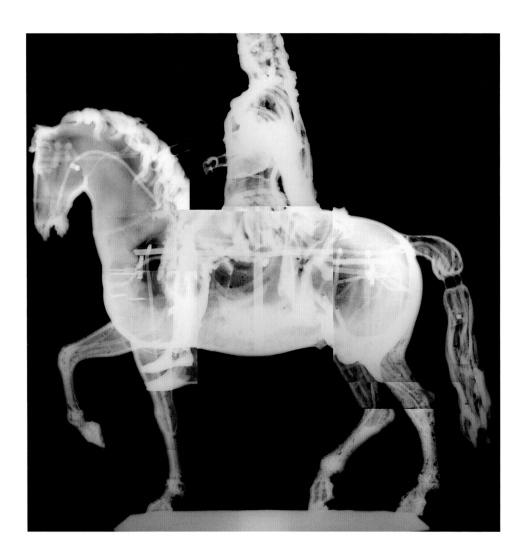

metallic zinc was not known as such in the West: brass was believed to be copper, 'coloured' golden yellow by the cementation process, which entailed heating it with calamine (zinc carbonate).

Pure copper is very ductile. It has a relatively high melting point of 1,100°C, is not easily liquefied and oxidises easily. By selectively combining it with other metallic elements such as tin, zinc and lead, one can obtain a variety of alloys with lower melting ranges, greater fluidity, and improved working properties, such as a greater hardness and tensile strength. Alloys were also chosen for their colour, which can range from golden to red to silvery grey depending on their composition. Typically, bronze alloys used for sculpture contain between 5% and 10% tin. The melting range of a bronze can be lowered by around 100°C by adding 10% tin, and by yet another 100°C with c. 20% tin.[2] Bronze with such high levels of tin is very fluid and is used to cast bells because of its acoustic properties; it was used for making mirrors in antiquity because of its silvery colour and potential for high polish. It is also very brittle, however, and has therefore rarely been used to cast statues. Less expensive elements such as lead have often been substituted for some portion of the tin. Lead helps to lower the melting range of the alloy and makes it more fluid, allowing for thin-walled bronzes and good reproduction of detail. However, it also softens the alloy and dulls the metal's sheen. Zinc enhances an alloy's fluidity, makes the metal softer, and affords better resistance to corrosive atmospheric agents. More recently, silicon bronze, an alloy without tin or lead, has found increased use in art foundries for its lower toxicity and because it oxidises less than traditional alloys.

The energy required to melt the metal is considerable; the heat and strain are most vividly captured in Benvenuto Cellini's autobiographical description of the near mis-casting of his monumental *Perseus* (see cats 99, 132).[3] Both the fuel types and the furnaces have evolved over time. Charcoal and coke; hand-, wind- and water-operated bellows; clay crucibles and reverberatory furnaces all required enormous physical effort. Although some of these set-ups are still in use to melt metal, most art foundries now use gas furnaces with electrically powered forced air.

Once liquefied, the bronze is poured into the mould, where – if all goes well – it flows through the channels, fills all the cavities left by the wax and quickly solidifies into a cast replica of the model (fig. 12.9). Next the outer mould is broken away, the metal sprues cut off, and flaws repaired (fig. 12.10).

In any form of casting, complex or large models may be divided into smaller components and cast separately. Such sectioning simplifies the moulding and casting processes and reduces the chance (and impact) of casting flaws. Sectioning also allows for thinner casting, and was used to produce many large ancient bronzes, including the *Dancing Satyr* (cat. 28) and the figures from Riace (figs 18, 43). In comparison, numerous Renaissance artists who sought to cast their large bronzes in one piece had to fashion them with much thicker walls to ensure that the metal would not solidify prematurely during its protracted journey through the mould. Examples include Lorenzo Ghiberti's *St Stephen* (cat. 81) and Benvenuto Cellini's *Perseus*. Joining and repair technologies have evolved throughout history and can therefore provide clues to dating such interventions. Today most sculptures are made in parts and welded.

Ultimately, it is the surface that we look at, the quality of the modelling, the textures and the coloration. Thus the finishing (or chasing) processes are very important (fig. 12.11). Traditionally, these account for a large part of the time and labour involved in making a bronze. Often the sculptor relies on skilled smiths wielding abrasives, hammers, chisels, punches, engravers, burnishers, files, wire brushes, grinders – the tools have changed little over time – to rework the metal surface of the cast, concealing imperfections, sharpening details, adding texture and polish. The most challenging surfaces to finish are highly polished, continuous, smooth expanses, such as those of Constantin Brancusi's *Maiastra* (cat. 144) or Anish Kapoor's *Untitled* (cat. 157); the slightest imperfection will attract attention and mar the desired effect. In contrast, the expressive modelling of the bronzes cast from Edgar Degas's wax models, which record the texture of his fingerprints, beg for minimal chasing (fig. 16). Lorenzo

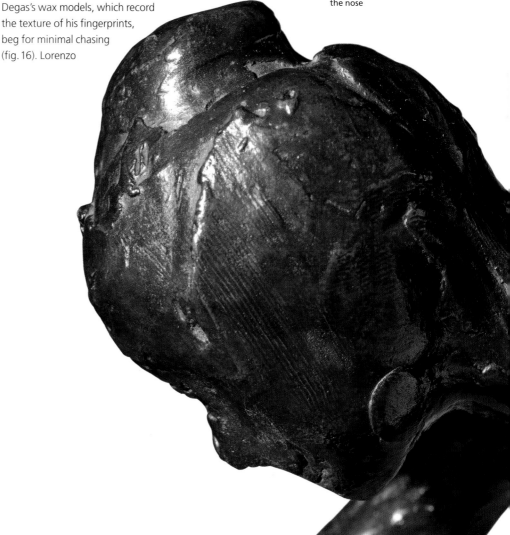

Fig. 16
This detail of the head of one of the casts made from the wax model of Degas's *Grande Arabesque, Third Time*, c. 1885–90 (Harvard Art Museums/Fogg Museum, Cambridge, Massachusetts) preserves the vertical streaks the artist's finger left in pushing soft modelling wax up the side of the figure's head. A small blob of wax served to enhance the jawline, and the recess of the eye socket was formed by pressing and pinching out a fine ridge of wax for the nose

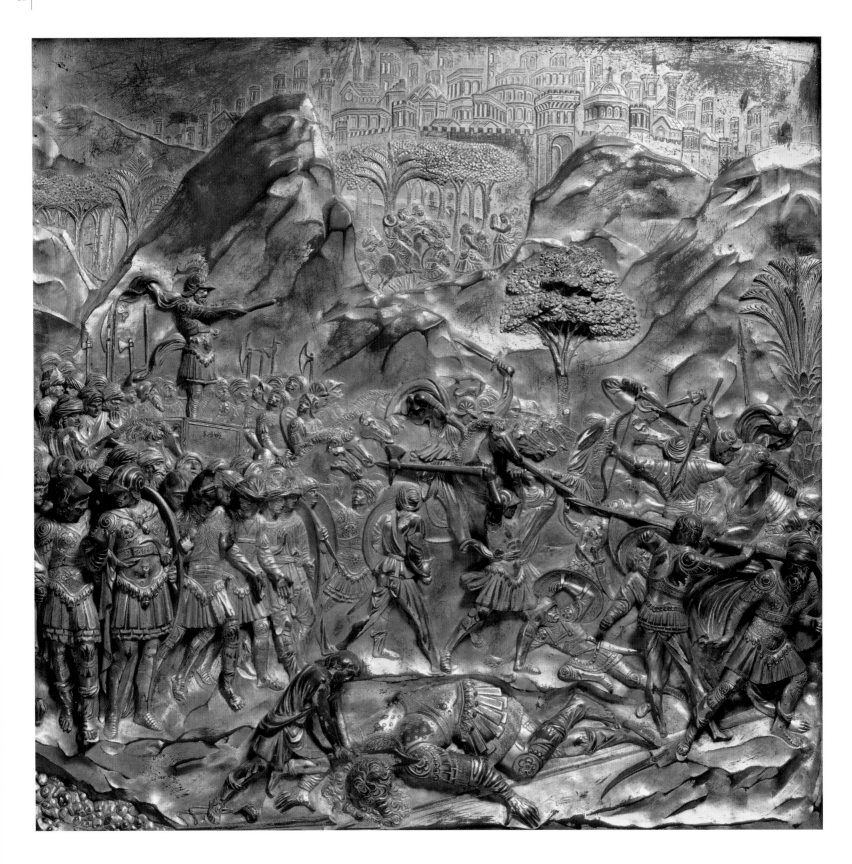

Fig. 17
The chasing of Lorenzo Ghiberti's
*Gates of Paradise: Relief of the
Battle against the Philistines and the
Killing of Goliath*, 1425–52 (Museo
dell'Opera di Santa Maria del Fiore,
Florence), included burnishing of
the smooth surfaces and decoration
of the cuirasses with a variety of
pattern-ended punches

Ghiberti and his workshop took over a decade to finish their *Gates of Paradise* for the Baptistery in Florence (fig. 73); as might be expected in the work of a goldsmith, the entire surface was reworked to perfection (fig. 17).[4] But not all surfaces on a sculpture were finished equally: areas hidden from view, such as the back of Ghiberti's *St Stephen* (cat. 81), which was intended for a niche on the exterior of the Florentine church of Orsanmichele, were left rough.

Another important visual element of a bronze sculpture is its surface coloration. The bright metallic hue of a freshly polished cast may be preserved and even enhanced by protective coatings. However, just as often, the surface is altered to add colour by a variety of techniques such as chemical patination, gilding, inlaying and painting.

Patination is the process by which a metal surface acquires an aesthetically pleasing colour distinct from its fresh metallic sheen. This can be brought about intentionally or can result from natural processes. Under certain environmental conditions bronze tends to revert back to more stable mineral compounds similar to the ores from which it is derived. This corrosion process is irreversible. Some archaeological bronzes preserve their original detail and develop an appealing enamel-like patina during centuries of burial that ranges in colour from light green to mottled green and red, to lustrous black; only a few preserve their original metallic sheen. Others are disfigured by corrosion set off by salts in the surrounding soil. Throughout history, these disfiguring corrosion layers and pustules have generally been cut or ground away during restoration in an attempt to reveal the 'original surface' of the object. Both corrosion and these attempted recovery operations can account for the patchwork of colours and the disrupted surfaces that one finds on both archaeological and historical outdoor bronzes. Giovanni Francesco Rustici's figures of *St John the Baptist Preaching to a Levite and a Pharisee* (cat. 88) would originally have been a uniform colour coated in some kind of protective varnish, with gilding in selected areas such as the sandals and edges of the garments.

Patinas have also been intentionally induced, often in an attempt to re-create the palette of natural patinas. Experience in pairing chemicals with alloys and experiments with the sequence of application have afforded artists an ever broader selection of colours and textures to animate the metal surface.[5] Patina can also be achieved through the application of a coating: in the Renaissance, for instance, the rich brown, translucent varnish on Giambologna's *Mercury* (cat. 107) was made with an oil-and-resin mixture baked onto the surface.[6]

Gold has also been used to embellish bronzes throughout the ages. It can be laid over the bronze substrate as a sheet, as in the fourteenth-century BCE *Chariot of the Sun* from Trundholm (cat. 7). A more stable method of gilding metal consists of dissolving gold in mercury (a process that has been largely outlawed because of health hazards). The resulting 'amalgam' is painted onto the surface of the object, which is heated to evaporate the mercury, leaving a thin coating of gold bonded with the substrate. Such a surface can be highly burnished, as for example in the Yongle *Kapâla-Hevajra and Nairâtmya* (cat. 76).

Bronzes can also be polychromed in a variety of ways, as can be seen in a number of works here. The variations offered by chemical patination have already been alluded to, although one might add to this the patination of only select areas of the bronze, as in Constantin Brancusi's *Sleeping Muse* (Metropolitan Museum of Art, New York), where the hair is darkened but the flesh tones are highly polished. A similar contrast is achieved in reverse by very different means in Antico's *Bust of a Youth* (cat. 92): the flesh is chemically darkened, and the hair highlighted with gold.[7] Inlaying presents almost endless possibilities and was used as early as 3000 BCE. The *Baptistère de St Louis* (Musée du Louvre, Paris) is a fabulous example of damascene work, fashioned by hammering pre-cut pieces of copper, silver and/or gold into carved-out, undercut patterns in the metal substrate.[8] In masterfully cast nineteenth-century Japanese bronzes, such as Suzuki Chōkichi's *Twelve Hawks* (National Museum, Tokyo), the smith used *shakudo*, a copper-gold alloy that takes on the appearance of a rich black lacquer when patinated, to create patterns that contrast with the surrounding bronze. In the Riace bronzes (fig. 43) and the head of Seuthes III (cat. 26), as in many other statues from the ancient world, the eyes inlaid with coloured stone, bone, shell and glass, the copper lips, and the silver-coated teeth create an extraordinary semblance of life (fig. 18).

Bronzes may also be colourfully painted, as one can see in Jasper Johns's *Painted Bronze (Ale Cans)* (cat. 153). Historical documentation suggests that there are antecedents for this throughout the ages, although the colour is long gone, and it is only through close examination that one may still find traces of polychromy on bronzes that now look monochromatic. For instance, traces of bright red paint can still be found on the cloak of Germain Pilon's *Cardinal René de Birague* (fig. 82).

Charles-Henri-Joseph Cordier's *Jewess from Algiers* (cat. 133) is an example of lavish polychrome sculpture in which bronze plays only a part: her elaborate drapery is carved in Algerian onyx-marble, her eyes are inset pieces of amethyst, and the rest of the work is made of bronze, some of which is gilt and enamelled. And Alfred Gilbert was wildly experimental in combining polychromed bronze, gilding,

painted gesso, plaster on cloth, and semi-precious stones in his *St Elizabeth of Hungary* (cat. 136).

Not all bronzes are lost-wax cast: alternative processes consist mainly of variations in the mould-making process. Sand-casting is a type of piece-moulding. It consists in ramming special sand bonded with clay or synthetic resin over a model in order to fashion the impression that is to be filled with metal. The packed sand is contained by rigid frames. Sculptures with undercuts require sand piece-moulds, and are often cast in parts to simplify the mould-making. For hollow casts, the cavity shaped by the model is used to make a replica in sand, which is pared down to the desired thickness and then suspended in the cavity with spacers or wires.[9] The process was already in use in the Renaissance to cast simple shapes such as medals and utilitarian objects and was further refined for purposes of warfare and industry. It became the primary method of casting sculpture during much of the nineteenth century in France and allowed for the production of multiples until the reintroduction of lost-wax casting, which came about largely through the efforts of the founder Honoré Gonon, who felt that the process captured the details of artists' creative gestures more accurately. Antoine-Louis Barye, for instance, turned to lost wax when it became available.[10]

The Chinese Shang and Zhou dynasties' ritual vessels such as the *gui* (cat. 12) or the *zun* in the shape of an elephant (cat. 11) were made by another variation of the piece-moulding process. In this instance, moulds were made from a fine loessic clay common in northern China, a material that preserves its shape without distortion during firing. The number and disposition of mould sections varied depending on the shape of the vessel and evolved over time. As with sand-casting, the casting space is fashioned by shaving down the core. The mould seam lines are ingeniously integrated into decorative features, such as the protruding flanges at the corners. Clay piece-moulds of another kind were also used to cast the many large statues that surround the tomb of Maximilian I in Innsbruck (fig. 81).[11] The fact that this kind of mould is reminiscent of those used for making cannons may not be a coincidence: cannon (and bell) founders had the most experience with large moulds and greater amounts of bronze, and were often called upon to help cast large sculptures.

Yet another way of forming bronze is by hammering or raising a flat piece of cast metal to make a thin-walled form such as a piece of armour or a vessel. Through repeated hammering and tooling from front and back of the thinned metal sheet (repoussé work or repoussage), it is also possible to create detailed decorative reliefs. It is not uncommon to combine in one object parts produced by different methods. For instance, the decorative bands on the Derveni Krater (fig. 9) are repousséed, the body of the vessel is raised, and the handles cast.[12]

The fact that casting is an inherently reproductive process that allows for the production of multiples both during and after an artist's lifetime challenges the notion of originality of a bronze sculpture. Moulds do not always remain in the artist's control and can be used by others. Many so-called Rodin bronzes are posthumous productions. And what of Degas's bronzes? They were all cast after his death.[13] Existing bronzes can easily be used as models, spawning new generations of casts ('aftercasts' or *surmoulages*) that are often difficult to distinguish from their 'original' models. Even when bronzes are the fruit of intentional collaboration between a sculptor and a number of other highly specialised craftsmen (mould-makers, wax-makers, founders, chasers, goldsmiths, *patineurs*), it is not always the sculptor who oversees the project. Thus, accurately describing a bronze and wrestling with the notion of authorship are complicated issues.

Clues to how a work of art was made can be drawn from a variety of sources: archaeological finds, written evidence from treatises and archival materials, and visual documentation. But the works of art themselves have many compelling tales to share about the skill and care of the people who made them. Adriaen de Vries's relief of Vulcan at his forge (cat. 113), crafting the armour of Aeneas, reminds us not only of the collaborative nature of most metalwork, but also engages more than one of our senses if we let ourselves be transported into the scene. Muscles aglow from the strain and heat, the smiths wield their hammers in a choreographed pattern that intimates the rhythm of the blows. The miniature dents that represent their first strikes on the amorphous lump of metal on the anvil are a promise of the wonders to come. When one looks and listens close enough to this and the other resplendent fruits of similar labours shown here, how can one not surrender wholeheartedly to the age-old spell of what Homer described as 'unwearying' bronze?[14]

Fig. 18
Multicoloured inlays in the eyes, silver-coated teeth and inset copper lips contribute to the lifelike appearance of *Riace Bronze A*, 460–430 BCE (Museo Nazionale, Reggio Calabria)

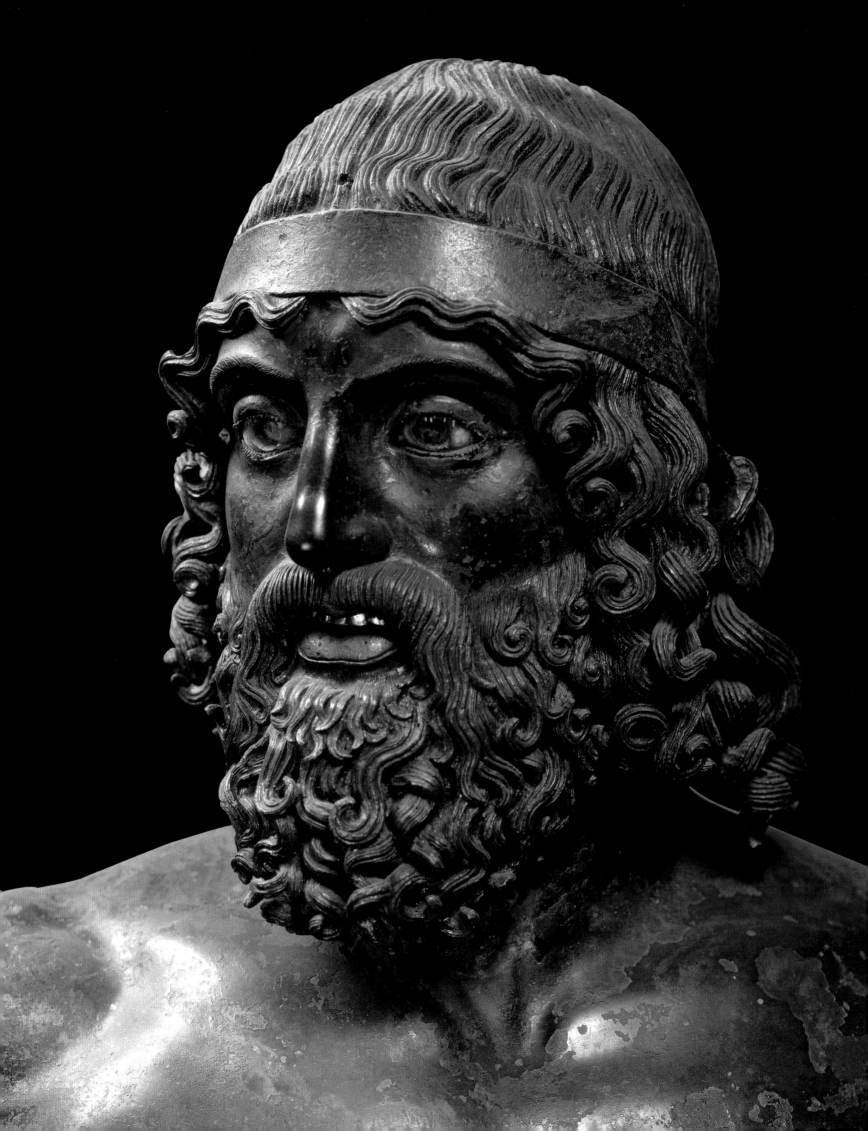

The Ancient Near East and Egypt

Timothy Potts

Beginnings

The earliest evidence for the working of copper comes from Neolithic villages in the 'fertile crescent' surrounding the Tigris-Euphrates river valleys of Iraq and into the highlands of Syria-Palestine, Turkey and Iran. By the seventh millennium BCE, lumps of naturally occurring 'native' copper were being hammered into pendants, awls, pins and other simple implements that had previously been fashioned from flint, obsidian (volcanic glass) and other stones. The date of the first smelting of copper from ores is difficult to determine but the steady increase in the appearance of artefacts at village sites over the next two thousand years implies a growing mastery of this more complex technology. Slag and other direct evidence of production remains elusive until the fourth millennium BCE, by which time copper was clearly the preferred material for awls, blades, axes, maceheads, spear heads and other tools, although stone also continued to be used.

The addition of tin to make true bronze developed slowly. Most early copper objects with low levels of tin or arsenic (which has much the same hardening effect as tin) – up to about 2% and 0.9% respectively – are due to the naturally occurring admixture of these metals in some copper ores. Isolated high-tin bronzes occur around 3000 BCE but it is not until the period of the Royal Tombs at Ur, c. 2500 BCE, that there is clear evidence of intentional alloying in Mesopotamia and southwest Iran, and even then practices vary considerably from region to region. A consistent preference for tin bronze does not appear until the Late Bronze Age, c. 1550–1200 BCE.

A hoard of 416 copper objects from a cave at Nahal Mishmar in Israel dating to the Chalcolithic period (c. 3700 BCE) is the earliest and by far the most spectacular evidence of a developed copper-casting tradition. Comprising mace heads, 'standards', cylindrical 'models' and vessels – some of all these types decorated with animals – this exceptionally rich and varied find indicates that the lost-wax casting of copper had reached a high level of technical and artistic sophistication before the emergence of large urban centres, writing and the other traditional touchstones of 'civilisation'. The works shown here (cats 1–5) include a horn-shaped vessel, a unique vulture standard and a crown-shaped object with two goat heads on its rim, probably a model animal enclosure or pot stand. Most numerous of all were a rich variety of mace heads, many with animal, geometrical and in one case human decoration. Some of the mace heads were cast integrally with a hollow shaft, which would have been attached to a wooden handle or pole.

The copper used for the Nahal Mishmar hoard, which occasionally displays elevated arsenic contents, was almost certainly mined in the Sinai Peninsula or Wadi Arabah, the latter a major focus of mining activity throughout the Bronze and Iron Ages and often proposed as the locale of King

Solomon's mines in the Old Testament. The other major sources of copper known from textual or archaeological evidence to have been exploited during the Bronze Age lay in the highlands of Turkey and Iran, as well as Oman, Cyprus and the Eastern Desert of Egypt. Although these sources are sometimes distinguishable by their trace elements, the prevalence of trade in metal ingots and the widespread practice of recycling damaged objects ensured that a large proportion of newly cast bronzes were of metallurgically mixed origins.[1]

As a valuable commodity, large-scale sculpture in copper/bronze would have been restricted principally to palaces, temples and other institutional contexts where it functioned as a vehicle of royal propaganda and sacred ritual. Unfortunately, hardly anything of this once spectacular body of material now survives and we must face the fact that our histories of sculpture and the applied arts for this period (excepting Egypt) are based on mere fragments, mostly of secondary quality. The different purposes of what we regard as 'art' in Near Eastern cultures must also be borne in mind. Sculpture of any significant scale that served a purely decorative function (the equivalent of Pompeii's 'garden sculpture') is virtually absent, and sizeable objects created purely for their decorative or aesthetic appeal remain elusive. The overwhelming majority of Near Eastern sculpture and other representational bronzework consists of surface decoration and decorative elements that form part of utilitarian objects: furniture, vessels, ritual objects, pins and dress ornaments, tools, weapons and armour, and horse trappings.

The Rise of Cities

By 3000 BCE the first urban, literate city-states were established along the Rivers Tigris and Euphrates in Sumer (southern Iraq), and smaller centres of religious and administrative authority were growing in importance along the Nile in Egypt. This newly urban life depended critically upon trade for obtaining metals and other raw materials, bringing in its wake a regular interchange in ideas,

technologies and artistic practices. Throughout the Bronze Age (c. 3200–1200 BCE) ingots of copper and tin were the mainstays of far-reaching trade networks extending from Afghanistan and the Indus Valley (Pakistan) in the east to Egypt and the Levant in the west, and thence by boat around the Mediterranean Sea. Other regularly traded materials included silver and gold, lapis lazuli and carnelian, glass and ivory, as well as finished luxury items of jewellery, pottery, textiles, weapons and works of art. Texts relate the exchange of lavish diplomatic gifts between the courts of the Babylonian, Hittite and Egyptian kings, and the taking of vast quantities of booty in battles between these and other states of the Near East, all of which resulted in significant movements of copper/bronze ingots and artefacts throughout the region.

By the mid-third millennium BCE, the key technologies for working these metals had also been mastered, in particular: open-mould and lost-wax ('investment') casting; the hammering of sheet copper over a wood/bitumen core for larger sculpture; the raising of low-relief decoration from the back (repoussé) and front (chasing) of sheet copper; and the use of solders, both 'soft' (lead-tin) and 'hard' (copper-based), for assembling complex objects. Precious sculptures might receive a gold or silver overlay, especially to faces and hands (fig. 28).

From cuneiform sources it is clear that the temples of Mesopotamia were adorned with sculptures of gods and sacred animals, and its palaces with images of kings and protective demons. Cult statues of the gods were the most luxurious of all, crafted in combinations of gold, silver, bronze, lapis lazuli and other precious materials, but unfortunately no certain examples of these have survived. The closest we come is a large Sumerian copper-alloy relief of c. 2500 BCE from a temple of Ninhursag at Tell al-Ubaid near Ur that probably originally stood above the main door to the temple (fig. 19). Showing the lion-headed eagle Imdugud grasping a pair of deer in its talons, the relief was made of sheet copper hammered over a wood and bitumen core. This same technique was used for a series of bull sculptures found

Fig. 19
Relief of Imdugud and Deer,
Tell al-Ubaid, Sumer, South Iraq,
c. 2500 BCE. Copper alloy, lead,
bitumen, 259.1 x 106.7 cm
British Museum, London, BM 114308

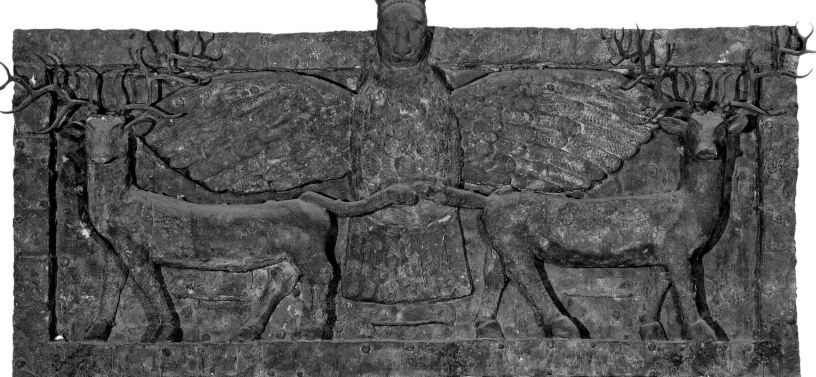

with the Imdugud; other animal heads from the temple are solid-cast.

The Imdugud relief provides a rare glimpse of the increasing artistic and technical sophistication of Sumerian copper/bronzework, and illustrates the important role that animal imagery played in Mesopotamian religion. Both real and imaginary animals (the latter sometimes partly human) constitute a recurrent theme in Near Eastern art, where they feature as elements of the natural landscape, victims of the hunt, and as the sacred companions or embodiments of gods and kings. Another example is the Sumerian foundation peg inscribed for Gudea, the Sumerian governor of Lagash in c. 2100 BCE (cat. 6), that shows a calf among sprouting plants. The inscription indicates that it was originally buried under the corner of a temple to Nanshe, where it was intended for the eyes of the gods. (Other foundation pegs often show the king or governor as the temple's builder, symbolically bearing a basket of soil [fig. 22]). Bulls, deer and mountain goats also appear on contemporary vessel stands in Sumer and Iran, and far to the north on a spectacular series of 'standards' (some probably chariot fittings) in a strikingly minimalist style found in the 'royal tombs' at Alaça Höyük in Turkey (fig. 20). Hybrid animal-human creatures too are attested. One intriguing type, that seems to be at home in western Iran or Sumer and dates to c. 3000–2800 BCE, is of a powerful striding man (a shaman?) with a beard and goat horns who wears a distinctive vulture cape and curled highland boots (fig. 21).

Many of these works combine in varying degrees two complementary approaches to the construction of figurative images: on the one hand the careful observation of natural forms and details and, on the other, a stylising minimalism in which lines become more fluid, divisions of musculature and physiognomy more articulated, and textures of hair and fur more patterned. This 'stylised naturalism' reaches a pinnacle of aesthetic and technical perfection in the art of the Akkadian empire (c. 2334–2154 BCE), which itself represents one of the highpoints in ancient Near Eastern art. The most celebrated Akkadian object of all is the life-size head of a king (fig. 5) – most likely Sargon of Akkad or his grandson Naram-Sin – from Nineveh, no doubt part of a full-figure statue of mixed materials originally placed in the king's palace or as an offering to a temple. This is one of the earliest large-scale, hollow-cast sculptures to have survived from the ancient world, which makes all the more remarkable the exquisitely fine rendering of hair, beard and facial features. An unprecedented technical and artistic achievement, it provides a rare glimpse of the heights that a major sculpture by a court artist of this time could attain. Later Assyrian and Babylonian art may sometimes be grander

Fig. 20
Stag Standard, 'royal tomb' B,
Alaça Höyük, c. 2300–2200 BCE.
Bronze and silver, height 52.5 cm
Museum of Anatolian Civilisations, Ankara, 11878

Fig. 21
*Statuette of Striding Demon (or
Shaman?)*, Sumer or western Iran,
c. 3000–2800 BCE. Arsenical copper,
height 17.2 cm
The Metropolitan Museum of Art, New York.
Purchase, Lila Acheson Wallace Gift, 2007,
2007.280

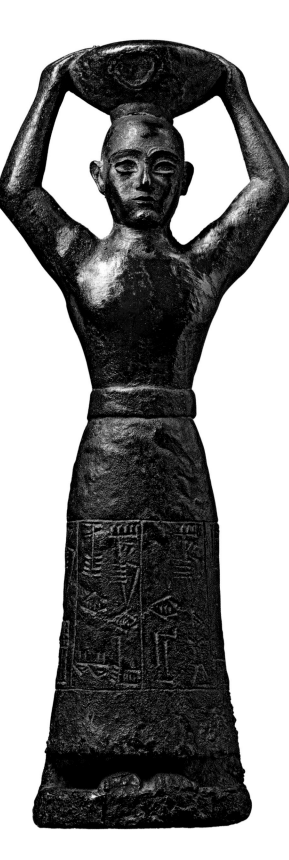

Fig. 22
*Foundation Peg of King Ur-Nammu
Bearing a Basket*, Sumer, South Iraq,
c. 2097–2080 BCE. Copper alloy,
height 33.5 cm
Morgan Library, New York, MLC 2628

or more spectacular, but nothing matches the purity of style and excellence of execution of this head and the finest Akkadian relief sculpture in stone.[2] Indeed it seems to have been recognised as a masterpiece even in antiquity, surviving for over 1,500 years until the sack of Nineveh by the Babylonians and Medes in 612 BCE, there to be found by British excavators over 2,500 years later in 1931. The gouging of the ears and one of the eyes was probably an act of symbolic desecration by the invaders.

A more veristic naturalism is rare in pre-classical art but sees a few brief flowerings. From the same time and culture as the Nineveh head comes the lower half of a copper statue of a naked, crouching 'guardian of the gate' holding a standard and dated by its inscription to Naram-Sin (fig. 25). The top half of the sculpture is lost but the surviving legs and feet are modelled with an assured and entirely convincing fidelity.[3] When complete the sculpture is estimated to have weighed around 200 kilograms. From the same period or a little later comes the head of an unknown ruler (fig. 23) whose rounded nose and out-turned ears suggest an explicit attempt to capture a more individual likeness. Subtle as the differences between this and the Nineveh head are, they create an entirely different effect.

Further afield in Egypt we see similar evidence both of elegant stylisation – this being the predominant and most enduring approach to image-making throughout pharaonic history (see cats 19, 30) – and, more rarely, of attempts to convey a heightened sense of individuality. Textual sources speak of a large copper statue of King Khasekhemwy of the Second Dynasty (c. 2667–2649 BCE) and of two copper funerary sun-boats, each one over four metres long, of the Fifth Dynasty pharaoh Neferirkare (c. 2446–2426 BCE) but nothing of this scale and date now survives.[4] The earliest evidence of sizeable copper-working are the life-size striding statues of Pepi I (Sixth Dynasty) and his son (fig. 24), c. 2289–2255 BCE, both shown naked except for their now-perished kilts.[5] As with contemporary sculpture in Sumer, these statues consist of hammered copper over wooden cores; the possibility that the extremities of some limbs were cast has been suggested but not confirmed.

Shown almost naked and with only the now-perished crown to distinguish him from statues of high officials,

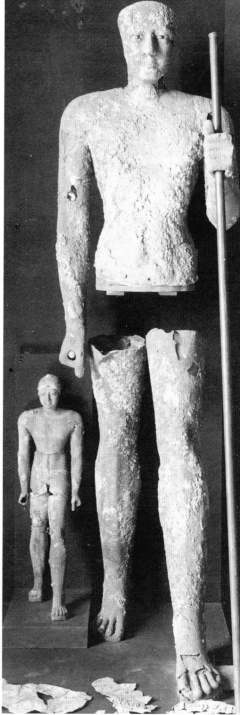

Fig. 23
Head of a Ruler, Mesopotamia or western Iran, *c.* 2300–2000 BCE. Copper alloy, height 34.3 cm
Metropolitan Museum of Art, New York. Rogers Fund, 1947, 47.100.80

Fig. 24
Statues of Pepi I and His Son, Hierokonpolis, Egypt, Sixth Dynasty, reg. c. 2289–2255 BCE. Copper, gilt gesso, wood, height 177 cm
Egyptian Museum, Cairo, JE 33034, 33035

Fig. 25
Statue of a Crouching Hero ('Guardian of the Gate') Holding a Standard, Akkadian, reign of Naram-Sin, Bassetki, near Dohuk, Iraq, 2220–2184 BCE. Copper, hollow cast, probably in piece mould, diameter 67 cm
Iraq Museum, Baghdad, IM77823

Fig. 26
Bust of Amenemhet III,
Twelfth Dynasty, 1842–1797 BCE.
Copper alloy, height 46.5 cm
George Ortiz Collection, Geneva

Fig. 27
Statuette of a Man or Deity,
Hittite, *c*. 1400–1200 BCE.
Bronze, height 21.5 cm
Amasya Library, Turkey

Fig. 28
Statuette Dedicated by Lu-Nanna,
Larsa, Babylonia, Iraq, reign of
Hammurabi, *c*. 1792–1750 BCE.
Copper and gold, height 19.6 cm
Musée du Louvre, Paris, AO 15704

Fig. 29
*Statue of Queen Napirasu, Wife of
the Elamite King Untash-Napirisha*,
Temple of Ninhursag, Susa, Iran,
c. 1250 BCE. Bronze and copper,
height 129 cm
Musée du Louvre, Paris, Sb 2731

King Pepi strikes a surprisingly amiable figure, not remotely fearsome or intimidating. His face has real character but it is hard to tell whether this reflects a true likeness or just the current image of benign kingship. A more explicit naturalism, strikingly at odds with the iconic otherworldliness of most Egyptian art, emerges in the portraits of some pharaohs of the Middle Kingdom, who are shown with the sunken cheeks and weary stares of middle-aged men. Most of these 'portraits' are in stone; a nearly life-size torso of Amenemhet III (fig. 26) is one of the rare large-scale works to survive in copper alloy, its musculature modelled as sensitively as the face to produce an image of pharaonic authority that emanates not so much power as stewardship. The particularity of the image conveys an altogether new sense of corporeal and psychological presence that is more personal and more affecting than anything in earlier Egyptian art.

Among other distinctive schools of sacred and royal imagery at this time considerable interest attaches to the reliefs and three-dimensional sculpture of the Hittites of central Turkey, whose empire at times challenged the Egyptians for control of Syria-Palestine. An expressive rendering of ageing strength is seen in a statuette of a deity (fig. 27) dating from about 1400–1200 BCE. This stands out conspicuously from the highly stylised renderings of the human body in most Hittite and Syria-Palestinian art – a reflection no doubt of their ritual and ceremonial purposes.

One of the major functions of Mesopotamian statuary was to represent the donor, or the king he served, in the act of worship, thus perpetually fulfilling a vow or commitment to the deity. One such *ex voto* statuette shows the dedicant down on one knee and touching his mouth in a gesture of reverence (fig. 28). The inscription on the base describes the statuette as a suppliant made of copper with a gold-plated face, and indicates that it was dedicated by the official Lu-Nanna to the god Amurru 'for the life of' King Hammurabi of Babylon (*c*. 1792–1750 BCE). A scene in relief on the plinth shows the worshipper again in the same kneeling stance in front of the god Amurru, adding yet another layer of self-reference to the play of images that stand in for the nominal agent.

A life-size standing statue of an Elamite queen, Napirasu – one of a series of large Middle Elamite bronzes of rulers and cultic scenes found at Susa in southwest Iran[6] – is a remarkable solid casting weighing 1,750 kilograms even in its incomplete state (fig. 29). Aside from its extraordinary

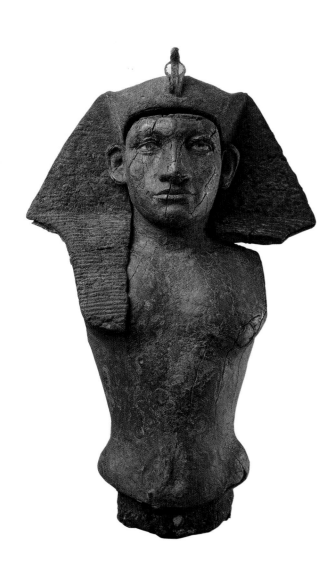

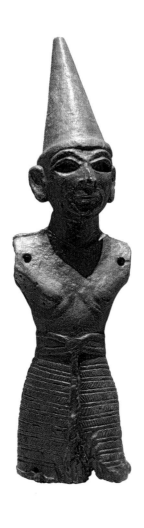

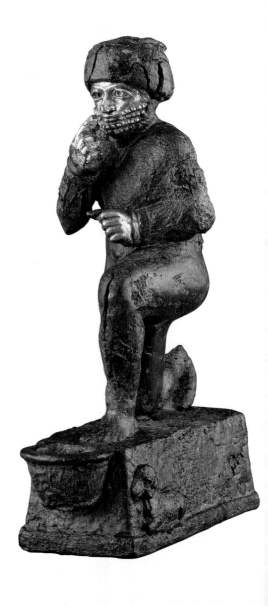

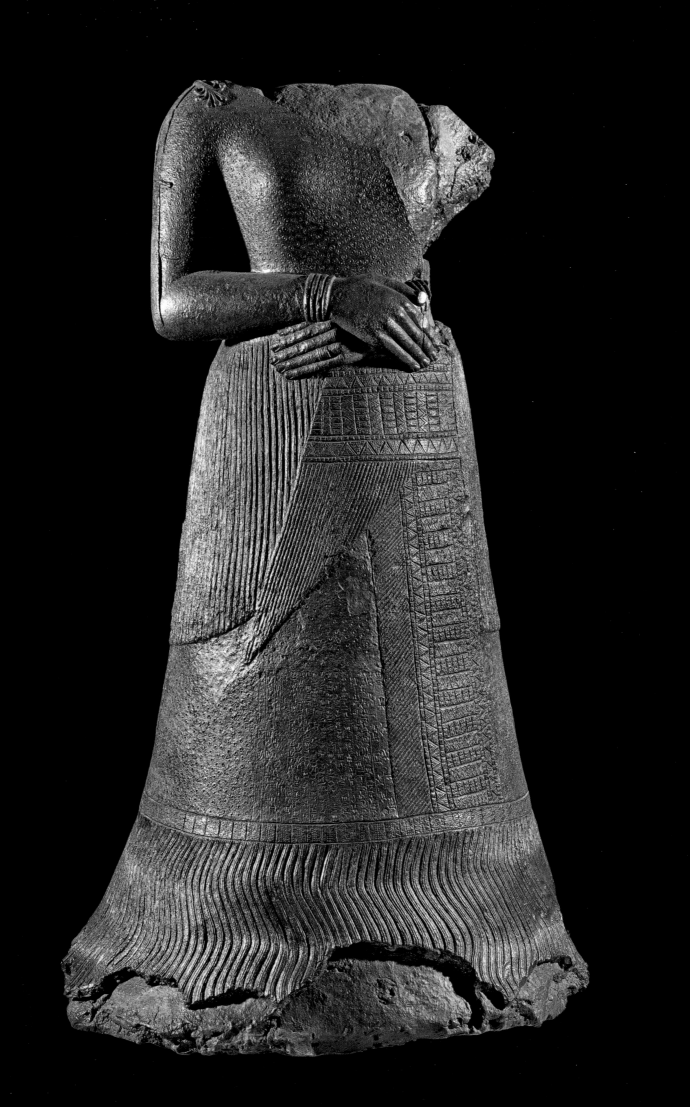

technical interest (a core of solid bronze pourings overlaid with a skin of copper), its artistic quality is most apparent from the sensitive modelling of the queen's clasped hands. The bell-shaped garments of her lower body function principally as regular surfaces to carry the various intricate patterns in the drapery that were cast and chased into the copper surface.

Beyond Iran lay the Harappan civilisation of the Indus River valley, a major urban culture of the later third and early second millennium BCE known to the Sumerians as Meluhha. Standing out from the utilitarian bronzes recovered at its sites is a strikingly original figurine from Mohenjo-Daro showing a naked girl holding a cup in one hand (fig. 30). Despite the small scale and stick-figure rendering of the girl's body, the work conveys a remarkable sense of life in the nonchalant hand-on-hip pose – even if the excavator's characterisation of her as a dancer is unlikely.

The Coming of Iron

The end of the Bronze Age, c. 1200 BCE, was marked by a widespread series of destructions at sites across the eastern Mediterranean Sea, from Greece and Turkey through the Levant to Egypt, where the marauding 'Sea Peoples' – both perpetrators and victims of the unrest – were eventually repelled. In some regions, including Greece, this was followed by a 'dark age' of reduced literacy and impoverished material culture, although the break seems not to have been as complete as was once believed. Further east in Mesopotamia and Iran, there is no clear interruption in culture, although these regions too were affected by movements of new peoples (among them various Indo-Iranians and Aramaeans) that the disturbances put in train.

The succeeding Iron Age (c. 1200/1000–330 BCE) saw the development of iron extraction and manufacturing technologies that made this metal gradually available as a more expensive supplement to bronze, especially for the working surfaces of tools and weapons, where its greater hardness commanded a premium. This did not however spell the demise of bronze, which remained the staple base metal for cast sculpture and many utilitarian objects for some centuries; iron became cheaper than bronze only in the Neo-Babylonian period (sixth century BCE). As with bronze, the main sources of iron were in the highlands, especially Turkey. In the Old Testament the Philistines are said to have held a monopoly on iron until their defeat at the hands of King David, traditionally dated c. 1000 BCE.

Among the new cultures to emerge around this time were the transhumant nomads of Luristan in western Iran, who were buried with surprising quantities of decorated bronze 'finials', pins, vessels, axes/adzes, daggers, horse-bits and other implements. The rich repertoire of human and animal and hybrid figures, illustrating an iconography radically different from neighbouring Assyria and Babylonia, is difficult to interpret in the absence of textual sources but has been much studied for its artistic interest. The examples displayed here include a horse-bit with cheek pieces of human-headed bulls together with a central figure attacked from behind by a lion (cat. 17). The long necks of the lions illustrate the thorough-going stylisation of animal forms that characterises this tradition, also seen on the 'finial' with symmetrical goats, each again attacked from behind by a long-necked lion (cat. 15). Utilitarian objects such as axes were also widely decorated, the one here receiving a row of animal heads along its butt (cat. 16).

As the evidence from Luristan demonstrates, sophisticated bronzeworking traditions were not restricted to the major urban centres but thrived also among some nomadic peoples of the Near East. This is nowhere more true than with the 'peoples of the steppe' who occupied a vast expanse of territory across the northern latitudes of Eurasia, from the Scythians north of the Black Sea to the Xiongnu of Mongolia. The nomadic lifestyle of these largely Turkic and Mongolian tribes as herders of horses, sheep and cattle is reflected in their richly decorated horse trappings, belt buckles and other 'animal-style' ornaments, featuring horses and deer (often with bird heads at the tips of their antlers) being attacked by felines and other predators.

The empires of Assyria and, later, Babylonia reached their maximum extent in the Iron Age and their arts continued to exert considerable influence on other cultures of the Near East. Assyrian depictions of complex narrative scenes, previously known almost exclusively from relief carvings in stone, appear now in copper/bronze, notably as decorations attached to the wooden gates of temples and palaces. Most of those that survive are mere fragments, with the notable exception of the bands from the gates of a Temple of Mamu at Balawat (near Nimrud), which illustrate the military campaigns of the ninth-century BCE kings Ashurnasirpal II and Shalmanesser III. The example illustrated here (fig. 31) shows tribute being offered to the Assyrian king from the Phoenician cities of Sidon and Tyre. The images are created in low relief by repoussé and chasing, with engraving (one of its earliest attested uses) used for internal detail and cuneiform inscriptions. Similar repoussé and chasing decoration was also used for Assyrian vessels in the form of animals' heads, goblets and other portable objects. Solid-cast figurines of

Fig. 30
Statuette of a Girl, Mohenjo-Daro, Pakistan, c. 2600–1900 BCE. Copper alloy, height 10.2 cm
National Museum, New Delhi, 195

this period consist mostly of apotropaic images of demons such as Pazuzu (fig. 32).

A body of larger, more spectacular Assyrian and Babylonian bronzework has perished almost entirely from the archaeological record. Assyrian kings boast in their inscriptions of making massive bronze doors and solid-cast colossal bulls and lions – essentially copper versions of the famous winged guardian statues in stone found at the Assyrian palaces of Nimrud, Khorsabad and Nineveh – each weighing a phenomenal 43 to 86 tons.[7] Nothing of these survives, and what we do have of other royal bronzes are fragments: remains of throne decorations from Nimrud in copper repoussé showing figures and ornaments, along with cast ram and bull heads; scraps of a large copper sculpture of a caryatid deity holding a vase issuing flowing water, from Assur; and a headless statuette of King Ashur-Dan II of the tenth century BCE.[8] Massive bronze gates were a feature also of Babylon (sixth century BCE), where Herodotus reports that 'there are a hundred gates in the circuit of the [city] wall, all of bronze with bronze uprights and lintels'.[9]

The lion was the royal animal *par excellence*, embodying the king's strength and valour in battle and serving as the natural victim of his prowess in the hunt, most famously on the stone bas-reliefs from Ashurbanipal's palace at Nineveh.[10] In such palaces, and those of the Babylonians and Achaemenid Persians after them, bronze lions were also used as weights (fig. 34). Although safely recumbent, the roaring faces and well-muscled bodies of these beasts retain a sense of their regal grandeur. The Urartians, Assyria's neighbours to the north, were also highly proficient metalworkers, as is illustrated by the remains of throne fittings in the form of bronze bulls and other animals, some of them incorporating stone inlay (fig. 33).

Trade and colonisation throughout the Mediterranean during this period led to an unprecedented level of cultural cross-fertilisation. The greatest sea traders of all were the Phoenicians, whose pottery, glass, metalwork, ivories, jewellery and sculpture, itself much influenced by Egypt, had a formative impact on Greek and Etruscan art of the later eighth to seventh centuries BCE, which is thus known as the 'Orientalising Period'. Griffins, sphinxes, rows of grazing animals, fertility goddesses and other eastern elements appear now in the arts of the Aegean, Italy and Spain, as well as the colonies in

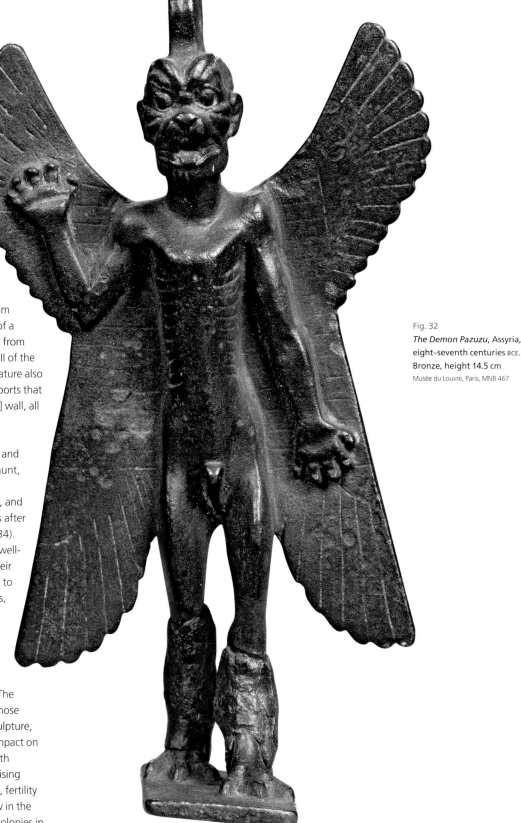

Fig. 32
The Demon Pazuzu, Assyria, eight–seventh centuries BCE. Bronze, height 14.5 cm
Musée du Louvre, Paris, MNB 467

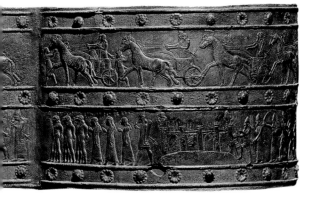

Fig. 31
Band from the Gates of King Shalmanesser III Showing Sidon and Tyre Offering Tribute, Balawat (ancient Imgur-Enlil), Assyria, northern Iraq, Neo-Assyrian, 858–824 BCE. Bronze, 27 x 180 cm
British Museum, London, ME 124661

Fig. 33
*Winged Human-headed Lion
(Throne Decoration)*, Urartu, Turkey,
eighth century BCE. Bronze and stone,
height 16 cm
State Hermitage Museum, St Petersburg, 16002

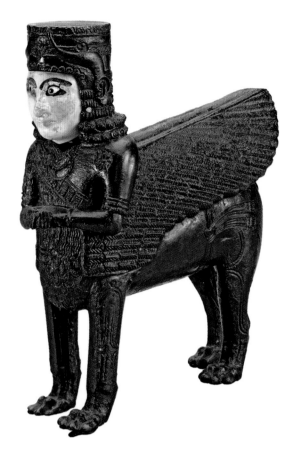

north Africa, where Carthage soon overtook its motherland as the centre of Phoenician power.

One of the most distant manifestations of Phoenician influence is the spectacular winged lion (cat. 21) thought to be from Tartessos on the Atlantic coast of Spain (Andalucia), a region famous in classical times for its wealth in metals. This magnificent beast, probably part of a throne, is not however a straightforward imitation of a Phoenician or Greek image: the artist has adapted the type to local style and taste. In a similar way, the artists of the Achaemenid Persians – masters of the largest empire the world had ever seen (c. 539–330 BCE) – took many basic types and models from Babylonian art but adapted them into supremely elegant stylisations of the human and animal form (fig. 35), bringing to a climax the process begun in the Akkadian period two millennia earlier. Greek craftsmen are known to have worked on the construction of Darius' palace at Persepolis, adding another layer to the eastern influences at play in the evolution of Archaic Greek art.

For most of pharaonic history, Egyptian culture had been largely a world unto itself, influencing, sometimes dominating, its neighbours but eschewing influence from them. Even the foreigners who periodically overran the country tended to adopt Egyptian ways rather than vice versa. Thus the statuettes of gods and their sacred animals that were produced in their thousands to be offered in temples during the Late Period (cats 19, 30) are conceptually and, for the most part, stylistically at one with works created a millennium and more earlier.

This cultural imperviousness was not seriously weakened until the conquest of Egypt by Alexander the Great in the late fourth century BCE opened the way to Greek (Ptolemaic) and then Roman rule. Portrait sculpture in particular often now adopts a classicising naturalism that can be at odds with the still-conventional dress and stance of their subjects, as are the 'painted' wax portraits in Roman style that were affixed to traditionally prepared mummies.

Even in this thoroughly hybrid culture, however, artistic environments created for sacred and royal worship continue to adhere to age-old pharaonic principles, as in the altar-table top in Turin (cat. 39). The iconography of the gods and their attributes here makes little if any

Fig. 34
Lion Weight, Khorsabad, Assyria,
northern Iraq, c. eight–seventh
centuries BCE. Bronze, length 63 cm
Musée du Louvre, Paris, Sb 2718

concession to classical principles. But neither did the craftsmen who made it – whether Egyptians or Romans – really understand the artistic tradition they were attempting to perpetuate, as the nonsensical hieroglyphs confirm. The inlaying of bronze with silver and gold already had a long history in Egypt for weapons and other small objects but applications at this scale are unusual and testify to the importance this object had within the cult of Isis in Roman Egypt.

The head of a young man from Yemen with long, corkscrew hair (cat.41) may be tentatively dated to the second century CE, when there was an active trade in frankincense, myrrh and other spices from this area – known to the Romans as Arabia Felix – along the Red Sea and on to Rome. Roman imperium in the east brought with it the trappings of classical culture that we see in this head, which probably represents one of the Dioscuri, the divine twins Castor and Pollux, who are typically depicted riding horses

(fragments of which were also found). Although by no means purely Roman in style, it is worlds apart from the alabaster heads of the contemporary native Sabaean tradition.

The classical tradition had a more transformative impact on art at the eastern extremity of the Greco-Roman world, especially in Gandhara (Afghanistan and northern Pakistan) where the musculature and drapery of Buddhist imagery of the first–third centuries CE are clearly derived from western models. The life-size statue of a Parthian prince from Iran (fig.36), although geographically closer to Rome, draws rather on Achaemenid models – a trend that becomes even more pronounced in the succeeding Sassanian dynasty. With the coming of Islam in the seventh century the tradition of large-scale figurative bronze sculpture in the Near East was supplanted by the decorative embellishment of bronze vessels and other functional objects. Artistically a new world had begun.

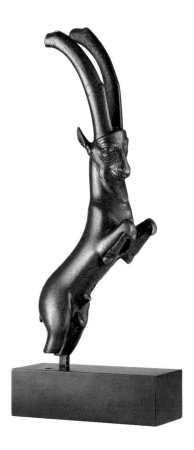

Fig. 35
Vessel Handle in the Form of an Ibex, Iran, Achaemenid Dynasty, c. fifth–fourth centuries BCE.
Bronze, height 19.1 cm
George Ortiz Collection, Geneva

Fig. 36
Statue of a Parthian Prince (detail), first century BCE – first century CE.
Bronze, height 194 cm
National Museum of Iran, Tehran

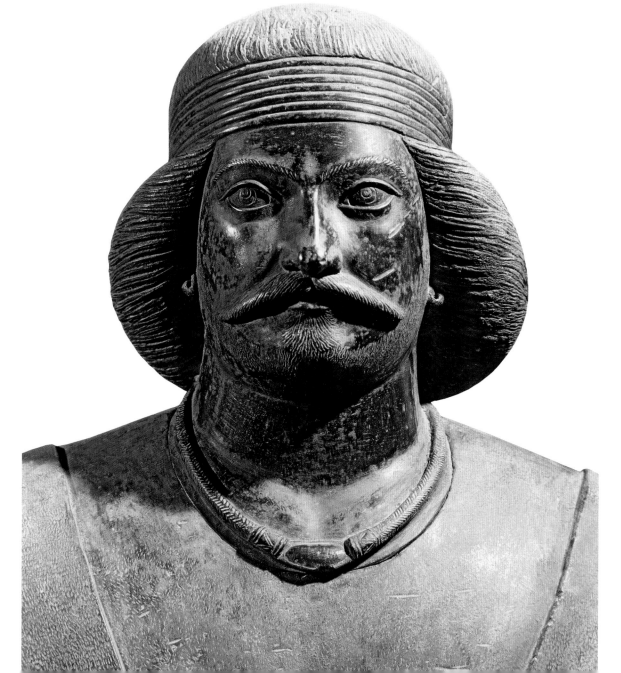

Chinese Bronzes

Jessica Rawson

A shallow bronze basin with a long inscription is one of the most famous and treasured bronzes in China (fig. 37). It is known as the Shi Qiang pan, Shi Qiang being the person who commissioned it and pan the word for a basin. The early Chinese chose to cast bronze vessels for the performance of important religious rituals, such as the offering of food and drink to their ancestors. So venerated were these bronzes that their owners had them inscribed to memorialise major events. The long inscription in the centre of the Shi Qiang pan gives an account of the kings of the Zhou royal house alongside that of the family to whom the basin belonged. In no other area of Eurasia do we find anything similar among many diverse bronze-working traditions. And such Chinese bronzes were not singletons. Literally thousands of bronze vessels for food, alcohol and water, many of them superlative works of casting and aesthetic impact, were produced in the Shang (1500–1045 BCE) and early Zhou (1045–771 BCE) periods.[1]

The Shi Qiang pan was found in a large hoard of bronzes all belonging to one family – but to members of different generations, buried when their owners were forced to flee from the Wei River eastwards, as outsiders from the steppes launched an attack in 771 BCE at the centre of the Zhou kingdom.[2] No expense was spared in material or craftsmanship in creating these vessels. Bronze was very rarely used for high-quality weapons, such as the Shang axe from Cologne (cat. 8). The early dynasties of China, indeed, presided over a bronze vessel age.

Why did the ancient Chinese sink so much valuable material and so much aesthetic endeavour into casting vessels, a genre of bronze-working rarely a priority elsewhere? Such bronze vessels as were cast in Western Asia or the ancient Mediterranean world were as a rule small and generally little ornamented. The majority of vessels in those regions were forged, while weapons, tools and sculpture dominated bronze production.

The need to honour ancestors with offerings was not the only factor in dynastic China's unusual choice. Several other concerns took the inhabitants of

Fig. 37
The Shi Qiang pan, Western Zhou dynasty, ninth century BCE. Bronze, height 16.8 cm, diameter 47.2 cm
Zhouyuan Administrative Office of Cultural Relics, Fufeng

the Yellow River valley in this direction. The first was that, as bronze-working arrived late in the Yellow River basin and was not it seems invented there,[3] other longstanding indigenous crafts – particularly ceramic manufacture and jade-working – were complicit in the ways in which bronze was absorbed into central China. For the purposes of this account, our attention is to the heart of early China, which lay along the central Yellow River basin. Both the northwest, through which bronze came from Siberia and further west, and the Yangtze River basin, to which the Shang bronze tradition spread, lay outside central China as here described.

In other cultures, the earliest use of metals was for personal ornaments. But, from about 5000 BCE, many groups living in different regions of present-day China adopted jade for ear ornaments and neck pendants and for ceremonial pieces, such as discs and sceptres.[4] Inhabitants of the Yellow River basin were not attracted by and thus felt no need to look for other coloured stones. They did not seek out malachite, for example, which might have led them towards sources of copper.[5] Their preference for jade may thus have inhibited experiments that might have led to metallurgy, and may even have prevented a search for metal ores. Thus, when metalworking was eventually introduced to central China from the northwest, it was encountered and accepted by the Chinese in a very fully developed form.

The purposes for which bronze was adopted in China included vessel-casting. This choice was determined by very early and highly developed ceramic-making traditions, which were closely linked to a longstanding practice of boiling and steaming food. As with bronze, the development of ceramics in the ancient world was uneven. China is famous for some of the very earliest ceramics in the world (from the astonishing date of c. 16000 BCE), and such vessels were used for boiling nuts, acorns and other foods to make them digestible.[6] In due course, rice, millet and later wheat were adapted to these forms of cooking. On the other side of Asia, grinding of grain for baking bread and roasting of meat over open fires or in ovens were alternatives; in consequence, ceramics developed later, more slowly and less inventively in regions west of the Tibetan massif.

When the Chinese eventually acquired the technique of bronze-making in around 1700 BCE, they turned to replicating their very fine ceramics, some of which were probably already made for ritual or burial purposes, as models. An elegant, lobed wine vessel, *jia*, from Cologne (cat. 10) illustrates directly the dependence of the Shang bronze vessels on their ceramic counterparts, such as a tri-lobed jug from a late Neolithic culture (fig. 38). Pottery cooking pots with three legs or three lobes, which could be placed over a fire to warm and cook food, were used by

many diverse groups of early farmers in both the Yellow River basin and the Yangtze region.

Translated into bronze, these almost sculptural forms attained a yet more formidable presence, especially for those élites who owned large numbers. When massed together, these vessels must have presented an overwhelming impression of the force and power of the ancestral spirits to whom the offerings were directed. The importance of food offerings and the need to boil and steam these offerings were the reasons why vessels and not weapons dominated the new bronze industry.[7] And it was in such vessels that the powers of the living and of the spirits were presented with an overwhelming material emphasis on bronze, both in rows on an altar or in movement in a ritual banquet (fig. 39). Deities in human form were not part of the visual vocabulary of the Shang and the Zhou and did not make a significant appearance in either bronze or stone in central China until the Han dynasty (206 BCE – 220 CE) and later with the introduction of Buddhism from the fourth century CE.

Although sculpture of human figures and animals was minimal in the principal central Chinese bronze traditions, Chinese craftsmen were masters of surface ornament that matched and enhanced their chosen vessel shapes.[8] Here too China's extraordinary ceramic tradition was manifest. Once again, the lobed vessel from Cologne (cat. 10) exemplifies the way in which a strongly articulated shape could be combined with a few salient relief elements: upright posts with caps on the lip, an animal's head on the handle and a small flange. But it is above all to the lobes that attention should be given. On each of these is a meticulously executed animal face, traditionally called a *taotie*, with eyes, jaws and ears and a long extension at the rear, set conspicuously against very fine angular spirals, known as *leiwen*. Intaglio rounded spirals across the face are bolder and balance the background.

Such exceptional detail was achieved only as a consequence of the ceramic piece-moulds used for casting. In Western Asia, the ancient Mediterranean world and Europe, lost-wax casting dominated, enabling sculptors to suggest fluent bodily movement. China, following its strong ceramic tradition, did not use lost-wax casting on any scale until it was introduced with Buddhism. Indeed, moulding may already have been developed to make complex ceramics in the later Neolithic period (fig. 38). Some of the similar containers with three lobes may have been formed within a mould, possible a two-part mould, and then joined with the upper part of the body to make a complete piece. The moulds for bronze vessels were initially formed of fine, sandy loess clay around a model of the proposed bronze. As the

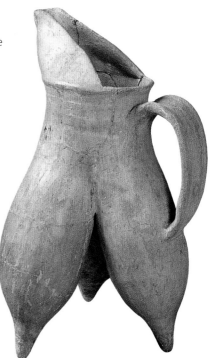

Fig. 38
Lobed Ewer, early second millennium BCE. White earthenware, height 22.5 cm. Excavated at Gongyi, Henan
Henan Provincial Museum

model was also of clay, the mould had to be cut off in sections and reassembled around a core before the bronze was poured. In the case of the Cologne *jia*, the principal divisions of the mould sections ran down the centre of the lobes. As the clay used for the moulds was very fine-grained, extremely detailed motifs could be achieved in it and realised on the bronzes.[9]

This decoration has been studied in detail, and a chronology of successive styles was proposed as long ago as 1953.[10] Relatively simple face patterns were succeeded by the more elaborate version seen on the *jia* and then by decoration in relief, as on the basin, *gui*, in the Fitzwilliam Museum (cat. 12). Elaboration of the face ornament took place throughout the Shang period, but there were differences in the complexity of decoration that reflected other factors too. Important vessels within a set, such as the wine vessels on the right-hand side of fig. 39, were larger and more elaborate than lesser vessels, such as containers for water. High relief seems likely to have been a prerogative of the élite, along with vessels with an angular profile (cat. 9).[11] The vessel set in fig. 39 also shows that a single owner might have possessed vessels in several completely different styles. The occupant of tomb M160 at Guojiazhuang, part of the territory of the late Shang capital at Anyang, had elaborate and seemingly newly fashionable wine cups and containers (on the right), while the food tripods, basins and water vessels (on the left) were much less complex in decoration and may have been made at different times.

Much progress has been made in understanding the range of motifs, their styles and combinations, yet no significant advances have been made in interpreting the imagery on the vessels. No texts exist that might tell us to what they refer. Diverse attempts have been made to suggest meanings, but so far none has been convincing. One problem has been that some authors have treated bronzes from all over China as belonging to a single tradition and, therefore, as all relevant to the associations of the face patterns on Shang bronzes. For example, a bronze with a tiger clasping the figure of man in its paws has been deployed to suggest that Shang motifs relate to Shamanism, and that the human figure is involved in shamanistic engagement with the tiger (fig. 40). However, the container in the shape of a tiger and figure does not come from the Shang capital of Anyang, north of the Yellow River, but from a different area altogether, in all probability from southeastern China; its meanings and associations may have had nothing to do with the way Shang vessels were used for offerings to ancestors, and any connection with Shamanism is also doubtful.

Indeed, the sculptural quality of the piece immediately indicates that it was produced by people with very different traditions from those of the Shang, even though some of the detail shows that its casters were familiar with both casting techniques and some of the stylistic vocabulary current in the Yellow River basin. The discoveries of the last thirty years have made it clear that the Shang and their successors the Zhou did not have a monopoly on bronze production in the territory we call China. Outside the Yellow River basin, very different preoccupations dominated. Centres along the Yangtze River, in Anhui, Jiangxi, Hunan and Sichuan, have all yielded highly unusual and very accomplished bronzes.[12]

Fig. 39
Drawings of a set of bronze offering vessels of the Shang dynasty, twelfth century BCE, from tomb M160 at Guojiazhuang, Anyang, Henan Province
Composite drawing by John Rawson

Two demands to which southern casters had to respond were for bells and sculptures, differentiating these centres from those of the Shang and the Zhou. Small bells appeared first, in the north with clappers. But large bells, supported by a handle below and with their mouths facing upwards, seem to have been central to bronze-casting in Jiangxi and Hunan. Each bell could be sounded by striking it in two positions, producing two notes. In due course, these bells came to be used in sets of graded sizes to produce music. Later bells were hung the other way up. Such instruments required musical skills as well as casting prowess for the outstanding results that were achieved.[13] Only from the tenth and ninth centuries BCE were large bells popular in the Yellow River basin, becoming part of standard ritual paraphernalia (cat. 24).

Sculptures, on the other hand, were to satisfy other demands of the southerners – their beliefs and customs required representational sculpture, notably of creatures. The ability to design and realise a moving animal in three dimensions was not a skill developed in the Shang centres. Elephants were especially favoured in the south. The example from the Musée Guimet (cat. 11) is much larger and more realistic than the few animal-shaped vessels produced at Anyang. Another, small elephant from Hunan province makes more obvious use of borrowed Shang surface decoration.[14] While elephants are straightforward creatures from the region, the presence of rams among southern bronzes is more puzzling.[15] They and the small standing figure of a deer on the top of the vessel from the Musée Cernuschi (fig. 40) seem to indicate an interest in steppe creatures that infiltrated the northwest and may have reached central southern China by way of the long tributaries flowing into the Yangtze from the north.

The biggest surprise in recent years has come from the southwestern site of Sanxingdui, in Sichuan province. Two pits filled with bronze, jade and large numbers of elephant tusks brought to light the only major early bronze representations of human figures (fig. 41).[16] One, alone, is complete. The individual, standing on a base, has large arms, with massive hands that may have encircled an elephant tusk. His anatomy is far from realistic, though immense pains have gone into presenting the detail of his dress. Large pointed and slanting eyes are surrounded by what appears to be a mask. Similar masks appear on other bronze heads found without bodies in the pits. The combination of the eyes and the masks gives the figures an inward-looking appearance, remote from their viewers. What or who they were we do not know, nor do we know what other strange faces with projecting bulging eyes represented, but they may have been connected with elephants. The importance of

such bronzes in this society is, however, evident, both from the huge expenditure on the metal itself and also from the rare and hence precious jade, gold and ivory with which the bronzes were found. And yet, despite the drama of the sculptures just mentioned, few successors were made. Experiments with full-scale sculpture had to wait until the arrival of Buddhism over a thousand years later.

Probably contemporary with the society at Sanxingdui, the Zhou moved into the Wei River valley and started to threaten the Shang, conquering Shang territory in 1045 BCE.[17] But unlike the southerners, the Zhou adopted Shang religious practices and bronze vessels for offerings. And this choice ensured that vessels were to dominate for the next thousand years. Yet while the Zhou took on Shang practices, including their casting technologies, they gave much more emphasis to food and less to wine than had their predecessors. Raising a *gui* basin on a square stand, as with the Bo Ju *gui* (cat. 14), offered it height and emphasised its presence, its contents and probably also its donor. Decoration was now ever more varied, ranging from simple thin raised lines to large relief motifs and complex compositions of creatures piled one on top of the other to form handles. Even the face motif took a more flamboyant turn.

Yet one of the greatest contributions of the Zhou was the casting of long inscriptions in the vessels (cat. 14 and fig. 37). These recorded the events that had occasioned the casting of the bronzes.[18] Here, we learn about the ways in which the kings managed society and of the struggles for success of the royal family and of individuals. The audience for such reports may have been the ancestors, and equally the living and future generations who would inherit the bronzes. The practice of using a vessel as a site for an important inscription gave birth to one of China's most enduring innovations: the use of script as both a decorative device and as a means to influence the audiences for artefacts. On a bronze, the information was passed down the generations. In later times

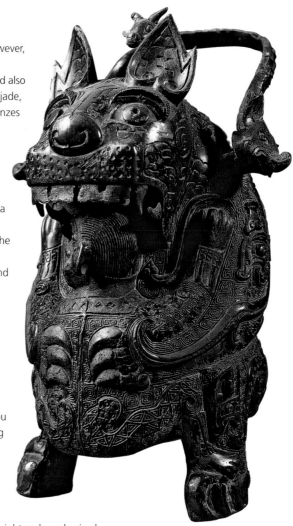

Fig. 40
Wine Vessel, possibly from the Yangtze area, twelfth century BCE. Bronze, height with handle, 35.2 cm
Musée Cernuschi, Paris, M.C. 6155

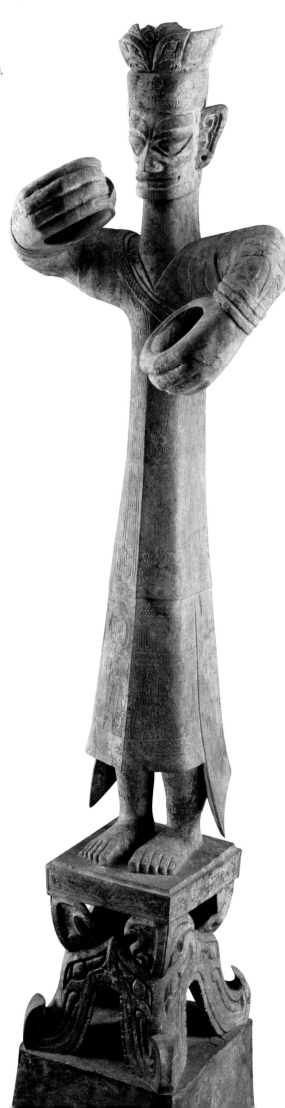

Fig. 41
Standing Figure, from Sanxingdui,
Guanghan, Sichuan province,
twelfth–eleventh centuries BCE.
Bronze, overall height 260.8 cm
Sanxingdui Museum

such inscriptions ensured the high regard in which the bronzes were held and the auspicious effects they were deemed to convey.

Another major contribution of the Zhou was a reform, a transformation, of the use of ritual vessels, leading to the manufacture of groups of identical pieces.[19] With such beginnings, a tradition of regulating the possessions of the élite in terms of numbers, colours, materials and ornament began to characterise Zhou centres and later all central Chinese official life. At the same time, the strongly compartmentalised decoration seen on the Cologne *jia* (cat. 10) was replaced by more flowing and abstract designs that were to be varied, elaborated and simplified during the time after 771 BCE, when the Zhou realm broke into many smaller independent states.

A large bell from the Jin state foundry at Houma in southern Shanxi province (cat. 24) displays some of the most accomplished casting of the sixth to fifth centuries BCE. By this date, detailed decoration was achieved with a new technique. Pattern blocks were carved in clay by expert craftsmen and then sections of the clay mould were repeatedly impressed from them. Thus one border on a bell might be made up of several units created from the one pattern block. This was an early form of mass-production by subdivision of labour. Figures of griffins often embedded among such face designs are a sign that by now the peoples of northern China were interacting closely with the nomads on their borders, integrating motifs from the steppes and even from distant Western Asia.[20] Occasional figural sculptures in bronze were also incorporated in the frameworks for furniture and stands for musical instruments and showed a local verve in interpreting borrowed forms from other regions. The magnificent crane with antlers in the Hubei Provincial Museum is an example of the extraordinary imagination of southern casting. Gold and silver inlay on vessels, weapons and personal ornaments was a sign of a growing exchange (cat. 25) with peoples on the borders.

In a society in which neither stone buildings, nor sculpture, so familiar in Western Asia and Europe, were made in the early centuries, the extraordinary bronze vessels of the Shang and Zhou generated a lineage of highly prized containers and boxes that were to become some of the dominant Chinese works of art treasured over generations. Moreover, during the following millennia, these bronze vessels were collected, valued and copied, encouraging a strong archaistic tradition that was to be the Chinese equivalent of the revival of classical architectural and figural styles in the West.

Greece, Etruria and Rome

Carol C. Mattusch

By about 900 BCE, small-scale bronzes were being cast throughout the Mediterranean world for dedication in sanctuaries or placement in graves. To the abstract simplicity of the individual 'geometric' figurines of birds, animals and humans were soon added groups of perhaps a mare, a cow or a doe with her young, and images of artisans and musicians, chariot groups, fighting animals, a man with a centaur, even a man fighting a lion, some of these perhaps early representations of myths. These statuettes were cast solid by the direct lost-wax process: wax was cut, rolled, pinched and tooled; wax body parts were stuck together; the resulting model was invested with a clay mould; the mould was baked to burn out the wax; and bronze was poured into the mould to replace the wax. An attachment for insertion into a base or the base itself was usually cast along with the figurine.

During the Orientalising period of the seventh century BCE, Mediterranean trade contacts had reached Egypt, Cyprus, Phoenicia, Syria, Phrygia and beyond, with the result that many foreign items and new ideas were arriving in Greece and Italy, affecting the style and subject-matter of native works. As a result, sirens or griffins or lions came to be added to the shoulders of dedicatory cauldrons or used to ornament furniture. From Egypt came knowledge of large-scale statue-types, as well as the technology for large-scale hollow casting, altered somewhat to fit local needs.

Few large-scale equestrian statues survive from the early periods, and those that do are in marble. However, the finely detailed Archaic bronze statuette of a cavalryman from Armentum (cat. 20), not far from Tarentum, is testimony to sophisticated bronze production in Magna Graecia, with perhaps a touch of Etruscan tradition as well.[1]

The Etruscans adapted Greek deities and myths to their own interests, and imported pottery first from Corinth and East Greece, then from Athens. Besides their lively wall paintings in tombs, for example those at Tarquinia and Chiusi, their particular expertise lay in metalworking. The Etruscans excelled at producing metal objects of all kinds, bronze votive statuettes, furniture fittings, vessels and armour. The snarling bronze Chimaera (cat. 23) found near Arezzo in 1553 is a stunning example of the Hellenisation of Etruscan art and myth, and of Etruscan skills at hollow casting by the lost-wax process. The creature's hackles are up, its mane bristles, the once-inset eyes are wide, and the lips are drawn back in a now-toothless roar. The goat's head has a wound in its neck spouting bronze blood, and *tinscvil* is inscribed in retrograde Etruscan letters on the right foreleg.[2] The work deftly combines the Orientalising and classical styles and mythology.[3] And a delicate elongated second-century BCE bronze votive statuette of a boy, hands pressed to his sides, preserves the early Etruscan tradition of stick-like votive images (cat. 32).[4]

Fig. 42
The Charioteer of Delphi, c. 474 BCE.
Bronze, height 180 cm
Delphi Archaeological Museum

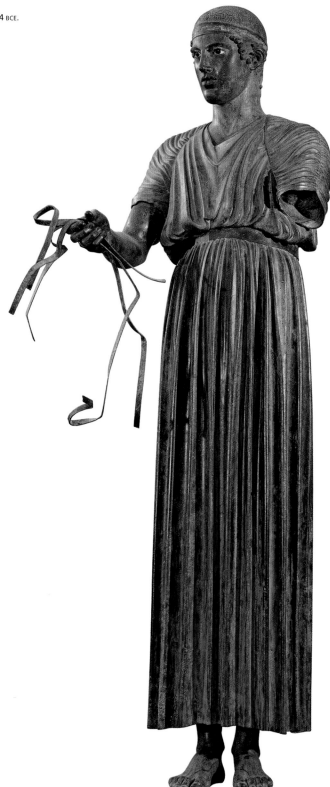

Large-scale Archaic and Classical bronze statues in the Greek world adhered in general to the same forms of standing, striding or seated figures that were being produced in stone, ignoring at first the advantages of the more lightweight and flexible medium of bronze. Lost-wax bronze casting is conducive to the production of multiples, and the ancient process of reproducing a model in bronze has remained very much the same over the centuries. Clay piece-moulds were taken from a model and lined with wax to make a thin-walled wax working-model. A bronze might be cast from that working model, or adjustments might be made in the wax before casting. The piece-moulds remained intact, and could be reused to make new wax working-models when additional bronzes were to be cast after the same original model (figs 12, 13).

Once the wax working-model had been made, the wax limbs of a statue could be adjusted and surface details such as beards and locks of hair added and worked to individualise the statue. Then the wax working-model was dismantled, and each section filled with fine clay core material and invested with a clay mould, the core being held in place by nails reaching from the core through the wax into the investment moulds. The cored and invested wax statue-parts, now much smaller and easier to handle than a whole statue, were baked to dry the clay and burn out the wax, after which molten bronze was poured into funnels and channelled into the moulds to cast the individual sections of the statue. After the pour, the clay investment moulds were broken away, the blackened surfaces of the bronze were polished, flaws repaired, and the bronze sections joined metallurgically or mechanically. Finishing touches might include insetting bone and stone eyes encased in copper lashes, tin or silver teeth, copper lips and nipples, and perhaps even tin or silver fingernails.[5] The magnificent life-size bronze charioteer from a monument in Delphi preserves some of these startlingly realistic details (fig. 42). He wears a fillet inlaid with silver and copper, copper lashes encase his large eyes, which are inlaid with white paste and set with chestnut-coloured irises and black onyx pupils, and his parted lips reveal silver teeth. Only the motionless, chiton-clad charioteer survives from the lavish chariot group dedicated by Polyzalos of Gela in about 474 BCE to honour his horses' victory in the chariot race at Delphi.[6] The group was destroyed by earthquake in 373 BCE, and its remains buried in fill-dirt during repairs to the sanctuary. During the 1896 French excavations of the site, the charioteer's right arm and hand, the upper torso and head, and the section from belt to feet were found, with the inlays intact, giving a rare glimpse of the original embellishments to a bronze statue. Only the green patina was acquired over time, as the

Fig. 43
Riace Bronzes A and B, 460–430 BCE.
Bronze inlaid with bone and glass, with silver and copper, height 197 and 198 cm
Museo Nazionale, Reggio Calabria

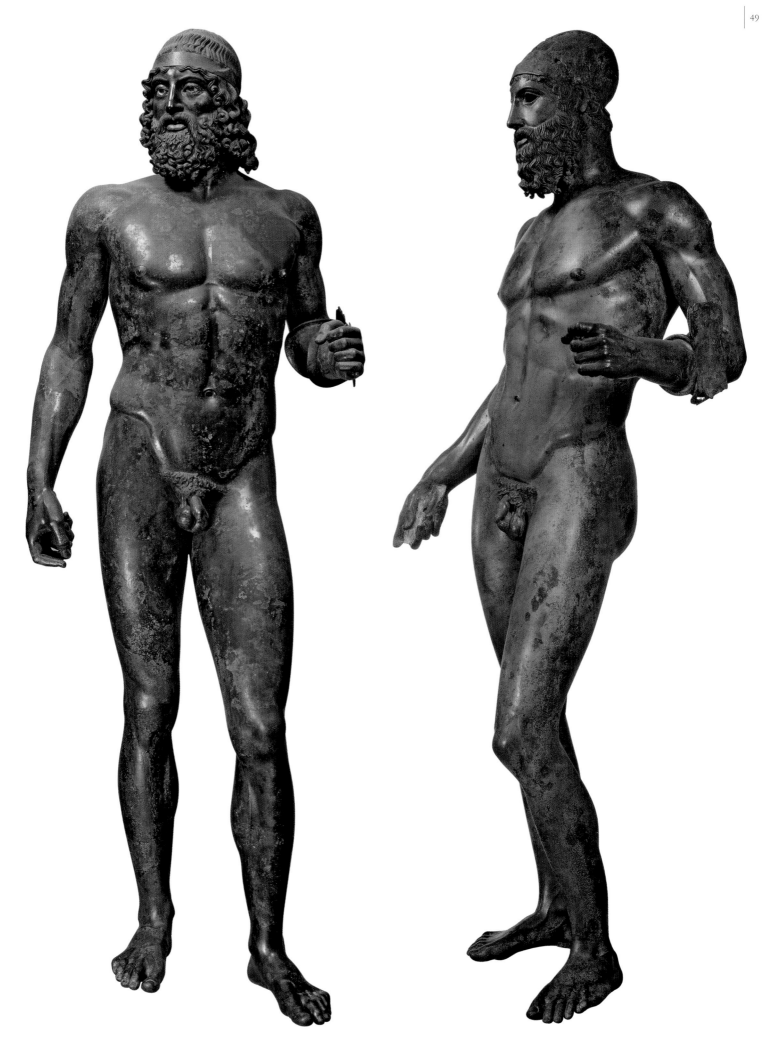

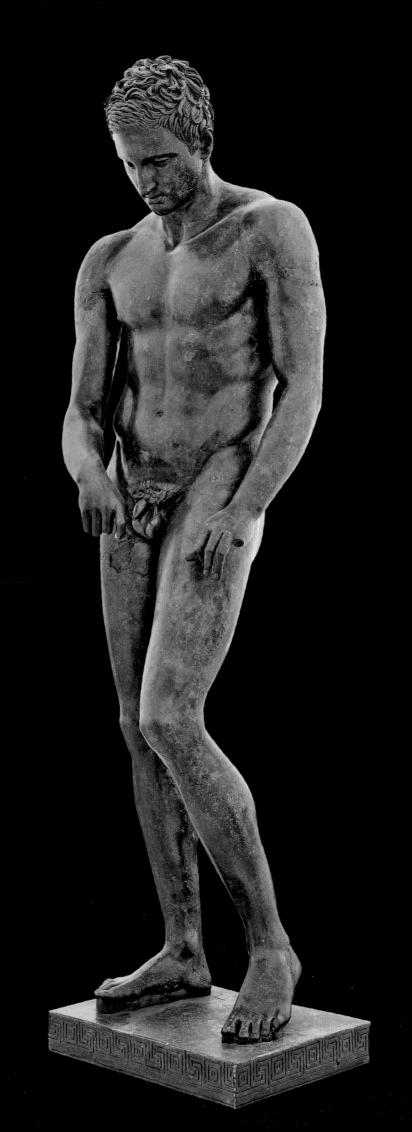

original surface of a bronze statue would have been shiny and coppery in colour.

The extraordinary Riace Bronzes (fig. 43) were probably first installed on a single base, an inscription beneath each identifying him as a legendary or historical hero. The two statues exemplify the naturalistic and idealised fifth-century Classical portrait, and at the same time they can be read as two editions cast from a single basic model, perhaps by different artisans who might even have worked in different places. Although the two statues have often been assigned to different dates, authors and even places of manufacture, they are undeniably similar in general appearance, in musculature and in pose. Each has the head turned to the right, the right hip cocked and the left foot slightly advanced, the left arm raised to hold a shield, the right hand lowered to grasp a spear. Because the individualised features of each version could be cut and modelled in the wax working-models before the waxes were cast, the resulting bronze statues have significant variations in the beards, the hair, and even a shift in the positioning of the feet. Thus two statues that began with the same basic model were produced so as to represent two different men. At the same time their similarities, particularly in dimensions, leave little doubt that they were produced for a single monument.[7]

For statues commemorating classical military leaders, standing nudes were the rule, influenced by the genre of athletic statuary. The physique and pose of a statue indicated the individual's abilities, and attributes such as shield and spear, along with an inscription, helped viewers to pinpoint his role. By the fifth century BCE, polished bronze was the preferred medium for free-standing public sculpture. Much later, Dio Chrysostom (c. 40–120 CE) provided a clue to the medium's popularity when he wrote that a certain boxer had skin the colour of a well-mixed bronze.[8] These sculptures were not about individual appearances: they were about achievement.

The representation of individuals by means of sculpted portraits that recognised achievements visually was one of the great accomplishments of classical art. A Greek portrait was a full statue, incorporating hair, facial features and physique into their statues, along with dress and attributes. A Roman portrait might be a statue, a bust or a head on a herm-post. Portraits of emperors tend to show dynastic links in the facial features, whereas their bodies and dress show them in their official roles, such as that of *pontifex maximus* (chief priest), or refer to their divine or heroic connections, portraying them as Jupiter or Hercules or other suitable figures. Roman aristocrats, however, might follow the Etruscan tradition in having themselves portrayed in vividly realistic portraits. And provincial leaders imbued their

portraits with characteristic local features, as exemplified in the head from a statue of the Thracian king Seuthes III (reg. c. 331–300 BCE) from a pit in front of his tumulus tomb near Stara Zagora in Bulgaria (cat. 26).[9] The piercing gaze, hooked nose and weather-beaten face of Seuthes, framed by his bushy hair, thick moustache and tufted beard, could never pass as those of a classical ruler, but rather they invoke the character of a fearsome and warlike Thracian, of whom his troops would be proud.

The use of close repetitions of a single model may not work for portraits, but the method is particularly well suited to athletic statuary, as is clear from two bronze statues of a young athlete scraping himself with his strigil (fig. 44).[10] The idea for the Apoxyomenos is attributed to the fourth-century BCE Greek sculptor Lysippos, whose family ran a foundry. Together they were known for streamlined production of naturalistic statues of athletes in vast quantities. According to Pliny the Elder,[11] Lysippos made 1,500 statues during his career, many of them standing figures like the Apoxyomenoi. Pliny credits Lysippos' brother Lysistratos with having developed a method of reproducing likenesses and of moulding copies from statues. His wax working-models for many of his athletes may not have been altered, but could have been cast just as they came out of the master moulds. This would have ensured rapid production, lending credence to Pliny's report about the many bronze statues produced by Lysippos, that is, by his family's foundry. And of course a statue 'by Lysippos', just like a statue 'by Rodin' nearly two thousand years later, would have been in great demand from potential buyers, even though Lysippos, like Rodin, undoubtedly turned over the actual production of his models in bronze to the bronze foundry.[12]

There were one hundred colossal statues at Rhodes, according to Pliny the Elder, including the Colossus, a statue of the sun god Helios by Chares, a pupil of Lysippos.[13] As for bronzes of human scale, we know from literary sources and from surviving stone statue bases that thousands of bronze statues were erected in the public places of the classical world: gods and goddesses, heroes, athletes, philosophers, rulers and statesmen. The commemorative statue-type was so well known that statues were reused, as was done all too often in Rhodes, to judge from Dio Chrysostom's withering remark: 'Whenever you people vote to honour someone with a statue – which you think of easily because you have such a vast supply of statues on hand – [you simply choose one from] … among all the statues that have previously been dedicated. Once the inscription that was on the base has been removed and another name has been engraved, the job is finished!'[14] There were so many bronze statues in the

Fig. 44
Apoxyomenos, second–first centuries BCE. Bronze, height 192 cm
Archaeological Museum, Zadar

cities and sanctuaries of the Mediterranean world that they were hard to manage. Pliny the Elder wrote:

Bronze statuary has been so popular that it could fill many volumes if one wanted to write about it, but who could do it justice? When Marcus Scaurus was magistrate (*aedile*) [he was consul in 115 BCE], three thousand statues were placed on the stage of a temporary theatre. After defeating Achaia [Greece, in 146 BCE], Mummius filled the city [of Rome] with statues … The Luculli also imported many statues [Lucullus was consul in 74 BCE]. And Mucianus, who was consul three times [64, 70 and 75 CE], says that there are still three thousand statues on Rhodes, and probably just as many in Athens, Olympia and Delphi. Who could name them all, and of what value would it be to know them all?[15]

In the second century CE, when Pausanias described the cities and sanctuaries of Greece, he wrote two books about Olympia, mentioning only the statues that were particularly notable or unusual in some way. At that site alone he found a few hundred statues that were noteworthy, not counting all the bronze athletes who were honoured there simply by generic standing statues.

In Rome, as early as 179 BCE, there were so many statues set up on columns on the Capitoline Hill that they obstructed the view of the Temple of Jupiter and had to be taken down.[16] By 158 BCE, the number of privately erected portrait statues in Rome was so great, especially in the Forum, that the censors ordered their removal.[17] In addition, after Aemilius Paullus had defeated Perseus of Macedonia at Pydna in 168 BCE, he returned to Rome for a three-day triumph, whose first day was devoted to 250 wagons carrying the statues and paintings that his troops had seized. Mummius acquired Corinthian bronzes after the destruction of that city in 146 BCE, and Sulla collected statuary in Athens after sacking the city in 86 BCE. Most of the booty was placed on public display in Rome. The case of Verres was different: governor of Sicily from 73 to 70 BCE, he confiscated vast numbers of Greek bronzes for his own personal collection. Cicero attacked him for this kind of theft, whereas he and other private Roman collectors of traditional classical works negotiated through dealers for their acquisitions of Greek works. Pliny the Elder devoted most of Book 34 of his *Natural History* to antique Greek bronzes that had been placed on public

display in Rome. And Pliny the Younger donated to his native town of Tifernum about a dozen statues of former emperors that he had inherited and for which he evidently had no space.[18]

With all these bronze statues noted by ancient authors, one might wonder why so few survive, and rarely more than one example of a particular statue-type. The reason is simple: a statue was at risk if it had fallen into disrepair, if it represented a pagan deity in a world adhering to a new faith, if there was a need for weapons and ammunition, and if there was a dealer in scrap-metal looking for resources. When the Saracens conquered Rhodes in 653 CE, they carted off 980 camel-loads of bronze from the toppled Colossus,[19] and there was certainly a great deal more scrap metal than that still available in Rhodes, considering that perhaps three thousand life-size statues were standing in that city in the mid-first century CE. Curiously enough, shipwrecks have sometimes preserved ancient statues from destruction. A ship that went down off Cape Artemision in Euboia, Greece, during the second to early first century BCE was rediscovered during the 1920s. Its cargo included a second-century BCE bronze racehorse with its boy jockey and a bronze attacking-god of about 460 BCE, both no doubt victims of the Roman conquest of Greece and en route to new owners in Rome.[20] Having lost his weapon to the sea, the 'God from Artemision' remains anonymous, although he probably represents Poseidon or Zeus (fig. 46). Even without a name, he is a masterful rendition of the familiar Greek type of a striding attacking-god or warrior, balancing his weapon just before striking. Another ancient shipwreck, discovered in 1992 near the Adriatic port of Brindisi, contained merely scrap metal: more than one hundred fragments of bronze statues dating from the third or second centuries BCE to the late Roman imperial period (fig. 45). And in a modern drama, a two-ton sculpture by Henry Moore worth £3m was stolen from the Henry Moore Foundation at Perry Green in Hertfordshire in 2005, reduced to scrap, and evidently sold abroad for no more than £1,500.[21]

Were it not for the numerous finds from the cities of Pompeii and Herculaneum buried by Vesuvius in 79 CE, relatively few classical bronzes would be known today. Twenty years of excavations around the Bay of Naples during the eighteenth century yielded nearly one hundred large-scale Roman bronzes, all of them buried and thus, ironically, protected by the massive eruption. These finds, including life-size statues representing public figures from Herculaneum's theatre, attracted a great deal of attention, particularly those that were found with

Fig. 45
Fragments of Roman bronze statues found in 1992 in a shipwreck off Brindisi

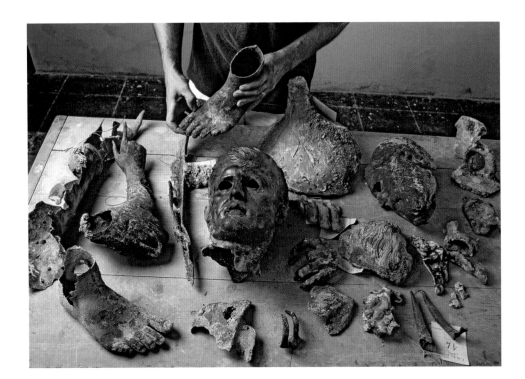

their inscribed bases, such as the togate portrait of Lucius Mammius Maximus (cat. 35), no doubt a generous donor.[22]

Not far from the town's theatre, part of a vast seaside villa was discovered, known today as the Villa dei Papiri for the many papyrus-rolls found therein. Parts of the villa were three storeys tall, and the still only partially excavated building covered at least 65,000 square feet, to judge from a preliminary estimate. Equally impressive was the collection of nearly one hundred statues and

busts, most of them bronze, all of them new products in traditional Greek styles. The techniques used in their production suggest that as many as five local workshops were involved. At one end of the pool in the large peristyle garden there once stood a pair of bronze boys poised for the start of a race and very much alike, their gazes still enhanced by inset eyes of bone and stone with black pupils and grey irises (fig. 47). The striking outward likenesses between these two classically inspired athletes and their shared production technique make it almost

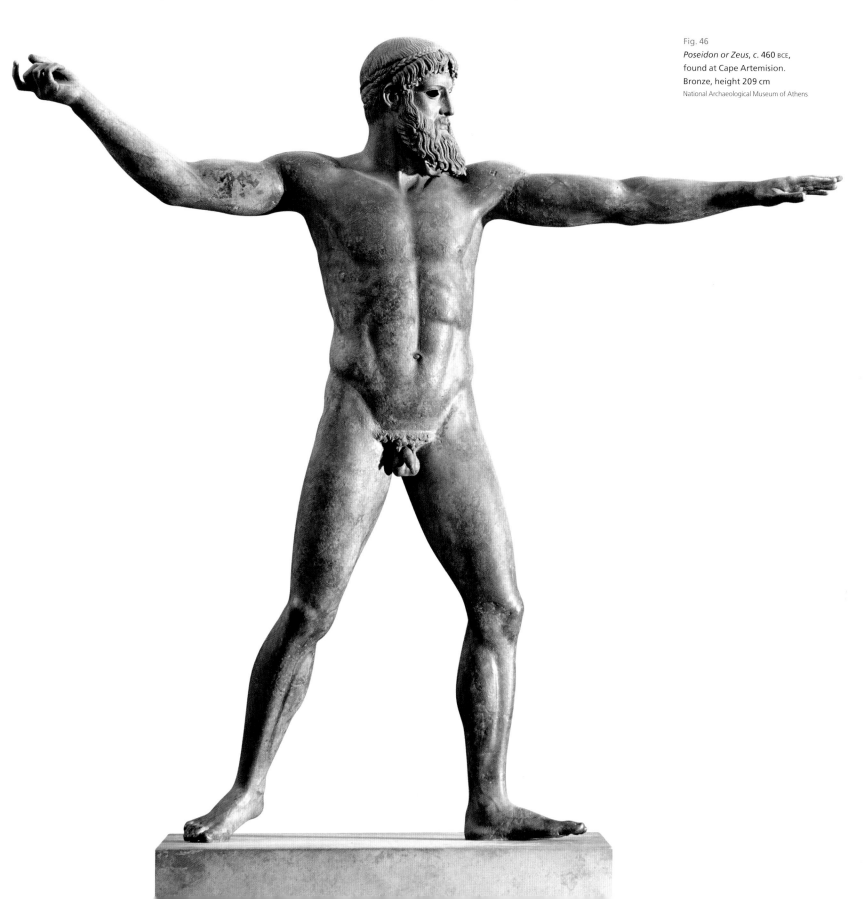

Fig. 46
Poseidon or Zeus, c. 460 BCE, found at Cape Artemision. Bronze, height 209 cm
National Archaeological Museum of Athens

certain that they were cast in the same foundry. But the very different alloys of the two statues reveal that they were not cast with the same batch of metal. Perhaps one statue was in stock when an order for two was placed, and a second one had to be cast. Or maybe a later owner purchased a second boy athlete to go with the one already in the garden.[23] The perfect bodies of these young athletes illustrate the continuing taste

Fig. 47
Athlete, Herculaneum,
first century CE. Bronze, height 118 cm
Museo Archeologico Nazionale, Naples, 5626

for the antique Classical style among Roman collectors. A study of the collection of bronzes in the Villa dei Papiri also reveals more exotic interests. The bust of a woman with corkscrew curls from an interior courtyard of the villa may be one of the queens of Egypt, her hairstyle that of the goddess Isis (cat. 40).[24] A joyful bronze piglet leaping in a life-like manner through the large garden further helps to identify the inhabitants of this villa as Epicureans, an outlook confirmed by the texts of Philodemos inscribed on the papyrus rolls found at the villa.[25]

These and other bronzes from the Villa dei Papiri are proof of the appeal to the buyer of bronze, which had traditionally been the preferred medium for freestanding statuary in Greece, at a time when many contemporary Romans were spending their money on marble statues in the archaic or Classical styles. Specifying that a work be made of bronze was itself a tribute to the Greek past, despite the current Roman preference for marbles, whose production was more costly than that of bronze.

Of the very few bronze statues of Dionysos/Bacchus or his followers to have survived, mention might be made of two works from Pompeii: the 'Narcissus', actually a young Dionysos with a delicate fawn- or goatskin knotted over one shoulder,[26] and the seductive, long-haired Dionysos standing on a two-part base and serving as a tray-bearer, his tray supported by vines hung with rich bunches of grapes.[27] Statuettes, gems, repoussé bronze vessels and marble reliefs attest to the popularity of scenes of Bacchic revelry, and in Book 5 of the *Deipnosophistai*, Athenaeus gives a lengthy, if secondhand, account of the Great Procession of Ptolemy II Philadelphus (reg. 286–243 BCE) in Alexandria, which provides rich evidence for the existence of this genre on a large scale. Along with a fifteen-foot-high statue of Dionysos, a mechanical statue of Nysa, probably the god's wet-nurse, stood up, poured an offering of milk, and sat down. There were also in the procession an abundance of silenoi, satyrs and maenads, some of them real people, others fabricated.[28] Picturing such an elaborate procession and its accoutrements has been greatly simplified by the discovery by fishermen in 1998 of a young nude dancing satyr in the midst of an exuberant leap, his mouth open, the whites of his wide, ecstatic eyes still in place, and his hair blowing out behind him to reveal his pointed ears (cat. 28).[29] This wildly dancing boy, arms and legs flying, reveals the extraordinary scope and sophistication of statuary style and production from the fourth century BCE onwards, and illustrates vividly the surprises that may await us from ancient bronzes that have yet to be discovered.

Sacred Metals in South and Southeast Asia

John Guy

Metallurgy has always been highly revered in the South Asian mind as a form of alchemy: the transformation of mundane materials into things precious. The keepers of these secrets were invested with the ability to create icons of transcendent and transformative power. More than makers of images in other media, those working in metal were understood to possess special gifts, bearing a responsibility to create, in partnership with attendant priests, icons of such refinement and grace that the gods themselves would be attracted to them.

The metalworker and the blacksmith are accorded recognition in many societies as persons with higher powers of a magical order, enabling them to transmute the elements of nature. A stone relief at the mountain temple of Candi Sukuh on Mount Lawu in central Java, dated to the first half of the fifteenth century, is seemingly devoted to this very theme (fig.48).[1] It depicts a blacksmith's workshop, an open pavilion with a tiled roof, and three participants: to the left, the seated master smith, holding the blade of a *keris* (the ancient dagger of the Malay-Javanese world) upon which he appears to be working; to the right, his assistant, pumping the vertical bellows to fuel the furnace; and in the centre, the animated, naked figure of an elephant-headed male, presumably Ganesha, looking as if he has just descended from a heavenly realm – note the cloud motif beneath his raised foot.[2] Ganesha holds an animal toy reminiscent of the

three-dimensional Javanese puppets known as *wayang golek*, and the unidentified narrative depicted may well reflect a *wayang* theatre storyline or *lakon*. All three actors are crowned in the *wayang* manner, indicating their high status as keepers of secret knowledge. The complex sets of meanings associated with this scene cannot be addressed here, but it may suffice to note that iron-working is the central activity in Java associated with the mystical powers of the *keris*, many examples of which are openly displayed in this workshop.[3]

The earliest inscription to refer to metalworking in Southeast Asia dates from the third or fourth century CE. An Indian goldsmith's touchstone, found in the vicinity of Wat Klong Thom, Krabi Province in peninsular Thailand, is identified in Tamil Brahmi as the property of the Tamil goldsmith Perumal.[4] A bronze triad of the deity Lokanatha with attendant Taras, recovered from the site of Gunungtua at Padang Lawas in north Sumatra and dated 1039, states in

Fig. 48
Relief with a Blacksmithy Scene and Ganesha, first half of the fifteenth century. Volcanic stone, 162 x 219 cm. Candi Sukuh, Mount Lawu, central Java

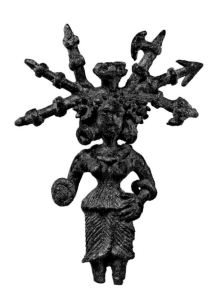

a lengthy dedicatory inscription that 'the master smith Suryya made this image of Lokanatha'.[5] Naming of the maker is, however, exceedingly rare, in India or Southeast Asia.

The curious smith's workshop at Candi Sukuh represents the last monumental expression of Hindu-Buddhist culture in Java, before the region finally submitted to the spread of Islam. But bronze-working in the region has an ancient history, reaching back into the pre-Hindu-Buddhist era in the first millennium BCE. The mastery of smelting, refining, alloying and casting were technical achievements much prized in the proto-historic period, both in Southeast Asia, as witnessed by the so-called Dongson bronze culture, and in early settlements in the Gangetic plains of northern India, by bronze-casting. However, the bronze anthropomorphs and harpoons of northern India in no way rival – either in scale or metal-casting sophistication – the achievements of the early bronze-workers of mainland and insular Southeast Asia.

It is telling that although evidence of the mastery of metalworking in bronze and iron is well documented in the archaeological record of South and Southeast Asia, the widespread appearance of figurative religious icons occurs

relatively late. The famous female dancer from Mohenjo-Daro (fig. 30), and other finds of chariots and wheeled animals from Harappan sites, including Lothal, the ancient port in western India, signal an early but discontinuous beginning, dating from the mid-third to the mid-second millennium BCE and with strong west Asian connections.[6] Such figurines are assumed to have served as votive offerings in Harappan rites.

The systematic production of metal images really only occurs in northern India in the Kushan era with the earliest finds from the Sonkh excavation at Mathura, and later finds from the Gandharan northwest.[7] These early finds tend to be miniature in scale. A goddess with weapons in her hair, most readily interpreted as a prototype of the Hindu warrior goddess Durga, is a rare survivor of this miniaturising tradition (fig. 49). The figure marks the beginnings of an unbroken tradition of casting small metal icons for personal use in household shrines, both urban and rural.[8] Among the earliest of the small number of miniature bronze figure images to have survived is a *yakshi* (nature spirit) and goose (*hamsa*) (fig. 50). Though miniaturised, the figure is beautifully flexed in a posture alluding to the archetypal tree-kicking posture (*salabhanjika*) of fertility goddesses of the early centuries CE. Here she holds a lotus bud, and a goose seemingly catches droplets that fall from it. This figure type is already an established motif in the gateway brackets of temples, such as those at Sanchi, and on Shunga, Kushan and Satavahana railing posts.[9] Another miniature bronze *yakshi,* attributed to the Deccan in the first century CE, is in the British Museum.[10]

The second category of Indian devotional metal icons is of an entirely different order: large-scale and often spectacularly detailed and sublimely modelled images of gods and goddesses are deployed both as major cult icons and as portable images for use in processions and parades for temple festivals. Such icons are worshipped all the year round in the shrines of the temple in which they are housed, and celebrated as central divinities in the annual temple festivals.[11]

The history of the royal households of Kashmir, the *Rajatarangini* ('The River of Kings'), chronicling the reigns of the Karkota dynasty (625–1003) and their immediate successors, provides a unique window into icon-making on a spectacular scale in medieval India.[12] Kalhana, the author, tells us that royal cults were lavishly endowed by successive Kashmiri rulers, with precious metal icons being installed in great numbers, and of great scale: gold and silver icons are named, as are the quantities of precious metals required for their making. Under the patronage of the greatest Karkota ruler, Lalitaditya-Muktapida (reg. 724–60) – a devout

Fig. 49
A Goddess with Weapons in Her Hair, North India, possibly Patna (ancient Pataliputra, Bihar), second–first centuries BCE. Copper alloy, height 7.1 cm
The Metropolitan Museum of Art, New York. Gift of Samuel Eilenberg, in honour of Steve Kossak, 1987.142.289

Fig. 50
Yakshi and a Goose, Deccan, possibly Satavahana dynasty, first–second centuries CE. Bronze, height 13.3 cm
Victoria and Albert Museum, London, IS 8-1989

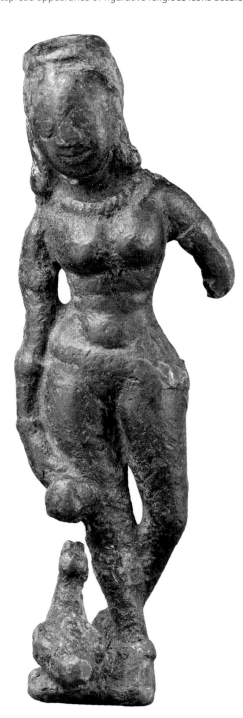

Vaishnavite – was erected 'the glorious silver figure of Vishnu *Parishasakesvara* [made from] many thousands of Palas of silver', and 'the famous image of Vishnu *Muktakesvara* [made of] 84,000 Tolakas of gold' and so on. Kalhana reserves special praise for the colossal image of the Buddha at the *Rajavihara* (royal monastery) at Parihasapura, [made from] 'many thousands of Prasthas of copper', 'which reached up to the sky'.[13] The scale of the Great Buddha (*Brhadbuddha*) can only be imagined, but comparison with the Sultanganj Buddha (fig. 51) provides a clue to its majesty and scale.

Almost nothing of this monumental tradition of metal image-making has survived. The great brass image of Brahma excavated from Mirpur Khas, Sind, in modern-day Pakistan, datable to the early sixth century, is one of the few large-scale Hindu icons extant from the Gupta period (c. 320–550). It displays an unprecedented naturalism in the fulsome and fleshy modelling of the torso, drawing on the Hellenistic-inspired tradition of the neighbouring Gandharan region; yet the four faces radiate a divine grace more associated with Buddha icons of this period (see cat. 48). In these northwestern regions, brass, an alloy predominantly of copper and zinc, was widely used.[14] This contrasts with late first-millennium eastern India and Nepal, and South India, where bronze predominated. The prescriptive literature requires sacred images to be cast from an alloy composed of the five (*pancha-dhatu*) or eight elements (*ashta-dhatu*).[15] The five metals are understood to mirror conceptually the five natural elements (*pancha mahabhutas*) that compose all matter: earth, water, fire, air and ether. The metals are predominantly copper, with lesser quantities of tin and lead, and minuscule parts of gold and silver, the latter to fulfil sastric or scriptural requirements.[16] Brass gives a more pronounced yellow cast to the metal, which can be interpreted as a more golden complexion, and a softer surface that responds more readily to devotional use, soon acquiring a patina and a softening of details.

A bronze head of Vaikuntha Vishnu in the Metropolitan Museum of Art, New York (fig. 52), provides a rare glimpse of this otherwise lost northwestern monumental tradition as described in the Kashmiri chronicles cited above. A near-life-size head of Vishnu is combined with his two primordial avatars, represented as lion (Narasimha) and boar (Varaha) emanations to create the three-faced form so popular in the wider Kashmiri world. Reduced altar-scaled versions of this subject are more numerous (see cat. 47 for example), reflecting the fusion of the Gupta influence via Kashmiri metalworking with the lingering Gandharan legacy, and serve as reminders of the parent-icons, the lost monumental versions.[17]

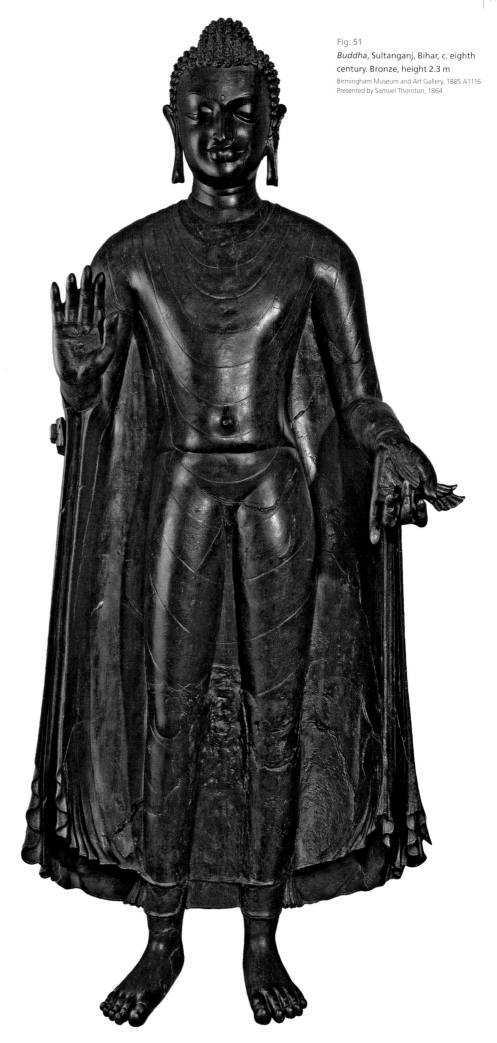

Fig. 51
Buddha, Sultanganj, Bihar, c. eighth century. Bronze, height 2.3 m
Birmingham Museum and Art Gallery, 1885.A1116.
Presented by Samuel Thornton, 1864

Fig. 52
Relief of Vaikuntha Vishnu,
possibly a processional mask,
Gandharan regions of Pakistan,
fifth–sixth centuries. Bronze,
33.7 x 31.8 x 12.7 cm
The Metropolitan Museum of Art, New York.
Gift of Donald and Polly Bruckmann, 2004.177

Fig. 53
Shakti Devi, probably Kaumari,
Karkota dynasty, eighth century.
Inscribed as commissioned by [king]
Meruvarman, the work of [the artist]
Gugga. Bronze, height 137 cm.
Under worship
Devi Shrine, Chatrarhi, Chamba valley, Himachal
Pradesh

In the isolated upper reaches of the Buddhal-Ravi river valley in Chamba, Himachal Pradesh, is the fortified township of Brahmaur, identified with the ancient capital of Brahmapura.[18] This remote, ancient capital is custodian of a unique cache of large-scale brass Hindu icons assignable to the first half of the eighth century. Preserved at the royal wooden temple complex are four brass Hindu icons, all over a metre in height, three of which are inscribed as being the product of King Meruvarman's patronage and the workmanship of the artist Gugga.[19] A fifth image, similarly inscribed, is preserved in a contemporary wooden temple at the nearby hilltop village of Chatrarhi, overlooking the valley of the River Ravi. These icons of Laksana, Ganesha, Narasimha, Nandi and Shakti Devi are emblematic of a spectacular metal-casting tradition of the early medieval period that is otherwise lost to us. Shakti Devi, carrier of the lance and tallest of the group at 137 cm, is a masterpiece of modelling and decoration, with all her jewellery and flower adornments integral to the cast image, thus conforming to the sastric (scriptural) prescriptive requirements of *alamkara* (ornamentation). Usually adorned with *puja* pigments and dressed in sari lengths, she is rarely seen by devotees as here, unclad (fig. 53). Standing in a gently flexed posture, she displays the lance (symbol of power), a bell, a fully blown lotus and a snake, and is understood to embody grace and beneficence. This is almost certainly a late work by Gugga or his workshop, post-dating his Brahmaur icons.

Isolated monumental finds in the Buddhist world are similarly rare, and it is only through contemporary inscriptions that we can learn of the spectacular scale and lavish use of precious metals of icons now lost to us: during the reign of the early Pāla king Dharmapāla (reg. 781–821), the Bodhgaya temple ('Vajrāsana'), the epicentre of the orthodox Buddhist world, boasted a number of large metal images flanking the entrance to the Mahabodhi shrine, including a large silver icon of the Vajrayana deity Heruka.[20] The single largest surviving monumental bronze Buddha, over 2.3 m in height, was recovered

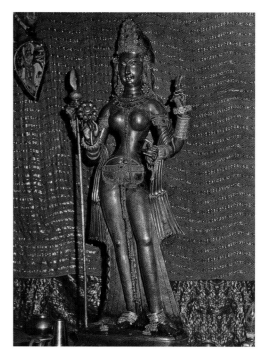

east of Bodhgaya in 1862 during railway construction from the site of a Buddhist monastery at Sultanganj, Bihar.[21] Cast in sections, this work is a rare reminder of the lost tradition of monumental metal-casting in Buddhist India whose prevalence has been confirmed by recent discoveries of large-scale metal images at Buddhist monastic sites in Bangladesh.[22] The monumental metal images in turn spawned multiple smaller-scale versions, often of superlative quality (cat. 48).

The region of India that has best preserved its medieval bronze-casting tradition is Tamil Nadu, in the south. Under the patronage of the Pallava (seventh–mid-ninth centuries) and the Chola royal households (mid-ninth–thirteenth centuries), the metal-casters of Tamil Nadu excelled, especially those centred in the districts near the Chola capital of Thanjavur.[23] The widespread production of large-scale bronze icons of Hindu deities and saints in the eighth and ninth centuries is intimately linked to the evangelising activity of the Shaiva and Vaishnava saints, among whom the poet-saints became the most famous.[24] Emblematic of Chola bronzes is the image of the dancing Shiva Nataraja (cat. 138). It is clear that this complex iconographic form emerged as an independent icon early in the history of processional image-making in southern India, being an innovation of the Pallava period.[25] It was however under Chola patronage that it became the tutelary deity (*kula-nayakam*) of the ruling household, especially celebrated under the king Rajaraja Chola (reg. 985–1014), and the processional image *par*

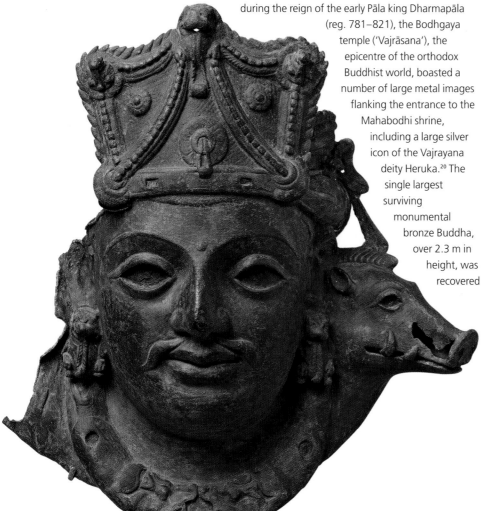

excellence. The Shaiva poet Campanar celebrated Shiva Nataraja in verse:

When our Lord who is both end and beginning
dances to the deep sound of the mulavam drum,
holding blazing fire in the hollow of his hand,
as the mountain's daughter watches,
the Ganga's murmuring stream with foaming waves
flows over the cool crescent moon.[26]

Shiva is seen performing the *tandava* dance through which the elemental forces of the universe are created, maintained, and cyclically destroyed. Ringed by a flaming aureole (*jvala mala*), he dances on the prostrate figure of the demon-dwarf Apasmara, the personification of ignorance and materialism. In his upper hands, Shiva holds the double-sided drum (*damaru*) to mark time, and the flame to signify destruction, while his lower hands frame a gesture of reassurance and protection, as does his raised leg, offering shelter to the devotee. On his headdress the diminutive figure of the river-goddess Ganga pays homage to her saviour. In this complex metaphysical construct, Shiva embodies the accretions of numerous mythologies and traditions. Shiva is honoured by his mount (*vahana*) Nandin, both in the form of a stone icon permanently installed in an open pavilion (*mandapa*) facing the entrance sight line directly into the sancta sanctorum where the *linga* is installed, and in bronze versions, for processional use (cat. 57).

As remarkable as the achievements of the bronze-casters of India are, the largest extant bronzes to survive do not come from India, but from mainland Southeast Asia. An early example is the proto-historic bronze ceremonial drum in Singapore, one of a series of large-scale ritual drums of unknown function that have been excavated at sites ranging from Vietnam and Cambodia to the Malay peninsula and Bali.[27] Bronzes of the Hindu-Buddhist period, up to a metre in height, appear regularly among the religious imagery of later first millennium Southeast Asia, as witnessed by a majestic eight-armed Maitreya belonging to early tenth-century Angkor (cat. 53).

Among the most impressive are the principally Buddhist images from the so-called Prakhon Chai hoard, with large-scale Maitreya and Avalokitesvara figures being among the most beautiful metal icons of the eighth century to survive from anywhere in the Buddhist diaspora.[28] The athletic beauty of the Kimbell Maitreya (fig. 54), clad only in a short waist-cloth, is among the finest of the group. Little is known about the identity of the Buddhist polity responsible both for marshalling metalworking skills of such a high order, and for bearing the major cost of making these icons.

Fig. 54
The Bodhisattva Maitreya, Prakhon Chai, Thailand, late eighth century. Bronze, 122.5 x 51 x 31.5 cm
Kimbell Art Museum, Fort Worth, AP 1965.01

Such spectacular icons were not alone in the region. It is widely accepted that a number of large Buddha images found in Southeast Asia were in fact imported from South India and, more often, Sri Lanka.[29] Historically Sri Lanka had an ambiguous relationship with Indian Buddhism. Although it prided itself as the preserver of the pure school of original Buddhism, it was also a major centre of Vajrayana Buddhism throughout the first millennium. The greatest gilt-bronze Tara to have survived from the Buddhist world is arguably the British Museum's Trincomalee Tara, who displays a full-bodied figure, her broad hips flexed to complement the open-handed gesture offered to devotees. Her conical coiffure must have displayed precious jewels of spectacular size. As the defender of Buddhism, Sri Lanka appears also to have assumed an evangelising role, exporting both Hinayana and Mahayana/ Vajrayana imagery to centres of Buddhism in Southeast Asia. The so-called Sulawesi Buddha (National Museum, Jakarta) and the Dong Duong Buddha (Vietnam History Museum, Ho Chi Minh City) are the most celebrated examples.

The circulation of metal images in the ancient and medieval world is well recorded from Mediterranean antiquity onwards, and South Asia and Southeast Asia can offer their parallel stories.[30] The Helgo Buddha, recovered from a Viking treasure hoard on Helgo island, near Stockholm, could no doubt tell an equally fascinating story, having presumably been traded westwards from the northwestern Indian region of the Swat valley and so traversing the eastern European river systems, and thence to the Baltic, where it was interned in the ship burial of

a Viking chief as a valued trophy of trade and conquest. The best-chronicled peregrinations in mainland Southeast Asia concern the so-called Arakan bronzes, a cache of monumental Angkorian bronzes looted by the Siamese in the fifteenth century, installed for worship at Ayutthaya, only to be looted in turn by the Burmese armies of Pegu, who surrendered them to the Arakanese, who finally deposited the remaining bronzes at a monastery in Mandalay, where the surviving elements of the cache remain (fig. 55).[31]

The majority of major cult images in Southeast Asia are local productions, however, as witnessed by the Prakhon Chai hoard and a standing four-armed goddess, missing her attributes but in all probability the goddess Durga. This powerful icon, 1.91 m tall, displays the distinctive style that evolved in the Cham territories of central Vietnam in the later first millennium, exhibiting close parallels with Buddhist icons associated with the Mahayanist cults as practised at the royal monastery of Dong Duong in Quang Nam Province in the late ninth and tenth centuries. The dating of the Buddhist imagery is associated with the 875 CE foundation inscription of King Indrapura II.[32]

The production of Buddhist imagery was intimately linked to monastic patronage in Southeast Asia. At the north-central Thai kingdom of Sukhothai, a number of royally endowed temples were built and sustained by the local ruling elite. Monumental bronzes were cast for the accumulation of merit, and as political fortunes waned, the appropriation of major cult icons constituted a significant part of a victor's spoils. Sukhothai came under the sway of

Fig. 55
Dvarapalas, Cambodia, late Angkorian period, thirteenth century. Bronze, estimated height 2 m. Preserved at the Mahamuni Paya monastery, Mandalay, photographed in *c.* 1900

the kingdom of Ayutthaya in the course of the early fifteenth century. Icons were transferred to the new centres of power, but images were also cast in older styles: the archetypal Sukhothai image is that of the walking Buddha, which can be traced to Sri Lanka in the form of surviving mural paintings of the twelfth–thirteenth century Polonnaruva shrine of Tivanka Pilgrimage.

In 1936 French archaeologists discovered the largest and most spectacular sculpture installation in eleventh-century Southeast Asia, located on a man-made island in the Western Baray at Angkor.[33] A monumental reclining bronze Vishnu Anantasayin (figs 56, 57), estimated to span six metres in its original state, was cast in sections and riveted together, before being embellished with mercury gilding, inlaid stones and precious metals. Such assembly techniques were standard in the later Angkorian period. The subject, Vishnu emerging from his slumber on the coils of the serpent Anantha/Sesha, has its origins in Hindu creation cosmologies, and was first translated into sculptural form in around the fifth century in a rock-cut shrine at Udayagiri in central India. No bronze versions dating from the first millennium are known in India. Commissioned during the reign of the Khmer king Udayaityvarman II (reg. 1050–66), this Vishnu is the largest bronze image ever recorded from Cambodia, and it is unrivalled in Southeast Asia, or indeed India. Its importance, however, transcends its size; aesthetically it is unmatched in the corpus of Angkorian bronzes, and it stands as one of the greatest achievements of the bronze artists of the medieval world.

Fig. 56
Fragments of the bronze *Vishnu Reclining on the Serpent Anantha*. Photographed during the Ecole Française d'Extrême-Orient's 1936 excavation of the temple sanctuary of the island shrine of West Mebon, Angkor, c. 1060

Fig. 57
Vishnu Reclining on the Serpent Anantha (Vishnu Anantasayin), West Mebon, Angkor, c. 1060. Bronze, 122 x 222 cm
National Museum of Cambodia, Phnom Penh, Ga 5387

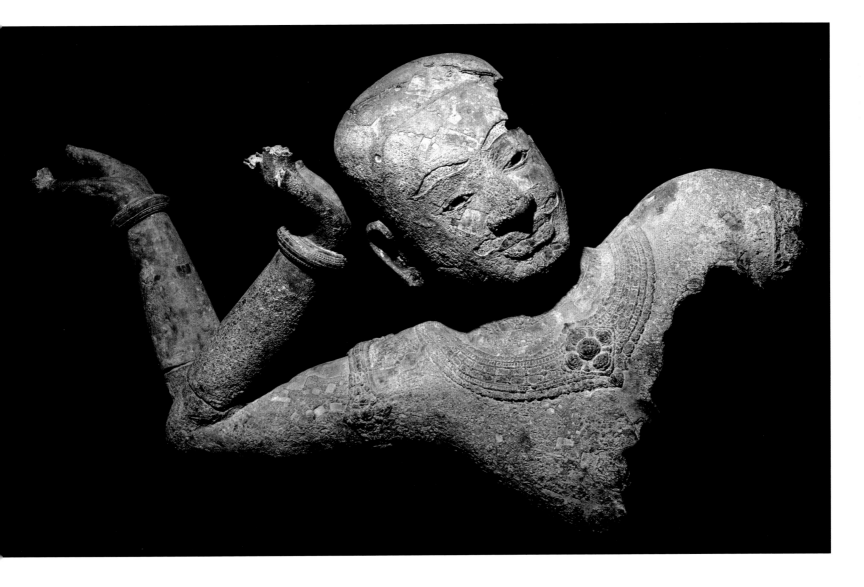

West Africa:
The Lower Niger Region

John Picton

The region to each side of the Lower Niger River, the area south of the confluence between the Niger and the Benue in what is now Nigeria, is well known for the rich traditions of its visual arts, an inheritance from an often unknown past that still flourishes today.[1] Every available medium has been employed: decoration of the human body, textile design, architecture, mural painting, ceramics, sculpture, masquerade, shrine installation, and (since the 1850s) photography; and while this inheritance has provided an essential resource for the evolution of local modernisms, the Lower Niger region has also been the location of several traditions and sites associated with lost-wax copper-alloy casting through more than a millennium.[2]

Igbo-Ukwu

Igbo-Ukwu is the earliest of these sites. Its bronzes were discovered entirely by accident in a village of no particular significance to the east of the Lower Niger. In 1939 a man digging a cistern for water storage beside his home had not gone down more than half a metre when he struck a highly decorated bronze bowl.[3] As he continued, more bronzes emerged, some of which were given away to those who thought they would be useful as magical-medicines. In due course, the colonial District Officer heard of these discoveries and purchased what was left. He gave a few pieces to the

British Museum, and, in 1946, the remainder to the Nigerian government's newly founded Department of Antiquities. Much later it turned out that archaeological material had also been found in a neighbouring house, and subsequently a third site was located. All three locations were excavated between 1959 and 1964.[4] The first seemed to be a treasury of highly ornamental castings,[5] and decorative vessels (fig. 58), including a roped pot on its stand (cat.58). The second was the burial chamber of a man who clearly enjoyed great wealth and status. It included hammered copper as well as cast tin-bronze regalia, 165,000 glass and carnelian beads, elephant ivory, textiles and carved wood.[6] We do not know the reasons for his wealth, although there were analogies with the office of *eze nri*, a priestly figure known from the recent past and a title still extant, whose authority rests on its holder's ability to settle disputes.[7] The third site contained more bronzes and some spectacular pottery, but its purpose was unclear: it appeared to be a pit into which its contents had been deliberately thrown away.

The burial chamber was dated to the ninth–tenth centuries CE,[8] which makes Igbo-Ukwu the earliest West African evidence for the working of copper and its alloys. Unlike Ife and Benin City, however, it seems not to have been a place of particular mythic value, and there were neither palaces nor city walls there. But for these bronzes, Igbo-Ukwu would have remained in obscurity, in a region where,

until the twentieth century, village groups were scattered through the forests without any major or central settlement. The absence of protective walls or ramparts suggests the area was not subject to the competition and conflict endemic to the west of the Lower Niger, where cities and towns clearly formed parts of the wealthy trade routes dominated by the empire of Mali and its trans-Saharan links, and, from the late fifteenth century onwards, to the coastal and Atlantic trade. And yet, as neither the glass nor the carnelian beads were locally made, they provide evidence of Igbo-Ukwu's openness to long-distance trade: the carnelian must have come from the Sahel/Sahara border region while the glass beads are from Egypt, India and Europe.[9]

Nevertheless, the excavations revealed a complex civilisation owing little to the world beyond, but for the quantity of beads. Yet by this time, the Lower Niger region was already fully engaged in a technology based upon smelting and forging iron; and the fact that the use of iron precedes the use of copper and its alloys throughout the sub-Saharan region suggests that the iron-working technology must have been imported from elsewhere, perhaps from North Africa via the trans-Saharan trade routes.[10] Could this also have been the source of the leaded tin-bronze, together with the techniques of alloying and lost-wax casting? Almost certainly not, for by the time of the Igbo-Ukwu castings, the copper alloy in common use around the Mediterranean region was zinc-brass not tin-bronze, except for certain specialised purposes. Notwithstanding the trans-Saharan origins of West African iron-working, therefore, North Africa is unlikely to be the source of Igbo-Ukwu copper and bronze metallurgy. After all, it was well known in the markets of Morocco that one way to obtain gold from Mali was to trade in copper and brass; and bronze, a more specialist commodity, would surely not find its way into the scrap-metal trade. On the other hand, local copper and lead deposits have now been identified that were clearly worked in antiquity;[11] and tin was also smelted in and around the Jos plateau in central Nigeria. So the metals needed to make leaded bronze were all at hand not too far from Igbo-Ukwu. Moreover, such peculiarities existed in the casting methods, uncommon elsewhere at that time, that it can be argued that Igbo-Ukwu represents the indigenous innovation of alloying and casting in this region of West Africa.[12] This would, of course, reinforce the impression of Igbo-Ukwu as a complex civilisation deep in the forests, owing little to

Mediterranean forms and technologies. Yet while the absence of urban walls and ramparts suggests that Igbo-Ukwu may have played little part in the wealth, trade and conflict that otherwise linked the Lower Niger region to Mali and North Africa, the 165,000 beads can only have arrived via networks stretching towards and indeed across the Sahara. Nevertheless, it largely remains its own independent source of art and innovation.

Ife

When we cross the Niger River towards the forests to the west, we find a very different social environment, one in which a city of substantial size – an area perhaps three or four times the City of London during the same period[13] – was protected from the outside world by walls, or ramparts. This in itself can be taken as an index of actual or potential conflict with rival cities,[14] and of the wealth of a city at a key point on local and regional trade networks – there must, after all, have been something worth raiding. The Ife walls show clear evidence of cycles of expansion and contraction in relation to events as yet unknown archaeologically. At the centre of the city was the king's palace, with roads radiating out from it. Located around the city there were the palaces of the nobility, shrines and temples to local deities, and monuments to mythic heroes. Beyond the walls, within the forest, each deity represented by a city temple also had a sacred grove, and it is evident that works of art might be found in any of these locations. Ife today is a vastly expanded modern city with its hotels, high-rise buildings, churches, mosques and a university; but the fundamental layout of palaces, groves and temples remains, albeit in a seemingly half-remembered relationship to its mythic past. The reasons for this are that in the nineteenth century, the whole region was overtaken by armed conflict in which cities formed alliances to gang up on other cities. Ife itself was twice abandoned, and in consequence the works of art found in its groves and temples, or otherwise excavated at unexpected sites, have been invariably fragmentary.

The major component of Ife art is provided by ceramic sculptures, mostly of the human figure and characterised by a naturalism not always expected of African art, but with some animal representations, dating from the eleventh to the fourteenth

Fig. 58
Snail Shell Surmounted by a Leopard,
Igbo-Ukwu, ninth–tenth centuries.
Bronze, length 20.1 cm
National Commission for Museums
and Monuments, Nigeria

(or perhaps fifteenth) centuries.[15] In addition, in the course of this period, perhaps in the thirteenth century, this ceramic tradition was transferred to the technique of lost-wax casting, mostly in zinc-brass but with a few examples in copper;[16] and whereas the raw materials needed for casting at Igbo-Ukwu were all available in the not-too-distant locality,[17] the use of brass at Ife must indicate its participation in trading relationships extending through West Africa and, via Mali, across the Sahara to North Africa. For the copper alloy in common use throughout the Mediterranean region was zinc-brass; and whereas tin was smelted in pre-industrial Africa, the particular qualities of zinc are such that its extraction and the process of alloying it with copper were beyond the capabilities of the local technology.[18]

The corpus of works of art from Ife cast in brass or copper includes a group of seventeen heads (cat. 73 is one of these) and the upper half of a torso found by chance when foundations were being dug for new buildings in a part of Ife just behind the royal palace (though perhaps once within it) during the dry season of 1938–39.[19] Other castings include a crowned head from the grove of Olokun, the deity of the sea and the wealth from beyond the sea;[20] a mask from the royal palace (cat. 72);[21] a group of figurative sculptures found in 1957 (fig. 59), again when digging foundations, in association with the interior of a palace or temple;[22] and the figure of a seated man from Tada (cat. 70), a small riverside village of no importance on the southern bank of the Middle Niger, in the Nupe-speaking region of Nigeria. The latter was cast in leaded copper, and, unusually for West African sculpture, it is asymmetrical in form. What it was doing in Tada is a complete mystery.[23] It obviously belongs to the same corpus as the castings found in Ife, and one suggestion is that Tada might once have been a riverside port linking Ife to the empire of Mali and that the figure was among the trappings of authority of the agent of the king of Ife, stationed there to oversee the trade coming from and going back into the forests to the south where Ife was located.[24]

The corpus of Ife brass- and copper-casting has long been recognised for what may be described as its serene naturalism, so much so, indeed, that at first outside commentators doubted that these sculptures came from the hands of artists local to the Lower Niger region. Now, we can be certain that the castings belong to a larger corpus of works that includes the far greater number of ceramic sculptures; and these, in turn, show a greater variety of imagery and subject-matter, a variety more akin to what we know of art in the Lower Niger region from the traditions of

the recent past. Moreover, the few cast-brass figure sculptures in the Ife corpus show bodily proportions typical of much West African sculpture, while the holes that would permit the attachments of beards and headgear (see cats 72, 73) are uncharacteristic of almost any sculptural tradition beyond the sub-Saharan region. So too is their likely mounting on rough-hewn wooden bodies to be covered with textiles and regalia for display in the post-burial obituary rites of the king and his nobility.[25] In this context, the heads would have been polished to shine brightly (an apotropaic aesthetic that persists to the present day throughout the Lower Niger region), and it may be that the vertical lines marked on some (for example cat. 73) were designed to make their display a little more realistic by moderating their shininess.[26]

Benin City

Benin City, more properly known as Edo,[27] has been the location for casting copper-alloy works through some seven hundred years, from the fourteenth century to the present time.[28] Casting is indeed alive and well, and thriving,[29] for the restoration of Edo kingship following the disaster of the 1897 expedition – when several thousand works of art in all manner of materials were looted by British naval and military forces (and their art-historical context destroyed for ever) – has ensured the continued flourishing of this art.

The earliest works of art from Benin City almost certainly date from the period before European contact, which was established by Portuguese traders in 1485 or 1486 as they opened up the coastal route around Africa to India and beyond.[30] From the arrival of the Portuguese onwards the alloy used in Edo-Benin casting was a leaded brass within which the proportion of zinc varied in accordance with the alloys traded in from Europe: the amount of zinc slowly increases to about 33% by 1800. When we turn to the rather small number of castings thought to date from the period immediately around (cat. 91) or before European contact, all those for which we have analyses make use of an alloy of leaded copper with small yet variable amounts of both tin and zinc, almost as if these early castings present us with a trace of both the (indigenous) Igbo-Ukwu and the (imported) Ife technologies. This could have happened through the practice of melting down older castings in order to recycle the alloy, a well-known source of metal among casters in the recent past. There are also formal developments in Edo-Benin art that can be dated to the period of direct European contact: the plaque form (cat. 103), images of Europeans themselves (fig. 60), the increasing size and ornamentation of the heads made

Fig. 59
Figure, probably of a King,
Ita Yemoo, Ife, late thirteenth –
early fifteenth centuries.
Brass, height 49 cm
National Commission for Museums
and Monuments, Nigeria

Fig. 60
*Plaque Showing a King in His Court:
A Portuguese Merchant Holds
a Manilla*, Benin, first quarter
of the sixteenth century. Brass,
43.5 x 41 x 10.7 cm
British Museum, London, Af1898,0115.23

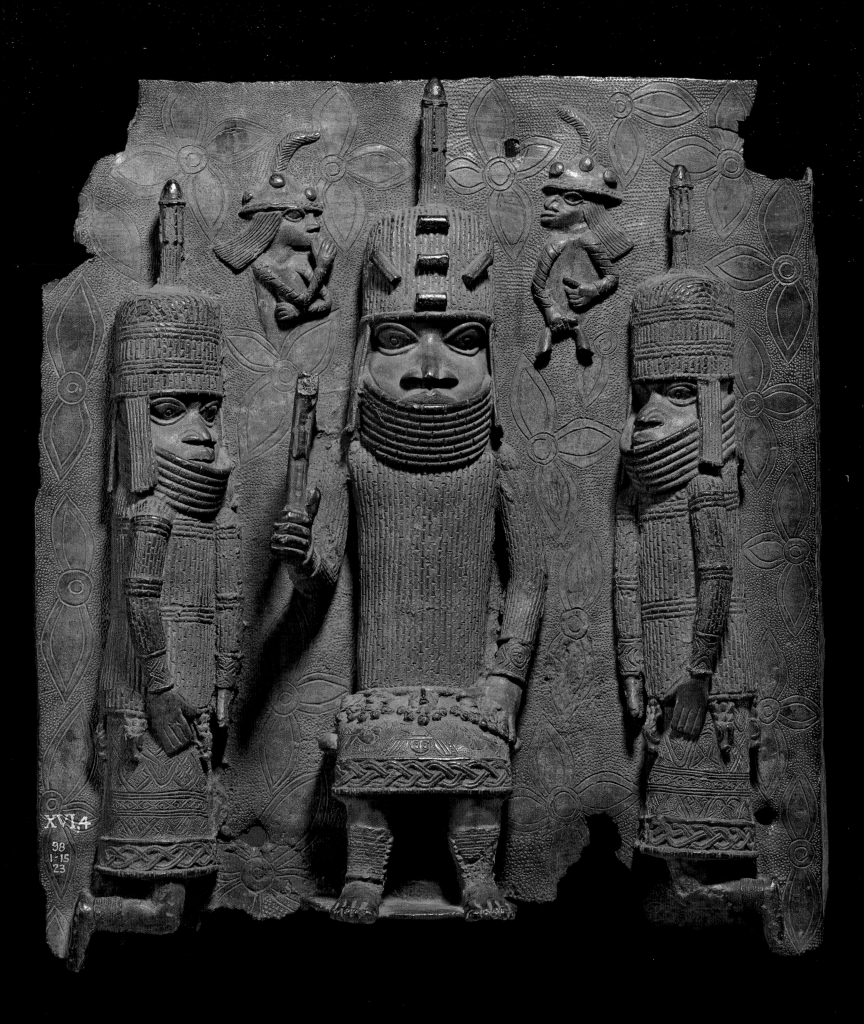

Fig. 61
Master of the Circled Cross,
Double Plaque of a Portuguese Man, Benin, c. 1500. Brass,
upper part: 42.5 x 41.5 x 7.7 cm;
lower part: 40 x 38 x 6 cm

Upper part: The Trustees of the British Museum, London, Af1898,0115.2

Lower part: Museum für Völkerkunde Wien, Vienna, VO 64.718

for the altars of deceased kings, and the veritable explosion in the quantity of brass casting from this time onwards.

The art of Benin City has, of course, been well described in a mountain of publications over the past hundred years and further comment here hardly seems necessary,[31] but for two observations in the present context. Firstly, the rectangular plaque form, made to cover the wooden pillars supporting the veranda roof in areas of the royal palace given over to public ceremonial, almost certainly emerged around 1500 in response to the Portuguese presence during the thirty years of their monopoly of the coastal trade. These plaques provide an invaluable documentary source for many aspects of Benin City court culture; and that in itself was a novel development in West African art, for the plaques are a descriptive art. Moreover, the earliest examples show artists grappling not just with a new form, but with a new type of representation; and we can recognise the hands of individual casters by the manner of their experimentation with these new possibilities. In a plaque by the Master of the Leopard Hunt (cat.103) Portuguese soldiers catch leopards for the king's menagerie.[32] In the work of another early hand, the Master of the Circled Cross (so named by William Fagg because of the distinctive background in his work), we can see him trying to deal with an essentially two-dimensional form without the use of foreshortening (fig.61). The later plaques take on a stiff hieratic mode (cat.125) as if their earlier experimentation has run its course, and by 1700 their production had ceased.[33] The second observation is that the coastal trade with Europe flourished alongside the development of mercantile relationships and military conflict between Benin City and neighbouring states to its north; and this is reflected in a series of equestrian figures.

Lower Niger Bronze Industries

'Lower Niger Bronze Industries' is the provisional label given by William Fagg many years ago to a heterogeneous group of castings[34] all without provenance; and they certainly do not represent a single tradition. One well-known group is the series of nine castings found in the Nupe-speaking riverside villages of Jebba and Tada. One of these, of course, we have already encountered (cat.70), but while that must belong to the Ife tradition, the remaining eight suggest, on the basis of their forms, several distinct casting centres, all unknown.[35] The finest of them, in my view, is the archer from Jebba (cat. 74; the arm with the bow is missing). A local mythic association with the founding hero of the Nupe state tells us nothing of any archaeological value. There are in addition a great many more castings, typically either figure sculptures or bells with animal and/or human features, and often sharing a fantastic magical imagery in which human victims are gobbled up while pythons or crocodiles emerge from the nostrils (fig.62). Some were collected at known sites or shrines in the area to the west of the Lower Niger; for others, however, such as the hunter carrying an antelope in the British Museum (cat.79), we have no data regarding a place of origin.[36] Nevertheless, they indicate that there must have been several casting centres in the Lower Niger region, although none of them is known archaeologically. Whatever the formal differences within this group of castings, the fantastic imagery suggests a unity of ideas and ritual practices also transcending ethnic and linguistic differences through several centuries. Moreover, all those castings for which we have the relevant data were made using leaded bronze, i.e. tin-bronze not zinc-brass, which suggests that in their metallurgy they are related, somehow, to Igbo-Ukwu (and the inception of an alloying and casting practice within the Lower Niger region) rather than to Ife (which employed an imported Mediterranean technology). Yet from the late fifteenth century onwards

Fig. 62
Bell, from an unknown location to the west of the Lower Niger, eleventh–fifteenth centuries. Bronze, 23 x 18 cm
Collection Monika Wengraf-Hewitt, London

brass was readily available via European coastal trade,[37] and a local smelting and alloying technology would surely have quickly died out, unable to compete with the new circumstances of supply and demand. If this is accepted, it follows that these tin-bronzes must date from a time before c. 1500.

There is also a much less well-known group of castings from sites in the Niger Delta, and from thence eastwards, comprising bells, leopard skulls (fig. 63) and unidentified quadrupeds.[38] They indicate a further set of casting locations also as yet unknown; and their metallurgical composition remains to be established.

Conclusion

With the exception of Ife, where casting entailed the transfer of a tradition already developed in ceramic, the copper-alloy castings discussed here provide us with the earliest evidence of the formal and aesthetic traditions of this part of Africa; and in the fantastic imagery shared by many of these works we have evidence of long-standing ritual concerns notwithstanding linguistic and other social differences across this region. Yet all these forms (and this includes Ife ceramic sculpture) simply appear, ready-formed as it were. Even those

sites known archaeologically lack a developmental context; and while some sites are documented in written records from the late fifteenth century onwards, others are known only from the works of art themselves, works that are unlikely to have been made anywhere near the places where they were first described. Some are even without that provenance, having found their ways to Europe from unknown locations.

Nevertheless, the bronzes of Igbo-Ukwu are evidence of the invention of an alloying and casting technology somewhere within the region, while the brass castings from Ife indicate a region also open to trans-Saharan trade. Ife remains the exception, however, for until the arrival of European coastal trade from 1500 onwards every other casting centre in the Lower Niger region continued to employ the local alloy. From that point on, however, sooner rather than later, bronze was to be overwhelmed, rendered irrelevant indeed by the sheer volume of brass now available, although for a while melted-down old bronzes would have figured among the materials available to casters. In some casting centres, existing forms now employed the ready-made alloy, while new forms also appeared, most obviously in Benin City.

Fig. 63
Leopard Skull, from an unknown location to the east of the Lower Niger, eleventh–fifteenth centuries. Bronze, length 19 cm
Royal Museum of Scotland, Edinburgh, A. 1946.697

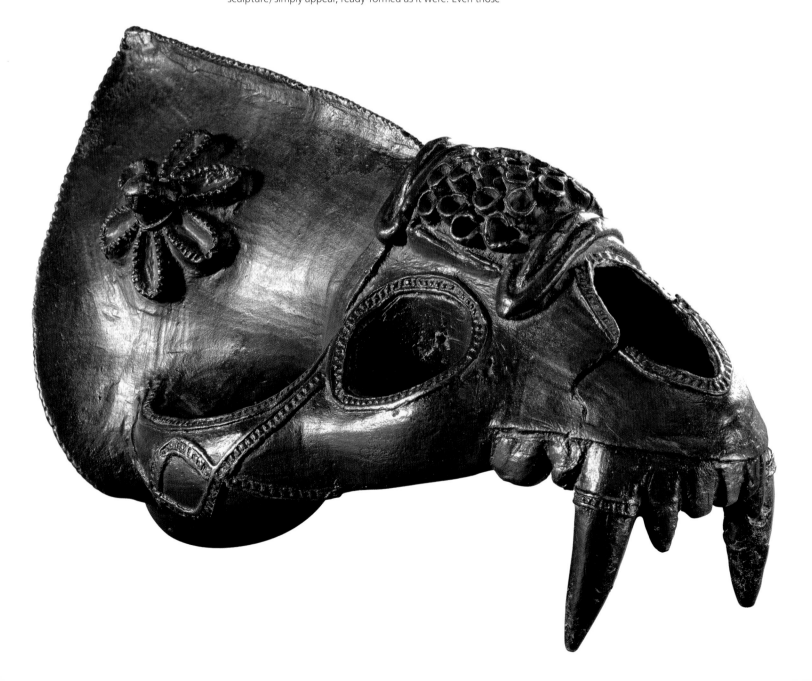

The Bronze Object in the Middle Ages

Ittai Weinryb

Fig. 64
Pair of door-knockers from the southwest portal of Trier Cathedral, thirteenth century. Bronze, diameter 29 cm
Trier Cathedral

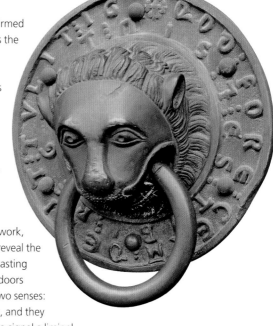

Alongside stone, bronze was the most popular medium for three-dimensional works of art in the Middle Ages. But whereas sculptures in stone were conceived, for the most part, as components of a medieval edifice, sculptures in bronze tended to be produced as single objects, usually freestanding and separate from their architectural surroundings.

The rise in quantity of monumental bronze artworks produced during the Middle Ages was due more than anything else to the revival of the lost-wax technique. Knowledge of this technique had a significant impact upon the facture of medieval works of art in bronze, and it enabled the production of small as well as large objects. The ring from the sanctuary of Durham Cathedral (cat. 65) exemplifies the spectacular results that could be achieved by medieval lost-wax bronze casters. The pair of door-knockers that used to decorate the doors of the Cathedral of St Peter at Trier (fig. 64) bear inscriptions that evoke the place of this unique technique and the standing of those who used it in the Middle Ages. One reads: 'That which the wax gives, the fire removes and the bronze returns to you,' indicating the medieval understanding of the durability of bronze objects, with the implication that they have a certain aura. On the other we read: 'Magister Nicholaus and Johannes of Bincio have made us.' This celebrated technique, with all its connotations of mysterious alchemy, is associated with the artistic ability of the makers, and this is reaffirmed in the use of the first-person plural, giving us the spoken, indeed animated, testimony of the door-knockers themselves.[1]

One of the early medieval manifestations of the lost-wax casting technique is to be found in the three separate sets of bronze doors at the threshold of Charlemagne's palatine church in Aachen, known today as the Cathedral of St Mary (fig. 65). The doors, which date from c. 800, mark a technical high point. Their bronze surface is highly polished, almost reflective in appearance. Astoundingly, as an integral part of the cast work, each door bears a lion-head knocker. These reveal the proficiency of those practising the lost-wax casting technique when it was revived. The Aachen doors represent a return to an ancient practice in two senses: they revive the technique of lost-wax casting, and they mimic the classical practice of using bronze to signal a liminal transition between exterior and interior, between sacred and secular realms.[2]

The monumentally scaled doors at Aachen provide a transition between the courtyard of the cathedral and its sanctuary. In the courtyard, Charlemagne assembled antique bronze

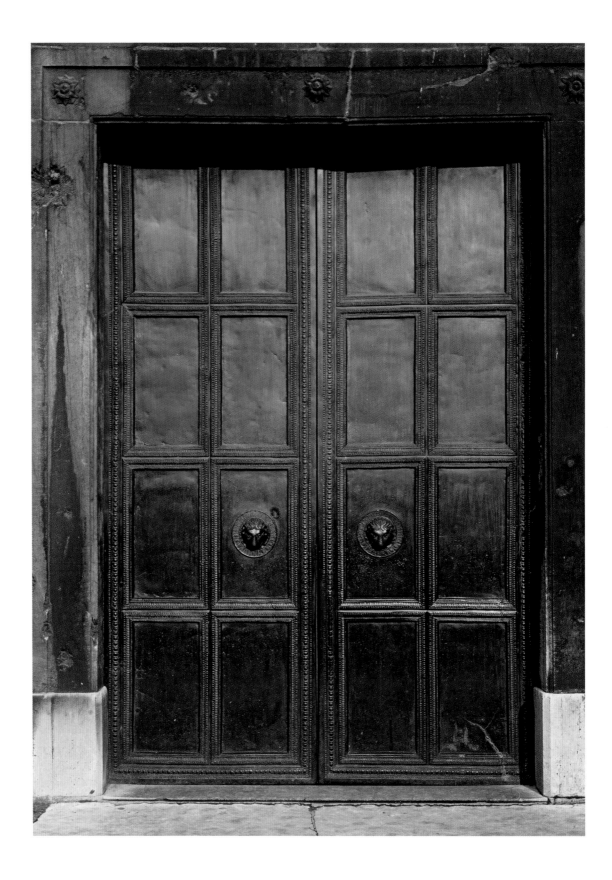

Fig. 65
Bronze doors, Cathedral of St Mary,
Aachen, *c.* 800

sculptures brought from Rome, where he was crowned Emperor by Pope Leo III on Christmas Day 800. The works in this 'collection', if we might call it that, included a large bronze sculpture of a pine cone and one of a she-bear. Both objects were made in antiquity through lost-wax casting. Thus for Charlemagne they operated in a dual sense: as part of an assembly of antiquities and also as demonstrations of the technique of lost-wax casting. The impetus for putting together this collection and its spatial link to the bronze doors with their noteworthy lion-headed knockers marks an important point in the re-evaluation of large-scale bronze sculpture. Medieval practice here imitated antique tradition, and revived an interest in the production of bronze objects in the Middle Ages.[3]

The bronze doors at Aachen were made in a prolific local workshop whose other extant pieces include the railings between the palatine church's balcony and its inner sanctuary. The doors were a forerunner to a greater and more lavish set: those at Hildesheim, which are thought to be the first historiated sculptural work of the Middle Ages (fig. 66). They were commissioned in 1015 by Bernward, who founded the monastery dedicated to St Michael and later became Bishop of Hildesheim. Unlike the plain doors at Aachen, those at Hildesheim, which measure more than four metres in height, were embellished with narrative scenes, masterpieces of low-relief lost-wax casting. It is important to stress how difficult it was to cast multiple scenes on a single door panel, and yet, stunningly, the casters at Hildesheim rose to the challenge. The entire cycle – from the creation of Eve to the expulsion from the Garden of Eden, and then the scenes leading to the murder of Abel by Cain – was cast as a single panel. The right valve of the doors tells the New Testament story, from the scenes of the Annunciation to the Life and Passion of Christ, ending with Mary Magdalene encountering the resurrected Christ, known as the Noli me Tangere. At the centre of the doors, two lion-headed door-knockers echo those on the earlier doors at Aachen.[4]

In one of the scenes, in which God with a cruciform halo confronts the sinful Adam and Eve, great technical attention is paid to God's garment as well as to the daring of his pose. God almost faces the viewer. Adam, Eve and a beastly, eight-legged snake are interspersed between an abundant array of flora; the detailed attention to the figures, plants and trees is testimony to the amazingly high level of craftsmanship found in this early period of the medieval revival of bronze casting. As well as the doors, Bernward commissioned a bronze column on which a winding narrative tells stories from Christ's life. Inspiration for this column, as well as for the doors, was probably found in the Roman antiquities that Bernward must have seen when he visited the Eternal City in

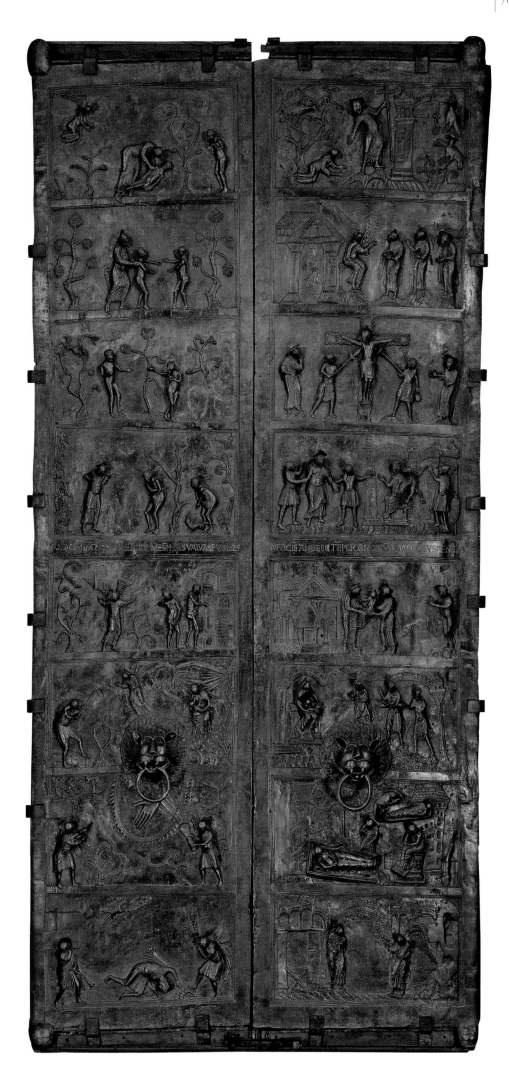

Fig. 66
Bronze doors, Cathedral of St Mary, Hildesheim, commissioned by Bishop Bernward, 1015

c. 1000 as a member of Otto III's entourage. The design at Hildesheim, however, particularly the formulation of an understanding of the decoration of bronze objects, was the great novelty.

The sacred interiors of churches were also a source of artistic innovation when it came to the production of bronze objects. Bronze was used for liturgical objects such as chalices and containers for the host, as well as large-scale sculptures including crucifixes and baptismal fonts. The use of bronze for liturgical objects looks back to biblical tradition. Famously, King Solomon furnished his temple in Jerusalem with a 'brazen sea': we know that this bronze basin was cast, although its purpose remains unclear. A passage in the First Book of Kings informs us that the basin was mounted on twelve bronze oxen that carried the water.[5] In the early twelfth century, Reiner de Huy cast a bronze baptismal font (fig. 67) that deliberately looked to the textual description of Solomon's brazen sea.[6] Reiner's font Christianised Solomon's basin, imbuing it with a new significance that made the church of Saint Barthélemy at Liège, where the font was housed, an analogue for the Temple of Solomon in Jerusalem. As an object cast as a single piece, the baptismal font at Liège evoked one of the more pedestrian objects in the church: its bronze bell. Although church bells are known to have been part of the Christian rite since the late fourth century, evidence of their casting as a single piece is found no later than the eighth century. The need for bells to produce a clear sound demanded that their bronze shells be made seamless, something that could only be achieved by casting them. The sonic purity demanded from bells was not a requirement for the font, which can be thought of, however, as a bell turned upside down.[7]

The expense of bronze, and the awe-inspiring technique with which it was cast, made it a highly prized means of expressing devotion when commissioning other works of art for liturgical use. Small bronze crucifixes became a popular medium for the devotional arts. A large number of them were produced in Cologne and its vicinity in the twelfth century.[8] With their delicate folds in Christ's loincloth and the detailed attention to Christ's physiognomy, lost-wax casting was the ideal technique for their manufacture. When it comes to the depiction of Christ, it makes sense that bronze was an elevated material for other reasons as well. Biblical passages stress the idea of creation as a process analogous to the lost-wax casting technique. Both Adam and Christ are created 'out of nothing' (ex nihilo). They were made in the likeness of God, a process that evokes the idea of generating work through the process of casting. Bronze casting, in which an object is generated as an exact likeness, became a prized means for fashioning Christ's portrait.

As a material, bronze was associated with the biblical tradition of the brazen serpent, which Moses cast in the desert. According to the story,[9] when God decided to test the Israelites, he sent serpents to bite them. He then instructed Moses to make a serpent out of bronze and place it on a pedestal. Those Israelites bitten by the serpents who gazed at the brazen serpent would be healed. In John's Gospel,[10] the author evokes the story of the brazen serpent, saying: 'Just as Moses lifted up the snake in the desert, so the Son of Man must be lifted up.' Christ on the cross paralleled the story of the brazen serpent, a connection that was stressed when medieval crucifixes were made out of bronze.[11] The brazen serpent and the crucifix became one, endowing the bronze crucifixes of Cologne with even greater symbolism, generated by the material from which they were made.

Because bronze was meaningful in both the antique and the Christian traditions, it became an important medium for medieval secular portrait sculpture. The tomb effigy of Rudolph of Saxony in Merseburg Cathedral is the first instance of the use of bronze for a portrait of a deceased king. The qualities afforded by the malleable material of bronze and the specific techniques of the facture of the sculpture provided a likeness of Rudolph that

Fig. 67
Reiner de Huy, *Baptismal Font*, between 1107/08 and 1125. Bronze
Saint Barthélemy, Liège

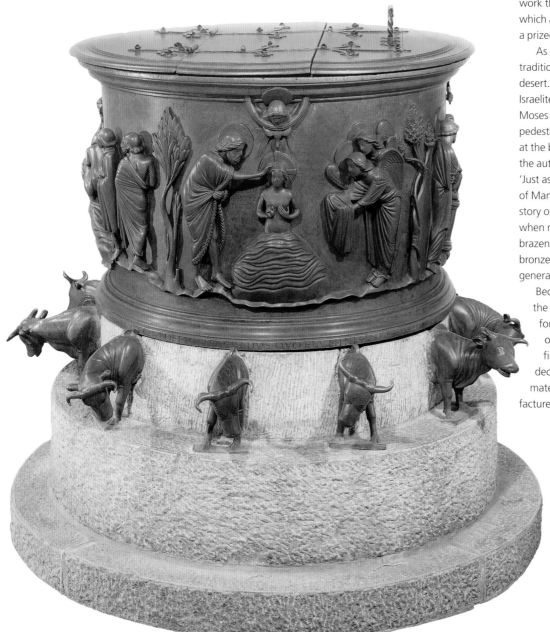

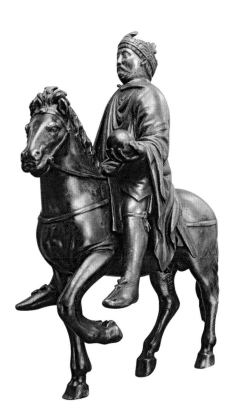

characteristics traditionally ascribed to bronze objects. The late eleventh–early twelfth-century Krodo altar from Goslar (cat.63) is a pierced bronze altar shaped as a rectangular box. The holes made in it create a cruciform shape reminiscent of the embellishments with precious stones found on liturgical objects. Inside the altar, candles and a censer generated fire and smoke, and light and smoke emerged through the cruciform-shaped holes: medieval pyrotechnics made to highlight the transubstantiation during the Eucharist.

Bronze sculpture's ability both to create a sensual experience for the viewer, particularly thanks to its reflective surface and its potential for likeness, encouraged the depiction of animals. Whereas the Roman she-bear brought by Charlemagne to Aachen appears to roar, a bronze sculpture of a griffin, made in the late eleventh or early twelfth centuries and now preserved in the Museo dell'Opera del Duomo at Pisa (fig.69), roared in a literal sense. It shares features with a bronze lion shown here of similar date (cat. 62). Within the interior of both animals' bodies an enclosed bronze chamber acted as a resonance device. The air that entered their mouths came out of their tails, bouncing against the inner chamber and generating

Fig. 68
Equestrian Statue of Charlemagne or Charles the Bald, ninth century. Bronze with traces of gilding, height 23.5 cm
Musée du Louvre, Paris, OA8260

Fig. 69
The Griffin from the roof of the apse of Pisa Cathedral, Islamic, late eleventh or early twelfth centuries. Bronze, 107 x 87 x 43 cm
Museo dell'Opera del Duomo, Pisa

was commented upon for its realism.[12] The head reliquary of Frederick Barbarossa (Schloss Cappenberg, near Selm) reveals a similar interest in the creation of a likeness, here in the form of a gilt-bronze bust that served as a reliquary. Contemporary texts describe Barbarossa's physiognomic features, and the technique of bronze casting achieved an accurate likeness. It is this attention to detail that made the effigy of Rudolph and the reliquary of Barbarossa animate, so to speak, the bodily fragments encased within them.[13]

Other types of object engaged with a different type of animation; namely, the creation of bronze sculptures inspired by antique models.[14] The small equestrian statue of Charlemagne made in the ninth century and now at the Musée du Louvre (fig.68) is a portrait in bronze that alludes to antique equestrian portraits of Roman emperors. The horse itself could be a Late Antique work, to which the seated figure of Charlemagne was added. Charlemagne holds an orb, an antique Roman symbol that signifies his sovereignty over the world. The sculpture looks back to the famous equestrian statue of Marcus Aurelius on the Capitoline Hill (fig.8) and the now-lost equestrian statue of Theodoric the Visigoth that, according to tradition, Charlemagne brought from Ravenna to his newly founded capital at Aachen, where it stood in the courtyard of the palatine church, next to the pine cone and the she-bear.[15]

As the inscription on the Trier door-knocker indicates, fire was a key component in the making of bronze objects. A reflective surface and resistance to heat, fire and light were

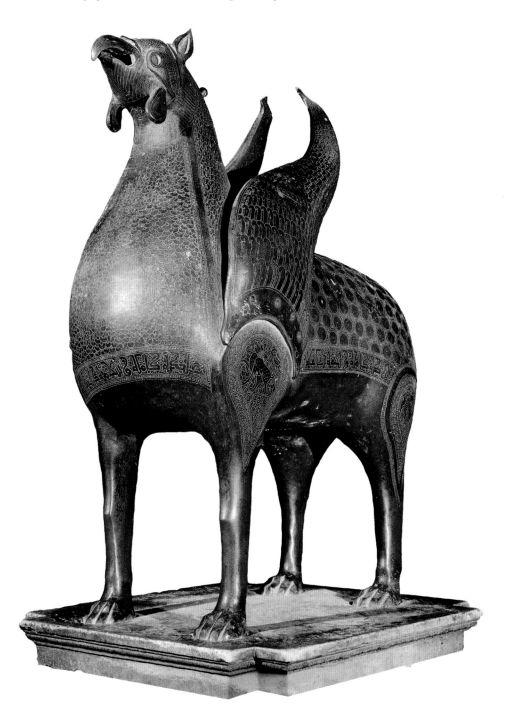

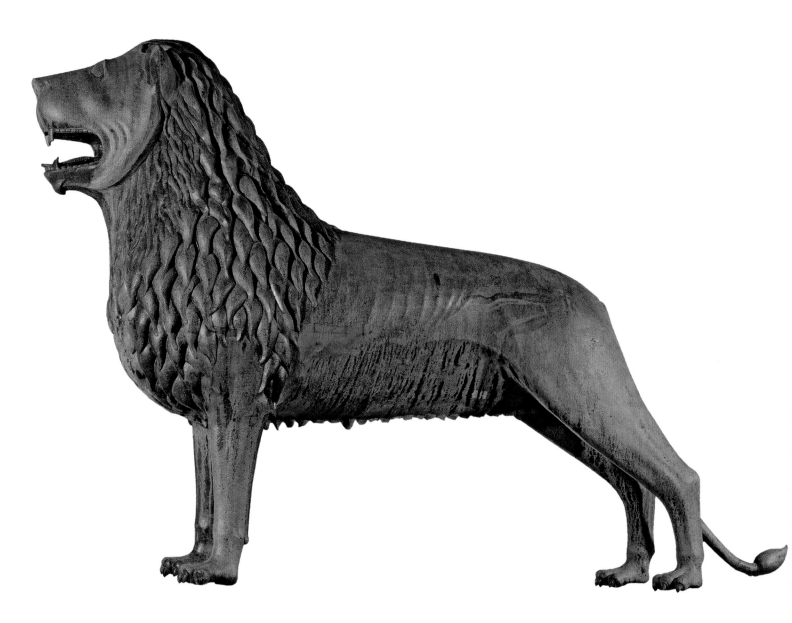

Fig. 70
Lion, commissioned by Henry
the Lion, Duke of Saxony, 1166.
Bronze, 178 x 279 cm
Burg Dankwarderode, Braunschweig

a hissing sound that could be perceived as a roar.[16] When the griffin was placed atop the roof of the cathedral's apse in Pisa, the wind, when of some strength, would have generated a roaring sound. The blustering noise struck awe into the hearts of worshippers and at the same time animated the bronze object. It thus summons a category of like objects to mind: automata.[17] The lion and the griffin also alluded to Charlemagne's she-bear and other bronzes in the Emperor's collection in the Aachen courtyard. A bronze lion now in Braunschweig also recalls exactly this tradition (fig. 70). Commissioned by Henry the Lion, Duke of Saxony, in the mid-twelfth century, the object refers to its patron's name. The lion was made in a spectacular single cast, with detailed attention to its facial features, especially its mane. By placing

a sculpture of a bronze animal outside his church, Henry was comparing himself to Charlemagne, legendary ruler of Europe. Evoking the same tradition, the Holy Roman Emperor Frederick II of Hohenstaufen placed a pair of antique bronze rams (cat.45) outside the Castello Maniace at Syracuse. Further underscoring a connection to Charlemagne's model, Frederick created his own collection of antique bronzes.[18]

In Pisa the bronze griffin looked down to one of the cathedral's thresholds, on the same side as the now-leaning tower. The bronze doors to Pisa Cathedral, manufactured in the 1180s, are the work of Bonannus of Pisa. Another contemporary set of bronze doors for the Cathedral at Monreale in Sicily were made by the same artist, which

allows us to date the examples in Pisa.[19] Like the doors at Hildesheim, those at Pisa boast an array of New Testament scenes depicting the life of Christ from the Annunciation to Pentecost and the Dormition of the Virgin. However, unlike Bernward's doors at Hildesheim, each scene here is accompanied by an inscription, further stressing the pedagogical role of the commission and indicating the doors' importance as a site of communal gathering. Whereas Bernward's were made of a single piece of bronze, Bonannus's bronze narratives are fashioned as multiple panels nailed to a wooden core.[20] Bonannus's bronze doors are a high point in the production of large-scale bronze sculpture in the Middle Ages.[21]

Bronze was used for important secular sculptural commissions, as we have discussed, and it became an important medium for civic monuments, which were often located in central areas of medieval cities. The Fontana Maggiore in Perugia (fig.71) is a prime example of this. Made by Nicola and Giovanni Pisano and unveiled during the 1278

celebrations of the free commune of Perugia, the fountain is a masterly return to ancient models combined with a medieval aesthetic and infused with Christian understanding of the public monument made in bronze. The fountain combined representations of saints and prophets, city magistrates and scenes from the Old and New Testaments as well as from Roman history; at its summit rests a large bronze basin made by the caster Rosso (Rubeus). Undoubtedly, this bronze basin carried with it a reference to Solomon's Brazen Sea. Rosso also cast three caryatids to stand on top of the basin and hold a second, smaller one from which the water of the fountain sprang.[22] Just as the wind produced sound from the Pisa griffin, water enlivened the bronze sculpture at Perugia. While the caryatids were at the cutting edge of technological innovation, they were at the same time looking back towards artistic models embedded in antiquity. On the façade of the nearby Palazzo dei Priori, overlooking the fountain, can be seen two bronze sculptures of a lion and a griffin. Whether the lion shown here (cat.62) and the Pisa

Fig. 71
Nicola and Giovanni Pisano, Fontana Maggiore, Piazza IV Novembre, Perugia, 1275–78

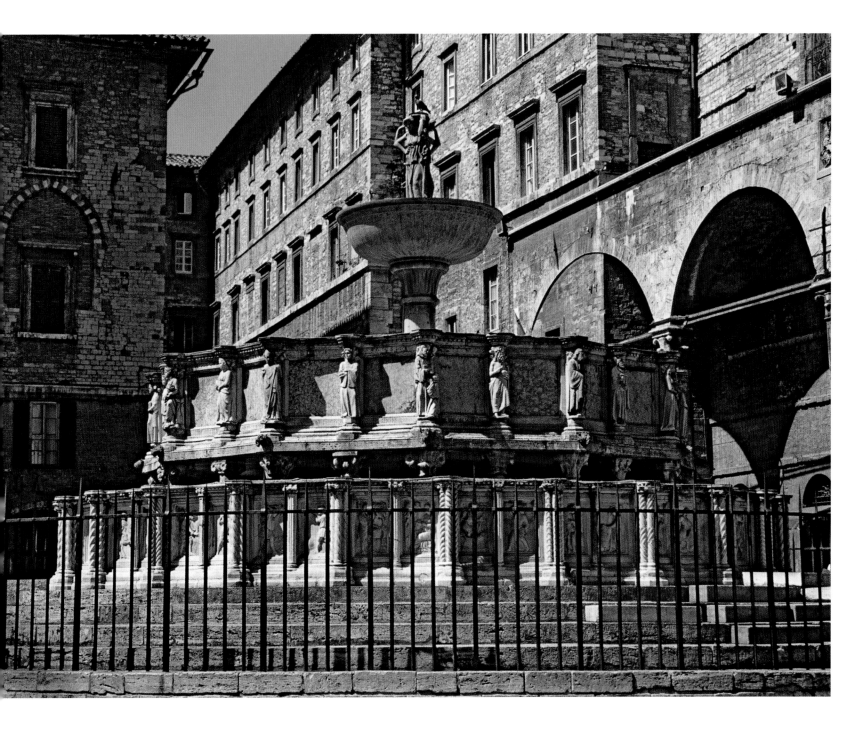

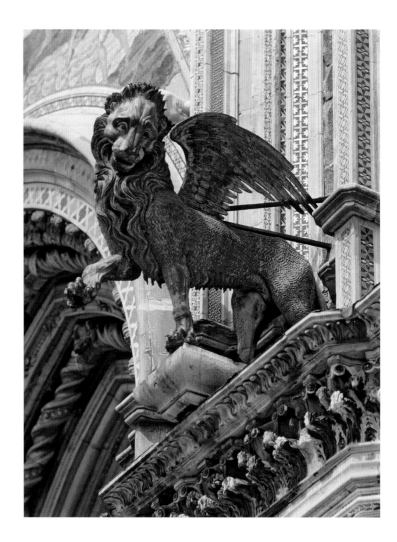

griffin were in the mind of the commissioner of the Perugia pieces, recalling their 'automatic' nature, we shall never know. But we can be certain that the place of bronze sculpture in the medieval public sphere found continuity not just in the material and technique of making but also in the motifs and iconography selected.

In the late thirteenth century, the same Rosso deployed innovative bronze decoration at the cathedral in Orvieto.[23] A bronze architrave bearing the image of Christ and the twelve apostles was substituted for bronze doors here. Later, in the early fourteenth century, Lorenzo Maitani created bronze sculptures of the angel, the lion, the ox and the eagle, symbolising the evangelists Matthew, Mark, Luke and John respectively (fig. 72.1–4). These were placed on pillars on the façade of the cathedral. Although – as has been observed – bronze sculptures of animals had existed in antiquity, Maitani's at Orvieto imbued the type with a new religious meaning.[24]

Bronze sculptures of animals also appeared in the domestic interiors of medieval palaces. Aquamanilia (from the Latin words *aqua* [water] and *manus* [hand]), whose purpose was to contain water, became a new type of object rendered in bronze (cat. 61). Bearing zoomorphic and anthropomorphic shapes, these vessels were popular in medieval western Europe from the early twelfth century onwards; the religious and ceremonial importance of hand-washing meant that this category of objects was elevated. An interest in zoomorphic shapes drove the creation of bronze aquamanilia. Centrepieces of the dining-room setting, they can be considered conversation pieces, objects that focused on and recalled stories, historical or fictional.[25] Alongside works of sculpture, basins, ewers and weapons in bronze were produced, all quotidian objects meant for constant use.

It might seem too glib to sum up such a diverse field of objects as sharing all the similarities we have outlined above. But we could say that bronze sculpture, made from a revived ancient practice, was an important aspect of the interior and the exterior of the medieval edifice, whether sacred or secular. The lost-wax casting technique offered the possibility of animating renderings of both animal and human forms. As the inscription on the door-knocker at Trier indicates, that which the wax gives, the fire removes, only to return to you as hardened bronze. This unique technique of casting, coupled with the special qualities of the material, ensured that bronze was one of the most engaging materials for the medieval artist to work with, and one of the more impressive for the viewer to encounter. It is in the Middle Ages, rather than in antiquity or the Renaissance, that we find constant negotiation between technique and material, expanding but at the same time limiting what could be defined as bronze sculpture.

Fig. 72.1–4
Lorenzo Maitani's early fourteenth-century bronze angel, lion, ox and eagle on the façade of Orvieto Cathedral, representing the evangelists Matthew, Mark, Luke and John

The Renaissance in Italy and Northern Europe

David Ekserdjian

As has been observed in the previous essay, the old notion that the practice of making sculpture in bronze on a grand scale all but died out in the Middle Ages does not reflect the realities of the situation. On the contrary, the colossal bronzes of a Griffin and a Lion for the façade of the Palazzo dei Priori in Perugia, which are first documented in 1276–77, their fourteenth-century counterparts on the façade of Orvieto Cathedral, representing angels around a stone group of the Virgin and Child, together with the symbols of the Four Evangelists (fig. 72.1–4), and the seated St Peter at St Peter's in Rome, generally attributed to Arnolfo di Cambio, all underline the extraordinary achievements of bronze casters long before 1400.[1] It nevertheless remains the case that the dramatic transformation of the arts of sculpture, architecture and painting in the first decades of the fifteenth century, above all in Florence, which has come to be known as the Renaissance, involved a genuine and radical break with the past.

In the present context, the emphasis will necessarily be on bronze, whose inherent appeal was only enhanced by the amazing range of possibilities it offered. Not only was it the medium of choice for monumental public sculpture, whether outdoors or in, but it was also ideal for the more private scale of the statuette, which was designed to be held in the hand and studied in intimate detail. Nevertheless, this should not be taken as meaning that other media – and above all

marble and stone south of the Alps – played no part in the evolution of Renaissance sculpture. Indeed, the greatest of all sculptors, Michelangelo, virtually never worked in bronze, and fate has decreed that the two bronzes he did create – a statue of David and a gigantic effigy of his patron Pope Julius II – are respectively lost and destroyed.[2] In the present exhibition, he is represented in the form of a much later gilt-bronze version by Massimiliano Soldani Benzi of his marble statue of Bacchus (cat.127).

In 1401 Lorenzo Ghiberti defeated Filippo Brunelleschi – and six others – in a competition to create a pair of monumental bronze doors for the Baptistery in Florence.[3] The format of this first set of doors was explicitly based upon that of an earlier set of doors for the same building by Andrea Pisano, which are dated 1330, but the visual language was quite different.[4] Ghiberti did not complete his first doors until 1424, and then immediately followed them with the even more celebrated second set (1425–52; fig. 73), of which Giorgio Vasari – in his Lives of the Artists (1550 and 1568) – recorded Michelangelo as having said: 'They are so beautiful that they would do well for the gates of Paradise.'[5] Their immaculate smoothness of surface, lyrical compositions, and pictorial elaboration established one of the possible approaches to relief sculpture for the next two centuries. These qualities are equally apparent in Ghiberti's Tomb Slab of Fra Leonardo Dati of 1425–26 (cat.80).

Fig. 73
Lorenzo Ghiberti, The Gates of Paradise, 1425–52
Baptistery, Florence

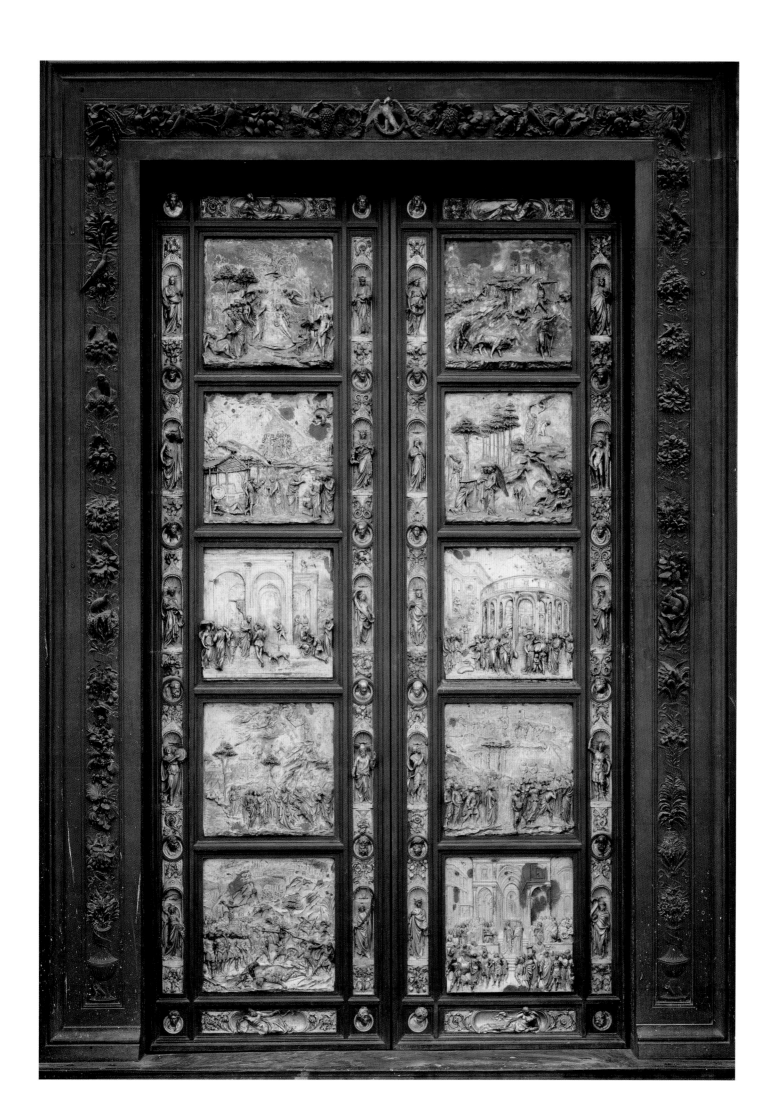

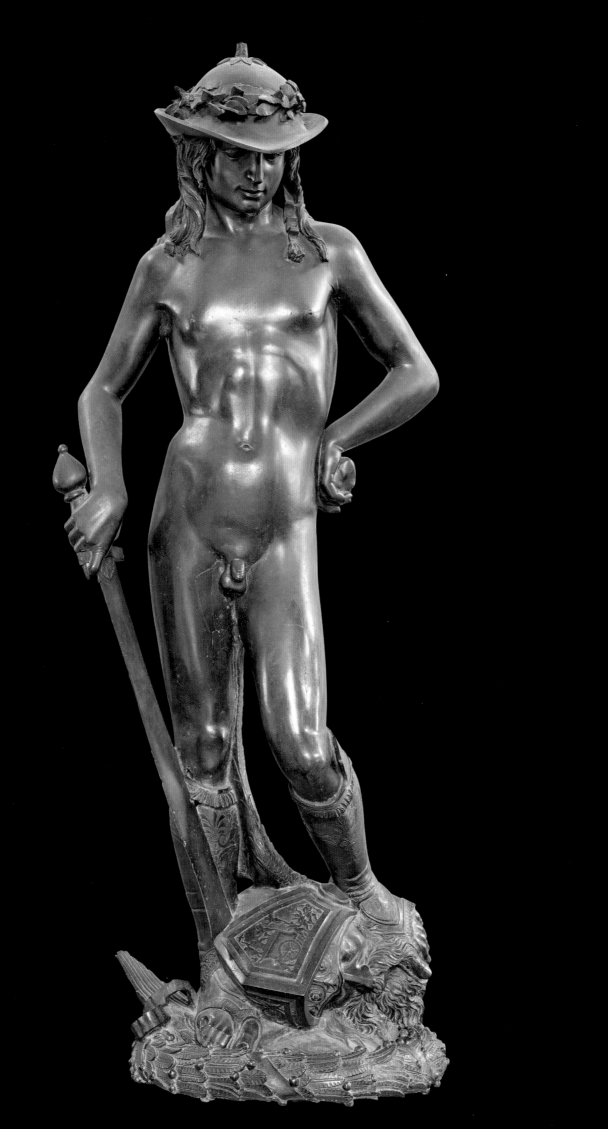

Concurrently, Ghiberti was engaged in making figure sculpture in bronze on a grand scale for three of the niches on the outside of the church of Orsanmichele in Florence. The first of these statues, *St John the Baptist* (1412–16), is still in large part gothic in style, but the other two – *St Matthew* (1419–22) and *St Stephen* (1425–29; cat.81) – are deeply responsive to the art of classical antiquity, above all in their fluid poses and naturalistic draperies.[6]

The other major Florentine sculptor of the first half of the fifteenth century was Donatello. It would be hard to imagine a more different artistic personality, but he too was profoundly drawn to bronze. In his nude statues of *David* (fig.74) and *Amor-Attis* (Bargello, Florence), he revived the pagan spirit of the ancients, while his gilt-bronzes of the Anti-Pope John XXIII for his tomb in the Baptistery and of St Louis of Toulouse for Orsanmichele, the Virgin and Child and Saints of the high altarpiece he created for the Basilica del Santo in Padua, and his *St John the Baptist* in Siena Cathedral all show the same exhilarating realism applied to religious subject-matter.[7] More important than all these works, however, in terms of his activity as a sculptor of the human figure, was his grandiose equestrian monument in front of the Basilica del Santo in Padua to the *condottiere* (mercenary general) Erasmo da Narni, known as 'Gattamelata' (fig.76), a true Renaissance rival to the ancient *Marcus Aurelius* in Rome (fig.8), which was to be followed in its turn by Verrocchio's monument to Bartolomeo Colleoni in Venice (fig.7), and a positive flood of subsequent emulations.[8]

At the same time, the narratives of four episodes from the life of St Anthony of Padua for the predella of the Santo Altarpiece demonstrate Donatello's extraordinarily bold and theatrical approach to relief sculpture, and were to be followed by the even more uncompromisingly raw Passion scenes on the pulpits in San Lorenzo in Florence, which he left unfinished at his death.[9] Also from this final period, a bronze group of *Judith and Holofernes* (fig.75) represents a new departure by virtue of the extent to which the invention is conceived in the round, as opposed to from a generally frontal viewpoint.[10]

Fig. 74
Donatello, *David with the Head of Goliath*, c. 1436–38. Bronze, height 158 cm
Museo Nazionale del Bargello, Florence

Fig. 75
Donatello, *Judith and Holofernes*, c. 1457–64. Bronze, height 236 cm
Palazzo Vecchio, Florence

Fig. 76
Donatello, *Equestrian Monument to Gattamelata*, c. 1447–53. Bronze, height 340 cm
Piazza del Santo, Padua

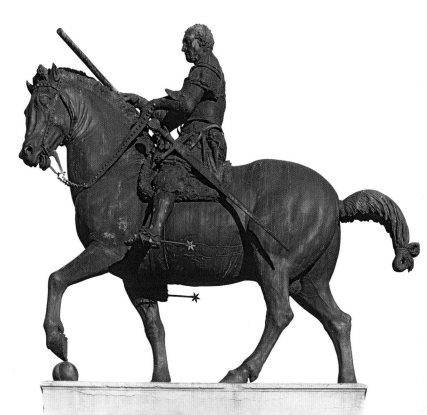

Donatello's legacy was dazzlingly wide-ranging: it determined the course of sculpture in bronze in his native Florence, in Siena, and throughout northern Italy. The most important Florentine sculptors of the next generation were Verrocchio and Antonio del Pollaiuolo, and they both worked at either end of the scale. In addition to his monument to Colleoni mentioned above, Verrocchio was responsible for the only group for one of the niches on Orsanmichele, a dramatic *Incredulity of St Thomas*, while Pollaiuolo executed the tombs of Popes Sixtus IV and Innocent VIII for St Peter's in Rome.[11] Conversely, both Verrocchio's *Putto with a Dolphin* (Palazzo Vecchio, Florence) and Pollaiuolo's *Hercules and Antaeus* (fig. 77) reveal their respective creators working on a much smaller scale and thinking in the round.[12] The scale of Verrocchio's *David* (fig. 78), in emulation of Donatello's, falls between the two extremes.[13]

After his departure from Padua and before his final return to Florence, Donatello settled in Siena.

Both he and Ghiberti, alongside the local sculptors Jacopo della Quercia and Giovanni Turini, had collaborated on the decoration of the font in the Siena Baptistery, a project that took from 1416 to 1430 to complete, so this was not his first contact with the city, and now once again he found himself working for the cathedral authorities.[14] The statue of *St John the Baptist* mentioned above was in due course placed in the chapel of San Giovanni, and – if it is accepted that cat. 85 was a trial relief for the project – there is evidence that he also started to work on a set of bronze doors for the building.[15] What is undeniable is the powerful effect his late manner had on the Sienese masters Francesco di Giorgio and Vecchietta, as is apparent both in the former's *Male Nude with a Snake (Aesculapius?)* (Skulpturensammlung, Dresden) and in the latter's *Risen Christ* for his own tomb, now on the high altar of the church of Santa Maria della Scala (fig. 79), which is a living presence of almost unequalled expressive force.[16]

It is not possible to establish either when during the fifteenth century or by whom the bronze statuette – a type of which countless ancient examples must have been in

Fig. 77
Antonio del Pollaiuolo, *Hercules and Antaeus*, c. 1475. Bronze, height 46 cm
Museo Nazionale del Bargello, Florence

Fig. 78
Andrea del Verrocchio, *David*, c. 1465. Bronze with traces of gilding, height 126 cm
Museo Nazionale del Bargello, Florence

Fig. 79
Vecchietta, *Risen Christ*, c. 1472–76.
Bronze, height 183 cm
Chiesa dell'Ospedale di Santa Maria della Scala,
Siena

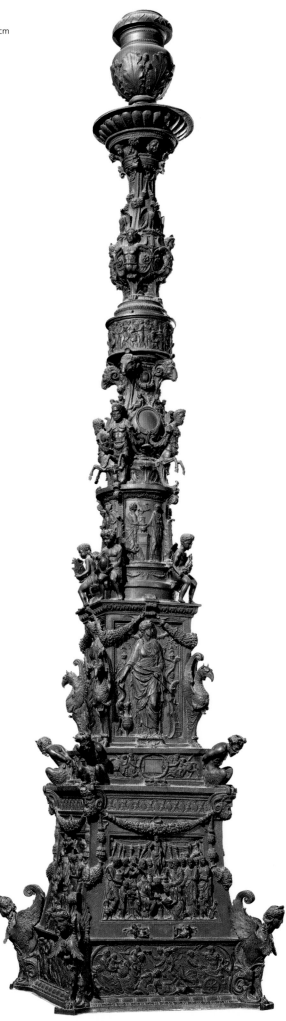

Fig. 80
Riccio, *Paschal Candlestick*,
c. 1507–15. Bronze, height 392 cm
Basilica del Santo, Padua

circulation at the time – was first revived, but it seems clear that a work such as Donatello's *Putto with Tambourine* (cat. 82), which originally adorned the Siena font, was at the very least the natural precursor of such independent creations. In the 1440s and 1450s, Antonio Averlino, known as Filarete, who was responsible for the bronze doors of St Peter's in Rome, was producing tabletop equestrian groups (cat. 83 is an example), and soon after similar statuettes were being created by associates of Donatello's in Padua and Florence such as Bartolomeo Bellano and Bertoldo di Giovanni.[17] By the end of the century, in the hands of Riccio in Padua and Antico in Mantua, the classically inspired statuette had become a fully established art form of extraordinary power, which allowed the former to respond to Donatello's unbridled pagan energy and roughness of surface, while the latter favoured a flawlessly smooth finish, and juxtaposed areas of brilliant gold against an almost black patina for flesh tones. In terms of their subjects, Riccio and such followers of his as Desiderio da Firenze explored the tenderly but also the explicitly erotic (cats 93, 94), while Antico tended to concentrate on the faithful reproduction of the most admired masterpieces of classical antiquity.[18] Both artists also worked on objects such as oil-lamps and vases, as well as on a larger scale, with Antico producing a select number of stunning busts (cat. 92), while Riccio's *Paschal Candlestick* for the Basilica del Santo in Padua (fig. 80), although composed of a whole multiplicity of individual layers and elements, is almost four metres high.[19]

By the beginning of the sixteenth century, small bronzes were also being made in northern Europe. One centre for their production was Nuremberg, where – among others – artists such as Peter Vischer the Younger and Peter Flötner (cat. 98) were powerfully influenced by Italian models.[20] At the same time, as had long been the case south of the Alps, they also began to work on a grander scale. The former's *Shrine of St Sebaldus* in Nuremberg contains literally dozens of small figures that cumulatively result in a monumental ensemble, but there were other, even more ambitious projects, such as the tomb of the Emperor Maximilian I in the Hofkirche at Innsbruck (fig. 81), in which the massed ranks of statues are over life-size.[21]

These artists were inspired by Italian prototypes, but there is no evidence that they ever went there. However, as the sixteenth century progressed, increasing numbers of sculptors did make the journey, and did not invariably return home. In the 1540s the immensely talented Benvenuto Cellini (cats 96, 99) went the other way, lured to the court of the French king, François Premier, and the Bolognese Francesco Primaticcio was licensed by Pope Paul III to make

Fig. 81
The Tomb of the Emperor
Maximilian I, 1502–66. Marble
with bronze statuary, overall
height with base 330 cm
Hofkirche, Innsbruck

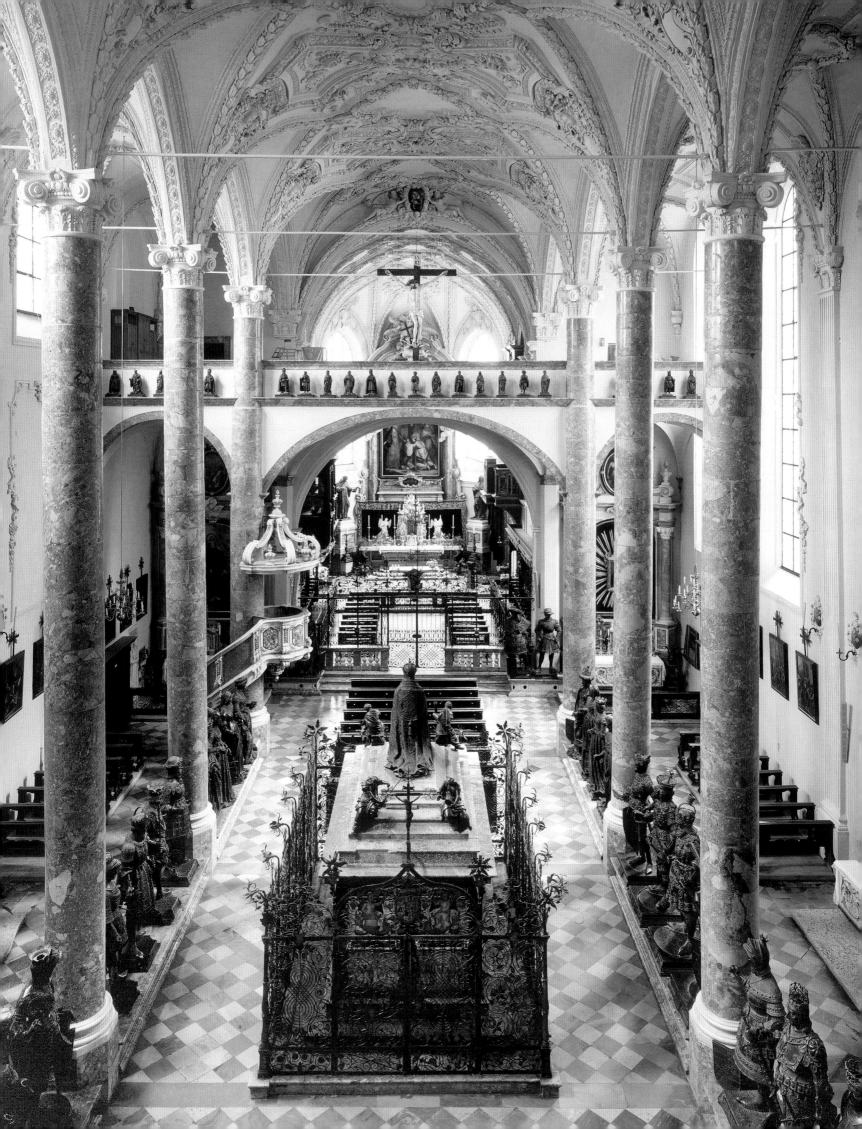

casts of a number of the most celebrated antiquities in Rome for his royal patron's château at Fontainebleau. In succeeding decades a whole host of gifted French sculptors, including Jean Goujon, Germain Pilon (cat. 97), Ponce Jacquiot (cat. 105) and Barthélemy Prieur (cat. 115), were all actively engaged in the manufacture of bronzes.[22] Of these four, Ponce and Prieur are known to have worked in Rome.[23] They produced a variety of full-scale figures and magnificent reliefs, often for funerary monuments, such as Pilon's tomb of Cardinal René de Birague (fig. 82), but were no less accomplished in the creation of supremely refined smaller-scale objects such as the king's stirrups (cat. 95) and statuettes on a whole range of subjects.[24] Some of these are straightforwardly mythological or religious in theme, as was customary. Others are equally unashamed in their lack of a conventional subject, and simply show such genre motifs as a woman milking a cow or a man doing a handstand (cat. 115).[25]

Just as François Premier recognised the need to import sculptural talent, so too did the Emperor Charles V. His choice fell upon Leone Leoni and his son Pompeo from Milan, but it was only the latter who actually moved to Spain. The most spectacular results of this association are the vast and imposing statue by Leone and Pompeo of *Charles V Overcoming Fury* in the Prado in Madrid (fig. 83), in which the figure's armour can be removed to reveal his nudity, Pompeo's stunning gilt-bronze figures of the Duke and Duchess of Lerma in Valladolid, and his majestic gilt-bronze portrait groups of the imperial family kneeling in adoration to either side of the high altar of the Royal Basilica of El Escorial.[26] Sadly, whereas Italian visitors to France jump-started a distinguished native tradition of sculpture in bronze, the same was not true of Spain. Ironically, the Leonis' one true pupil of distinction was Adriaen de Vries, who worked on the Escorial high altar and will be discussed more fully below, but who never actually went to Spain, and instead sent his statues from Milan.[27] A similar scenario led to Henry VII's tomb at Westminster Abbey being executed by another imported Italian,

Pietro Torrigiano, the Florentine sculptor who had broken Michelangelo's nose when they were apprentices together.[28]

Among the most talented northerners who worked in Italy for some years before returning to his native Holland was Willem Danielsz. van Tetrode, who produced a number of small bronzes, all based on antique models, which were designed to adorn a wooden cabinet (*studiolo* is the term used in the contemporary documents) for Niccolò Orsini, Count of Pitigliano. It has not survived, but something of its appearance is known through descriptions in Medici inventories, and the bronzes have all ended up in the Bargello.[29] Tetrode's most impressive creation, however, is the *Hercules Pomarius* (cat. 104), in which both the rippling musculature of the figure and his supremely confident stance define a very particular masculine ideal. Other immensely accomplished Dutch sculptors who learned their craft in Italy were Johann Gregor van der Schardt, who came from Nijmegen in Gelderland, and Hubert Gerhard, who spent much of his career at the court of Duke Wilhelm V in Munich. Both were capable of enchanting flights of fancy and compelling feats of naturalistic observation (cat. 116).[30]

For all the qualities of individuals such as these, by far the greatest sculptor of the second half of the sixteenth century – north or south of the Alps – was another northerner, Giambologna.[31] Born in Douai in Picardy in 1529, Jean de Boulogne – as he was originally called – was in Rome by 1550, where he is recorded as having encountered the aged Michelangelo, whose most faithful follower he arguably was.[32] He was blessed with an immensely fertile visual imagination, but he was also indefatigably industrious and technically accomplished. He could certainly execute large-scale marble sculptures and groups, of which the grandest and most daring is the *Rape of the Sabine* in the Loggia dei Lanzi in Florence, and was also responsible for monumental equestrian statues in bronze of the rulers of the city, but there can be no real doubt that his supreme gift was for small-scale bronzes.[33] Most of these were exquisitely finished, but he also produced some stunningly freely rendered bronze animals and birds, of which the *Turkey* (cat. 111) is unquestionably the most irresistible.

Giambologna's statuettes and groups were by no means the first bronzes to be created in multiple versions by the sculptor himself, but his were the first to achieve a truly international reputation. The result is that during his lifetime there were examples of his pieces at the courts of the French King Henri IV in Paris, the Elector Christian I of Saxony in Dresden, and the Emperors Maximilan II in Vienna and Rudolph II at Prague, not to mention all over Italy, and that their influence on his contemporaries and successors was immense.[34]

Fig. 82
Germain Pilon, *Cardinal René de Birague*, c. 1583–84. Bronze, 140 x 210 x 85 cm
Musée du Louvre, Paris, L.P. 396

What most impresses about them is their range of formal solutions and moods. When it comes to nude figures in isolation, Giambologna is brilliantly able to capture the slender grace and seemingly weightless flight of *Mercury* (cat. 107), but also the gladiatorial stance of *Mars* and the sinuous elegance of *Venus*.[35] In his groups, he can combine the muscular violence and might of the centaur Nessus with the writhing resistance of his victim Deianira (cat. 109), but is equally accomplished when it comes to bringing to life the dreamy sleep of a reclining nymph with the lascivious attentions of a spying satyr (cat. 110). In both instances, there are classical sources of inspiration – the Quirinal *Horse Tamers* for Nessus and the *Sleeping Ariadne/Cleopatra* (Vatican Museums) for the nymph – but the final effect is unmistakably Giambologna's alone.[36]

In view of the brilliance of all these northerners, and especially Giambologna, it is important to underline the fact that the native sculptural tradition was alive and well in sixteenth-century Italy. In the main, especially when it came to sculpture in bronze, it tended to be confined to the major centres, from which works were also exported elsewhere. In Florence, for example, Giambologna was only the first among equals within an impressively talented team of sculptors who executed a series of classical gods and goddesses for Francesco de' Medici's Studiolo in the Palazzo Vecchio in Florence.[37] Similarly, in Venice there was a long tradition of bronze sculpture. Jacopo Sansovino executed four mythological bronzes for the Loggetta at the base of the campanile of St Mark's, and a bronze door for its sacristy, while Alessandro Vittoria executed a number of elegant statuettes on sacred and secular themes (cat. 106), but they were by no means alone, as is demonstrated by the extensive production of such admittedly less gifted figures as Girolamo Campagna and Niccolò Roccatagliata.[38] Rome, too, should have been a natural home for bronze, and could indeed boast the monumental achievement of Guglielmo della Porta's effigy of the seated pontiff on the tomb of Pope Paul III at St Peter's, but there was virtually no corresponding production of statuettes (cat. 101 are exceptions).[39]

Giambologna's fame was without question unrivalled at the end of the sixteenth century, but from today's perspective he is surely matched, if not surpassed, by Adriaen de Vries.[40] De Vries was responsible for a select number of exquisite statuettes, but where he excelled was in the creation of large-scale bronzes, both religious and mythological, of spectacular compositional boldness and thrillingly fluid finish, such as his *Seated Christ* from the Liechtenstein Collection (cat. 114) and his *Hercules, Nessus and Deianira* from Drottningholm (cat. 119). The freedom with which their surfaces are treated is also found in his reliefs, of which the *Forge of Vulcan* (cat. 113) is unquestionably the finest,[41] and is a kind of sculptural equivalent to the electrifyingly bold brushwork of late Titian.[42] In both contexts, what can seem like a final evolution within the context of the Renaissance was to prove the catalyst for all sorts of subsequent developments down the centuries.

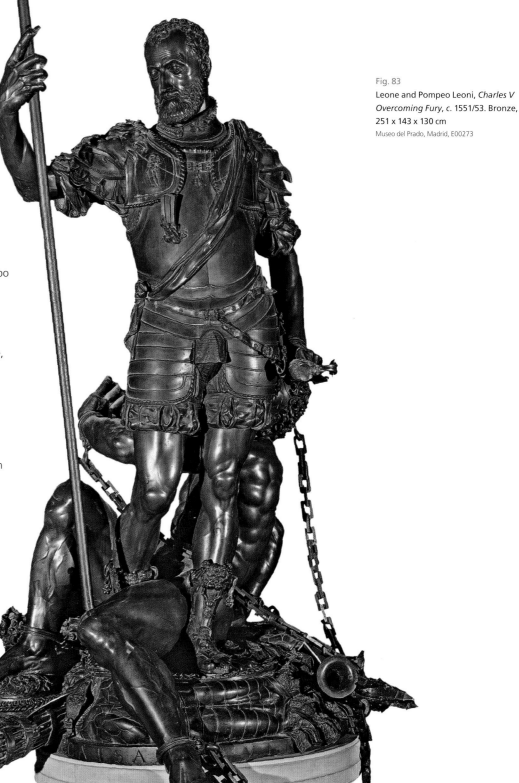

Fig. 83
Leone and Pompeo Leoni, *Charles V Overcoming Fury*, c. 1551/53. Bronze, 251 x 143 x 130 cm
Museo del Prado, Madrid, E00273

The Seventeenth and Eighteenth Centuries

Eike D. Schmidt

Whereas bronze sculpture during the Renaissance had been chiefly concerned with the single human figure, and occasionally with the pairing of two – such as a horse and a rider, or two men in combat – the interacting figural pair became one of the foremost artistic tasks during the seventeenth and eighteenth centuries, and aiming even further, bronze sculptors regularly set their hands to the challenge of multi-figured bronze groups. Giambologna (whose work is discussed in more detail in the previous chapter) laid the foundations for this development. His bronzes arguably belong to the baroque period as much as to the late Renaissance or Mannerism, since they continued to be cast, copied and competed with time and again throughout the seventeenth and eighteenth centuries. It is evident that not all of his inventions sparked the same attention during the following centuries: when Louis XIV ordered copies after bronzes by Giambologna in Florence in 1664, he specifically requested 'groups of figures, that is to say two, three or four figures together rather than single figures'.[1]

The Fleming's *Labours of Hercules* played a crucial role in establishing the two-figured group as a pre-eminent exercise in the field of metal sculpture. But even more important was his *Rape of the Sabine*, since it is emblematic of a new evaluation of bronze versus marble as the primary and most genuine material of sculpture. Tellingly, the three-figured and over-life-sized marble version (1582) is derived from a two-figured bronze created by the artist three years earlier for Duke Ottavio Farnese of Parma (fig. 84). Without the afterthought of the crouching male Sabine – a prop necessitated in marble for structural reasons – the composition is rendered in the bronze in a more convincing fashion from a narrative point of view. Moreover, its size allows for convenient circumambulation, or perhaps installation on a turntable, as Adriaen de Vries had required in a letter to his patron for his bronze reduction of the *Farnese Bull* (1614; 103.5 cm high).[2] By contrast, the colossal marble version of the *Rape of a Sabine* called for a troublesome hike around the statue on the part of the beholder to unravel its composition, if its architectural setting in the Loggia dei Lanzi in Florence had not blocked many of its desirable views (and the continuum of their perception) in the first place. Following a principle that is contrary to the reduction of famous marble statues from classical antiquity into bronzes of a much smaller size, as had been practised since the early Renaissance, Giambologna's marbles were essentially blown-up versions of much smaller bronzes.

Not by coincidence, the most successful artists who emerged from Giambologna's workshop and, after his death, dominated the scene in Florence – Antonio Susini (1558–1624) and Pietro Tacca (1577–1640) – specialised entirely in bronze sculpture. Susini, who originally trained

Fig. 84
Giambologna, *Rape of the Sabine*, 1579. Bronze, height 99.5 cm
Museo e Gallerie Nazionali di Capodimonte, Naples

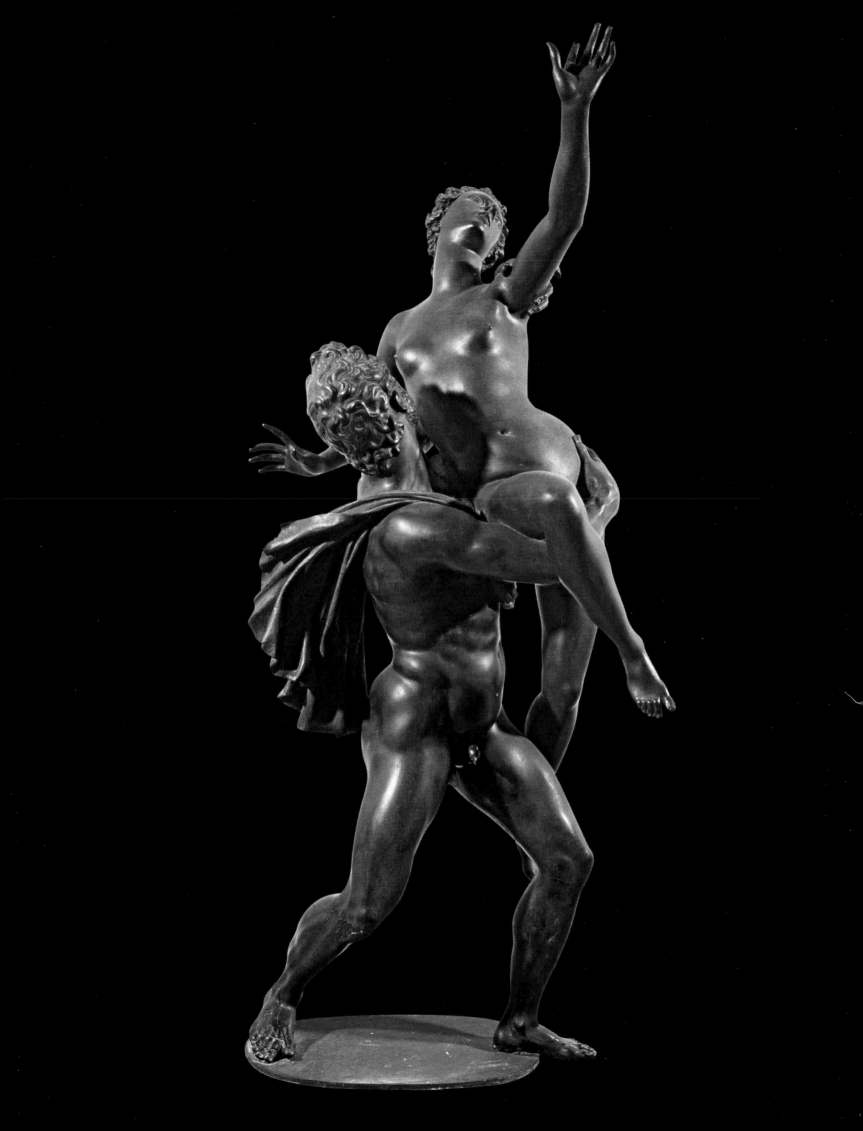

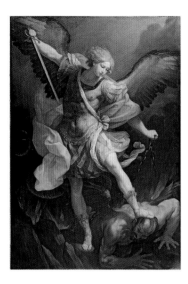

as a goldsmith, relinquished the more expensive metals for bronze. Tacca loathed marble carving, as Baldinucci recounts,[3] despite or because of his birth and youth in Carrara. Both sculptors worked for patrons across Europe, as did a number of Giambologna's students who settled elsewhere, such as Pietro Francavilla in Paris, Adriaen de Vries in Prague and Hans Reichle in Munich. Even the following generation of bronze sculptors in Florence, with Antonio Susini's nephew Gian Francesco (1585–1653) and Pietro Tacca's son Ferdinando (1619–1686) dominating the stage, remained deeply indebted to Giambologna's models.

The younger Susini's *Abduction of Helen by Paris* (cat. 120) is clearly recognisable as a variation upon the theme of Giambologna's bronze and marble versions of the *Rape of a Sabine*, but it transforms and updates it according to high baroque ideals. Both sixteenth-century examples are all about vertical elevation, but Susini's is at least as much concerned with horizontal forward motion. His figure of Helen seems to be captured snapshot-like in the act of running, and is in this respect reminiscent of Bernini's marble *Daphne* at the Villa Borghese in Rome. In fact the entire work evokes a much greater sense of speed than any bronze from the previous century would have been intended to convey. As a consequence of its higher pace, the composition is much more open, riddled with empty spaces, while limbs in mid-air protrude in different directions. As this group demonstrates, no other material could compare with bronze when it came to effortlessly providing compositions with an open silhouette.

In a similar vein, Ferdinando Tacca took the subject of the rearing horse a degree further than his father, an accomplished *animalier* who had cast the *Porcellino* for the Fountain of the Mercato Nuovo in Florence (cat. 112) after an ancient marble, and had made a number of mid-sized bronzes of rearing horses with streaming manes and tails.[4]

Significantly accelerating the dynamism of previous examples, Ferdinando's horses appear to jump across ditches or streams, with their long manes and tails often wildly yet elegantly fluttering in the wind (fig. 86). Captivated by the appeal of the dramatic group, Ferdinando Tacca and Damiano Cappelli created equestrian hunters (both domestic and exotic) chasing and stabbing boars, bulls, stags and lions. These took their ultimate inspiration from Giovanni Bandini's *Hunt of Meleager* (1583; Museo del Prado, Madrid). Bandini's former student and heir, Francesco Fanelli, became court sculptor to King Charles I in 1632 (see cat. 123). He also had a particular penchant for equine and sporting bronzes, which according to contemporary inventories enjoyed an enormous success, and became the first category of bronzes to be avidly collected by the English nobility.

Elaborating upon Giambologna's theme of a *Satyr Approaching a Sleeping Nymph*, Ferdinando Tacca created a highly influential series of mythological and literary couples: *Venus and Adonis*, *Mercury and Juno*, *Angelica and Medoro*, *Ruggero and Angelica*. Since these subjects were very popular in Florentine painting of the time as well, it is unsurprising if several cases of influences in one direction or the other have been pointed out.[5] But nowhere did bronze sculptors pay as much attention to the most recent innovations in the two-dimensional arts as in Rome, where ancient sculpture gave way to contemporary painting as a source of inspiration. Not only did devices of visual rhetoric or individual details of style travel from oils on canvas into bronze (such as the use of drapery as a means of emphasis, or the stylised shapes of its folds), but entire compositions were transposed from paintings or engravings into three dimensions. A prime example of this is Alessandro Algardi's *St Michael Overcoming the Devil* (cat. 121), which has rightly been traced back to Guido Reni's painting of the same subject in Santa Maria della Concezione in Rome (fig. 85).[6] All three protagonists of baroque sculpture in the Eternal City – Algardi, Gianlorenzo Bernini and François Duquesnoy – carried out major works in bronze. Andrea Bolgi from Carrara, a more specialised bronze artist (although he was also the author of the colossal marble of *St Helena* in the crossing of St Peter's), had started his career as an assistant to Pietro Tacca, whom he helped to cast the four *Captives* for the *Monument to Grand Duke Ferdinando de' Medici* in Livorno; he then worked with Bernini for many years, before finally settling in Naples.

French sculptors came to Rome as *pensionnaires* of the French Academy, which was founded in 1666, or before that independently, as did Michel Anguier who worked in Bernini's and Algardi's ateliers during his stay in Rome from 1641 to 1651. These artists not only exported individual

stylistic features to France, but they especially took to heart the principle of the painterly bronze. An excellent example of a two-dimensional model turned into a bronze is François Lespingola's *Death of Dido* (fig. 87), which is based upon Gérard de Lairesse's engraving of the same subject (1668).[7] Even without knowledge of the specific source, the beholder may perceive several elements that point to the paradigmatic medium of an easel painting: the composition arranged for one primary point of view, and moreover within an approximately rectangular field; the proscenium-like steps that function as a base; and the utterly unsculptural depiction of the rainbow as a flattened rod, bent in a quarter circle, to which the personification of Iris is screwed. In bronzes such as this, the traditionally distinct genres of (high) relief and freestanding statuary in the round have merged into a new category.

This type of bronze, which frequently depicted Ovidian subjects, became instantly popular in Florence as well. Under Cosimo III de' Medici the city became the other main centre of late baroque bronze sculpture after Paris. The painterly approach to the staging of pictorial compositions within a three-dimensional space, in a way comparable to the later practice of re-creating them with human actors as *tableaux vivants*, favoured an even greater increase in the number of figures represented in a single bronze. As François Girardon expanded the scene of the *Entombment* to ten figures in his bronze relief for Notre-Dame in Paris, Massimiliano Soldani Benzi – who had studied in Rome (1678–81) and in Paris (1681) – augmented the number of figures in his bronze *Pietà* in the round (Seattle Art Museum) to six, by surrounding Christ and the weeping Virgin with angels of various ages. In his relief version of the same subject, Soldani Benzi further increased the number of figures to nine. The sculptor's reliefs of the *Four Seasons* feature between 19 and 26 human and animal figures each. As another consequence of the desire to blur the boundary between relief and sculpture in the round, individual figures within the former genre frequently tend to be pushed out of the pictorial ground in extremely high relief, or sculpted fully in the round. This is the case in Giovanni Battista Foggini's relief of the *Crucifixion* (Palazzo Pitti, Florence), in which the most important figure, Christ, is emphasised in the round. The relief may moreover allude to the crucifix as an art object, which is integrated here into the narrative relief, and through this contextualisation again questions and redefines the boundaries of traditional genres.

An even greater multiplication of the possible number of figures than in the painterly bronze group (which might be described as a high relief without a back wall) was provided by the mountain- or pyramid-shaped structures that were occasionally employed for projects of particular prestige. The 235 cm-high *French Parnassus* (fig. 88) marks the zenith of the development of the multi-figured bronze sculpture. A bronze mountain, celebrating literature and music at the court of Louis XIV, the work was conceived in 1708 by Evrard Titon du Tillet, and carried out in bronze by Girardon's pupil, Louis Garnier (and Simon Curé, as far as the bronze medallions are concerned), between 1718 and 1721.[8] Ironically, in the eyes of its inventor the huge bronze ensemble was but a mere model for a far larger *Parnassus* to be erected in the centre of either Paris or Versailles. Titon dedicated his lifetime and patrimony to promoting the building of such a monument, which he hoped would be about 18 metres high, with over-life-sized bronze figures of the poets and musicians who flourished under the Sun King. But the project was never carried out on the megalomaniac scale envisioned by its inventor. Originally the *Parnassus* represented eight men of letters and the composer Jean-Baptiste Lully (plus three female poets in the guise of the three dancing Graces) beneath the figures of Louis XIV as Apollo, the rearing Pegasus, and a nymph personifying the Seine. In addition to these fifteen principal figures, 22 winged geniuses held medallions of seven further literary luminaries, and inscriptions on scrolls. In the following decades Titon enriched his bronze *Parnassus* with further medallions. After Titon's death in 1762, his nephew commissioned Augustin Pajou to add Titon's own likeness, and as he was instructed in his uncle's will, he donated the *Parnassus* to Louis XV. In the end this collective monument featured the portraits of 42 French writers and musicians in relief and in the round, and the inscribed names of 223 further *hommes illustres*, who were all distinguished for their intellectual pursuits. Among the latter several connoisseurs and patrons of the arts are listed,

Fig. 87
François Lespingola,
The Death of Dido, c. 1700.
Bronze, 59.3 x 63 x 42 cm
Staatliche Kunstsammlungen
Skulpturensammlung, Dresden,
H4 154/15

Fig. 88
Evrard Titon du Tillet, *The French Parnassus*, 1718–21, with later additions until *c.* 1766–76. Bronze, 235 x 260 x 230 cm

Bibliothèque nationale de France, on long-term loan to the Musée National des Châteaux de Versailles et de Trianon, MV6023

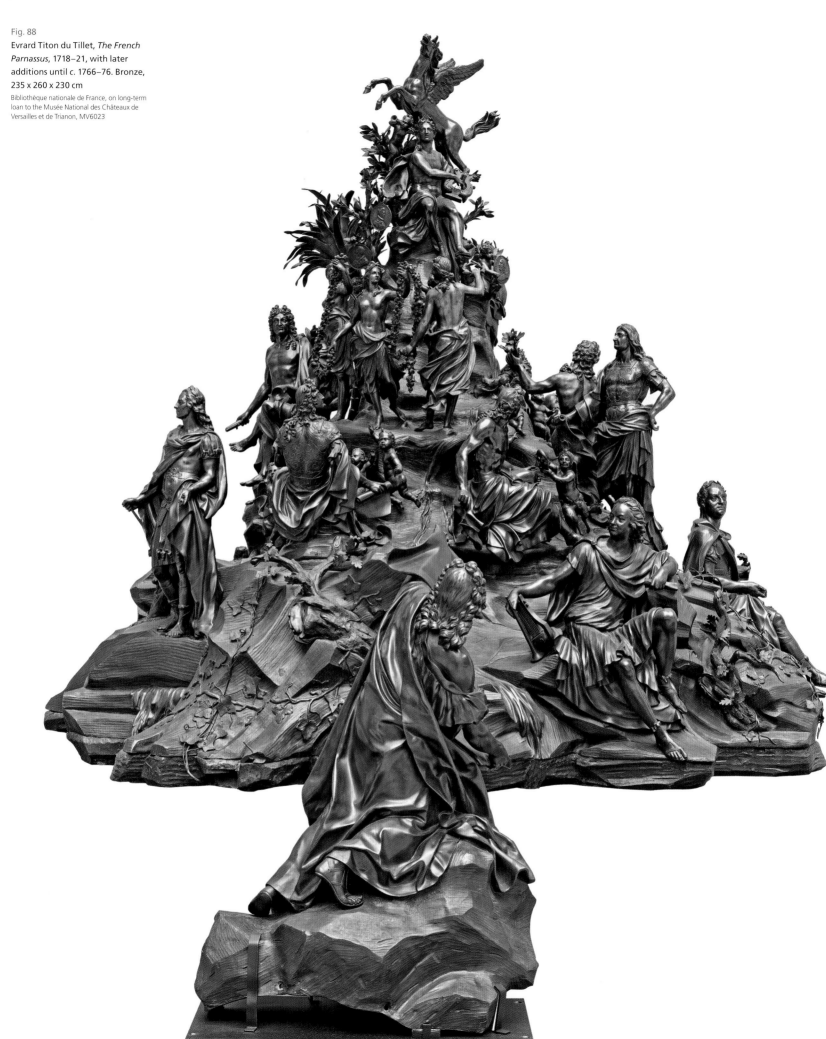

but no visual artist was immortalised on the bronze mountain.

In his extensive commentary and description of the *French Parnassus* (1732), Titon pointed to the *Niobe and Her Children* (Galleria degli Uffizi, Florence) and the *Farnese Bull* (Museo Nazionale, Naples) as ancient Roman prototypes for multi-figured sculptural groups; elsewhere, he compares his venture with François Girardon's *Apollo and the Nymphs of Thetis* – a marble group composed of seven figures – at Versailles.[9] But the *French Parnassus* was not the only attempt to create a colossal, multi-figured bronze monument in the early eighteenth century. Virtually at the same moment when Titon du Tillet first had the idea for it, the Fleming Gabriel Grupello started work on a *Bronze Pyramid* (1709–16) for the Elector Palatine, Johann Wilhelm II, in Düsseldorf. (It was moved to the Paradeplatz in Mannheim in 1738, where it still stands today.)[10] The *French Parnassus* undoubtedly holds the record for the number of figures, but the *Bronze Pyramid*, which measures 7 metres without its marble base, is approximately three times higher. With the allegories of Time, Truth and Fame at its pinnacle, followed by Hercules and the Hydra, the falling bodies of toppled vices, military trophies, the four cardinal virtues, river gods, and an abundance of allegorical flora and fauna, the monument blends and amasses elements from the traditional repertoire of celebratory political iconography.

On a much smaller, more domestic scale, but significantly larger than conventional tabletop bronzes, pyramids constructed of seemingly weightless figures piled up like circus acrobats were the speciality of the Paduan Francesco Bertos (1678–1741). Riddled with wide openings, most of these compositions depict mnemonic groupings and systems of knowledge by means of allegory and personification. Unlike the gigantic undertakings of the *French Parnassus* and the Mannheim *Bronze Pyramid*, which are unique in their ways, Bertos created dozens of these groups, albeit with different iconographic programmes. A few of Bertos's bronze triumphs include more than ten figures, but the majority are limited to a handful each. Rather than through knowledge of the projects in France and Germany, Bertos was most probably inspired by richly decorated candlesticks, fountains or similar utilitarian bronzes from the Renaissance. Some of his pyramids were made as pairs, but the 107 cm-high allegory of *Sculpture, Arithmetic and Architecture* (cat. 129) was one of a set of four.

Unexpectedly, at the very height of the late baroque period the single human figure became the focus of attention again for a short time, and for a highly specific purpose. After repeated campaigns to make actual-sized, large bronze casts based upon the most famous classical

Greco-Roman statuary for France (Primaticcio, 1541; Hubert Le Sueur, 1648; Balthasar Keller, 1687; Vinache, *c.* 1690; and Girardon, *c.* 1690 [cat. 124]),[11] Soldani Benzi cast actual-size bronzes of the *Medici Venus*, the *Dancing Faun* and Michelangelo's *Bacchus* (cat. 127) for Johann Adam Andreas of Liechtenstein from 1695 to 1702. He repeated the *Dancing Faun* and the *Medici Venus* and added the *Knife Grinder* and the *Wrestlers* (also from the Tribuna at the Uffizi) for Blenheim Palace, Oxfordshire, in 1711. Soldani's former assistant, Pietro Cipriani, cast the *Medici Venus* and the *Dancing Faun* once again in 1724, for the 1st Earl of Macclesfield (this pair was recently acquired by the J. Paul Getty Museum, Los Angeles). Soldani's and Cipriani's bronzes trump all previous casts after the antique for detail worked onto the surfaces of the metal in the cold, and for the unprecedented precision with which the ancient models are rendered and actually in many points improved. This leads to the suspicion that these artists were well aware that they were retranslating marble copies after lost bronzes back into their original material! Although these rare, commissioned casts thematically paved the way for the numerous small bronzes offered to Grand Tourists in the second half of the eighteenth century by Giacomo and Giovanni Zoffoli, Francesco Righetti or Giuseppe Boschi, they artistically prefigure works from the end of the century such as Jean-Antoine Houdon's *Diana* (fig. 89): works, that is, on a large scale and with amazingly polished and chased surfaces, that live out of the pose, gesture and gaze of a single, nude human body, rather than out of its relation to other bodies or objects.

By the second quarter of the eighteenth century, figural bronzes were replaced by other materials in a number of different functional contexts. The small bronze was driven out of the interior by fashionable porcelain. On a larger scale, lead alloys – which had already been used on occasion for medals during the Renaissance – became highly popular throughout Europe: from René Frémien's *Perseus and Andromeda* in the garden of La Granja (*c.* 1721–38), near Segovia, to Georg Raphael Donner's fountain figures in Vienna and Franz Xaver Messerschmidt's physiognomical studies in Pressburg (now Bratislava), to garden statuary in Holland and England. But the reduced number of bronze casts towards the end of the eighteenth century turned out to be a temporary lull before a new, century-long storm.

Fig. 89
Jean-Antoine Houdon, *Diana*, modelled 1776, cast 1790. Bronze, 206 x 90 x 114.5 cm (excluding arrow)
Musée du Louvre, Paris, CC204

The Nineteenth and Twentieth Centuries

Patrick Elliott

Marble was the preferred material of the neoclassical sculptors who dominated western sculpture in the latter part of the eighteenth century and the first quarter of the nineteenth. A renewed interest in bronze developed in the 1830s, particularly in France, springing from a desire to portray dramatic movement and contained energy. In order to do this successfully, sculptors needed to create subtle surface modelling and intricate detail. These goals could best be achieved by modelling a sculpture in clay, a material that could catch every nuance of the sculptor's rapid and expressive finger movements, and casting that clay into bronze. Whereas marble limbs, fingers and heads are liable to break, bronze can hold almost any shape – a major advantage for the sculptor wishing to portray movement. The sculptors who breathed new life into bronze in the 1830s were Frenchmen: François Rude, David d'Angers, the *animalier* sculptor Antoine-Louis Barye, Auguste Préault and, a little later, Jean-Jacques Feuchère. David d'Angers's bronze bust of the violinist Niccolò Paganini (fig. 90) is the Romantic bronze *par excellence* – both in its virtuoso modelling and in its subject of

a virtuoso musician. Slightly larger than life, the bulging cranium seems barely able to contain the febrile mind locked within. The dramatic intensity of the style is completely appropriate to the bronze: the fine detailing and tousled hair would have been impossible to realise in marble. Whereas white marble suggests calm and purity, here the dark bronze with glinting highlights suggests contained passion. It was cast by the bronze founder Honoré Gonon, one of the unsung heroes in the revival of bronze sculpture in the nineteenth century. It was Gonon who re-established the technique of lost-wax casting in France in the 1830s, when the conventional approach to bronze-casting was the sand-cast method.[1] Sand-casting, which was an industrial technique, was fine for simple shapes and for very large sculptures, but lost-wax casting could preserve much finer detail, even fingerprints. Gonon also cast work for Antoine-Louis Barye, the greatest *animalier* sculptor of the nineteenth century (cat. 131). The most difficult technical achievement that a sculptor and bronze founder could realise together was to cast in a single pour, and do so with such precision that the bronze did not need to be chiselled or chased. A cast of Barye's *Stag Brought Down by Two Large*

Fig. 90
David d'Angers, *Paganini*, 1830–33.
Bronze, 60 x 30 x 25 cm
Musée des Beaux-Arts, Angers, MBA 836-3

Greyhounds (fig. 91) bears the proud inscription: 'Fondu d'un jet sans ciselure par Honoré Gonon et ses deux fils' (Cast in a single pour without chiselling by Honoré Gonon and his two sons). The extraordinary surface detail, the stag's slender ten-point antlers, and the rapacious, muscular dogs that appear to writhe like snakes over the bulky, dying stag mark a high-point in casting of any era.

The making of bronzes in the nineteenth century took two distinct paths in terms of quality and finish. Sculptors would lavish time and effort on important commissions, and would control the casting, finish and patina. These bronzes could be unique or made in a small number of examples, often with slight variations. The same sculptors would also produce small bronzes for the expanding commercial market, either casting the works themselves (as Christophe Fratin did from 1837, and Barye did from 1839) or under contract to a bronze foundry, which would produce the bronzes almost like a publisher produced books. Foundries working in this way were in fact called *éditeurs*. Bronze had two distinct advantages over marble: first it was possible to make small sculptures crammed with narrative detail – the kind of detail you simply could not get with a chisel in a small-scale carving. And secondly, once a sculptor had made a model, it could be cast in countless copies, much like a book or print.

The mass production of bronze multiples for the burgeoning middle-class market was stimulated by an invention that facilitated the accurate reduction of large sculptures into smaller, mantelpiece versions. Achille Collas, who had earlier invented a roller for wallpaper production, created such a device in the mid-1830s, and for a few years manufactured small-scale versions of the *Venus de Milo*. In 1839 he sold the patent to the Parisian bronze founder Ferdinand Barbedienne. The sculptor James Pradier was contracted to the Susse foundry in Paris (Barbedienne's main rival) in 1841 and François Rude signed a contract with Barbedienne in 1843. Auguste Clésinger's agreement with Barbedienne gave them rights over his entire *oeuvre*, including all future production: Barbedienne even advised Clésinger on his subjects. In 1827 French bronze foundries had an estimated turnover of 5 million francs per annum and employed some 840 workers. By 1878 the market had increased to 80 million francs per annum and the number of workers to 7,500, employed by 600 different companies.[2] Sculptors such as Albert-Ernest Carrier-Belleuse, Jean-Baptiste Carpeaux and Emmanuel Fremiet produced work on an industrial scale and doubled up as businessmen. At its peak, Carpeaux's studio was turning out more than twenty works a month in different materials.[3] Whereas at the beginning of the nineteenth century, a bronze sculpture

had cost more to make than a marble, by the end of the century the positions were reversed. For example, in 1907 Rodin wanted 3,500 francs for the bronze version of his *Bust of Victor Hugo*, although he asked 8,000 francs for the same work in marble.[4] That same year, he was asking 8,000 francs for a bronze cast of *The Thinker*, and 18,000 francs for the marble.[5]

Auguste Rodin was no stranger to commercial activity. Between 1898 and 1918 Barbedienne cast small-scale versions of Rodin's marble carving *The Kiss*. More than 300 versions of *The Kiss* were made in four different sizes.[6] Rodin would probably not have seen, let alone worked on, most of these bronzes. Records show that he used at least 28 different foundries throughout his career, chosen on grounds of quality, convenience and cost.[7] He was, at the same time, responsible for the most radical innovations in bronze sculpture, innovations that had a profound impact on twentieth-century sculpture. The first of these was his method of manipulating clay to create a vibrant surface when cast in bronze. The surface of a human body is relatively smooth, but the problem in presenting it as such is that it can look lifeless and bland. By adding blobs of clay, gouging the surface, emphasising muscular structure and presenting the human form as a mass of exaggerated bumps and hollows, Rodin made light and shadow play across the surface of his sculptures, animating them with life. His second major innovation was to make fragmentary figures lacking limbs or head, so that we see the work above all as a sculpture, and not as a reproduction of a human being. His third innovation, developed in the 1890s, is a technical one: he would allow the viewer to see some of the working processes involved in making a bronze. He did this by leaving the casting seams and remnants of the internal armature unchased and plainly visible (fig. 92) and, in the case of some of the fragmentary figures, he allows the viewer to peer inside and see the interior of the bronze. These three related practices served to highlight the creative processes involved in the making of bronze sculpture, declaring in effect that artistic representation was not a matter of mimesis, but one of invention and freedom.

Throughout this period, a small number of sculptors chose to cast their own bronzes or become involved in the work of the bronze foundry. Barye opened his own foundry in the late 1830s, though this was as much to do with practical

Fig. 91
Antoine-Louis Barye, *Stag Brought Down by Two Large Greyhounds*, 1833. Bronze, height 34.3 cm
The Ashmolean Museum, Oxford

Fig. 92
Auguste Rodin, *The Inner Voice
(The Muse)*, c. 1896–97. Bronze,
height 144.5 cm
Victoria and Albert Museum, London,
A.36-1914

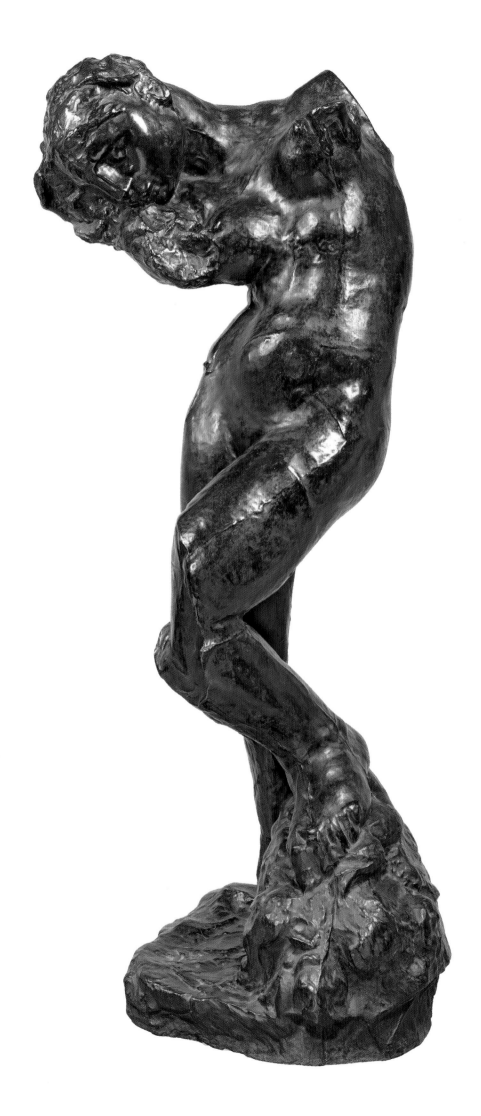

and economic matters as with a desire to maintain control over quality. Henry Moore cast his own works in the late 1930s but did so in lead, which has a much lower melting temperature than bronze, and can be done in household pots and pans. Perhaps the greatest sculptor-caster was Medardo Rosso (cat. 141). He moved from Milan to Paris in 1889 and became a friend of Rodin – only to fall out with him when he became convinced that Rodin had 'stolen' his ideas. His casting days, when he would invite friends around to his studio to watch him pour the molten metal and then celebrate with champagne, became legendary. Precisely because of his lack of technical expertise, he achieved some spectacular, crusty surfaces, marked with holes, nails, bubbles and ragged seams. Some of the patinas have gone a chalky white in places, as if they had endured volcanic heat. Another Italian, Vincenzo Gemito, opened his own lost-wax foundry in Naples in 1883 and produced superbly detailed casts, often featuring experimental patinas. Sculptors working in Italy, such as Rembrandt Bugatti, Ernesto Bazzaro and Paul Troubetzkoy, brought something new to bronze in their bravura modelling technique: Troubetzkoy's bronzes look as if they had been modelled in warm butter. Even in Paris Italian workmen were often at the forefront of bronze casting. Albino Palazzolo, often cited as the greatest lost-wax caster of all time (he masterminded the posthumous casting of Edgar Degas's bronzes), was the main technician at the Hébrard foundry in Paris and another Hébrard employee was the Italian Claude Valsuani, who left to set up his own lost-wax bronze foundry also in Paris, working for Bugatti, Matisse, Picasso, Maillol and others.

In Britain, the so-called 'New Sculptors' of the 1880s sought to revive lost-wax casting in order to give their nudes greater surface naturalism. Alfred Gilbert was perhaps the most innovative bronze sculptor working in Britain in the nineteenth century, producing bronzes with strikingly subtle detail (cat. 136). Bronze sculpture was not common in Britain before about 1850. The situation improved with the creation of the Young and Co. bronze foundry in Pimlico in the 1860s, and in the 1880s the Singer foundry in Somerset began to specialise in the casting of art bronzes. But British foundries were still basic compared to their French and Italian counterparts and Gilbert had to go to Naples in order to cast his *Icarus* (fig. 93) via the lost-wax method. On his return he tried to relaunch lost-wax casting in Britain, as too did Harry Bates and Edward Onslow Ford. In 1884 *The Times* reported that the lost-wax method 'is beginning to be greatly preferred by the most accomplished sculptors to the ordinary method of casting in sand. Certainly the crispness and sharpness of mould … should direct attention to this

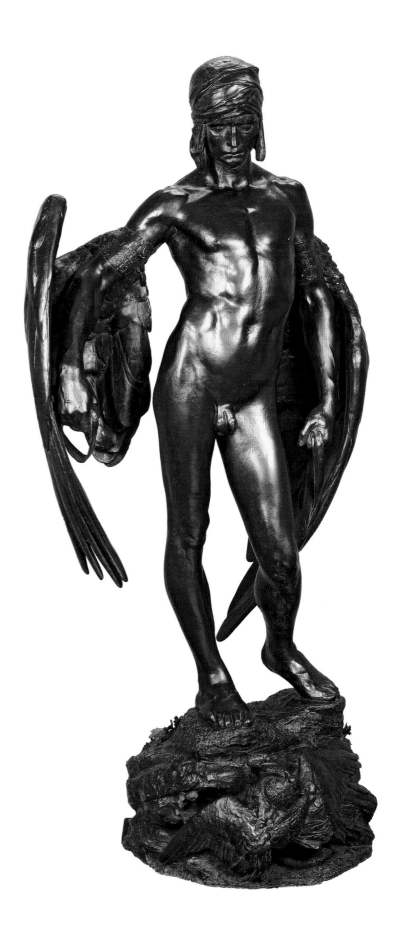

Fig. 93
Alfred Gilbert, *Icarus*, 1884.
Bronze, height 106.7 cm
National Museum of Wales, Cardiff

method, which enables the actual touch of the artist to be far more clearly seen than in statues cast on the older plan.'[8]

The situation was similar in the United States. Sand-casting was the norm until an Italian émigré, Riccardo Bertelli, opened the Roman Bronze Works in New York in the late 1890s and employed the lost-wax method. One of their first customers was Frederic Remington, who had begun making bronze sculptures of cowboys just a few years earlier (cat. 139). He was so impressed by the detail he could get through the lost-wax process that he asked the foundry to make moulds of the sand-cast bronzes he had already made elsewhere, and re-made the same pieces by the lost-wax technique, but with added detail.[9]

Another way for the sculptor to take more control over the bronze was to colour or polish it. Painted surfaces, coloured patinas and mixed media stretch back to the Greeks but were taken to new, elaborate lengths in the nineteenth century by sculptors such as Charles-Henri-Joseph Cordier (cat. 133) in France, Pietro Calvi in Italy and Gilbert in Britain (cat. 136).[10] In the twentieth century, Alexander Archipenko was one of the few to experiment with different colour patinas, using red, sage green and blue, as well as the traditional blacks and browns. The Swiss *animalier* sculptor Edouard Marcel Sandoz, who had trained as a chemist (he was heir to the Sandoz pharmaceuticals empire), developed his own patinas and gilding techniques. One approach, which seems to have been more than an urban myth, was to urinate on the bronze during the patination stage. Emile-Antoine Bourdelle is known to have done this.[11] Picasso tried this technique on a bust of Dora Maar but it came out an unpleasant green colour.[12] Picasso also rubbed mutton fat into his bronzes, in an effort to improve the patina, but it only served to make his studio smell.[13]

A few sculptors left their bronzes unpatinated, choosing instead to polish the metal to a brilliant, reflective sheen. Constantin Brancusi was the first to make a polished, unpatinated bronze, with his *Sleeping Muse* (1910; Centre Georges Pompidou, Paris), but a number of others, including Archipenko, Zadkine and Arp, soon followed his lead. Brancusi paid close attention to the individual finish of each bronze, giving casts of the same work slightly different details and finishes, and often employing bronze with a particularly high copper content, to produce a stunning, yellow-gold colour. It is in fact much more difficult to make a polished bronze than one with a patina, since the patina normally hides minor flaws. The polished surfaces of Brancusi's sculptures suggest weightlessness, and by reflecting the viewer and the surroundings they conspire to deny the sculpture's mass and weight (cats 143, 144).

Brancusi offered little in the way of explanation for these works. When he sent the polished bronze *Princess X* to New York in 1916 he remarked: 'The bronze is completely polished and so fine that it would have been a shame to cover it even in the most beautiful patina.'[14] He was so particular about the highly reflective surfaces that when he exhibited a polished sculpture of *Leda* in Paris in 1927, he sent his assistant, Isamu Noguchi, along to the exhibition every now and again, specifically to polish it.[15] Jean Arp, on the other hand, liked to leave his unpatinated bronzes unpolished, and let them develop a dull sheen. By the mid-1920s polished bronze had become shorthand for modernity, exemplified by the Oscar statuettes, first awarded in 1928. (In fact, the Oscars are shiny because they are gold-plated.)

Bronze as a medium for making sculpture came under attack in the twentieth century. The Cubists, Futurists and Surrealists scorned it as boring, traditional and expensive. Umberto Boccioni (cat. 145) called upon sculptors to 'destroy the literacy and traditional "dignity" of marble and bronze statues' and to 'insist that even twenty different types of materials can be used in a single work of art'.[16] Direct carving in stone and wood came into fashion across Europe and America in the 1920s and 1930s. Commercially produced metal casts were descending in quality, with cheap casts in spelter (a zinc and lead alloy) and cold-painted bronzes gaining in popularity. How could sculptors working in bronze regain some autograph control over their work, yet remain commercially viable? The answer was the limited edition.

Publishers of books and prints had spearheaded limited-edition products in the last quarter of the nineteenth century but the limited-edition bronze only took off in the early 1900s. None of the bronzes that Rodin made during his lifetime (he died in 1917) was marked as being from a limited edition. Some of his bronzes were unique casts (and were offered for sale as such), some were cast in small numbers (the small versions of the six *Burghers of Calais* figures were limited to five casts of each) and there are instances of bronzes being inscribed 'première épreuve' – 'first cast' – as if that gave the work added value. But Rodin never marked the edition details on his bronzes, and some of his works were cast in vast numbers. There were no legal or ethical restrictions on the matter. A few nineteenth-century sculptors did occasionally stamp numbers on their bronzes: Barye did this in the 1840s, but it was really a book-keeping practice, designed to ensure that he received correct payments from his business manager. There are a number of references in the 1890s, in France and England, to strictly controlled limited editions, and edition details are sometimes specified in sales contracts, but it appears that no bronze pre-dating 1900 actually carries full edition details. This is

a difficult area to research, since what one is looking for is cast-iron evidence of the specific date of a specific cast, not the date of the model. Henri Matisse (cats 142.1–4) was among the first artists to adopt a strict numbering practice: a cast of his *Head of a Child*, made at the Bingen et Costenoble foundry, is inscribed '2/10' and was certainly made by April 1908, when it was bought by a German collector.[17] The 1/10 example was presumably cast a little earlier and it has been argued that Matisse began to number his editions around 1906.[18] When Matisse showed a dozen bronzes at the Salon d'Automne in October 1908, the catalogue specified that the bronzes were 'casts limited to ten numbered examples'. Matisse was already numbering his prints by this date, and this may have inspired him to number his bronzes in the same fashion. Matisse could well have been introduced to the Bingen et Costenoble foundry by his good friend Aristide Maillol. Maillol worked at the foundry for a while, learning the secrets of casting, chiselling and patination. He may have begun to number his casts as early as 1905, although there appears to be no firm evidence for this.[19] Maillol had good cause to control his production. Around 1902 he sold some plaster sculptures to the dealer Ambroise Vollard on the understanding that he would cast ten of each, but he later complained that Vollard had made not ten but 10,000 of each.[20] Maillol was probably not the only artist to nickname the dealer 'Voleur' or 'Thief'. Maillol moved to new dealers, Eugène and Elie Druet of the Galerie Druet, who also represented Matisse: the notion of strictly numbering the casts may have come from them. Maillol tended to limit his editions to four examples, Henri Laurens to five examples, Jacques Lipchitz to seven and Charles Despiau to nine or ten. The random nature of the practice was only codified by French law in 1968, when twelve casts became the accepted limit. Most of the early examples of numbered limited editions were produced by lost-wax casting, by Parisian foundries such as Hébrard (opened in 1902), Bingen et Costenoble (opened in 1903: they also employed the sand-cast method) and Valsuani (opened by 1905). While the sand-casting method produced identical casts from the same rigid mould, lost-wax casting involved the casting of a wax original each time; and each wax had to be retouched, signed and individually numbered before it was cast. The

limited edition thus implied exclusivity, rarity, quality and resale value.

Bronze continued to dominate mainstream figurative sculpture in the interwar period, with the French artists Maillol, Bourdelle and Despiau – who all specialised in modelled work cast in bronze – exerting an enormous influence over European and American sculpture. Bourdelle, Rodin's closest assistant and disciple, carried on Rodin's fingered, 'expressive' technique, but gave it a more structured form. Two of his students, Alberto Giacometti and Germaine Richier (cat. 148), adopted the technique, but pushed it further, making a heavily manipulated modelling technique a hallmark of their work. Giacometti's haunted, ravaged figures (cat. 147) became leitmotifs of postwar alienation, inspiring a whole generation of sculptors who emerged in the late 1940s and 1950s, and revivifying bronze as a medium favoured by the avant-garde. They were the antidote to the gigantic neoclassical bronzes that had become popular across Europe in the 1930s, culminating in the work of Arno Breker, Hitler's favourite sculptor.

The 1950s was a rich decade for bronze sculpture. Artists who were now in their sixties or seventies, including Picasso, Lipchitz, Arp and Zadkine, made some of their best and largest bronzes during these years. Picasso's approach to bronze was typically innovative, using it as a unifying medium in which to cast assemblages made out of disparate materials, such as *She-goat* (fig. 94) and *Baboon and Young* (cat. 146). In the former,

Fig. 94
Pablo Picasso, *She-goat*, 1950, cast 1952. Bronze, 117.7 x 143.1 x 71.4 cm
Museum of Modern Art, New York. Mrs Simon Guggenheim Fund

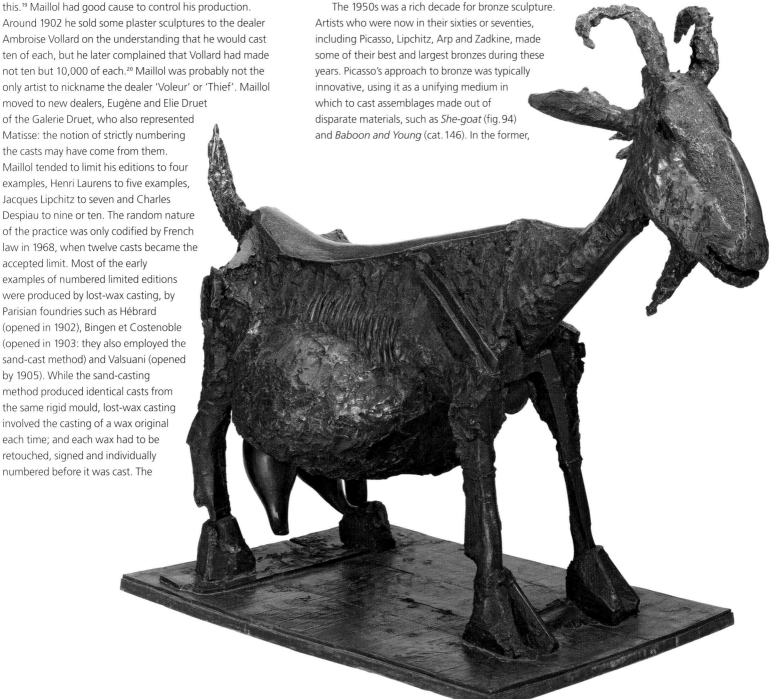

the goat's body is fashioned from a wicker basket while the udders are derived from jugs; in the latter, the head of the baboon is, famously, formed from a toy car. Now that the war was over and industry was being rebuilt, the generation born around 1900 and including Giacometti, Richier, Giacomo Manzù, Moore (cat. 152), Hepworth and Marini at last had the sales, commissions and exhibitions to enable them to make major work on a large scale. The younger generation, born around 1920, had a subject to feed off: the war. In Britain an extraordinary group of sculptors emerged all at once, including Eduardo Paolozzi (fig. 95), William Turnbull, Lynn Chadwick, Bernard Meadows and Reg Butler. Their work enjoyed international acclaim when shown at the Venice Biennale of 1952. The French sculptors César, Robert Couturier and Martine Boileau won attention as did, for example, Fritz Wotruba in Austria, Fritz Koenig, Emil Cimiotti and Heinrich Kirchner in Germany, Alfio Castelli in Italy and the Czech-born Otto Hajek. The scarred, battered surface, encrusted with casting grog, became a characteristic feature of the bronzes made by this postwar generation, acting as a metaphor for human suffering. Marino Marini was particularly innovative in reworking his bronzes after casting, often chiselling and painting them until no two casts looked alike.

Bronze suddenly became unfashionable in the 1960s. Many of the artists who had made crusty, emotionally charged bronzes in the 1950s now made sculptures with cool, coloured, flat surfaces, often in steel. Such established artists as David Smith (cat. 149), Anthony Caro, William Turnbull and Eduardo Chillida now eschewed bronze for iron and steel. Jasper Johns's *Painted Bronze (Ale Cans)* (cat. 153) – cast in bronze and painted – mocks the medium, while the Pop Artists and the Minimalists preferred plastics, steel and colour. Artists involved in Happenings, Conceptual Art and Land Art had no interest in bronze, or indeed in permanent materials of any kind. Bronze carried a heavy baggage associated with tradition and convention, and it was tradition and convention that this generation abhorred. Tony Cragg was one of the sculptors who championed new materials, particularly plastic, in the 1970s and a decade later he found the idea of making bronze incredibly difficult: 'I knew that I had to make a bronze but it took almost a year to pluck up the courage; the Henry Moore legacy looms down on us and you think "I don't want to do that."'[21]

A recent book on world sculpture of the past thirty years includes 462 illustrations of sculptures, of which just thirteen are in bronze.[22] Other materials on offer are frozen blood, cast dirt and MDF. Yet bronze still ranks as one of the materials *par excellence* for the sculptor, used in recent years by artists as diverse as Damien Hirst, Tony Cragg (cat. 158), Louise Bourgeois (cat. 155), Barry Flanagan and Thomas Houseago. This is partly because of the long tradition of bronze sculpture, and partly because the material is almost indestructible. But above all, it is because bronze can assume almost any shape, hold any amount of detail, accept a glorious array of subtle patinas, and stand up to any size a sculptor cares to make.

Fig. 95
Eduardo Paolozzi at the Hanover Gallery, London, in 1958, with *Icarus (Second Version)*, 1957, to the left and *Icarus (First Version)*, 1957, in the right foreground

Catalogue Plates

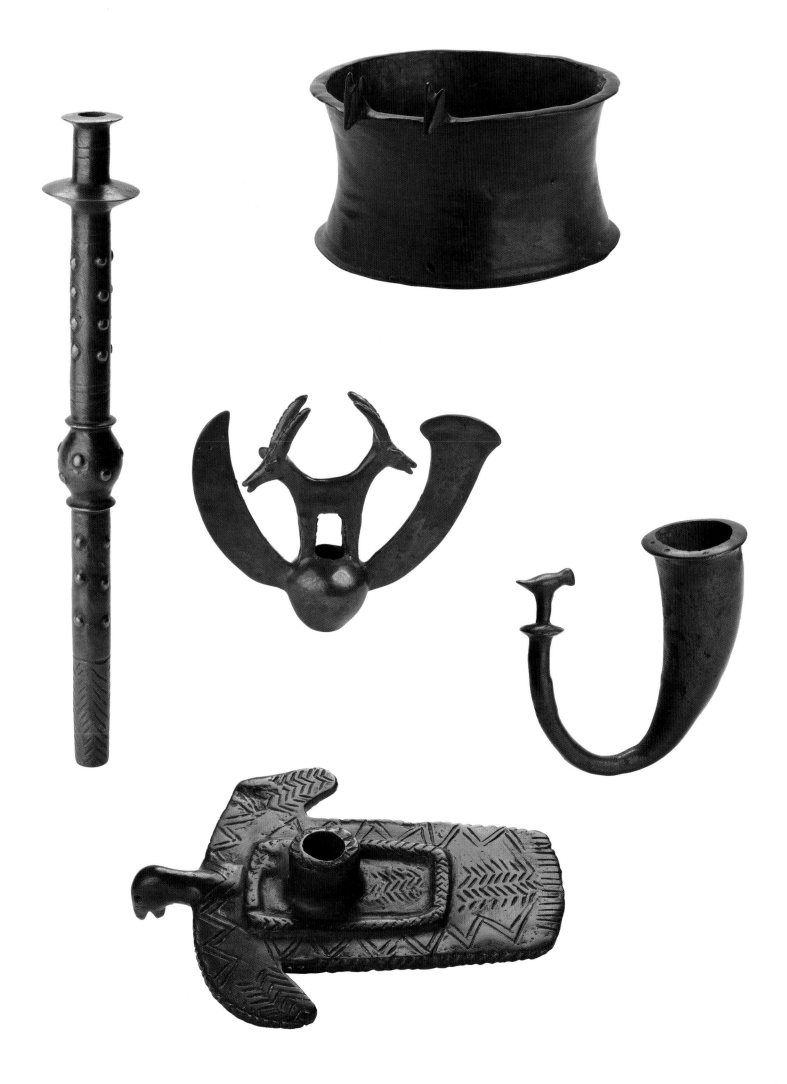

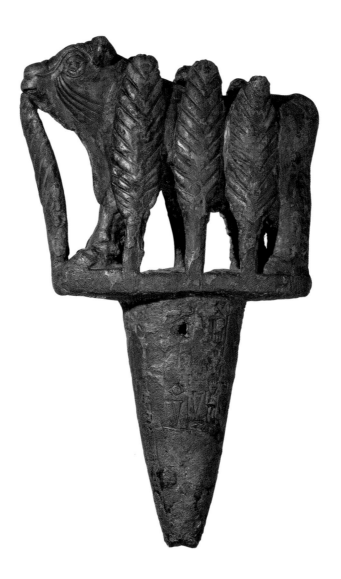

1—5

Nahal Mishmar, Israel
Clockwise from left

Sceptre
Crown
Mace Head
Cornet
Vulture Standard

Chalcolithic period, c. 3700 BCE
Copper alloy, height 31.3 cm, height
9 cm, 11 × 14.3 cm, height 13.3 cm,
height 4.8 cm

Israel Antiquities Authority. Exhibited at the Israel
Museum, Jerusalem

6

Mesopotamia, Second Dynasty of
Lagash, reign of King Gudea

**Foundation Peg with a Bull
and Sprouting Plants**

c. 2090 BCE
Copper alloy, 19.4 × 12 cm

On loan from the British Museum, London

7 *(overleaf)*

Trundholm, Seeland
Chariot of the Sun

Fourteenth century BCE
Bronze and gold leaf,
35 × 60 × 20 cm

The National Museum of Denmark, Danish
Prehistory, Copenhagen

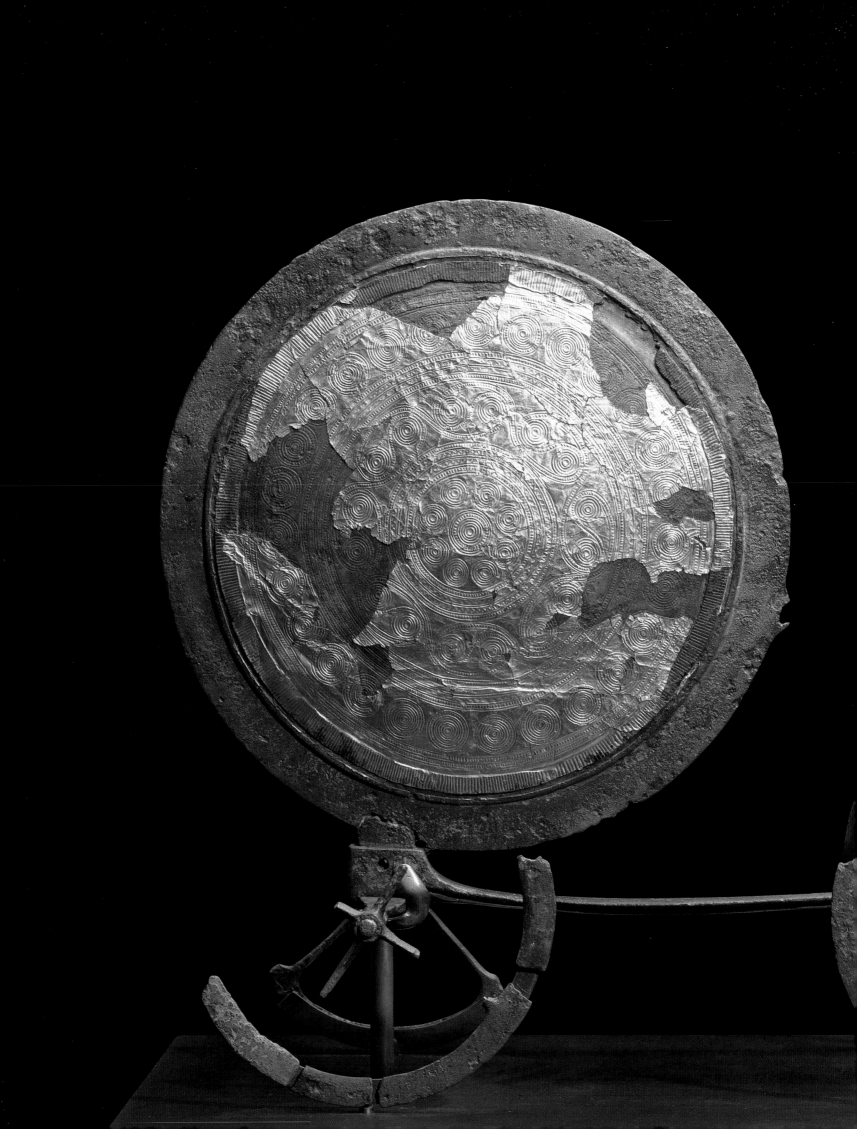

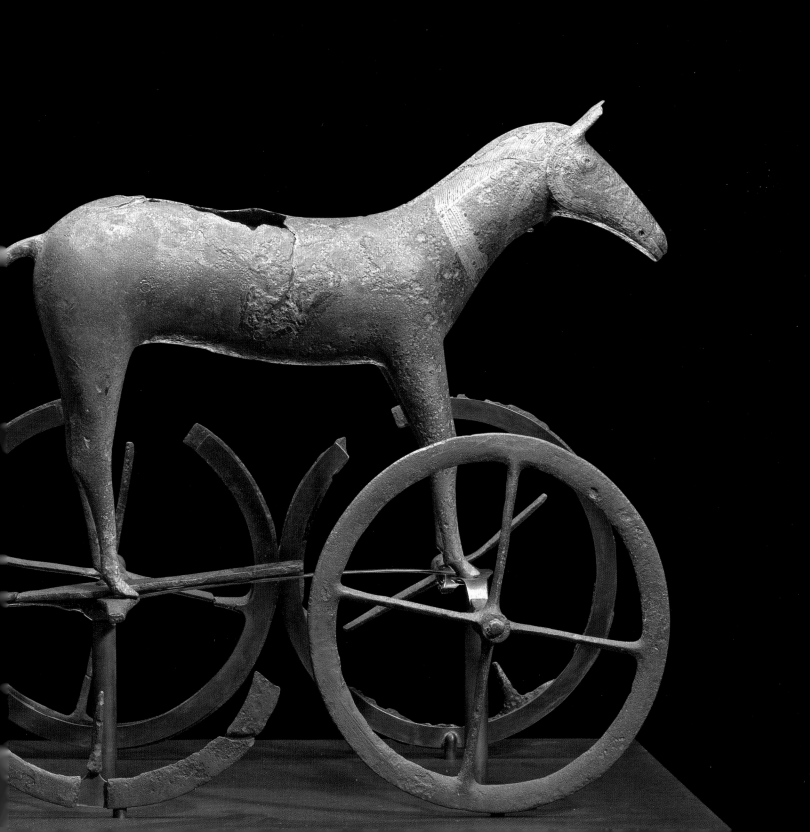

8

China, Shang dynasty

Axe Head of the type *yue*

Thirteenth century BCE
Bronze, height 35 cm,
width 37.8 cm

Museum für Ostasiatische Kunst, Cologne

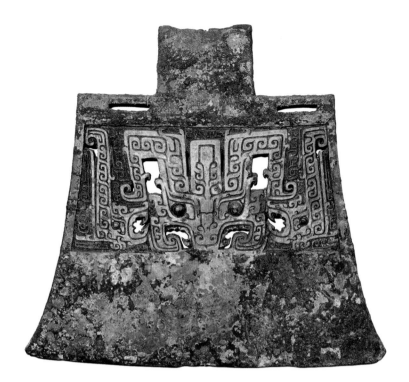

10

China, Shang dynasty

Vessel of the type *jia*

Thirteenth century BCE
Bronze, 39.5 × 24 cm,
diameter 19.8 cm

Museum für Ostasiatische Kunst,
Cologne

9

China, Shang dynasty

Vessel of the type *fang yi*

Twelfth century BCE
Bronze, 27 × 17 × 14 cm

On loan from the British Museum, London.
Bequeathed by Brenda Zara Seligman

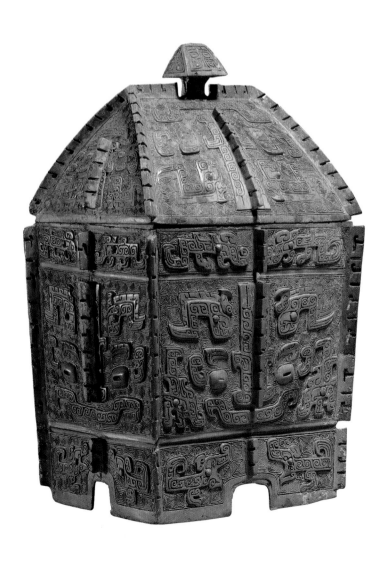

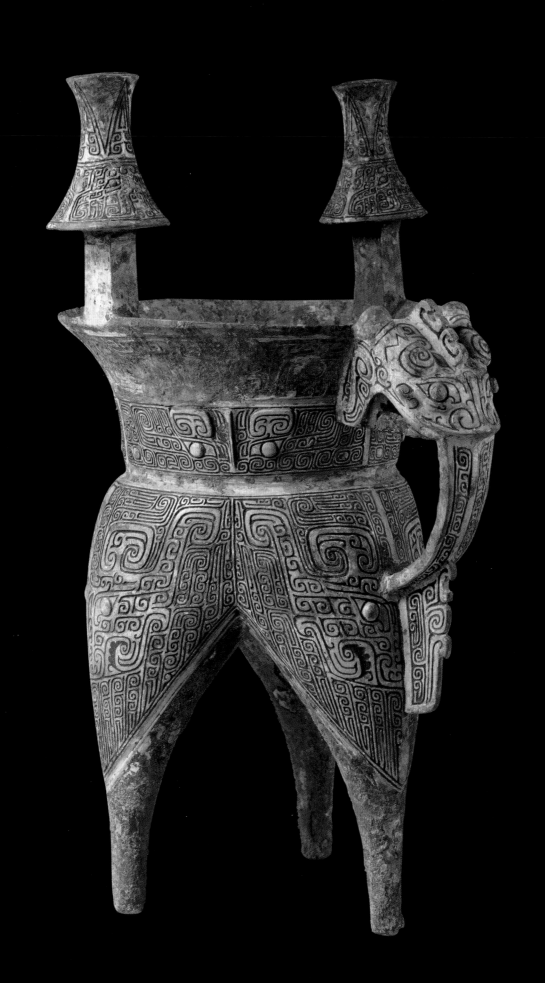

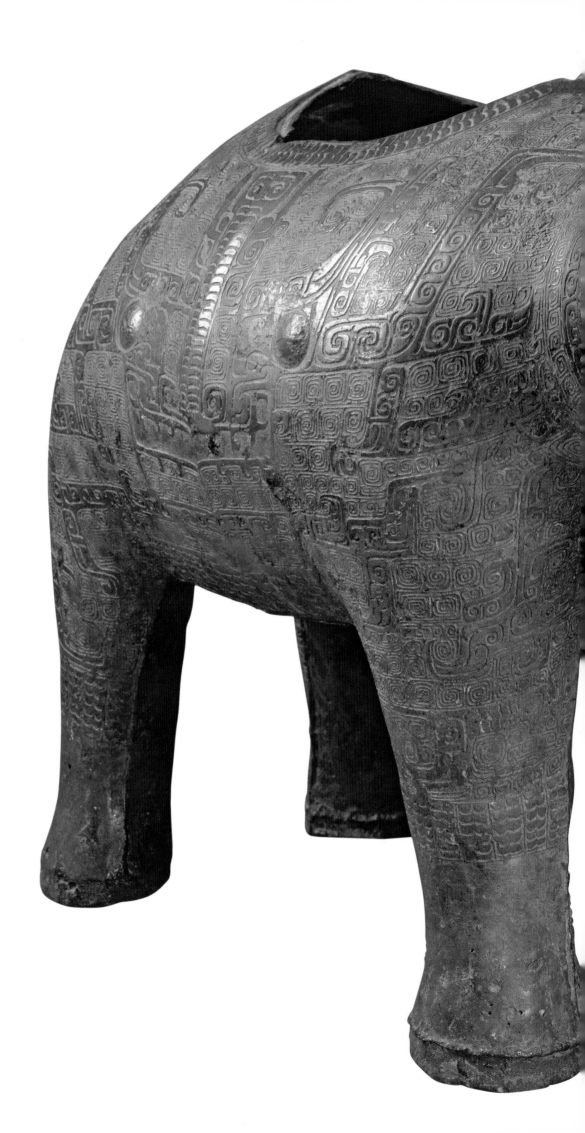

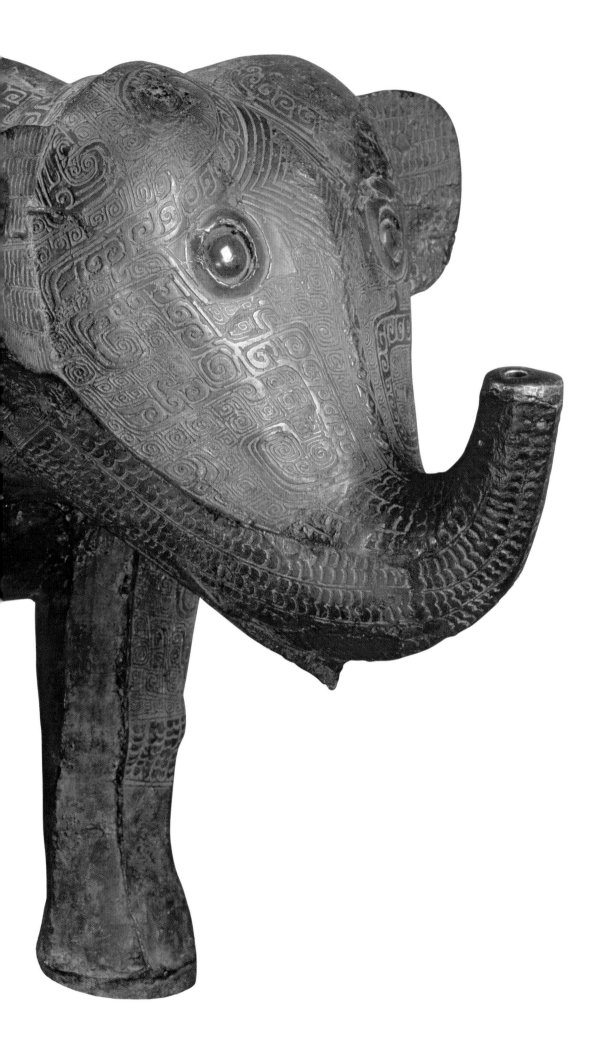

11

China, Shang dynasty

Vessel of the type *zun* in the form of an Elephant

c. 1100–1050 BCE
Bronze, 64 × 96 × 34 cm

Musée Guimet, Paris

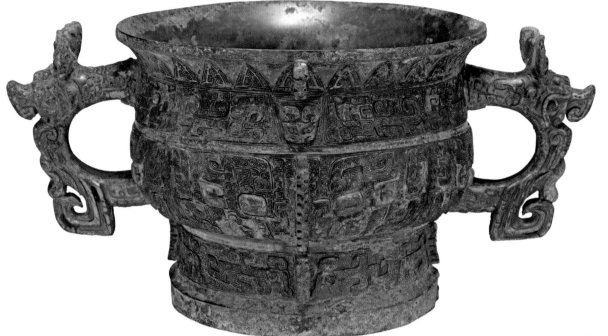

12

China, late Shang or early
Zhou dynasties
Vessel of the type _gui_

Eleventh century BCE
Bronze, height 13.5 cm, width
28.5 cm including handles

Lent by the Syndics of the Fitzwilliam Museum,
Cambridge

14

China, early Western Zhou dynasty
**Vessel of the type _gui_, know
as the _Bo Ju gui_**

Eleventh–tenth centuries BCE
Bronze, 23.7 × 30.5 × 20 cm

Private collection

13

China, Shang dynasty
**Vessel of the type _you_ in the
form of a Double Owl**

Twelfth–eleventh centuries BCE
Bronze, height 16.7 cm, width
13.5 cm

Lent by the Syndics of the Fitzwilliam Museum,
Cambridge

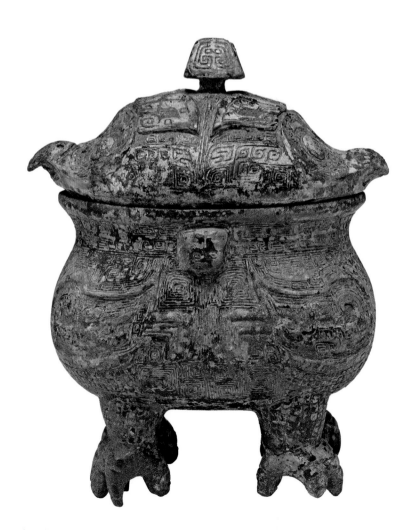

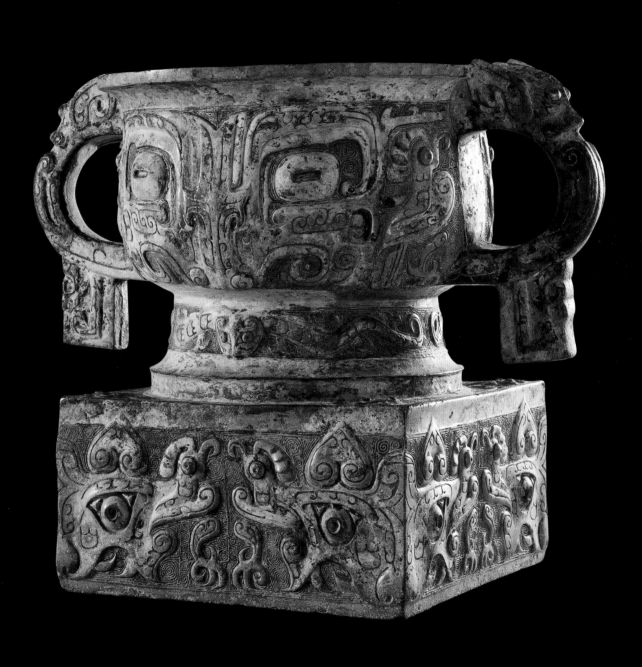

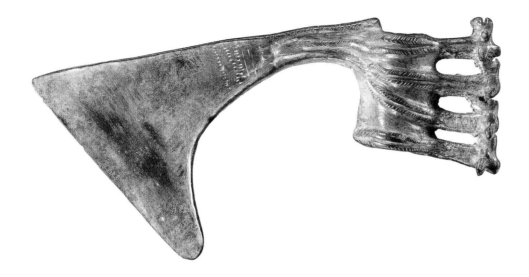

1 5—1 7

Luristan

Standard-finial
Axe Head
Bridle-bit with Cheek-pieces

Ninth–eighth centuries BCE
Copper alloy, 18 × 11 cm,
22 × 9.5 cm, 10 × 15 cm

On loan from the British Museum, London.
Cat. 15 donated by Louis Clark

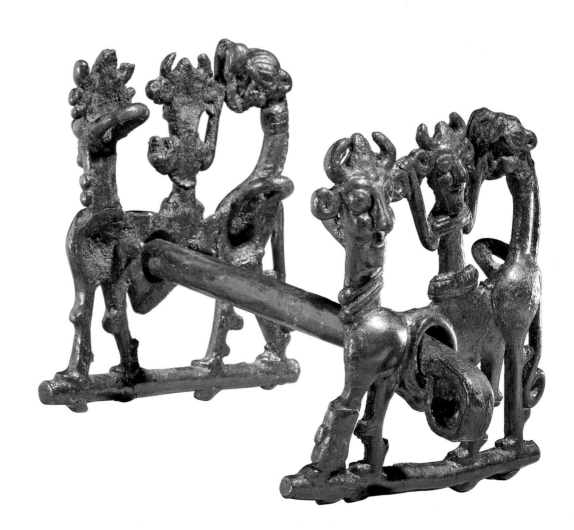

18

Sardinia, Nuragic period
Capotribù (Tribal Chief)

Eighth–fourth centuries BCE
Bronze, 39 × 20 × 23 cm
Museo Archeologico Nazionale di Cagliari

19

Egypt, Twenty-sixth Dynasty
Ptah

Seventh–sixth centuries BCE
Bronze partly blackened and
inlaid with gold and silver,
17.9 × 6.1 × 3.9 cm
The Ashmolean Museum, Oxford

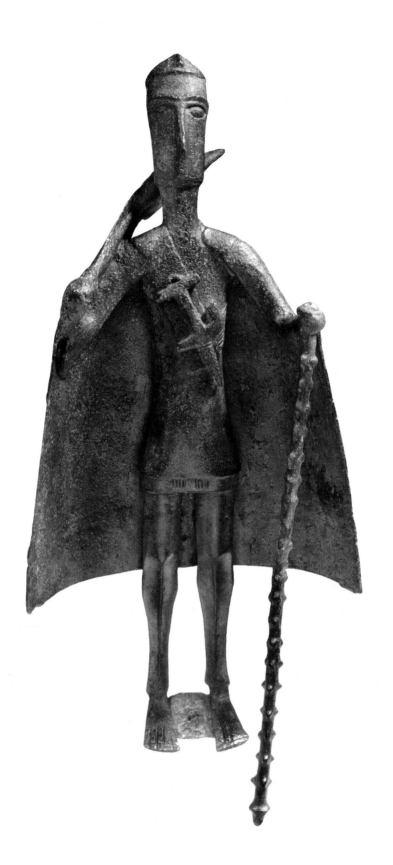

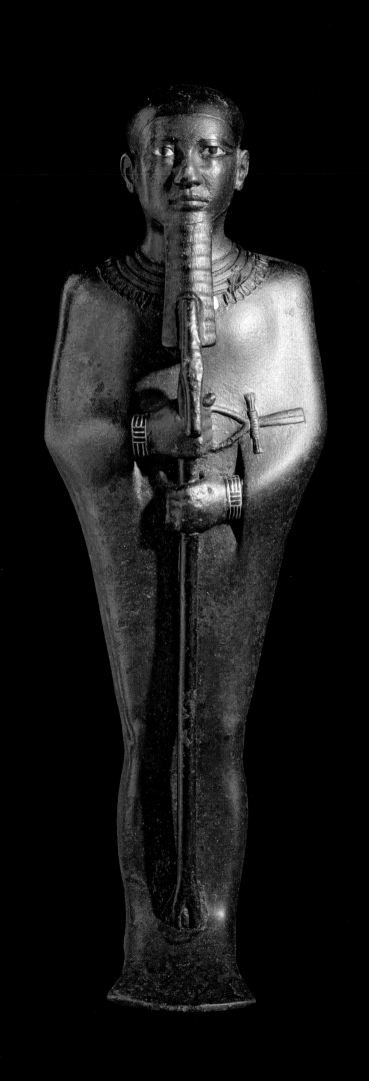

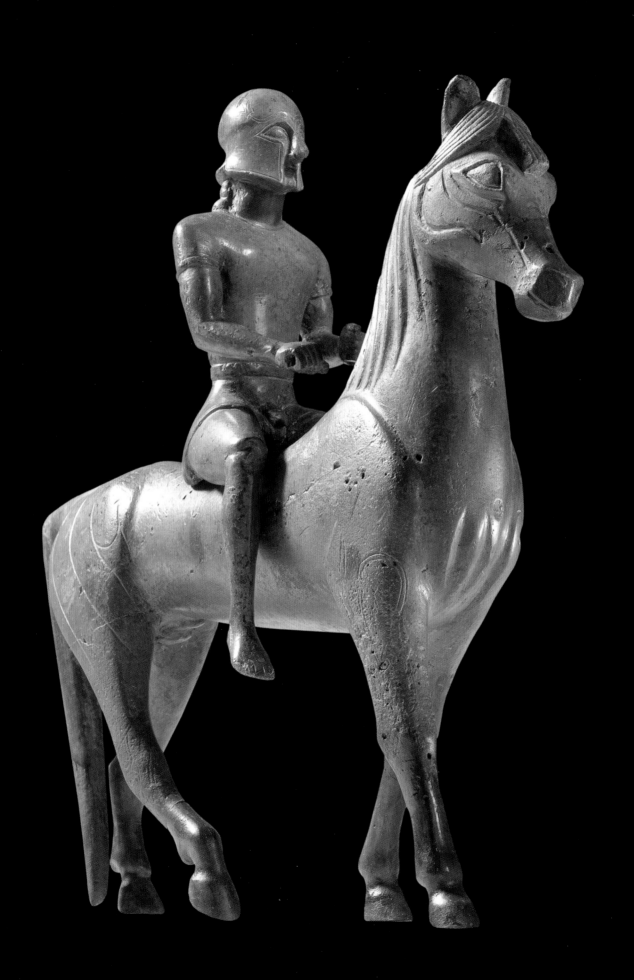

20

Western Greek, Taranto

The Armento Rider

c. 560–550 BCE
Bronze, 27 × 26.8 × 7 cm

On loan from the British Museum, London

21

Tartessian, Spain

Winged Feline

700–575 BCE
Bronze with gilding,
61 × 19.4 × 33 cm

The J. Paul Getty Museum, Los Angeles,
Villa Collection, Malibu, California

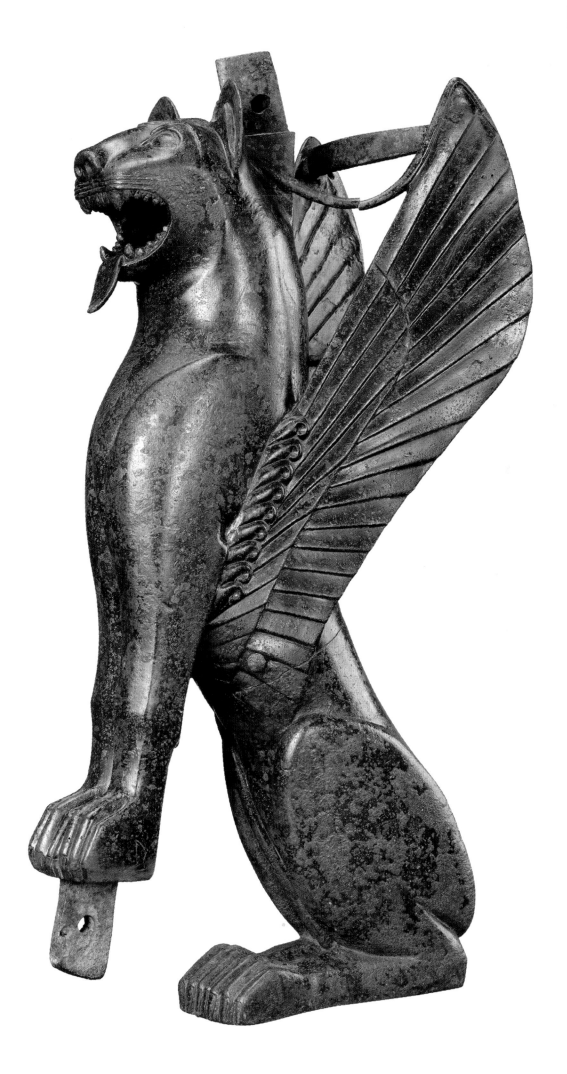

22

Hallstatt culture

Cult Chariot of Strettweg

c. seventh century BCE
Bronze, height 46.2 cm

Universalmuseum Joanneum, Alte Galerie, Graz

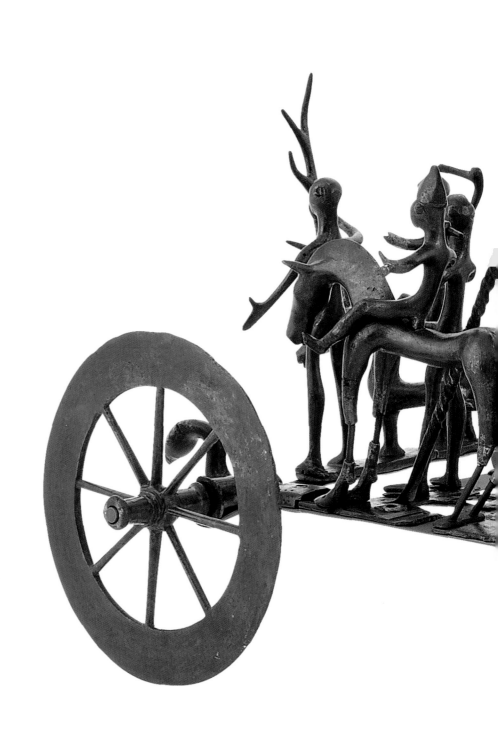

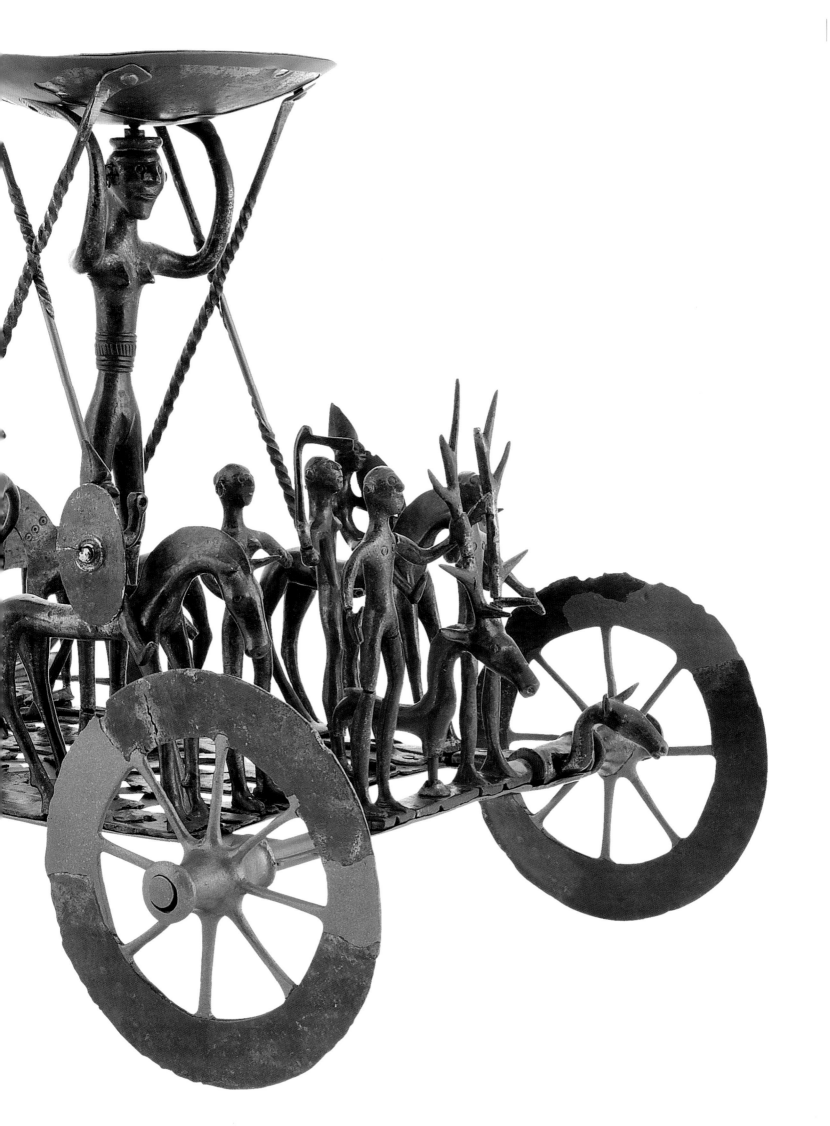

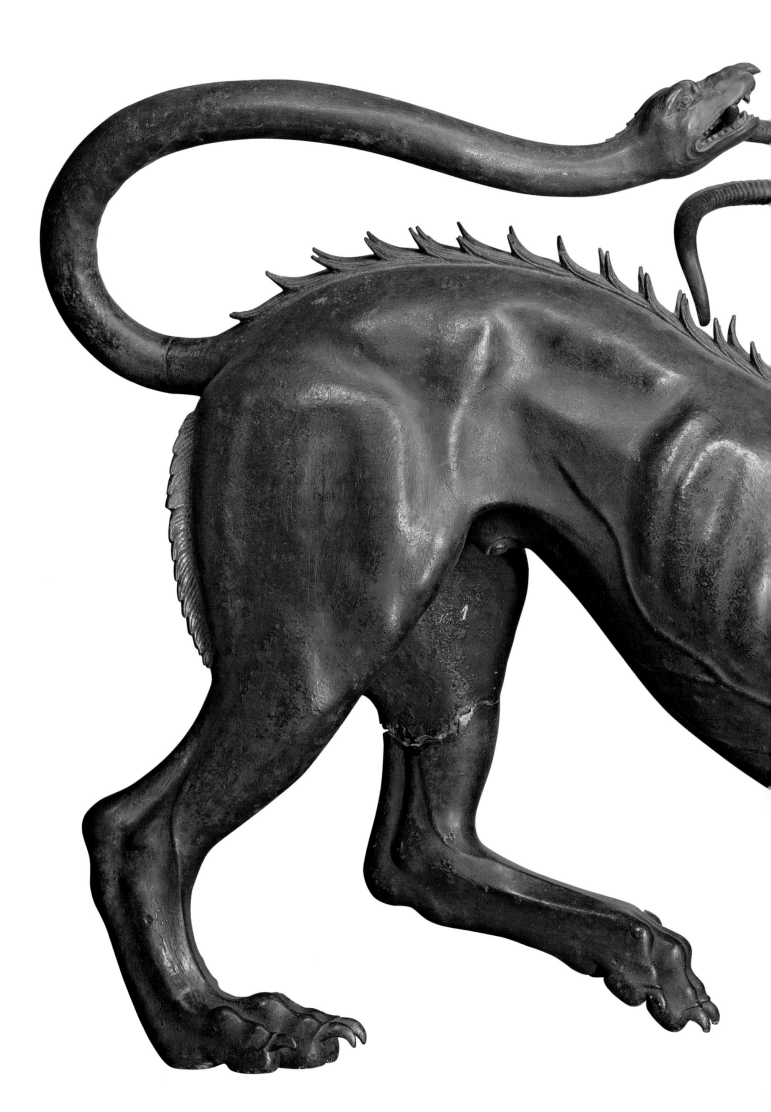

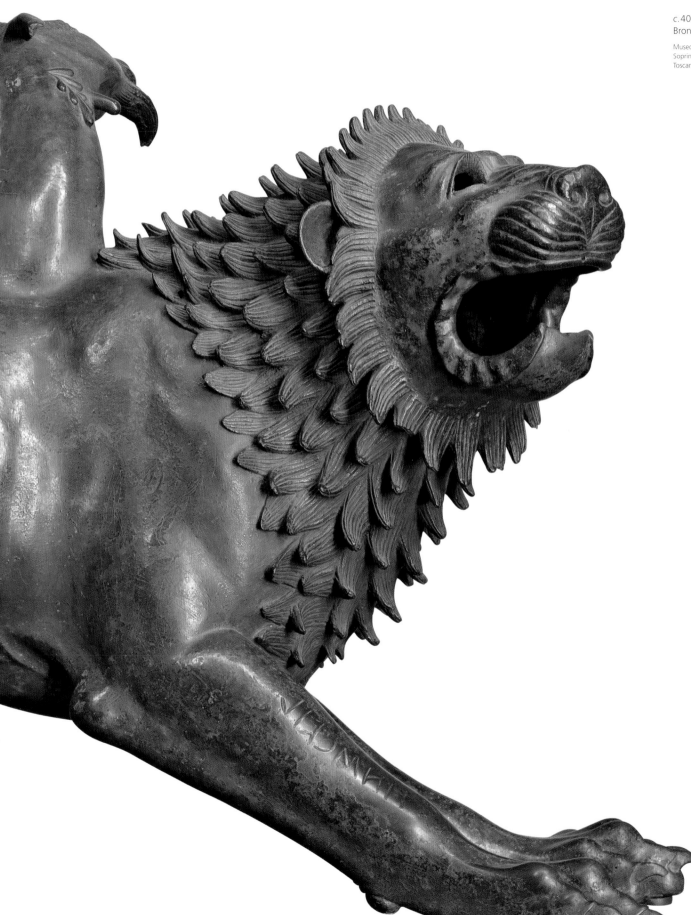

23

Etruscan

Chimaera of Arezzo

c. 400 BCE
Bronze, 78.5 × 129 cm

Museo Archeologico Nazionale, Florence.
Soprintendenza per i Beni Archeologici della
Toscana

24

China, Eastern Zhou period

Bell, known as a *bo*

Fifth century BCE
Bronze, 55 × 42 × 33 cm

On loan from the British Museum, London

25

China, Eastern Zhou dynasty

Vessel of the type *hu*

Zhanguo period, fourth century BCE
Bronze with gold and silver inlay,
38.1 × 25.1 cm

The Alice and Pierre Uldry Collection, on long-
term loan to the Museum Rietberg, Zurich

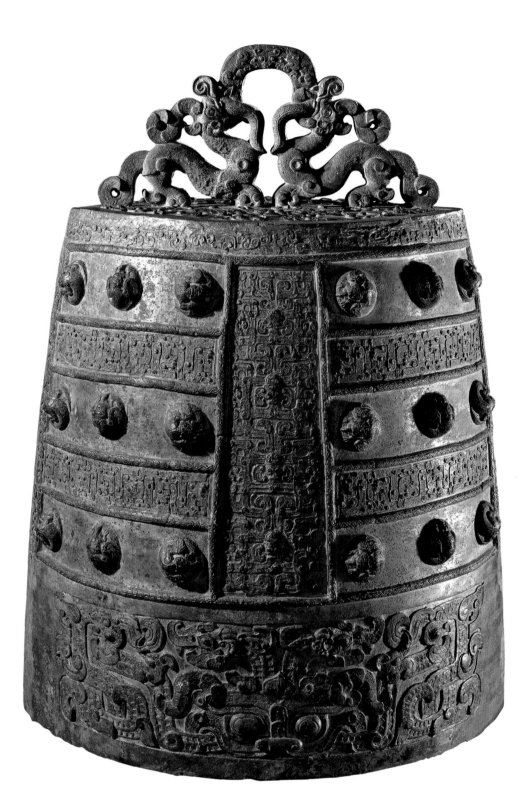

26

Early Hellenistic period, Thracian

**Portrait Head of King
Seuthes III**

Late fourth – early third centuries BCE
Bronze, copper, alabaster and glass
paste, 32.5 × 28 cm

National Institute of Archaeology with Museum,
Bulgarian Academy of Sciences, Sofia

27

Insular La Tène art

Battersea Shield

c. 350–50 BCE
Bronze with enamelled glass inlay,
77.7 × 35.3 × 5.2 cm

On loan from the British Museum, London

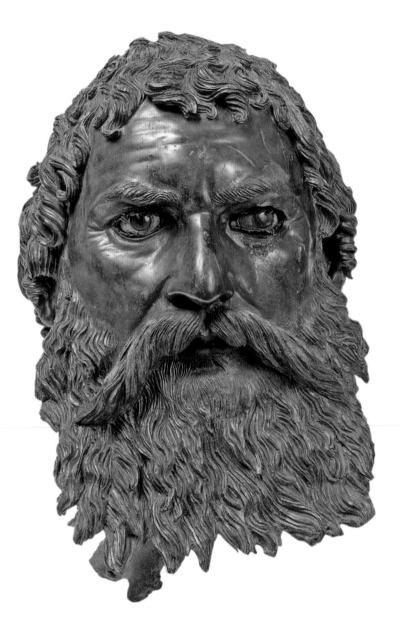

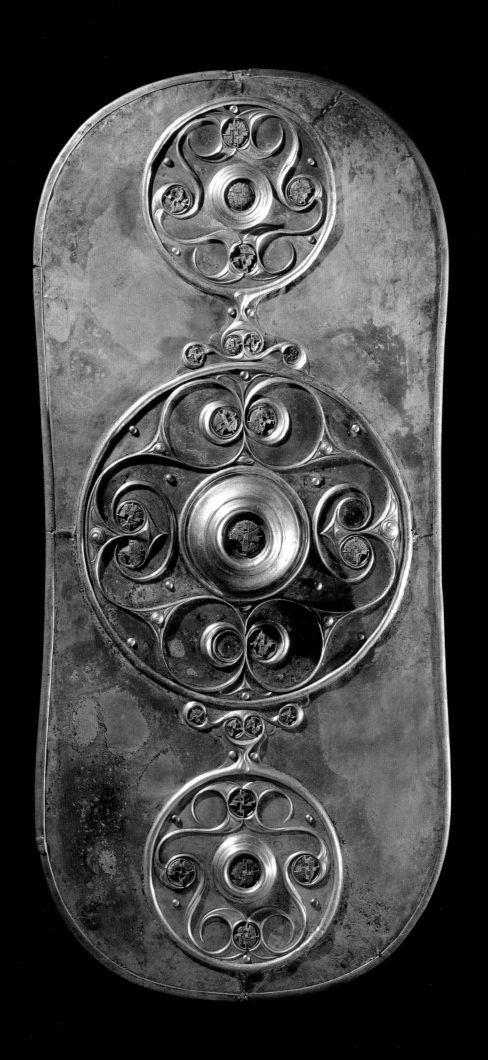

28

Greek

Dancing Satyr

Second half of the fourth century BCE
Bronze, with white alabaster eyes,
height 200 cm

Museo del Satiro, Church of Sant'Egidio,
Mazara del Vallo

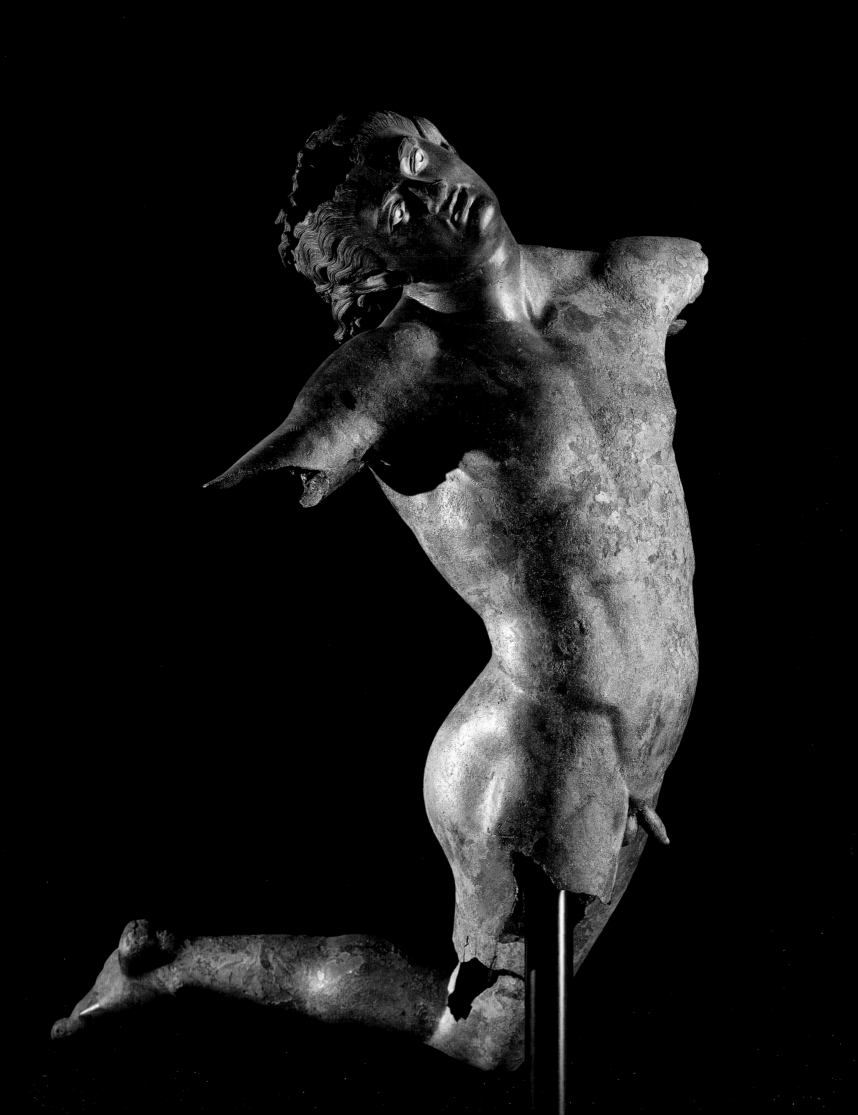

29

Etruscan

Chrysippos Cista

c. 350 BCE
Bronze, height 61 cm,
diameter 33 cm

Museo Nazionale Etrusco di Villa Giulia, Rome.
Soprintendenza per i Beni Archeologici dell'Etruria
Meridionale

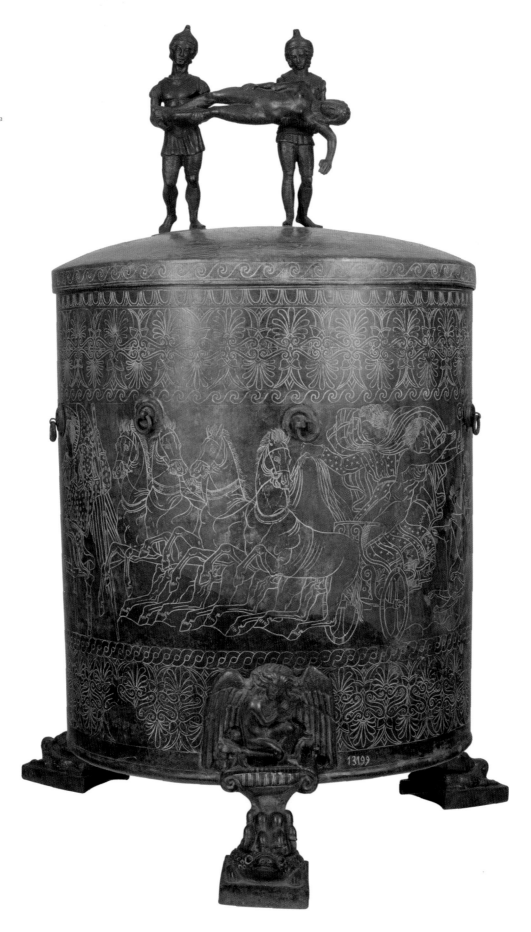

31

Etruscan

Strigil with Handle in the Form of a Girl

c. 300 BCE
Bronze, 40 × 25 × 7.6 cm

On loan from the British Museum, London

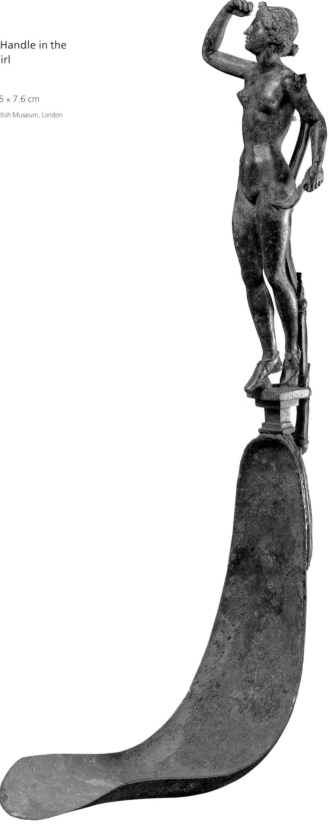

30

Egypt, Early Ptolemaic period
Seated Cat

c. 300 BCE
Bronze, 33.5 × 23 × 14 cm

The Raymond and Beverly Sackler Collection

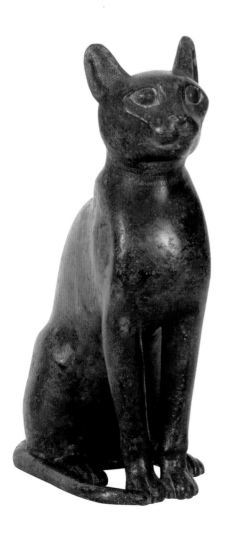

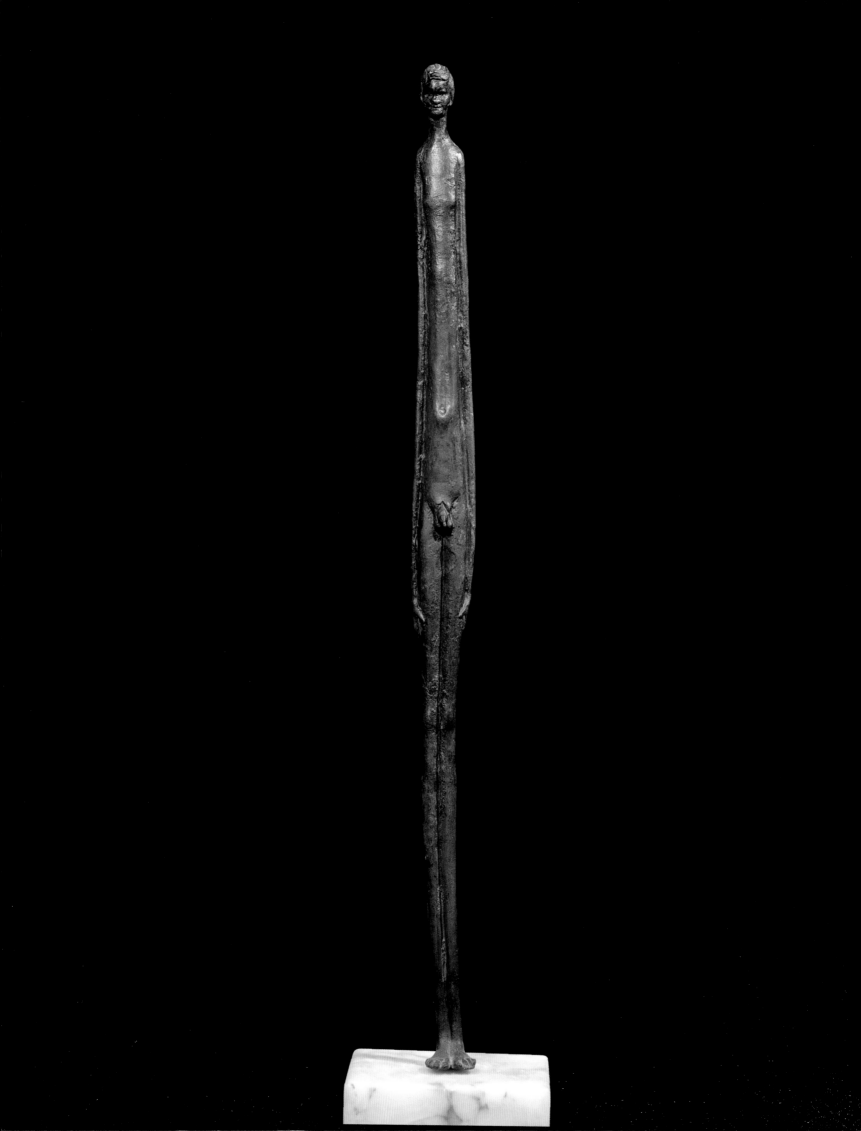

32

Etruscan
**Votive Figure
(Evening Shadow)**

Second century BCE
Bronze, height 57.5 cm

Museo Etrusco Guarnacci, Volterra

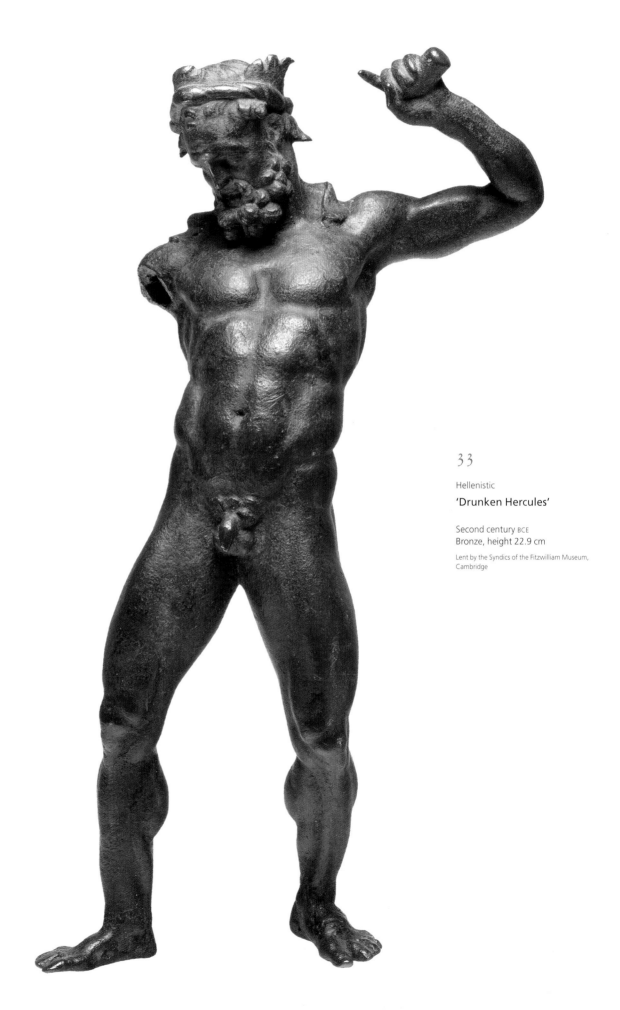

33

Hellenistic
'Drunken Hercules'

Second century BCE
Bronze, height 22.9 cm

Lent by the Syndics of the Fitzwilliam Museum,
Cambridge

34

Alexandria
Nubian Boy

After 58 BCE
Bronze, molten silver on eyes and
teeth, height 19.1 cm

Bibliothèque nationale de France, Paris

35

Roman
Lucius Mammius Maximus

41–54 CE
Bronze, height 212 cm

Museo Archeologico Nazionale, Naples.
Soprintendenza Speciale per i Beni Archeologici
di Napoli e Pompei

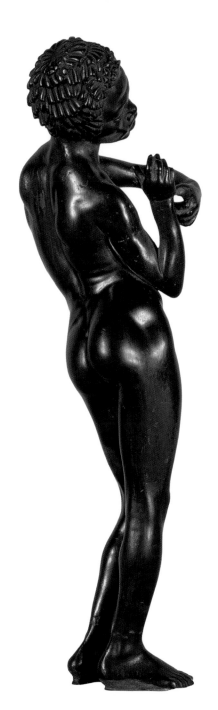

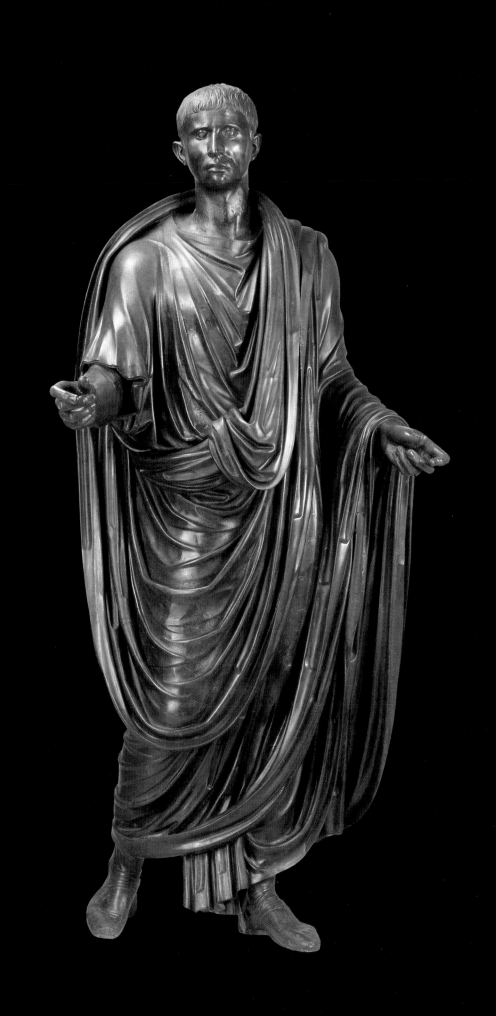

36

Roman

**Beam End in the Form
of a Wolf's Head**

37–41 CE
Bronze, 40 × 25 × 50 cm

Museo Nazionale Romano, Rome. Soprintendenza
Speciale per i Beni Archeologici di Roma

37

Roman

**Architectural Fitting in the
Shape of an Acanthus Leaf**

First–second centuries CE
Bronze, 34 × 30 × 7.2 cm

On loan from the British Museum, London

38

Roman

**Candelabrum in the
Form of a Tree**

First century CE
Bronze, 87 × maximum 50 cm

Museo Archeologico Nazionale, Florence.
Soprintendenza per i Beni Archeologici della
Toscana

39

Roman Egypt
Mensa Isiaca, altar-table top

First century CE
Bronze inlaid with other metals,
74 × 123 × 7 cm

Fondazione Museo delle Antichità Egizie, Turin

40

Roman

Woman with Corkscrew Curls ('Tolomeo Apione')

c. 49–25 BCE
Bronze with applied copper curls,
41 × 31 cm

Museo Archeologico Nazionale, Naples.
Soprintendenza Speciale per i Beni Archeologici
di Napoli e Pompei

41

Ghayman, Yemen

Head of a Man

Possibly second century CE
Bronze, 20.8 × 17.5 × 18.5 cm

The Royal Collection

42

Roman

Crosby Garrett Helmet

Late first–second centuries CE
Bronze and tinned bronze,
height 40.7 cm

Private collection

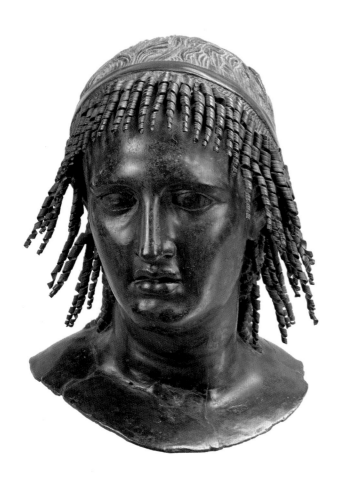

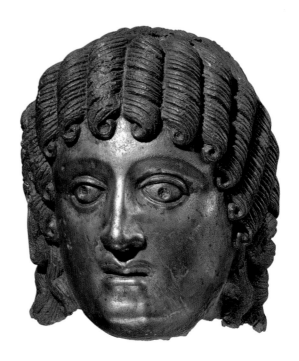

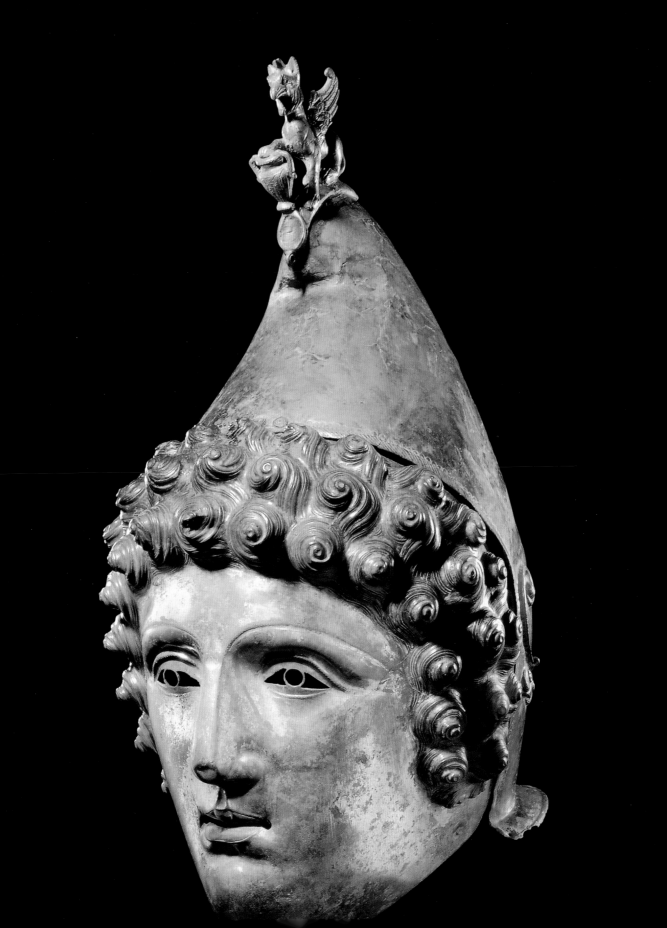

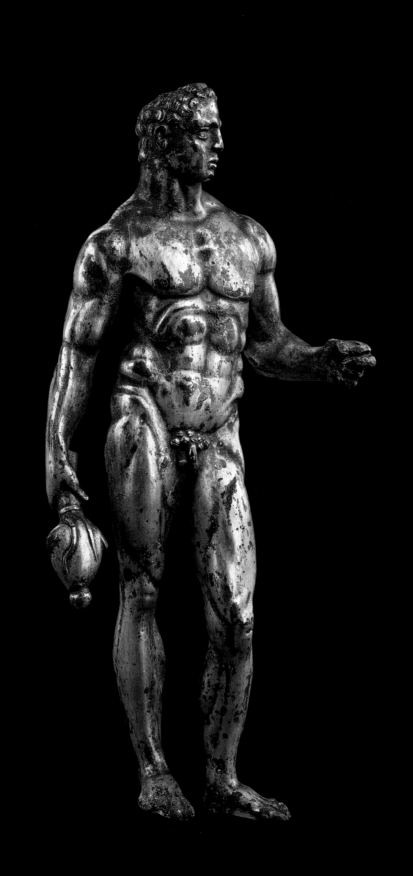

43

Gallo-Roman

Mercury of Bavay

First or second century CE
Gilt bronze, 21 × 10 × 5 cm

Musée d'Art Classique de Mougins

44

Late Hellenistic

Dionysos

First century BCE – first century CE
Bronze, 135.8 × 62 × 52 cm

Private collection, courtesy of Rupert Wace
Ancient Art

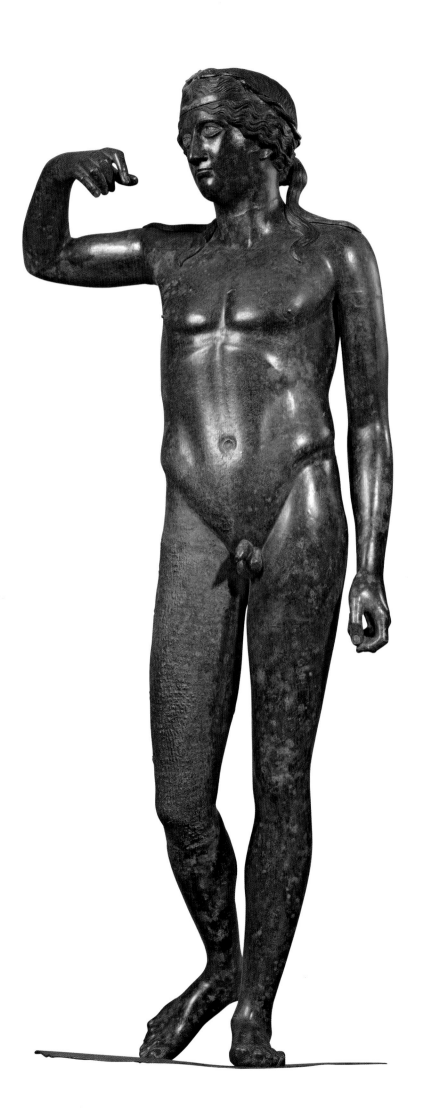

45

Roman
Ram

Second century CE
Bronze, 80 × 135 × 62 cm

Museo Archeologico Regionale Antonino Salinas, Palermo

46

Late classical or early Hellenistic
**Head of a Horse
('Medici Riccardi Horse')**

Mid-fourth century BCE
Bronze, height 81 cm

Museo Archeologico Nazionale, Florence.
Soprintendenza per i Beni Archeologici della Toscana

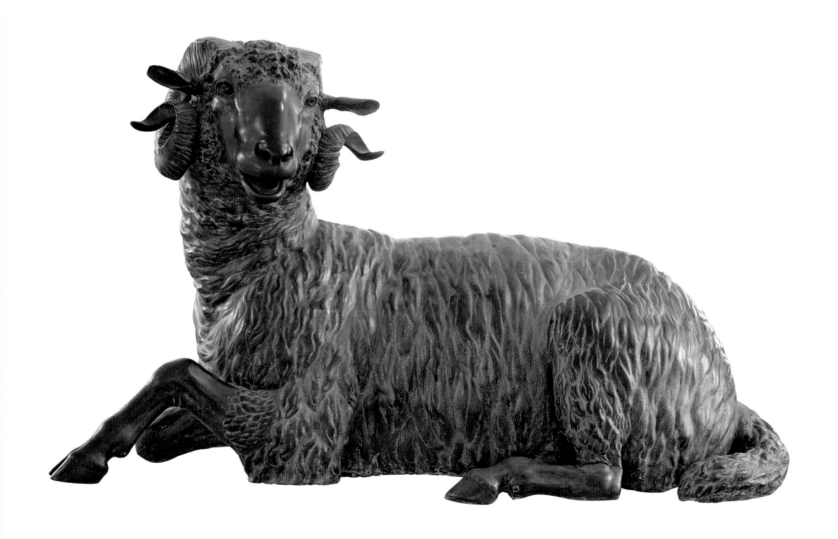

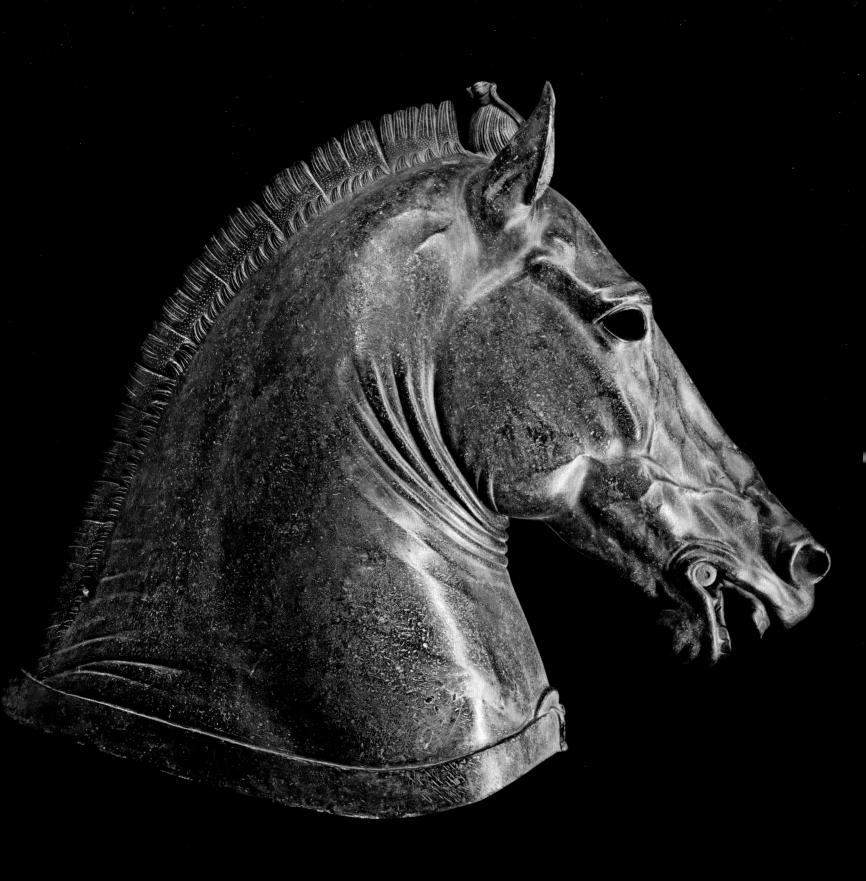

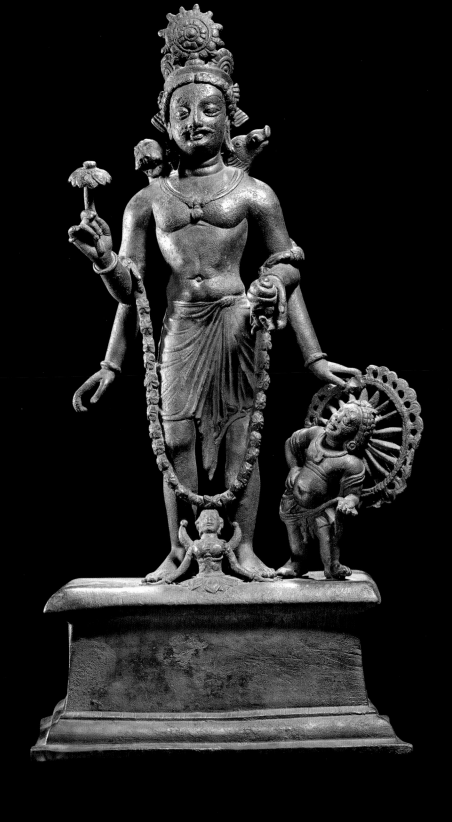

47

Swat Valley, North Pakistan

Vaikuntha Vishnu

Sixth–seventh centuries
Bronze, height 48.5 cm

Staatliche Museen zu Berlin, Museum
für Asiatische Kunst

48

India, probably Bihar

**Buddha Shakyamuni
in Abhaya-Mudra**

Late sixth century
Bronze, 68.6 × 27.3 × 17.8 cm

Asia Society, New York. Mr and Mrs John
D. Rockefeller 3rd Collection

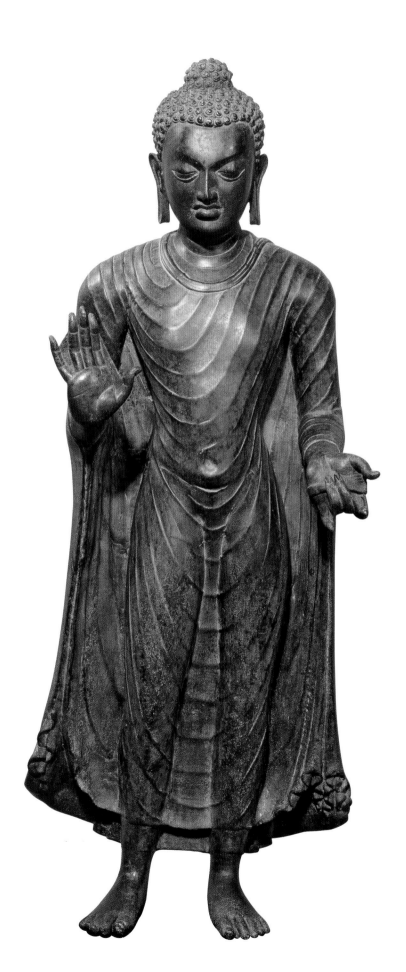

49

Korea
Pensive Bodhisattva

Sixth century
Gilt bronze, height 15.5 cm

Musée Guimet, Paris

50

China, late Northern Wei
or Eastern Wei dynasties

**Altarpiece Dedicated
to Buddha Maitreya**

c. 525–35
Gilt leaded bronze,
59.1 × 38.1 × 19.1 cm

Lent by The Metropolitan Museum of Art,
New York. Rogers Fund, 1938

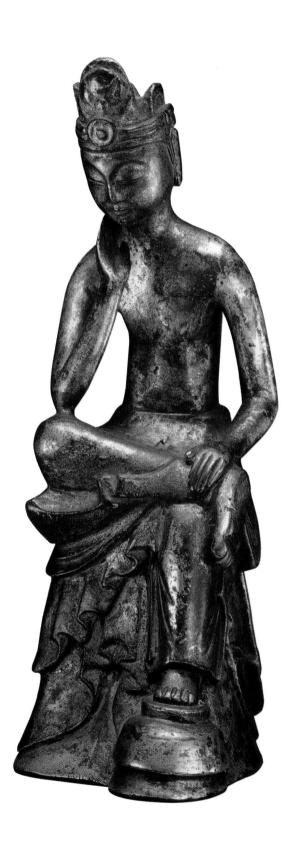

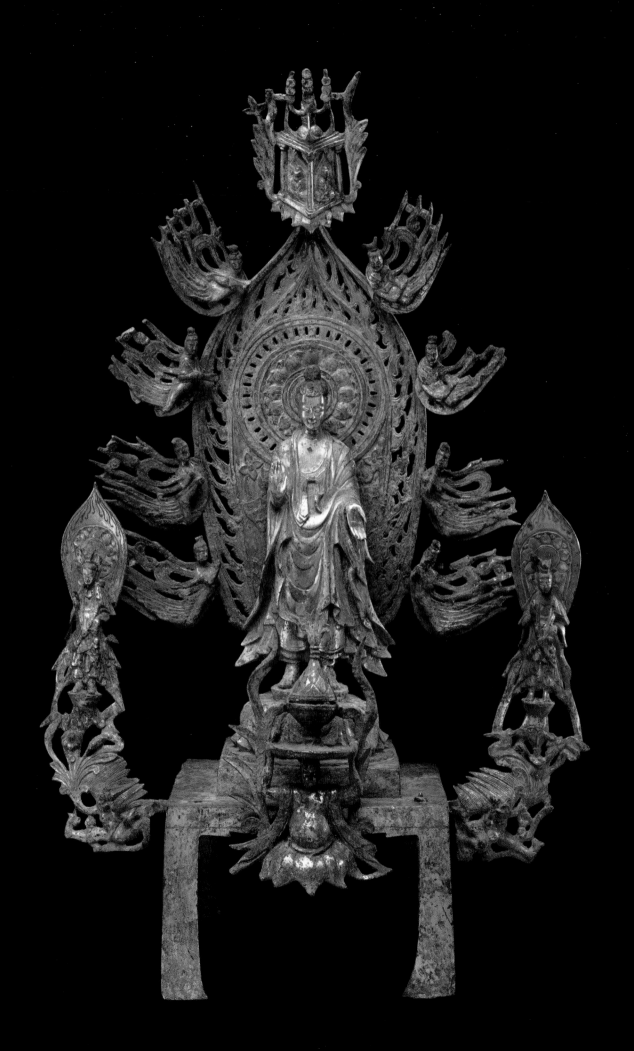

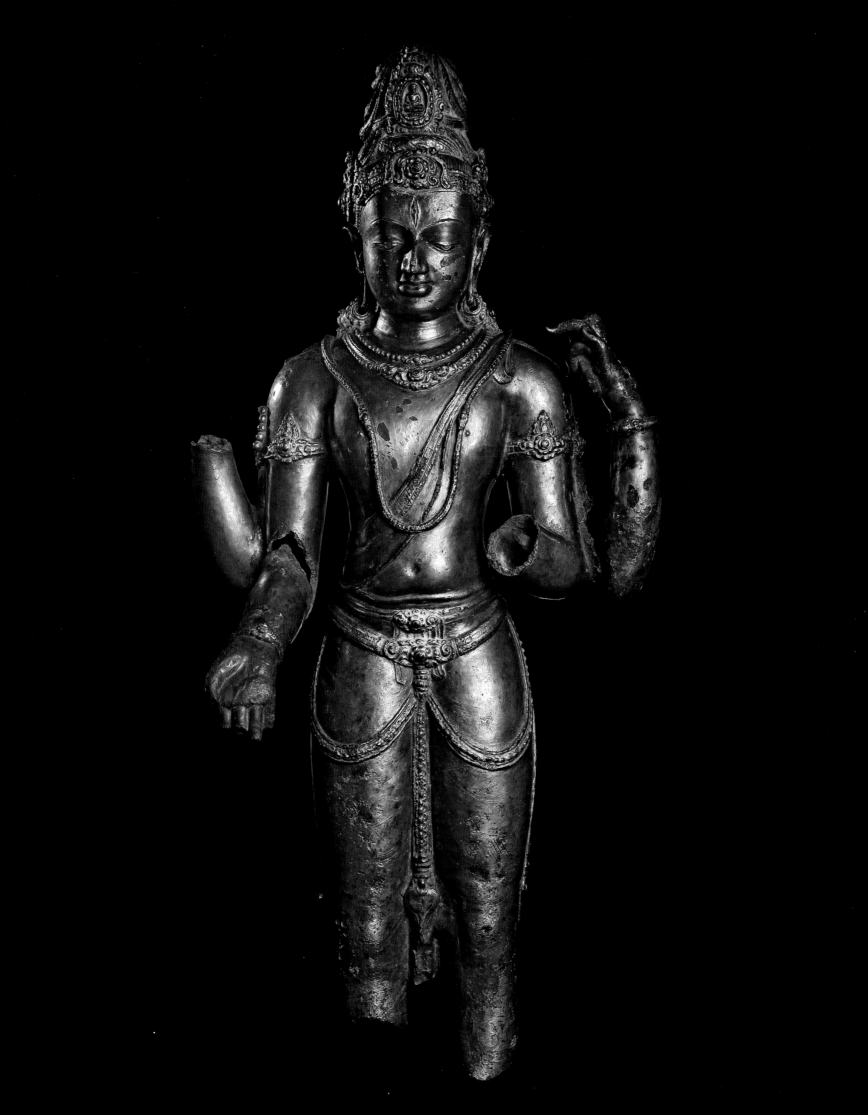

51

Java

Avalokiteshvara

Ninth–tenth centuries
Silvered bronze with traces of gilding,
101 × 49 × 28 cm

National Museum Indonesia, Jakarta

52

Cambodia, Baphuon period

Shiva/Avalokiteshvara

Dated 1044
Bronze with silver and obsidian inlays,
110 × 36 × 32 cm

Private collection

53

Cambodia, Early Angkor period

Maitreya

First quarter of the tenth century
Bronze with silver and obsidian inlays,
75.5 × 50 × 23 cm

National Museum of Cambodia, Phnom Penh

54

Cambodia, Baphuon period

Kneeling Woman

Second half of the eleventh century
Bronze with silver inlay and traces
of gilding, 43.2 × 19.7 cm

Lent by The Metropolitan Museum of Art, New
York. Purchase, bequest of Joseph H. Durkee,
by exchange, 1972

55

Nepal

Uma

Early eleventh century
Copper alloy with traces of gilt and ser
precious stones, 35.6 × 27.9 × 25.4 cm

The Cleveland Museum of Art, Leonard C. Hanna
Jr Fund

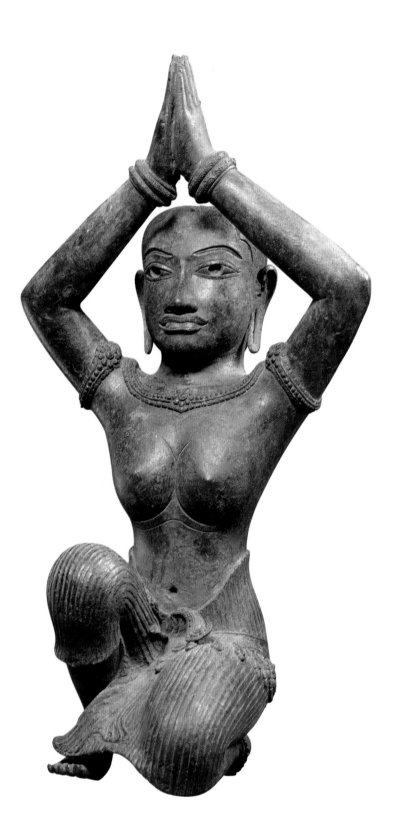

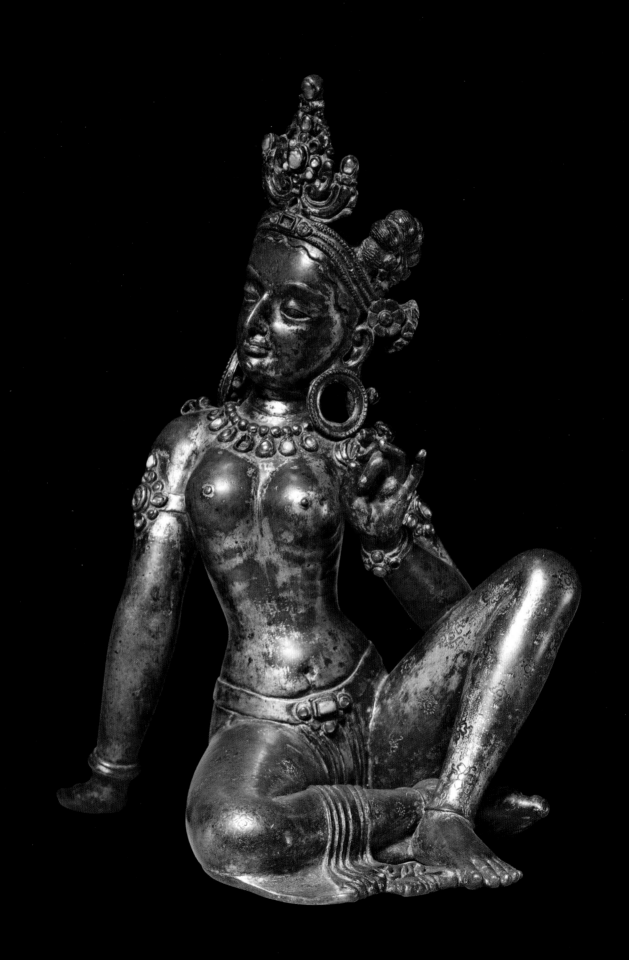

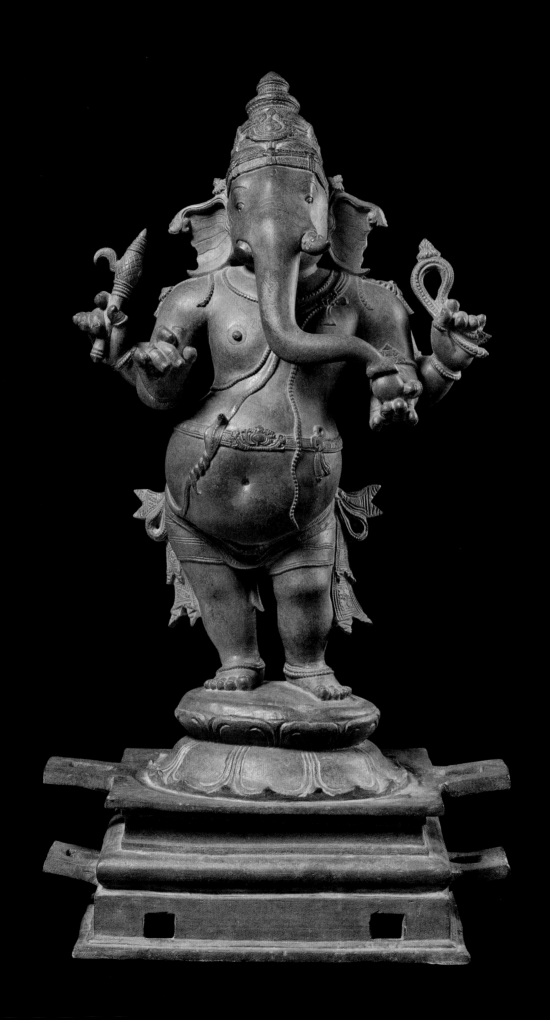

56

Southern India, Chola

Ganesh

Late eleventh – early twelfth centuries
Bronze, height 57 cm

A European private collection

57

Southern India, Tamil Nadu,
Chola period

Nandi

c. 1200
Copper alloy, 51.4 × 52.1 × 33.6 cm

Asia Society, New York. Mr and Mrs John
D. Rockefeller 3rd Collection

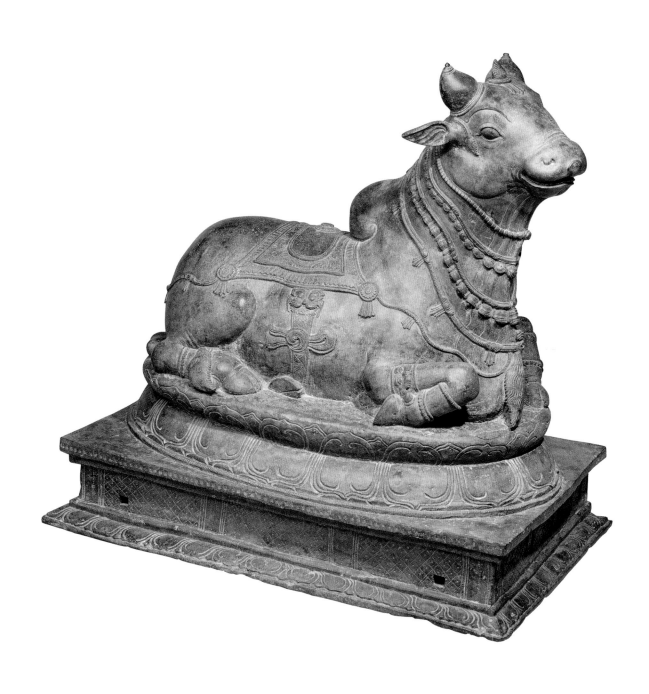

58

Nigeria, Igbo-Ukwu

Roped Pot on a Stand

Ninth–tenth centuries
Leaded bronze, height 32.2 cm

National Museum, Lagos. National Commission
for Museums and Monuments, Nigeria

59

Cambodia, Angkor period

Oil Lamp

Twelfth century
Bronze, 30.5 × 25 × 13 cm

National Museum of Cambodia,
Phnom Penh

60

Cambodia, Bayon period

**Miniature Shrine with
Hevajra in a Circle
of Yoginīs**

Late twelfth – early
thirteenth centuries
Bronze, partially gilded,
height 20.5 cm

National Museum of Cambodia,
Phnom Penh

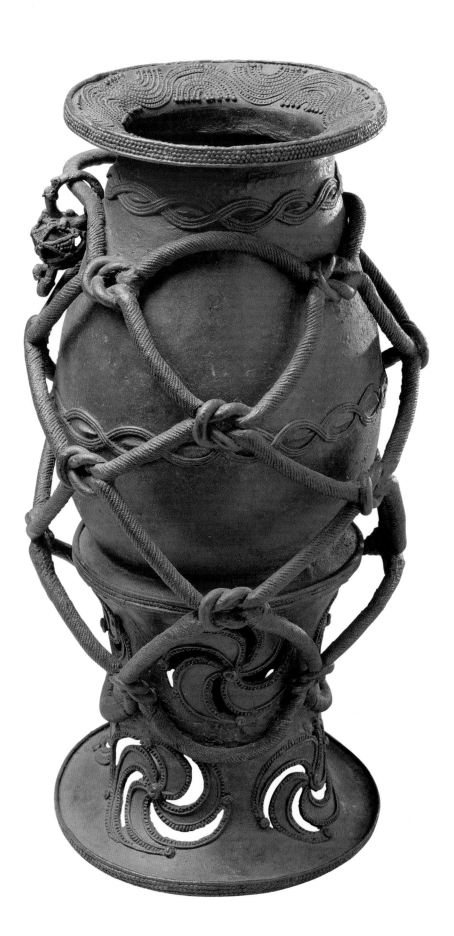

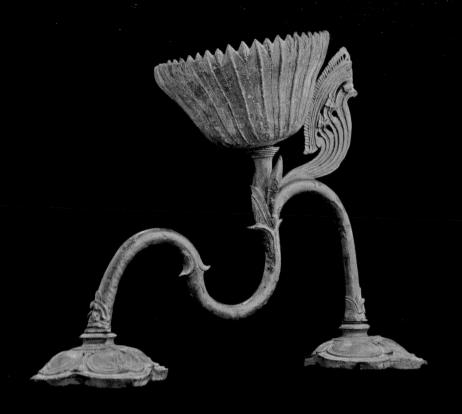

61

Hildesheim

**Aquamanile in the
Form of a Lion**

c. 1215–30
Bronze, 27.5 × 26.2 × 13.2 cm

Victoria and Albert Museum, London

62

Southern Italy or Sicily

Islamic Lion

Late eleventh or early
twelfth centuries
Bronze, 73 × 45 cm
(lacking lower legs)

The Mari-Cha Collection Ltd

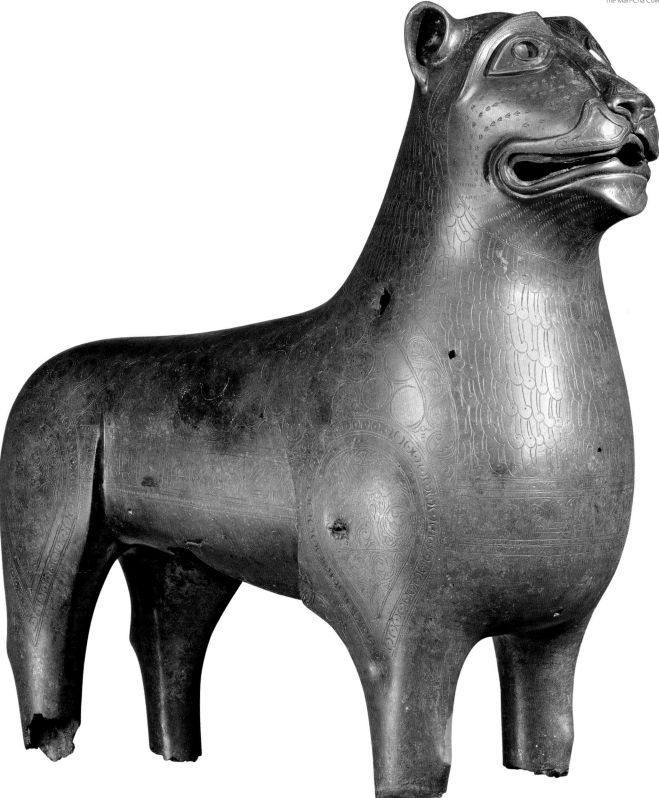

63

Ottonian

Krodo Altar

Late eleventh – early twelfth centuries
Bronze, height 70 cm (box), 40 cm
(caryatid figures)

Stadt Goslar, Goslarer Museum

64

Northern German or Mosan

Crucifix with Corpus

c. 1150–1180
Gilt bronze, 27.5 × 17 cm

Private collection, London

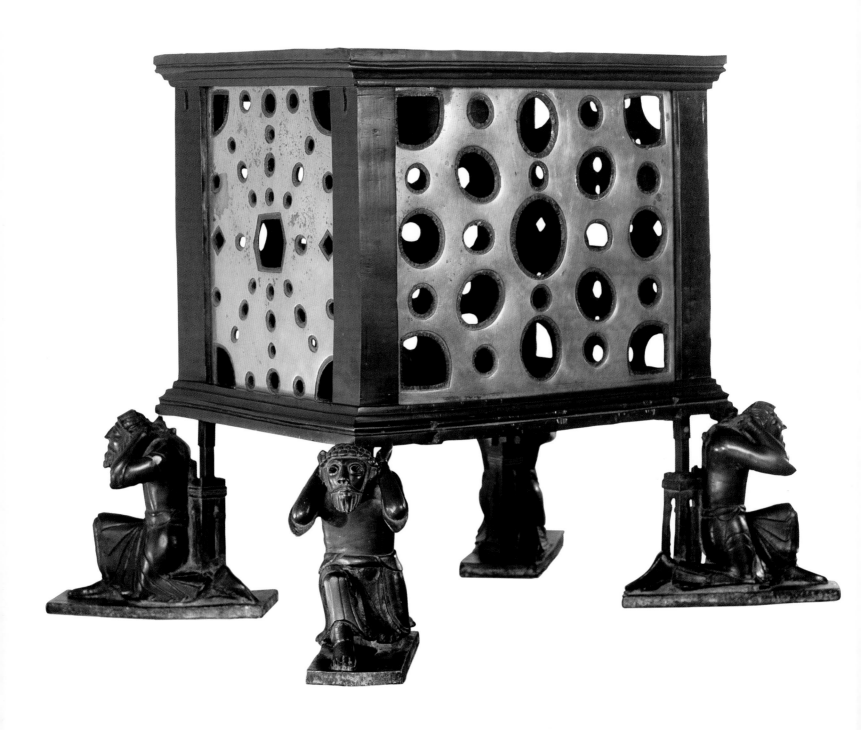

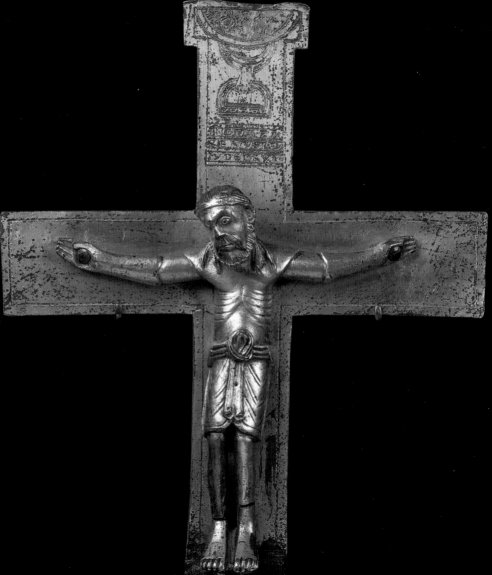

65

English

Sanctuary Ring

c. 1170–80
Bronze, height 67 cm

Chapter of Durham Cathedral

66

Eastern Turkey

Mirror of Artuq Shah

1203/04 or 1261/62
Bronze, diameter 24 cm

The David Collection, Copenhagen

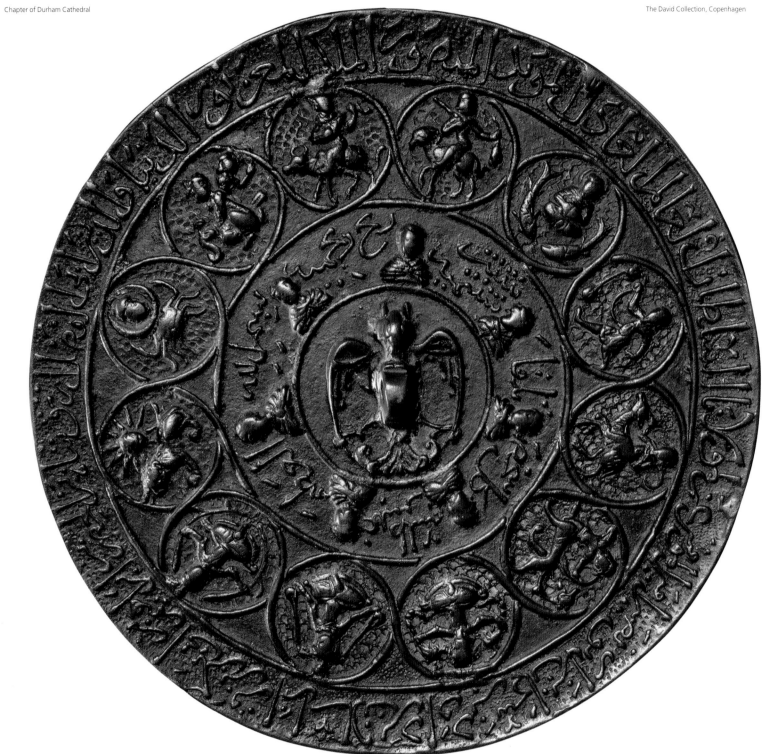

67

English
The Asante Ewer

c. 1390–1400
Bronze, height 62.3 cm

On loan from the British Museum, London

68.1–2

Lower Saxony
St James the Greater
St John the Evangelist

Mid-fourteenth century
Gilt bronze, heights 32.1 and 32.8 cm

Private collection

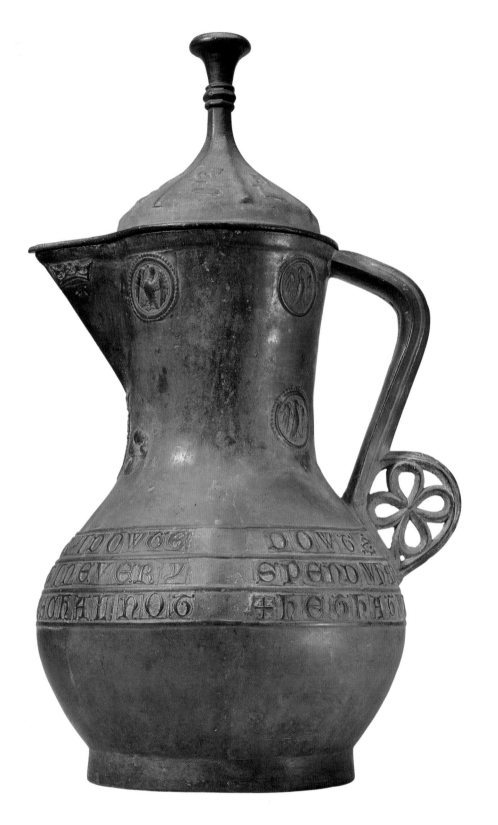

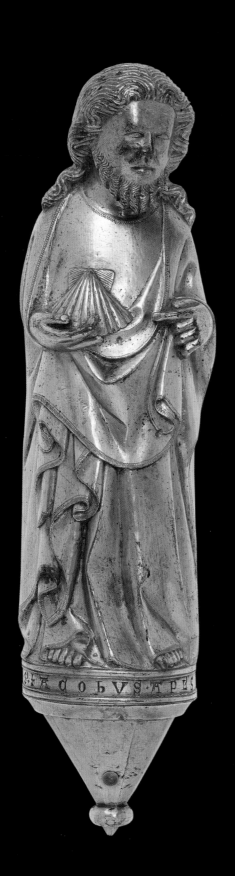
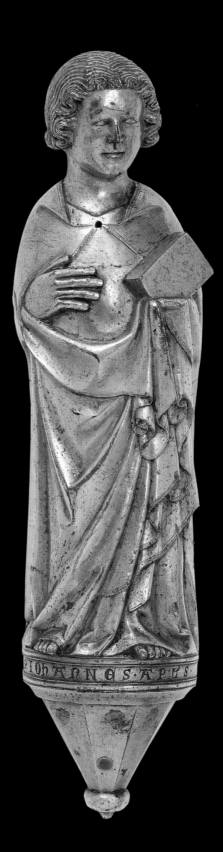

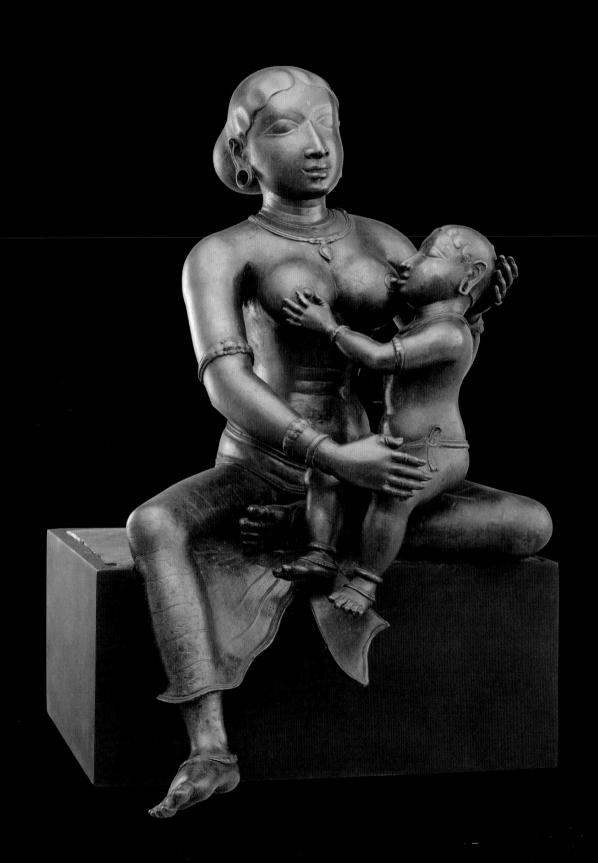

69

Southern India, Tamil Nadu,
Pudukkottai and Tanjavur districts,
Chola period

**Yashoda Nursing the Infant
Krishna**

880–1279
Bronze, 44.5 × 30 × 27.6 cm

Lent by The Metropolitan Museum of Art,
New York. Purchase, Lita Annenberg Hazen
Charitable Trust Gift, in honour of Cynthia
Hazen and Leon B. Polsky, 1982

70

Nigeria, Tada

Seated Figure

Late thirteenth–fourteenth centuries
Copper with traces of arsenic, lead
and tin, height 53.7 cm

National Museum, Lagos. National Commission
for Museums and Monuments, Nigeria

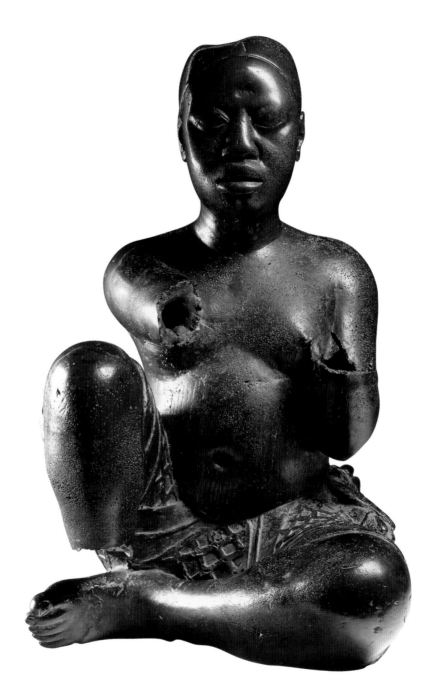

71

Japan, Kamakura period

Head of a Buddha

First half of the thirteenth century
Gilt bronze, height 34 cm

Museum of Fine Arts, Boston. Julia Bradford
Huntington James Fund

72

Nigeria, Ife

Mask of Obalufon II

Fourteenth – early fifteenth centuries
Copper, height 29.5 cm

National Museum, Lagos. National Commission
for Museums and Monuments, Nigeria

73

Nigeria, Ife

Head with Crown

Fourteenth – early fifteenth centuri
Brass, height 24 cm

National Museum, Lagos. National Commission
for Museums and Monuments, Nigeria

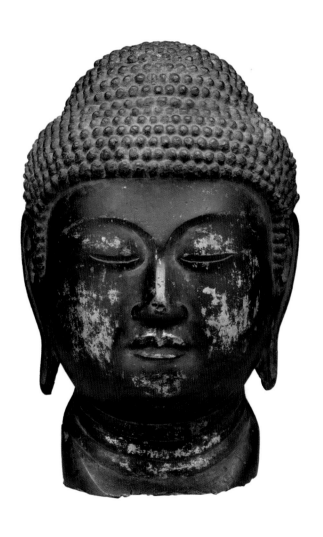

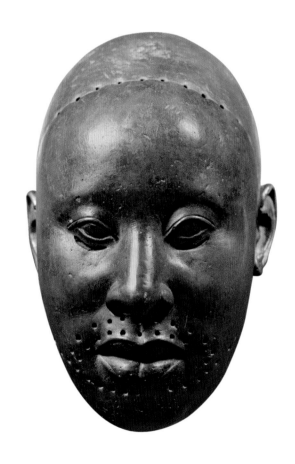

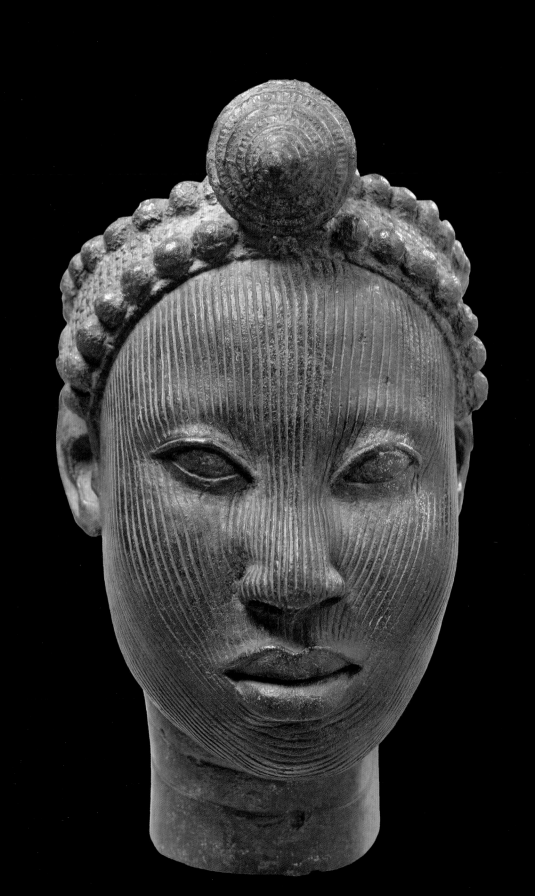

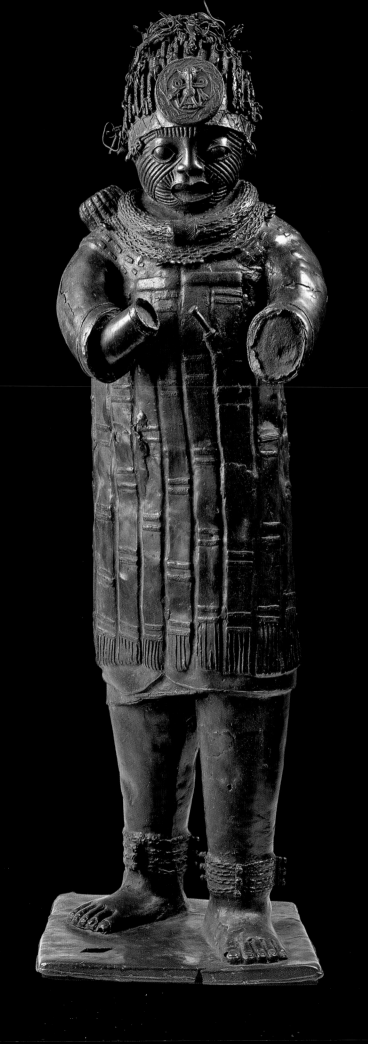

74

Nigeria, Jebba Island

Bowman

Fourteenth–fifteenth centuries
Bronze, height 95 cm

National Museum, Lagos. National Commission
for Museums and Monuments, Nigeria

75

Nigeria, Benin (?)

Female Figure

Seventeenth–eighteenth centuries
Brass, 46.5 × 22.6 × 18.7 cm

Staatliche Museen zu Berlin,
Ethnologisches Museum

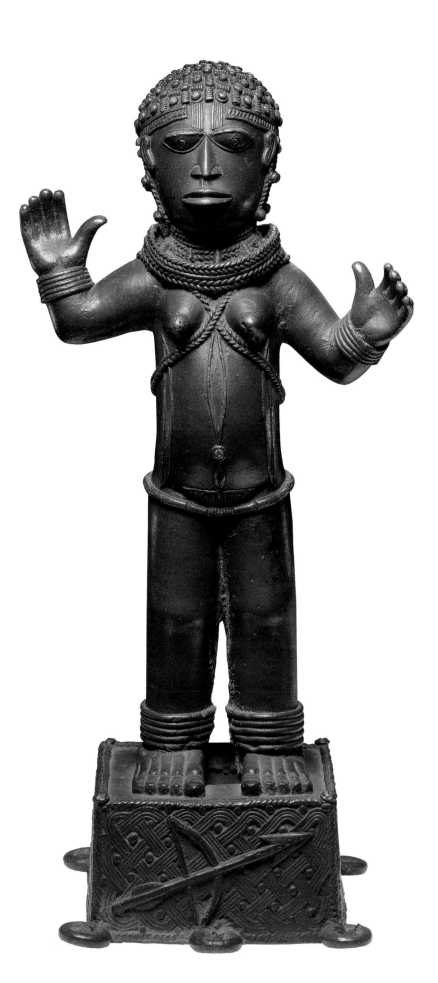

76

China, early Ming dynasty,
Yongle period

**Kapâla-Hevajra and
Nairâtmya**

1403–24
Gilt bronze with polychromy
and semi-precious stones,
66 × 54 × 30 cm

Collection Bodhimanda Foundation /
Wereldmuseum, Rotterdam

77

Central Tibet

Eleven-headed Avalokiteshvara

c. 1400
Bronze with silver and copper inlay,
semi-precious stones and polychromy,
120.7 × 39.8 × 25 cm

Private collection, courtesy Rossi & Rossi, London

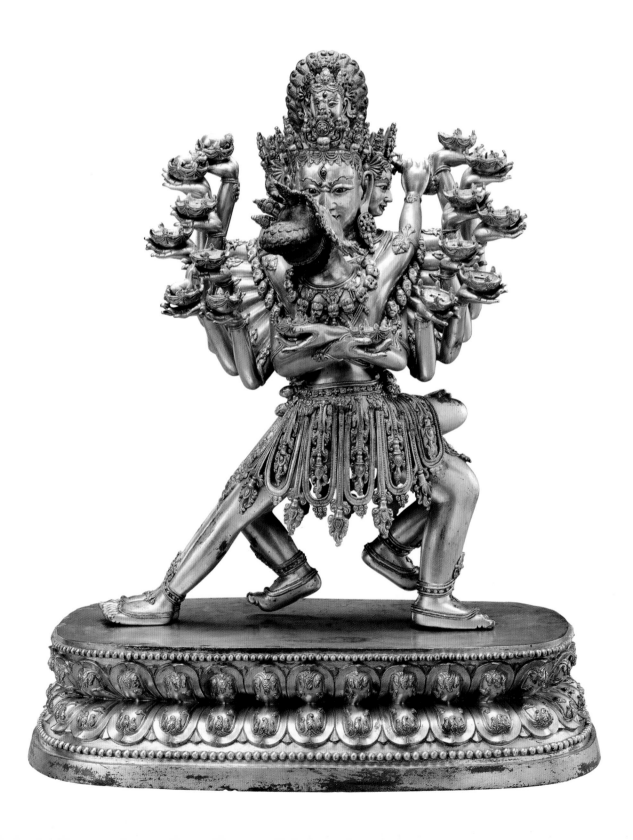

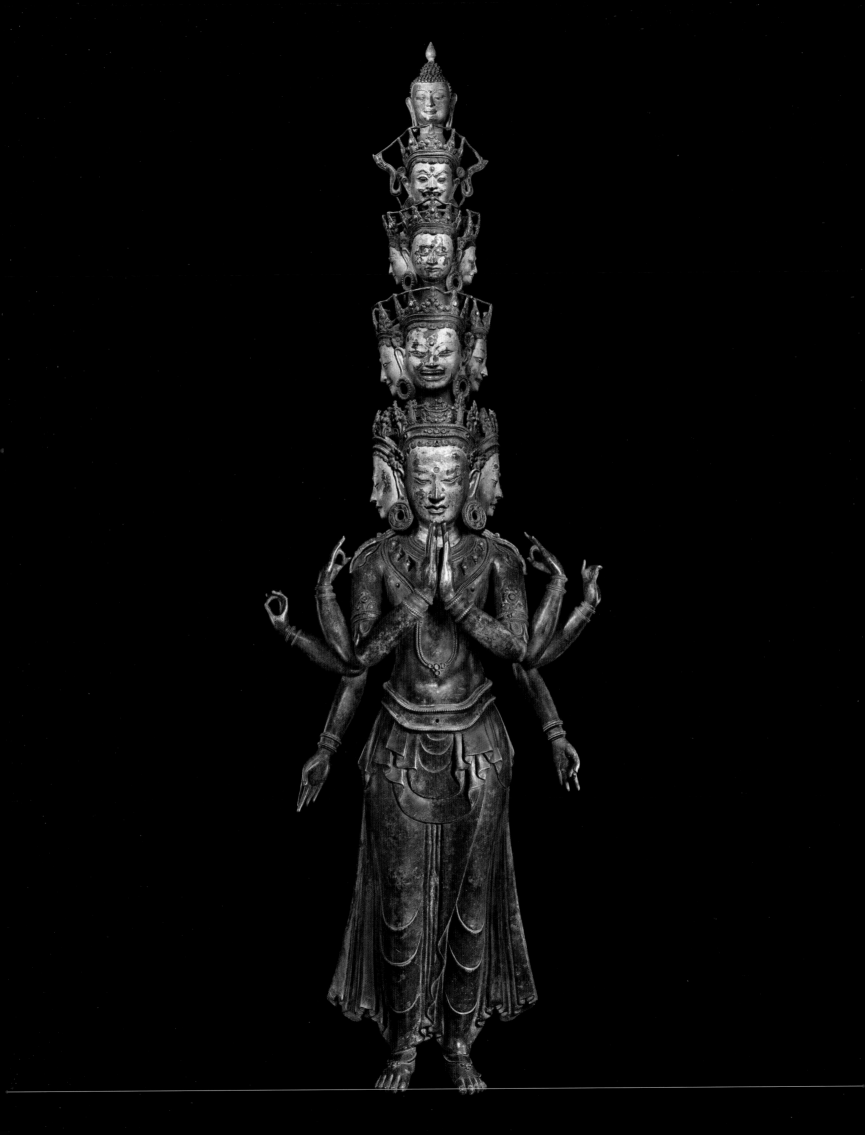

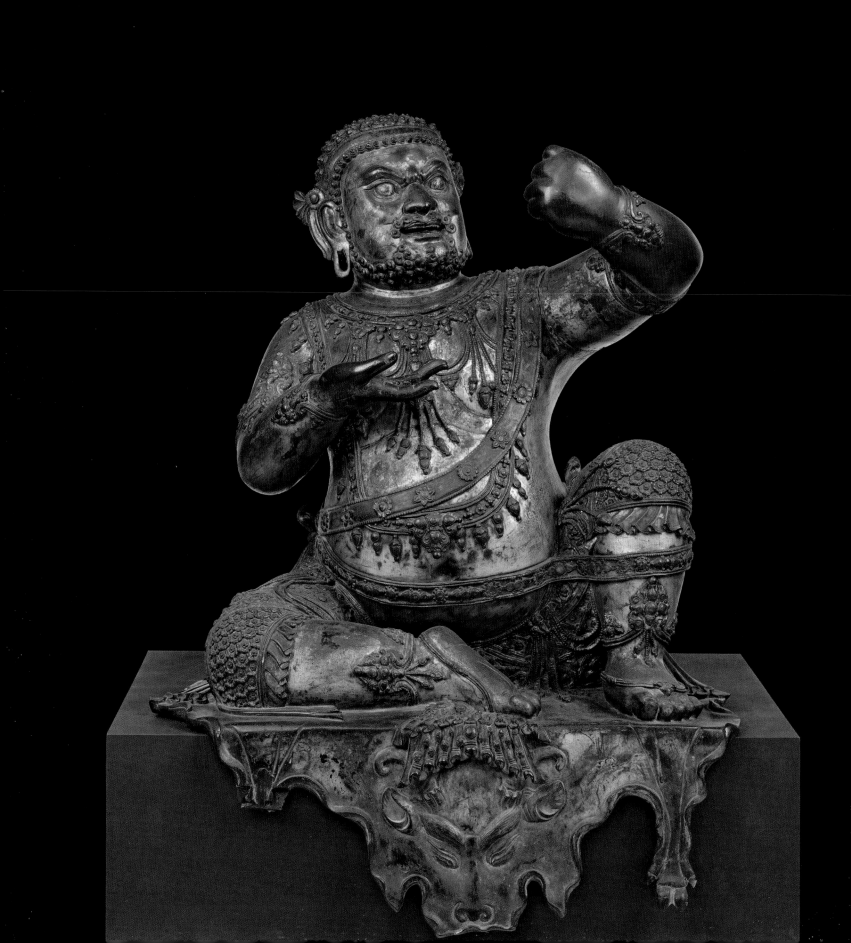

78

China, early Ming dynasty,
Yongle period
Mahāsidda Virūpa

First quarter of the fifteenth century
Gilt bronze, 79 × 60 × 43 cm

Victoria and Albert Museum, London.
Purchased with support from the Robert H. N.
Ho Family Foundation

79

Nigeria
**Huntsman Carrying
an Antelope**

Probably pre-1500
Bronze, 37 × 17.5 × 15.5 cm

On loan from the British Museum, London

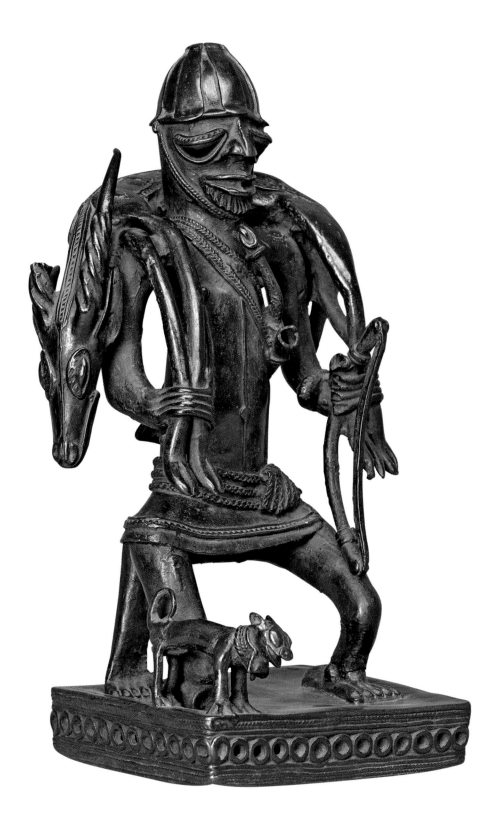

80

Lorenzo Ghiberti (c. 1378–1455)

**Tomb Slab of
Fra Leonardo Dati**

1425–26
Bronze, 229 × 87 cm

Santa Maria Novella, Florence. Fondo Edifici di
Culto, amministrato dal Ministero dell'Interno –
Dipartimento per le Libertà Civili e l'Immigrazione –
Direzione Centrale per l'Amministrazione del
Fondo Edifici di Culto Soprintendenza Speciale
per il Patrimonio Storico Artistico ed
Etnoantropologico e Polo Museale della città
di Firenze

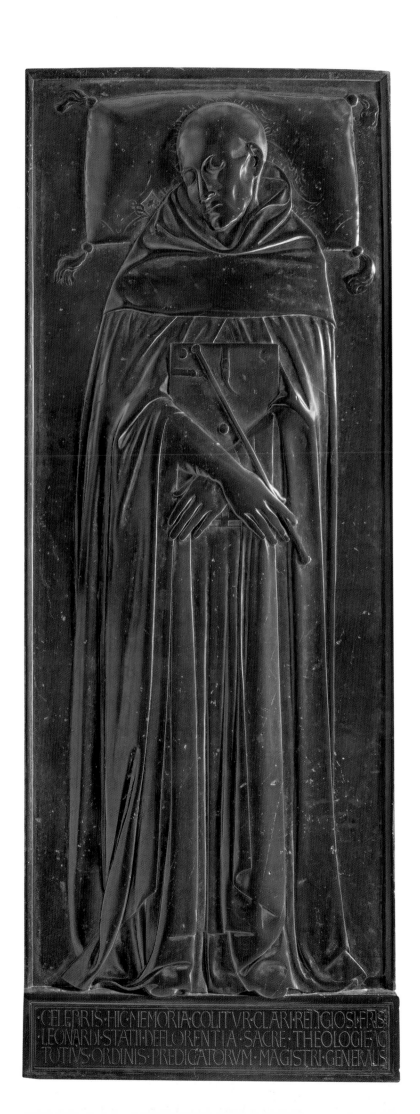

81

Lorenzo Ghiberti (c. 1378–1455)

St Stephen

1425–29
Brass, with eyes of silver laminate
height 268 cm

Chiesa e Museo di Orsanmichele, Florence

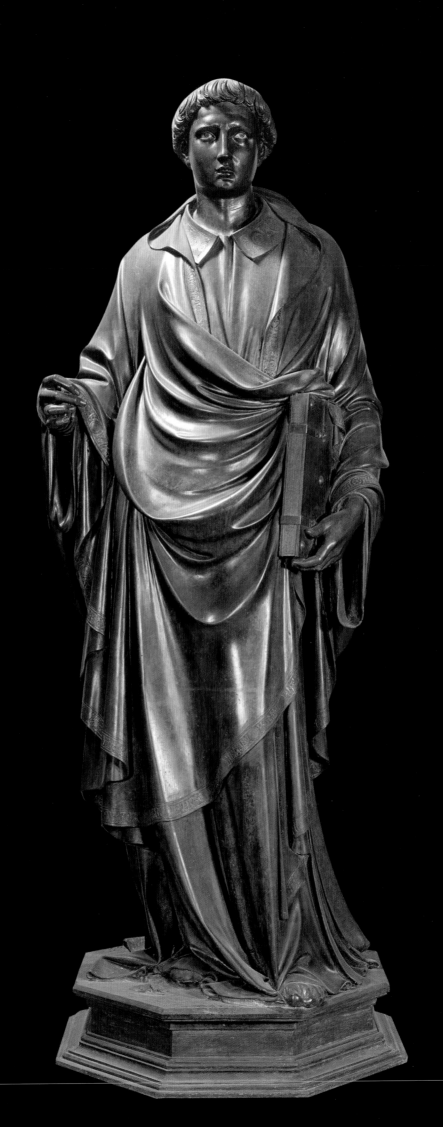

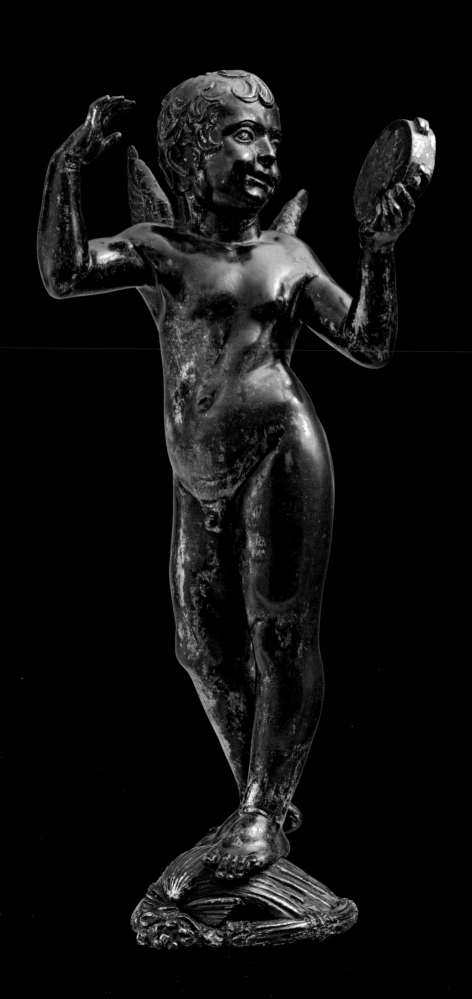

82

Donatello (c. 1386–1466)

Putto with Tambourine

1429
Bronze with traces of gilding,
36.5 × 15 × 16.2 cm

Staatliche Museen zu Berlin, Skulpturensammlung
und Museum für Byzantinische Kunst

83

Filarete (Antonio Averlino)
(c. 1400–c. 1469)

Hector on Horseback

1456
Bronze, 27.5 × 25.5 × 12.5 cm

Museo Arqueológico Nacional, Madrid

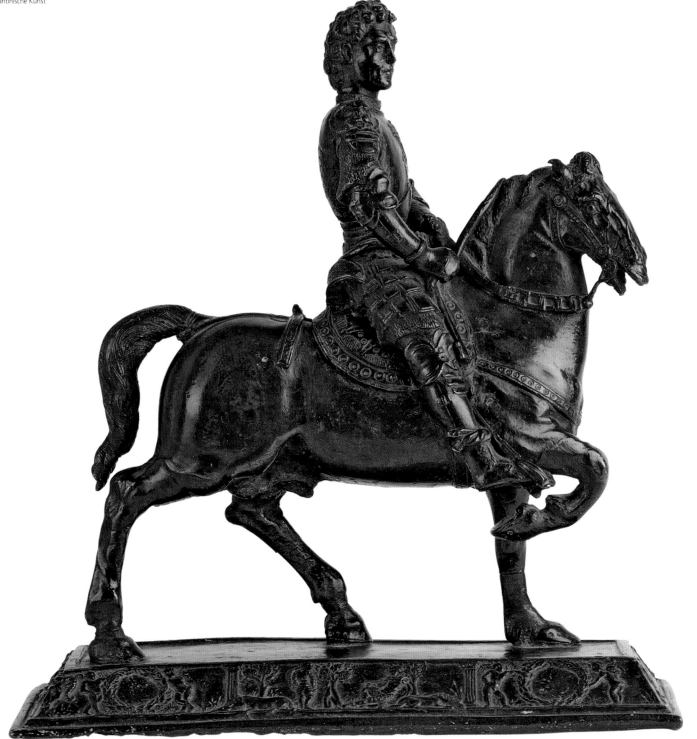

176

84.1–6

Attributed to Jan Borman the
Younger (active 1479–1520)
and cast by Renier van Thienen
(active 1465–1498)

Six Weepers

1475–76
Bronze, heights 54.5–59 cm

Rijksmuseum, Amsterdam. On loan
from the City of Amsterdam

85

Donatello (c. 1386–1466)

**Lamentation over the
Dead Christ**

c. 1455–60
Bronze, 32.1 × 41.7 × 6.3 cm

Victoria and Albert Museum, London

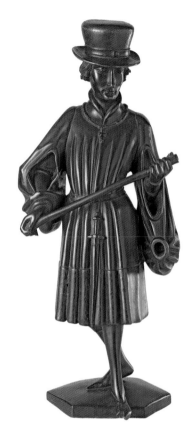
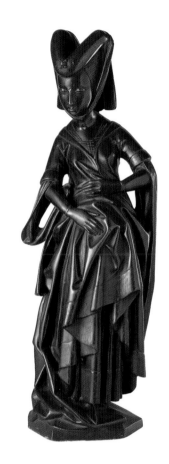
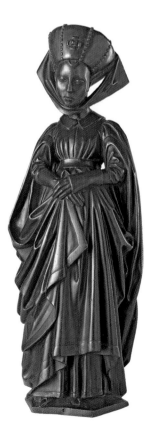
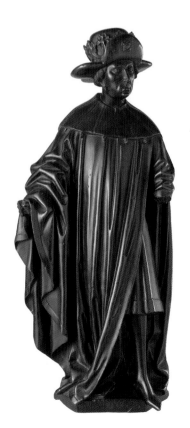

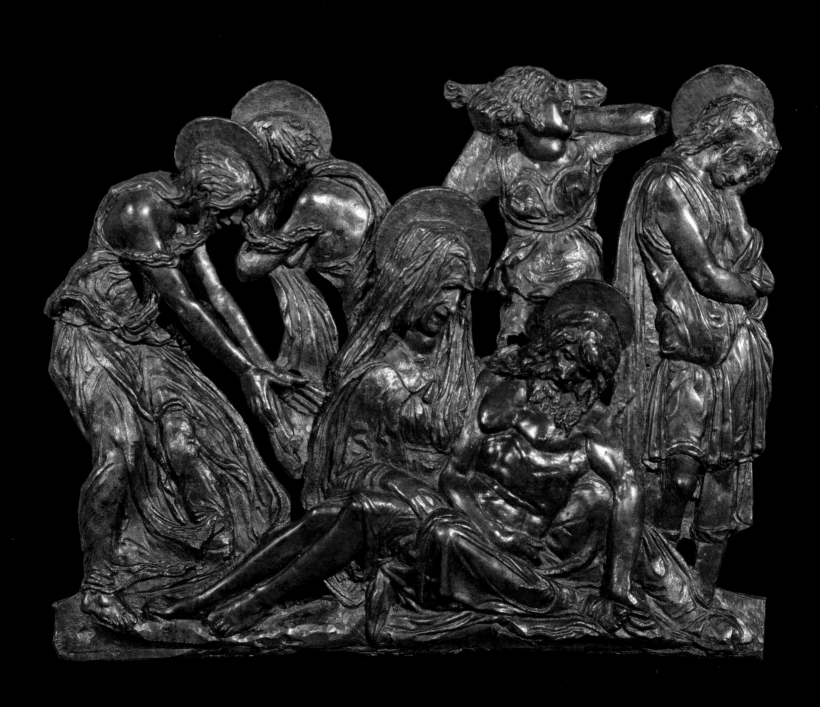

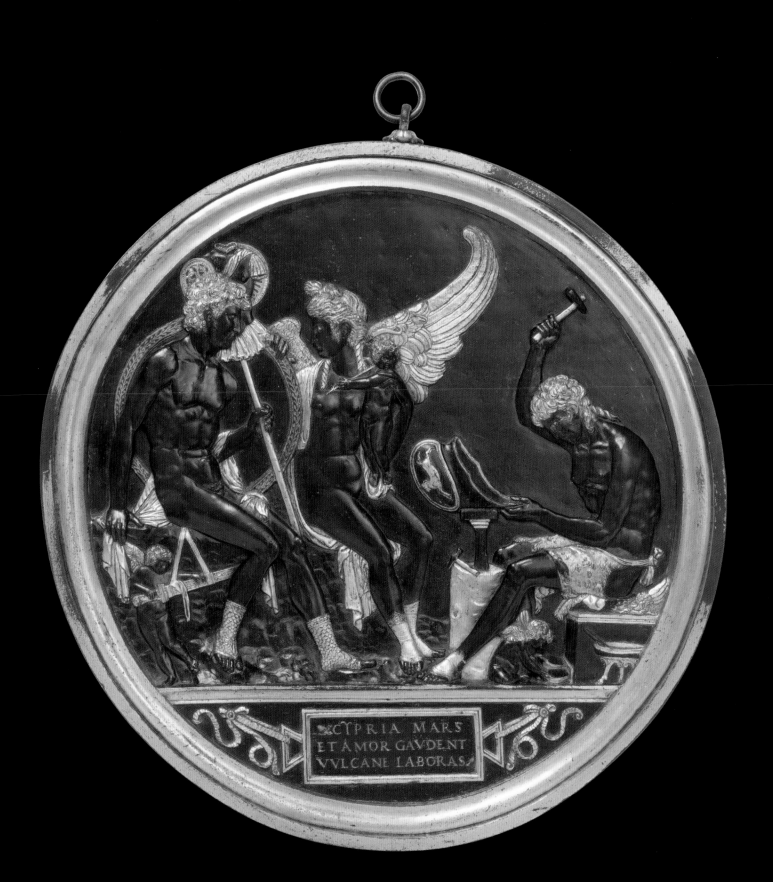

86

Circle of Antico, possibly Gian Marco
Cavalli (c. 1454 – d. after 1508)

**Mars with Venus and Cupid
at the Forge of Vulcan**

c. 1480–1500
Bronze, partially gilded and silvered,
diameter 42 cm

H. E. Sheik Saoud Bin Mohammed Bin Ali Al-Thani

87

Circle of Giulio Romano
(c. 1500–1546)

Apollo or Hymen

First half of the sixteenth century
Bronze, 75.4 × 18 × 17.4 cm

Private collection, London

88

Giovan Francesco Rustici (1475–1554)

**St John the Baptist Preaching
to a Levite and a Pharisee**

1506–11
Bronze, 267 × 93 × 71 cm,
272 × 90 × 70 cm, 262 × 103 × 60 cm

Opera di Santa Maria del Fiore, Florence. The
restoration of the sculpture has been carried out
with sponsorship from the Association 'Friends
of Florence'

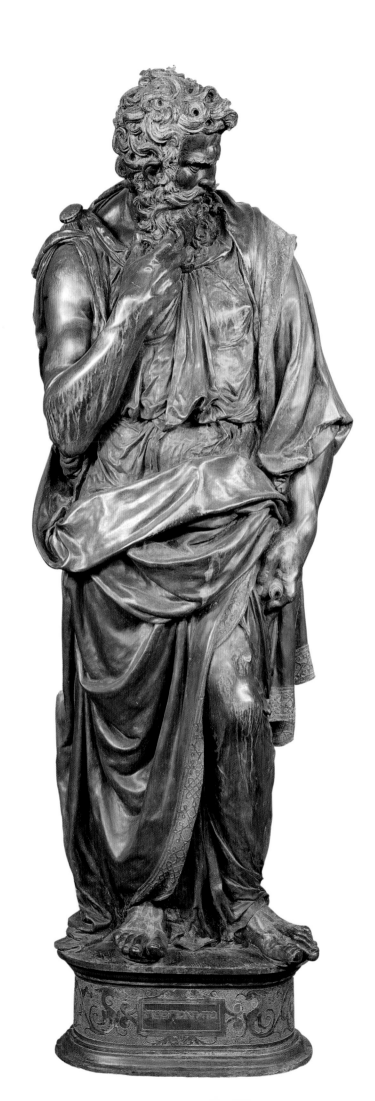

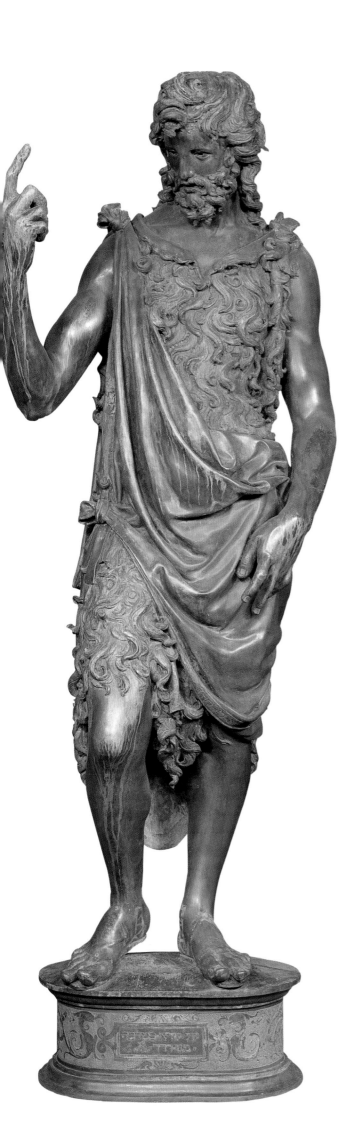

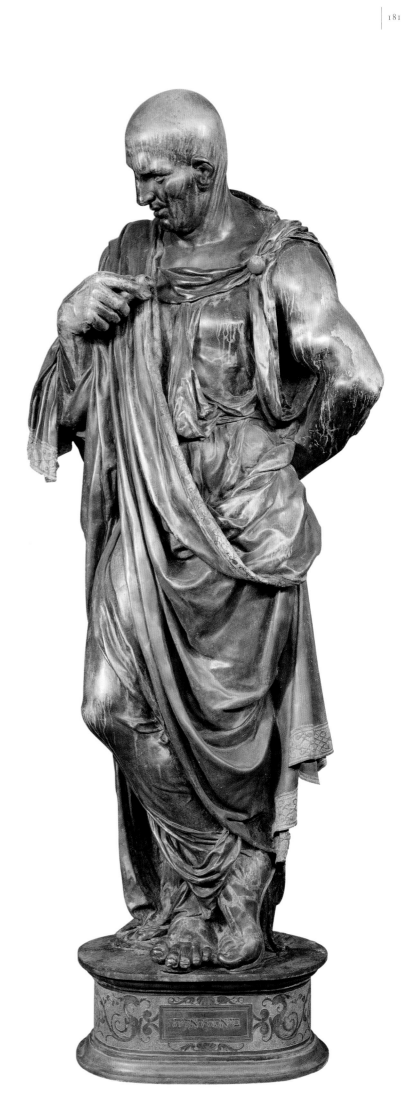

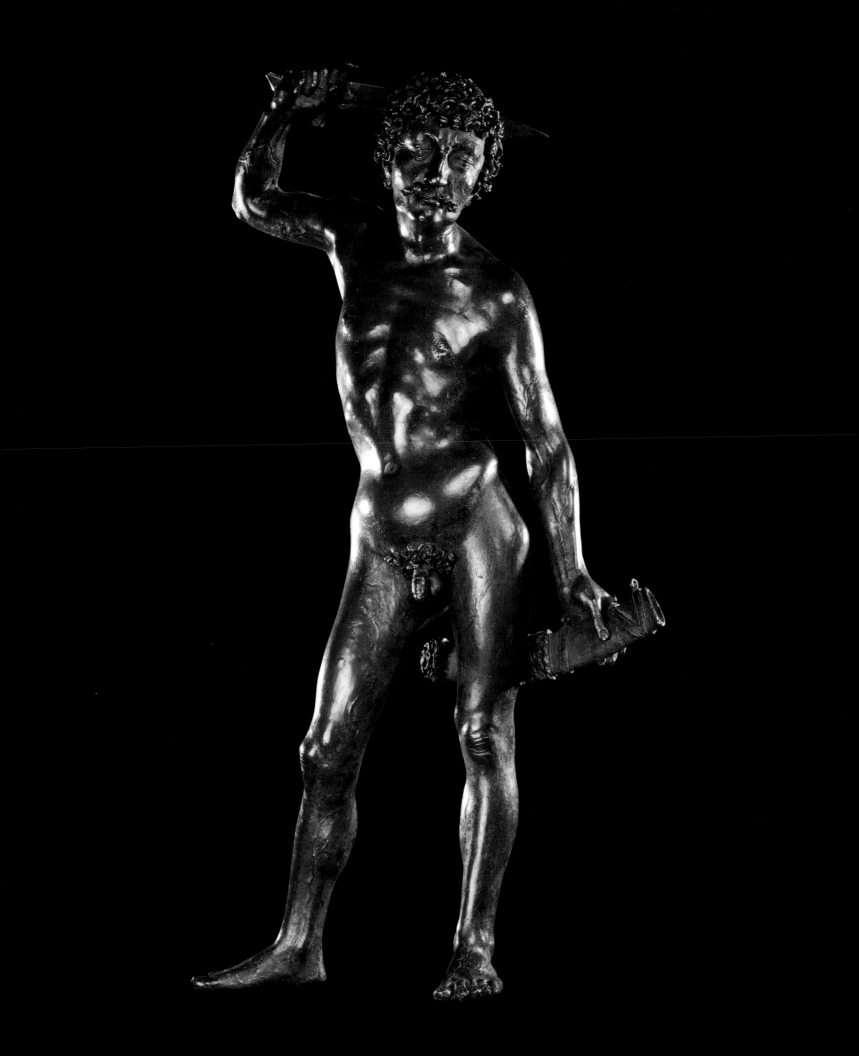

89

Leonhard Magt (d. 1532), cast by
Stefan Godl (doc. 1508–34)

Nude Warrior

1526
Bronze, height 53.3 cm

Universalmuseum Joanneum, Alte Galerie, Graz

90

Andrea Briosco, called Riccio
(1470–1532)

Man with a Strigil

c. 1515–20
Bronze, height 31.9 cm

Collection of Mr and Mrs J. Tomilson Hill

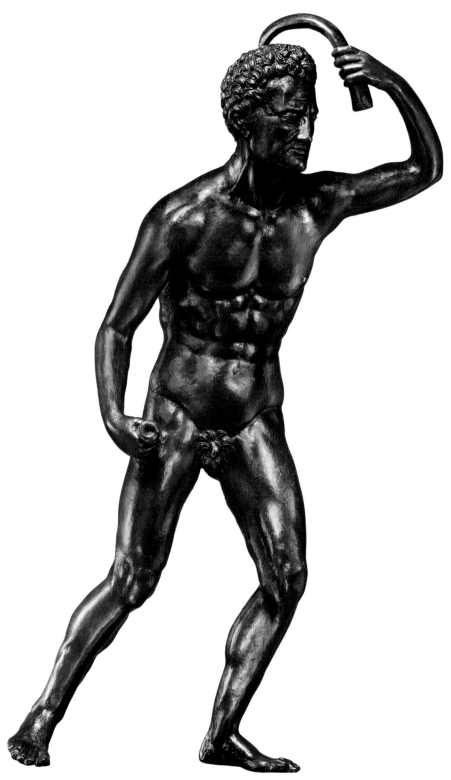

91

Nigeria, Benin

Queen Mother Head

Early sixteenth century
Copper alloy, height 51 cm

National Museum, Lagos. National Commission
for Museums and Monuments, Nigeria

92

Pier Jacopo Alari-Bonacolsi,
called Antico (c. 1460–1528)

Bust of a Youth

c. 1520
Bronze with olive-brown patina
under black lacquer patina under oil
gilding, height 56.5 cm

The Princely Collections, Vaduz-Vienna

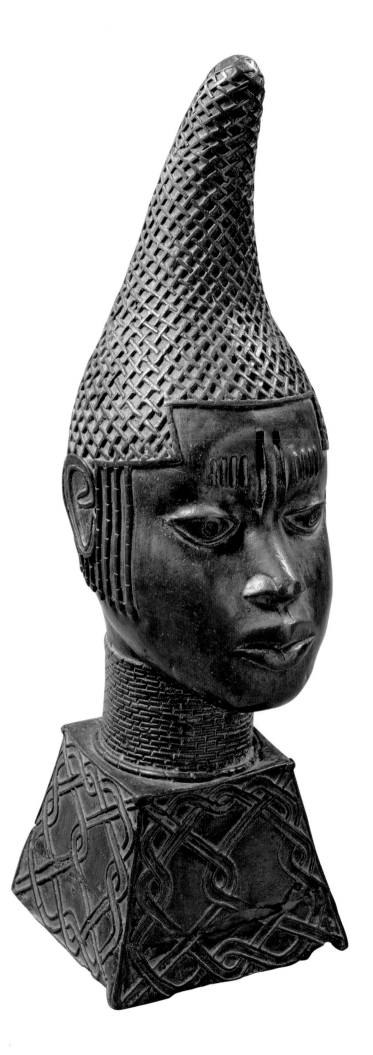

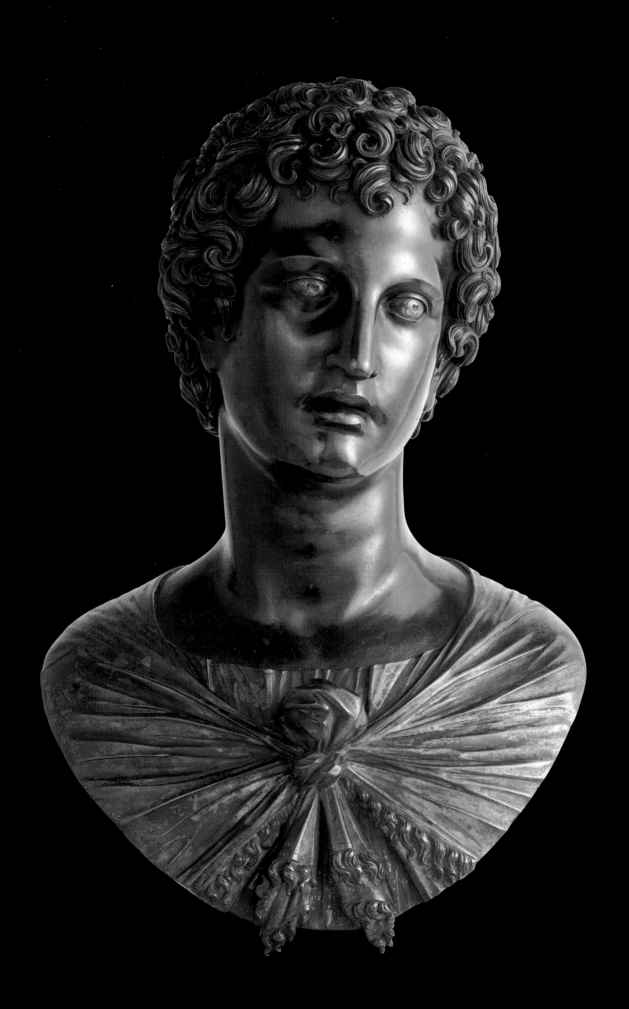

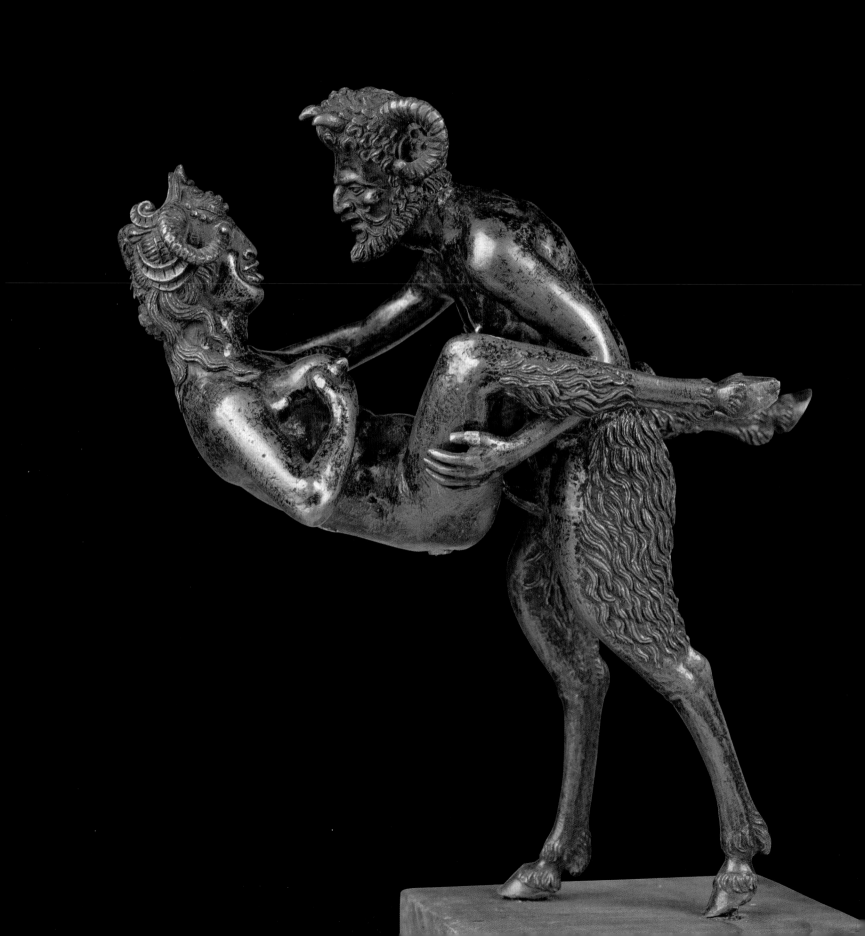

93

Attributed to Desiderio da Firenze
(doc. 1532–1543)

Satyr and Satyress

c. 1532–43
Bronze, height 27.5 cm

Musée National de la Renaissance, Château
d'Ecouen

94

Andrea Briosco, called Riccio
(1470–1532)

Satyr and Satyress

c. 1510–20
Bronze, 24 × 16.5 × 17.9 cm

Victoria and Albert Museum, London.
Presented by the Art Fund

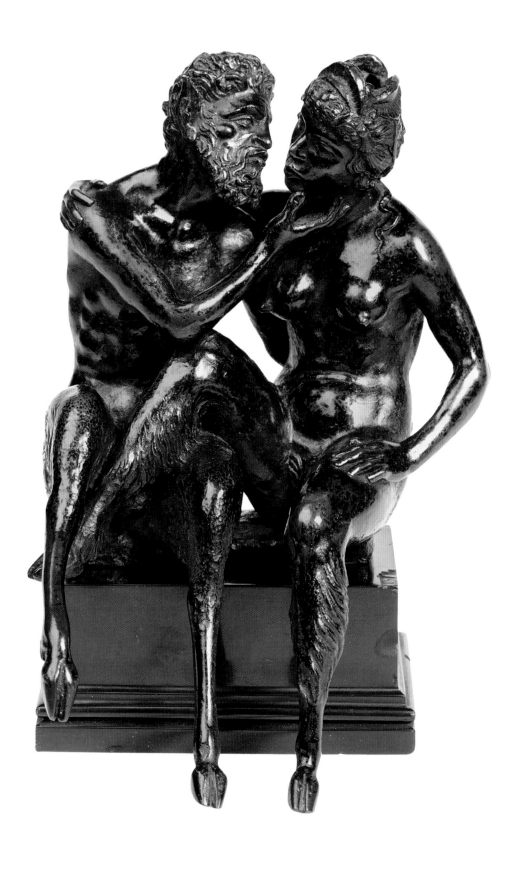

95

School of Fontainebleau
Pair of Stirrups

c. 1515–1525
Gilded bronze, 15 × 29 cm

Musée National de la Renaissance, Château
d'Ecouen

97

Germain Pilon (doc. 1540–1590)
**Lamentation Over the Dead
Christ**

c. 1583–84
Bronze, 47.6 × 82.2 × 5.8 cm

Musée du Louvre, Paris. Département des
Sculptures

96

Benvenuto Cellini (1500–1571)
Saluki Dog

1544–45
Bronze, 19.6 × 27 cm

Museo Nazionale del Bargello, Florence.
Istituti museali della Soprintendenza Speciale
per il Polo Museale Fiorentino

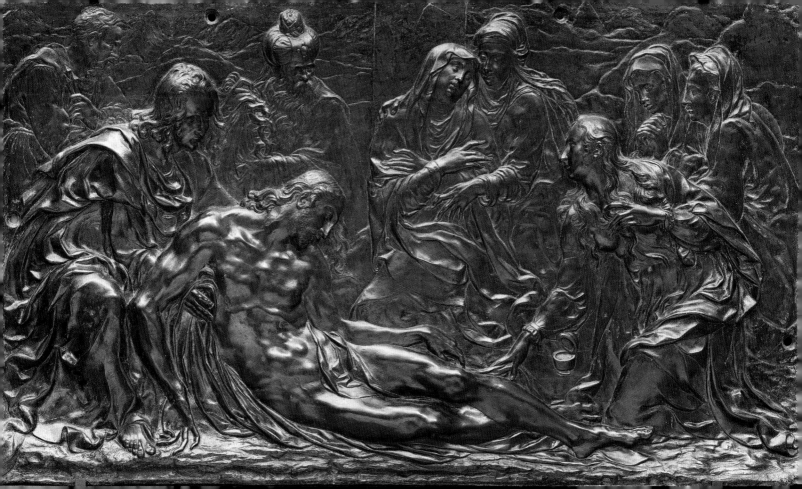

98

Peter Flötner (c. 1485–1546), cast by
Pancraz Labenwolf (1492–1563)

Apollo Fountain

1532
Brass, height 100 cm

On long-term loan to the Fembohaus, Nuremberg.
Lent by the Museen der Stadt Nürnberg, Gemälde-
und Skulpturensammlung

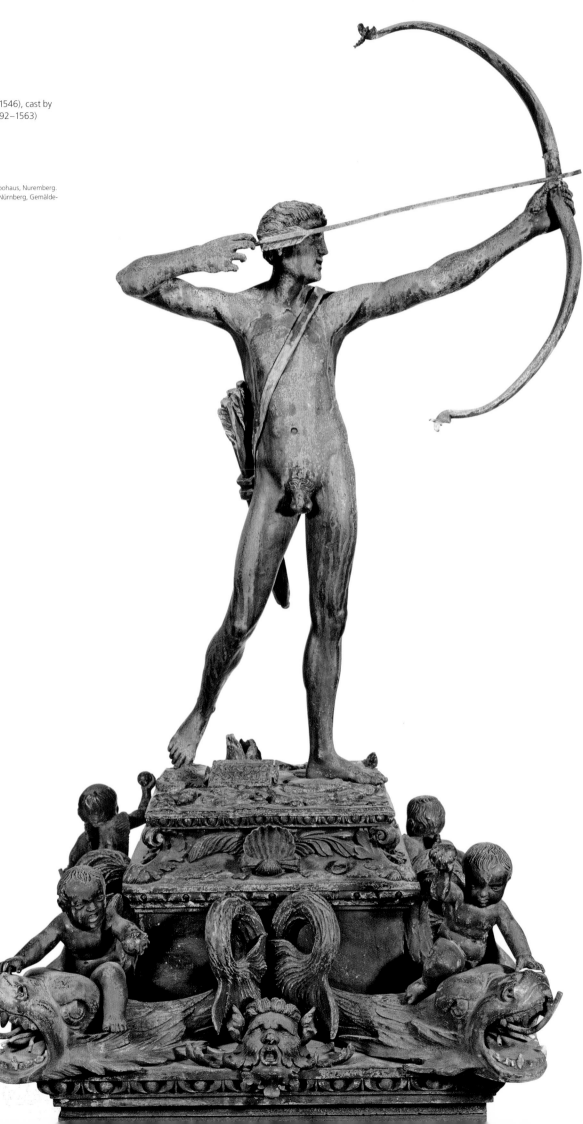

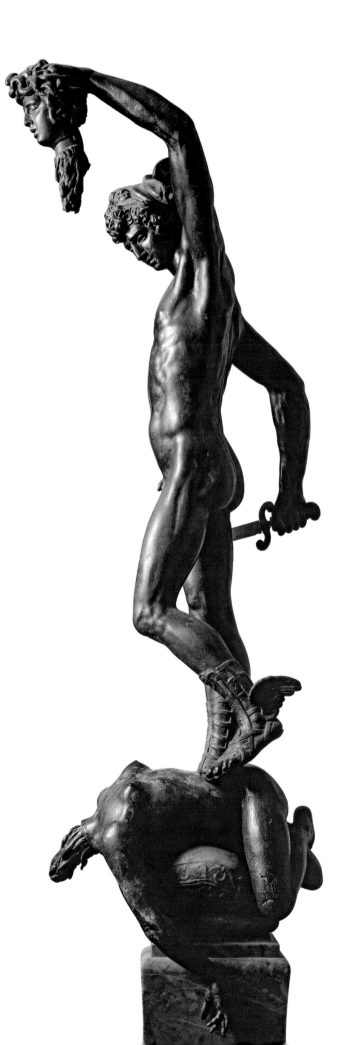

99

Benvenuto Cellini (1500–1571)
Modello for Perseus

c. 1545–54
Bronze with traces of gilding,
height including base 85.5 cm

Museo Nazionale del Bargello, Florence.
Istituti museali della Soprintendenza Speciale
per il Polo Museale Fiorentino

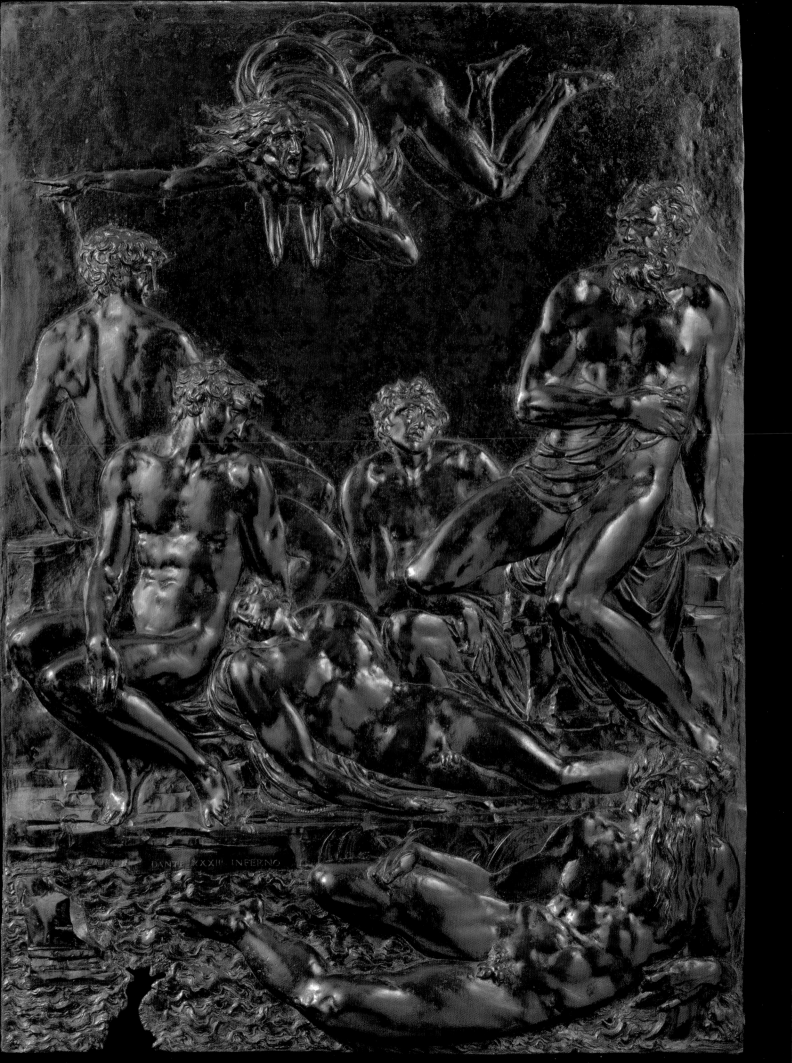

DANTE XXXII. INFERNO

100

Pierino da Vinci (1530–1553)

The Death of Count Ugolino della Gherardesca and His Sons

1548–49
Bronze with brown patina and traces of blackish-brown lacquer, 65.4 × 46.5 cm

The Princely Collections, Vaduz-Vienna

101

Rome

Bacchants Riding on Panthers

c. 1550
Bronze, each 93 × 80 cm

Private collection

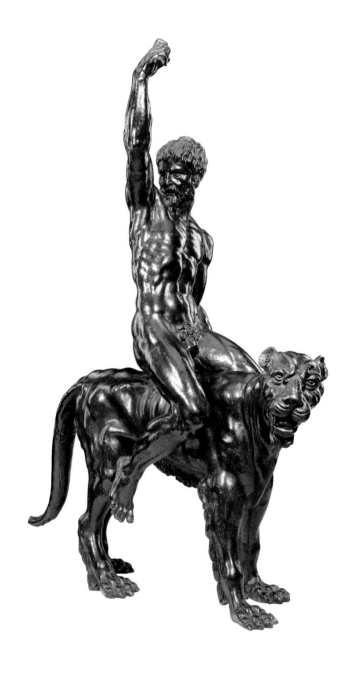

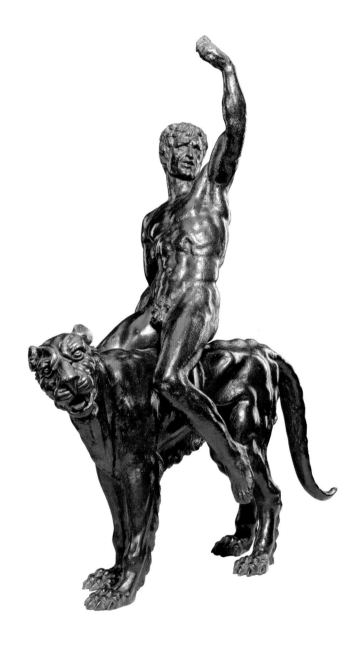

102

Nigeria, Benin
Pair of Leopards

Mid-sixteenth century
Brass, length 69 cm

National Museum, Lagos. National Commission
for Museums and Monuments, Nigeria

103

Nigeria, Benin
The Leopard Hunt

Sixteenth century
Brass, 55.2 × 39.2 × 3.9 cm

Staatliche Museen zu Berlin,
Ethnologisches Museum

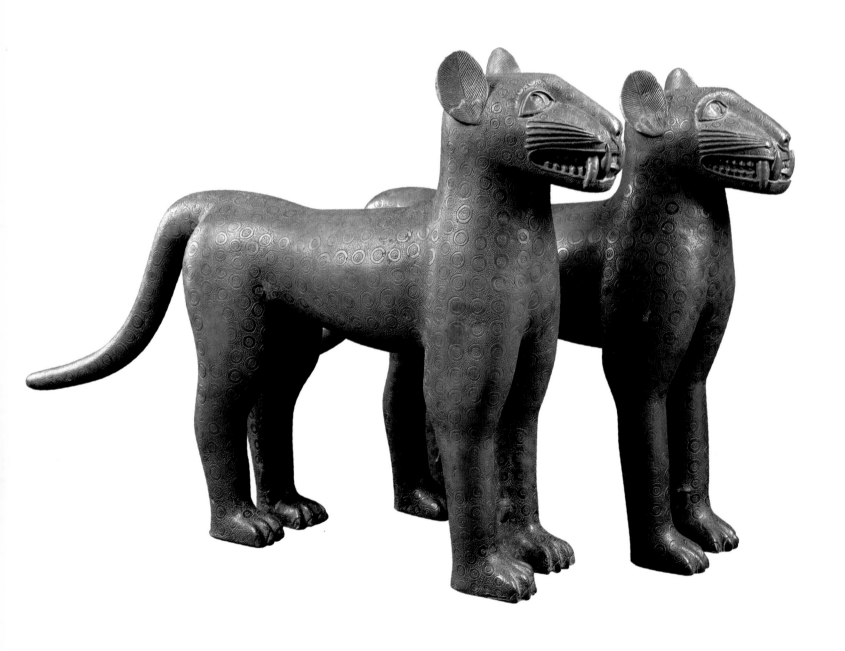

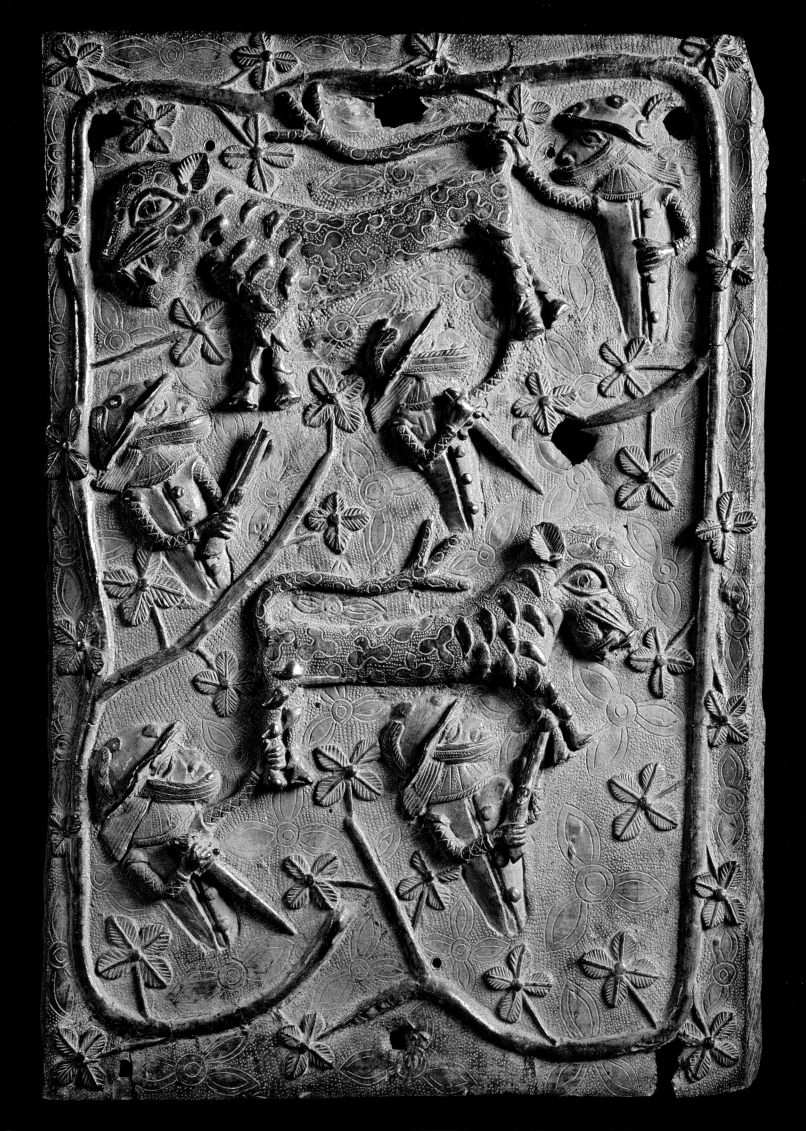

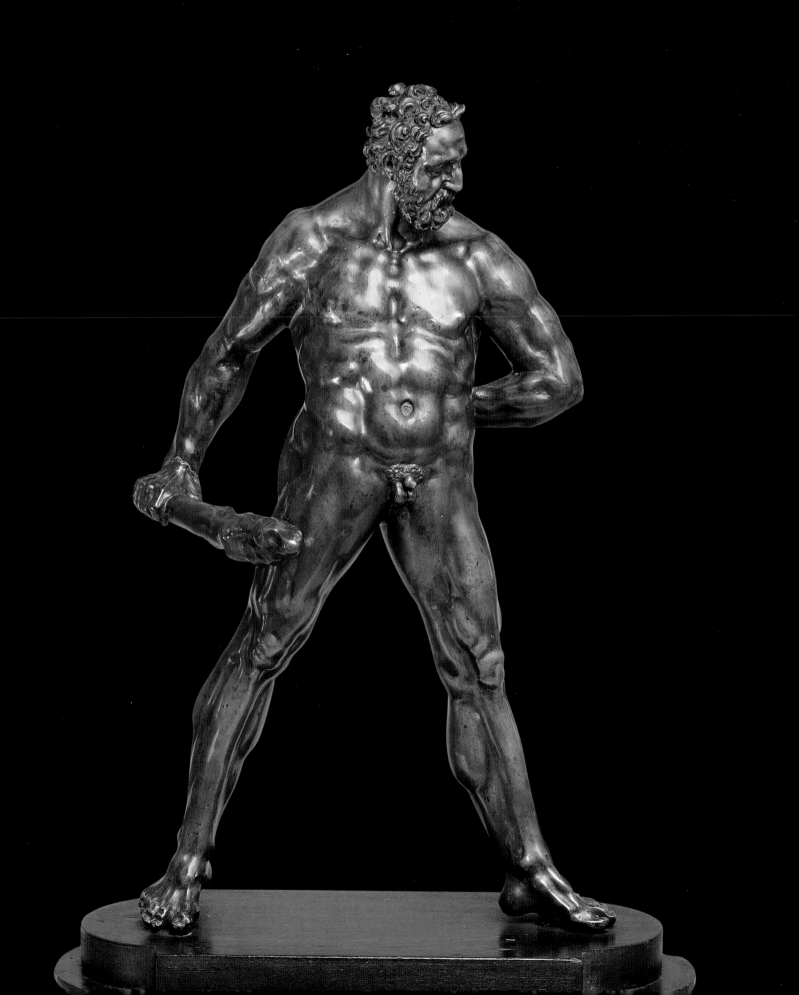

104

Willem Danielsz. van Tetrode
(c. 1525–1580)

Hercules Pomarius

1562–67
Bronze, height 39.9 cm

Abbott-Guggenheim Collection

105

Ponce Jacquiot (active 1553–1570)

**Venus (?) Extracting a Thorn
from Her Foot**

c. 1560–70
Bronze, 25.3 × 23.5 × 12.5 cm

Victoria and Albert Museum, London

106

Alessandro Vittoria (1525–1608)

Jupiter

c. 1580–85
Bronze, height 72 cm

Musée National de la Renaissance, Château
d'Ecouen

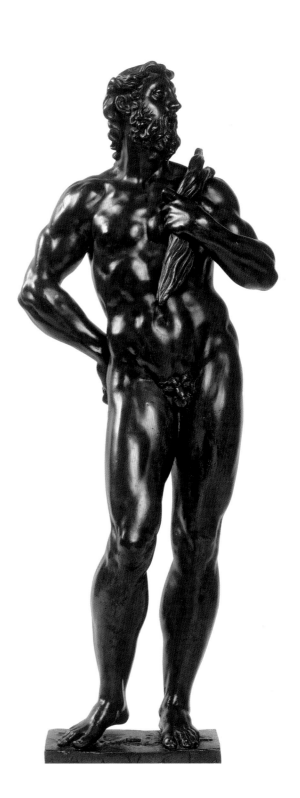

107

Giambologna (1529–1608)

Mercury

After 1580
Bronze, height 72 cm

Museo Nazionale del Bargello, Florence.
Istituti museali della Soprintendenza Speciale
per il Polo Museale Fiorentino

108

Germain Pilon (doc. 1540–1590)

Catherine de' Medici

1580–1600
Bronze, 87 × 58.5 × 30.5 cm

The Royal Collection

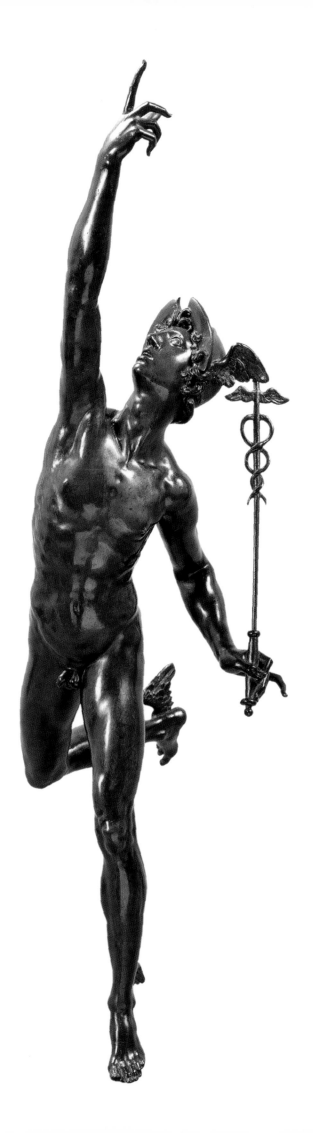

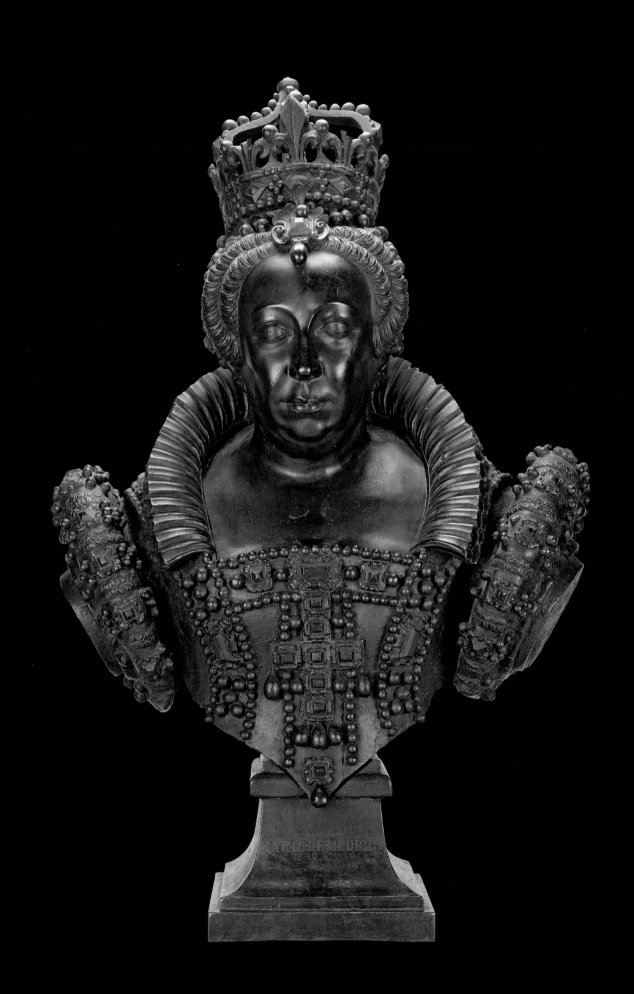

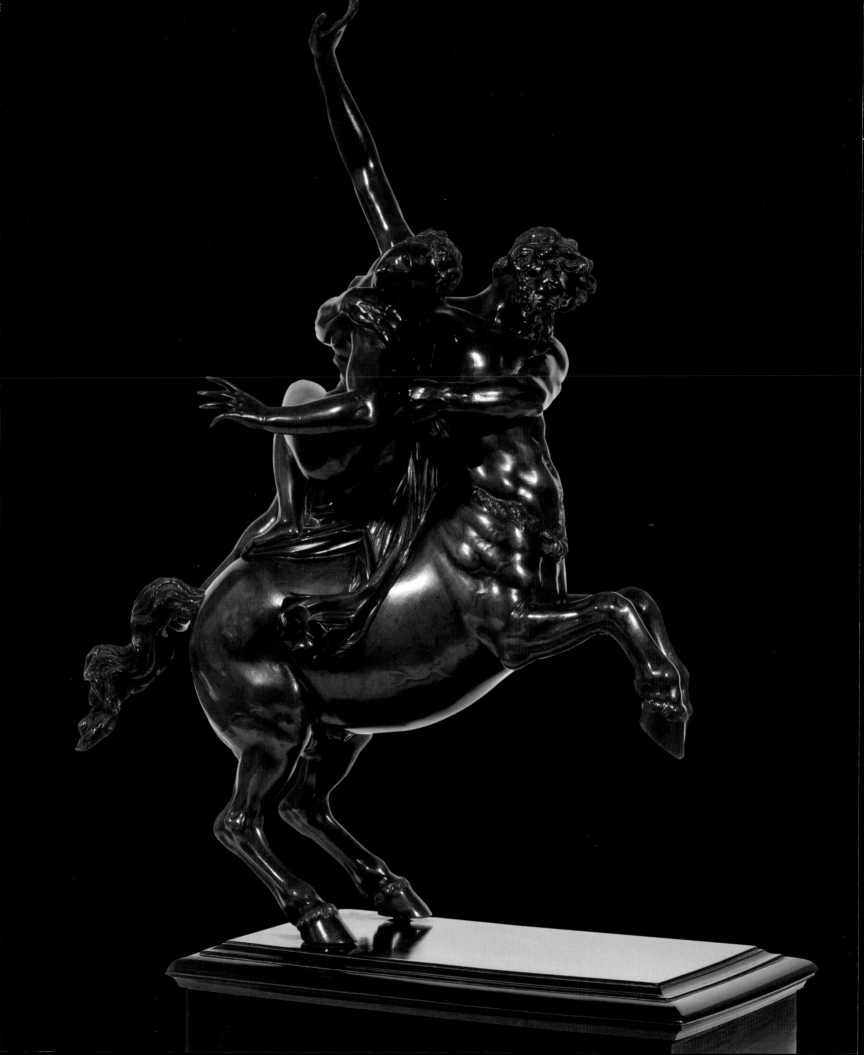

109

Giambologna (1529–1608)

Nessus and Deianira

After 1576
Bronze, height 42.2 cm

Private collection

110

Antonio Susini (1558–1624), after a
model by Giambologna (1529–1608)

Sleeping Nymph with Satyr

Late sixteenth – early
seventeenth centuries
Bronze, height 21.6 cm

The Robert H. Smith Collection

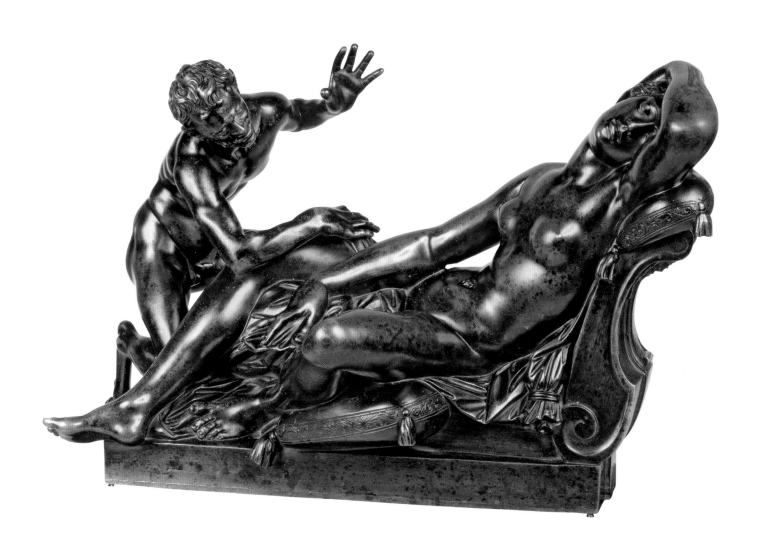

III

Giambologna (1529–1608)
Turkey

c. 1567–70
Bronze, 59 × 47.7 cm

Museo Nazionale del Bargello, Florence.
Istituti museali della Soprintendenza Speciale
per il Polo Museale Fiorentino

II2

Pietro Tacca (1577–1640)
Il Porcellino

1620–33, nineteenth-century base
Bronze, height 125 cm

Musei Civici Fiorentini – Museo Stefano Bardini

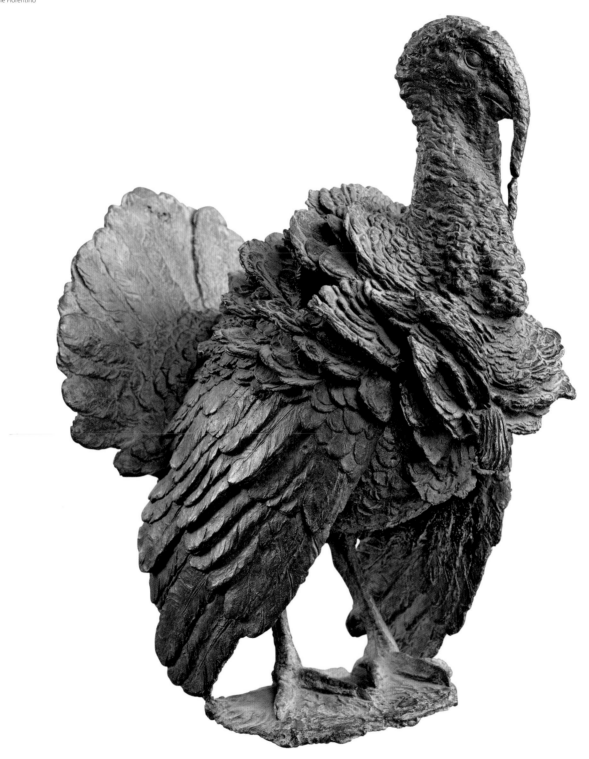

113

Adriaen de Vries (1556–1626)

Forge of Vulcan

1611
Bronze, 47 × 56.5 × 6 cm

Bayerisches Nationalmuseum, Munich

114

Adriaen de Vries (1556–1626)

Seated Christ

1607
Bronze, 149 × 78 × 71 cm

The Princely Collections, Vaduz-Vienna

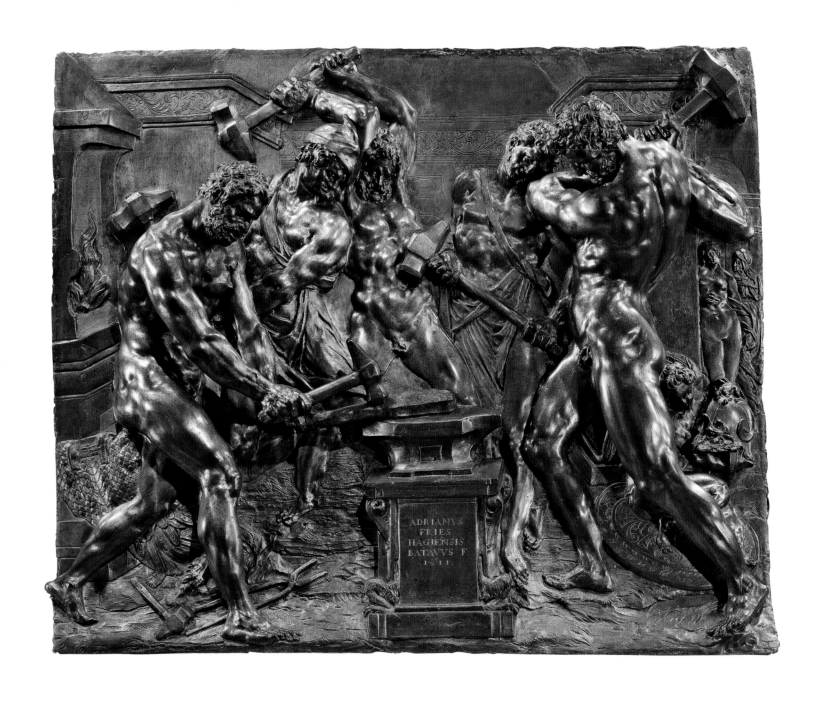

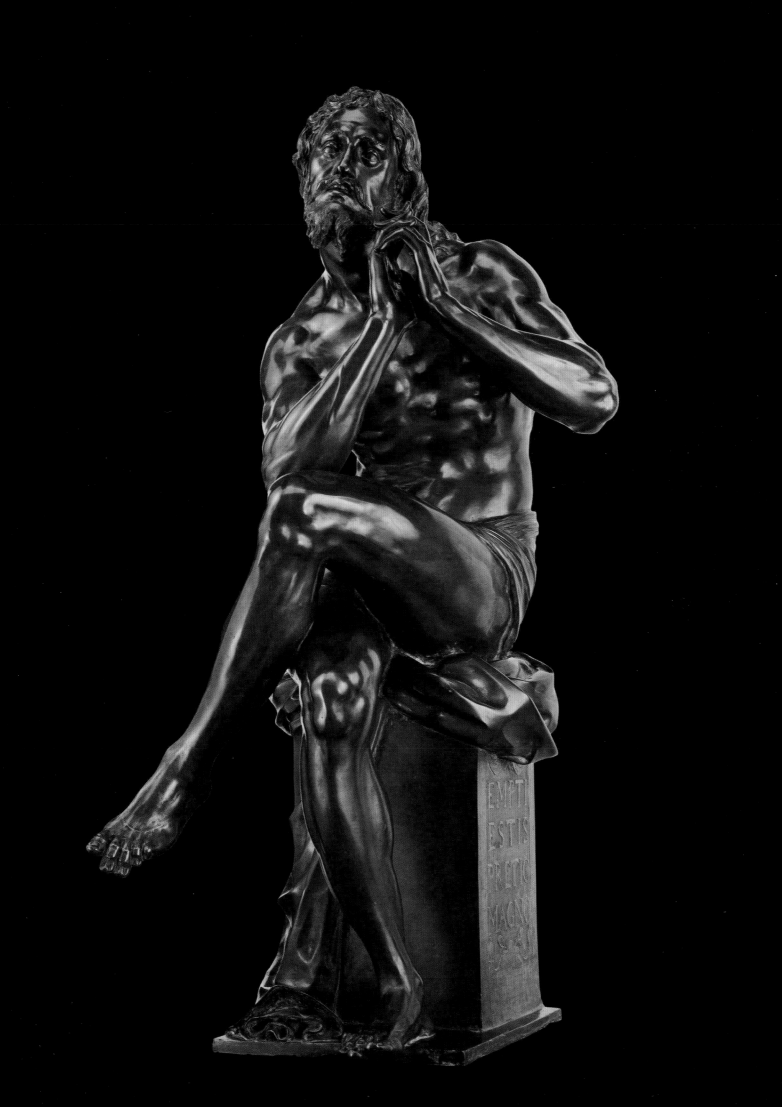

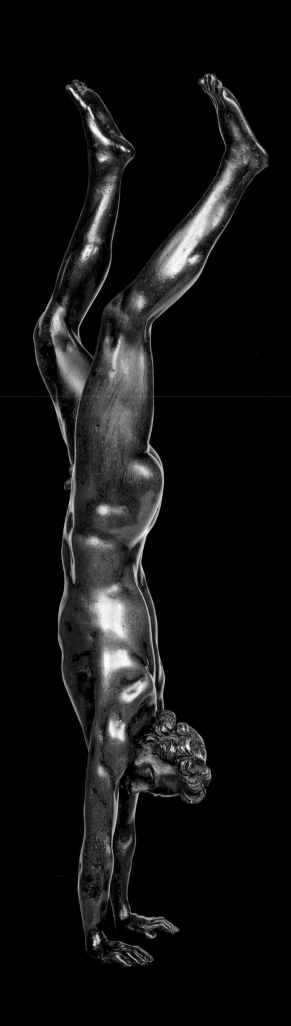

115

Barthélemy Prieur (c. 1536–1611)

**Acrobat Performing
a Handstand**

c. 1600–30
Bronze, height 30 cm

Lent by the Syndics of the Fitzwilliam Museum,
Cambridge

116

Hubert Gerhard (c. 1540/50–1620)

Pug

1600/10
Bronze, 45 × 23 × 65 cm

Museumlandschaft Hessen Kassel, Sammlung
Angewandte Kunst

117.1–2

Antonio Susini (1558–1624), after
models by Giambologna (1529–1608)

**Lion Attacking a Bull
Lion Attacking a Horse**

First quarter of the seventeenth
century
Bronze, 24.1 × 27.9 cm
and 20.3 × 27.3 cm

Private collection

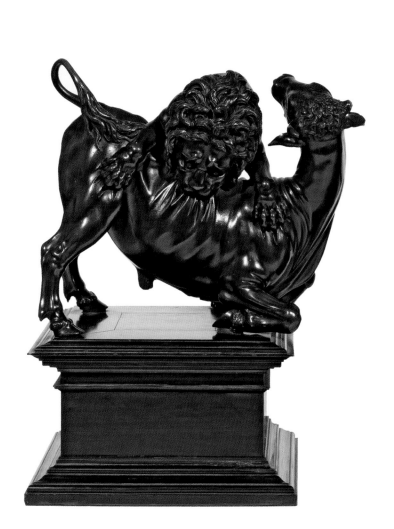

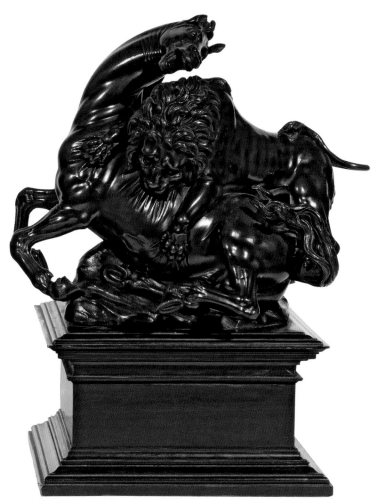

118

Ferdinando Tacca (1619–1686)

Hercules Wrestling with Achelous in the Guise of a Bull

c. 1650
Bronze, 58.4 × 57.2 cm

Private collection, courtesy of Pyms Gallery, London

119

Adriaen de Vries (1556–1626)

Hercules, Nessus and Deianira

1622
Bronze, 128 × 93 × 33 cm

Nationalmuseum, Stockholm

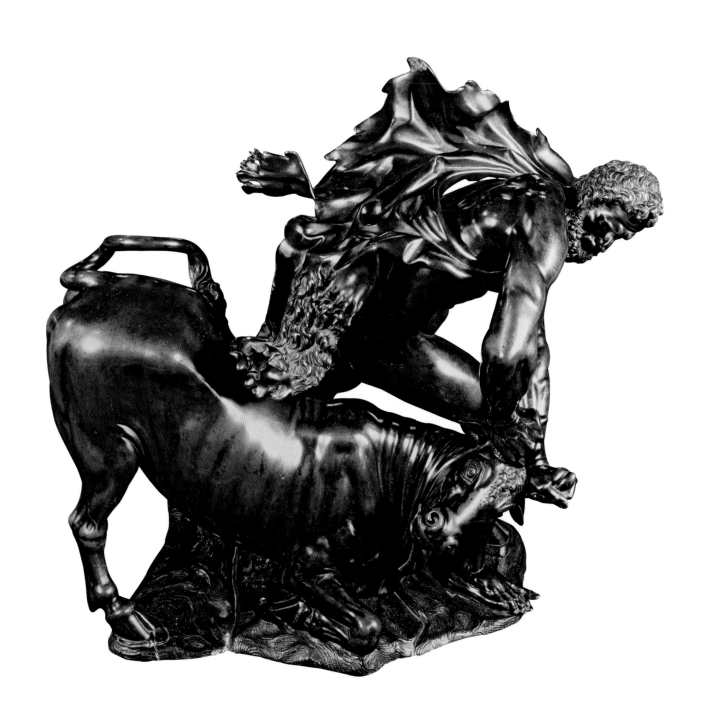

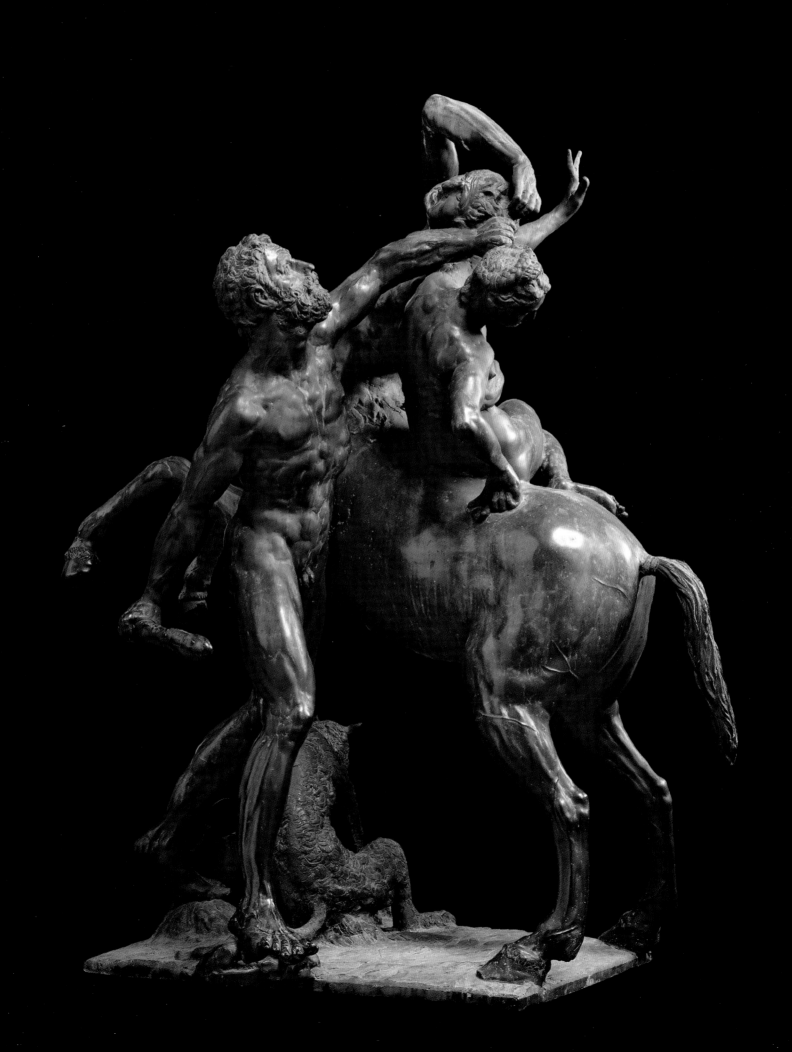

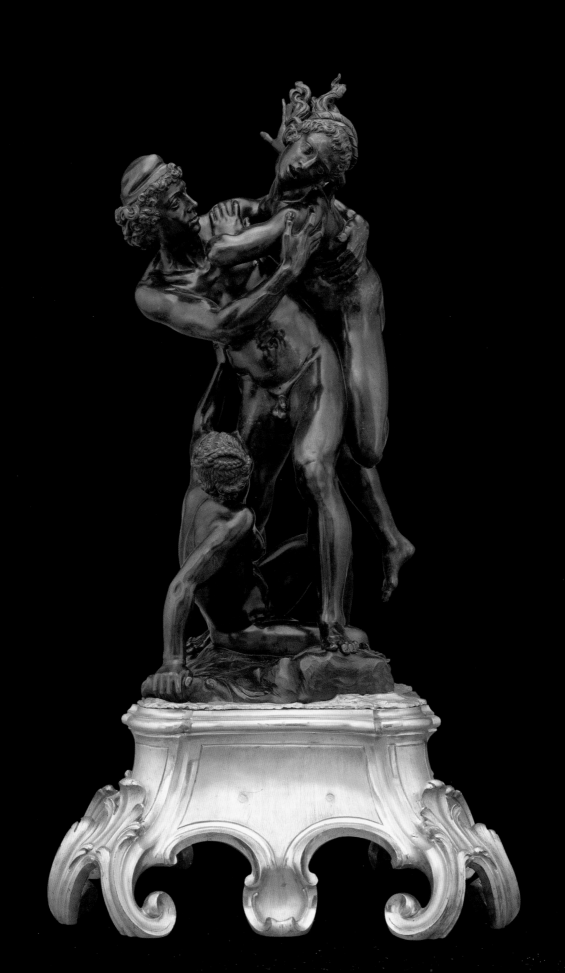

120

Gian Francesco Susini (1585–1653)

**The Abduction of Helen
by Paris**

1627
Bronze, 67.9 × 34.3 × 33.7 cm
(with base)

The J. Paul Getty Museum, Los Angeles

121

Alessandro Algardi (1598–1654),
cast by Domenico Guidi (1625–1701)

**St Michael Overcoming
the Devil**

c. 1647
Bronze, height 83 cm

Museo Civico Medievale, Bologna

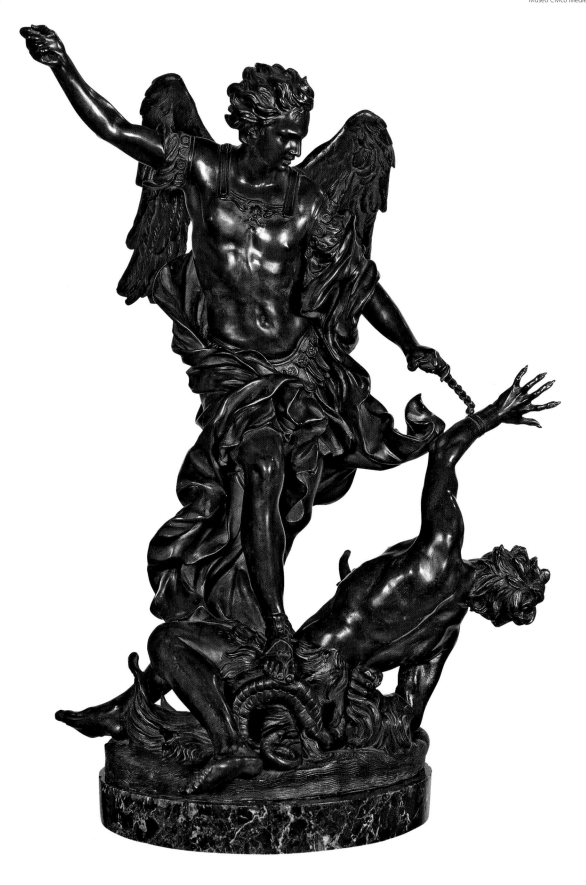

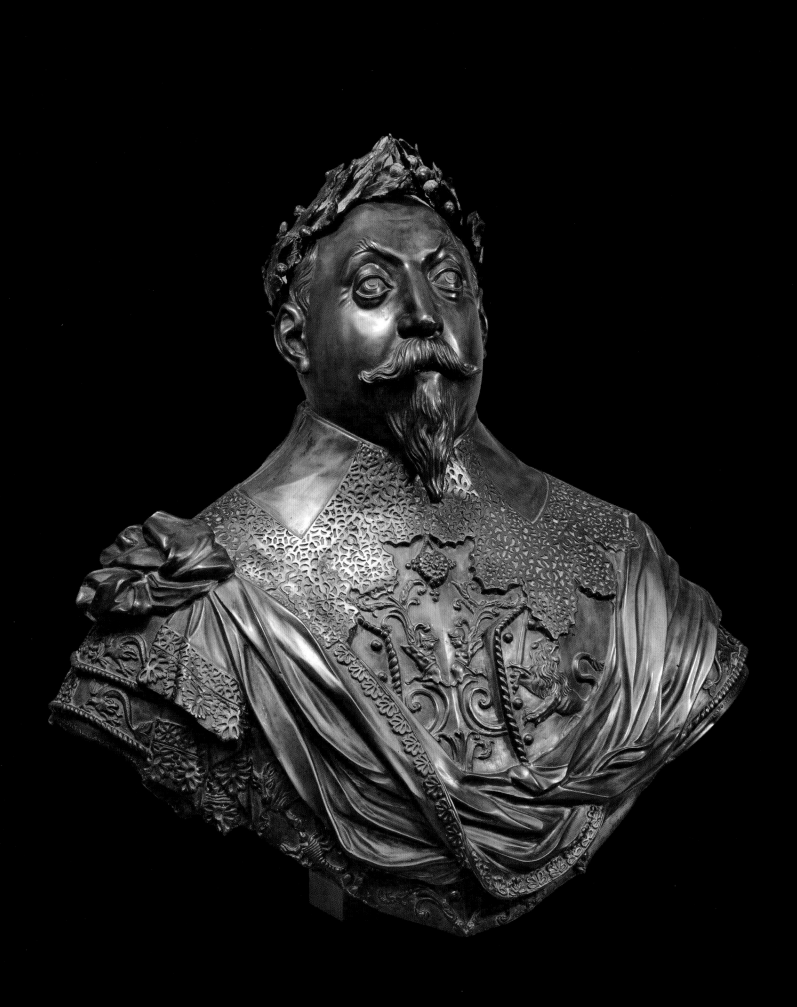

122

Georg Petel (c. 1601/02–1634),
cast by Christoph Neidhardt
(doc. 1639–1646)

**Gustavus Adolphus
of Sweden**

1632, cast 1643
Bronze, 66 × 68 × 45 cm

Nationalmuseum, Stockholm

123

Francesco Fanelli (b. 1577)

Charles I

c. 1635
Bronze, 24.2 × 13 × 7.6 cm

Victoria and Albert Museum, London.
Purchased with the assistance of the Art Fund

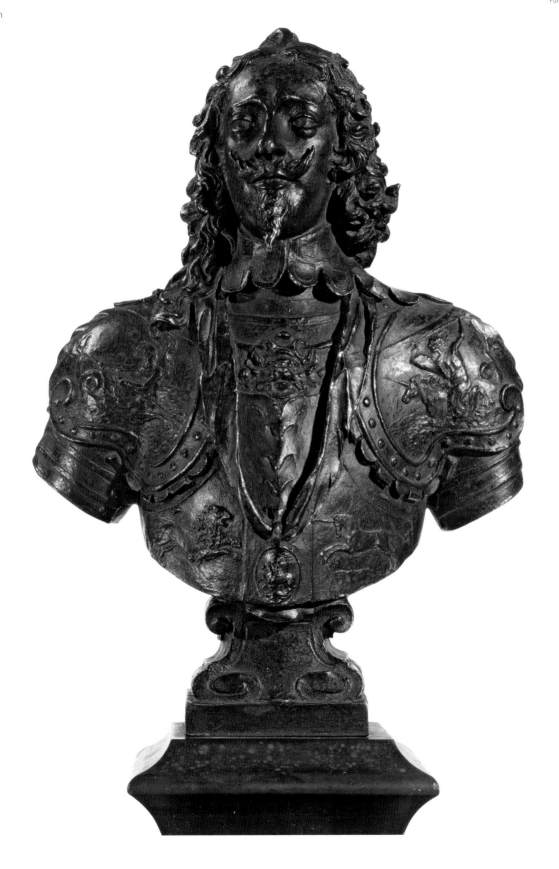

124

François Girardon (1628–1715)

Laocoön and His Sons

c. 1690
Bronze, 233 × 158 × 100 cm

Houghton Hall, Norfolk

125

Nigeria, Benin

**Plaque Showing a Warrior
with Attendants**

Seventeenth century
Brass, height 53.5 cm

National Museum, Lagos. National Commission
for Museums and Monuments, Nigeria

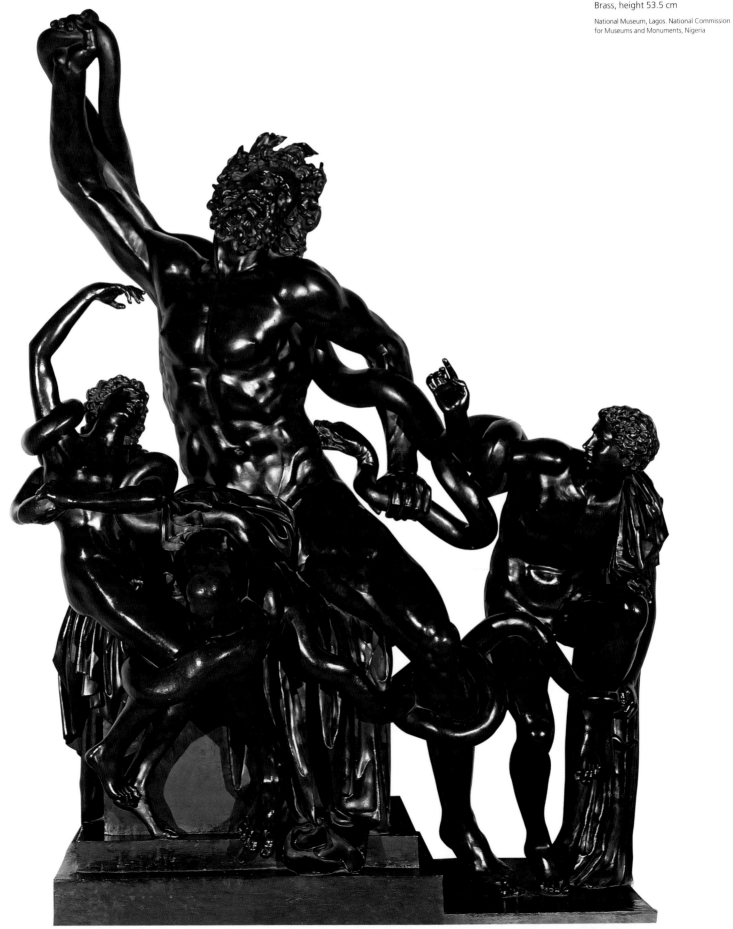

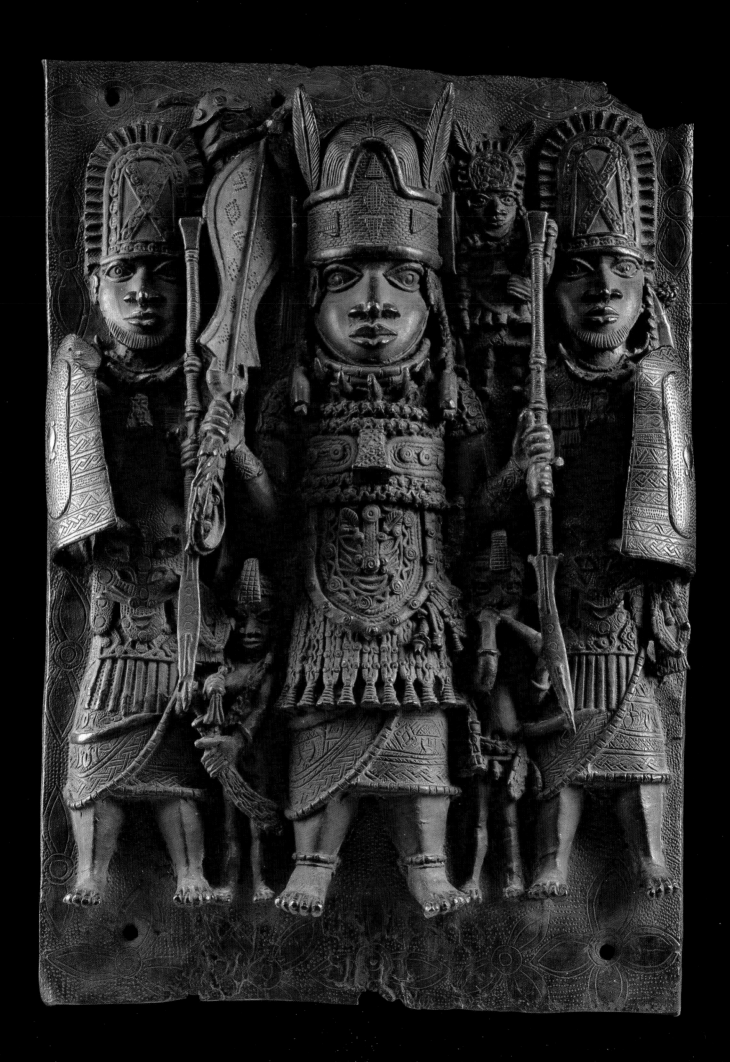

126.1–9

Ghana, Asante

Goldweights

Clockwise from top left
Two Grasshoppers Copulating,
Lens-shaped Weight with Copper
Inserts, Horse-tail Whisk,
A Transaction Involving Goldweights,
Rider on Horse with Decorative
Harness, Nursing Mother, Various
Fruits and Seeds, Sawfish,
Leopard with Antelope

Sixteenth–nineteenth centuries
Brass, various dimensions

Collection Tom Phillips

127

Massimiliano Soldani Benzi
(1656–1740), after Michelangelo
Buonarroti (1475–1564)

Bacchus

1699–1701
Bronze, 198 × 72 × 65 cm

The Princely Collections, Vaduz-Vienna

128

Massimiliano Soldani Benzi
(1656–1740), after Gianlorenzo
Bernini (1598–1680)

Damned Soul

1705–07
Bronze, 39 × 27.5 × 28 cm

The Princely Collections, Vaduz-Vienna

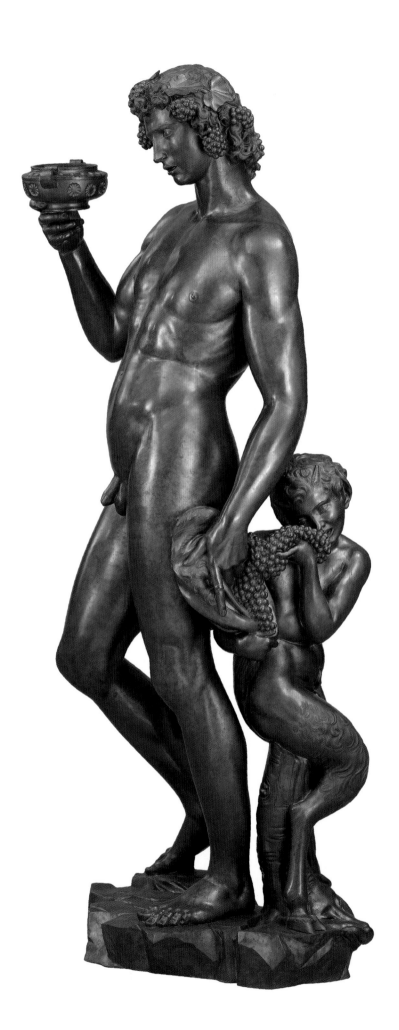

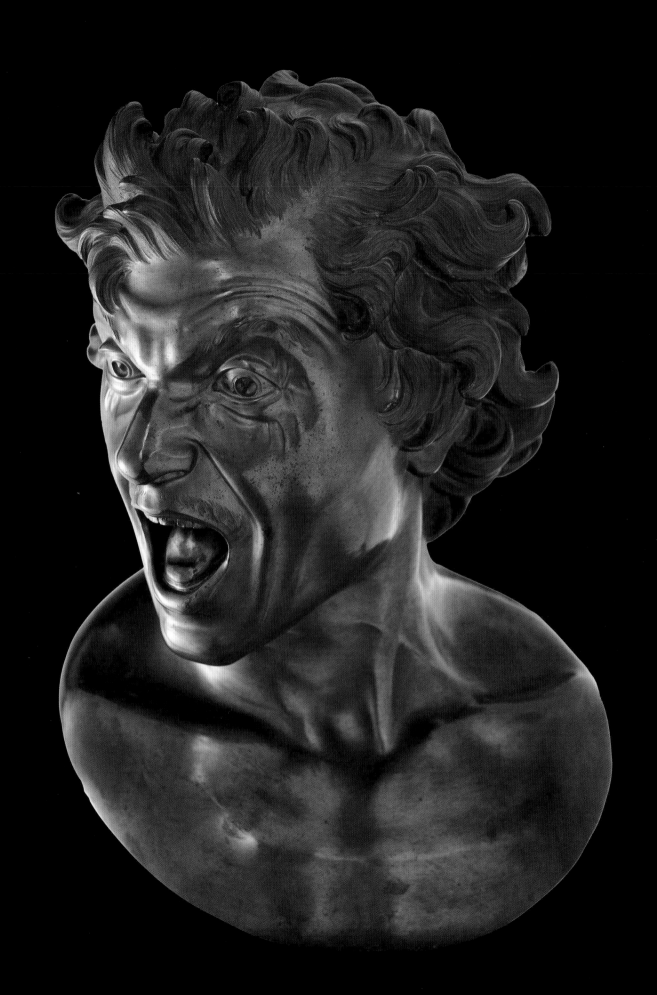

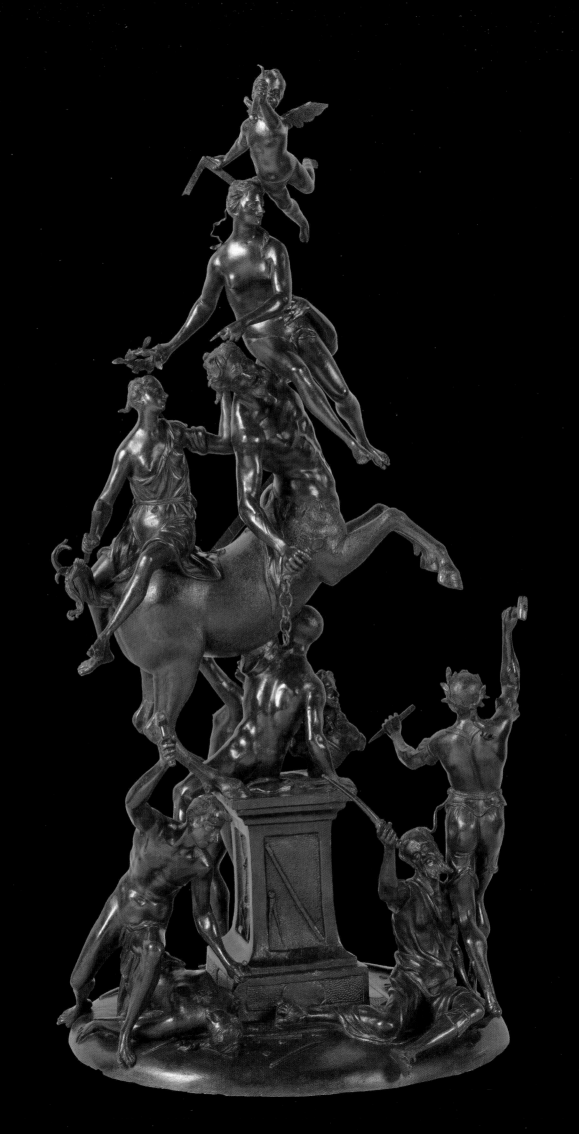

129

Francesco Bertos (1678–1741)

Sculpture, Arithmetic and Architecture

c. 1732–39
Bronze, 107 × 45 × 51 cm

Museo Nacional del Prado, Madrid

130

Anne Seymour Damer (1749–1828)

Mary Berry

1793
Bronze, height 34.3 cm

Lent by the National Portrait Gallery, London

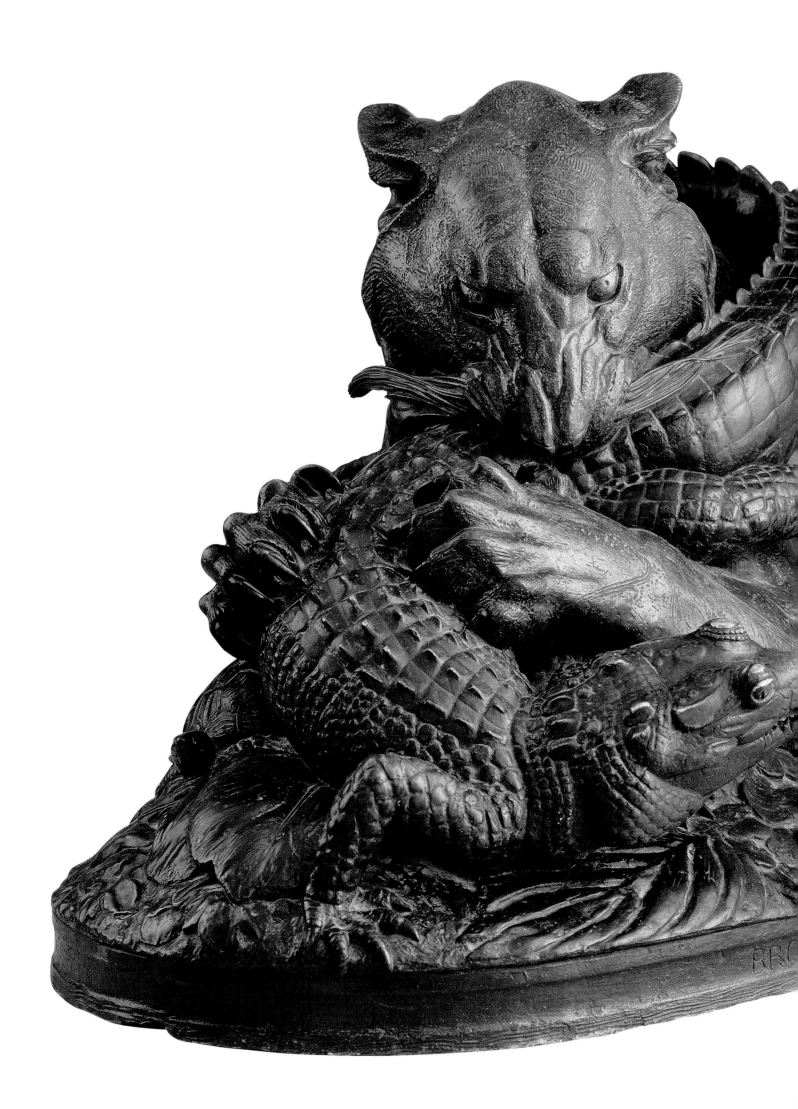

131

Antoine-Louis Barye (1795–1875),
cast by Honoré Gonon (1780–1850)

Tiger Devouring a Gavial

1832
Bronze, 39.7 × 105.6 × 40.5 cm

Musée du Louvre, Paris. Département des
Sculptures

132

Benvenuto Cellini (1500–1571),
cast by Clemente Papi (1802–1875)

Perseus and Medusa

1844
Bronze, height 320 cm

The Italian Gardens at the Trentham Estate

133

Charles-Henri-Joseph Cordier
(1827–1905)

Jewess from Algiers

c. 1862
Onyx, partially gilt, bronze, silvered
bronze, enamel, semi-precious
stones, 93 × 63 × 31 cm

Van Gogh Museum, Amsterdam

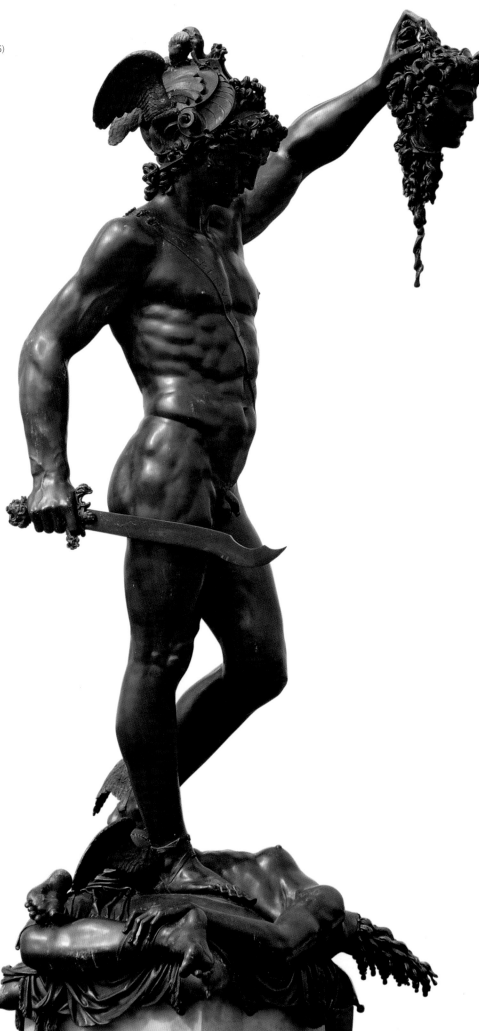

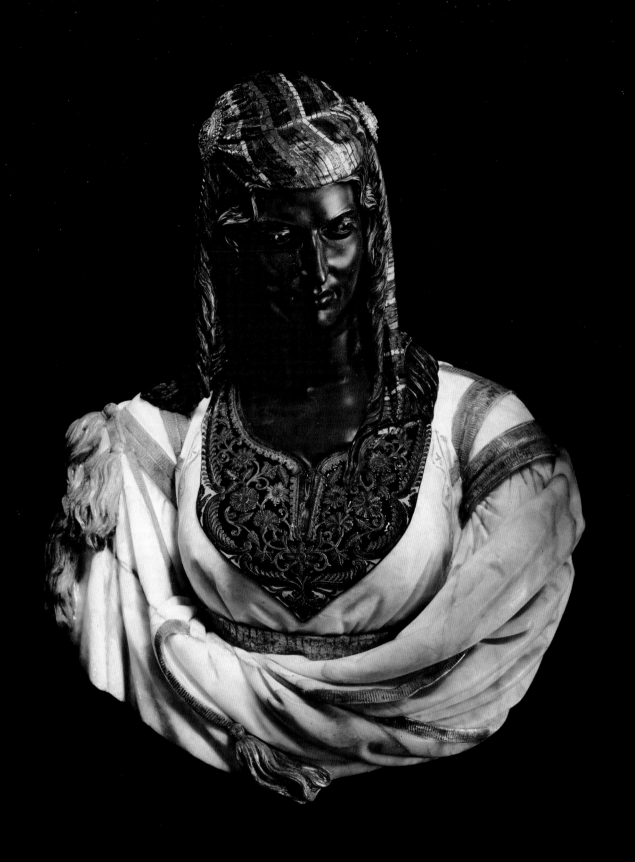

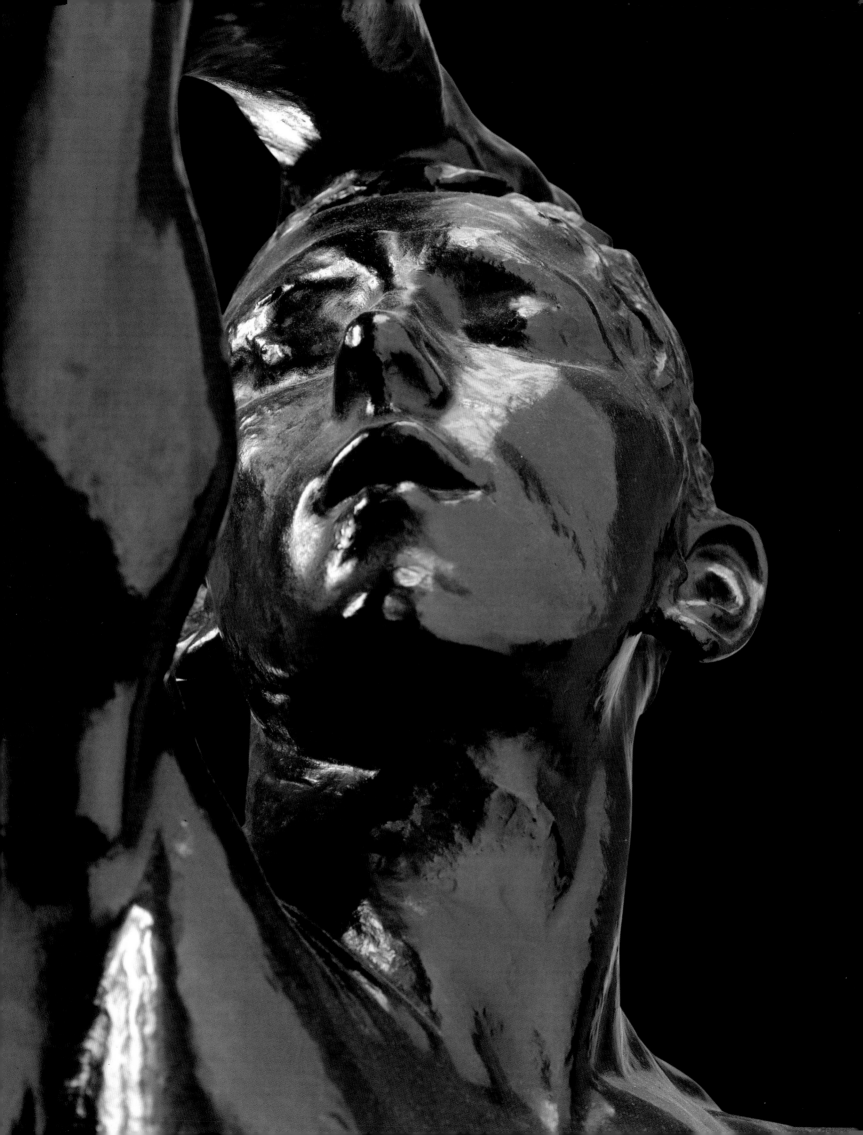

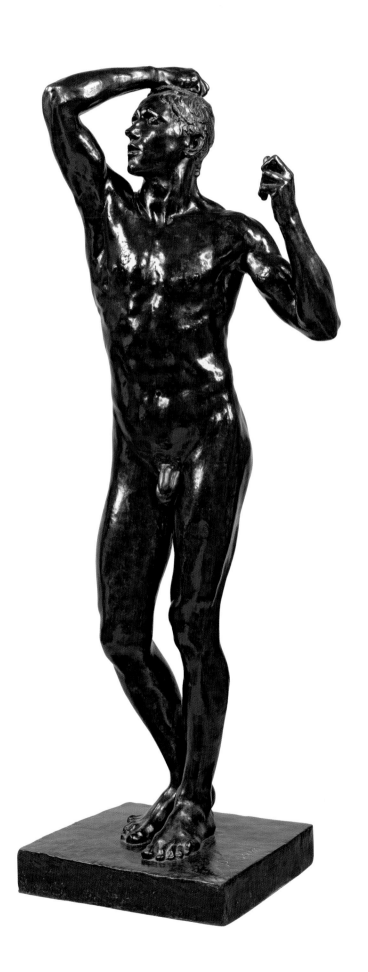

134

Auguste Rodin (1840–1917)

The Age of Bronze

1877
Bronze, 180.3 × 60 × 60 cm

Victoria and Albert Museum, London.
Given by the artist

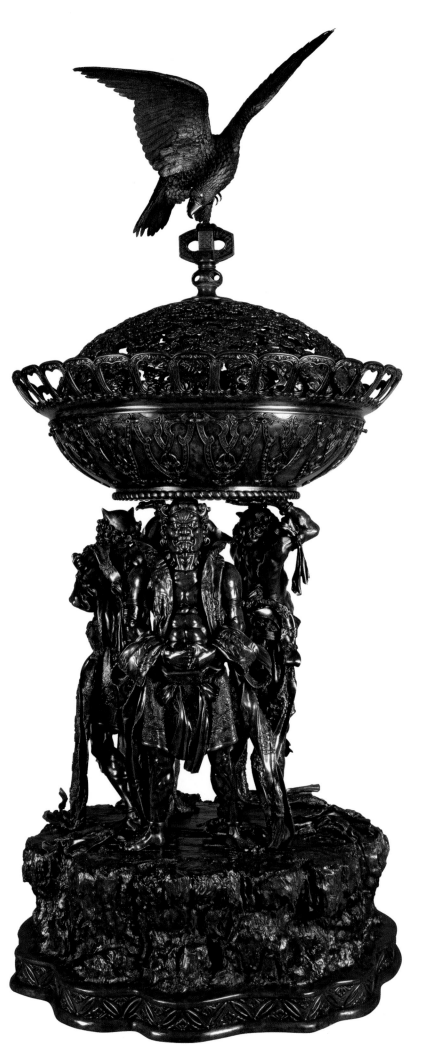

135

Suzuki Chōkichi (1848–1919)

Incense Burner

c. 1880
Bronze, 280 × 130 cm

The Khalili Collections

136

Alfred Gilbert (1854–1934)

St Elizabeth of Hungary

1899
Bronze, ivory, tin inlaid with mother-
of-pearl and semi-precious stones,
height 53.3 cm

Kippen Parish Church, Stirlingshire

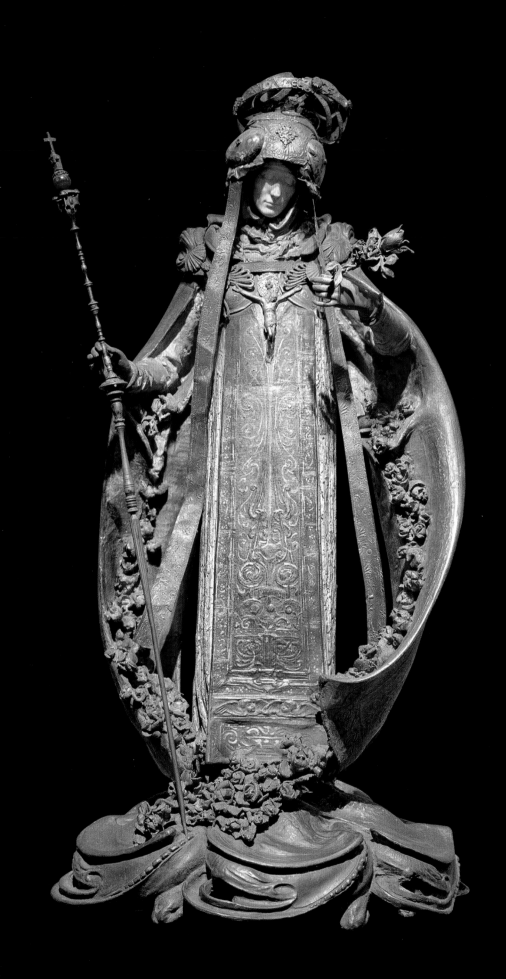

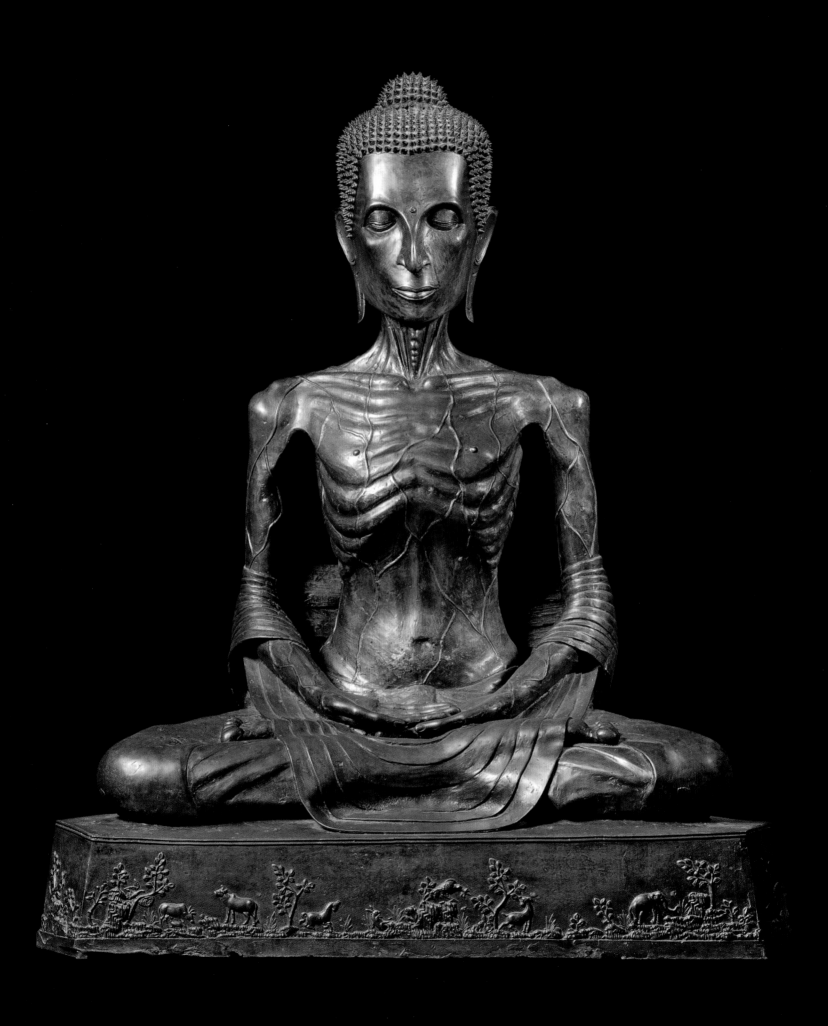

137

Thailand
Emaciated Buddha

c. 1870
Bronze, 89 × 77 × 35 cm

Ger Eenens Collection, Netherlands /
Wereldmuseum, Rotterdam

138

India
Shiva Nataraja

Early twentieth century
Bronze, 196 × 153 cm

Private collection, London

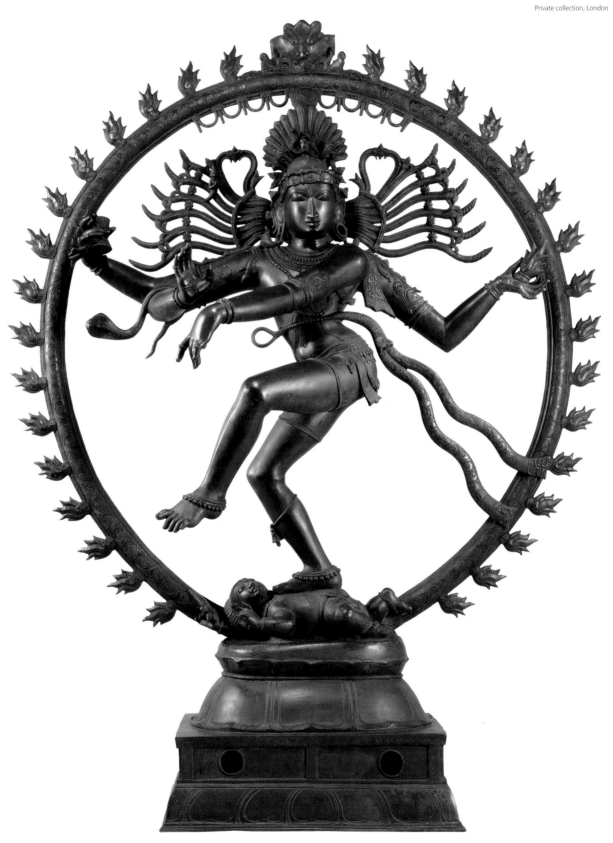

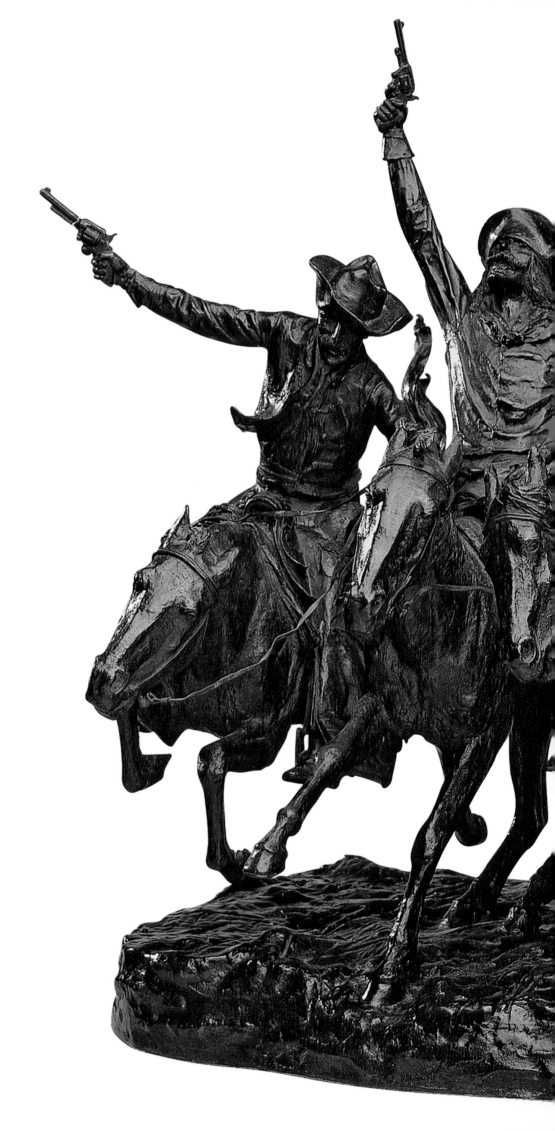

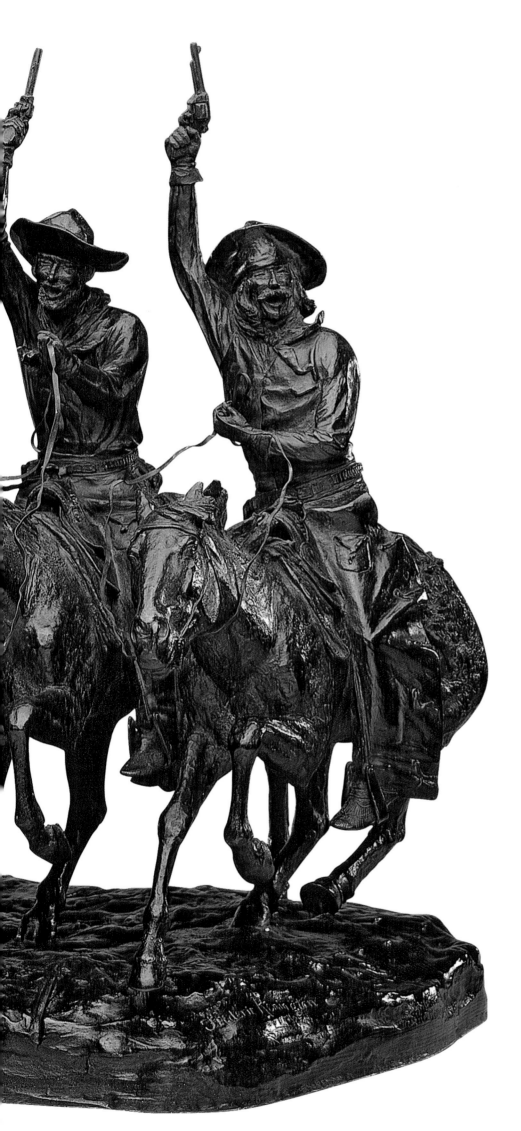

139

Frederic Remington (1861–1909)

Off the Range (Coming through the Rye)

Modelled 1902, cast 1903
Bronze with green patina,
71.8 × 71.1 × 71.1 cm

Corcoran Gallery of Art, Washington DC.
Museum purchase

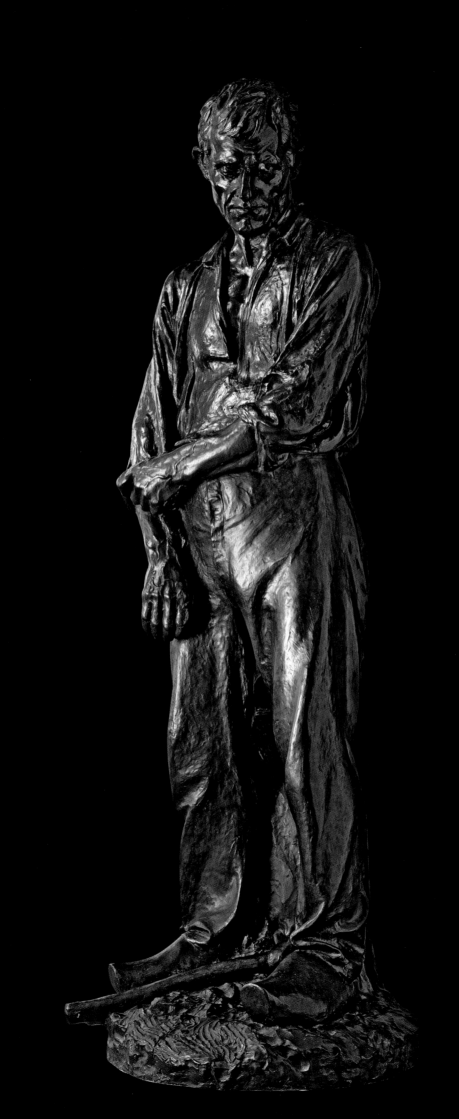

140

Aimé-Jules Dalou (1838–1902)

The Great Peasant

1904
Bronze, 197 × 170 × 68 cm

Musée d'Orsay, Paris

141

Medardo Rosso (1858–1928)

Ecce Puer (Behold the Child)

1906
Bronze, 44 × 37 × 27 cm

Musée d'Orsay, Paris. Gift of Francesco Rosso, 1928

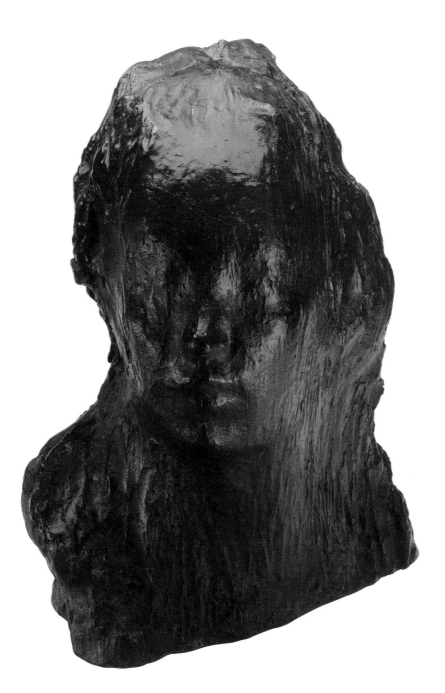

142.1–4

Henri Matisse (1869–1954)

Back I

1908–09
Bronze, 189.9 × 116.8 × 18.4 cm

Tate. Purchased 1955

Back II

1913
Bronze, 189.2 × 120.6 × 19 cm

Tate. Purchased with assistance from the Matisse
Appeal Fund 1956

Back III

1916
Bronze, 188 × 113 × 17.1 cm

Tate. Purchased with assistance from the Matisse
Appeal Fund 1957

Back IV

c. 1931
Bronze, 189.2 × 113 × 15.9 cm

Tate. Purchased with assistance from the Knapping
Fund 1955

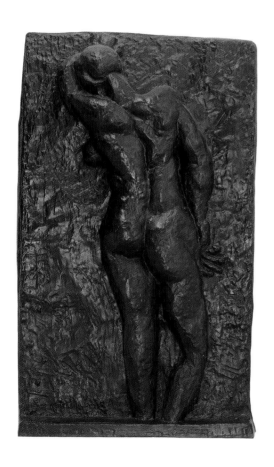
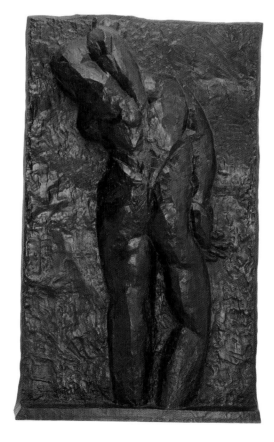
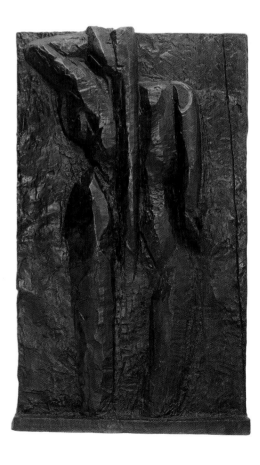

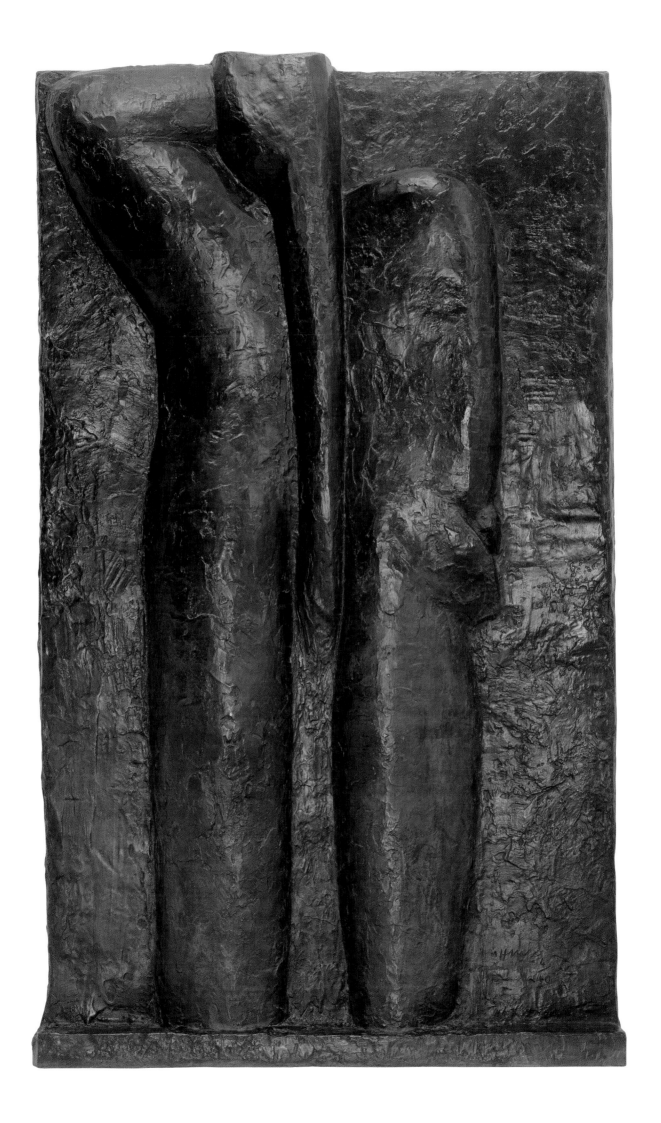

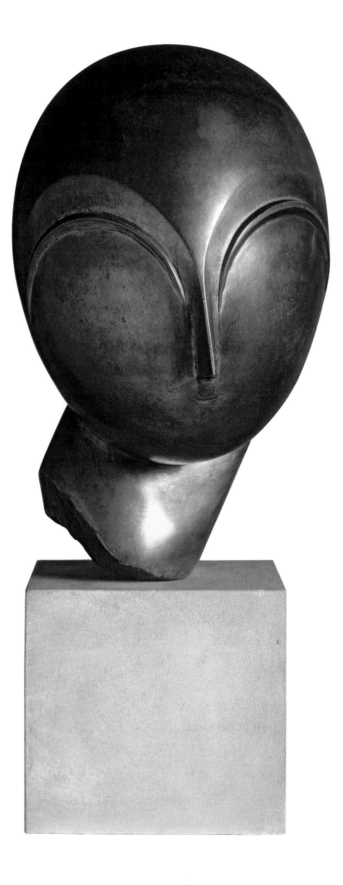

143

Constantin Brancusi (1876–1957)

Danaïde

c. 1918
Bronze on a later limestone base,
28 × 16.5 × 21 cm

Tate. Presented by Sir Charles Clore, 1959

144

Constantin Brancusi (1876–1957)

Maiastra

1911
Polished bronze on stone base,
90.5 × 17.1 × 17.8 cm

Tate. Purchased 1973

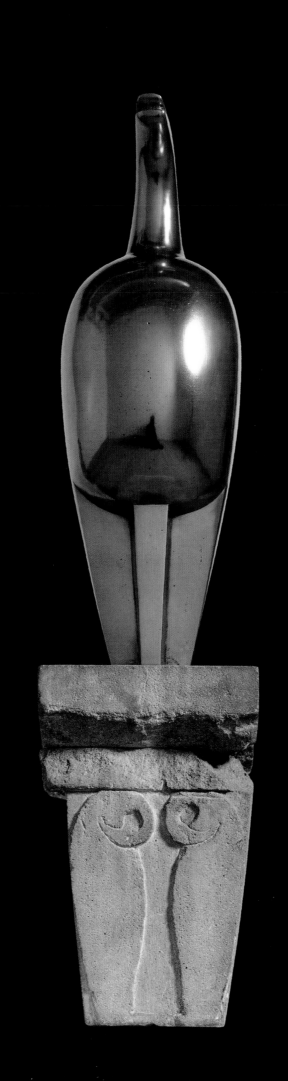

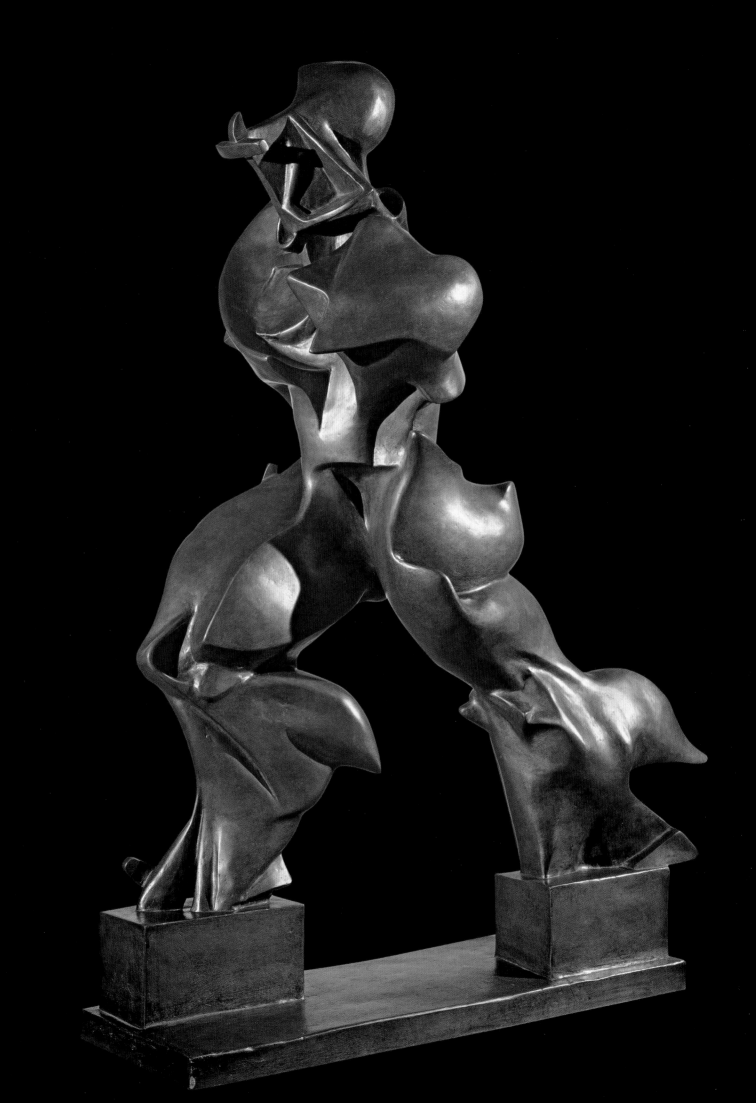

145

Umberto Boccioni (1882–1916)

**Unique Forms of Continuity
in Space**

1913, cast 1972
Bronze, 117.5 × 87.6 × 36.8 cm

Tate. Purchased 1972

146

Pablo Picasso (1881–1973)

Baboon and Young

1951
Bronze, 54.6 × 33.3 × 61 cm

Lent by the Minneapolis Institute of Arts.
Gift of funds from the John Cowles Foundation

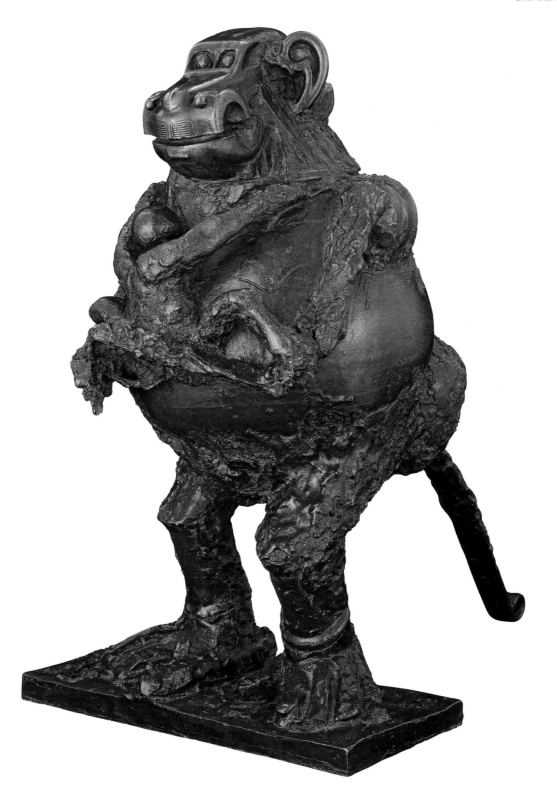

147

Alberto Giacometti (1901–1966)
The Cage (First Version)

1950
Bronze, 90.6 × 36.5 × 38 cm
Private collection

148

Germaine Richier (1904–1959)

Praying Mantis

1946
Bronze, 158 × 56 × 78 cm

Famille Germaine Richier

149

David Smith (1906–1965)

Portrait of a Painter

1954
Bronze, 244.3 × 62.2 × 30.2 cm

Private collection, New York

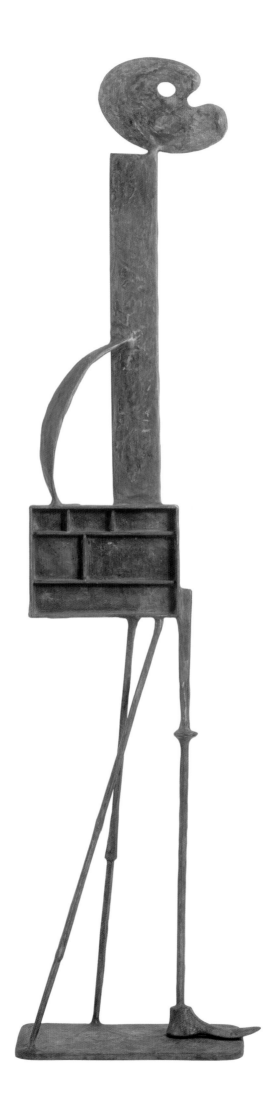

150

Willem de Kooning (1904–1997)
Clam Digger

1972
Bronze, 151.2 × 75.6 × 153.2 cm

Collection of Mr and Mrs J. Tomilson Hill

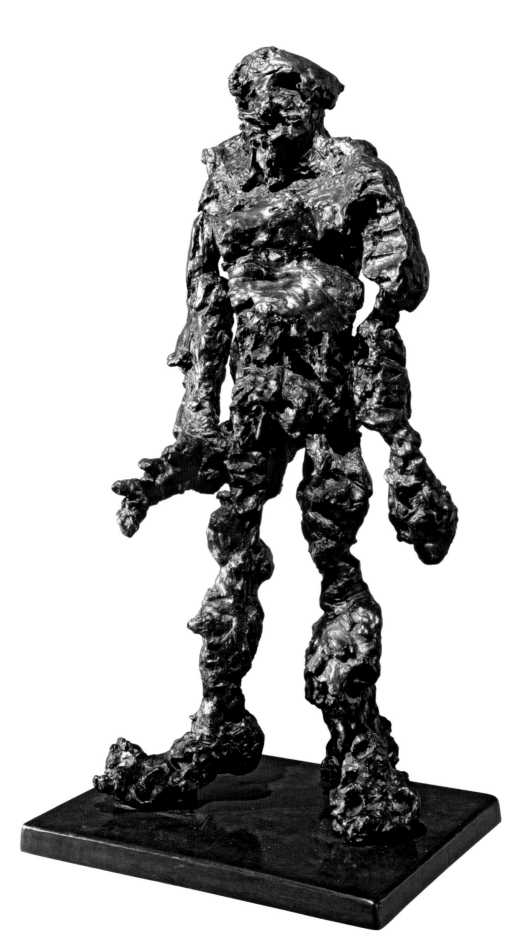

151

Barbara Hepworth (1903–1975)

Curved Form (Trevalgan)

1956
Bronze, 90.2 × 59.7 × 67.3 cm

British Council Collection

152

Henry Moore (1898–1986)

Helmet Head no. 3

1960
Bronze, 36 × 33.5 × 28.5 cm
(including base)

Lent by the Syndics of the Fitzwilliam Museum,
Cambridge

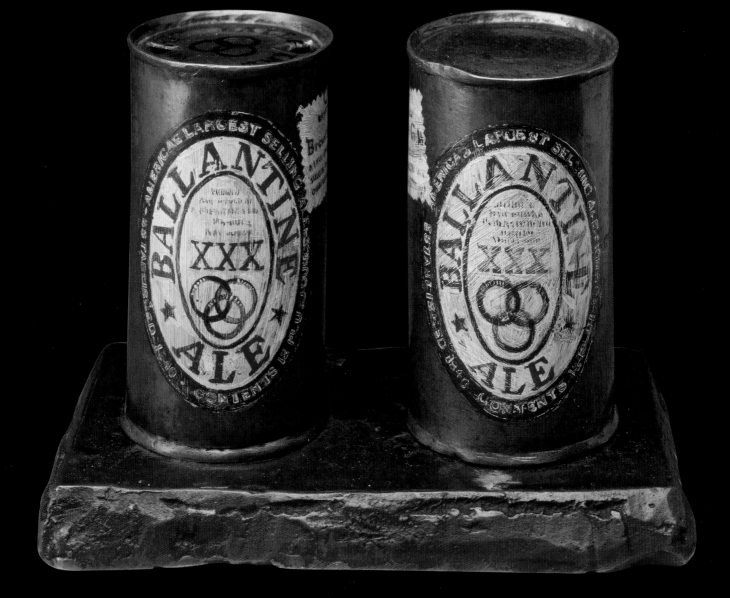

153

Jasper Johns (b. 1930)

Painted Bronze (Ale Cans)

1960
Painted bronze, 14 × 20.3 × 12.1 cm

Museum Ludwig, Cologne. Peter and Irene
Ludwig Foundation

154

Jeff Koons (b. 1955)

Basketball

1985
Bronze, diameter 30 cm

JPMorgan Chase Art Collection

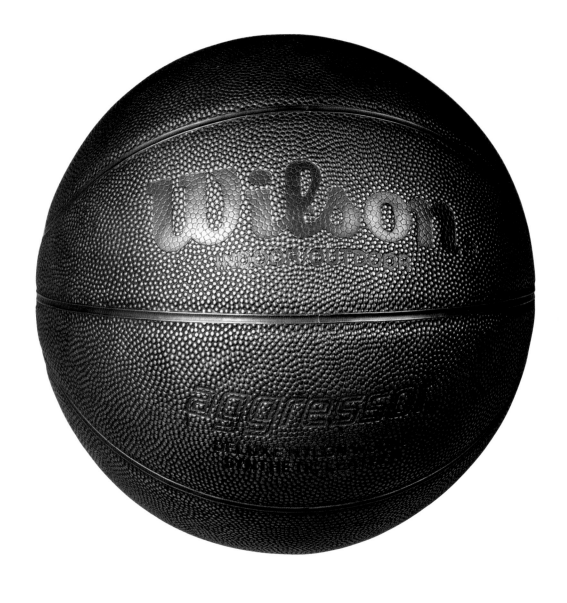

155

Louise Bourgeois (1911–2010)
Spider IV

1996
Bronze, 203.2 × 180.3 × 53.3 cm

The Easton Foundation, courtesy Hauser & Wirth
and Cheim & Read

Richard Deacon (b. 1949)
Bronze Nails

2007
157 bronze nails, each 2 × 28 × 2 cm
Private collection

157

Anish Kapoor (b. 1954)

Untitled

2012
Copper alloy and lacquer,
160 × 160 × 28 cm

Kemal Has Cingillioglu

158

Tony Cragg (b. 1949)

Points of View

2007
Bronze, 107 × 65 × 65 cm

Courtesy Tony Cragg

Catalogue Entries

Authorship is indicated by the following initials:

RC Richard Camber
DE David Ekserdjian
VLV Valeria Li Vigni
ANM Anne Nishimura Morse
MR Maria Reho
CT Cecilia Treves
ST Sebastiano Tusa
EV Eleni Vassilika
AV Agata Villa

—5

ahal Mishmar, Israel

ceptre, Crown, Mace ead, Cornet, Vulture candard

halcolithic period, c. 3700 BCE
opper alloy, height 31.3 cm,
eight 9 cm; 11 × 14.3 cm,
eight 13.3 cm, height 4.8 cm

ael Antiquities Authority. Exhibited at the Israel
useum, Jerusalem, IAA 1961-68, IAA 1961-175,
A 1961-119, IAA 1961-167, IAA 1961-151

LECTED REFERENCES: Bar-Adon 1980;
oorey 1988

hese five pieces belong to the Nahal Mishmar hoard, cache of no fewer than 416 copper and copper alloy rtefacts found in March 1961 in a cave in the Judean esert near the Dead Sea. Some of the items were still rapped in a reed mat, and Carbon-14 analysis of this dicates a date of about 3700 BCE. The types of some of ne objects relate to other survivals from the Chalcolithic eriod, but the majority are unparalleled in design and ppearance, and the finest of them are hauntingly eautiful works of art. As if this were not exciting nough, they were made using the lost-wax technique, ne earliest attested use of this technology. The exact unctions and purposes of the various classes of object re in the main uncertain, so the names given to them are the nature of intelligent guesses. The principal ecorative vocabulary consistently involves more and less tylised animals (such as the paired ibexes on the mace ead) and birds (on the cornet, the crown and the vulture candard). DE

)

Mesopotamia, Second Dynasty of agash, reign of King Gudea

oundation Peg with a ull and Sprouting Plants

2090 BCE
opper alloy, 19.4 × 12 cm

n loan from the British Museum, London,
974,0119.1

LECTED REFERENCES: Collon 1995, pp. 82–83,
g. 63; New York 2003, p. 442, no. 315

his peg is one of a considerable number to have survived rom ancient Mesopotamia, precisely because they were uried as 'foundation deposits' under the corners of emples, and therefore remained hidden until they were ediscovered in modern times by archaeologists. It was ne of the duties of Mesopotamian kings to build or epair temples, and the Sumerian inscription in cuneiform n the present example reveals the fact that it ommemorates the refurbishment of the temple of the oddess Nanshe at Sirara (modern-day Zerghul in outhern Iraq) by the Sumerian ruler of Lagash, Gudea. he precise association between Nanshe and the bull epresented here remains a mystery, but what is not in oubt is the extraordinary, timeless realism with which he beast, who is flanked by three sprouting plants to ither side and appears to be nibbling at a seventh in ront of it, has been observed. The short horns that enote the animal's calfhood and the wrinkled, jowly eck almost conspire to convince one that this is an ffectionate portrait of a particular animal. DE

7

Trundholm, Seeland

Chariot of the Sun

Fourteenth century BCE
Bronze and gold leaf,
35 × 60 × 20 cm

The National Museum of Denmark,
Danish Prehistory, Copenhagen, B7703

SELECTED REFERENCES: Sandars 1995,
pp. 283–86, figs 267–69; Copenhagen 1999,
pp. 134–135, no. 175

The *Chariot of the Sun* is one of the rarest of survivals from a world of which we know almost nothing. It was found in a bog at Trundholm, near Nykøbing in Seeland in Denmark, in 1902, long before the analysis of associated pollen might have been employed to assist in its dating, but it is generally agreed to have been manufactured around the fourteenth century BCE. Both the fact that it is a lost-wax cast and the refinement of the surface decoration on the horse and the disc – which is subtly different on each side – underline the work's extraordinary sophistication at this very early date. In all probability the chariot would have been the focus of religious rituals enacted by a shaman or priest before worshippers, in which it was pulled from east to west with the gold or 'sun' side representing day in evidence, and then back from west to east with the 'sunless' or night side on display. It is also to be assumed that the horse was not conceived of as a mere domestic animal, but rather as its divine equivalent riding across the heavens. DE

8

China, Shang dynasty

Axe Head of the type *yue*

Thirteenth century BCE
Bronze, height 35 cm,
width 37.8 cm

Museum für Ostasiatische Kunst, Cologne,
C76,1

SELECTED REFERENCES: Rawson 1987;
Schlombs and Girmond 1995, no. 2, and related
bibliography

This magnificent axe head incorporates in its design a large monster face (*taotie*) flanked on either side by a dragon in profile and repeated on the obverse. Integral to these motifs are protruding eyes and several voids that pierce the thickness of the blade, accentuating the stylised forms of mouths, jaws, horns and tails. Two slots along the straight edge of the axe head, on either side of the tang, secured the blade to a wooden handle. Ritual axe heads of this size are only very rarely found among Shang dynasty burial goods. In tombs of high-ranking individuals, where comparable albeit less refined examples have been excavated, there is evidence of human sacrifice, which suggests that such pieces were not merely emblematic of the deceased's status but were used to carry out ritual killings as part of the burial ceremony. CT

9

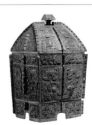

China, Shang dynasty

Vessel of the type *fang yi*

Twelfth century BCE
Bronze, 27 × 17 × 14 cm

On loan from the British Museum, London.
Bequeathed by Brenda Zara Seligman,
OA 1973,0726.1

SELECTED REFERENCES: Rawson and Bunker
1990; Rawson 1992, fig. 32, and related
bibliography

Strong form and bold decoration are combined in this covered vessel, which is usually described as a wine container. Bronze ritual-vessel shapes tended to be derived from ceramic counterparts. Box-like in shape, this is an angular version of a covered ceramic jar. Both lid and body feature face-mask designs (*taotie*). Bristling vertical flanges along the edges and down the centre of each side isolate the vessel's compartments. Within each division, spirals (*leiwen*) of abstract uniformity create a low-relief background out of which fantastical creatures stare. The significance of the *taotie* remains a subject of debate. There is no evidence to confirm whether the *taotie* was part of a contemporary religious iconography during the Shang period; nevertheless the use of the motif is ubiquitous and its many permutations enabled it to inhabit a great variety of differently shaped surfaces. The crisp articulation of this vessel's design and its pale greenish tonality, reminiscent of jade, lend it a particularly refined quality. CT

10

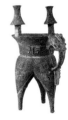

China, Shang dynasty

Vessel of the type *jia*

Thirteenth century BCE
Bronze, 39.5 × 24 cm,
diameter 19.8 cm

Museum für Ostasiatische Kunst,
Cologne, C76,2

SELECTED REFERENCES: Schlombs and
Girmond 1995, no. 3, and related bibliography

Bronze ritual vessels – food, alcohol and water containers for offerings to the ancestors – were used in family ceremonies and were also buried in tombs, their number, size and decoration indicators of status. The tri-lobed vessel shape seen here echoes ceramic prototypes of the Neolithic period (see fig. 38). In this impressive example of the type known as *jia*, subtle variations in ornamentation are achieved by altering the density of the intaglio patterns on the surface of the bronze. This strengthens the legibility of the *taotie* monster faces and the vessel's more sculptural elements, such as the splendid handle. The latter consists of an animal head with protruding eyes and horns from whose fanged, gaping mouth escapes the tail of a snake or dragon-like creature. The decoration is accentuated further by the application of a black pigment to give added contrast to recessed lines, enhancing the even patination. Two capped posts that stem from the lip may have served for lifting the vessel from the fire that heated its contents. The superb quality of the casting is evident in the seamless joins from the mould sections and the complexity of design that has been achieved. CT

11

China, Shang dynasty

Vessel of the type *zun* in the form of an Elephant

c. 1100–1050 BCE
Bronze, 64 × 96 × 34 cm

Musée Guimet, Paris, EO 1545

SELECTED REFERENCES: Bagley 1987, fig.184

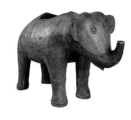

In form and decoration this sculptural bronze vessel differs from those made in central China. In a spirit of regional autonomy distinct from the conventions of the Shang capital Anyang in Henan, the maker has given it the form of a real four-legged animal, its shape and ornamentation characteristic of examples that originate in southern China, where other quadrupeds such as rams, buffaloes, boars and rhinos were also cast. It has been assumed that these animal-shaped vessels, like the more standardised containers of the Shang, were intended to hold particular types of food and drink. This vessel, often designated with the generic term *zun*, was a container for wine and would once have been filled from the opening on the elephant's back (the lid is now missing, the spout truncated). An unusually large piece, this bronze is an impressive example of the creativity of zoomorphic casting in southern China. CT

12

China, late Shang or early Zhou dynasties

Vessel of the type *gui*

Eleventh century BCE
Bronze, height 13.5 cm, width 28.5 cm (including handles)

Lent by the Syndics of the Fitzwilliam Museum, Cambridge, O.3-1941

SELECTED REFERENCES: Bagley 1987, fig. 102.3, and related bibliography

Vessels are the most prevalent of ancient Chinese bronzes to have been found by archaeologists. They take diverse forms, depending on their various sacrificial functions, from storage to cooking and serving. This wide-mouthed container for food, known as a *gui*, is a fine example of a typical shape made during the Shang and Zhou dynasties. Smaller than average but highly sculptural, the bowl stands on a foot-ring. Each of its handles carries an animal form with upright horns, a snout and an openwork tail projecting from its profile with a baroque flourish. The 'S'-curved profile of the *gui* is accentuated by flanges on the central axes – interrupted by a small three-dimensional animal head – that emphasise the division of the design into quarters. The handles were cast on; the decoration on the main and upper registers continues uninterrupted beneath. The proportionately large handles, of a type that flourished after the end of the Shang, distinguish this vessel as belonging to a later tradition. CT

13

China, Shang dynasty

Vessel of the type *you* in the form of a Double Owl

Twelfth–eleventh centuries BCE
Bronze, height 16.7 cm, width 13.5 cm

Lent by the Syndics of the Fitzwilliam Museum, Cambridge, O.186-1946

SELECTED REFERENCES: Bagley 1987, figs 63.3 and 152, and related bibliography

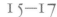

The appealing form of this unusual double-owl-shaped vessel vividly expresses the bird's characteristics: hooked beak, compact winged body, and feathered and clawed legs (such realistic talons are rarely seen on this vessel type). The owls' heads form the lid. Just below the rim, where their two bodies are conjoined, another smaller head – perhaps that of a ram – is repeated on either side. On some *you* a handle springs from these points; this unconventional piece, however, shows no evidence of having had one. The faceted knob of the vessel's cover is decorated with *leiwen*, their spiral patterns enveloping much of the rest of the bronze. The mottled variations in patina are not deliberate artistic effects but rather accidental changes that have taken place over the centuries, as moisture and other environmental factors have affected the copper content of the bronze. CT

14

China, early Western Zhou dynasty

Vessel of the type *gui*, known as the *Bo Ju gui*

Eleventh–tenth centuries BCE
Bronze, 23.7 × 30.5 × 20 cm

Private collection

SELECTED REFERENCES: Chen Mengjia 1977, A207; Rawson 1990, fig.37, and related bibliography

'Bo Ju made this precious offering vessel' reads the inscription that appears inside the basin and gives this highly prized *gui* its name. Bo Ju is named on a number of other bronzes; this is the most striking. Some of these others are recorded in the catalogue of the collection formed by the Qianlong Emperor in the eighteenth century. The practice of inscribing vessels was developed by the Zhou and served as a legacy of their owners' achievements, both for their ancestors and for their descendants. Forms were also elaborated to produce variant shapes. Here the base serves to anchor the vessel, a characteristic of examples from the Zhou period. The rounded body of the *gui* contrasts markedly with the integral box-like base, which is hollow. A particularly impressive piece, with many highly distinctive features – not least the animal faces with heart-shaped horns mirrored on each corner of the base – this *gui* carries a design whose fantastical creatures appear to burst beyond the confines of the vessel's form. Documented by a Qing scholar in the nineteenth century, this archaic bronze is distinguished by its exceptional pedigree and design. CT

15–17

Luristan

Standard-finial, Axe Head, Bridle-bit with Cheek-pieces

Ninth–eighth centuries BCE
Copper alloy, 18 × 11 cm, 22 × 9.5 cm, 10 × 15 cm

On loan from the British Museum, London. Cat. 15 donated by Louis Clark, 1934,1108.1 (123541), 1930,0718.2 (122915), 1920,0511.1 (123276)

SELECTED REFERENCES: Moorey 1974, p.30, plate IX; Curtis 2000, pp.28–33

Luristan bronzes, so called after the region of Iran from which the majority of them seem to originate, are not only highly distinctive in appearance but also exceptionally numerous (the British Museum possesses some 175). They are approximately datable by comparison with related artefacts from Assyria and the Greek island of Samos, yet surprisingly little is known about the civilisation that produced them. The majority have been plundered from ancient cemeteries without attention to their archaeological context, but it seems clear that the nomads who created them were accomplished horsemen, and some of the most representative items are bridle-bits with cheek-pieces in the form of fantastical animals, in the present instance with human heads. The so-called standard-finials, which are presumed to have had some religious significance, conceivably in household shrines, are arguably even more impressive: they customarily comprise symmetrically disposed animals, in the present case lions attacking goats. The third piece shown here is an axe whose butt is in the form of stylised animal heads. DE

18

Sardinia, Nuragic period

Capotribù (Tribal Chief)

Eighth–fourth centuries BCE
Bronze, 39 × 20 × 23 cm

Museo Archeologico Nazionale di Cagliari, 10867

SELECTED REFERENCES: Lilliu 1966, pp.50–53, no.7, figs 18–20; Lilliu 1984, p.186, fig.221

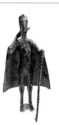

This superb statuette is without question the finest example, as well as the largest, of the sculptural tradition that has come to be associated with the Sardinian *nuraghi* (literally 'heaps of stones with internal cavity'), the island's unique tower-like structures dating from the Bronze Age. The authority of the man's pose, not to mention the knobbly staff of office in his left hand, the huge dirk slung over his right shoulder, and the smaller dagger at his breast, all suggest that the traditional identification of such standing figures as tribal chiefs – or alternatively shepherd kings – is by no means unreasonable. In his pioneering *Geschichte der Kunst des Altertums* of 1764, Johann Joachim Winckelmann perhaps predictably described four related bronzes he had studied in the Museo Kirkeriano in Rome (they are now in the Museo Preistorico-Etnografico L. Pigorini there) as 'ganz barbarisch' (totally barbaric), presumably because of their shortcomings as representations of physical reality, whereas to a modern eye what is so enchanting about these votive offerings is their intensely stylised formal purity. DE

9

Egypt, Twenty-sixth Dynasty

Ptah

seventh–sixth centuries BCE
Bronze partly blackened and inlaid with gold and silver,
17.9 × 6.1 × 3.9 cm

The Ashmolean Museum, Oxford,
AN1986.50

SELECTED REFERENCES: Penny 1993, pp.225–26,
plate 199; London 1995, no.1.62;
Whitehouse 2009, p.108

This extremely well-preserved bronze figure of Ptah, god of the city of Memphis and patron of craftsmen, is a masterpiece in miniature. A solid lost-wax cast, the bronze retains the exquisite details that were worked into the wax model. Emerging from the god's tightly wrapped shroud a pair of hands clasp a *was* sceptre, symbol of power, with the head of the mythical animal Seth at the upper end and bifurcated at the other. The sceptre would have been made separately and then inserted into Ptah's hands. One hand also holds the *ankh* sign, symbolic of life. The colouristic effects on this piece lend it a particularly refined quality. The warm brown surfaces contrast with those areas that have been stained black, such as the eyes and brows, the close-fitting cap and the straight beard. The precious metal inlay that was applied to pick out details such as the jewellery survives in the bracelets. Used for private devotion, statuettes like these would have been housed in temple settings or personal shrines. CT

20

Western Greek, Taranto

The Armento Rider

560–550 BCE
Bronze, 27 × 26.8 × 7 cm

On loan from the British Museum, London,
2004,0703.1

SELECTED REFERENCES: Rolley 1986, p.32;
Arn 1991, pp.102–03, plate 87

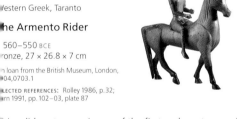

This solid-cast group is one of the first and most powerful sculptural productions of Magna Graecia (literally 'great Greece'), which is the term used to refer to the Greek colonisation of southern Italy. The group was purchased in Naples by a Hungarian collector in 1833, and although it was formerly believed that it was excavated at Grumentum, it is now known as the Armento Rider after what is agreed to be its findspot, a mere twelve kilometres away, a place where other archaic bronzes have also been discovered. The horse's separately cast rider wears a Corinthian-style helmet, which is missing its transverse crest. He would originally have been equipped with reins, presumably made of copper wire, a spear and shield, but the work is in all other respects both exquisitely made and very well preserved. Although to our eyes the group may look relatively small, it is actually an unusually large piece of this type, whose commanding presence – regardless of its scale – is immediately apparent. DE

21

Tartessian, Spain

Winged Feline

700–575 BCE
Bronze with gilding,
61 × 19.4 × 33 cm

The J. Paul Getty Museum, Los Angeles,
Villa Collection, Malibu, California,
79.AC.140

SELECTED REFERENCES: Towne-Markus 1997,
pp.30–31; Getty 2002, p.11

Both the style of the present piece and the manner of its construction from a number of individual bronze elements support the idea that it was made in the ancient kingdom of Tartessos. Tartessos was located on the Atlantic coast of Spain, close to the Straits of Gibraltar, and was consequently on the trade routes of a number of important civilisations, which explains why its artistic productions combine the native Iberian tradition with outside influences, as a result of contact with Greek, Etruscan and Phoenician merchants. This winged feline must originally have formed one of the two front legs of a throne, to whose other – presumably wooden – elements it would have been attached by the brackets at its top and bottom. In the end, however, and regardless of its function, it is the almost abstract beauty and commanding poise of the creature – enlivened by its gaping mouth and protruding tongue – that make this such a memorable work of art. DE

22

Hallstatt culture

Cult Chariot of Strettweg

c. seventh century BCE
Bronze, height 46.2 cm

Universalmuseum Joanneum, Alte Galerie,
Graz, 2000

SELECTED REFERENCES: Megaw 1989,
pp. 33–34; Sandars 1995, pp. 323–24,
figs 321–22; Egg 1996, pp. 14–36

This spectacular object takes its name from its findspot, a barrow at Strettweg near Graz, where the male cremation burial also included an axe, a spear, three horse-bits, and pottery. The large central female figure, who bears some resemblance to Greek geometric bronzes of much the same period, carries a bowl on her head, which is protected by a cushion, and wears only a belt and earrings. She is surrounded by a rigorously symmetrically disposed cast of wholly naked subordinate figures, facing towards the front and rear of the chariot. Moving outwards from the centre, these consist of pairs of armed and helmeted horsemen, each with a standing ithyphallic man with an axe and a standing woman between them, and finally sexless and therefore presumably young female figures flanking stags with massive antlers. Various interpretations of this enigmatic ensemble have been proposed, and although there may never be a consensus concerning its significance, it seems hard to doubt not only that it possessed immense cultic power in its day, but also that it is not merely the accident of survival that makes it so exceptional. DE

23

Etruscan

Chimaera of Arezzo

c. 400 BCE
Bronze, 78.5 × 129 cm

Museo Archeologico Nazionale, Florence, 1.
Soprintendenza per i Beni Archeologici
della Toscana

SELECTED REFERENCES: Brendel 1978,
no.248, p.327; Cristofani 1985, pp.64–70,
no.121; Arezzo 1990; Iozzo 2009; Los Angeles
2010

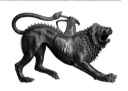

The *Chimaera* is one of the most arresting of all animal sculptures and the supreme masterpiece of Etruscan bronze-casting, its only rivals in the latter respect being the *Mars* from Todi in the Vatican and the Capitoline *She-wolf*. It was discovered in Arezzo on 15 November 1553 with a number of smaller bronzes. Immediately hailed as a spectacular discovery, the work passed into the possession of Duke Cosimo I de' Medici, and was restored by no less a figure than Benvenuto Cellini, who discusses it in his *Autobiography*, as does Vasari, who believed the inscription to Tinia (the Etruscan equivalent of Zeus) was a signature. The Chimaera was a mythical fire-breathing monster, which combined in its person elements of a lion, a goat and a serpent, and was the legendary foe of the hero Bellerophon. He rode into battle against it and defeated it on his mount Pegasus, and it therefore seems all but certain that this piece was originally part of a larger sculptural ensemble. In this treatment, the lion predominates, the goat erupts from the middle of the creature's back, while the serpent (actually a replacement of 1785 by either Francesco Carradori or Innocenzo Spinazzi) forms the tail. DE

24

China, Eastern Zhou period

Bell, known as a *bo*

Fifth century BCE
Bronze, 55 × 42 × 33 cm

On loan from the British Museum, London,
1965,0612.1

SELECTED REFERENCES: Lion-Goldschmidt
and Moreau-Gobard 1962, no.40; Rawson
1987, no.35, and related bibliography; Rawson
1992, fig.41, and related bibliography;
Falkenhausen 1993, fig.84; Washington 2000B

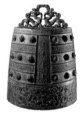

Impressive to see and hear, such bells were cast in sets and made in large numbers. The use of pattern blocks facilitated their production. One pattern block could be used to produce strips of clay to decorate the surface of a casting mould with repeat patterns and, by extension, for the moulds of several different bells. In this magnificent example, probably made in the state of Jin in northern China, the same pattern of dragon interlace fills the bell's low-relief borders. Small coiled creatures preying on birds protrude to form bosses aligned in rows all around the bell. *Taotie* faces stare out from the top of the bell and from the rim. Known as a *bo*, this instrument is distinguished by an elliptical edge that is flat, not arched, and lacks a tubular handle. Suspended instead from a loop handle contrived as two facing dragons, the bell would have hung in an assemblage with many others. It belonged to one of the great collectors of Chinese art, the Belgian Adolphe Stoclet, whose residence, designed by the Viennese Secessionist Josef Hoffman, was decorated by Klimt. CT

25

China, Eastern Zhou dynasty

Vessel of the type hu

Zhanguo period, fourth century BCE
Bronze with gold and silver inlay,
38.1 × 25.1 cm

The Alice and Pierre Uldry Collection, on long-term loan to the Museum Rietberg, Zurich, UG 22

SELECTED REFERENCES: Mizuno 1959, plate 144; Rawson and Bunker 1990, fig.44

Few vessels were inlaid with gold and silver; pieces such as this would have been particularly valuable. The practice of inlaying with metal was not native to China but acquired from the West through the nomadic cultures of the Central Asian steppes. The vessel's form, with rings on its shoulders and looped cover, presents traces of earlier rope-slung containers of portable design made in other materials. Concentric bands in low relief cast in the bronze separate wide bands of flowing gold and silver decoration cut to fit the grooves and inlaid by hand. The introduction of gleaming colour to the surface tonality of the bronze offered exciting new possibilities and drew on motifs that find parallels in lacquerware and textiles. This vessel, complete with its cover, would once have held wine. CT

26

Early Hellenistic period, Thracian

Portrait Head of King Seuthes III

Late fourth – early third centuries BCE
Bronze, copper, alabaster and glass paste, 32.5 × 28 cm

National Institute of Archaeology with Museum, Bulgarian Academy of Sciences, Sofia, 8594

SELECTED REFERENCES: Kitov 2005; Lehmann 2006; Lombardi 2009

This portrait head, found in the Golyama Kosmatka tumulus in the vicinity of the town of Shipka in central Bulgaria, was carefully buried only a few metres from the entrance to the monumental tomb of Seuthes III, an Odrysian ruler who occupied a central place in the history of relations between Macedonia and Thrace during the Early Hellenistic period. The archaeological context and the comparison with coin portraits in profile of Seuthes III indicate that the head is a portrait of the Thracian ruler; it might well have belonged to a statue set up in the nearby Thracian city of Seuthopolis.

The head was made by the indirect method of lost-wax casting whereas the details were completed by means of cold working. Separately cast locks of hair were added during the metal-finishing processes. The sculptural masterpiece of a Greek artist of the Attic School working in southern Thrace for the Odrysian court, the head is distinguished by its high-quality modelling, the tense expression enhanced by the frowning forehead and the swollen vein on the right temple, and the depth of the gaze, which is strengthened by the polychrome eyes: their whites in alabaster, light brown irises surrounded by a light green aureole, dark brown, almost black pupils, red tear ducts of glass paste and eyelashes of warm-coloured copper. MR

27

Insular La Tène art

Battersea Shield

c.350–50 BCE
Bronze with enamelled glass inlay,
77.7 × 35.3 × 5.2 cm

On loan from the British Museum, London, P&E 1857,0715.1

SELECTED REFERENCES: Stead 1985; Megaw 1989, pp.200–201, fig.339; Sandars 1995, p.409, fig.426

The *Battersea Shield*, so-called because it was found in the Thames at Battersea Bridge, entered the British Museum as early as 1857, and is one of the most stunning masterpieces of Celtic design. It would in fact originally have formed the front cover of a wooden shield, which was clearly intended for display as opposed to warfare, and may very possibly have been placed in the river as part of some kind of sacrificial ritual. There is no consensus concerning precisely when it was made, with some scholars placing it in the middle of the fourth century BCE, while others have argued that it postdates the Roman occupation of Britain, but there can be no doubt that its gleaming surface, which comprises sheet bronze with rivets to hold it together and is adorned with sinuous patterned bosses highlighted with red glass enamels, must always have marked it out as a very superior object. DE

28

Greek

Dancing Satyr

Second half of the fourth century BCE
Bronze, with white alabaster eyes, height 200 cm

Museo del Satiro, Church of Sant'Egidio, Mazara del Vallo

SELECTED REFERENCES: Parisi Presicce 2003; Moreno 2005; Andreae 2009

Although it has been suggested that the *Dancing Satyr* may have been a figurehead at the prow of a ship or a talisman at its stern, it seems more likely that it formed part of a group of dancing satyrs and maenads aboard one of two vessels laden with precious objects stolen by Giseric, King of the Vandals, after the Sack of Rome in 455 CE. The sculpture was discovered in 1998 by fishermen in the Straits of Sicily dragging nets at a depth of about 500 metres.

Made using the lost-wax technique, the unique cast shows its subject at the climax of an ecstatic dance, which would doubtless have been followed by a long and restorative sleep. The satyr's raised arms, now missing, would probably have held a *thyrsos* (a staff topped with a pine cone) and a *kantharos* (drinking cup); he may have worn a *pardalide* (a panther skin) to keep warm in his sylvan abode.

Scholars have been unable to agree on a definitive date for the *Dancing Satyr*. Some think the sculpture is a Hellenistic masterpiece dating from the third century BCE, but the most convincing hypothesis has been developed by Paolo Moreno and Bernard Andreae, who attribute the work to the famous Greek sculptor Praxiteles, who was active in the second half of the fourth century BCE. VLV, ST

29

Etruscan

Chrysippos Cista

c.350 BCE
Bronze, height 61 cm, diameter 33 cm

Museo Nazionale Etrusco di Villa Giulia, Rome, 13199. Soprintendenza per i Beni Archeologici dell'Etruria Meridionale

SELECTED REFERENCES: Haynes 1985, pp.310–11, no.172; Brendel 1995, pp.352–54, fig.274

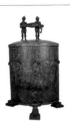

This type of *cista* seems to have served as a container for a lady's toiletries in life, and then to have been placed in her grave to accompany her into the next world. These objects have survived in considerable numbers, and the finest of them are among the most impressive Etruscan works of art. Like many other examples, the present piece comes from Praeneste (modern-day Palestrina), and comprises a simple cylindrical container with a decorated body, standing on four lions' feet (in this instance treading on frogs), and crowned by a figurative handle (here, as elsewhere, composed of a dead warrior being carried by two companions). The engraved decoration, which is picked out in white to produce a kind of drawing in relief, is divided into three horizontal bands, with the figurative central scenes topped and tailed by abstract foliate patterns. As so often, the subject-matter, which like the style is closely related to that of contemporary Apulian vase painting, involves a seemingly incoherent group of Greek myths, which in this case include Chrysippos abducted by Laios, the future king of Thebes, and the Judgement of Paris. DE

30

Egypt, Early Ptolemaic period

Seated Cat

c.300 BCE
Bronze, 33.5 × 23 × 14 cm

The Raymond and Beverly Sackler Collection

SELECTED REFERENCES: Malek 1993

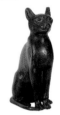

Cats often give one the impression that they regard themselves as deities, and the ancient Egyptians agreed with them. One consequence was that the customarily lion-headed goddess Bastet was also on occasion shown with the head of a cat, and since these images often show her holding a basket, as if out shopping, they have acquired the nickname 'housewife Bastet'. At the same time, statuettes of cats were also presented as votive offerings to temples dedicated to Bastet, and may sometimes have housed the remains of actual cats within their hollow interiors. The earliest cats of Bastet appear to date from around 900 BCE, but the majority of them – like this bronze – date from the Ptolemaic period, and therefore from after 332 BCE. The present work, whose surface is in part oxidised greenish-blue, is a very handsome example of the type, with an incised collar and pierced ears, which would once have been adorned with earrings. The placement of the tail curved round to the front on the creature's right-hand side is an all but universal characteristic, and relates to the form of the cat hieroglyph. DE

31

Etruscan

Strigil with Handle in the Form of a Girl

c. 300 BCE
Bronze, 40 × 25 × 7.6 cm

On loan from the British Museum, London, 1873,0820.2

SELECTED REFERENCES: Haynes 1985, pp. 312–13, no. 176

This bronze strigil of Etruscan manufacture was found at Palestrina (the ancient Praeneste), a city in Lazio southeast of Rome whose considerable importance in antiquity is made spectacularly apparent by the presence there of the monumental remains of the temple of Fortuna Primigenia. Strigils were employed by athletes after exercise in order to scrape away the oil with which they anointed themselves before taking part in sports, and also to remove the accumulated sweat and sand that must have got mixed up with the oil. In a self-reflexively witty conceit, the present example, which most unusually has a figurative handle, is adorned with an otherwise naked girl wearing leather laced-up shoes – presumably the ancient equivalent of trainers – who is herself wielding a strigil. In spite of her small scale, the girl is brilliantly brought to life by her tiptoed stance and the way she raises her right hand, presumably to shield her eyes from blinding sunlight. DE

32

Etruscan

Votive Figure (Evening Shadow)

Second century BCE
Bronze, height 57.5 cm

Museo Etrusco Guarnacci, Volterra

SELECTED REFERENCES: Cristofani 1985, p. 275, no. 75; Haynes 1985, p. 322, no. 199; Spivey 1997, pp. 144–45, fig. 131

This extraordinary statuette, which has come to be known as the 'Ombra della Sera' (Evening Shadow), is inevitably famous above all today because of the profound influence it had upon the equally etiolated conception of the human figure espoused by the twentieth-century Swiss-Italian sculptor Alberto Giacometti. In the context of its own times, whether in Volterra or elsewhere, it remains highly anomalous, but it has been plausibly suggested that it would originally have been one of a number of votive offerings around an altar, and that the figure's elongation may have represented a bid for particular attention from the presiding deity, the sculptural equivalent of standing on tiptoe within a crowd. Be that as it may, the extreme simplification of the nude, whose head and features are scrupulously not elongated, and whose arms and legs all but merge with the body, represents a fascinating refusal to reproduce the literal appearance of the human body. DE

33

Hellenistic

'Drunken Hercules'

Second century BCE
Bronze, height 22.9 cm

Lent by the Syndics of the Fitzwilliam Museum, Cambridge, GR.1-1864

SELECTED REFERENCES: Nicholls 1982

A number of broadly similar versions of the present statuette are known, including a second, somewhat later and more complete one also in the Fitzwilliam Museum. The earliest among them, such as this piece, date from the Hellenistic period, but there are also Renaissance replicas. The apparently stumbling and unsteady attitude of the protagonist has traditionally led to the supposition that Hercules is in a state of advanced inebriation. In support of such a notion would seem to be the fact that a number of sculptural groups exist in which an incontrovertibly drunken Hercules is shown being propped up by assorted followers of Bacchus. More recently, however, it has been plausibly argued that these single figures once formed part of the decoration of large metal vessels (the other Fitzwilliam Hercules not only retains his club, but also part of an attachment fixture), and that they are currently misaligned, and would originally have been perfectly upright. Regardless of its original context, the statuette certainly bears exemplary witness to the refinement that the most accomplished makers of small bronzes were capable of attaining in antiquity. DE

34

Alexandria

Nubian Boy

After 58 BCE
Bronze, molten silver on eyes and teeth, height 19.1 cm

Bibliothèque nationale de France, Paris, 1009

SELECTED REFERENCES: Conney 1971; Paris 1988, pp. 37–38 and 58–60, no. 8, plate III; Bindman, Gates and Dalton 2010, p. 344

The earliest documentation of this sinuous and swaying statuette of a young Nubian boy associates it with an archaeological find at Chalon-sur-Saône in France in 1763 (the feet have been replaced), and it has been therefore been presumed from the time of its first publication that it must be a classical antiquity. It has further been suggested that it is a copy of a Hellenistic original made in Alexandria in Ptolemaic Egypt. Moreover, the figure has been associated with a *Standing Black Beggar* in bronze in the Cleveland Museum of Art, and it has been argued not only that the two works must have been manufactured in the same workshop, but also that they represent the peak of artistic production of that school. More recently, it has been proposed that the present piece is a much later counterfeit dating from around 1600, in all probability created in Italy. Such a vast discrepancy is a mark of how difficult it can be to be sure about the dating and authorship of bronzes, although the quality of this piece is not in doubt. It is generally assumed that the boy must once have held a now missing attribute, but opinion is divided over whether the object in question was a musical instrument or an elephant tusk. DE

35

Roman

Lucius Mammius Maximus

41–54 CE
Bronze, height 212 cm

Museo Archeologico Nazionale, Naples, 5591. Soprintendenza Speciale per i Beni Archeologici di Napoli e Pompei

SELECTED REFERENCES: London 1976, no. 46; Formigli 2012, pp. 248 and 252, fig. 17

The present figure, with its marble pedestal and a dedicatory inscription in bronze ('To L[ucius] Mammius Maximus, Augustalis, [this statue is erected] by the citizens and other residents, by public subscription') was discovered in the theatre at Herculaneum on 24 December 1743. There are five further inscriptions connected with L. Mammius Maximus at Herculaneum: two record his generosity, while the others are dedications to Livia, who was deified by the Emperor Claudius; to Antonia, the latter's mother; and to his niece Agrippina, mother of Nero. Cumulatively they reveal approximately when Lucius Mammius lived. The term 'Augustalis' almost certainly indicates that he was a freed slave who ultimately achieved great wealth and power. Large-scale bronze portrait statues of this kind, paying tribute to prominent individuals, must have been commonplace for aristocrats in antiquity, but almost none has survived. Nevertheless, it is hard to imagine that this animated and well-finished piece was not a particularly fine example, and the carefully rendered portrait is certainly the opposite of an assembly-line production. DE

36

Roman

Beam End in the Form of a Wolf's Head

37–41 CE
Bronze, 40 × 25 × 50 cm

Museo Nazionale Romano, Rome. Soprintendenza Speciale per i Beni Archeologici di Roma

SELECTED REFERENCES: Ucelli 1940, fig. 227; Reggiani Massarini 1998

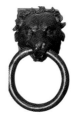

The present *Wolf's Head* is only one of a number of similar objects that were recovered by an antiquities dealer, Eliseo Borghi, in 1895 from Lake Nemi in the Alban Hills around twenty miles from Rome. They came from two enormous ships 71 and 67 metres in length that were constructed for the notoriously extravagant Emperor Caligula, and must therefore predate his assassination in 41 CE. The ships remained at the bottom of the lake until they were salvaged between 1927 and 1933 after it had been ingeniously drained under Mussolini, and were then placed in a specially constructed museum. However, they only survived until 1944, when the building was set on fire by the retreating German army, and the ships destroyed. No details are known concerning the original context of the present piece and other examples, but it is assumed that they were set on the end of wooden beams within the ships, while the massive rings through the various animals' mouths suggest that they served a practical purpose, and that ropes were attached to them. The savage energy with which they are brought to life places them among the most vigorously realistic animal sculptures of antiquity. DE

37

Roman

Architectural Fitting in the Shape of an Acanthus Leaf

First–second centuries CE
Bronze, 34 × 30 × 7.2 cm

On loan from the British Museum, London,
1851,0813.137

UNPUBLISHED

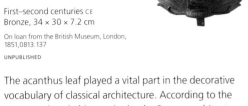

The acanthus leaf played a vital part in the decorative vocabulary of classical architecture. According to the account given in his treatise by the Roman architect Vitruvius, the Corinthian capital was invented by a Greek architect and sculptor named Callimachus after he observed the way in which the leaves of an acanthus plant had intertwined with the weave of a basket containing toys and topped by a square tile to protect them that had been left as a votive offering at a young girl's tomb. The original context of the present, impeccably observed but now as it were disembodied leaf, which was discovered in the nineteenth century at the Gorge du Loup near Lyons in France, is unknown, but the projecting fixture designed to attach it to something else demonstrates that it must originally have been a decorative embellishment of some larger ensemble. It has been proposed that it may have adorned a tomb. DE

38

Roman

Candelabrum in the Form of a Tree

First century CE
Bronze, 87 × maximum 50 cm

Museo Archeologico Nazionale, Florence,
70798. Soprintendenza per i Beni
Archeologici della Toscana

SELECTED REFERENCES: Livorno 2009, p. 33,
no. II.5

The idea of creating anything even remotely resembling a fully three-dimensional sculptural equivalent of a still-life, whether in bronze or any other material, almost never seems to have arisen, at least until very recent times (see cat. 153). It is true that naturalistic plant forms have often been reproduced in stone as parts of the decoration of capitals or architectural friezes, and that *trompe l'oeil* reliefs in wood have long been regarded as a particular challenge to the virtuosity of carvers, but the present lovingly observed miniature model of a barren tree cast in bronze is a wholly different proposition. Unsurprisingly, it must originally have fulfilled a utilitarian function, and is believed to have served as a candelabrum, from which numerous oil lamps – all now missing – would have been hung. Paradoxically, it is arguably only now, when it can be seen in splendid isolation, that its purely artistic merits can be fully appreciated. DE

39

Roman Egypt

Mensa Isiaca, altar table top

First century CE
Bronze inlaid with other metals, 74 × 123 × 7 cm

Fondazione Museo delle Antichità Egizie,
Turin, C.7155

SELECTED REFERENCES: Pignorio 1670; Scamuzzi
1939; Leospo 1978; Sternberg El-Hotabi 1994

The presence of the remarkable *Mensa Isiaca* altar-table top in Turin inspired the Duke of Savoy to send the botany professor Vitaliano Donati to Egypt in 1753 to acquire further objects that might explain its significance. The work had been acquired in Rome from Cardinal Pietro Bembo and then via the House of Gonzaga by Duke Carlo Emanuele I of Savoy between 1625–30 or later.

This exceptional bronze, inlaid with variously coloured metal sheets and fine wires, depicts three registers of scenes showing a pharaoh and his queen in an Egyptian temple. However, many of the attributes are invented, and the hieroglyphic inscriptions, which are made of hammered wires, are nonsensical. Because of this, scholars have debated whether the *Mensa* was manufactured in antiquity in Egypt or in Rome (for a temple of Isis), or whether it was an Egyptianising product of the Renaissance.

Recent studies have established that the iconography is Egyptian, whereas some decorative elements, friezes and hieroglyphs are eclectic or 'Egyptianising'. Metallurgically, the *Mensa* displays a colourful palette of alloys, most of which are not attested in imperial Rome, and none of them in the Renaissance. Thus we can conclude that the *Mensa*, despite its incomprehensible texts, was produced in Egypt and was intended to play a prominent role within a temple of Isis at Rome, where her cult had gained a footing. EV

40

Roman

Woman with Corkscrew Curls ('Tolomeo Apione')

c. 49–25 BCE
Bronze with applied copper curls,
41 × 31 cm

Museo Archeologico Nazionale, Naples,
5598. Soprintendenza Speciale per i Beni
Archeologici di Napoli e Pompei

SELECTED REFERENCES: Mattusch 2005,
pp. 230–31, figs 5.99–104; Winckelmann 2010,
p. 91

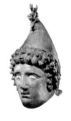

The present bust, which was discovered on top of a herm-post in the square courtyard of the Villa dei Papiri at Herculaneum, and of which the earliest report dates from 16 November 1759, is puzzling in a number of respects. Originally believed to be a portrait of the flautist Thespis (from whose name the word 'thespian' derives), who was celebrated at the court of Ptolemy I Soter, it has more recently been assumed to portray an Egyptian ruler. Yet even the gender of the person represented has been much debated, although the figure is now generally agreed to be a princess as opposed to a prince. The status of the extraordinary corkscrew curls is equally uncertain, but it is widely supposed that they are at the very least in part eighteenth-century replacements for curls of the same type. In 1762, to quote the English version of his text, Johann Joachim Winckelmann commented that the

head 'has 68 locks, but these are flat like a thin paper wrapper that has been rolled between one's fingers and then pulled apart; those on the back of the head have twelve coils.' DE

41

Ghayman, Yemen

Head of a Man

Possibly second century CE
Bronze, 20.8 × 17.5 × 18.5 cm

The Royal Collection, RCIN 69744

SELECTED REFERENCES: London 2002C,
pp. 128–29, no. 151

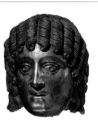

The stunning quality of the present piece, one of a mere handful of comparable survivals, serves to underline just how advanced the arts of metalworking were in Southern Arabia at this early date. The head was discovered at Ghayman, southeast of Sanaa City, the capital of Yemen, a site that has not been excavated scientifically, but which has also yielded other important finds, most notably in 1929 a large rearing horse (now in Dumbarton Oaks, Washington) that must originally have had a rider. An inscription proves that the Washington horse was one of a pair, and in 1931 elements of a second horse and a fragmentary head, presumably of its rider, were found. Thus it seems reasonable to assume that the present head belonged to the rider of the Washington horse, while the idealised facial type beneath the wonderfully ringletted hair points to the two figures having been divine as opposed to mortal, in which case they may well have been representations of the Dioscuri Castor and Pollux, the Heavenly Twins. The present head was a gift from Imam Yahya to King George VI on the occasion of his coronation. DE

42

Roman

Crosby Garrett Helmet

Late first–second centuries CE
Bronze and tinned bronze,
height 40.7 cm

Private collection

SELECTED REFERENCES: Christie's, London,
7 October 2010, lot 176

This spectacular Roman parade cavalry helmet was discovered by a metal detectorist at Crosby Garrett, Cumbria, in May 2010, and sold at auction later that year. It is one of only three such pieces to have been discovered in Britain complete with face masks, the other two being the *Ribchester Helmet* in the British Museum and the *Newstead Helmet* in the Museum of Antiquities in Edinburgh. The *Crosby Garrett Helmet* is particularly remarkable both for its completeness and its iconography: the Phrygian cap topped by a griffin is an extremely rare adjunct to the face mask. Moreover, the hauntingly impassive expression of the mask, whose silvered surface would originally have contrasted dramatically with the darker patina of the rest of the helmet, not to mention the exquisitely rendered curls of the hair, mark it out as one of the great masterpieces of Roman metalwork. It is clear that such objects were not worn in battle, but were instead adornments designed for cavalry sports events known as *hippica gymnasia*. DE

43

Gallo-Roman

Mercury of Bavay

First or second century CE
Gilt bronze, 21 × 10 × 5 cm

Musée d'Art Classique de Mougins,
MACM781

SELECTED REFERENCES: Pierre Bergé &
Associates, Drouot Montaigne, Paris,
December 2011, lot 402

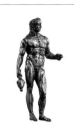

This exquisite but at the same time muscular gilt-bronze statuette, purchased by Charles Delaporte (1878–1974) in 1912, was virtually unknown until its reappearance at auction in 2011, although it had been studied by Edmond Haraucourt, a curator at the Musée de Cluny in Paris, not long after its acquisition by Delaporte. It was discovered in Bavay (the ancient Bagacum), which was founded in 20 BCE. The town was of considerable importance in Roman times, and well known in the nineteenth century for its antiquities. Indeed, in 1844 the writer Isidore Lebeau commented: 'There is as much bronzework in Bavay as leaves on the trees in the nearby forest.' As in cat. 107, the subject is the god Mercury, who is shown holding a purse in his right hand and presumably originally had a caduceus, or wand, in his left. The caduceus must have been separately cast, as was the now missing top of his head. The choice of subject is entirely fitting for ancient Gaul, since – according to Julius Caesar – 'The god they [the Gauls] honour above all others is Mercury. He has a great number of statues; they consider him the inventor of all the arts and the guide of travellers, and he presides over all manner of trade.' DE

44

Late Hellenistic

Dionysos

First century BCE – first century CE
Bronze, 135.8 × 62 × 52 cm

Private collection, courtesy of Rupert Wace
Ancient Art

SELECTED REFERENCES: Cambridge, Mass.,
1996, pp.224–31, no.23

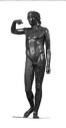

It is recorded that the present figure of Dionysos was found in Syria in the late 1950s. At the time of its discovery, the figure was in essence complete, but the head, the locks of hair on the shoulders, and much of the left leg had broken off, and had to be reattached. Nevertheless, its legibility was severely compromised by extensive corrosion, notably around the eyes, and its overall appearance has been transformed by restoration earlier this year. Originally, Dionysos would almost certainly have held two of his most familiar attributes: a *kantharos* (wine cup) would have dangled from his raised right hand, while a *thyrsos*, a staff topped by a pine cone, would have been grasped in his left. The small bronze strut joining the little finger of his left hand to the palm was evidently required as a structural support. The comfortable stance of the adolescent god and the refined treatment of his musculature and hair all point to a late Hellenistic date. DE

45

Roman

Ram

Second century CE
Bronze, 80 × 135 × 62 cm

Museo Archeologico Regionale Antonino
Salinas, Palermo, 8365

SELECTED REFERENCES: Villa and Carruba
2009

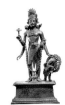

This bronze ram is the sole survivor of a pair mentioned in historical sources by such authorities as Claudio Maria Arezzo, Tommaso Fazello, Jean-Pierre Houël and Johann Wolfgang von Goethe. The original location and purpose of the rams is unknown, but in the Middle Ages they stood on plinths on either side of the entrance to the Castello Maniace in Syracuse. In the sixteenth century they were moved to various locations within the province of Palermo: the Castello di Ventimiglia at Castelbuono in 1448; the Palazzo dei Vicerè, today known as Palazzo Steri, in 1510–11; the Castello a Mare in around 1517; and the Palazzo Reale in the mid-sixteenth century. After a brief sojourn in Naples in 1735, they were returned to the Palazzo Reale in Palermo. One of the pair was destroyed during the 1848 revolutions. The remaining ram was consigned to the museum in Palermo.

Cast using the indirect lost-wax method, the sculpture is distinguished by its superlative artistic quality and by the highest level of skill that is displayed in its execution. A recent study of the work following its restoration (Villa and Carruba 2009) dated the work to Roman antiquity rather than Hellenistic. AV

46

Late classical or early Hellenistic

Head of a Horse ('Medici Riccardi Horse')

Mid-fourth century BCE
Bronze, height 81 cm

Museo Archeologico Nazionale,
Florence, 1639. Soprintendenza
per i Beni Archeologici della Toscana

SELECTED REFERENCES: Haskell and Penny 1981,
p.74; Florence 1996, p.8; Esposito and Guidotti
2006, p.54 (A. Rastrelli)

This extremely impressive horse's head must originally have belonged to a life-size equestrian group along the lines of the statue of Marcus Aurelius in Rome (fig. 8). Although it is first recorded in 1492 in the post-mortem inventory of the possessions of Lorenzo the Magnificent de' Medici, it is tempting to wonder if it was in Florence earlier in the fifteenth century, in which case it may very possibly have been known to Donatello and Verrocchio, who both famously executed monumental equestrian groups, respectively of Gattamelata (fig. 76) and Colleoni (fig. 7). If they did indeed have access to the head, its appeal over the head of Marcus Aurelius' horse would have been that it could be studied at close range. Lorenzo also owned another equine head in bronze, now in Naples, which was much admired as an antiquity in the late seventeenth century, but is now generally assumed to be a Renaissance counterfeit. DE

47

Swat Valley, North Pakistan

Vaikuntha Vishnu

Sixth–seventh centuries
Bronze, height 48.5 cm

Staatliche Museen zu Berlin, Museum
für Asiatische Kunst, MIK I 24

SELECTED REFERENCES: Härtel 1960,
pp.73–74, plates 42 and 43; Pal 1975,
pp.64–65, no.8

Although this stunning bronze has generally been dated to the seventh century, both the facial type of Vishnu, in particular his moustache, and the base point to influences from Gandharan sculpture of the fifth century and may therefore encourage an earlier date. The god is shown with two subordinate heads, respectively of a lion and a boar, flanking his human aspect and representing his two avatars Narasimha and Varaha. Similarly, he wears a triple crown, whose central and largest medallion is in the form of a wheel. He has four attribute-bearing arms: two are raised and hold the lotus and the conch shell, while the other two are lowered. The left one still rests on a wheel which doubles as a kind of halo for the dwarf Chakrapurusha (or personified wheel), while the right hand would once have rested on a now lost mace and its female personification, Gadanari. At the front of the base and between Vishnu's feet a diminutive figure of the earth goddess emerges from a lotus flower. DE

48

India, probably Bihar

Buddha Shakyamuni in Abhaya-Mudra

Late sixth century
Bronze, 68.6 × 27.3 × 17.8 cm

Asia Society, New York. Mr and Mrs John
D. Rockefeller 3rd Collection, 1979.008

SELECTED REFERENCES: Czuma 1970;
Chandra 1985

The present standing figure of the Buddha is an extremely rare early survival, and must date from the sixth century. Made in northern India in the region that corresponds to the modern state of Bihar, it reveals the influence of the sculptural style associated with the immediately preceding Gupta period, which lasted from 319 to 500. Almost every detail of the figure's appearance would have been designed to remind the faithful of episodes of the Buddha's life or of aspects of his personality. Thus, the Buddha is shown with his right hand raised to the level of his chest and with the open palm facing us, in a gesture of reassurance (*abhaya-mudra*). Similarly, the significance of such elements as the protuberance at the top of the head, known as the *ushnisha*, which denotes the 'expanded wisdom' of the Buddha at the time of his enlightenment, or the mark in the middle of his forehead, known as the *urna*, which refers to his supernatural wisdom, would have been instantly understood. At the same time, the remarkable panache with which the figure's legs are evoked through his clinging draperies may be allowed to have a purely sculptural appeal. DE

49

Korea

Pensive Bodhisattva

Sixth century
Gilt bronze, height 15.5 cm

Musée Guimet, Paris, EO 601

SELECTED REFERENCES: Cambon 2001,
pp.282–83, no.8; Jarrige et al. 2004,
pp.359, 363, plate 187

The relaxed and smiling attitude of this seated male
figure represents the highly characteristic motif in Korean
sculpture known as *panga sayu sang*, and corresponds
particularly closely in pose to a celebrated larger bronze in
the National Museum of Korea in Seoul, formerly in the
Toksu Palace. In both, the meditatively bowed head is
supported by the slender fingers of the raised right hand,
while the right elbow rests on the right knee, and the left
hand on the ankle of the right leg, which is crossed at
right angles over the left leg. The figure may well
represent the Buddha Maitreya, but in the absence of
confirmatory inscriptions or attributes, it is generally
identified as a Bodhisattva. The style of the piece confirms
its provenance from the Paekche kingdom, in the south
of Korea, and indicates that it must date from the Three
Kingdoms era (18 BCE – 660 CE), and more specifically
from the sixth century. Although Korean art of this period
was open to outside influences, the overall effect is
entirely distinctive. DE

50

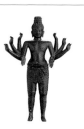

China, late Northern Wei or
Eastern Wei dynasties

Altarpiece Dedicated
to Buddha Maitreya

c.525–35
Gilt leaded bronze,
59.1 × 38.1 × 19.1 cm

Lent by The Metropolitan Museum of Art,
New York. Rogers Fund, 1938, 38.158.2a-e

SELECTED REFERENCES: Penny 1993, plates
205–06; Patry Leidy, Strahan et al. 2010, no.76

Wei Buddhist sculpture, whether in metal, stone or clay,
adopts a hierarchical arrangement that is designed to be
viewed from the front. Made in China during a period
that witnessed a flourishing of Buddhism – an imported
religion – this intricate work is conceived as an
assemblage of separately cast elements. At the centre,
Maitreya, Buddha of the Future, stands on an inverted
lotus elevated on a table-like stand. Before him is an
incense burner in the form of a lotus bud, borne aloft by
a seated figure. Flanked by bodhisattvas supported on
either side by projecting flower stems that spring from
the mouths of monstrous creatures, Maitreya is set
against a pierced flaming mandorla, to which are also
attached hovering *apsaras*, angel-like beings that here
play music. The altarpiece is crowned with a structure
that enshrines seated Buddhas on two sides. The surface
of this freestanding gilt altarpiece would have flickered in
lamplight, enlivening its quivering, rising forms. The linear
design of the whole embodies imagery of fire and light,
symbolic of the Buddha's radiance. CT

51

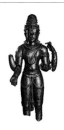

Java

Avalokiteshvara

Ninth–tenth centuries
Silvered bronze with traces
of gilding, 101 × 49 × 28 cm

National Museum Indonesia, Jakarta,
509, A. 238 and 238 a

SELECTED REFERENCES: Rawson 1967,
pp.240–41, fig.202; Brussels 2010, p.140,
fig.194

The high point of art and architecture on the Indonesian
island of Java was attained around 800, with the building
and sculptural decoration of Borobodur, to this day the
largest Buddhist temple in the world and one of the
pinnacles of world art. However, Borobodur is no isolated
masterpiece, but rather the best and the grandest of
a whole sequence of spectacular monuments, almost all
of which are adorned with remarkably fine sculptures,
both in the round and in relief. It remains the case,
nevertheless, that almost all Indonesian sculpture is
carved out of the local stone, which makes the present
piece a particularly miraculous survival. Elements of this
Avalokiteshvara from Tekaran, in Surakarta, not far from
Borobodur (see cat. 77 for the subject), which would
originally have been a full-length standing figure, are
missing, but the quality of what remains – and not least
the refinement of the casting and finishing of the details
– is immediately apparent. The work is in addition the
largest extant bronze known to have been made in
Indonesia. DE

52

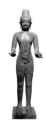

Cambodia, Baphuon period

Shiva/Avalokiteshvara

Dated 1044
Bronze with silver and obsidian
inlays, 110 × 36 × 32 cm

Private collection

SELECTED REFERENCES: Bunker and
Latchford 2011, pp.219–24, figs 7.1a-d

The Baphuon is the major temple-mountain built by King
Udayadityavarman II, which has given its name to one of
the most fertile periods in the history of Khmer sculpture.
This stunning piece, whose integral base is inscribed with
the year 966 *saka*, which translates as 1044, must
therefore actually date from the last years of his great
precursor, Suryavarman I, whose reign lasted from 1010
until his death in 1049. The presence of the third eye in
the figure's forehead suggests it was meant to represent
Shiva, but the fact that it is now missing the identifying
attribute that once adorned the god's piled-up hair
suggests it may have begun life as a bodhisattva, and
thus been transformed from a Buddhist image into a
Hindu one. Inlays in both silver and obsidian embellish the
eyes, and the now empty channels for them reveal that
further inlays would originally have represented the
eyebrows, moustache and beard. It seems only
reasonable to assume that such a figure was intended to
be appreciated in the round, in view of the extraordinary
elegance of the almost detached back bow of the *sampot*
that the god wears around his middle. DE

53

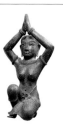

Cambodia, Early Angkor period

Maitreya

First quarter of the tenth century
Bronze with silver and obsidian
inlays, 75.5 × 50 × 23 cm

National Museum of Cambodia,
Phnom Penh, Ga2024

SELECTED REFERENCES: Washington 2010,
pp.31–34, nos 5 and 5a; Bunker and Latchford
2011, pp. 144 and 148, figs 5.7a and 5.7b

Maitreya is the bodhisattva, or 'Buddha yet to come',
who is here represented standing with a miniature stupa
within his spiralling pyramidal coiffure. Clearly denoted as
male by virtue of his stylised beard and moustache, the
idea of showing him with eight arms appears to be a
Khmer innovation, which has the effect of transforming
him into an iconographic counterpart of the equally
eight-armed Lokeshvara (also called Avalokiteshvara)
of the *Karandavyuha Sutra*. The style of this commanding
yet delicate figure, which was found at Wat Ampil Teuk
in Kampong Chhnang Province in Cambodia, allows it
to be dated to the later part of the Bakheng period, so
called – as is commonly the case in this context – after
the most prominent temple built at that time by King
Yashovarman, whose reign lasted from 889 to around
915. This magnificent structure comprised a pyramid with
five terraces and no fewer than 109 sanctuary towers. DE

54

Cambodia, Baphuon period

Kneeling Woman

Second half of the eleventh
century
Bronze with silver inlay and traces
of gilding, 43.2 × 19.7 cm

Lent by The Metropolitan Museum of Art,
New York. Purchase, bequest of Joseph
H. Durkee, by exchange, 1972, 1972.147

SELECTED REFERENCES: Bunker and Latchford
2011, pp.234–35, fig.7.12

It has been suggested that the present piece, which is
closely related to a male kneeling figure of the same
height in the Cleveland Museum of Art, may date from
the reign of King Harshavarman III, who succeeded his
brother, Udayadityavarman II, in 1066, and reigned until
1080. They – like a number of other major Khmer
bronzes – are said to have been found on the Korat
Plateau in what is now the border region between
Cambodia and northeast Thailand, in the vicinity of the
temple of Prasat Muang Tam. Such figures do not possess
any of the attributes associated with either Hindu or
Buddhist deities. Their kneeling and supplicatory attitudes
support the notion that they are representations of donor
figures, presumably designed as subsidiary elements
within some larger religious context. The way in which
the eyebrows are reserved for inlays involves exactly the
same technique as that found in the standing Shiva
(cat. 52), and may suggest that both were products of
the same workshop tradition, which could have operated
for a considerable period of time. DE

55

Nepal

Uma

Early eleventh century
Copper alloy with traces of
gilt and semi-precious stones,
45.6 × 27.9 × 25.4 cm

The Cleveland Museum of Art, Leonard
C. Hanna Jr Fund, 1982.49

SELECTED REFERENCES: Chicago 2003, p.32, no.8

In Hinduism, the goddess Uma is the wife of Shiva, and
in consequence an extremely important deity. Both the
symmetrical pose of the present figure, who sits in a
relaxed attitude with her legs crossed and the left one
raised, and her engaged sideways glance indicate that
this solid-cast statuette must originally have formed part
of a larger ensemble of the type known as an
Umamahesvara. In fact, it has been suggested that the
Los Angeles County Museum of Art's slightly taller figure
of Shiva, 40 cm high, may very possibly have been its
companion, a connection that might ultimately be
resolved by technical and metallurgical analyses. The easy
naturalism of the pose of this lithe and at the same time
voluptuous presence, together with the brilliantly
characterised facial expression, make this Uma stand
out from the crowd, while her bejewelled crowned
headdress, earrings, necklace and belt add to her
elegantly regal aspect. DE

56

Southern India, Chola

Ganesh

Late eleventh – early
twelfth centuries
Bronze, height 57 cm

A European private collection

SELECTED REFERENCES: Los Angeles 1977,
pp.130–31, no.75; London 2006,
pp.90–94, no.14

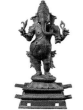

In Hindu theology, Ganesh is the elder son of Shiva and
Uma Parvati, a benign deity whose support is believed
to guarantee good fortune for all new enterprises.
A number of different explanations are given for his
elephant head, as a rule relating to the notion that his
original head was forfeited and then replaced by that of
the first creature that happened to be passing. The
present piece, which dates from around the end of the
eleventh century or the beginning of the twelfth, is a fine
example of the unvarying mode of his representation in
Chola sculpture. Chubby-limbed and pot-bellied, he is
shown with appropriate attributes in each of his four
hands. His right and left rear hands hold a battleaxe and
a lasso, while their respective counterparts in front hold
one of his own tusks, which doubles as a cornucopia,
and a sweetmeat known as a *modaka*. His sweet tooth
is proverbial, and explains his impressive embonpoint. DE

57

Southern India, Tamil Nadu,
Chola period

Nandi

c. 1200
Copper alloy,
51.4 × 52.1 × 33.6 cm

Asia Society, New York. Mr and Mrs John
D. Rockefeller 3rd Collection, 1979.030

SELECTED REFERENCES: Patry Leidy 1994;
London 2006, pp.72–73, no.8

One of the many different ways in which the god Shiva
is represented in Hindu iconography is as Vrishabhavana,
which means Rider of the Bull. Nandi is the name of
Shiva's bull, and he was ubiquitous in the form of stone
sculptures within temples dedicated to his master.
Bronzes of Nandi are considerable rarities, however,
because such images were seldom carried in religious
processions. The fact that the present piece is equipped
with pairs of matching holes on the sides of its
rectangular base proves that it could have been
supported on poles during such festivities, and
appropriately enough Nandi is shown resplendently
adorned with a saddle, metal covers over his horns, and
jewelled chains around his neck and ankles. Despite all
this decorative detail, both the treatment of the animal
itself and the restfulness of its pose are entrancingly
realistic. Opinions differ as to when it was made, with
some authorities placing it in the tenth or eleventh
centuries, but it probably dates from rather later, around
1200. DE

58

Nigeria, Igbo-Ukwu

Roped Pot on a Stand

Ninth–tenth centuries
Leaded bronze, height 32.2 cm

National Museum, Lagos, 79.R.4.
National Commission for Museums
and Monuments, Nigeria

SELECTED REFERENCES: Fagg and Plass
1968, pp.120–21; Shaw 1970, pp.105–12,
plates 196–203; London 1982, no.16

Likened to Fabergé for their virtuosity, the castings found
at Igbo-Ukwu in southeastern Nigeria attest to an
extraordinary flowering of technology and creativity that
still has no explained source or context. One of the most
astonishing bronzes from Igbo-Ukwu is this intricate
vessel resting on a stand. It consists of an elongated pot
and an openwork base, criss-crossed by a rope with
repeated knots at the junctions. Its form appears to copy
in bronze the local practice of tying rope around a pot to
facilitate carrying. A freely sliding pendant, which may
have served as a travelling handle, hangs from one of the
upper sections of rope. The wide lip of the vessel is
further embellished with curved and dotted lines; also
decorated, its neck and belly bear an interlace design in
relief. The pot, rope cage and stand were cast in sections
and then joined in a complex sequence of steps. The pot
was found in a storehouse of ritual objects uncovered at
Igbo Isaiah, a site named after Isaiah Anozie, one of three
brothers whose adjacent plots were excavated. Igbo
Isaiah contained many of the most beautiful objects. CT

59

Cambodia, Angkor period

Oil Lamp

Twelfth century
Bronze, 30.5 × 25 × 13 cm

National Museum of Cambodia,
Phnom Penh, Ga5730

SELECTED REFERENCES: Washington 2010,
pp.120–26, no.61; Bunker and Latchford
2011, pp.321, 326, fig.8.38

The central importance of the lotus flower in Buddhist
lore and ritual is brilliantly brought to life in this
enchantingly arabesquing oil lamp, which brilliantly
combines purely formal beauty with practical utility. The
large open lotus would have acted as the reservoir for oil,
and such lamps would have been held by priests to
illuminate cult images during religious ceremonies. This
type of vessel appears to have originated in India, where
comparable examples are known to have existed at an
earlier date thanks to their representation in relief
sculpture. The present piece has been given a distinctively
Khmer flavour by the addition of the five-headed *naga*
(serpent), which would have appeared to hover
protectively next to the sacred flame. *Nagas* are a virtually
ubiquitous feature of Cambodian temples, at whose
entrances they commonly serve as the terminal features
of balustrades. Such decorative objects must once have
existed in considerable quantities, but now only a handful
survive. DE

60

Cambodia, Bayon period

**Miniature Shrine with
Hevajra in a Circle
of Yoginīs**

Late twelfth – early
thirteenth centuries
Bronze, partially gilded,
height 20.5 cm

National Museum of Cambodia,
Phnom Penh, Ga2494

SELECTED REFERENCES: Washington 2010, pp.63
and 66–67, no.27; Bunker and Latchford 2011,
pp.357 and 373–75, figs 9.13a and 9.13b

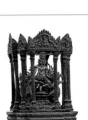

This miniature shrine would originally have been crowned
by a superstructure, but is otherwise largely intact. Within
the inner sanctum and at its centre is the figure of
Hevajra, the principal deity of Tantric Buddhism, who is
the personification of enlightenment in the here and
now. Eight-headed and sixteen-armed, here he is the
only gilded element of this exquisite ensemble, and is
represented in a swaying, dancing pose with his left
foot trampling on the four Mara (three of whose heads
are visible), embodiments of evil who stand in the way
of enlightenment. Eight dakinis (also called yoginīs)
originally danced in homage around him, poised on their
right and therefore opposite feet, but two of them are
now missing. They are emanations of Hevajra who
combat evil, and their number is related to the four points
of the compass and their intermediates, thus connecting
them with the pillared shrine that they inhabit. DE

61

Hildesheim

Aquamanile in the Form of a Lion

c. 1215–30
Bronze, 27.5 × 26.2 × 13.2 cm

Victoria and Albert Museum, London,
246-1894

SELECTED REFERENCES: Williamson 1995,
p. 81, fig. 122; New York 2006, pp. 95–96,
ill. p. 97

In the medieval period aquamanilia were equally prevalent in sacred and secular contexts, and served as containers for water for hand-washing. The present example is therefore typical, both in having a handle but also in being made in the form of an animal (knights on horseback were another popular variant). The type of the lion suggests some awareness of the monumental bronze lion at Braunschweig (fig. 70), which dates from 1166, but there are altogether closer stylistic parallels with the lion on the early thirteenth-century font at Hildesheim, where it features as the symbol of St Mark; it has been convincingly suggested that this aquamanile must also have been manufactured there. Hildesheim had been a major centre of bronze-making since the time of St Bernward, its bishop at the end of the tenth century and the beginning of the eleventh, so although this work is a comparatively late flowering of that tradition, the playful turn of the beast's head and its smiling expression both mark it out as a minor masterpiece. DE

62

Southern Italy or Sicily

Islamic Lion

Late eleventh or early twelfth centuries
Bronze, 73 × 45 cm
(lacking lower legs)

The Mari-Cha Collection Ltd

SELECTED REFERENCES: Venice 1993,
pp. 126–31 and figs 43a and 43b; Contadini,
Camber and Northover 2002; Palermo 2003,
vol. 2, pp. 79–80, no. 18 (C. T. Little); Doha 2008,
no. 60; Contadini 2010

Since this bronze's appearance on the London art market in 1993, there has been considerable speculation about its place of manufacture and its original function. The work's monumental scale, proportions and engraved decoration, particularly the wording of the engraved benediction in kufic script on the saddle cloth, immediately associate it with what is to be found on the celebrated Islamic Griffin in Pisa (fig. 69). Both works, moreover, have similar, although not identical, cast vessels inserted into their interiors. The Pisa Griffin is now generally believed to come from late eleventh- or early twelfth-century Spain, whereas the closest stylistic parallels for the Lion are to be found in sculpture produced in Campania, Puglia and Sicily during the same period, particularly at Salerno, Bari, Brindisi, Siponto and Cefalù. The purpose of the internal vessels remains unclear, but it seems likely that they originally formed part of an acoustic mechanism. Both the Griffin and the Lion are currently the subject of a major scientific research programme, which it is hoped will resolve many of the issues that still surround these two remarkable castings.
RC

63

Ottonian

Krodo Altar

Late eleventh – early twelfth centuries
Bronze, height 70 cm (box),
40 cm (caryatid figures)

Stadt Goslar, Goslarer Museum, SGF 060

SELECTED REFERENCES: Lasko 1994,
pp. 138–39, plate 192; Paderborn 2006,
vol. 2, pp. 92–95, no. 78 (R. Kahsnitz)

In its present form, the *Krodo Altar* comprises a box-like altar table with perforated sides and four kneeling caryatid figures at its corners. However, it is has been suggested that these two elements did not always belong together, and that the supporters were made for a different object, the so-called Imperial Throne, of which only the equally perforated back and sides have survived, also in Goslar in Saxony. In the case of the altar, the symmetrically ordered holes on its sides, some arranged in cruciform patterns, must originally have been filled by jewelled and filigreed insets of translucent crystal or semi-precious stones, whose already considerable splendour would have been further enhanced by backlighting from lamps placed inside the box. The austere dignity of the bowed supporters creates a dramatic contrast, and at the same time underlines the hieratic power of the finest Romanesque sculpture. DE

64

Northern German or Mosan

Crucifix with Corpus

c. 1150–1180
Gilt bronze, 27.5 × 17 cm

Private collection, London

SELECTED REFERENCES: London 2005B,
pp. 16–17, no. 3

Although the earliest known representation of the Crucifixion – on the wooden doors of Santa Sabina in Rome – is a comparatively late arrival, dating from around 432, the subject of Christ on the Cross has been a standard feature of Christian iconography ever since, both in narrative contexts and in various functional roles. In the Roman Catholic tradition, all altars were meant to be equipped with a cross (crucifix), with or without the figure of Christ (corpus). Moreover, large crosses were commonly employed in religious processions, while smaller ones – such as the present, elegantly gilded example – served as aids to private devotion. The starkly simplified forms, rigid body and staring eyes of the figure of Christ here mark out the crucifix as a typical work of the twelfth-century Romanesque, and specifically as having been produced either in Northern Germany or the region of the valley of the River Meuse (hence Mosan). The Latin inscription follows the gospel account and refers to Jesus of Nazareth as the King of the Jews. The figure is crowned by the hand of God the Father emerging from heaven. DE

65

English

Sanctuary Ring

c. 1170–80
Bronze, height 67 cm

Chapter of Durham Cathedral

SELECTED REFERENCES: Mende 1981,
pp. 29–31, 215–16, no. 27, figs 54–55;
Geddes 1982

The *Sanctuary Ring* adorned the north door of Durham Cathedral for centuries, but has more recently been replaced by a copy and removed to the safety of the cathedral's museum. It takes its name from the fact that in the Middle Ages people who 'had committed a great offence' could knock on the door and would be granted sanctuary for 37 days, during which time they might either achieve reconciliation with their pursuers or plan an escape. The present piece consists of a grotesque leonine head with deep-set eyes, a great bulbous nose, and wrinkled cheeks, ringed by what appears to be a sunburst of tongues of flame rather than a conventional mane, together with the ring, which passes through the grinning jaws of the fantastical creature. Given the context, the hideousness of the monster's features is clearly designed to ward off evil from the place of sanctuary. DE

66

Eastern Turkey

Mirror of Artuq Shah

1203/04 or 1261/62
Bronze, diameter 24 cm

The David Collection, Copenhagen, 4/1996

SELECTED REFERENCES: Kühnel 1970, p. 160,
fig. 131; New York 1995, pp. 8–11, no. 2

The present bronze mirror is one of the great masterpieces of Islamic metalwork, and is arguably the finest existing example of the type that have come to be known as magic mirrors. The piece is decorated with a double inscription, which informs us both about the recipient and about the date of its manufacture. The former was Artuq Shah, last of the Ortoquid rulers of Kharput, and the date has been interpreted as either 600H or 660H (after the Hirja, the journey of Mohammed from Mecca to Medina), which translates as 1261/62. Since his father died in 622H, the later date would indicate that Artuq Shah must either have succeeded him at a young age or lived a long life. The later date would also place the mirror after 631H, when the Ortoquids were overthrown by the Seljuks of Rum. The centre of the mirror is decorated with a bird, almost certainly the characteristic Ortoquid motif of the owl, which is surrounded by an inner band of decoration with seven busts, presumably of the seven planetary deities, and then by an outer band with the twelve signs of the zodiac, brilliantly conceived and equipped with the various identifying attributes still associated with them to this day. DE

67

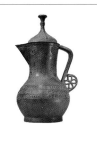

nglish

he Asante Ewer

1390–1400
ronze, height 62.3 cm

n loan from the British Museum, London,
396,0727.1

ELECTED REFERENCES: London 1987,
p.524–25, no.726 (J. Cherry); Bailey
993; London 1993A, p.50, fig.8, and p.94,
.11

he present piece is adorned with a poetic inscription in
ombardic capitals, and with the royal arms of England as
hey were used from 1340 to 1405. Moreover, other
lements of the decoration, and in particular the inclusion
f a stag, indicate that the ewer must date from the reign
f King Richard II, and in all probability from the final
ecade of the fourteenth century. Although the Robinson
ug in the Victoria and Albert Museum, London, and the
Venlok Jug, belonging to Wardown Park Museum, Luton
recently stolen and currently untraced), were very
ossibly made in the same workshop, conceivably by a
ondon bell-founder, the Asante Ewer is a particularly
emarkable survival because it has not lost its seven-sided
d. Altogether more extraordinary, however, is the fact of
s rediscovery in the palace of King Prempeh of Asante –
ence its name – at Kusami in the Gold Coast (now
Ghana) in 1895, since it is impossible to imagine how it
rrived there or what travels it must have undergone in
he intervening five hundred years. DE

68.1–2

ower Saxony

t James the Greater
t John the Evangelist

Mid-fourteenth century
Gilt bronze, heights 32.1
nd 32.8 cm

Private collection

ELECTED REFERENCES: Hackenbroch
962, pp.xxxviii–xxxix; Kofler-Truniger 1965,
p.45–46, no.E 137, and plate 79; Kansas City
983, no.100

The present gilt-bronze reliefs originally formed part of
a set of the twelve apostles, of which eight have thus far
been identified. In addition to these two, they comprise
SS. Peter and Paul in the Detroit Institute of Arts; SS.
James the Less and Philip in the Untermyer Collection,
Metropolitan Museum of Art, New York; St Bartholomew
n the Art Institute of Chicago; and St Thaddeus in a
private collection. All these figures are identified by
inscriptions on the bases upon which they stand, and
many of them are also equipped with appropriate
attributes. Thus, the bearded figure of St James is shown
holding his pilgrim's shell in his right hand, while St John
has the book of his gospel in his left. They presumably
belonged to the predella zone of an altarpiece or
reliquary shrine, and numerous compelling parallels have
been adduced with wooden sculptures from Lower
Saxony that are datable to the middle of the fourteenth
century. DE

69

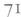

Southern India, Tamil Nadu,
Pudukkottai and Tanjavur districts,
Chola period

Yashoda Nursing the
Infant Krishna

880–1279
Bronze, 44.5 × 30 × 27.6 cm

Lent by The Metropolitan Museum of Art,
New York. Purchase, Lita Annenberg Hazen
Charitable Trust Gift, in honour of Cynthia Hazen
and Leon B. Polsky, 1982, 1982.220.8

SELECTED REFERENCES: Los Angeles 1977,
pp.128–29, no.74

The present group shows the infant Krishna seated on the
raised left thigh of his scantily clad foster mother or wet
nurse Yashoda. Yashoda was the wife of a cowherd, and
is characterised as a wholesome, full-breasted earth
mother, cradling Krishna's head with her left hand. He is
shown suckling at her left breast and simultaneously
squeezing her right nipple between the thumb and index
finger of his left hand. The remarkable ease and
naturalism of both figures and the tenderness of their
interaction sets them apart from the altogether more
stylised and hieratic modes of the majority of Indian
bronzes. The subject is extremely rare in Indian sculpture,
and this piece is both the largest and by far the most
artistically impressive surviving representation of the
theme, whose iconography can hardly fail to suggest
thoughts of its Christian counterpart, the Madonna del
Latte (literally 'Madonna of the milk'), in the mind of
anyone familiar with Italian art of the Renaissance. DE

70

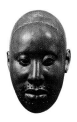

Nigeria, Tada

Seated Figure

Late thirteenth–fourteenth
centuries

Copper with traces of arsenic,
lead and tin, height 53.7 cm

National Museum, Lagos, 79.R.18. National
Commission for Museums and Monuments,
Nigeria

SELECTED REFERENCES: London 1982, no.92;
London 1995, no.5.64, pp.406–07; London
2009C, no.36 and related bibliography

This life-like figure's fleshy corporeality and asymmetric
pose make it one of the most original sculptures to have
been produced in Africa. Found in a shrine in Tada village
on the River Niger north of Ife, the figure, associated with
the hero Tsoede, legendary founder of the Nupe state,
was regularly taken to the river and scrubbed with gravel
by a priest as part of a fertility cult. This accounts for the
missing parts and the somewhat eroded appearance of
some features – such as the eyes and the latticework
pattern on the textile – while the almost pure copper
used in the casting has contributed to the porosity of the
work's surface. Why this masterpiece of Ife art was found
so far north is unclear. Unlike other sculptures associated
with Tsoede (see cat. 74), the present example must have
been cast by an Ife artist. It may be that its location
marked Ife's authority in the region. Thermoluminescence
dating of part of the sculpture's clay core has established
that this is the earliest of Ife's metal sculptures. CT

71

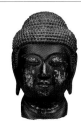

Japan, Kamakura period

Head of a Buddha

First half of the thirteenth century
Gilt bronze, height 34 cm

Museum of Fine Arts, Boston. Julia
Bradford Huntington James Fund, 15.942

SELECTED REFERENCES: Morse and Tsuji
1998; Nagoya 2002

With its moon-shaped face, downcast eyes and small
rounded nose, this head is characteristic of Japanese
representations of the Buddha popular during the latter
part of the Heian period (794–1185) and continuing into
the thirteenth century. The facial expression of this superb
cast (a single casting from a mould joined front and back)
embodies a particular gentleness that distinguishes many
Japanese Buddhist images from their continental
counterparts. In its idealised features the head bears
strong stylistic similarities to sculptures that followed the
idiom established by the master sculptor Jōchō (d. 1057)
for the Heian-period aristocracy at such temples as the
Byōdō-in in Uji and the Kunitsune-dō in Kyoto. In Japan,
statues were generally sculpted following set
measurements, the most common of which was the
joroku size, which was approximately sixteen feet tall
when the figure was erect. The proportions of this head
indicate that the original figure – no longer extant –
would have been of the half-*joroku* size, making it a
monumental work in bronze. Traces of gold visible on
the cheeks and the folds of the neck reveal that the
statue was once gilded. ANM

72

Nigeria, Ife

Mask of Obalufon II

Fourteenth – early
fifteenth centuries
Copper, height 29.5 cm

National Museum, Lagos, 38.1.2.
National Commission for Museums
and Monuments, Nigeria

SELECTED REFERENCES: Preston Blier 1985;
London 1995, no.5.62, p.405; London 2009C,
no.37 and related bibliography

Despite the fact that this mask weighs more than 5 kg,
it was made to be worn. In the shadow of the lower lids
are narrow apertures through which to see; the lips are
parted to allow the wearer to speak. These are not the
only openings: around the edge of the mask are holes
that may have been made to hold a costume in place,
and around the mouth and hairline are others, which
may have been used to affix a beaded veil. Beautifully
modelled ears and eyes complete the mask's most
naturalistic features, the mouth and nose; the play of
curves around the nostrils is rendered with great skill.
The quality of this singular and highly accomplished work
is all the more remarkable as it is made of nearly pure
copper, a particularly difficult material to cast when
unalloyed with other metals. The mask is now identified
with Obalufon II, a mythic early king of Ife, but the
antiquity of this tradition is unknown. CT

73

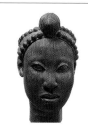

Nigeria, Ife

Head with Crown

Fourteenth – early fifteenth
centuries
Brass, height 24 cm

National Museum, Lagos, 79.R.11.
National Commission for Museums
and Monuments, Nigeria

SELECTED REFERENCES: Willett 1967; London
2009C, no.1 and related bibliography

Discovered accidentally with sixteen other heads and
part of a figure while foundations were being dug for
a new building in Wunmonije compound – a site once
encompassed by the royal palace – this beautiful
sculpture was purchased in 1938 by the American
anthropologist William Bascom, who later returned it to
Nigeria. Smaller than life-size, it is one of three extant cast
heads to bear a crown (in the present example the
upright central element is lost). While the lips are smooth,
the face is striated with incised lines, which may or may
not depict scarification, a marker of a particular person,
place or rank. Some refute this and suggest the lines may
simply be designed to render the effect of beaded veils or
give texture to the surface. The function of this head is
unknown (the holes in the neck suggest that it was
attached to something, whether to a base or to part of
a figure remains unclear), as is the identity of the person
depicted, man or woman. Nevertheless it stands out as
an image of great dignity. CT

74

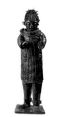

Nigeria, Jebba Island

Bowman

Fourteenth–fifteenth centuries
Bronze, height 95 cm

National Museum, Lagos, 79.R.19.
National Commission for Museums
and Monuments, Nigeria

SELECTED REFERENCES: London 1982,
no. 94; London 2009C, no. 104 and
related bibliography

This imposing bronze statue, found on Jebba Island in
the Niger River, represents a bowman in hunting clothes.
He carries a quiver of arrows on his back but his bow is
missing, as are the hands that held it. His thick, woven
and fringed tunic-like garment conceals a knife in a breast
pocket; he wears cowrie-shell necklaces, ankle bracelets
and a headdress that bears a disc with a 'snake-winged
bird' emblem, a motif found elsewhere on sculptures
and carvings in Ife, Owo and Benin. The bowman's face
is lined with scarifications that radiate in all directions. His
pronounced form and features are made up of volumetric
components that presage Léger's abstractions of the
modern age. The use of tin bronze for this casting
suggests an early date, since by the late fifteenth century
trading contacts with Europeans brought alloys of copper
and zinc. As with cat. 70, this figure is associated with
other metal sculptures found at Tada and Jebba that are
said to have been transported there by the hero Tsoede,
but they do not form a homogenous group. It is likely
that the present work originated elsewhere, from a centre
with metalworkers who possessed the skill to cast some
of the largest African bronzes known today. CT

75

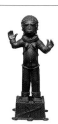

Nigeria, Benin (?)

Female Figure

Seventeenth–eighteenth centuries
Brass, 46.5 × 22.6 × 18.7 cm

Staatliche Museen zu Berlin, Ethnologisches
Museum, III C 10864

SELECTED REFERENCES: Fagg 1963,
plates 36–37; London 1995, no.5.60h,
pp.398–99 and related bibliography;
Vienna 2007, no.218

By comparison with the number of large standing statues
representing the Oba and his attendants, the scarcity of
female figures from Benin makes this piece difficult to
classify stylistically. Although particular features, such as
the scarification on face and body, are akin to classic
Benin works, the modelling of hair, eyes, cylindrical legs
and squared-off feet is more difficult to locate. Attempts
to identify the figure in Benin myth have also proved
inconclusive. The motif of a bow and arrow cast in relief
on the base may be the attributes of Ake, deified hero
and god of archery, whose beloved wife may be
represented here. However this is not the only
interpretation. Although these puzzling elements might
consign this figure to a disparate corpus of southern
Nigerian bronze castings, the sharp detail on the cast,
its state of preservation and the figure's pose make it
one of the most arresting sculptures from the region. CT

76

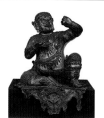

China, early Ming dynasty,
Yongle period

**Kapâla-Hevajra
and Nairâtmya**

1403–24
Gilt bronze with polychromy
and semi-precious stones,
66 × 54 × 30 cm

Collection Bodhimanda Foundation /
Wereldmuseum, Rotterdam, V-383

SELECTED REFERENCES: Bruijn 2011, p.56

The present fire-gilt bronze group is Chinese in origin.
The style places it in the Yongle period of the early
Ming dynasty, which is to say in the first quarter of the
fifteenth century. This bronze, although without imperial
signature, must have been created in one of the imperial
workshops in Beijing, and was meant for one of the
Tibetan-Buddhist temples in the Chinese capital. The
eight-headed Kapâla-Hevajra is entwined in a cross
between a passionate embrace and a dance with his
consort Nairâtmya. His four paired legs seem almost
to defy gravity, and two of his sixteen arms are joined
behind her back just above the waist, while the remainder
hold cups in the form of skulls that would originally have
contained images of gods and animals (a number of
these are now missing). Nairâtmya in her turn tilts her
head to one side, looks up adoringly into Kapâla-Hevajra's
eyes, and curls her right leg round his left thigh. Kapâla-
Hevajra is the personification of the Hevajra Tantra,
a scriptural text designed to lead its Buddhist readers
in the direction of spiritual enlightenment. The sculpture
is exceptional not only by virtue of its superb quality of
modelling, casting and gilding, but also of its sheer size.
DE

77

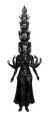

Central Tibet

**Eleven-headed
Avalokiteshvara**

c. 1400
Bronze with silver and copper
inlay, semi-precious stones and
polychromy, 120.7 × 39.8 × 25 cm

Private collection, courtesy Rossi & Rossi,
London

SELECTED REFERENCES: Chicago 2003, p.226,
no.147

In this form of representation, the bodhisattva
Avalokiteshvara, whose popularity in Tibet is guaranteed
by virtue of the fact that the Dalai Lamas are believed to
be his emanations, is shown with eleven heads
(Ekadasamukha is the term used to denote the type).
These heads form five registers set one on top of the
other, with the lower three comprising triads composed
of frontal heads flanked by companions looking to left
and right, while the upper two are singletons. In terms of
their iconography, three of the heads are tranquil and
seven are angry, while the crowning head is that of
Amitabha, the parental Buddha of Avalokiteshvara. The
pyramid of heads is also complemented by no fewer than
four pairs of arms (which would once have held various
attributes), including the central pair in front of the
figure's breast, joined in the traditional gesture of
greeting. The grace and serenity of the body are not at all
disturbed by the colourful exuberance of the painted
heads above. DE

78

China, early Ming dynasty,
Yongle period

Mahāsidda Virūpa

Fiirst quarter of the
fifteenth century
Gilt bronze, 79 × 60 × 43 cm

Victoria and Albert Museum, London.
Purchased with support from the Robert
H. N. Ho Family Foundation, IS.12-2010

SELECTED REFERENCES: Clarke and Heath
forthcoming

This corpulent figure represents the Mahāsiddha Virūpa
seated on an antelope pelt, whose draped silhouette is
highly unconventional in its illusionistic treatment. An
Indian yogic adept who lived during the ninth century,
Virūpa was revered in Tibet as a Buddhist master.
Eccentric in their behaviour and appearance,
mahāsiddhas (a Sanskrit term for a great being who has
attained his spiritual goal) led unorthodox lifestyles. This
rare statue – one of the largest and most arresting to
have survived – was cast during the reign of the Emperor
Yongle (reg. 1403–24), a devout Buddhist who promoted
close contacts with Tibet. Strongly Tibetan in style and
iconography, the bronze was probably an imperial
commission produced at the Chinese court and made
either as a diplomatic gift or for a Tibetan Buddhist
temple in China proper. The hole in the palm of the open
hand would once have been used to affix a skull-cup.
Besides his jewellery, Virūpa's other attributes include, as
seen here, the yogic meditation strap that encircles his
left leg and torso, drawing a contour around his belly. CT

79

Nigeria

Huntsman Carrying an Antelope

Probably pre-1500
Bronze, 37 × 17. 5 × 15.5 cm

On loan from the British Museum, London,
Af1952,11.1

SELECTED REFERENCES: Fagg 1952, p.145;
Fagg 1963, plate 58; Monaco 2005, no.31a

This unconventional sculpture came to Britain with thousands of other works of art as a result of the British Punitive Expedition of 1897. Although presumed to have been taken from Benin City, the *Huntsman Carrying an Antelope* is likely to have been made elsewhere, as it shares few features with the castings of that centre. Unlike any other bronze in pose or iconography, this piece is one of the most important in a large and diverse group of works tentatively labelled 'Lower Niger Bronze Industry'. Bristling with taut energy, from clenched fists to firmly planted toes, the huntsman is armed with bow and quiver. Accompanied by a small dog, he genuflects while shouldering the burden of his kill. CT

80

Lorenzo Ghiberti (c.1378–1455)

Tomb Slab of Fra Leonardo Dati

1425–26
Bronze, 229 × 87 cm

Santa Maria Novella, Florence. Fondo Edifici di Culto, amministrato dal Ministero dell'Interno – Dipartimento per le Libertà Civili e l'Immigrazione – Direzione Centrale per l'Amministrazione del Fondo Edifici di Culto Soprintendenza Speciale per il Patrimonio Storico Artistico ed Etnoantropologico e Polo Museale della città di Firenze

SELECTED REFERENCES: Krautheimer and Krautheimer-Hess 1970, vol.1, pp.147–48 and 152–53, and vol.2, plate 75; Pope-Hennessy 1993, p.90, fig.78

In his autobiographical *Commentaries*, Ghiberti writes: 'I also made in bronze the tomb of Messere Leonardo Dati, the general of the Dominican friars; he was a very learned man whom I portrayed from nature; the tomb is in low relief, it has an epitaph at the bottom.' The result is without question the most easily overlooked of all Ghiberti's works, a remarkable conception in which – even allowing for its rubbed state – the simplification of the forms in the extremely low relief engenders a mood of almost other-worldly abstraction, within which only the turn of the head to one side on the pillow interrupts the otherwise rigorous symmetry. When Ghiberti stated that he portrayed his subject 'from nature', he may have meant that he employed a death mask, or perhaps more simply that he knew Dati – who was born in 1360 and died in 1425 – in life, but in either case he has almost wholly purged the serene features of any sense of the suffering of death. DE

81

Lorenzo Ghiberti (c.1378–1455)

St Stephen

1425–29
Brass, with eyes of silver laminate,
height 268 cm

Chiesa e Museo di Orsanmichele, Florence

SELECTED REFERENCES: Krautheimer and Krautheimer-Hess 1970, vol.1, pp.97–100, vol.2, plates 12a, 14–17; Zervas 1996, pp.438–40, plates 29–32; Nannelli 2012, pp.327–29, figs 12–15

This *St Stephen* was – after the *St John the Baptist* and the *St Matthew* – the last of a trio of monumental sculptures in metal executed by Ghiberti for external niches on the church of Orsanmichele. Recent technical examination has revealed that all were cast in brass as opposed to bronze, presumably because the alloy was more easily worked on this scale. The patron was the Wool Guild, whose consuls recognised at a meeting on 2 April 1425 that they were lagging behind their rivals in other guilds, and determined to replace the statue in their niche. In 1427 and 1428 Ghiberti executed the new figure, which – as was customary – represents the first Christian martyr tonsured and wearing the robes of a deacon (he would originally have held a palm in his right hand). The gently swaying pose and the billowing folds combine to create an effect of tranquil harmony. DE

82

Donatello (c.1386–1466)

Putto with Tambourine

1429
Bronze with traces of gilding,
36.5 × 15 × 16.2 cm

Staatliche Museen zu Berlin,
Skulpturensammlung und Museum
für Byzantinische Kunst, 2653

SELECTED REFERENCES: Janson 1963, pp.65–75; Detroit 1985, p.123, no.22; Pope-Hennessy 1993, pp.86–87, figs 73–75; Berlin 1995, pp.130–31, no.1 (V. Krahn)

It is hard to resist the notion that Donatello must have made independent small bronzes, but not a single plausible candidate has survived. This electrifyingly animated figure of a putto standing on a cockle-shell in a dancing attitude and holding a tambourine in his left hand, which dates from 1429, is the next best thing. However, it was not originally an independent piece, and its location would have made it effectively impossible to see it either close up or in the round. It was one of a group of six (two others by Donatello remain in place) that formed part of the decoration of the font of the Baptistery of Siena Cathedral, on which Donatello collaborated with Ghiberti and the Sienese sculptors Jacopo della Quercia and Giovanni Turini (he also contributed figures of Faith and Hope as well as a relief of the Feast of Herod). DE

83

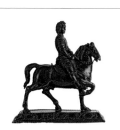

Filarete (Antonio Averlino)
(c.1400–c.1469)

Hector on Horseback

1456
Bronze, 27.5 × 25.5 × 12.5 cm

Museo Arqueológico Nacional, Madrid,
52173

SELECTED REFERENCES: Coppel 1987;
Berlin 1995, pp.134–35, no.3

When the present group was restored in 1987, the inscription 'OPUS ANTONIY 1456' (the work of Antonio 1456) was rediscovered, which confirmed its attribution to Antonio Averlino, also known as Filarete (lover of virtue). Filarete, sculptor of the gigantic bronze doors of Old St Peter's in Rome, which were incorporated into the façade of the new basilica, was also an architect of note and the author of an important if distinctly indigestible architectural treatise. This noble piece and his Dresden group of *Marcus Aurelius* after the antique, which is dated 1465 but may have been created in the 1440s, are among the first dated bronze statuettes of the Italian Renaissance. In 1456 Filarete was in Milan at the court of Francesco Sforza. While there he presumably came across the obscure and wholly unorthodox local literary tradition that Hector was the vanquisher of Hercules, and incorporated this in an inscription on the base of his group, alongside a series of diminutive classicising reliefs. DE

84.1–6

Attributed to Jan Borman the
Younger (active 1479–1520) and
cast by Renier van Thienen (active
1465–1498)

Six Weepers

1475–76
Bronze, heights 54.5–59 cm

Rijksmuseum, Amsterdam.
On loan from the City of Amsterdam,
BK-AM-33-B, C, E, F, G, H

SELECTED REFERENCES: London 2005A,
pp.26–31, no.2 (F. Scholten); Scholten 2007

These six standing figures originally formed part of a set of twenty-four on the tomb of Isabella of Bourbon, second wife of Charles the Bold (1433–1477), of which ten survive. The monument – commissioned by her daughter, Mary of Burgundy, in 1476 for St Michael's in Antwerp, where Isabella had died in 1465 – was a victim of the Iconoclastic Fury of 1566, and only these statues and her reclining bronze effigy (now in Antwerp Cathedral) still remain. Such accompanying mourners, traditionally known as Weepers, would originally have been arranged around the tomb-chest, and are often presumed to represent either living members of the family or forebears of the deceased. In the present case, the single crowned and bearded ruler holding an orb could conceivably be meant for an ancestor, but the remainder are all dressed in fashionable contemporary dress, and look for all the world like the sculptural equivalents of their counterparts in the paintings of Rogier van der Weyden and Hans Memling. DE

85

Donatello (c. 1386–1466)

Lamentation over the Dead Christ

c. 1455–60
Bronze, 32.1 × 41.7 × 6.3 cm

Victoria and Albert Museum, London,
8552-1863

SELECTED REFERENCES: Hartt 1974, p.423;
Detroit 1985, pp.138–39, no.32; Pope-Hennessy
1993, p.192, fig.187; London 2000, p.128,
no.52; London 2007, p.144, no.25

This powerfully emotional if fragmentary relief may be dated on stylistic grounds to the second half of the 1450s, both on account of the roughness of its surface textures and by virtue of the unflinching realism of the figure types. At that period, Donatello was resident in Siena, and the idea that this was a trial panel for the planned bronze doors of Siena Cathedral has much to recommend it. The conception of the subject, which was to prove immensely influential on such artists as Andrea Mantegna, focuses on the intensity of the Virgin's grief as she cradles her dead son in her lap, and adds to it by showing a whole range of variously theatrical and restrained reactions on the part of the standing figures of the three Marys and St John the Evangelist. Such was the length of Donatello's career that he subsequently executed an even later variation on this theme on one of the two pulpits in the church of San Lorenzo in Florence, a project he left unfinished at his death in 1466. DE

86

Circle of Antico, possibly
Gian Marco Cavalli (c. 1454 –
d. after 1508)

Mars with Venus and Cupid at the Forge of Vulcan

c. 1480–1500
Bronze, partially gilded and
silvered, diameter 42 cm

H. E. Sheik Saoud Bin Mohammed Bin Ali Al-
Thani, 04587 CH

SELECTED REFERENCES: Christie's, London,
11 December 2003, lot 20; Washington 2011,
p.150, fig.32

This spectacular relief, which was only rediscovered in the last decade, is directly dependent on the example of Antico (for whom, see cat. 92), and must have been made by an artist in his immediate circle in Mantua. The alluring suggestion has been made that the presence of a horse ('cavallo' in Italian) may be the punning signature of Gian Marco Cavalli, a goldsmith and metalworker documented in Mantua in the late fifteenth century, by whom no securely attributed works are known.

The scene represents a resplendently winged – and therefore on one level explicitly celestial – Venus and her son Cupid, who pricks her breast with a gold arrow, in the forge of her husband Vulcan, smith of the gods in classical mythology. Also present, however, is her adulterous lover, Mars, and the inclusion of two further cupids, one of whom unsheathes Mars' sword while the other fans the flames of the forge, is unquestionably intended to underline the erotic piquancy of the scene, which is also pointed up by the Latin hexameter below, which translates as 'Venus, Mars and Cupid enjoy themselves while Vulcan works'. DE

87

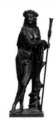

Circle of Giulio Romano
(c. 1500–1546)

Apollo or Hymen

First half of the sixteenth century
Bronze, 75.4 × 18 × 17.4 cm

Private collection, London

SELECTED REFERENCES: Berlin 1995,
pp.182–83, no.21 (V. Krahn)

A pen-and-ink drawing by Giulio Romano, who was Raphael's artistic heir and from 1524 the court painter of the Gonzaga in Mantua, represents an all but identical figure. The only significant iconographic difference is that the object he holds in his left hand is a flaming torch, but since both the left hand of this bronze and his staff are later replacements, he may originally have been similarly equipped. If so, then the figure may most plausibly be identified as Hymen, god of matrimony, rather than as Apollo the python-slayer, as the inclusion of a serpent spiralling around the supporting tree-stump might otherwise suggest.

In any event, there remains the uncertainty of whether Giulio's drawing is his design for a statue to be made by a specialist bronze-maker under his supervision, or rather his copy of an earlier piece he had admired in Mantua. If the former, then its style is decidedly old-fashioned, since it is directly inspired by the example of Antico, who executed a statuette of a cross-legged faun in a very similar pose after a celebrated antique prototype. DE

88

Giovan Francesco Rustici
(1475–1554)

St John the Baptist Preaching to a Levite and a Pharisee

1506–11
Bronze, 267 × 93 × 71 cm,
272 × 90 × 70 cm,
262 × 103 × 60 cm

Opera di Santa Maria del Fiore, Florence.
The restoration of the sculpture has been carried
out with sponsorship from the Association
'Friends of Florence'

SELECTED REFERENCES: Sénéchal 2009;
Florence 2010, pp.256–66, no.6; Minning 2010

This monumental ensemble, executed for the Merchants' Guild by Giovan Francesco Rustici between 1506 and 1511 as a replacement for a much earlier marble group representing the same subject above the north door of the Florentine Baptistery, remained in situ until its recent restoration. Rustici was a close associate of Leonardo da Vinci, and in Giorgio Vasari's biography of the artist of 1568, he stated that 'some believe, without knowing it for a fact, that Leonardo worked on it with his own hand, or at least that he assisted Giovanfrancesco with his advice and good judgement'. Arguably the most impressive aspect of the work is the way in which it combines a variety of echoes of the Florentine tradition, and explicitly of the achievements of Donatello in the previous century, with a new assurance and grandeur, both in the representation of the human figure and in what Vasari refers to as the 'heroic gravity' of the heads. DE

89

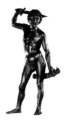

Leonhard Magt (d. 1532), cast by
Stefan Godl (doc. 1508–34)

Nude Warrior

1526
Bronze, height 53.3 cm

Universalmuseum Joanneum, Alte Galerie,
Graz, P 120

SELECTED REFERENCES: Berlin 1995,
pp.248–49, no.53 (F. M. Kammel); Becker
2005, p.100, no.31

For all that the heroic nudity of this martial figure and the elegant contrapposto of his stance reveal its creator's awareness of Italian Renaissance models, the overall and anatomically less than perfect effect could not be more quintessentially northern. This statuette, which was cast by Stefan Godl in 1526 after a model by Leonhard Magt, was produced as a direct result of a wager made in Augsburg the previous year by Archduke Ferdinand of Tyrol to the effect that Magt was the best sculptor in bronze in Germany. Magt satisfied the requirement that he should execute 'a full-length figure of a naked man, most skillfully and carefully proportioned, and in an elegant attitude with one elbow raised' to the letter, and it is a mark of the flawlessness of his cast that it appears to have required no afterwork. The decorative elaboration of the imitation textile of the octagonal base, of the curved scabbard, and even of the pubic hair, moustache and ringlets all conspire to endow the figure with an idiosyncratic and quirky charm. DE

90

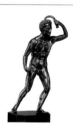

Andrea Briosco, called Riccio
(1470–1532)

Man with a Strigil

c. 1515–20
Bronze, height 31.9 cm

Collection of Mr and Mrs J. Tomilson Hill

SELECTED REFERENCES: New York 2008A,
pp.258–63, no.26

Unlike Antico, for example, Riccio was not in the habit of creating autograph variants of the same basic model, achieved by using an indirect lost-wax casting method. Yet both this figure and a fractionally smaller Warrior in a private collection are shown in what is in essence an identical pose, albeit with different attributes. The Warrior was once equipped with a separately cast – and now lost – sword and shield, whereas the present figure is equipped with an integrally cast ointment vase and strigil (for an actual strigil, see cat. 31). Strigils were employed in classical antiquity in the context of ablution rituals performed after physical exercise. After the anointing of the skin with oils, these and the accumulated sweat were scraped off to cleanse the body. Riccio would have been familiar with Pliny the Elder's account of a celebrated statue of the Apoxyomenos (strigillator) (fig. 44), but not with actual versions of the type, and the present figure is his imaginative response to the literary description. DE

91

Nigeria, Benin

Queen Mother Head

Early sixteenth century
Copper alloy, height 51 cm

National Museum, Lagos, 79.R.17.
National Commission for Museums
and Monuments, Nigeria

SELECTED REFERENCES: London 1982,
no.76 and related bibliography

In Benin the tradition of casting heads for altars dedicated to the deceased mother of a king is said to have been instigated by the early sixteenth-century ruler Esigie, who gave his mother the formal title and status of Queen Mother. Here the Queen Mother wears a ceremonial high collar and tall, pointed headdress comparable to examples of later costumes that have survived. A head in the British Museum shares similar features: both have four scars on each eyebrow separated by two bands inlaid with iron, which is also applied to the pupils. A join in the base of this fine cast shows clearly that the molten metal poured into the mould was insufficient, meaning that the casting had to be completed with a second pour that did not fuse completely with the first. This is one of the most famous heads from Benin, striking for the subtly elegant modelling of the features that are combined with highly stylised elements, their textures contrasting palpably with the skin. CT

92

Pier Jacopo Alari-Bonacolsi,
called Antico (c. 1460–1528)

Bust of a Youth

c. 1520
Bronze with olive-brown patina
under black lacquer patina under
oil gilding, height 56.5 cm

The Princely Collections, Vaduz-Vienna,
SK 535

SELECTED REFERENCES: Frankfurt 1986,
pp.257–61, no.58; Paris 2008B, p.86, no.4

Antico, as the name by which he came to be known suggests, was one of the most committed Renaissance devotees of the *all'antica* (antique) style. A spectacularly gifted craftsman, his talents were amply recognised by the ruling Gonzaga family in Mantua. The overwhelming majority of his production was of small-scale partially gilt bronzes after much admired ancient statues. In contrast, this bronze is one of a handful of busts from his own hand, and equally combines a very dark patina with the contrasting colour accents accomplished through the use of gilding and silvered eyes.

It has been proposed that it may be identical to a head with bust of Alexander the Great, of bronze, fairly large' that is listed among the contents of the 'studio delle antiquità' (study of antiquities) of Duke Federico II Gonzaga in 1542. The beauty of the young Alexander was universally remarked upon, and Plutarch specifically referred to his upward gaze and the turn of the head to the left. If the subject is indeed Alexander, then the extremely prominent and otherwise distinctly unexpected knotting of the drapery at the base might be explained as a witty allusion to the story of the cutting of the Gordian knot. DE

93

Attributed to Desiderio da Firenze
(doc. 1532–1543)

Satyr and Satyress

c. 1532–43
Bronze, height 27.5 cm

Musée National de la Renaissance,
Château d'Ecouen, E.Cl. 2752 a, b

SELECTED REFERENCES: Jestaz 1983; London
1983, pp. 377–78, no.24; Padua 2001,
pp. 186–87, no.45 (F. Pellegrini); Jestaz 2005,
pp. 162–65, figs 71–73

The authorship of this arresting group, which was uncoupled in the nineteenth century and only reassembled as recently as the 1980s, when it was realised that its constituent parts fitted together, is by no means certain. Neither the work's invention nor its finish support the notion that it is by Riccio, but it does seem to derive from his immediate circle, which could suggest Desiderio da Firenze, whose only absolutely securely documented work is the *Voting Urn* in the Museo Civico in Padua. In any event, there can be little doubt that its explicit subject-matter was inspired by Marcantonio Raimondi's *Modi*, a series of prints of sexual positions based on drawings by Giulio Romano executed in Rome in the 1520s, whose fifteenth position appears to be the specific source for the acrobatics represented here. It is impossible to gauge how common such groups were, since they would have been prime candidates for prudish destruction, but in a post-mortem inventory of 1559 a Parmese collector called Francesco Baiardo is recorded as owning 'a satyr and a satyress of metal who join themselves together'. DE

94

Andrea Briosco, called Riccio
(1470–1532)

Satyr and Satyress

c. 1510–20
Bronze, 24 × 16.5 × 17.9 cm

Victoria and Albert Museum, London.
Presented by the Art Fund, A.8-1949

SELECTED REFERENCES: New York 2008A,
pp.98–103, no.1 (P. Motture)

Riccio was arguably the most extravagantly talented maker of small bronzes active at the end of the fifteenth century and the beginning of the sixteenth. The crackling energy of his surface textures, achieved through careful finishing and hammering, allowed him to explore a remarkable emotional range. In such pieces as his celebrated *Shouting Horseman* (also in the Victoria and Albert Museum) he captures the bestial violence of battle, while here on the contrary he invites us to intrude on the tender intimacy of a satyr and satyress, creatures conventionally associated – as in cat. 93 – with priapic excess. While the satyr leans across to caress his beloved's chin with one hand and stretches the other round her waist, his companion puts her right arm round his far shoulder and lets her hairy leg slide between his. These two lovers are seated comfortably one beside the other, and their contentment is perfectly captured. DE

95

School of Fontainebleau

Pair of Stirrups

c. 1515–1525
Gilded bronze, 15 × 29 cm

Musée National de la Renaissance, Château
d'Ecouen, E.Cl. 21108 a, b

SELECTED REFERENCES: Crépin-Leblond
1997; Ecouen 2010, p.96, no.113

A spectacular instance of the extravagant care and attention occasionally lavished upon ostensibly everyday pieces of equipment, these stirrups were never actually intended to be used other than ceremonially, as their gilding makes clear. They are decorated with salamanders, which during the Renaissance were reputed to be able to live in fire and were in addition the personal emblem of King François Premier of France (whose name is inscribed upon them, together with the motto 'NVTRISCO ESTINGO', meaning 'I nourish and extinguish'). The fact that they are first recorded in the treasury of the Abbey of Saint-Denis on the outskirts of Paris, where French royalty were customarily buried at this period, and which indeed houses François's tomb, powerfully suggests that – although they were very possibly created at an earlier date – they may have been among the accoutrements that accompanied him to his grave in 1547. There is no evidence concerning either the authorship of their design or who was responsible for their manufacture, but the exquisite quality of both the invention and their workmanship is triumphantly apparent. DE

96

Benvenuto Cellini (1500–1571)

Saluki Dog

1544–45
Bronze, 19.6 × 27 cm

Museo Nazionale del Bargello, Florence,
19 b. Istituti museali della Soprintendenza
Speciale per il Polo Museale Fiorentino

SELECTED REFERENCES: Avery and Barbaglia
1981, plate XVI, p.91, no.40; Pope-Hennessy
1985, pp.225–26, and plate 122

This enchanting relief of a saluki, a breed of dog extremely popular at the Medici court in Florence, is recorded in a note written by Cellini on 25 August 1545, in which it is valued at ten gold ducats, and described as 'a dog in bas relief, about half a *braccia* in size, which dog was made as a trial to test the clays to be used for the casting of the Perseus, and which was had by His Excellency'. Its destination is confirmed by its appearance in an inventory of Duke Cosimo de' Medici's possessions dating from 1553. Cellini's prowess as an *animalier* had already been proved by the menagerie on display in his relief of the *Nymph of Fontainebleau*, now in the Louvre, but the effect on this altogether more intimate scale is very different, and makes it almost impossible to doubt that this is a portrait of a particular and much loved hound. DE

97

Germain Pilon (doc. 1540–1590)

**Lamentation Over
the Dead Christ**

c. 1583–84
Bronze, 47.6 × 82.2 × 5.8 cm

Musée du Louvre, Paris. Département des
Sculptures, LP 44

SELECTED REFERENCES: Beaulieu 1990;
Brisbane 1988, pp.46–47, no.5; Paris 2008C,
pp.94–97, no.10

It was the French king, François I, who lured Benvenuto
Cellini and other Italian artists to his court at
Fontainebleau, and thus set in train the transformation of
his country's native school. Pilon was one of the most
gifted members of the golden generation of sculptors
active in France from the middle of the sixteenth century
onwards who knew how to respond to these influences
to forge a new tradition. In this, his only known relief,
which originally formed part of the tomb of the
chancellor of France, René de Birague (1506–1583) (see
fig. 82), in the church of Sainte-Catherine-du-Val-des-
Ecoliers in Paris, he looked to two related etchings of the
same subject by the Italian artist Parmigianino
(1503–1540) for inspiration, above all for the figure of
the dead Christ. Within the deliberately cramped yet
entirely legible composition, Pilon ingeniously layers his
low relief to isolate a foreground group comprising
Christ, St John the Evangelist at his head, and Mary
Magdalene at his feet. DE

98

Peter Flötner (c. 1485–1546),
cast by Pancraz Labenwolf
(1492–1563)

Apollo Fountain

1532
Brass, height 100 cm

On long-term loan to the Fembohaus,
Nuremberg. Lent by the Museen der Stadt
Nürnberg, Gemälde- und Skulpturensammlung,
PL 1206/PL 0024

SELECTED REFERENCES: New York 1986, p.439,
no.248; Berlin 1995, pp.250–51, no.54
(F. M. Kammel)

The present elaborate ensemble, which was cast in
numerous sections for which Flötner must have made
wood and wax models, is one of the supreme
achievements of the metalworker's art in the Renaissance
in Germany. Although a related preliminary drawing
for the fountain dated 1531 exists in a private collection,
and the work itself bears the date 1532 in appropriately
Roman numerals on a tablet on its base, its authorship
was only established through the publication of the
correspondence between the Bishop of Trento, Bernhard
von Cles, and Christoph Scheurl in Nuremberg, in which
the sculpture is discussed because the bishop coveted
a version of it. Executed for the local Guild of Archers,
the fountain represents a spectacular act of northern
obeisance to the classical modes of the Italian
Renaissance, in this instance filtered through the prints
of the Venetian Jacopo de' Barbari, who had settled in
Nuremberg. Paradoxically, however, and for all the
figure's classical grace and the putti and sea monsters
surrounding him, the *Apollo Fountain* could never be
mistaken for an authentically Italian production. DE

99

Benvenuto Cellini (1500–1571)

Modello for Perseus

c. 1545–54
Bronze with traces of gilding,
height including base 85.5 cm

Museo Nazionale del Bargello, Florence,
359B. Istituti museali della Soprintendenza
Speciale per il Polo Museale Fiorentino

SELECTED REFERENCES: Avery and Barbaglia 1981,
plates XXX–XXXII, p.95, no.50; Pope-Hennessy
1985, pp.169–70, and plates 89–90, 92, 96;
Cambridge, Mass. 1996, pp.15–17, fig.1

Benvenuto Cellini's monumental bronze statue of *Perseus*
in the Loggia dei Lanzi in Florence is without question his
masterpiece, and at the same time one of the greatest
sculptures of all time. Signed and dated 1553, it
represents the nude hero holding aloft the decapitated
head of the gorgon Medusa, her naked corpse at his feet.
Unsurprisingly, given the importance of the commission,
the sculpture was preceded by a number of models in
various media, including the present piece and an earlier
wax of comparable dimensions, also in the Bargello. The
major differences between the solution envisaged here
and the final work concern the way the hero's left leg
projects outwards, and the manner in which his head
looks down and away to his left. The fact that this piece
has been partially gilded and made to serve as a table
fountain demonstrates how something that started life
as a working tool could end up as a work of art. DE

100

Pierino da Vinci (1530–1553)

**The Death of Count
Ugolino della
Gherardesca and His Sons**

1548–49
Bronze with brown patina and
traces of blackish-brown lacquer,
65.4 × 46.5 cm

The Princely Collections, Vaduz-Vienna, SK 1597

SELECTED REFERENCES: Fenton 1988, pp.68–87;
Penny 1992, vol.1, pp.95–100, nos 72–73;
Avery 2001

The story of Count Ugolino della Gherardesca, who was
locked in a tower with his sons and left to starve to death
at the behest of the Archbishop of Pisa, is recounted in
Canto XXXIII of Dante's *Inferno* in one of the greatest
narrative set-pieces of the entire *Divine Comedy*. By the
nineteenth century the theme was a common one, but
it was highly unusual during the Renaissance, and the
inscription 'DANTE XXXIII INFERNO' on the riverbank here
would have helped identify the subject.

Pierino, Leonardo's phenomenally precocious but
tragically short-lived nephew, was the protégé of Luca
Martini (1507–1561), a courtier who was made
provveditore of Pisa by Cosimo de' Medici in 1547, a
circumstance that must explain this commission. The
piece itself, which used to be inset into a statue base at
Chatsworth, and of which there also exist versions in
other media, was discussed at length in Vasari's biography
of Pierino, and bears Martini's coat of arms on its only
recently revealed reverse. It is a *tour-de-force* of shallow
relief, in which the graceful mortal protagonists occupy
an intermediate realm between the flying personification
of Famine (specifically referred to by Dante) above and
the river god representing the Arno below. DE

101

Rome

**Bacchants Riding
on Panthers**

c. 1550
Bronze, each 93 × 80 cm

Private collection

SELECTED REFERENCES: Sotheby's, London, 8 July
2002, lot 109; Amsterdam 2003, p. 16, figs 8–9

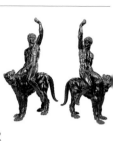

The authorship of these two impressive groups has been
much debated, but remains unresolved. When in the
collection of Adolphe de Rothschild in the nineteenth
century, they were given to Michelangelo, which is a clear
indication of the high esteem in which they were held at
that time. In the mid-twentieth century, they were
attributed to Alessandro Vittoria (for whom, see cat. 106)
which would place them in Venice. When they appeared
at auction in 2002, they were catalogued as North Italian
while more recently still they have been dated to the
1550s and implausibly associated with the northern
sculptor Willem Danielsz. van Tetrode (for whom, see cat.
104), an associate of Guglielmo della Porta in Rome
at that time. Nevertheless, both this time-frame and
context seem perfectly reasonable, which means the
old association with Michelangelo – if understood in
the most general terms – does indeed make sense.

The fact that these two muscular nude figures, who
must originally have been brandishing something in their
raised hands, are riding panthers confirms that they are
intended to represent attendants of Bacchus, although
this does not clarify either their original context, or
whether they once formed part of some larger ensemble.
DE

102

Nigeria, Benin

Pair of Leopards

Mid-sixteenth century
Brass, length 69 cm

National Museum, Lagos, 52.13.1–2.
National Commission for Museums
and Monuments, Nigeria

SELECTED REFERENCES: London 1982,
nos 81–82 and related bibliography

Because leopards enjoyed associations of royal power and
authority in Benin tradition, they held an important place
within the court of the Oba. Captured as cubs, leopards
were domesticated and formed part of the king's
menagerie. Royal mandate decreed that only the Oba
was permitted to slay leopards in sacrificial ceremonies.
Visual evidence on plaques indicates that cast leopards
such as these were placed on royal ancestor altars. Some
served as aquamanilia, vessels for water, which would
pour out of the nose and be refilled through the top of
the head. In this magnificent pair, keen observation and
heavily stylised features such as ears, menacing teeth and
spotted fur markings are combined to striking effect. CT

103

Nigeria, Benin

The Leopard Hunt

Sixteenth century
Brass, 55.2 × 39.2 × 3.9 cm

Staatliche Museen zu Berlin,
Ethnologisches Museum, III C 27485

SELECTED REFERENCES: Fagg 1963, plate 23;
Koloss 1999, no. 24; Vienna 2007, no. 236

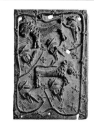

Reminiscent of a page from an illuminated manuscript, this brass plaque depicts a leopard hunt. Ascribed with a small number of other reliefs to an anonymous artist termed 'the Master of the Leopard Hunt', the work abandons single-point perspective and instead adopts a view from above, across the whole field. Within a border of stems and flowers, five Portuguese hunters corner two leopards and hold them by their legs – and, in one case, by the tail. Delicate trefoil motifs are incised into the background to create a rich layering of pattern and subtle ranges of depth on the surface of the cast metal, so that, for example, three-dimensional effects such as the leopards' markings are modulated from high relief to incised pattern. The leopard's beauty and ferocity are linked to the attributes of kingship. CT

104

Willem Danielsz. van Tetrode
(c. 1525–1580)

Hercules Pomarius

1562–67
Bronze, height 39.9 cm

Abbott-Guggenheim Collection

SELECTED REFERENCES: Amsterdam 2003,
pp. 33–34, and p. 37, fig. 39; Radcliffe and
Penny 2004, pp. 136–41, no. 22; Schwartz et al.
2008, pp. 144–45, no. 74

This representation of Hercules, who holds his club in his right hand and the apples he stole from the Garden of the Hesperides concealed behind his back in his left, is known in four autograph versions, of which the present example is generally deemed the finest by virtue of its being a seemingly flawless cast that has been worked up in the metal. Although there is no absolute proof that the inventor of the model was Tetrode, a Netherlander who spent a number of years working in Italy, it is widely believed that it corresponds to a sculpture and a piece-mould of a 'great Hercules' by Tetrode owned by the Delft goldsmith Thomas Cruse in 1624; stylistic parallels have also been adduced with two documented bronzes by Tetrode, now in the Bargello in Florence, both after the ancient Farnese Hercules. The supremely confident stance of the muscle-bound hero, with his legs wide apart, appears to have been inspired by earlier Italian prototypes, and was in its turn to prove immensely influential, above all in Tetrode's native land. DE

105

Ponce Jacquiot (active 1553–1570)

Venus (?) Extracting a Thorn from Her Foot

c. 1560–70
Bronze, 25.3 × 23.5 × 12.5 cm

Victoria and Albert Museum, London,
A.13-1964

SELECTED REFERENCES: Berlin 1995, p. 414,
no. 135; Paris 2008C, pp. 80–83, nos 5a and 5b
(G. Bresc-Bautier)

Ponce was active in Rome in the 1550s alongside his compatriot Barthélemy Prieur (see cat. 115), and then back in France worked on the tombs of Kings François I and Henri II for the Abbey of Saint-Denis outside Paris. The present piece is the only bronze statuette that is securely attributed to him, and may possibly date from his Italian period, since in 1557 his patron there, Cardinal Giovanni Ricci, was recorded as having been given a pontifical licence to export what appears to have been this very work. Its design is an unquestionable if loose homage to an invention of Raphael's, which in its turn was inspired by the ancient *Spinario* (Palazzo dei Conservatori, Rome). Raphael's *Spinaria*, showing Venus removing a thorn from her foot, was widely disseminated in the form of an engraving by one of his acolytes. Ponce retained the motif but modified the pose, and at the same time failed to endow the nude with any identifying attribute to confirm that she is indeed the Goddess of Love. A fractionally larger but in all essentials identical and no less exquisite terracotta version of the figure, in the Louvre, may have served as the model for the bronze. DE

106

Alessandro Vittoria (1525–1608)

Jupiter

c. 1580–85
Bronze, height 72 cm

Musée National de la Renaissance, Château
d'Ecouen, Ec. 23

SELECTED REFERENCES: London 1983,
p. 387, no. 36; Berlin 1995, pp. 302–03,
no. 85 (M. Leithe-Jasper); Trento 1999,
pp. 380–81, no. 85 (M. Leithe-Jasper)

Alessandro Vittoria was the most prominent Venetian sculptor of the latter part of the sixteenth century. He is perhaps most admired today for his compellingly animated portrait busts in terracotta and marble, but he was also responsible for a handful of remarkable celebrations of the male and female nude in the form of bronze statuettes. These include a standing male figure, variously identified as a *St Sebastian* and a *Marsyas*, of which there is a signed cast in the Metropolitan Museum of Art in New York, as well as this elegantly sinuous standing *Jupiter* (his identity confirmed by the thunderbolt he clutches to his breast), and a *Venus* or *Diana* in Berlin. In view of the fact that the Berlin goddess's height is identical to that of the present piece, it would be tempting to assume that they were created as a pair, were it not for the stylistic differences between them and also the way they both look to their left and consequently not at each other. DE

107

Giambologna (1529–1608)

Mercury

After 1580
Bronze, height 72 cm

Museo Nazionale del Bargello, Florence,
210. Istituti museali della Soprintendenza
Speciale per il Polo Museale Fiorentino

SELECTED REFERENCES: Avery 1987,
pp. 127–28, plate 127, and p. 261, no. 73;
Gasparotto 2005, pp. 72–79; Florence 2006,
pp. 266–67, no. 56 (B. Bertelli)

Giambologna executed five closely related representations of Mercury, all of which have in common the conceit of showing the nude messenger of the gods – identified as such by the caduceus he holds in his left hand and by his winged helmet and shoes – balancing on one foot and seemingly flying through the air. The earliest is a model connected with a commission of 1563 for a never-executed large-scale statue for a Bolognese patron. A year later a version of Mercury 'as big as a boy of 15' was sent from Florence to the Emperor Maximilian II; it may be the bronze now in a Swedish private collection. A smaller variant, now in Naples, was sent to the Duke of Parma, Ottavio Farnese, in 1579, while a full-size and somewhat different treatment, also in the Bargello, appears to date from 1580. The present version corresponds to a bronze statuette in Vienna inscribed with the sculptor's initials and another in Dresden that arrived there in the spring of 1587, and this invention appears to be Giambologna's last word on the subject. With the figure's apparent weightlessness, topped by the right index finger pointing heavenwards, this solution surpasses all the others in its exultant evocation of flight. DE

108

Germain Pilon (doc. 1540–1590)

Catherine de' Medici

1580–1600
Bronze, 87 × 58.5 × 30.5 cm

The Royal Collection, RCIN 20796

SELECTED REFERENCES: Marsden 2006;
Paris 2008C, pp. 98–99, no. 11 (J. Marsden)

Catherine (1519–1589) was the daughter of Lorenzo de' Medici, Duke of Urbino, who was immortalised in highly idealised form by Michelangelo in the Medici Tombs in San Lorenzo in Florence, as well as being the wife of Henri II of France, the mother of three kings, Francis II, Charles IX and Henry III, and the mother-in-law of Mary, Queen of Scots. This chillingly remote portrait bust, which appears to be based upon the head of the recumbent marble effigy of the queen in the Abbey of Saint-Denis outside Paris, is a stunning evocation of the power and determination of this formidable woman, who was widowed in 1559 and spent the rest of her life trying – ultimately unsuccessfully – to safeguard the dynastic succession. The sitter's head and bust are surrounded by the extraordinary carapace-like arrangement of her heavily bejewelled costume, with its large ruff and spiralling arm-pieces, while the whole is topped by her crown, encrusted with fleurs-de-lys. DE

109

Giambologna (1529–1608)

Nessus and Deianira

After 1576
Bronze, height 42.2 cm

Private collection

SELECTED REFERENCES: Avery 1987,
pp. 144–45, plate 146, and pp. 263–64,
no. 90; Gasparotto 2005, pp. 126–27;
Florence 2006, pp. 170–71, no. 6 (A. Scherner)

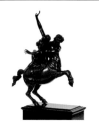

Before Giambologna, the subject of the centaur Nessus abducting Hercules' wife Deianira was rare in Renaissance art. Yet in his hands it acquires an inevitability that subsequent treatments (see cat. 119) have done nothing to dispel. It is an image of triumph, both in terms of the movement represented and in terms of the sculptor's gravity-defying virtuosity. The centaur is shown boldly rearing up, in a pose clearly inspired by the antique marble horses of the Quirinal in Rome. He envelops Deianira with his left arm and binds her around with her discarded drapery. She writhes in a complicated attitude that is the essence of what was known in the period as *contrapposto*, her arms flailing and her face contorted by awareness of her plight. Nessus' death by Hercules' arrow, and his subsequent posthumous revenge on the hero by means of his poisoned shirt, lie in the future. Giambologna designed three main variations in bronze on the theme, differentiated in terms of size and composition, of which this is both the most successful and the most reproduced. DE

110

Antonio Susini (1558–1624),
after a model by Giambologna
(1529–1608)

**Sleeping Nymph
with Satyr**

Late sixteenth–early seventeenth
centuries
Bronze, height 21.6 cm

The Robert H. Smith Collection

SELECTED REFERENCES: Radcliffe and Penny 2004,
pp. 192–95, no. 32 (M. Camberari)

The subject of a sleeping female figure – whether an otherwise unidentified nymph or Venus accompanied by Cupid – both alone and spied upon by another figure, often a satyr, is commonly found in Italian painting from the early sixteenth century, and is here translated into sculptural form. In the present group, the sleeping female figure is directly based upon a classical marble statue now in the Vatican and variously identified as Ariadne or Cleopatra, but Giambologna's idea of showing her on a chaise-longue is entirely novel. It is uncertain whether the present arrangement was the original one, or conversely whether the satyr was a subsequent addition. 'A nude woman asleep' is recorded in 1584, while the version of this group now in Dresden is documented in 1587. The diminutive scale of the jaunty satyr arguably supports the notion that his inclusion was an afterthought, and some scholars have attributed him to Adriaen de Vries, who was attached to Giambologna's workshop at the time. DE

111

Giambologna (1529–1608)

Turkey

c. 1567–70
Bronze, 59 × 47.7 cm

Museo Nazionale del Bargello, Florence,
109B. Istituti museali della Soprintendenza
Speciale per il Polo Museale Fiorentino

SELECTED REFERENCES: Avery 1987,
pp. 154–45, plate 158, and p. 267, no. 123;
Gasparotto 2005, pp. 91–92; Florence 2006,
pp. 249–52, no. 50 (D. Heikamp)

This *Turkey* is by far the most arresting of a group of bronzes of birds made by Giambologna for a grotto in the gardens of the Medici villa at Castello outside Florence. In May 1567 the sculptor wrote a letter asking permission to take advantage of the warm weather to dry out the clay models for them, but it is not known precisely when they were installed. Not least in view of the fact that Giambologna is universally renowned for the matchlessly smooth finish of his small bronzes, there is something particularly exhilarating about the extraordinary freedom of this piece, in which he has responded with such seemingly spontaneous delight to the bird's exotic appearance (the first turkey had only reached Europe as recently as 1511). In its original setting, its wattled and feathered surface textures could only have been seen at a distance, but now the fact that they may be enjoyed at close range only adds to their appeal. DE

112

Pietro Tacca (1577–1640)

Il Porcellino

1620–33, nineteenth-century base
Bronze, height 125 cm

Musei Civici Fiorentini – Museo Stefano
Bardini, MCF-B.A. 1916-45.a

SELECTED REFERENCES: Carrara 2007,
pp. 136–39, ill. p. 137; Nesi 2011

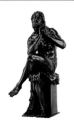

Pietro Tacca's *Porcellino*, an affectionate diminutive that literally means 'little piglet', is actually a full-scale bronze replica of an ancient marble of a wild boar from the Florentine grand-ducal collections, now in the Uffizi. In all probability, the classical model itself is a later Roman copy of a Hellenistic bronze dating from the third century BCE, which may well have been part of a larger group of some kind, conceivably narrating an episode from the story of the hunt for the Calydonian boar. Tacca's bronze formed the centrepiece of a fountain, and he added an elaborate base of plants and creatures, a number of which appear to be cast from the life. For centuries, the fountain was located in the Mercato Nuovo, near the Piazza della Signoria, where it soon became one of Florence's best-loved landmarks; the boar's muzzle gleams as a result of having been stroked by generations of admirers. Likewise, wear and tear to the original base meant that it had to be replaced by a copy in the nineteenth century. DE

113

Adriaen de Vries (1556–1626)

Forge of Vulcan

1611
Bronze, 47 × 56.5 × 6 cm

Bayerisches Nationalmuseum, Munich,
69/57.1-2

SELECTED REFERENCES: Berlin 1995,
pp. 448–49, no. 156; Amsterdam 1998,
pp. 187–89, no. 27

The subject of this relief can hardly have failed to have a particular resonance for one of the greatest sculptors in bronze who has ever lived. It therefore comes as no surprise that De Vries proudly signed this magnificent piece and dated it 1611 on the base of the anvil around which Vulcan, the smith of the gods, and four of his assistants form a semicircle. The variety of their attitudes and expressions creates an almost cinematic effect of movement and the passage of time, with their muscular nude bodies representing the age's ideal of masculine beauty. Despite the overwhelming emphasis on the figures in the foreground, the presence of Venus and Cupid beyond, who have come to collect the armour of her mortal son Aeneas, explains the action. Further exquisitely rendered details include the discarded paraphernalia in the foreground and the licking flames of the hearth at the left margin.

It is a mark of the timelessness of this invention that Rodin's copy of the composition – which exists in bronze and plaster – was until recently assumed to be his own independent creation. DE

114

Adriaen de Vries (1556–1626)

Seated Christ

1607
Bronze, 149 × 78 × 71 cm

The Princely Collections, Vaduz-Vienna,
SK 515

SELECTED REFERENCES: Amsterdam 1998,
pp. 162–65, no. 19

Adriaen de Vries (or Fries), who was born in The Hague but learnt his craft in Italy, was the greatest sculptor of the generation after Giambologna. He worked almost exclusively in bronze, and although his work is less technically flawless than that of his first master and fellow Netherlander Giambologna, he is increasingly revered for the energy, animation and fluidity of the surfaces of his sculptures. The present work, which is signed and dated 1607, bears a second inscription that reveals it was commissioned by Karl von Liechtenstein, a prominent courtier in the Prague of the Emperor Rudolf II who had converted to Catholicism in 1599, presumably for the parish church of Feldsberg (Valtice). It represents Christ seated with his hands joined in prayer, and is directly based on Dürer's woodcut for the title page of his *Large Passion*. Nevertheless, although the pose is virtually identical, the absence of the Crown of Thorns, the flails and the mocking soldier holding up a reed in the print mean that – unlike Dürer's – De Vries's *Christ* is not fixed at any particular moment in time. DE

115

Barthélemy Prieur (c. 1536–1611)

Acrobat Performing a Handstand

1600–30
Bronze, height 30 cm

Lent by the Syndics of the Fitzwilliam Museum, Cambridge, M.21-1979

SELECTED REFERENCES: Berlin 1995, pp.424–25, no.142; London 2002B, no.26

Prieur was in Rome as early as the 1550s, before moving to Turin in 1564 as court sculptor. Back in France in 1571 and recognised as a bronze specialist, he worked on funerary monuments and other major projects, but suffered as a protestant as a result of the Edict of Nemours (1585), which revoked religious freedom. From 1594 onwards, however, Prieur was back in favour and produced portraits and other works for and of the royal family. Yet it is for his smaller bronze statuettes – not least of genre subjects such as a *Woman Milking a Cow* – that Prieur is now most admired, in spite of the fact that his responsibility for them has only relatively recently been established. In the case of this *Acrobat*, which is known in a number of casts (Prieur was a master of indirect lost-wax casting), its free-flowing movement and bold weightlessness mean it is a more than worthy rival to Giambologna's incomparably more celebrated *Mercury*. DE

116

Hubert Gerhard (c. 1540/50–1620)

Pug

1600/10
Bronze, 45 × 23 × 65 cm

Museumlandschaft Hessen Kassel, Sammlung Angewandte Kunst, B VIII.198

SELECTED REFERENCES: Berlin 1995, pp.466–67, no.165 (U. Becker)

Gerhard, who was successively active in Augsburg, Munich and Innsbruck, was the supreme exponent of the late Renaissance sculptural tradition in southern Germany and Austria. His masterpiece is arguably the monumental *St Michael Defeating Lucifer* on the façade of the Michaelskirche in Munich, but here he reveals himself as a perhaps unexpectedly irresistible animal sculptor. The idea that he was responsible for this *Pug*, as indeed for two further, somewhat larger bronzes of dogs in the Bayerisches Nationalmuseum in Munich, is based upon stylistic comparisons with his known works as opposed to documentary evidence, but it seems perfectly reasonable. In any event, the sheer quality and charm of this wonderfully lumbering baggy-skinned creature rather than its authorship explain its inclusion in the present menagerie. At the time, the Chinese origins of pugs made them particularly prized as exotic imports, not least at the court of the Wittelsbachs in Munich. DE

117.1–2

Antonio Susini (1558–1624), after models by Giambologna (1529–1608)

Lion Attacking a Bull
Lion Attacking a Horse

First quarter of the seventeenth century
Bronze, 24.1 × 27.9 cm and 20.3 × 27.3 cm

Private collection

SELECTED REFERENCES: Fogelman, Fusco and Cambareri 2002, pp.177–89, no.23

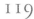

Giambologna's extraordinary gifts as a creator of *animalier* bronzes were given full rein in this pair of groups. The prototype for the *Lion Attacking a Horse* was a fragmentary marble group (Palazzo dei Conservatori, Rome), which Michelangelo is reputed to have described as 'most wonderful'. It was restored in 1594 by the Milanese sculptor Ruggiero Bescapè, with the horse's head bowed forward in surrender. A rare variant by Giambologna shows a very similar solution, but here he imagined a far more dramatic reconstruction, in which the horse's neck is twisted back in agony, and its head is racked by pain, an attitude that was to inspire both Stubbs and Picasso in *Guernica*. The *Lion Attacking a Bull*, which is clearly designed as its pendant, also has an antique prototype, albeit a less celebrated one. Giambologna's achievement was to make both groups even more intensely violent than their models, and also to forge them into a harmonious but at the same time savage pairing, not least by making the two lions virtually – but not quite – identical. DE

118

Ferdinando Tacca (1619–1686)

Hercules Wrestling with Achelous in the Guise of a Bull

c. 1650
Bronze, 58.4 × 57.2 cm

Private collection, courtesy of Pyms Gallery, London

SELECTED REFERENCES: Radcliffe 1976; Mann 1981, p.47, no.S 124, and plate 32

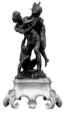

The present group has often been assumed to portray Hercules with the Cretan bull, but must in fact represent Hercules in combat with Achelous, a river god who metamorphosed into a bull and whose horn he broke off. The horn was subsequently offered to Ceres and transformed into the cornucopia or horn of plenty. The direct source of inspiration for this and a number of other bronzes featuring the same protagonist on the same scale is Giambologna's significantly earlier series of groups of the Labours of Hercules. Their attribution to Ferdinando Tacca, son of Pietro (for whom, see cat. 112), is now universally accepted, and the openness of the composition is indeed strikingly different from the more compact solutions favoured by Giambologna. A pair of gilt-bronze versions of the same model and Ferdinando's group of Hercules and Nessus is in the Wallace Collection, London. This stunning cast, the finest known, is inscribed 'No. 302' and recorded under that number in the 1713 inventory of the bronzes belonging to King Louis XIV of France. DE

119

Adriaen de Vries (1556–1626)

Hercules, Nessus and Deianira

1622
Bronze, 128 × 93 × 33 cm

Nationalmuseum, Stockholm, NMDrh Sk 65

SELECTED REFERENCES: Larsson 1992, p.92, no.33; Amsterdam 1998, pp.232–33, no.39

This ambitious and dramatic group is signed and dated 1622. Both its scale and the inclusion of a ewer designed to have water pouring from it support the notion that it was intended from the outset to serve as a fountain sculpture for a garden setting, but it is not known for whom it was originally made. Since the centaur Nessus was ferrying Hercules' wife Deianira across the River Euenus when he tried to ravish her and was killed by the hero with a poisoned arrow, the subject is an eminently suitable one for such a watery context.

The obvious point of departure for such a representation would have been Giambologna's two-figure group of *Nessus and Deianira* (cat. 109), and De Vries has clearly borrowed the centaur's springing attitude from his model, but in all sorts of other respects he has sought to distance himself from it. This is particularly apparent in the openness of the composition, in the addition of the figure of Hercules, whose pose is inspired by the classical *Borghese Gladiator* in the Louvre, and indeed by the inclusion of a characteristically brilliantly observed hound at the base. DE

120

Gian Francesco Susini (1585–1653)

The Abduction of Helen by Paris

1627
Bronze, 67.9 × 34.3 × 33.7 cm (with base)

The J. Paul Getty Museum, Los Angeles, 90.SB.32

SELECTED REFERENCES: Fogelman, Fusco and Cambareri 2002, pp.190–99, no.24

Gian Francesco Susini was the nephew of Giambologna's gifted associate Antonio Susini, and evidently learnt his craft from both of them. There is therefore a sense in which he represents the third generation of an ongoing sculptural tradition. The present group, signed and dated 1627, is an almost identical variant of a likewise signed and dated group of the previous year, now in Dresden. The only significant difference is that the earlier piece includes in relief on the rocky base a representation of Aeneas fleeing Troy with his father Anchises and son Ascanius, and thus makes it clear that the principal subject is the abduction of Helen. The work's obvious source is Giambologna's three-figure marble group of the *Rape of the Sabine* in the Loggia dei Lanzi in Florence, of which there also exist versions in bronze, the main difference being the even greater openness and spiralling energy of the composition. DE

121

Alessandro Algardi (1598–1654),
cast by Domenico Guidi
(1625–1701)

St Michael Overcoming
the Devil

c. 1647
Bronze, height 83 cm

Museo Civico Medievale, Bologna, 1504
SELECTED REFERENCES: Pope-Hennessy 1964,
vol. 2, pp. 613–14, no. 645; Heimbürger Ravalli
1973, pp. 161–62, no. 60; Montagu 1985: vol. 1,
p. 200; and vol. 2, pp. 365–66, no. 65, and
fig. 193

After Bernini, Algardi – although born in Bologna – was
the greatest sculptor of the Roman baroque, and in this
splendidly energetic bronze he set out to compete with
one of the supreme masterpieces of Roman baroque
painting, Guido's Reni's altarpiece of the same subject
for the church of Santa Maria della Concezione (fig. 85),
of which he made a copy drawing, now in Düsseldorf.
Early sources record that the group was made for 'the
most Reverend General Pepoli his most affectionate lord
and friend', who appears to have been one Taddeo Pepoli
(d. 1674), who belonged to a distinguished Bolognese
family and became the General of the Olivetan order in
1651, and that it was cast by Domenico Guidi, who was
in Rome from 1651. It would be a mistake to exaggerate
Algardi's dependence on Reni's work, since the individual
poses of both the archangel and of Lucifer have been
considerably modified, but what is clear is the 'pictorial'
emphasis on the primacy of the frontal view of the group.
DE

122

Georg Petel (c. 1601/02–1634),
cast by Christoph Neidhardt
(doc. 1639–1646)

Gustavus Adolphus
of Sweden

1632, cast 1643
Bronze, 66 × 68 × 45 cm

Nationalmuseum, Stockholm, NMSk 353
SELECTED REFERENCES: Larsson 1992, pp. 52–55,
no. 17; Berlin 1995, pp. 520–21, no. 190
(M. Raumschüssel)

There exist three different versions of this portrait: the
present example, which is unique in showing the king
wearing a laurel wreath; another in the Royal Castle,
Stockholm, which in all probability corresponds with a
bronze recorded as having been cast in 1632 by Wolfgang
Neidhardt III, and is universally regarded as the most lively
of the three; and a later cast in Dresden. Here, the lower
edge of the bust is inscribed with a text stating that it was
sculpted from the life ('ad vivi') by Georg Petel in 1632,
and cast by Christoph Neidhardt in Augsburg in 1643.
The sitter's hieratically aloof appearance has led some to
wonder if Petel truly made it 'ad vivi', and it has rightly
been pointed out that he may well have drawn
inspiration from a print of the king made by Lukas Kilian.
However, in view of the fact that by 1643 both the
sculptor and his subject (1594–1632) were long dead,
and that the bust was made in the last year of the
monarch's life, the insistence on the authenticity of the
likeness does not seem especially surprising. DE

123

Francesco Fanelli (b. 1577)

Charles I

c. 1635
Bronze, 24.2 × 13 × 7.6 cm

Victoria and Albert Museum, London.
Purchased with the assistance of the Art
Fund, A.3-1999
SELECTED REFERENCES: Pope-Hennessy
1968, pp. 166–71, fig. 197

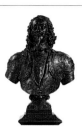

In his inventory of the collections of King Charles I, Van
der Doort lists a number of small bronzes – including a
Cupid on Horseback and a *St George and the Dragon* –
that he attributes to 'ffrancisco the one eyed Italian',
namely Francesco Fanelli, who is indeed documented in
England and at Charles's court in the 1630s and 1640s.
Examples of these models and other related bronzes,
which were seen at Welbeck Abbey by George Vertue
in the eighteenth century and also said to be by Fanelli,
form a stylistically coherent group. To them has been
added, again on stylistic grounds, this exquisitely finished
bust of the King, which appears to be a unique cast. All
too many Fanelli bronzes must be later repetitions and
their surfaces are disappointingly blurry, but this stunning
miniature reveals just what a gifted sculptor he was at his
best, and at the same time gives notice that Van Dyck was
not the only artist to merit the title of recording angel of
the doomed monarch. DE

124

François Girardon (1628–1715)

Laocoön and His Sons

c. 1690
Bronze, 233 × 158 × 100 cm

Houghton Hall, Norfolk
SELECTED REFERENCES: Haskell and Penny
1981, pp. 243–47, no. 52, fig. 125; London
2002A, p. 336, no. 249, and p. 387, no. 199

In the 1752 edition of his *Aedes Walpolianae*, Horace
Walpole refers to the present group in its current location,
on a base designed by none other than William Kent in
the Stone Hall at Houghton, as follows: 'Before a Nich,
over against the Chimney, is the Laocoon, a fine Cast in
Bronze, by Girardon, bought by Lord Walpole, at Paris.'
Lord Walpole was Horace's elder brother Robert, son of
Sir Robert Walpole, who is documented as having
purchased the piece for the princely sum of a thousand
guineas on his Grand Tour, which lasted from 1722 to
1723. The group itself, which was cast by the Kellers
under the direction of Girardon, is likely to have been
executed somewhat earlier, and a date of around 1690
has been suggested. Hailed by Pliny the Elder in his
Natural History, the marble original of the *Laocoön* in the
Vatican has been regarded as one of the most impressive
of all classical sculptures ever since its rediscovery in Rome
in 1506, and has been much copied. The most notable
difference between the original marble's present
appearance and the Houghton bronze concerns
Laocoön's extended right arm, which was a sixteenth-
century restoration. It has now been removed in favour
of an antique bent arm without a hand, which was
discovered in 1906 and is presumed to be the original. DE

125

Nigeria, Benin

Plaque Showing a
Warrior with Attendants

Seventeenth century
Brass, height 53.5 cm

National Museum, Lagos, 48.36.1.
National Commission for Museums
and Monuments, Nigeria
SELECTED REFERENCES: London 1982, no. 86

Rectangular plaques such as this were mounted on the
wooden pillars that supported the roof of the Royal
Palace in Benin City. Three figures dominate this
masterfully executed relief, most prominent among them
the warrior chief, who is shown in full ceremonial dress,
complete with a leopard's-tooth necklace. He is flanked
by attendants carrying shields, while four smaller figures
find their place in between, one of them a Portuguese
shown in profile: contact with Portugal through trade
was by now well established. The quatrefoil motif on a
stippled ground is a common feature of the background
of such plaques. Many have holes showing where they
were nailed to columns, and, as here, the plaques seem
to have been wrenched off and broken when such
decoration fell out of favour. CT

126.1–9

Ghana, Asante

Goldweights

Sixteenth–nineteenth centuries
Brass, various dimensions

Collection Tom Phillips
SELECTED REFERENCES: Phillips 2009

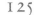

This splendidly diverse group of weights for gold, which
comprise only a fraction of a much more extensive
collection, underlines the remarkable variety of
imaginative solutions that were devised for these
functional objects. The making of such weights has a
long history, which continues to this day, with the present
examples ranging in date from the sixteenth to the
nineteenth centuries. A number of the pieces are
representations of humans and animals, such as the
three-figure group showing a gold transaction in
progress, the sawfish, the leopard, and those staples of
European and Asian sculpture the nursing mother and
the equestrian group. Others, such as the copulating
grasshoppers and the shells, are life (or strictly speaking
death) casts of actual creatures, which must have been
killed in the process. Still others are bronze versions of
everyday utensils, such as a horse-tail whisk, or abstract
patterned disks. DE

127

Massimiliano Soldani Benzi
(1656–1740), after Michelangelo
Buonarroti (1475–1564)

Bacchus

1699–1701
Bronze, 198 × 72 × 65 cm

The Princely Collections, Vaduz-Vienna,
SK 573

SELECTED REFERENCES: Frankfurt 1986,
pp. 226–27, no. 46

Michelangelo's marble *Bacchus* (Bargello, Florence) of
1496–97 is one of the most ambitious and impressive of
his early works. In 1572 Francesco I, Grand Duke of
Florence, acquired the group and placed it among his
collection of classical statuary in the Uffizi. The notion
that Michelangelo's *Bacchus* was deliberately created
as a counterfeit of an antiquity seems convincing, and is
supported by the fact that it is already shown lacking
its right hand and penis in a drawing by Maerten van
Heemskerck datable to 1532–35, although both the hand
and the wine-cup held in it were reinstated at an early
date. Soldani's full-scale version was commissioned by
Prince Johann Adam Andreas of Liechtenstein in 1699
and completed by 1701. Ironically, Soldani's exceptional
fidelity to his model did not please the Prince: in 1703,
when the piece arrived in Vienna, he described the result
as 'a badly designed work … in an ugly pose, a terrible,
 very idea', and was presumably distressed by what would
now be regarded as the splendidly anti-classical
conception of the unsteady and tipsy God of Wine. DE

128

Massimiliano Soldani Benzi
(1656–1740), after Gianlorenzo
Bernini (1598–1680)

Damned Soul

1705–07
Bronze, 39 × 27.5 × 28 cm

The Princely Collections, Vaduz-Vienna,
SK 517

SELECTED REFERENCES: Paris 2008B, p. 108,
no. 33

Both this bronze and its pendant representing a *Blessed
Soul* are based upon a pair of marble originals by
Gianlorenzo Bernini, the supreme sculptural genius of the
Baroque, which were carved in around 1619 for his patron
Monsignor Pedro de Foix Montoya and are now in the
Palazzo di Spagna in Rome. In 1705 Soldani proposed
that he should produce bronzes of the pair, which he
described as 'things in the most beautiful style', for his
patron Prince Johann Adam Andreas of Liechtenstein,
and by 1707 they had been completed. There is no
denying that to most modern eyes the charms of the
Blessed Soul are dangerously saccharine, and they are
certainly no match for the hyper-real physiognomical
distortions of the *Damned Soul*. Be that as it may, what
makes this piece such a triumph is the fact that Soldani
was heroically undaunted by the challenge of trying to
measure up in bronze to the bravura marble carving of
Bernini. DE

129

Francesco Bertos (1678–1741)

**Sculpture, Arithmetic
and Architecture**

c. 1732–39
Bronze, 107 × 45 × 51 cm

Museo Nacional del Prado, Madrid, E-505

SELECTED REFERENCES: Avery 2008,
pp. 212–13, no. 108

The gravity-defying virtuosity of the productions of
Francesco Bertos of Padua, which exist in both marble
and bronze, make him one of the most instantly
recognisable of all sculptors. The present group originally
formed part of a set of four bronzes (of which two more
are in the Prado, while the whereabouts of the last are
currently unknown), and also corresponds in every
particular to one of a pair of now lost marble groups
recorded in the collection of Field Marshal Johann
Matthias von der Schulenburg in 1741, which it was
claimed attracted the attentions of the Inquisition 'since it
seemed impossible that the human hand could achieve
such wonders'. Starting at the top and moving
downwards, Love of Virtue flies above Perfection, who is
shown crowning Sculpture, seated on the back of the
centaur, who represents Truth and Falsehood. Deceit is
seated on the pedestal with the bust of Schulenburg,
while down below are Merit raising up Valour carving
Memory, together with Intellect carving Truth, as well
as Arithmetic and Architecture. DE

130

Anne Seymour Damer
(1749–1828)

Mary Berry

1793
Bronze, height 34.3 cm

Lent by the National Portrait Gallery,
London, NPG 6395

SELECTED REFERENCES: Whinney 1988,
pp. 319–20; Clifford 2000; Roscoe, Hardy and
Sullivan 2009, pp. 333–37

Anne Seymour Damer was the granddaughter of the 4th
Duke of Argyll, and the wife of the eldest son of Lord
Milton, later 1st Earl of Dorchester. She was also a great
favourite of Horace Walpole, who was later to leave her
Strawberry Hill. As a female member of the late Georgian
aristocracy, she was highly unusual in her pursuit of a
career in the world of sculpture. She did, however, study
under both Ceracchi and John Bacon the Elder, and is
perhaps best known for her personifications of the Rivers
Thames and Isis, which were carved for Henley Bridge in
1785. She also executed a number of delicate, classicising
busts of friends and acquaintances, including this
meditative portrait of 1793 of Mary Berry, an author and
protégée of Walpole's, which is inscribed in Greek with
the names of both sculptor and sitter. She also inspired
the fervent admiration of the great Italian sculptor
Antonio Canova, who seems to have been more than
half in love with her, and gave her three of his terracotta
modelli, two of which are now in the National Galleries
of Scotland in Edinburgh. DE

131

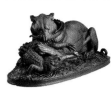

Antoine-Louis Barye (1795–1875),
cast by Honoré Gonon
(1780–1850)

Tiger Devouring a Gavial

1832
Bronze, 39.7 × 105.6 × 40.5 cm

Musée du Louvre, Paris. Département des
Sculptures, RF 2991

SELECTED REFERENCES: Benge 1984, pp. 31–34,
fig. 22; Amsterdam 1996, pp. 190–91, no. 61;
Baltimore 2006, p. 93, no. 14

Barye exhibited the plaster original of the present work at
the Paris Salon in 1831, and this piece was cast employing
the lost-wax technique in the following year. It is a mark
of its immediate success that it was purchased by the
French Minister of the Interior for the Louvre as early as
1842. Arguably one of the greatest animal sculptors of
all time, Barye unquestionably reigns supreme among
nineteenth-century *animaliers*, and this is his early
masterpiece. Later casts, among them that of the Van
Gogh Museum in Amsterdam, contrast the dark brown
of the tiger with the greenish patina of the gavial
(a species of Indian crocodile). Barye was not alone
among nineteenth-century artists in specialising in
representations of exotic fauna, but he did not travel to
the wilds to study his subjects. On the contrary, like the
somewhat younger Douanier Rousseau, his acquaintance
with them was above all through the bars of their cages
at the zoo in Paris. DE

132

Benvenuto Cellini (1500–1571),
cast by Clemente Papi
(1802–1875)

Perseus and Medusa

1844
Bronze, height 320 cm

The Italian Gardens at the Trentham Estate

SELECTED REFERENCES: Avery and Barbaglia
1981, plates XXXIII–XLIII, pp. 95–96, nos 57–58;
Pope-Hennessy 1985, p. 162–213 and plates 86,
97–107; Rizzo 2012

Benvenuto Cellini's monumental bronze statue of *Perseus*
of 1553 in the Loggia dei Lanzi in Florence is without
question his masterpiece, and at the same time one of
the greatest sculptures of all time. The present full-scale
bronze cast was made by Clemente Papi, the foundryman
to the Tuscan court, who proudly signed it with his name
and the date 1844 in Roman numerals on the thong of
Perseus' left sandal. According to an inscription on its
base, 'This replica, made by order of the 2nd Duke of
Sutherland with the permission of his friend the then
Grand Duke of Tuscany, was originally erected here on
the reconstruction of Trentham Hall MDCCCXL', and was
'Restored and replaced here by Elizabeth Countess of
Sutherland MDCCCLXVI'. In fact the date of its completion
must have been a few years later. At Trentham, it is
positioned at the end of the formal parterre in front
of the lake, where it originally formed the climax of
the prospect from the now demolished house. DE

276

133

Charles-Henri-Joseph Cordier
(1827–1905)

Jewess from Algiers

c. 1862
Onyx, partially gilt, bronze, silvered
bronze, enamel, semi-precious
stones, 93 × 63 × 31 cm

Van Gogh Museum, Amsterdam

SELECTED REFERENCES: Durand-Revillon 1982;
Amsterdam 1996, pp. 173–74, no. 49

By Charles Cordier's day, there was nothing intrincisally novel about the idea of polychromy in sculpture, but what was altogether more original was the notion of combining bronze with other materials and adding colour. His *Jewess from Algiers*, which is frequently paired – as it is in the Van Gogh Museum – with a pendant bust of an Arab sheik, is a characteristic example not only of Cordier's gift for elaborate and evocative ethnographic portraiture, but also of a more general nineteenth-century fascination with the otherness of the exotic. The model dates from around 1862, and was very frequently reproduced by the artist, almost invariably with minor variations in the details of the decoration. In the celebrated example at Troyes, for instance, part of the figure's drapery is made of porphyry, which adds to the chromatic boldness of the whole, but conversely the overall effect is simplified by the omission of the dangling tassel found here. DE

134

Auguste Rodin (1840–1917)

The Age of Bronze

1877
Bronze, 180.3 × 60 × 60 cm

Victoria and Albert Museum, London.
Given by the artist, A.33-1914

SELECTED REFERENCES: London 1986B,
pp. 14–17, fig. 28, no. 11; Grunfeld 1987,
pp. 97–106; Washington 2000A, pp. 310–15

In classical antiquity, the ages of human history were associated with different metals. What in English is known as the age of bronze provided the title of Rodin's early masterpiece, *L'Age d'airain*, although that literally translates as 'the age of brass'. The title was not given to the piece by the sculptor himself: the original plaster version of the figure was first exhibited in Brussels in 1877 as *Le Vaincu* (the defeated one), before being shown at the Paris Salon later the same year under the name by which it has been known ever since. As a consequence of the extraordinary realism of Rodin's treatment, a number of early commentators on the work hinted that he could only have achieved such a living presence by means of *surmoulage*, in other words by making a life cast of an actual model. Such techniques were indeed exploited by sculptors at the time, but Rodin's achievement has nothing to do with trickery, and it is hardly surprising that he furiously denied the slur, and insisted that on the contrary he had spent a year and a half slaving over the work. DE

135

Suzuki Chōkichi (1848–1919)

Incense Burner

c. 1880
Bronze, 280 × 130 cm

The Khalili Collections, M062

SELECTED REFERENCES: London 1994A,
p. 62, no. 36; Impey, Fairley and Earle 1995,
no. 1; Earle 2002, pp. 42–43, no. 4

This monumental multi-element triumph of the metalworker's craft is one of a number of such pieces by Suzuki Chōkichi, whose art name was Kako. As a rule Kako made these works for display at international exhibitions in Europe; a notable example of c. 1877–78 with peacocks is in the Victoria and Albert Museum, London. The present piece is signed 'Dai Nippon Toto Ju Kako Chu' (cast by Kako, resident in the Eastern Capital of Japan), and unusually it is not known exactly when or for what purpose it was manufactured. Remarkably, by the time of its presentation to the Kunstgewerbemuseum in Berlin in 1886, it was believed to date from the earlier nineteenth century. Its form is that of an incense burner, but there is no reason to believe it would ever have performed such a function. In addition to its technical virtuosity, the piece is a splendidly dramatic anthology of quintessentially oriental – and in part specifically Japanese – motifs, both decorative and figurative, ranging from the splendidly vigorous eagle that crowns the ensemble to the three muscle-bound, bug-eyed grimacing demons who stand on a rocky base supporting its upper half. DE

136

Alfred Gilbert (1854–1934)

St Elizabeth of Hungary

1899
Bronze, ivory, tin inlaid with
mother-of-pearl and semi-precious
stones, height 53.3 cm

Kippen Parish Church, Stirlingshire

SELECTED REFERENCES: London 1986A,
p. 167, no. 76; Amsterdam 1996, pp. 156–58,
no. 36

Alfred Gilbert may be best known to posterity as the creator of a single work, the statue of *Eros* in Piccadilly Circus, which is made of aluminium, but in fact he had a long and many-faceted career. The present bronze – together with an equally boldly colourful statuette of the Virgin – dates from 1899, and was originally devised for the tomb of the Duke of Clarence (1864–1892), grandson of Queen Victoria and eldest son of the Prince and Princess of Wales, at Windsor. Gilbert received the commission almost immediately in 1892, and devised a hugely ambitious monument, which was to include twelve standing figures of saints in niches around the reclining effigy of the Duke. He made good progress to begin with, but after the turn of the century all but abandoned the project; the final five saints were not installed until 1928. The figure of St Elizabeth on the Windsor tomb is a somewhat simplified version of the present work, which dates from 1899, and which Gilbert sold separately. A third and later cast is in the National Gallery of Victoria, Melbourne. DE

137

Thailand

Emaciated Buddha

c. 1870
Bronze, 89 × 77 × 35 cm

Ger Eenens Collection, Netherlands /
Wereldmuseum, Rotterdam, GECN-20101

SELECTED REFERENCES: Bruijn 2011,
pp. 90–96

This representation of the Buddha, Gautama Sakyamuni, is connected with the stage on his path to enlightenment when he ate no more than a single grain of rice a day in order to purify his body and increase his powers of meditation. Comparable images dating from the second to fourth centuries CE are known within the Gandharan tradition, but the iconography subsequently all but lapsed. It was revived in Thailand by King Chulalongkorn, also known as Rama V (reg. 1868–1910). A devout Buddhist, he was personally responsible for commissioning this piece. The figure style is painfully realistic, with the starved body and exposed ribcage shown criss-crossed by prominent veins, while the timeless facial type harks back to the modes of the Sukhothai period, which lasted from 1238 to 1438. In contrast, the base is decorated with an idyllic landscape populated by a wide variety of animals. DE

138

India

Shiva Nataraja

Early twentieth century
Bronze, 196 × 153 cm

Private collection, London

SELECTED REFERENCES: Dehejia 2003,
pp. 91–95

The present bronze portrays Shiva as Nataraja, Lord of the Dance. The work corresponds not only in all the various details of its iconography, but also in terms of its stylistic vocabulary, with Chola pieces dating from the eleventh and twelfth centuries, but does not appear to be an exact replica of any specific sculpture. Instead it underlines the timelessness of the artistic tradition to which it belongs, which sees no reason – as had long been second nature in the European context – to effect a radical break with the ways of the past. Shiva is shown within a circle, with various attributes extending outwards towards the rim or even extending beyond it, and with the diminutive figure of Mushalagan, demon of darkness and ignorance, being trampled under his right foot. The fundamental features of this type involve the left leg and foremost left arm crossing in front of the body in order to convey the dancing movement of the god's body. DE

139

deric Remington (1861–1909)

**f the Range
oming through
e Rye)**

odelled 1902, cast 1903
onze with green patina,
8 × 71.1 × 71.1 cm

coran Gallery of Art, Washington DC.
seum purchase, 05.7

SELECTED REFERENCES: Shapiro 1985, pp. 141–42,
156; Heartney at al. 2002, pp. 204–205
(Ballew Neff)

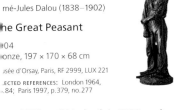

though he was also a painter, illustrator and writer,
mington's vision of the American West was expressed
supreme effect in his sculptures. In his own words: 'I
ropose … to put the wild life of our West into something
at burglar won't have, moth eat, or time blacken.' His
st group, *Bronco Buster*, dates from 1895, and was
llowed by only 21 subsequent bronzes, of which the
esent work of 1902, which was cast the next year by his
under Riccardo Bertelli, is arguably the most visually
ompelling as well as the most technically accomplished.
have six horses' feet on the ground and ten in the air,'
emington boasted, a bravura accomplishment that he
hieved by capturing the rightmost horse of the group
holly suspended in mid-air and attached to its nearest
ompanion. The subtitle of the group, *Coming through
e Rye*, is taken from a poem by Robert Burns, which was
est known in musical form as a popular ballad. DE

40

mé-Jules Dalou (1838–1902)

he Great Peasant

04
onze, 197 × 170 × 68 cm

usée d'Orsay, Paris, RF 2999, LUX 221

SELECTED REFERENCES: London 1964,
..84; Paris 1997, p. 379, no. 277

om 1897 until his death in 1902, and very much in
ccordance with his socialist political convictions, Dalou
worked on an extraordinarily ambitious *Monument aux
ouvriers* (*Workers' Monument*). Had it ever been
ompleted, the ensemble would have been a towering
2 metres tall. Twelve bronze statues of working men
ere to have appeared in niches around its base
erracotta models for them are in the Musée du Petit
alais in Paris), and the whole was to have been crowned
y a single figure, the present posthumously cast work.
he peasant wears wooden clogs on his feet, and is
hown rolling up his right sleeve prior to wielding the
ool of his trade on the ground at his feet. The dignity of
bour, which had been celebrated in paint with equal
ympathy by Dalou's slightly older contemporary Jean-
rançois Millet (1814–1875), is here brilliantly conveyed
y this ostensibly realistic yet at the same time undeniably
eroic evocation of a man of the people who lives by the
weat of his brow. DE

141

Medardo Rosso (1858–1928)

**Ecce Puer
(Behold the Child)**

1906
Bronze, 44 × 37 × 27 cm

Musée d'Orsay, Paris. Gift of Francesco
Rosso, 1928, RF 3285

SELECTED REFERENCES: New York 1988,
pp. 15–21, and p. 102, no. XIII; London 1994B,
pp. 36–37, no. 45; Cambridge, Mass. 2003

The present bust, which dates from 1906 and was
originally modelled in wax, was created at the time of
Rosso's stay in London for a one-man show. It is a portrait
of the five- or six-year-old Alfred William Mond, whose
father Emil was the nephew of Dr Ludwig Mond, the
celebrated collector of Old Master paintings and donor to
London's National Gallery. After initially failing to capture
the boy's likeness, Rosso is said to have glimpsed him for
a moment through parted curtains, and then worked
through the night to immortalise him. Although Rosso's
highly distinctive surfaces have on occasion been
regarded as the sculptural equivalent of Impressionist
painting, they arguably have even more in common with
the traditions of the sketch on paper and in oil, while the
effect of blurring of the features is highly evocative of the
kinds of veilings in marble that were such a speciality of
the Neapolitan Rococo sculptors Antonio Corradini
(1668–1752) and Innocenzo Spinazzi (d. 1798). Rosso
himself described the piece as 'a vision of purity in a banal
world', and intended that it should only be seen from
a single fixed viewpoint. DE

142.1

Henri Matisse (1869–1954)

Back I

1908–09
Bronze, 189.9 × 116.8 × 18.4 cm

Tate. Purchased 1955, T00081

142.2

Henri Matisse (1869–1954)

Back II

1913
Bronze, 189.2 × 120.6 × 19 cm

Tate. Purchased with assistance from the
Matisse Appeal Fund 1956, T00114

142.3

Henri Matisse (1869–1954)

Back III

1916
Bronze, 188 × 113 × 17.1 cm

Tate. Purchased with assistance from the
Matisse Appeal Fund 1957, T00160

142.4

Henri Matisse (1869–1954)

Back IV

c. 1931
Bronze, 189.2 × 113 × 15.9 cm

Tate. Purchased with assistance from the
Knapping Fund 1955, T000082

SELECTED REFERENCES: Gowing 1979,
pp. 81–85; Wilson 1991, p. 152; Schneider
2002, pp. 553–56

Matisse's four *Backs*, upon which he worked from 1909
until the early 1930s, are without question his most
ambitious – albeit not his only – sculptural sequence.
Virtually unknown until the first, third and fourth were
exhibited in 1949 and 1950, they – together with the
second, which did not re-emerge until after the
artist's death – were only posthumously cast in bronze.
A photograph of a still earlier state of the invention,
known as *Back 0*, indicates that from the outset the
evolution of the series progressed from relative naturalism
and *contrapposto* in the direction of ever-greater
abstraction and verticality. Matisse's treatment of the
monumental female nude figure seen from the rear is
often – and rightly – associated with the influences of
such immediate precursors as Cézanne and Gauguin,
but in fact the tantalising fascination of figures seen
from behind, whose facial expressions we are
consequently forced to imagine, was celebrated by
Leon Battista Alberti as long ago as the 1430s in his
treatise *On Painting*. DE

143

Constantin Brancusi (1876–1957)

Danaïde

c. 1918
Bronze on a later limestone base,
28 × 16.5 × 21 cm

Tate. Presented by Sir Charles Clore,
1959, T00296

SELECTED REFERENCES: Alley 1981,
pp. 73–74, no. T.296

As was the case with his *Maiastra* (cat. 144), Brancusi produced a number of versions of this bust, in this instance over an even longer period of time, from 1910 to 1931. His model was Margit Pogany, a Hungarian art student whom the sculptor encountered at a boarding house where he ate and she lodged. His original white marble, which was exhibited as early as 1914 under the unexpectedly ominous title *Danaïde* (the Danaids were the daughters of King Danaus of Argos, who murdered their husbands on their wedding-night on their father's instructions, and were condemned to fill sieve-like vessels with water for eternity), was carved from memory. After Brancusi had shown it to Pogany in July 1910 and she had recognised that – for all its extreme stylisation of her physiognomy – she was its subject, she sat for him on a number of occasions, but he invariably destroyed the resulting works. It was only after Pogany left Paris in January 1911, that – once again in her absence – Brancusi was able successfully to embark on a series of busts of her in marble and bronze, some including her arms. The present bust appears to date from around 1918, and was purchased by Jacques Doucet, the pioneering collector of Art Nouveau, Art Deco and Cubism, in 1924. DE

144

Constantin Brancusi (1876–1957)

Maiastra

1911
Polished bronze on stone base,
90.5 × 17.1 × 17.8 cm

Tate. Purchased 1973, T01751

SELECTED REFERENCES: Alley 1981,
pp. 71–73, no. T.1751; Wilson 1991, p. 151

In Paris, far from his native Romania, Brancusi recalled the folk mythology of his homeland, and was inspired by the Romanian equivalent of Stravinsky's *Firebird*, the Pasarea Maiastra (literally 'wonderful bird'), a golden bird celebrated for the beauty of its song. Within Brancusi's practice, his sequence of variations on the theme of the Maiastra, which in their turn led to the even more elongated and abstracted subsequent series of *Birds in Space*, represented a crucial development away from the mimetic tradition embodied in the works of Rodin, a type of sculpture that Brancusi dismissed as 'beefsteak'. The original *Maiastra*, which appears to date from 1910–12, was carved in white marble. The present piece – the earliest of the bronze versions – must be derived from a plaster cast made in 1911 before the marble's completion, since the two are not absolutely identical. The rough stone base, which is adorned with two equally stylised carved birds by Brancusi, contrasts deliberately and dramatically with the flawlessly smooth polished surface of the bronze. The first owner of this piece was the distinguished American photographer Edward Steichen, who had certainly purchased it by 1913. DE

145

Umberto Boccioni (1882–1916)

Unique Forms of Continuity in Space

1913, cast 1972
Bronze, 117.5 × 87.6 × 36.8 cm

Tate. Purchased 1972, T01589

SELECTED REFERENCES: Alley 1981,
pp. 59–61, no. T.1589; London 2009B,
pp. 234–35, no. 80 (E. Coen)

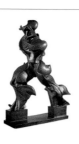

Boccioni was first and foremost a painter, but his isolated forays into the realm of sculpture prior to his early death are among the most exciting of all his works. Three earlier striding figures in plaster – respectively entitled *Synthesis of Human Dynamism*, *Speeding Muscles* and *Spiral Expansion* – are only known from photographs, because they were destroyed by workmen in the immediate aftermath of the memorial exhibition of the artist's work at the Palazzo Cova in Milan in 1916–17. The plasters of both the present piece, which dates from 1913, and of *Development of a Bottle in Space* (1912), were also damaged, but fortunately Boccioni's fellow-Futurists Filippo Tommaso Marinetti and Fedele Azari were able to salvage them and piece them together. All the casts of *Unique Forms* are consequently posthumous, and it is a moot point whether Boccioni would have been in favour of a bronze version of what has turned out to be his most celebrated creation. On the other hand, the work's scintillating energy and sense of movement not only mean that it would be impossible to exclude from an overview of this kind, but also that in the present context it is bound to suggest visual correspondences across the millennia. DE

146

Pablo Picasso (1881–1973)

Baboon and Young

1951
Bronze, 54.6 × 33.3 × 61 cm

Lent by the Minneapolis Institute of Arts.
Gift of Funds from the John Cowles
Foundation, 55.45

SELECTED REFERENCES: London 1994C,
pp. 279–80, no. 120; Spies 2000, pp. 270–73,
and p. 414, no. 463

Baboon and Young, which was cast and stamped on the base by the Claude Valsuani foundry in October 1951 in an edition of six, is one of the most winningly affectionate and at the same time imaginatively metamorphic of all Picasso's sculptural creations. The principal incorporation involves the cannibalising of two toy cars – a Panhard and a Renault – which the artist had given to his young son, Claude, and which were transformed into the head of the ape. In addition, a pair of cup handles represented the ears, while a large double-handled jug became the creature's body, and a spring from a car turned into its tail. One of the principal delights of the piece is the way these found elements only gradually disclose themselves, and yet paradoxically they do nothing to diminish the sense of tender intimacy that is projected by this monkey-house counterpart of a Madonna and Child. DE

147

Alberto Giacometti (1901–1966)

The Cage (First Version)

1950
Bronze, 90.6 × 36.5 × 38 cm

Private collection

SELECTED REFERENCES: Edinburgh 1996, p.
165, no. 130, and plate 40; Norwich 2001,
pp. 68 and 152, no. 27

Giacometti made two versions of *The Cage* in 1950. The second was immediately cast in bronze and first exhibited that same year in a monographic show of Giacometti's work held at the Pierre Matisse Gallery in New York, whereas this first version was initially made in plaster in 1950, and only cast in bronze after the artist's death. In a contemporary letter to Pierre Matisse, Giacometti said of the subsequent version: 'I saw this composition in its form and colour before starting on it but the figure had outstretched arms and hands.' The same letter makes it clear that the figures were conceived as being in a room which makes this work the sculptural equivalent of a favourite subject for paintings across the centuries, namely the interior. The almost 'crucified' appearance of the standing female figure in this first conception is the major difference between the two, although the – male bust here is also notably smaller, as indeed is the base of the structure. DE

148

Germaine Richier (1904–1959)

Praying Mantis

1946
Bronze, 158 × 56 × 78 cm

Famille Germaine Richier, GR113

SELECTED REFERENCES: Crispolti 1966,
plate II; London 1993B, p.42; Saint-Paul
de Vence 1996, p.66, no.28

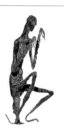

Germaine Richier was one of the most interesting sculptors to emerge in the immediate postwar period. The present piece, which is arguably her most memorable bronze but not her only large-scale sculpture of an insect, dates from 1946, and represents a praying mantis. Hitherto, insects cannot be said to have attracted the attention of many sculptors, although there are exceptions, such as Wenzel Jamnitzer, who made life – or, strictly speaking, death – casts of a stag beetle and other small creatures (which were killed in the process) for the lid of a silver writing case of c. 1570, now in Vienna. Moreover, and hardly surprisingly, praying mantises have not regularly been singled out as subjects by artists in any media, although one does appear in the foreground of Filippino Lippi's *Four Saints* at San Michele in Foro, Lucca, and they make a number of appearances in the art of the Surrealists. By monumentalising the mantis, whose anthropomorphic character is implicit in its name, Richier almost seems to transform it into a spindly yet menacing entomological *Doppelgänger* of Rodin's *Thinker*. DE

49

David Smith (1906–1965)

Portrait of a Painter

1954
Bronze, 244.3 × 62.2 × 30.2 cm
Private collection, New York
SELECTED REFERENCES: Gray 1968, p. 89

David Smith is perhaps best known for his innovative use of welded steel as a sculptural medium. Nevertheless, he also produced a remarkable body of work in bronze, of which *Portrait of a Painter*, which dates from 1954, is arguably the high point. In it, he combined found objects – most notably the painter's palette that becomes the head of the figure, but also the paint box in its 'hand' – with made elements to forge a wittily abstract and yet at the same time compellingly animated human presence. His use of sand-casting would have enabled him to create multiple replicas of the bronze, had it not been for the fact that he regarded the work as a unique piece and worked on each element of it and its every surface texture with meticulous care. In view of the fact that Smith passionately rejected what he saw as the false distinction between sculpture, painting and drawing, there is a sense in which this monumental piece may be read as a symbolic self-portrait. DE

50

Willem de Kooning (1904–1997)

Clam Digger

1972
Bronze, 151.2 × 75.6 × 153.2 cm
Collection of Mr and Mrs J. Tomilson Hill, 5.1363
SELECTED REFERENCES: New York 2011B, p. 405–18, fig. 160

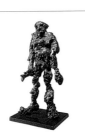

De Kooning, who was born in Rotterdam but was in the United States from 1926, is best known for his paintings. Associated with Abstract Expressionism and Action Painting for a period, he went on to work in a variety of different styles that embraced the figurative – above all in his great series of *Woman* paintings – alongside the abstract. His engagement with sculpture was both short-lived and relatively less productive, and yet his small corpus of bronzes is impressive. Of these, *Clam Digger*, which dates from 1972, is unquestionably the most ambitious in scale and arguably the most striking. Its lumpen attitude and viscous simplification of the human form are entirely characteristic, but its abstracting tendency does nothing to reduce the sense of an actual living presence. In terms of subject-matter, the bronze follows on from de Kooning's painting *Clam Diggers*, which was executed in 1963, when the artist and his wife moved to the Atlantic shore and settled at East Hampton, Long Island. DE

151

Barbara Hepworth (1903–1975)

Curved Form (Trevalgan)

1956
Bronze, 90.2 × 59.7 × 67.3 cm
British Council Collection
SELECTED REFERENCES: Liverpool 1994, pp. 103–04 and 164, no. 53

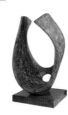

Barbara Hepworth's own account of the genesis of the present work, in which the landscape around St Ives, where she had settled during the Second World War, is metamorphosed into a simple abstract form, is more eloquent than any subsequent commentary can hope to be: 'This "Curved Form" was conceived on the hill called Trevalgan between St Ives and Zennor where the land of Cornwall ends and the cliffs divide as they touch the sea facing west. At this point, facing the setting sun across the Atlantic, where sky and sea blend with hills and rocks, the forms seem to enfold the watcher and lift him towards the sky.' Hepworth's engagement with bronze was occasional as opposed to constant, and it seems clear that this was a particularly fertile moment, since her masterly *Stringed Figure (Curlew) (Version II)* also dates from the same year, 1956. DE

152

Henry Moore (1898–1986)

Helmet Head no. 3

1960
Bronze, 36 × 33.5 × 28.5 cm
(including base)
Lent by the Syndics of the Fitzwilliam Museum, Cambridge, AA, M.3-1960 (12477)
SELECTED REFERENCES: Florence 1972, p. 66, no. 110; London 1988, p. 190, no. 41, and p. 185, no. 124; London 2010B, p. 159, no. 88, and pp. 226–28, nos 111–15

In 1939–40 Moore executed a *Helmet* in lead, which he said he intended to look 'like a face peering out from inside a prison'. Ten years on, in 1950, he produced a number of related pieces: a unique cast of a *Small Helmet Head* in bronze; *Helmet Head no. 1*, again in lead; and *Helmet Head no. 2* in bronze. Another decade was to pass before he returned to the theme with the present piece, which was to be followed by a final *Helmet Head no. 4* in bronze in 1963. The idea of looking inside the outer carapace of the ominous helmet to discover what it contained remained a constant throughout, but from the outset Moore also appears to have been playing games with scale, since the original *Helmet* appears to encase a figure and not a head. Be that as it may, there can be no doubt of the sinister effect created by the robotic inhumanity of the entire series. DE

153

Jasper Johns (b. 1930)

Painted Bronze (Ale Cans)

1960
Painted bronze,
14 × 20.3 × 12.1 cm
Museum Ludwig, Cologne. Peter and Irene Ludwig Foundation, ML 01439
SELECTED REFERENCES: Francis 1984, pp. 29–40, 91; Crichton 1994, pp. 42 and 86, plates 67 and 122

For all the assurance and fascination of the handful of pieces in question, Jasper Johns's engagement with sculpture has been at most occasional. He made his first sculptures, which were of flashlights and lightbulbs, in 1958. Two years later, in 1960, the year that also witnessed the creation of his *Painted Bronze (Savarin)*, the inspiration behind the present work, according to the artist himself, was a chance remark. In his own words: 'Somebody told me that Bill de Kooning said [of the dealer Leo Castelli] that you could give that son of a bitch two beer cans and he could sell them. I thought, what a wonderful idea for a sculpture.' The seemingly artless reproduction of two Ballantine's ale cans on the contrary involved a complicated process of manufacture ('I was deliberately making it difficult to tell how it was made'), starting with plaster of Paris and ending with the painting of the bronzes. In 1964 the bronze was followed by a lithograph of the ale cans. DE

154

Jeff Koons (b. 1955)

Basketball

1985
Bronze, diameter 30 cm
JPMorgan Chase Art Collection, 10707
SELECTED REFERENCES: Holzwarth 2007, pp. 142–50; New York 2008B, p. 84, ill. p. 85

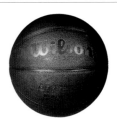

The stippled surface and prominent logo of this bronze basketball, which dates from 1985, make it a compellingly accurate replica of the real thing. Yet at the same time the fact that it is blatantly made of bronze induces a sense of its weight in our minds. This artful double effect is clearly part of its appeal, as is also the case with the other bronzes that Koons made at this time: soccer balls, a lifeboat, an inflatable lifejacket, three types of snorkel, and a scuba tank. For all their seemingly unmediated reproduction of the appearance of their prototypes, some proved exhaustingly hard to perfect, with *Aqualung* requiring no fewer than thirty moulds before it worked out. *Basketball*, like the other bronzes, formed part of Koons's seminal 'Equilibrium' show in New York and Chicago in 1985, which also featured real basketballs suspended in liquid within glass tanks, another only apparently simple trick, for which Koons drew upon the advice of the Nobel Prize-winning physicist Richard Feynman. DE

155

Louise Bourgeois (1911–2010)

Spider IV

1996
Bronze, 203.2 × 180.3 × 53.3 cm

The Easton Foundation, courtesy Hauser
& Wirth and Cheim & Read, BOUR-4017

SELECTED REFERENCES: Milan 1997, p.254;
London 1998, p.28, ill.p.29

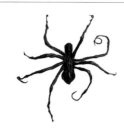

In her later years, Louise Bourgeois came to be associated with her sequence of sculptures of spiders, whether as floor or – as here – wall pieces, almost to the exclusion of all her other works. In part, this was a predictable consequence of the sheer monumentality of the largest of them, but it was also unquestionably related to what many would construe as their menacing presence. Bourgeois herself made a number of suggestive pronouncements on the subject, and on one occasion gave this memorable explanation: 'With the *Spider* I try to put across the power and personality of a modest animal. Modest as it is, it is very definite and it is indestructible. It is not about the animal itself, but my relation to it. It establishes the fact that the spider is my mother, believe it or not. I am not interested in myself, in this case I am interested in her.' Elsewhere, she described the *Spider* as a protective presence, not least against mosquitoes and the diseases they carry, but also more all-embracingly as 'a defence against evil'. DE

156

Richard Deacon (b. 1949)

Bronze Nails

2007
157 bronze nails,
each 2 × 28 × 2 cm

Private collection

SELECTED REFERENCES: Deacon 2007

One of the most striking and distinctive features of independent small bronzes is that they were generally not designed to be viewed either from a single viewpoint or indeed in a fixed context. On the contrary, one of the particular pleasures of such pieces is that their owners can inspect them close to, holding them in the hand and revolving them through 360 degrees, almost to the point where they come to seem like a multiplicity of works. In the case of a contemporary assemblage such as Richard Deacon's *Bronze Nails*, which dates from 2007, both the number of nails that it comprises and their arrangement are capable of almost endless modification under the artist's supervision. Here they are presented as a compact mass, whereas on at least one previous occasion they were nailed into a wall at considerable intervals. In either form, and not least since they are cast in bronze, they challenge our usual preconceptions concerning the opposition between the utilitarian and the non-functional. DE

157

Anish Kapoor (b. 1954)

Untitled

2012
Copper alloy and lacquer,
160 × 160 × 28 cm

Kemal Has Cingillioglu, AK 12-065

SELECTED REFERENCES: Anfam 2009;
London 2009A

Mirrored surfaces both concave and convex have proved to be a major feature of Anish Kapoor's *oeuvre*, and surely most memorably in his *Cloud Gate* (2004) in Chicago's Millennium Park, affectionately known as 'The Bean', which can fairly claim to be the most irresistibly engaging, reaction-inspiring work of public sculpture ever created. Within this group of works, however, bronze – as opposed to the more customary stainless steel – has proved to be a comparative rarity. The present piece, which dates from 2012, is notable for its almost austere purity of form, but is of course invariably enlivened for its viewers by the distorted reflections of themselves that appear on its surface as they approach. The work is at the same time very consciously bronze-coloured, as if in timeless homage to the metal of which it is made. DE

158

Tony Cragg (b. 1949)

Points of View

2007
Bronze, 107 × 65 × 65 cm

Courtesy Tony Cragg

SELECTED REFERENCES: Edinburgh 2011,
no.29

Tony Cragg, who first came to prominence in the late 1970s, is a fascinating example of a contemporary sculptor who frequently – but by no means exclusively – works in bronze, and endeavours to employ the material in strikingly novel ways, while at the same time responding to the medium's remarkable flexibility. His *Points of View*, which dates from 2007, is one of a series of works entitled *Rational Beings* in bronze, stainless steel, plaster, stone and wood that ingeniously combine the representational with the abstract. Within its three seemingly viscous and flowing columnar forms, there emerge a series of simplified but instantly recognisable profiles, which appear and disappear as the work is viewed in the round. It has long been a feature of Cragg's artistic practice not only to work in series, but also to work on a number of unrelated series at once: *Rational Beings* has overlapped with *Early Forms*. DE

Notes

Bronze Casting: The Art of Translation
Francesca G. Bewer
Pages 24–31

1 For De Vries's process, see Bewer 2001.

2 For a good overview of the use and properties of bronze alloys in art, see Paul Craddock's entries entitled 'Bronze' and 'Metal' in the *Grove Online Dictionary of Art*.

3 Cellini 1898, pp. 114–24; Cellini 1956, pp. 341–47.

4 For a detailed study of the cold work on Ghiberti's relief panels, see Formigli 2007.

5 For a historical overview and a wide range of modern-day recipes, see Hughes and Rowe 1991.

6 Stone 2010.

7 Stone 2011.

8 Clare and Lins 2012 is a wonderful resource on decorative techniques.

9 For a beautifully illustrated description of the sand-casting of a complex sculpture, see Birks 1998, pp. 71–87.

10 For Renaissance examples see, for instance, Biringuccio 1540, pp. 324–28, and Smith and Beentjes 2010, p. 133. For a fascinating account of the vicissitudes of sand- and lost-wax casting of sculpture in France in the nineteenth century, see Lebon 2003 and Lebon 2012.

11 On Chinese piece-moulding see, for instance, Chase 1991. See Knitel n.d. for the casting process of the Maximiliansgrab bronzes.

12 Barr-Sharrar and Lie 2002.

13 On the question of bronzes and originality see Parigoris 1997, and on the casting history of Degas bronzes, see Glover Lindsay 2011.

14 Quoted in Ayrton 1965, p. 16.

The Ancient Near East and Egypt
Timothy Potts
Pages 32–41

1 See Potts 1994, pp. 145–59, and Moorey 1994, pp. 242–54, 297–301. The source of the tin used in the Near East and Egypt has been the subject of longstanding debate. Textual and archaeological evidence suggests that Afghan tin was arriving in Mesopotamia by the third millennium BCE, mostly by ship along the Persian/Arabian Gulf. Other possible sources at this time include southern Turkey (Amanus Mountains) and parts of Iran. In the Iron Age (first millennium BCE), tin from Spain and possibly Cornwall was also used.

2 For example New York 2003, no. 131, and Moortgat 1969, plates 136–37.

3 This is almost certainly the 'hero with six curls' featured on Akkadian cylinder seals; see New York 2003, no. 145.

4 K. Sethe, *Journal of Egyptian Archaeology*, 1, 1914, pp. 233–36. I am grateful to Helen Strudwick for providing this reference.

5 Quibell and Green 1902, pp. 46ff., plates L–LVI.

6 Amiet 1966, figs 291, 297, 305.

7 Stephanie Dalley, 'Neo-Assyrian Textual Evidence for Bronzeworking Centres', in Curtis 1988, pp. 97–110.

8 Layard 1853, pp. 198ff; Braun-Holzinger 1984, no. 342; Moorey 1994, p. 273; Spycket 1981, plate 240.

9 Herodotus, i, 179.

10 Curtis and Reade 1995, pp. 82–88, nos 26–30.

Chinese Bronzes
Jessica Rawson
Pages 42–46

1 For wide-ranging illustrations of Shang and Zhou ritual bronze vessels and bells, see Bagley 1987 and Rawson 1990.

2 The hoard is known as the Zhuangbai hoard from the name of the village where it was found in Fufeng country, west of Xi'an in Shaanxi province. For a discussion of the archaeology of the Zhou period and of the hoard, see Rawson 1999.

3 Research over the last fifteen to twenty years has underscored the late development of the use of bronze in central China relative to the dates of such work in other areas of Eurasia, especially Western Asia. Investigations into the transmission of metalworking skills across Eurasia owe much to the work of E. N. Chernykh and Jianjun Mei; see Chernykh 1992 and Mei 2009.

4 Generally, the English term jade refers only to the minerals nephrite and jadeite. In early China, nephrite was the hardest and seemingly the most highly prized mineral among the several pale green stones to which the Chinese have given the term *yu*, translated as jade in English. Thus, while the English word jade refers primarily to nephrite (and on some occasions to jadeite) the Chinese word is more inclusive. For an account of early jade see Rawson 1995.

5 Franklin 1983 noted that when peoples first sought out metals, these were generally employed for personal ornaments. Mei 2011, building on this idea, has shown that on the borders of central China ornaments were made of copper and bronze (and occasionally gold). This was not a use to which the peoples of the central plains first put their bronze.

6 For the very early and persistent use of boiling and steaming, see Fuller and Rowlands 2011. Southern China, Eastern Siberia and Japan produced the earliest ceramics in Eurasia. Kuzmin 2006 provides a survey of this material.

7 Remarkably, the early uses of bronze did not include the manufacture of tools, for which stone continued to be employed.

8 Bagley 1987, pp. 19–30.

9 See Ledderose 2000, pp. 24–49, for a lively discussion of the methods by which the motifs were varied and elaborated.

10 The chronology was proposed by Max Loehr; see Loehr 1953.

11 Ch'en Fang-mei 2009.

12 New York 2011A.

13 Bagley 2000.

14 New York 2011A, no. 10.

15 A magnificent wine container, *zun*, in the British Museum is supported by two rams. On the basis of its

sculptural quality and its surface decoration in the form of scales it has long been recognised as a southern bronze (Rawson 1992, fig. 33).

16 Seattle 2001.

17 Li Feng 2006.

18 Shaughnessy 1991.

19 Rawson 1999.

20 Houma 1996.

Greece, Etruria and Rome
Carol C. Mattusch
Pages 47–54

1 Richardson 1983, vol. 1, p. 5.

2 The inscription *tinscvil* probably refers to Tinia, the Etruscan version of Jupiter or Zeus.

3 See Iozzo 2009. The snake is apparently not ancient.

4 Cristofani 1985, pp. 180, 275, no. 75; Haynes 1985, p. 322, no. 199.

5 A life-size bronze finger with a silver nail, said to be from the Acropolis in Athens, is in the collection of the Princeton Art Museum, Princeton University: inv. no. 40-169. See Cambridge, Mass. 1996, p. 205, no. 10.

6 Chamoux 1955; Mattusch 1988, pp. 127–35.

7 For the production of these two statues and for a summary of discussion regarding their origins and identities, see Mattusch 1988, pp. 200–08.

8 Dio Chrysostom, *Orationes*, 28, 3.

9 Pia Guldager Bilde et al., 'Archaeology in the Black Sea Region in Classical Antiquity, 1993–2007: Thracian Inland Sites', *Archaeological Reports 2008*, 54, 123, http://journals.cambridge.org.

10 The other statue is in the collection of the Kunsthistorisches Museum, Vienna.

11 Pliny the Elder, *Natural History*, 34, 37.

12 Albert E. Elsen, 'Rodin's "Perfect Collaborator", Henri Lebossé', in Washington 1981, pp. 249–60; Wasserman 1975.

13 Pliny the Elder, *Natural History*, 34, 41.

14 Dio Chrysostom, *Orationes*, 31, 9.

15 Pliny the Elder, *Natural History*, 34, 36–37.

16 Livy, 40, 51, 3.

17 Pliny the Elder, *Natural History*, 34, 30.

18 Pliny the Younger, Letter to Trajan, 10, 8.

19 Constantine Porphyrogennetos, *De Administrando Imperio*, 20–21.

20 Mattusch 1988, pp. 150–53; Hemingway 2004, passim.

21 http://www.guardian.co.uk/artanddesign/2009/may/17/henry-moore-sculpture-theft-reclining-figure.

22 Lahusen and Formigli 2007, pp. 83–91, no. S9.

23 Mattusch 2005, pp. 189–94.

24 Naples, NM 5598. Mattusch 2005, pp. 230–33.

25 Naples, NM 4893. Mattusch 2005, pp. 327–31. Also Sider 2005.

26 Found at Pompeii in 1862: House VII.12.17/21. Naples, NM 5003, height 63 cm. Washington 2008, pp. 150–51, no. 54.

27 Found at Pompeii in 1960: House of Fabius Rufus (VII.16[ins. occ.].22). Pompeii 13112. Washington 2008, pp. 136–37, no. 44.

28 Rice 1983. The account of *c.* 200 CE by Athenaeus is based upon a much earlier description of the event by Kallixeinos of Alexandria.

29 The satyr is housed in the Chiesa di Sant'Egidio, Mazara del Vallo, Sicily. Petriaggi 2003.

Sacred Metals in South and Southeast Asia
John Guy
Pages 55–61

1 A series of *in-situ* inscriptions range from 1416 to 1459; see Bernet Kempers 1959, pp. 101–03.

2 This interpretation is that of Jan Fontein, in Washington 1990, no. 33.

3 Solyom 1978.

4 Karashima 2002, p. 10.

5 National Museum, Jakarta, inv. no. 626d. For a reading of the date, see Coedes and Damais 1982.

6 Agrawal 2000.

7 For Harappan bronzes, see Dhavalikar 1988; for Kushan see Cleveland 1985, and concerning Sonkh, Härtel 1993.

8 For a good survey of this category of village icons, see Berlin 1998; see also Mukherjee 1978, and Brouwer 1995.

9 National Museum, New Delhi, no. J.275, published in Berlin 2003A, no. 28.

10 Published in Barcelona 2007, no. 11.

11 Guy 2007, chapter 4; see also London 2006.

12 Written by the Kashmiri Brahman pundit Kalhana in the twelfth century; Stein 1900.

13 Palas, Tolakas and Prasthas were medieval units of measurement; see Stein 1900, Bk. IV, p. 194, and notes.

14 See Reedy 1997 for a metallurgical study of Himalayan metal sculpture.

15 Mukherji 2001.

16 For northern India, see Riederer 1985; Reedy 1997; and for South India, Srinivasan 1999.

17 Barrett 1962; many of the Kashmir bronzes first published by Barrett and Pal in 1975 evoke a strong feeling of being modelled after now lost large-scale prototypes, embodying a sense of monumentality beyond their scale. See also Guy 1988.

18 Vogel 1911, p. iii, and Goetz 1955.

19 Vogel 1911, pp. 138–45. See also Postel, Neven and Mankodi 1985.

20 Chattopadhyaya 1970, pp. 274, 279.

21 Irwin 1954.

22 Paris 2008A.

23 Barrett 1965, Rathnasabapathy 1982.

24 Orr 2004; Guy 2006A; Guy 2006B.

25 Kaimal 1999; Guy 2004B.

26 Campanar, I.39.1, translated in Peterson 1989, p. 118.

27 Calò 2009.

28 The nomenclature applied to this group has recently been challenged by Bunker (see Bunker and Latchford 2011, p. 82), who, in her 1971–72 publication of this cache, appears to have misrepresented the site name. The identifier Prakhon Chai is retained here for clarity of identification.

29 See Guy 2004A and Paris 2005, pp. 206–09, for a discussion of the Dong Duong Buddha and related examples.

30 See Davis 1997 for the circulation of icons in India.

31 These epic wanderings were first reconstructed by the Burmese scholar Taw Sein Ko in 1916, and recounted by Boisselier in 1968.

32 Guy 2011.

33 Guy 2010, p. 97–99.

West Africa: The Lower Niger Region
John Picton
Pages 62–68

1 Cole and Aniakor 1986; Abiodun et al. 1994; Anderson and Peek 2002; Foss 2004; Vienna 2007 (Plankensteiner); Berns et al. 2011.

2 Shaw 1978; Detroit 1980 (Eyo and Willett). One of the few things we can say with any certainty about these works is that they are all cast from leaded copper and that almost all contain small amounts of either tin or zinc, or in a few cases both. These differences might, of course, seem trivial: conventionally all are called 'bronzes'; and yet the differences are relevant to what little we can infer about the technological history of this region, and about the dating of sites and their works of art.

3 See Shaw 1977 for the discovery of the bronzes and the protracted negotiations surrounding their subsequent excavation.

4 Shaw 1970 gives the full account of these excavations.

5 These included ornamental objects of uncertain use, perhaps intended for conspicuous display. Many were decorated with insect figures: works from Igbo-Ukwu are almost unique in the entire corpus of African art in this.

6 For discussion of the beads found at Igbo-Ukwu, see Insoll and Shaw 1997.

7 Although the Igbo-Ukwu burial and the present-day office of *eze nri* seem to be shadows of each other, any continuity is unlikely to be direct and straightforward. In a similar vein, it is often suggested that perhaps this material is the earliest evidence of the skills of the present-day smiths and brass-workers of the nearby modern city of Awka (more properly spelled Oka), but as nothing is known of its archaeology this is little more than wishful thinking. See Cole and Aniakor 1986, pp. 52–53, for further discussion.

8 See Insoll and Shaw 1997 for more recent dates suggesting a spread between the eighth and eleventh centuries. Igbo-Ukwu remains, however, the earliest evidence for the use of copper and its alloys in West Africa.

9 Again, see Insoll and Shaw 1997.

10 In the evolution of metalworking, one can expect copper to appear in the archaeological record earlier than iron simply because of its lower melting point; and once the technology of extracting copper from its ores by smelting was in place, experimentation with earthy substances would have led to the discovery of iron. Curiously, Pharaonic Egypt remained a 'bronze-age' civilisation: iron was known but not used for its tool-making capacities until the Roman period. It was once suggested that the Nile valley and Meroe in the Sudan were the source of sub-Saharan iron-working, but the earliest furnaces excavated in West Africa rule out this possibility. There is evidence for early copper smelting in the southern Saharan region, but not for the local evolution of an iron-working technology. See Tylecote 1975; Shaw 1978, pp. 69–88; Shaw, Sinclair, Andah and Okpoko 1993, pp. 1–31.

11 The site was previously unrecorded as it was not commercially viable in the modern industrial world.

12 See Craddock and Picton 1986. This paper reviewed all the data so far published on the metallurgical analyses of copper-alloy material from the various places covered in the present text and provided substantial additional analyses of material in the British Museum collection, including in particular the museum's collection of the so-called Lower Niger Bronze Industries. The 1986 paper was entitled 'Part II' as Craddock had already published, as 'Part I', the relevant background in Mediterranean metalworking history.

13 This is, admittedly, a rough-and-ready guess based on the maps of Ife and its city walls, for which see Willett 1967, p. 16; Garlake 1978, p. 135; London 2009C, p. 23 (Drewal and Schildkrout).

14 None is known archaeologically; yet knowing the region from its recent past it is hard to imagine Ife as the only place on the map!

15 Drewal and Schildkrout (see London 2009C) provide an extensive photographic account of this material, though for the most exhaustive account see Willett 2003. Most of the art of Ife art is ceramic. Although it is often described in the literature as 'terra cotta', this designation of the clay used is misleading as it has the same rough texture as domestic pottery. The single largest group of shrine sculptures was retrieved from the Grove of Iwinrin just beyond the western walls of the city. Already fragmentary by the late nineteenth century, it includes a figure group only partially

reconstructed: see Willett 1967, p. 144, plate 76; London 1995, p. 409 (Phillips). In addition there is a good quantity of sculpture in granite or quartz also associated with some groves, temples and mythic figures: see London 2009C, pp. 14–21, 82, 87 (Drewal and Schildkraut). But although the ceramic and cast-brass sculptures comprise a single tradition, the relationship of the works in stone to that tradition is unknown. So too is the dating. It has been hinted that works in stone belonged to an aboriginal hunting population, while the ceramic sculpture developed once the place was settled by a farming people; and that brass-casting came with a group of conquering heroes who established a new royal dynasty. There is, of course, no evidence for any of this.

16 In a few cases, such as the mask from the king's palace (cat. 72), the alloy is leaded copper. For more detail see Willett 1967, p. 55; Craddock and Picton 1986.

17 As we shall see below in regard to the unprovenanced 'Lower Niger Bronze Industries' casting in bronze was evidently widespread throughout the Lower Niger region, a context, therefore, in which Ife is the exception.

18 Craddock 1985; Craddock 1990.

19 This was at the Wunmonije Compound. Although later excavation at the site found nothing, the fact that it once lay within the palace must be significant.

20 Willett 1967, pp. 14–15; London 2009C, pp. 26–27 (Drewal and Schildkraut). The original was purchased by Leo Frobenius, the German ethnologist, in 1910 but the British colonial authorities made him give it back; yet the present head was identified by Leon Underwood as a modern sandbox casting! The results of further examination of this head when it was in London in 2009 have yet to be published.

21 Willett 1967, p. 33; London 2009C, pp. 48–49 (Drewal and Schildkraut).

22 This was the site known as Ita Yemoo: see Willett 1967, pp. 31–51. The finds included ceramic sculptures in association with potsherd paving, as well as brass castings including a single figure of a king and a double figure of a king and queen arm in arm and leg in leg: the significance is not known. Later discoveries of ceramic sculptures were excavated by Peter Garlake to give us a careful reconstruction of a shrine with its sculpture; Garlake 1978.

23 It is without any archaeological context and its ethnographic context is entirely misleading as it was grouped with a series of diverse castings – see below in the Lower Niger section of this essay – all said to be related to the journey taken by the mythic hero responsible for founding the Nupe nation.

24 Garlake 1978, pp. 134–36; London 2009C, pp. 38–42 (Drewal and Schildkraut). This explanation is entirely hypothetical.

25 Willett 1966.

26 It is worth noting that the evident demise of the casting tradition in Ife is unexplained. There is no continuity with the present time, for the only brass caster in Ife at the time of Willett's research was a recent immigrant from elsewhere in the Yoruba-speaking region. In this context it is perhaps also worth remembering that as yet we still have no archaeological proof of casting in Ife.

27 The words 'Benin' for the city and 'Bini' for the ethnic group to which the city and its surroundings belong are both derived from ubini, a name given by outsiders. The Benin Republic, formerly known as

Dahomey, has no historical or other relationship to the city of Benin.

28 There is no archaeological evidence for the history of casting in Benin City.

29 See Gore 1997; Nevadomsky and Osemweri 2007; Gore 2007.

30 How long before is anyone's guess! For the standard accounts of Benin art and its history see Fagg 1963; Dark 1973. For discussion thereof see Ben-Amos 1995; Gore and Picton 2010.

31 Vienna 2007 (Plankensteiner) is the latest authoritative survey of this field, a veritable 'who's who' of Benin scholarship with a broader range of illustrations than any previous publication.

32 The beauty and ferocity of the leopard were fitting allusions to royal authority and it is hardly surprising that its imagery can be found across many visual traditions in Lower Niger, including Igbo-Ukwu and the Niger Delta – see below.

33 The emergence of the plaque form around 1500 is linked to the appearance of the Portuguese, to the huge quantities of brass they brought with them, to a series of heroic kings whose ceremonial activity and military exploits were to be represented, and, perhaps, to the casters' sight of illustrated books in the possession of the Portuguese. This is perhaps the most experimental phase in the history of Benin art. For works by the Master of the Leopard Hunt, see Vienna 2007, pp. 335, 435, 455, 493 (Plankensteiner); and for the Master of the Circled Cross, see Vienna 2007, pp. 390, 454 (Plankensteiner). Both artists are evidently trying to solve problems of two-dimensional representation without the visual trickery of foreshortening: see Williams 1974; Gore and Picton 2010. The seventeenth century was in contrast a time of weak kings who gambled away the wealth of the state, and it ended with civil war and the destruction of the royal palace. Descriptions of the newly rebuilt palace in the early 1700s make no mention of plaques; and in 1897 they were found in a palace storehouse where they were consulted as a repository of information concerning details of costume and ceremonial.

34 Fagg 1963. William Fagg was, of course, the great pioneer in the British study of African art and of the Lower Niger in particular, assisted by his younger brother Bernard, an archaeologist working in Nigeria from the late 1930s until his appointment to the Pitt Rivers Museum, Oxford, in 1963.

35 Given that there is no reason to suppose that they were made anywhere near Jebba and Tada, even their presumed location within the Lower Niger group is no more than guesswork. For illustrations see Willett 1967, p. 194; London 1995, p. 413 (Phillips); London 2009C, pp. 150–55, 159 (Drewal and Schildkraut).

36 I would like to think that the British Museum huntsman carrying an antelope (cat. 79) might be an early example from a site in the Yoruba-speaking region; but we really have no idea where it is from. Indeed, one might wonder if any of the unprovenanced Lower Niger works are forerunners of the Yoruba brass-casting traditions known from a more recent past: places such as Oyo-Ile, Owo, Obo and Ijebu-Ode. Although excavations have been carried out at Oyo-Ile and Owo, the history of their casting industries remains unknown. For the most comprehensive discussion of this material so far published see Williams 1974; also Gore and Picton 2010. For illustrations of this material see Willett 1967, p. 195; London 1995, pp. 414, 416, 417, 418 (Phillips); London 2009C, pp. 144–47 (Drewal and Schildkraut).

37 For example, during his twenty months as the agent

in Ughoton, the Portuguese base for trade with Benin City, in 1505–06, Bastiam Fernandez expended 12,750 brass and copper manilas, mostly on slaves. See Ryder 1969, p. 40.

38 See Peek and Nicklin 2002, who provide the fullest account of copper-alloy castings around the Niger Delta and to the east of the Lower Niger.

The Bronze Object in the Middle Ages
Ittai Weinryb
Pages 69–77

1 First inscription: 'QUOD FORE DEDIT TULIT IGNID ET ES TIBI REDDIT.' Second inscription: 'MAGISTER NICOLAVS (ET) MAGISTER IO/HANNES DE BINCIO NOS FECERONT.' The name Bincio probably refers to either the town of Bingen in modern-day Germany or Binche in modern-day Belgium. Mende 1981, p. 262; Raff 1994, p. 84; Kessler 2004, p. 24.

2 Mende 1983, pp. 21–24, 131–33; Fillitz 1990.

3 Herklotz 1985; Gramaccini 1995.

4 Cohen and Derbes 2001; Crivello 2004.

5 1 Kings 7, vv. 23–26: 'Then he made the cast sea; it was round, ten cubits from brim to brim, and five cubits high. A line of thirty cubits would encircle it completely. Under its brim were panels all round it, each of ten cubits, surrounding the sea; there were two rows of panels, cast when it was cast. It stood on twelve oxen, three facing north, three facing west, three facing south, and three facing east; the sea was set on them. The hindquarters of each were towards the inside. Its thickness was a handbreadth; its brim was made like the brim of a cup, like the flower of a lily; it held two thousand baths.' See also Reudenbach 1984.

6 Reudenbach 1984.

7 On medieval church bells, see Drescher 1992.

8 Cologne 1985, vol. 2, pp. 391–400.

9 Numbers 29, vv. 4–9.

10 John 3, v. 14.

11 Fricke 2007, pp. 136–41; Kessler 2009.

12 Hinz 1994; Dale 2002.

13 Dale 2008; Reudenbach 2008.

14 Gramaccini 1987; Gramaccini 1996.

15 Thürlemann 1977; Brenk 1987.

16 Contadini, Camber and Northover 2002; Contadini 2010.

17 On automata and their culture, see recently Kang 2011, pp. 14–102.

18 Calò Mariani 1993.

19 Boeckler 1953; Melczer 1987; Melczer 1988.

20 Melczer 1988.

21 Boeckler 1953; Melczer 1984; Walsh 1990.

22 White 1970; Gramaccini 1996, pp. 186–205.

23 Gramaccini 1987.

24 Gramaccini 1987.

25 New York 2006.

The Renaissance in Italy and Northern Europe
David Ekserdjian
Pages 78–87

1 See respectively Cuccini 1994, White 1987, pp. 452–64, Salmi 1960 and Bearzi 1960.

2 Hirst 2011, pp. 48–52, and 79–82, for the most recent discussion of these bronzes.

3 Goffen 2002, pp. 4–8.

4 Moskowitz 1986.

5 Krautheimer and Krautheimer-Hess 1970, vol. 1, pp. 157–225, and Vasari 1996, vol. 1, p. 304.

6 Krautheimer and Krautheimer-Hess 1970, vol. 1, pp. 69–100.

7 Pope-Hennessy 1993 and Caglioti 2000, especially for the David and Amor-Attis.

8 See respectively Pope-Hennessy 1993, pp. 199–210, and Butterfield 1997, pp. 158–83.

9 See respectively Pope-Hennessy 1993, pp. 211–47 and 292–313.

10 Pope-Hennessy 1993, pp. 280–88, and Caglioti 2000, vol. 1, pp. 223–81.

11 See respectively Butterfield 1997, pp. 56–80, and Wright 2005, pp. 358–408.

12 See respectively Butterfield 1997, pp. 126–35, and Wright 2005, pp. 335–40.

13 Butterfield 1997, pp. 18–31.

14 Pope-Hennessy 2000, vol. 1, pp. 266–67.

15 See respectively Pope-Hennessy 1993, pp. 288–91, and Rosenauer 1993, p. 289, no. 60, where it is suggested that the scale may have been too small for such a location.

16 See respectively London 2007, pp. 197–99, no. 47 (L. Syson), and Pope-Hennessy 2000, vol. 2, p. 393.

17 Berlin 1995, pp. 132–45, nos 2–7.

18 See respectively Trento 2008, New York 2008A, Mantua 2008 and Washington 2011.

19 Mantua 2008, pp. 132–33, no. I.9, pp. 168–71, nos III.1–2, pp. 174–77, nos III.4–5, pp. 258–69, nos VII.1–6, for the Gonzaga Vase and other busts by Antico, and Davide Banzato, 'Riccio's Humanist Circle and the Paschal Candelabrum', in New York 2008A, pp. 41–63.

20 Bange 1949 and Berlin 1995, pp. 232–69, nos 45–71.

21 See respectively New York 1986, p. 390, fig. 135, and Panofsky 1992, fig. 251.

22 See Pope-Hennessy 1985.

23 Paris 2008C, p. 102.

24 Paris 2008C, p. 53, fig. 4.

25 Paris 2008C, pp. 140–41, no. 30 (R. Seelig-Teuwen).

26 Madrid 1994, pp. 102–09, no. 1 (R. Coppel Areizaga), and Mulcahy 1994, pp. 189–211.

27 Rosemarie Mulcahy, 'Adriaen de Vries in the Workshop of Pompeo Leoni', in Amsterdam 1998, pp. 46–51.

28 Pope-Hennessy 2000, vol. 2, plates 164–65.

29 Emilie van Binnebeke, 'A Majestic Showpiece: Willem van Tetrode and the *Studiolo* of the Count of Pitigliano', in Amsterdam 2003, pp. 78–90.

30 Berlin 1995, pp. 316–23, nos 92–97, and pp. 460–71, nos 161–67.

31 Edinburgh 1978 and Avery 1987.

32 Baldinucci 1845–47, vol. 2, p. 556.

33 Avery 1987, p. 254, no. 12, p. 257, no. 38, p. 258, no. 47.

34 Avery 1987, p. 235.

35 Edinburgh 1978, pp. 93–99, nos 42–48, and pp. 62–63, nos 1–4.

36 Bober and Rubinstein 1986, pp. 158–61, no. 125, and pp. 113–14, no. 79, and Haskell and Penny 1981, pp. 136–41, no. 3, figs 71–72, and pp. 184–87, no. 24, fig. 96.

37 Vitzthum 1969.

38 Boucher 1991 and Berlin 2003B.

39 Pope-Hennessy 2000, vol. 3, pp. 502–03, plates 257–59.

40 Amsterdam 1998.

41 Amsterdam 1998, pp. 190–91, no. 28, for Rodin's *Les Forgerons*, and its very recent identification as a copy after De Vries.

42 Vasari 1996, vol. 2, p. 394, for a contemporary witness.

The Seventeenth and Eighteenth Centuries
Eike D. Schmidt
Pages 88–93

1 Quoted from the translation in Warren 2010, p. 26.

2 Almut Schuttwolf, in Berlin 1995, no. 157, p. 450.

3 For instance Baldinucci 1845–47, vol. 4, p. 84.

4 With a rider, the signed Equestrian Monument of Carlo Emanuele I, Duke of Savoy, Museumlandschaft Hessen, Kassel, GK III 3489, height 75 cm (Carrara 2007, no. 22, pp. 172–73); without a rider, Bargello, Florence, 141B, height 63 cm (Carrara 2007, no. 20, pp. 168–69).

5 Pizzorusso 1989, pp. 61–62, figs 50–51b; Maffeis 2006.

6 Andreas Meinecke, in Berlin 1995, no. 176, p. 490.

7 Robert Wenley, in Paris 2008C, no. 84, pp. 304–05. It cannot have been inspired by Antoine Coypel's painting of the same subject of *c.* 1715–17, since Lespingola had died in 1705. For an overall discussion of French bronzes informed by paintings and theatre, see Wenley 2008.

8 Colton 1979; Alexandre Maral, in Paris 2008C, no. 98, pp. 353–59.

9 Colton 1979, pp. 116–17, 140.

10 Kultermann 1968, pp. 128–44; Düsseldorf 1971.

11 Paris 2008C, no. 1, pp. 64–69; no. 50, pp. 190–91; no. 66, pp. 252–55.

The Nineteenth and Twentieth Centuries
Patrick Elliott
Pages 94–99

1 Lebon 2003, pp. 168–70.

2 Chevillot 1992, p. 62.

3 Richarme 2003, p. 37.

4 Letter of 5 November 1907 in Beausire and Cadouot 1986, p. 224.

5 Letter of 7 March 1907, in Beausire and Cadouot 1986, p. 205.

6 Le Normand-Romain 2007, vol. 1, pp. 160–63.

7 Laurent 1981, p. 286.

8 *The Times*, 19 May 1884, quoted in London 1986A, p. 110.

9 Michael D. Greenbaum, in Ogdensburg 1996, pp. 30–37.

10 Amsterdam 1996.

11 Interview with Bourdelle's daughter, Rhodia Dufet-Bourdelle, February 1988.

12 Brassaï 2003, p. 277 (28 November 1946).

13 Richardson 1999, p. 237.

14 Hulten, Dumitresco and Istrati 1986, p. 106: letter to Marius de Zayas of The Modern Gallery.

15 Noguchi 1968, p. 17.

16 Umberto Boccioni, *Technical Manifesto of Futurist Sculpture*, 11 April 1912; translated in Apollonio 1973, p. 65.

17 Duthuit 1997, no. 16, p. 40.

18 Ann Boulton notes that Matisse's *Small Head with Comb* was 'probably cast in 1906' by Bingen and Costenoble; see Boulton 2007, p. 80. A conception and casting date of 1907 has also been proposed for this work; see Duthuit 1997, no. 33, p. 82; and Parker 2011, no. 205, p. 425.

19 Paris 1996, p. 8.

20 Rewald 1975, p. 11.

21 Tony Cragg interviewed by Richard Mowe, 'Master of Plastic Arts', in *Scotland on Sunday*, 26 July 1992, p. 39.

22 Collins 2007.

Bibliography and Sources

Abiodun et al. 1994
Rowland Abiodun, Henry J. Drewal and John Pemberton III (eds), *The Yoruba Artist*, Washington and London, 1994

Agrawal 2000
D. P. Agrawal, *Ancient Metal Technology and Archaeology of South Asia*, Delhi, 2000

Alley 1981
Ronald Alley, *Catalogue of the Tate Gallery's Collection of Modern Art other than British Artists*, London, 1981

Alsop and Charlton 1973
Ian Alsop and Jill Charlton, 'Image Casting in Oku Bahal', *Contributions to Nepalese Studies*, 1, 1, 1973, pp.22–49

Amiet 1966
Pierre Amiet, *Elam*, Auvers-sur-Oise, 1966

Amsterdam 1996
Andreas Blühm (ed.), *The Colour of Sculpture 1840–1910*, exh. cat., Van Gogh Museum, Amsterdam, and Henry Moore Institute, Leeds, 1996–97

Amsterdam 1998
Frits Scholten (ed.), *Adriaen de Vries 1556–1626*, exh. cat., Rijksmuseum, Amsterdam, Nationalmuseum, Stockholm, and J. Paul Getty Museum, Los Angeles, 1998–2000

Amsterdam 2003
Frits Scholten (ed.), *Willem van Tetrode, Sculptor (c. 1525–1580), Guglielmo Fiammingo Scultore*, exh. cat., Rijksmuseum, Amsterdam, and Frick Collection, New York, 2003

Anderson and Peek 2002
Martha G. Anderson and Philip M. Peek (eds), *Ways of the Rivers: Arts and Environment of the Niger Delta*, Los Angeles, 2002

Andreae 2009
Bernard Andreae, *Der tanzende Satyr von Mazara del Vallo und Praxiteles*, Akademie der Wissenschaften und der Literatur, Geistes- und sozialwissenschaftliche Klasse, Jahrgang 2009, 2, Stuttgart, 2009

Anfam 2009
David Anfam, *Anish Kapoor*, London, 2009

Anyang 1998
Zhongguo shehui kexueyuan kaogu yanjiusuo (ed.), *Anyang Yinxu Guojiazhuang Shangdai muzang*, Beijing, 1998

Apollonio 1973
Umbro Apollonio, *Futurist Manifestos*, London, 1973

Arezzo 1990
La Chimera e il suo mito, exh. cat., Museo Archeologico Nazionale Gaio Cilnio Mecenate, Arezzo, 1990

Avery 1987
Charles Avery, *Giambologna: The Complete Sculpture*, Oxford, 1987

Avery 2001
Charles Avery, 'Pierino da Vinci's "Lost" Bronze Relief of "The Death by Starvation of Count Ugolino della Gherardesca and His Sons" Rediscovered at Chatsworth', in *Studies in Italian Sculpture*, vol.3, London, 2001, pp. 167–90

Avery 2008
Charles Avery, *The Triumph of Motion: Francesco Bertos (1678–1741) and the Art of Sculpture. Catalogue Raisonné*, Turin, 2008

Avery and Barbaglia 1981
Charles Avery and Susanna Barbaglia, *L'opera completa del Cellini*, Milan, 1981

Ayrton 1965
Michael Ayrton, 'Unwearying Bronze,' *Horizon*, 7, 1, 1965, pp. 16–37

Bagley 1987
Robert W. Bagley, *Shang Ritual Bronzes in the Arthur M. Sackler Collections*, Washington DC, 1987

Bagley 2000
Robert W. Bagley, 'Percussion', in Washington 2000B, pp.35–63

Bailey 1993
Martin Bailey, 'Two Kings, Their Armies and Some Jugs: The Ashanti Ewer', *Apollo*, 138, 382, December 1993, pp.387–90

Baldinucci 1845–47
Filippo Baldinucci, *Notizie dei professori del disegno da Cimabue in qua*, Ferdinando Ranalli (ed.), 5 vols, Florence, 1845–47

Baltimore 1969
Albert E. Elsen, *The Partial Figure in Modern Sculpture from Rodin to 1969*, exh. cat., Baltimore Museum of Art, 1969

Baltimore 2006
William R. Johnston and Simon Kelly, with contributions by Ann Boulton et al., *Untamed: The Art of Antoine-Louis Barye*, exh. cat., Walters Art Museum, Baltimore, 2006

Bange 1949
Ernst Friedrich Bange, *Die deutschen Bronzestatuetten des 16. Jahrhunderts*, Berlin, 1949

Bar-Adon 1980
Pessah Bar-Adon, *The Cave of the Treasure: The Finds from the Caves in Nahal Mishmar*, Jerusalem, 1980

Barcelona 2007
John Guy (ed.), *L'Escultura en Els Temples Indis. L'Art de la Devoció*, exh. cat., Fundacion la Caixa, Barcelona, 2007

Barr-Sharrar and Lie 2002
Beryl Barr-Sharrar and Henry Lie, 'A New Scientific Study of the Derveni Crater', in *I bronzi antichi: produzione e tecnologia: atti del XV congresso sui bronzi antichi*, Alessandra Giumlia-Mair (ed.), Montagnac, 2002, pp. 100–07

Barrett 1962
Douglas Barrett, 'Bronzes from Northwest India and Western Pakistan', *Lalit Kala*, 11, 1962, pp.35–44

Barrett 1965
Douglas Barrett, *Early Cola Bronzes*, Bhulabhai Memorial Institute, Bombay, 1965

Bearzi 1960
Bruno Bearzi, 'Esame tecnologico e metallurgico della statua di S. Pietro', *Commentari*, 11, 1960, pp.30–32

Beaulieu 1990
Michèle Beaulieu, 'La Déploration sur le corps du Christ par Germain Pilon et ses répétitions', in *Germain Pilon et les sculpteurs français de la Renaissance*, Conférences et colloques, Actes du colloque organisé au musée du Louvre par le service culturel, 26–27 October 1990, pp. 255–71

Beausire and Cadouot 1986
Alain Beausire and Florence Cadouot (eds), *Correspondence de Rodin, vol.II, 1900–1907*, Paris, 1986

Becker 2005
Ulrich Becker, *Alte Galerie: Masterpieces*, Graz, 2005

Ben-Amos 1995
Paula Girshick Ben-Amos, *The Art of Benin*, London, second edition, 1995

enge 1984
Glenn F. Benge, *Antoine-Louis Barye: Sculptor of Romantic Realism*, Pennsylvania, 1984

erlin 1995
Volker Krahn (ed.), *Von allen Seiten schön: Bronzen der Renaissance und des Barock*, exh. cat., Skulpturensammlung, Staatliche Museen zu Berlin, 1995

erlin 1998
Cornelia Mallebrein, *Darshan. Blickkontakte mit indischen Göttern. Die ländliche und tribale Tradition*, exh. cat., Museum für Indische Kunst, Berlin, 1998

erlin 2003A
Anmut und Askese. Frühe Skulpturen aus Indien. (The Sublime and the Ascetic in Early Sculptures from India), exh. cat., Museum für Indische Kunst, Berlin

erlin 2003B
Volker Krahn, *Bronzetti veneziani: Die venezianischen Kleinbronzen der Renaissance aus dem Bode-Museum Berlin*, exh. cat., Georg-Kolbe-Museum, Berlin, Kunsthistorisches Museum, Vienna, and Ca' d'Oro, Venice, 2003–06

erman 1974–80
Harold Berman, *Bronzes, Sculptors and Founders 1800–1930*, 4 vols, Chicago, 1974–80

ernet Kempers 1959
A. J. Bernet Kempers, *Ancient Indonesian Art*, Cambridge, Mass., 1959

erns et al. 2011
Marla C. Berns, Richard Fardon and Sidney Littlefield Kasfir (eds), *Central Nigeria Unmasked: Arts of the Benue River Valley*, Los Angeles, 2011

ewer 2001
Francesca G. Bewer, 'The Sculpture of Adriaen de Vries: A Technical Study', in Debra Pincus (ed.), *Small Bronzes in the Renaissance* (Studies in the History of Art, 62), Washington DC, 2001, pp.158–93

indman, Gates and Dalton 2010
David Bindman, Henry Louise Gates and Karen C. C. Dalton, *The Image of the Black in Western Art: From the Pharaohs to the Fall of the Roman Empire*, Cambridge, Mass., 2010

iringuccio 1540
The Pirotechnia of Vannoccio Biringuccio, Venice, 1540; Cyril Stanley Smith and Martha Teach Gnudi (trans.), New York, 1942

irks 1998
Tony Birks, *The Alchemy of Sculpture*, Yeovil, 1998

ober and Rubinstein 1986
Phyllis Pray Bober and Ruth Rubinstein, *Renaissance Artists and Antique Sculpture: A Handbook of Sources*, London, 1986

oeckler 1953
Albert Boeckler, *Die Bronzetüren des Bonanus von Pisa und des Barisanus von Trani*, Marburg, 1953

oisselier 1968
Jean Boisselier, 'Notes sur l'art du bronze dans l'ancien Cambodge', *Artibus Asiae*, 29, 1968, pp.275–334

oucher 1991
Bruce Boucher, *The Sculpture of Jacopo Sansovino*, 2 vols, New Haven and London, 1991

Boulton 2007
Ann Boulton, 'The Making of Matisse's Bronzes', in Dorothy Kosinksi, Jay McKean Fisher and Steven Nash (eds), *Matisse: Painter as Sculptor*, exh. cat., Baltimore Museum of Art, 2007, pp.73–98

Brandon Strehlke 2012
Carl Brandon Strehlke (ed.), *Orsanmichele and the History and Preservation of the Civic Monument*, New Haven and London, 2012

Brassaï 2003
Brassaï, *Conversations with Picasso*, Chicago, 2003

Braun-Holzinger 1984
Eva Andrea Braun-Holzinger, *Figürliche Bronzen aus Mesopotamien*, Munich, 1984

Brendel 1978
Otto J. Brendel, *Etruscan Art*, London and New York, 1978

Brendel 1995
Otto J. Brendel, *Etruscan Art*, second edition, New Haven and London, 1995

Brenk 1987
Beat Brenk, 'Spolia from Constantine to Charlemagne: Aesthetics versus Ideology', *Dumbarton Oaks Papers*, 41, 1987, pp.103–09

Brisbane 1988
Masterpieces from the Louvre: French Bronzes and Paintings from the Renaissance to Rodin, exh. cat., Queensland Art Gallery, South Brisbane, 1988

Brouwer 1995
Jan Brouwer, *The Makers of the World: Caste, Craft and Mind of South Indian Artisans*, Delhi, 1995

Bruijn 2011
Erik Bruijn, *Masterpieces of the Wereldmuseum: Tibet-China and Japan*, Rotterdam, 2011

Brussels 2010
Jan van Alphen and Richard L. Smith (eds), *A Passage to Asia: 25 Centuries of Exchange between Asia and Europe*, exh. cat., Palais des Beaux-Arts, Brussels, 2010

Bunker 1971–72
Emma Bunker, 'Pre-Angkorian Bronzes from Pra Kon Chai', *Archives of Asian Art*, 1971–72, pp.67–76

Bunker and Latchford 2011
Emma Bunker and Douglas Latchford, *Khmer Bronzes: New Interpretations of the Past*, Chicago, 2011

Burn 1991
Lucilla Burn, *The British Museum Book of Greek and Roman Art*, London, 1991

Butterfield 1997
Andrew Butterfield, *The Sculpture of Andrea del Verrocchio*, New Haven and London, 1997

Caglioti 2000
Francesco Caglioti, *Donatello e i Medici: Storia del David e della Giuditta*, 2 vols, Florence, 2000

Calò 2009
Ambra Calò, *The Distribution of Bronze Drums in Early Southeast Asia*, Oxford, BAR Series, 2009

Calò Mariani 1993
Maria Stella Calò Mariani, 'Federico II collezionista e antiquario', in V. Abbate (ed.), *Aspetti del collezionismo in Italia da Federico II al primo Novecento*, Trapani, 1993, pp.15–55

Cambon 2001
Pierre Cambon, *L'Art coréen au Musée Guimet*, Paris, 2001

Cambridge, Mass. 1996
Carol C. Mattusch (ed.), *The Fire of Hephaistos: Large Classical Bronzes from North American Collections*, exh. cat., Harvard University Art Museums, Cambridge, Mass., Toledo Museum of Art and Tampa Museum of Art, 1996–97

Cambridge, Mass. 2003
Harry Cooper and Sharon Hecker, with contributions by Henry Lie and Derek Pullen, *Medardo Rosso: Second Impressions*, exh. cat., Fogg Art Museum, Harvard University Art Museums, Cambridge, Mass., Arthur M. Sackler Gallery, Smithsonian Institution, Washington, Saint Louis Art Museum and Nasher Sculpture Center, Dallas, 2003–04

Carrara 2007
Franca Falletti (ed.), *Pietro Tacca: Carrara, la Toscana, le grandi corti europee*, exh. cat., Centro Internazionale delle Arti Plastiche (ex-Convento di San Francesco), Carrara, 2007

Cellini 1898
Benvenuto Cellini, *Treatises on Goldsmithing and Sculpture*, Charles R. Ashbee (trans.), London 1898; republished New York, 1967

Cellini 1956
The Autobiography of Benvenuto Cellini, George Bull (trans.), Harmondsworth, 1956

Chamoux 1955
François Chamoux, 'L'Aurige de Delphes', *Fouilles de Delphes*, 4, 5, Paris, 1955

Chandra 1985
Pramod Chandra et al., *The Sculpture of India 3000 BC – AD 1300*, London, 1985

Chase 1991
William T. Chase, *Ancient Chinese Bronze Art: Casting the Precious Sacral Vessel*, New York, 1991

Chattopadhyaya 1970
Debiprasad Chattopadhyaya (ed.), *Taranatha's History of Buddhism in India*, Delhi, 1970

Ch'en Fang-mei 2009
Ch'en Fang-mei, 'A Study of Bronze Artefacts in Their Social Contexts: A Case Study from the Yinxu Period II', *Bulletin of the Museum of Far Eastern Antiquities*, 77, 2009, pp.13–47

Chen Mengjia 1977
Chen Mengjia, *A Corpus of Chinese Bronzes in American Collections*, 2 vols, Tokyo, 1977

Chernykh 1992
E. N. Chernykh, *Ancient Metallurgy in the USSR: The Early Metal Age*, translated by Sarah Wright, Cambridge, 1992

Chevillot 1992
Catherine Chevillot, 'Les stands industriels d'édition de sculptures à l'Exposition universelle de 1889: l'exemple de Barbedienne', *Revue de l'art*, 95, 1992, pp.61–67

Chicago 2003
Pratapaditya Pal, *Himalayas: An Aesthetic Adventure*, exh. cat., Art Institute of Chicago and Arthur M. Sackler Gallery, Smithsonian Institution, Washington, 2003

Clare and Lins 2012
Tami Lasseter Clare and Andrew Lins, *Finishing Techniques in Metalwork: An Introduction to the History and Methods of Decorating Metal*, Philadelphia Museum of Art (http://www.philamuseum.org/booklets/7_41_71_1.html), consulted May 2012

Clarke and Heath forthcoming
John Clarke and Diana Heath, 'A New Image of the Mahasiddha Virupa', a paper given at the Courtauld Buddhist Forum, Courtauld Institute of Art, London, 9–14 April 2012, forthcoming

Cleveland 1985
Stanislaw J. Czuma, with Rekha Morris, *Kushan Sculpture: Images from Early India*, exh. cat., Cleveland Museum of Art, Asia Society, New York, and Seattle Art Museum, 1985–86

Clifford 2000
Jane Clifford, 'Miss Berry and Canova: A Singular Relationship', *Apollo*, 2000, 152, 463, pp.3–12

Coedes and Damais 1992
George Coedes and Louis-Charles Damais, *Srivijaya. History, Religion, and Language of an Early Malay Polity*, Malaysian Branch of the Royal Asiatic Society, Kuala Lumpur, monograph no.20, 1992

Cohen and Derbes 2001
Adam S. Cohen and Anne Derbes, 'Bernward and Eve at Hildesheim', *Gesta*, 40, 1, 2000, pp.19–38

Cole and Aniakor 1986
Herbert M. Cole and Chike C. Aniakor, *Igbo Arts: Community and Cosmos*, Los Angeles, 1986

Collins 2007
Judith Collins, *Sculpture Today*, London, 2007

Collon 1995
Dominique Collon, *Ancient Near Eastern Art*, London, 1995

Cologne 1985
Anton Legner (ed.), *Ornamenta Ecclesiae: Kunst und Künstler der Romanik in Köln*, exh. cat., Schnütgen Museum, Cologne, 1985

Colton 1979
Judith Colton, *The Parnasse Français. Titon du Tillet and the Origins of the Monument to Genius*, New Haven and London, 1979

Conney 1971
L. D. Conney, 'A Miscellany of Ancient Bronzes', *Bulletin of the Cleveland Museum of Art*, 58, 7, 1971, pp.210–14

Contadini 2010
Anna Contadini, 'Translocation and Transformation: Some Middle Eastern Objects in Europe', in Lieselotte E. Saurma-Jeltsch and Anja Eisenbeiss (eds), *The Power of Things and the Flow of Cultural Transformation: Art and Culture between Europe and Asia*, Berlin, 2010, pp. 42–65

Contadini, Camber and Northover 2002
Anna Contadini, Richard Camber and Peter Northover, 'Beasts that Roared: The Pisa Griffin and the New York Lion', in Warwick Bell and Leonard Harrow, *Cairo to Kabul: Afghan and Islamic Studies Presented to Ralph Pinder Wilson*, London, 2002, pp.65–78

Coomaraswamy 1914
Ananda Kentish Coomaraswamy, *Bronzes of Ceylon, Chiefly in the Colombo Museum*, Colombo Museum, Ceylon, 1914







Goffen 2002
Rona Goffen, *Renaissance Rivals: Michelangelo, Leonardo, Raphael, Titian*, New Haven and London, 2002

Gore 1997
Charles Gore, 'Casting Identities in Contemporary Benin City', *African Arts*, 30, 3, 1997, pp. 54–61

Gore 2007
Charles Gore, *Art, Performance and Ritual in Benin City*, Edinburgh, 2007

Gore and Picton 2010
Charles Gore and John Picton, 'Denis Williams in Africa: A New Approach to Its Arts and Technologies', in Charlotte Williams and Evelyn A. Williams (eds), *Denis Williams: A Life in Works*, Rodopi, Amsterdam and New York, 2010, pp. 153–68

Gowing 1979
Lawrence Gowing, *Matisse*, London, 1979

Gramaccini 1987
Norberto Gramaccini, 'Zur Ikonologie der Bronze im Mittelalter', *Städel-Jahrbuch*, 11, 1987, pp. 147–70

Gramaccini 1995
Norberto Gramaccini, 'Die karolingischen Großbronzen. Brüche und Kontinuität in der Werkstoffikonographie', *Anzeiger des Germanischen Nationalmuseums*, 1995, pp. 130–40

Gramaccini 1996
Norberto Gramaccini, *Mirabilia: Das Nachleben antiker Statuen vor der Renaissance*, Mainz, 1996

Gray 1968
Cleve Gray (ed.), *David Smith by David Smith: Sculpture and Writings*, New York, 1968

Grunfeld 1987
Frederic V. Grunfeld, *Rodin: A Biography*, New York and Oxford, 1987

Guy 1988
John Guy, 'Medieval Kashmir Bronzes: Defining a Style', in Mary F. Linda (ed.), *The Real, the Fake, and the Masterpiece*, exh. cat., Asia Society, New York, 1988, pp. 29–33

Guy 1995
John Guy, 'The Avalokitesvara of Yunnan and Some South East Asian Connections', in Rosemary Scott and John Guy (eds), *South East Asia and China: Art, Commerce and Interaction*, Percival David Foundation Colloquies on Art and Archaeology of Asia, no. 17, University of London, 1995, pp. 64–83

Guy 2004A
John Guy, 'South Indian Buddhism and Its Southeast Asian Legacy', in Anupa Pande and Parul Pandya Dhar (eds), *Cultural Interface of India with Asia*, National Museum Institute Monographs Series, no. 1, New Delhi, 2004, pp. 155–75

Guy 2004B
John Guy, 'The Natarajamurti and Chidambaram: Genesis of a Cult Image', in Vivek Nanda and George Michell (eds), *Chidambaram: Home of Nataraja*, Mumbai, 2004, pp. 70–81

Guy 2006A
John Guy, 'Parading the Gods: Bronze Devotional Images of Chola South India', in London 2006, pp. 12–26

Guy 2006B
John Guy, 'Seeing and Being Seen: When the Gods Go Walking in South India', *Orientations*, 37, 7, 2006, pp. 24–30

Guy 2007
John Guy, *Indian Temple Sculpture*, London, 2007

Guy 2010
John Guy, 'Angkorian Metalwork in the Temple Setting: Icons, Architectural Adornment and Ritual Paraphernalia', in Washington 2010, pp. 88–131

Guy 2011
John Guy, 'Pan-Asian Buddhism and the Bodhisattva Cult in Champa', in Tran Ky Voung and Bruce Lockwood (eds), *The Cham of Vietnam: History, Society and Art*, Singapore, 2011, pp. 300–22

Hackenbroch 1962
Yvonne Hackenbroch, *Bronzes, Other Metalwork and Sculpture in the Irving Untermyer Collection*, London, 1962

Härtel 1960
Herbert Hartel, *Indische Skulpturen: Teil 1, Die Werke der Fruhindischen, Klassischen und Fruhmittelalterlichen Zeit*, Berlin, 1960

Härtel 1993
Herbert Härtel, *Excavations at Sonkh: 2,000 Years of a Town in Mathura District*, Berlin, 1993

Hartt 1974
Frederick Hartt, *Donatello: Prophet of Modern Vision (The Complete Works)*, London, 1974

Haskell and Penny 1981
Francis Haskell and Nicholas Penny, *Taste and the Antique: The Lure of Classical Sculpture 1500–1900*, New Haven and London, 1981

Haynes 1985
Sybille Haynes, *Etruscan Bronzes*, London and New York, 1985

Heartney et al. 2002
Eleanor Heartney et al., *A Capital Collection: Masterworks from the Corcoran Gallery of Art*, Washington and London, 2002

Heimbürger Ravalli 1973
Minna Heimbürger Ravalli, *Alessandro Algardi Scultore*, Rome, 1973

Hemingway 2004
Seán Hemingway, *The Horse and Jockey from Artemision: A Bronze Equestrian Monument of the Hellenistic Period*, Berkeley, 2004

Herklotz 1985
Ingo Herklotz, 'Der Campus lateranensis im Mittelalter', *Römisches Jahrbuch für Kunstgeschichte*, 22, 1985, pp. 1–43

Hinz 1994
Berthold Hinz, 'Konig Rudolfs Grab-denkmal in Merseburger Dom: Innovation aus dem Zusammenbruch', in Herbert Beck and Kerstin Hengevoss-Diirkop (eds), *Studien zur Geschichte der europdischen Skulptur im 12./13. Jahrhundert*, Frankfurt, 1994, vol. 1, pp. 515–31

Hirst 2011
Michael Hirst, *Michelangelo: The Achievement of Fame*, New Haven and London, 2011

Holzwarth 2007
Hans Werner Holzwarth (ed.), *Jeff Koons*, Cologne, 2007

Houma 1996
Institute of Archaeology of Shanxi Province, *Art of the Houma Foundry*, Princeton, 1996

Hughes and Rowe 1991
Richard Hughes and Michael Rowe, *The Colouring, Bronzing and Patination of Metals*, London, 1991

Hulten, Dumitresco and Istrati 1986
Pontus Hulten, Natalia Dumitresco and Alexandre Istrati, *Brancusi*, Paris, 1986

Impey, Fairley and Earle 1995
Oliver Impey, Malcolm Fairley and Joe Earle (eds), *Meiji no takara (Treasures of Imperial Japan): The Nasser D. Khalili Collection of Japanese Art, vol. 2, Metalwork*, London, 1995

Insoll and Shaw 1997
Timothy Insoll and Thurstan Shaw, 'Gao and Igbo-Ukwu: Beads, Interregional Trade and Beyond', *The African Archaeological Review*, 14, 1, March 1997, pp. 9–23

Iozzo 2009
Mario Iozzo et al. (eds), *The Chimaera of Arezzo*, Florence, 2009

Irwin 1954
John Irwin, 'Some Unknown Gupta Sculptures from Sultanganj', *Artibus Asiae*, 27, 1954, pp. 34–38

Janson 1963
Horst W. Janson, *The Sculpture of Donatello*, Princeton, 1963

Jarrige et al. 2004
Jean-François Jarrige et al., *Spiritual Journey: Sacred Art from the Musée Guimet*, Bern, 2004

Jestaz 1983
Bertrand Jestaz, 'Un Groupe de bronze érotique de Riccio', *Monuments et memoires publiés par l'Académie des inscriptions et belles-lettres*, 25, 1983, pp. 25–54

Jestaz 2005
Bertrand Jestaz, 'Desiderio da Firenze. Bronzier à Padoue au XVIe siècle, ou le faussaire de Riccio', *Fondation Eugène Piot: Monuments et Mémoires*, 84, 2005, pp. 99–171

Kaimal 1999
Padma Kaimal, 'Shiva Nataraja: Shifting Meaning of an Icon', *Art Bulletin*, 83, 3, 1999, pp. 390–420

Kang 2011
Minsoo Kang, *Sublime Dreams of Living Machines: The Automaton in European Imagination*, Cambridge, Mass., 2011

Kansas City 1983
Medieval Enamels and Sculptures from the Keir Collection, exh. cat., Nelson-Atkins Museum of Art, Kansas City, 1983

Karashima 2002
Noboru Karashima (ed.), *Ancient and Medieval Commercial Activities in the Indian Ocean: Testimony of Inscriptions and Ceramic-sherds*, Tokyo, 2002

Keightley 1983
David Keightley, *The Origins of Chinese Civilization*, Berkeley, Los Angeles and Oxford, 1983

Kessler 2004
Herbert L. Kessler, *Seeing Medieval Art*, Peterborough, Ont., 2004

Kessler 2009
Herbert L. Kessler, 'Christ the Magic Dragon', *Gesta*, 48, 2, 2009, pp. 119–34

Kitov 2005
Georgi Kitov, 'The Newly Discovered Tomb of the Thracian Ruler Seuthes III', *Abulg*, 9, 2005, 2, pp. 39–54

Kjellberg 1989
Pierre Kjellberg, *Les Bronzes du XIXe Siècle. Dictionnaire des Sculpteurs*, Paris, 1989 (English edition: *Bronzes of the Nineteenth Century*)

Knitel n.d.
Otto Knitel, *Die Giesser zum Maximiliangrab: Handwerk und Technik*, Innsbruck, n.d.

Kofler-Truniger 1965
Sammlung Kofler-Truniger: Goldschmiede- und Metallarbeiten, Lucerne, 1965

Koloss 1999
Hans-Joachim Koloss, *Afrika: Kunst und Kultur*, Munich, 1999

Krautheimer and Krautheimer-Hess 1970
Richard Krautheimer and Trude Krautheimer-Hess, *Lorenzo Ghiberti*, 2 vols, Princeton, 1970

Kühnel 1970
Ernst Kühnel, *Islamic Arts*, London, 1970

Kultermann 1968
Udo Kultermann, *Gabriel Grupello*, Berlin, 1968

Kuzmin 2006
Yaroslav Kuzmin, 'Chronology of the Earliest Pottery in East Asia: Progress and Pitfalls', *Antiquity*, 80, 2006, pp. 362–71

Lahusen and Formigli 2007
Götz Lahusen and Edilberto Formigli, *Grossbronzen aus Herculaneum und Pompeji: Statuen und Büsten von Herrschern und Bürgern*, Worms, 2007

Larsson 1992
Lars Olof Larsson, *Swedish National Art Museums: European Bronzes 1450–1700*, Stockholm, 1992

Lasko 1994
Peter Lasko, *Ars Sacra 800–1200*, second edition, New Haven and London, 1994

Laurent 1981
Monique Laurent, 'Observations on Rodin and His Founders', in Washington 1981, pp. 285–93

Layard 1853
Sir Austen Henry Layard, *Discoveries among the Ruins of Nineveh and Babylon*, London, 1853

Le Normand-Romain 2007
Antoinette Le Normand-Romain, *The Bronzes of Rodin: Catalogue Raisonné of the Works in the Musée Rodin*, Paris, 2007, 2 vols

Lebon 2003
Elisabeth Lebon, *Dictionnaire des fondeurs de bronze d'art. France 1890–1950*, Perth, 2003

Lebon 2012
Elisabeth Lebon, *Fonte au sable, fonte à cire perdue – Histoire d'une rivalité*, Paris, 2012

Ledderose 2000
Lothar Ledderose, *Ten Thousand Things: Module and Mass Production in Chinese Art*, Princeton, 2000

Lehmann 2006
Stefan Lehmann, 'Mit langem Haar und Patriarchenbart. Das frühhellenistische Herrscherbildnis Seuthes III', in S. Conrad (ed.), *Pontos Euxeinos. Manfred Oppermann zum 65. Geburtstag*, Langenwei bach, 2006, pp. 155–69

Leospo 1978
Enrichetta Leospo, *La Mensa Isiaca di Torino*, Leiden, 1978

Li Feng 2006
Li Feng, *Landscape and Power in Early China: The Crisis and Fall of the Western Zhou, 1045–771 BC*, Cambridge, 2006

Li, Bower and He 2010
Li Zhiyan, Virginia Bower and He Li, *Chinese Ceramics from the Paleolithic Period through the Qing Dynasty*, New Haven and London, 2010

Lilliu 1966
Giovanni Lilliu, *Sculture della Sardegna Nuragica*, Verona, 1966 (new edition, 2008)

Lilliu 1984
Giovanni Lilliu, with an introduction buy Alberto Moravetti, *La civiltà nuragica*, Sassari, 1984

Lion-Goldschmidt and Moreau-Gobard 1962
Daisy Lion-Goldschmidt and Jean-Claude Moreau-Gobard, *Chinese Art: Bronze, Jade, Sculpture, Ceramics*, New York, 1962

Liverpool 1994
Penelope Curtis and Alan G. Wilkinson, *Barbara Hepworth: A Retrospective*, exh. cat., Tate Gallery, Liverpool, Yale Center for British Art, New Haven, and Art Gallery of Ontario, Toronto, 1994–95

Livorno 2009
Stefano Bruni (ed.), *Alle origini di Livorno. L'età etrusca e romana*, exh. cat., Granai di Villa Mimbelli, Livorno, 2009

Loehr 1953
Max Loehr, 'The Bronze Styles of the Anyang Period', *Archives of the Chinese Art Society of America*, 7, 1953, pp.42–53

Loewe and Shaughnessy 1999
Michael Loewe and Edward L. Shaughnessy (eds), *The Cambridge History of Ancient China from the Origins of Civilisation to 221 BC*, Cambridge, 1999

Lombardi 2009
Gianni Lombardi, 'The Casting Core Composition and Provenance of the Goljama Kosmatka (Bulgaria) Bronze Head', *Journal of Archaeological Science*, 36, 2009, pp. 520–27

London 1964
Sculptures by Jules Dalou (1838–1902), exh. cat., Mallett, London, 1964, no.84

London 1973
Albert E. Elsen, *Pioneers of Modern Sculpture*, exh. cat., Hayward Gallery, London, 1973

London 1976
Pompeii AD 79, exh. cat., Royal Academy of Arts, London, 1976

London 1982
Ekpo Eyo and Frank Willett, *Treasures of Ancient Nigeria*, exh. cat., Royal Academy of Arts, London, 1982–83

London 1983
Jane Martineau and Charles Hope (eds), *The Genius of Venice, 1500–1600*, exh. cat., Royal Academy of Arts, London, 1983

London 1986A
Richard Dorment (ed.), *Alfred Gilbert: Sculptor and Goldsmith*, exh. cat., Royal Academy of Arts, London, 1986

London 1986B
Catherine Lampert, *Rodin: Sculpture and Drawings*, exh. cat., Hayward Gallery, London, 1986–87

London 1987
Jonathan Alexander and Paul Binski (eds), *The Age of Chivalry: Art in Plantagenet England 1200–1400*, exh. cat., Royal Academy of Arts, London, 1987

London 1988
Susan Compton et al., *Henry Moore*, exh. cat., Royal Academy of Arts, London, 1988

London 1993A
Dillian Gordon, *Making and Meaning: The Wilton Diptych*, exh. cat., National Gallery, London, 1993

London 1993B
Frances Morris, *Paris Post War: Art and Existentialism 1945–55*, exh. cat., Tate, London, 1993

London 1994A
Victor Harris, *Japanese Imperial Craftsmen: Meiji Art from the Khalili Collection*, exh. cat., British Museum, London, 1994

London 1994B
Luciano Caramel, *Medardo Rosso*, exh. cat., Whitechapel Art Gallery, London, Scottish National Gallery of Modern Art, Edinburgh, and Henry Moore Institute, Leeds, 1994

London 1994C
Elizabeth Cowling and John Golding, *Picasso: Sculptor/Painter*, exh. cat., Tate Gallery, London, 1994

London 1995
Tom Phillips (ed.), *Africa: The Art of a Continent*, exh. cat., Royal Academy of Arts, London

London 1996
Jessica Rawson (ed.), *Mysteries of Ancient China: New Discoveries from the Early Dynasties*, exh. cat., British Museum, London, 1996

London 1998
Louise Bourgeois: Recent Works, exh. cat., Serpentine Gallery, London, 1998–99

London 2000
Gabriele Finaldi, *The Image of Christ*, exh. cat., National Gallery, London, 2000

London 2002A
Larissa Dukelskaya and Andrew Moore, *A Capital Collection: Houghton Hall and the Hermitage*, exh. cat., Somerset House, London, 2002

London 2002B
Victoria Avery, *Renaissance and Baroque Bronzes from the Fitzwilliam Museum, Cambridge*, exh. cat., Daniel Katz Ltd, London, 2002

London 2002C
St John Simpson (ed.), *Queen of Sheba: Treasures of Ancient Yemen*, exh. cat., British Museum, London, 2002

London 2005A
Frits Scholten and Monique Verber, *From Vulcan's Forge: Bronzes from the Rijksmuseum, Amsterdam, 1450–1800*, exh. cat., Daniel Katz Ltd, London, and Liechtenstein Museum, Vienna, 2005–06

London 2005B
Paul Williamson, *Medieval and Later Treasures from a Private Collection*, exh. cat., Victoria and Albert Museum, London, 2005

London 2006
Chola: Sacred Bronzes of Southern India, exh. cat., Royal Academy of Arts, London, 2006

London 2007
Luke Syson (ed.), *Renaissance Siena: Art for a City*, exh. cat., National Gallery, London, 2007–08

London 2009A
Anish Kapoor, exh. cat., Royal Academy of Arts, London, 2009

London 2009B
Didier Ottinger (ed.), *Futurism*, exh. cat., Tate Modern, London, 2009

London 2009C
Henry John Drewal and Enid Schildkrout, *Kingdom of Ife: Sculptures from West Africa*, exh. cat., British Museum, London, 2009

London 2010A
Beauty and Power: Renaissance and Baroque Bronzes from the Peter Marino Collection, exh. cat., Wallace Collection, London, Huntington Collections, San Marino, and Minneapolis Institute of Arts, 2010–11

London 2010B
Chris Stephens (ed.), *Henry Moore*, exh. cat., Tate Britain, London, 2010

Los Angeles 1977
Pratapaditya Pal, *The Sensuous Immortals: A Selection of Sculptures from the Pan-Asian Collection*, exh. cat., Los Angeles County Museum of Art, 1977

Los Angeles 2010
Mario Iozzo (ed.), *The Chimaera of Arezzo*, exh. cat., J. Paul Getty Museum, Los Angeles, 2010

Madrid 1994
Los Leoni (1509–1608): Escultores del Renacimiento italiano al servicio de la corte de España, exh. cat., Museo del Prado, Madrid, 1994

Maffeis 2006
Rudolfo Maffeis, 'A rebours: retrospettiva giambolognesca nella pittura fiorentina del Seicento', in Florence 2006, pp.332–42

Malek 1993
Jaromir Malek, *The Cat in Ancient Egypt*, London, 1993

Mann 1981
J. G. Mann, *Wallace Collection Catalogues: Sculpture, with Supplement*, London, 1981

Mantua 2008
Filippo Trevisani and Davide Gasparotto (eds), *Bonacolsi l'Antico: Uno scultore nella Mantova di Andrea Mantegna e di Isabella d'Este*, exh. cat., Palazzo Ducale, Mantua, 2008–09

Marsden 2006
Jonathan Marsden, 'A Newly Discovered Bust of Catherine de Medici by Germain Pilon', *Burlington Magazine*, 148, 1245, December 2006, pp.833–36

Mattusch 1988
Carol C. Mattusch, *Greek Bronze Statuary: From the Beginnings through the Fifth Century BC*, Ithaca, 1988

Mattusch 2005
Carol C. Mattusch, with Henry Lie, *The Villa dei Papiri at Herculaneum: Life and Afterlife of a Sculpture Collection*, Los Angeles, 2005

Megaw 1989
Ruth and Vincent Megaw, *Celtic Art: From Its Beginnings to the Book of Kells*, London, 1989

Mei 2009
Jianjun Mei, 'Early Metallurgy in China: Some Challenging Issues in Current Studies', in Mei and Rehren 2009, pp.9–16

Mei 2011
Jianjun Mei, 'From Personal Ornaments to Ritual Objects', paper presented to the conference held at Bac in Shaanxi Province, November 2011: *Emergence of Bronze Age Societies: A Global Perspective*

Mei and Rehren 2009
Jianjun Mei and Thilo Rehren, *Metallurgy and Civilisatio Eurasia and Beyond*, London, 2009

Melczer 1984
William Melczer, *La Porta di Bronzo di Barisano da Trani a Ravello: Iconografia e Stile*, Cava de' Tirreni, 1984

Melczer 1987
William Melczer, *La Porta di Bonanno a Monreale: Teologia e Poesia*, Palermo, 1987

Melczer 1988
William Melczer, *La Porta di Bonanno nel Duomo di Pisa Teologia ed Immagine*, Ospedaletto, 1988

Mende 1981
Ursula Mende, *Die Türzieher des Mittelalters (Bronzegeräte des Mittelalters, 2)*, Berlin, 1981

Mende 1983
Ursula Mende, *Die Bronzetüren des Mittelalters, 800–1200*, Munich, 1983

Milan 1997
Jerry Gorovoy, *Louise Bourgeois: Blue Days and Pink Days*, exh. cat., Fondazione Prada, Milan, 1997

Minning 2010
Martina Minning, *Giovan Francesco Rustici (1475–1554 Forschungen zu Leben und Werk des Florentiner Bildhauers*, Münster, 2010

Mizuno 1959
Seiichi Mizuno, *Bronzes and Jades of Ancient China*, Tokyo, 1959

Monaco 2005
Ezio Bassani (ed.), *Arts of Africa: 7,000 Years of African Art*, exh. cat., Grimaldi Forum, Monaco, 2005

Montagu 1985
Jennifer Montagu, *Alessandro Algardi*, 2 vols, New Haven and London, 1985

Moorey 1974
P. R. S. Moorey, *Ancient Bronzes from Luristan*, London, 1974

Moorey 1988
P. R. S. Moorey, 'The Chalcolithic Hoard from Nahal Mishmar, Israel, in Context', *World Archaeology*, 20, 2, 1988, pp. 171–89

Moorey 1994
P. R. S. Moorey, *Ancient Mesopotamian Materials and Industries*, Oxford, 1994

Moortgat 1969
Anton Moortgat, *The Art of Ancient Mesopotamia*, London and New York, 1969

Moreno 2005
Paolo Moreno, 'Satiro in estasi di Prassitele', in Petriaggi 2005, pp. 198–227

Morse and Tsuji 1998
Anne Nishimura Morse and Nobuo Tsuji, *Japanese Art in the Museum of Fine Arts, Boston I: Buddhist Painting, Buddhist Sculpture, Buddhist Decorative Arts, Buddhist Robes, No Masks, Ink Painting, Early Kano School Painting, and Rimpa*, Boston and Tokyo, 1998

Moskowitz 1986
Anita Fiderer Moskowitz, *The Sculpture of Andrea and Nino Pisano*, Cambridge, 1986

Mukherjee 1978
Meera Mukherjee, *Metalcraftsmen of India*, Anthropological Survey of India, Calcutta, 1978

Mukherji 2001
Parul Dave Mukherji, *The Citrasutra of the Vishnudharmaottara Purana*, Indira Gandhi National Centre for the Arts, New Delhi, 2001

Mulcahy 1994
Rosemarie Mulcahy, *The Decoration of the Royal Basilica of El Escorial*, Cambridge, 1994

Nagaswamy 1983
Ramachandran Nagaswamy, *Masterpieces of Early South Indian Bronzes*, National Museum, New Delhi, 1983

Nagaswamy 1995
Ramachandran Nagaswamy, 'On Dating South Indian Bronzes', in John Guy (ed.), *Indian Art and Connoisseurship: Essays in Honour of Douglas Barrett*, IGNCA, Delhi, 1995, pp. 100–39

Nagoya 2002
Ajia no kokoro, bukkyo bijutsu ten (Buddhist Arts of Asia), exh. cat., Nagoya/Boston Museum of Fine Arts, 2002–03

Nannelli 2012
Francesca Nannelli, 'Orsanmichele: Some Recent History', in Brandon Strehlke 2012, pp. 315–38

Nesi 2011
Antonella Nesi (ed.), *Il Porcellino di Pietro Tacca: le sue basi, la sua storia*, Florence, 2011

Nevadomsky and Osemweri 2007
Joseph Nevadomsky and Agbonifo Osemweri, 'Benin Art in the Twentieth Century', in Vienna 2007, pp. 254–61

New York 1985
Elisabeth and Robert Kashey, *Nineteenth-century French and European Sculpture in Bronze and Other Media*, exh. cat., Shepherd Gallery, New York, 1985

New York 1986
Gothic and Renaissance Art in Nuremberg 1300–1550, exh. cat., Metropolitan Museum of Art, New York, and Germanisches Nationalmuseum, Nuremberg, 1986

New York 1988
Luciano Caramel, *Medardo Rosso: Impressions in Wax and Bronze 1882–1906*, exh. cat., Kent Fine Art Inc., New York, Kamakura Gallery, Tokyo, and David Grob Ltd, London, 1988–89

New York 1993
Prudence O. Harper, Joan Aruz and Françoise Tallon (eds), *The Royal City of Susa: Ancient Near Eastern Treasures in the Louvre*, exh. cat., Metropolitan Museum of Art, New York, 1993

New York 1995
An Exhibition of Medieval Renaissance and Islamic Works of Art, exh. cat., Newhouse Galleries, New York, 1995

New York 2003
Joan Aruz (ed.) with Ronald Wallenfels, *Art of the First Cities: The Third Millennium BC from the Mediterranean to the Indus*, exh. cat., Metropolitan Museum of Art, New York, 2003

New York 2006
Peter Barnet and Pete Dandridge, *Lions, Dragons and Other Beasts: Aquamanilia of the Middle Ages, Vessels for Church and Table*, exh. cat., Bard Graduate Center, New York, 2006

New York 2008A
Denise Allen with Peta Motture, *Andrea Riccio: Renaissance Master of Bronze*, exh. cat., Frick Collection, New York, 2008–09

New York 2008B
Collected Visions: Modern Art and Contemporary Works from the JP Morgan Chase Art Collection, exh. cat., Bronx Museum, New York, JP Morgan Building, Dubai, and Pera Museum, Istanbul, c. 2008

New York 2011A
Chen Jianming, Jay Xu and Fu Juliang (eds), *Along the Yangzi River, Regional Culture of the Bronze Age from Hunan*, exh. cat., China Institute Gallery, New York, 2011

New York 2011B
John Elderfield (ed.), *Willem de Kooning*, exh. cat., Museum of Modern Art, New York, 2011–12

Nicholls 1982
Richard Nicholls, 'The Drunken Herakles: A New Angle on an Unstable Subject', *Hesperia: The Journal of the American School of Classical Studies at Athens*, 51, 3, July–September 1982, pp. 321–28

Noguchi 1968
Isamu Noguchi, *A Sculptor's World*, New York, 1968

Norwich 2001
Michael Peppiatt, *Alberto Giacometti in Postwar Paris*, exh. cat., Sainsbury Centre for Visual Arts, UEA, Norwich, and Fondation de l'Hermitage, Lausanne, 2001–02

Ogdensburg 1996
Icons of the West: Frederic Remington's Sculpture, Frederic Remington Art Museum, Ogdensburg, 1996

Orr 2004
Leslie Orr, 'Processions in the Medieval South Indian Temple: Sociology, Sovereignty and Soteriology', in Jean-Luc Chevillard (ed.), *South-Indian Horizons. Felicitation Volume for François Gros on the Occasion of His Seventieth Birthday*, Institut Français de Pondichéry/EFEO, 2004, pp. 437–70

Orthmann 1985
Winfried Orthmann (ed.), *Der Alte Orient*, Propyläen Kunstgeschichte, 18, 1985

Paderborn 2006
Christoph Stiegemann and Matthias Wemhoff, *Canossa 1077: Erschütterung der Welt. Geschichte, Kunst und Kultur am Anfang der Romanik*, exh. cat., Diözesanmuseum, Paderborn, 2 vols, 2006

Padua 2001
Donatello e il suo tempo. Il bronzetto a Padova nel Quattrocento e nel Cinquecento, exh. cat., Palazzo della Ragione, Padua, 2001

Pal 1975
Pratapaditya Pal, *Bronzes of Kashmir*, Graz, 1975

Palermo 2003
Wilfried Seipel (ed.), *Nobiles officinae: die koniglichen Hofwerkstatten zu Palermo zur Zeit der Normannen und Staufer im 12 und 13 Jahrhundert*, exh. cat., Palazzo dei Normanni, Palermo, and Kunsthistorisches Museum, Vienna, 2003–04

Panofsky 1992
Erwin Panofsky, *Tomb Sculpture: Its Changing Aspects from Ancient Egypt to Bernini*, London, 1992

Parigoris 1997
Alexandra Parigoris, 'Truth to Material: Bronze, on the Reproducibility of Truth', in Anthony Hughes and Erich Ranfft (eds), *Sculpture and Its Reproductions*, London, 1997, pp. 131–51

Paris 1988
Vrai ou Faux? Copier, imiter, falsifier, exh. cat., Bibliothèque nationale de France, Paris, 1988

Paris 1996
Dina Vierny and Bertrand Lorquin, *Maillol, le Passion du bronze*, exh. cat., Fondation Dina Vierny / Musée Maillol, Paris, 1996

Paris 1997
Anne Pingeot and Robert Hoozee (eds), *Paris–Bruxelles, Bruxelles–Paris. Realisme, impressionnisme, symbolisme, art nouveau: les relations artistiques entre la France et la Belgique, 1848–1914*, exh. cat., Galeries nationales du Grand Palais, Paris, and Musee des Beaux-Arts, Ghent, 1997

Paris 2005
Pierre Baptiste and Thierry Zephir (eds), *Trésors d'art du Vietnam. La sculpture du Champa, V–XV siècles*, Paris, 2005

Paris 2008A
Vincent Lefèvre, *Art of the Ganges Delta: Masterpieces from Bangladeshi Museums*, exh. cat., Musée Guimet, Paris, 2008

Paris 2008B
Alexis Kugel, *Les Bronzes du Prince de Liechtenstein: chefs-d'oeuvre de la Renaissance et du Baroque*, exh. cat., J. Kugel Antiquaires, Paris, 2008

Paris 2008C
Geneviève Bresc-Bautier, Guilhem Scherf and James David Draper (eds), *Cast in Bronze: French Sculpture from Renaissance to Revolution*, exh. cat., Musée du Louvre, Paris, Metropolitan Museum of Art, New York, and J. Paul Getty Museum, Los Angeles, 2008–09

Parisi Presicce 2003
Claudio Parisi Presicce, 'Il Satiro Mainomenos di Mazara del Vallo: un possibile contesto originario', *Sicilia Archaeologica*, 101, 2003, pp. 25–40

Parker 2011
Robert McD. Parker, 'Catalogue of the Stein Collections', in Janet Bishop, Cécile Debray and Rebecca Rabinow, *The Steins Collect*, exh. cat., San Francisco Museum of Modern Art, 2011, pp. 394–457

Patry Leidy 1994
Denise Patry Leidy, *Treasures of Asian Art: The Asia Society's Mr and Mrs John D. Rockefeller 3rd Collection*, New York, 1994

Patry Leidy, Strahan et al. 2010
Denise Patry Leidy, Donna Strahan et al., *Wisdom Embodied: Chinese Buddhist and Daoist Sculpture in the Metropolitan Museum of Art*, New Haven, 2010

Payne 1986
Christopher Payne, *Animals in Bronze: Reference and Price Guide*, Woodbridge, 1986

Peek and Nicklin 2002
Philip M. Peek and Keith Nicklin, 'Lower Niger Bronze Industries and the Archaeology of the Niger Delta', in Anderson and Peek 2002, pp. 38–59

Penny 1992
Nicholas Penny, *Catalogue of European Sculpture in the Ashmolean Museum: 1540 to the Present Day*, 3 vols, Oxford, 1992

Penny 1993
Nicholas Penny, *The Materials of Sculpture*, New Haven and London, 1993

Peterson 1989
Indira Viswanathan Peterson, *Poems to Siva: The Hymns of the Tamil Saints*, Princeton, 1989; reprinted New Delhi, 1991

Petriaggi 2003
Roberto Petriaggi (ed.), *Il Satiro Danzante*, Milan, 2003

Petriaggi 2005
Roberto Petriaggi (ed.), *Il Satiro Danzante di Mazara del Vallo: Il Restauro e l'Immagine*, Naples, 2005

Phillips 1995
See London 1995

Phillips 2009
Tom Phillips, *African Goldweights: Miniature Sculptures from Ghana, 1400–1900*, London and Bangkok, 2009

Pignorio 1670
Lorenzo Pignorio, *Mensa Isiaca, qua sacrorum apud Aegyptios ratio et simulacra, subjectis tabulis aeneis exhibentur et explicantur*, Amsterdam, 1670

Pizzorusso 1989
Claudio Pizzorusso, *A Boboli e altrove. Sculture e scultori fiorentini del Seicento*, Florence, 1989

Plankensteiner 2007
See Vienna 2007

Pope-Hennessy 1964
John Pope-Hennessy, *Catalogue of Italian Sculpture in the Victoria and Albert Museum*, 3 vols, London, 1964

Pope-Hennessy 1968
John Pope-Hennessy, *Essays on Italian Sculpture*, London, 1968

Pope-Hennessy 1985
John Pope-Hennessy, *Cellini*, London, 1985

Pope-Hennessy 1993
John Pope-Hennessy, *Donatello Sculptor*, New York, London and Paris, 1993

Pope-Hennessy 2000
John Pope-Hennessy, *An Introduction to Italian Sculpture*, 3 vols: 1, *Italian Gothic Sculpture*; 2, *Italian Renaissance Sculpture*; 3, *High Renaissance and Baroque Sculpture*, London, 2000

Postel, Neven and Mankodi 1985
Michel Postel, Armand Neven and Kirit Mankodi, *Antiquities of Himachal*, Project for Indian Cultural Studies, Mumbai, 1985

Potts 1994
Timothy Potts, *Mesopotamia and the East: An Archaeological and Historical Study of Foreign Relations 3400–2000 BC*, Oxford, 1994

Preston Blier 1985
Suzanne Preston Blier, 'Kings, Crowns and Rights of Succession: Obalufon Arts at Ife and Other Yoruba Centers', *Art Bulletin*, 67, 3, 1985, pp. 383–401

Quibell and Green 1902
J. E. Quibell and F. W. Green, *Hierakonpolis*, part 2, London, 1902

Radcliffe 1976
Anthony Radcliffe, 'Ferdinando Tacca, the Missing Link in Florentine Baroque Bronzes', in *Kunst des Barock in der Toskana*, Munich, 1976, pp. 14–23

Radcliffe and Penny 2004
Anthony Radcliffe and Nicholas Penny, *The Robert H. Smith Collection: Art of the Renaissance Bronze 1500–1650*, London, 2004

Raff 1994
Thomas Raff, *Die Sprache der Materialien: Anleitung zu einer Ikonologie der Werkstoffe*, Munich, 1994

Rathnasabapathy 1982
S. Rathnasabapathy, *The Thanjavur Art Gallery Bronze Sculptures*, Thanjavur, 1982

Rawson 1967
Philip Rawson, *The Art of Southeast Asia*, London, 1967

Rawson 1987
Jessica Rawson, *Chinese Bronzes: Art and Ritual*, London, 1987

Rawson 1990
Jessica Rawson, *Western Zhou Ritual Bronzes from the Arthur M. Sackler Collections*, Washington DC, 1990

Rawson 1992
Jessica Rawson (ed.), *The British Museum Book of Chinese Art*, London, 1992

Rawson 1995
Jessica Rawson, *Chinese Jade from the Neolithic to the Qing*, London, 1995

Rawson 1999
Jessica Rawson, 'Western Zhou Archaeology', in Loewe and Shaughnessy 1999, pp.352–449

Rawson and Bunker 1990
Jessica Rawson and Emma Bunker, *Ancient Chinese and Ordos Bronzes*, Oriental Ceramic Society of Hong Kong, 1990

Ray, Khandalavala and Gorakshkar 1986
Nihar Ranjan Ray, Karl Khandalavala and Sadashiv Gorakshkar, *Eastern Indian Bronzes*, New Delhi, 1986

Reedy 1997
Chandra L. Reedy, *Himalayan Bronzes: Technology, Style and Choices*, Newark, 1997

Reggiani Massarini 1998
Anna Maria Reggiani Massarini, 'Le Navi di Nemi', in Adriano La Regina (ed.), *Palazzo Massimo alle Terme*, Rome, 1998, pp.156–59

Reudenbach 1984
Bruno Reudenbach, *Das Taufbecken des Reiner von Huy in Lüttich*, Wiesbaden, 1984

Reudenbach 2008
Bruno Reudenbach, 'Visualising Holy Bodies: Observations on Body-part Reliquaries', in Colum Hourihane (ed.), *Romanesque Art and Thought in the Twelfth Century: Essays in Honor of Walter Cahn*, University Park, Pa., 2008, pp.95–106

Rewald 1975
John Rewald, 'Maillol Remembered', in *Aristide Maillol: 1861–1944*, exh. cat., Solomon R. Guggenheim Museum, New York, 1975, p.11

Rice 1983
E. E. Rice, *The Grand Procession of Ptolemy Philadelphus*, Oxford, 1983

Richardson 1983
Emeline Richardson, *Etruscan Votive Bronzes: Geometric, Orientalizing, Archaic*, Mainz, 1983

Richardson 1999
John Richardson, *The Sorcerer's Apprentice: Picasso, Provence and Douglas Cooper*, London, 1999

Richarme 2003
Alain Richarme, 'Carpeaux et les éditions', in Michel Poletti and Alain Richarme, *Jean-Baptiste Carpeaux, Sculpteur: catalogue raisonné de l'oeuvre édité*, Paris, 2003, pp.31–43

Riederer 1985
Josef Riederer, 'Metal Analysis of Indian Bronze Sculptures', *Journal of Archaeological Chemistry*, 3, 1985, pp.69–72

Rizzo 2012
Giuseppe Rizzo, 'Clemente Papi 'Real Fonditore': Vita e Opere di un Virtuosistico Maestro del Bronzo nella Firenze dell'Ottocento', *Mitteilungen des Kunsthistorischen Institutes in Florenz*, 54, 2 (2010–12), June 2012, pp.295–318

Rolley 1986
Claude Rolley, *Greek Bronzes*, London, 1986

Roscoe, Hardy and Sullivan 2009
Ingrid Roscoe, Emma Hardy and M. G. Sullivan, *A Biographical Dictionary of Sculptors in Britain 1660–1851*, New Haven and London, 2009

Rosenauer 1993
Artur Rosenauer, *Donatello*, Milan, 1993

Ryder 1969
Alan Ryder, *Benin and the Europeans, 1485–1897*, London and Harlow, 1969

Saint-Paul de Vence 1996
Jean-Louis Prat, *Germaine Richier: rétrospective*, exh. cat., Fondation Maeght, Saint-Paul de Vence, 1996

Salmi 1960
Mario Salmi, 'Il problema della statua bronzea di S. Pietro nella Basilica Vaticana', *Commentari*, 11, 1960, pp.22–29

Sandars 1995
N. K. Sandars, *Prehistoric Art in Europe*, second edition, New Haven and London, 1995

Scamuzzi 1939
Ernesto Scamuzzi, *La 'Mensa Isiaca' del Regio Museo di Antichità di Torino*, Pubblicazioni egittologiche del R. Museo di Torino, 5, Rome, 1939

Schlombs and Girmond 1995
Adele Schlombs and Sybille Girmond, *Meisterwerke aus China, Korea und Japan: Museum für Ostasiatische Kunst Köln*, Munich, 1995

Schneider 2002
Pierre Schneider, *Matisse*, London, 2002

Scholten 2007
Frits Scholten (translated by Lynne Richards), *Isabella's Weepers: Ten Statues from a Burgundian Tomb*, Rijksmuseum Dossiers, new series, 8, Amsterdam, 2007

Schroeder 1981
Ulrich von Schroeder, *Indo-Tibetan Bronzes*, Hong Kong, 1981

Schwartz et al. 2008
Margaret H. Schwartz et al., *European Sculpture from the Abbott-Guggenheim Collection*, New York, 2008

Seattle 2001
Robert W. Bagley (ed.), *Ancient Sichuan, Treasures from a Lost Civilisation*, exh. cat., Seattle Art Museum, 2001

Sénéchal 2009
Philippe Sénéchal, 'Giovan Francesco Rustici, with and without Leonardo', in Gary M. Radke (ed.), *Leonardo da Vinci and the Art of Sculpture*, exh. cat., High Museum of Art, Atlanta, and J. Paul Getty Museum, Los Angeles, 2009–10, pp.160–93

Shapiro 1985
Michael Edward Shapiro, *Bronze Casting and American Sculpture 1850–1900*, London and Toronto, 1985

Sharma 2000
Deo Prakash and Madhuri Sharma, *Early Buddhist Metal Images of South Asia*, Delhi, 2000

Shaughnessy 1991
Edward Shaughnessy, *Sources of Western Zhou History, Inscribed Bronze Vessels*, Berkeley, Los Angeles and Oxford, 1991

Shaw 1970
Thurstan Shaw, *Igbo-Ukwu: An Account of Archaeological Discoveries in Eastern Nigeria*, 2 vols, London, 1970

Shaw 1977
Thurstan Shaw, *Unearthing Igbo-Ukwu*, Ibadan, 1977

Shaw 1978
Thurstan Shaw, *Nigeria: Its Archaeology and Early History*, London, 1978

Shaw, Sinclair, Andah and Okpoko 1993
Thurston Shaw, Paul Sinclair, Bassey Andah and Alex Okpoko (eds), *The Archaeology of Africa: Food, Metals and Towns*, London and New York, 1993

Sider 2005
David Sider, *The Library of the Villa dei Papiri at Herculaneum*, Los Angeles, 2005

Sivaramamurti 1963
C. Sivaramamurti, *South Indian Bronzes*, New Delhi, 1963

Smith and Beentjes 2010
Pamela H. Smith and Tonny Beentjes, 'Nature and Art, Making and Knowing: Reconstructing Sixteenth-century Life-casting Techniques', *Renaissance Quarterly*, 63, 2010, pp.128–79

Solyom 1978
Garrett and Bronwen Solyom, *The World of the Javanese Keris*, Honolulu, 1978; reissued 1988

Spies 2000
Werner Spies, *Picasso: The Sculptures. Catalogue Raisonné of the Sculptures in Collaboration with Christine Piot*, Centre National d'Art et de Culture Georges Pompidou, Paris, 2000

Spivey 1997
Nigel Spivey, *Etruscan Art*, London and New York, 1997

Spycket 1981
Agnès Spycket, *La Statuaire du Proche-Orient ancien*, Leiden, 1981

Srinivasan 1999
Sharada Srinivasan, 'Lead Isotope and Trace Element Analysis in the Study of Over a Hundred South Indian Metal Icons', *Archaeometry*, 41, 1, 1999, pp.91–116

Stead 1985
Ian Mathieson Stead, *The Battersea Shield*, London, 1985

Stein 1900
M. Aurel Stein, *Kalhana's Rajatarangini: A Chronicle of the Kings of Kashmir*, London, 1900, 2 vols; reprinted Delhi, 1961

Sternberg El-Hotabi 1994
Heike Sternberg El-Hotabi, 'Die Mensa Isiaca und die Isis-Aretalogien', *Chronique d'Egypte*, 69, 1994, pp.54–86

Stone 2008
Richard E. Stone, 'Riccio: Technology and Connoisseurship', in Denise Allen and Peta Motture (eds), *Andrea Riccio: Renaissance Master of Bronze*, exh. cat., The Frick Collection, New York, 2008, pp.81–96

Stone 2010
Richard E. Stone, 'Organic Patinas on Small Bronzes of the Italian Renaissance', *Metropolitan Museum Journal*, 45, 2010, pp.107–24

Stone 2011
Richard E. Stone, 'Understanding Antico's Patinas', in Leonora Luciano (ed.), *Antico: The Golden Age of Renaissance Bronzes*, exh. cat., National Gallery of Art, Washington DC, pp.178–82

Sydney 2011
Homage to the Ancestors: Ritual Art from the Chu Kingdom, exh. cat., Art Gallery of New South Wales, Sydney, 2011

Thürlemann 1977
Félix Thürlemann, 'Die Bedeutung der Aachener Theoderich-Statue von Karl den Grossen (801) und bei Walahfrid Strabo (829): Materialien zu einer Semiotik visueller Objekte im frühen Mittelalter', *Archiv für Kulturgeschichte*, 1, 1977, pp.25–65

Towne-Markus 1997
Elana Towne-Markus, *Masterpieces of the J. Paul Getty Museum: Antiquities*, Los Angeles and London, 1997

Trento 1999
Andrea Bacchi, Lia Camerlengo and Manfred Leithe-Jasper, *La Bellissima Maniera – Alessandro Vittoria e la scultura veneta del Cinquecento*, exh. cat., Castello del Buonconsiglio, Trento, 1999

Trento 2008
Andrea Bacchi and Laura Giacomelli (eds), *Rinascimento e passione per l'antico: Andrea Riccio e il suo tempo*, exh. cat., Castello del Buonconsiglio and Museo Diocesano Tridentino, Trento, 2008

Tylecote 1975
R. F. Tylecote, 'The Origin of Iron Smelting in Africa', *West African Journal of Archaeology*, 5, 1975, pp.1–9

Ucelli 1940
Guido Ucelli, *Le Navi di Nemi*, Rome, 1940

Vasari 1996
Giorgio Vasari, *Lives of the Painters, Sculptors and Architects*, 2 vols, ed. and intro. by David Ekserdjian, London, 1996

Venice 1993
Giovanni Curatola (ed.), *Eredità dell'Islam: Arte Islamica in Italia*, exh. cat., Palazzo Ducale, Venice, 1993–94

Vienna 2007
Barbara Plankensteiner (ed.), *Benin Kings and Rituals: Court Arts from Nigeria*, exh. cat., Museum für Völkerkunde, Vienna, 2007

Villa and Caruba 2009
Agata Villa and Anna Maria Carruba, 'Storia e tecnica dell'Ariete bronzeo di Palermo', *Boreas*, 32, 2009, pp.93–144

Vitzthum 1969
Walter Vitzthum, *Lo studiolo di Francesco I a Firenze*, Milan, 1969

Vogel 1911
Jean Philippe Vogel, *Antiquities of Chamba State. Part I. Inscriptions of the Pre-Muhammadan Period*, Archaeological Survey of India, Calcutta, New Imperial Series, vol.36, 1911; reprinted facsimile 1990, with an introduction by Nik Douglas

Walsh 1990
David Allen Walsh, 'The Bronze Doors of Brianus of Trani', in Salvatorino Salomi (ed.), *Le porte di bronzo dall'antichità al secolo XIII*, Rome, 1990, pp.399–407

Warren 2010
Jeremy Warren, 'Florence, Paris, Rome: Cultural Crossing Points', in London 2010A, pp.21–37

Washington 1981
Albert E. Elsen (ed.), *Rodin Rediscovered*, exh. cat., National Gallery of Art, Washington, 1981

Washington 1990
Jan Fontein, *Sculpture of Indonesia*, exh. cat., National Gallery of Art, Washington, Museum of Fine Arts, Houston, Metropolitan Museum of Art, New York, and Asian Art Museum of San Francisco, 1990–92

Washington 2000A
Ruth Butler and Suzanne Lindsay Glover, *European Sculpture of the Nineteenth Century*, exh. cat., National Gallery of Art, Washington, 2000

Washington 2000B
Jenny F. So (ed.), *Music in the Age of Confucius*, exh. cat., Freer Gallery of Art and Arthur M. Sackler Gallery, Smithsonian Institution, Washington, 2000

Washington 2008
Carol C. Mattusch, *Pompeii and the Roman Villa: Art and Culture around the Bay of Naples*, exh. cat., National Gallery of Art, Washington, and Los Angeles County Museum of Art, 2008

Washington 2010
Louise Allison Cort and Paul Jeff (eds), *Gods of Angkor: Bronzes from the National Museum of Cambodia*, exh. cat., Arthur M. Sackler Gallery, Smithsonian Institution, Washington, and J. Paul Getty Museum, Los Angeles, 2010–11

Washington 2011
Eleonora Luciano, Claudia Kryza-Gersch, Stephen Campbell et al., *Antico: The Golden Age of Renaissance Bronzes*, exh. cat., National Gallery of Art, Washington, and Frick Collection, New York, 2011–12

Wasserman 1975
Jeanne L. Wasserman (ed.), *Metamorphoses in Nineteenth-century Sculpture*, Cambridge, Mass., 1975

Wenley 2008
Robert Wenley, 'Paintings in Metal', in Paris 2008C, pp.372–79

Whinney 1988
Margaret Whinney, *Sculpture in Britain 1520–1830*, revised by J. Physick, New Haven and London, 1988

White 1970
John White, 'The Reconstruction of Nicola Pisano's Perugia Fountain', *Journal of the Warburg and Courtauld Institutes*, 33, 1970, pp.70–83

White 1987
John White, *Art and Architecture in Italy 1250–1400*, second edition, New Haven and London, 1987

Whitehouse 2009
Helen Whitehouse, *Ancient Egypt and Nubia in the Ashmolean Museum, Oxford*, Oxford, 2009

Wilkinson, Sherratt and Bennett 2000
Toby C. Wilkinson, Susan Sherratt and John Bennett, *Interweaving Worlds, Systemic Interactions in Eurasia, Seventh to the First Millennium BC*, Oxford, 2011

Willett 1966
Frank Willett, 'On the Funeral Effigies of Owo and Benin, and the Interpretation of the Life-size Bronze Heads from Ife', *Man (Journal of the Royal Anthropological Institute)*, 1966, pp.34–45

Willett 1967
Frank Willett, *Ife in the History of West African Sculpture*, London, 1967

Willett 2003
Frank Willett, *The Art of Ife: A Descriptive Catalogue and Database*, The Hunterian Museum and Art Gallery, University of Glasgow, 2003: available as a CD-ROM, see www.museum.gla.ac.uk

Williams 1974
Denis Williams, *Icon and Image: A Study of Sacred and Secular Forms of African Classical Art*, London, 1974

Williamson 1995
Paul Williamson, *Gothic Sculpture, 1140–1300*, Pelican History of Art, New Haven and London, 1995

Wilson 1991
Simon Wilson, *Tate Gallery: An Illustrated Companion*, London, 1991

Winckelmann 2010
Johann Joachim Winckelmann, *Letter and Report on the Discoveries at Herculaneum*, trans. Carol C. Mattusch, Los Angeles, 2010

Woodward 2003
Hiram Woodward, *The Art and Architecture of Thailand: From Prehistoric Times through the Thirteenth Century*, Leiden, 2003

Wright 2005
Alison Wright, *The Pollaiuolo Brothers: The Arts of Florence and Rome*, New Haven and London, 2005

Xi'an 2010
Qingtong zhu wenming, exh. cat., Baoji Qingtong Bowuguan, Xi'an, 2010

Zervas 1996
Diane Finiello Zervas (ed.), *Orsanmichele, Florence*, Modena, 1996

Lenders to the Exhibition

Abbott-Guggenheim Collection

H. E. Sheik Saoud Bin Mohammed
 Bin Ali Al-Thani

Amsterdam
Rijksmuseum
Van Gogh Museum

Berlin
Staatliche Museen zu Berlin
Ethnologisches Museum
Museum für Asiatische Kunst
Skulpturensammlung und Museum
 für Byzantinisches Kunst

Bologna
Musei Civici d'Arte Antica

Boston
Museum of Fine Arts

Cagliari
Museo Archeologico Nazionale
 di Cagliari

Cambridge
Fitzwilliam Museum

Kemal Has Cingillioglu

Cleveland
The Cleveland Museum of Art

Cologne
Museum für Ostasiatische Kunst
Museum Ludwig

Copenhagen
The David Collection
National Museum

Tony Cragg CBE RA

Durham
Durham Cathedral

The Easton Foundation

Ecouen
Musée National de la Renaissance

Florence
Chiesa e Museo di Orsanmichele
Fondo Edifici di Culto, amministrato
 dal Ministero dell'Interno –
 Dipartimento per le Libertà Civili e
 l'Immigrazione – Direzione Centrale
 per l'Amministrazione del Fondo
 Edifici di Culto Soprintendenza
 Speciale per il Patrimonio Storico
 Artistico ed Etnoantropologico e Polo
 Museale della città di Firenze
Istituti museali della Soprintendenza
 Speciale per il Polo Museale
 Fiorentino
Musei Civici Fiorentini – Museo Stefano
 Bardini
Museo Nazionale del Bargello
Opera di Santa Maria del Fiore
Soprintendenza per i Beni Archeologici
 della Toscana

Goslar
Stadt Goslar, Goslarer Museum

Graz
Universalmuseum Joanneum,
 Alte Galerie
Universalmuseum Joanneum,
 Archäologiemuseum

Jakarta
National Museum Indonesia

Jerusalem
Israel Antiquities Authority

JP Morgan Chase Art Collection

Kassel
Museumlandschaft Hessen Kassel

The Khalili Collections

King's Lynn
Houghton Hall

Kippen
Kippen Parish Church

Lagos
The National Commission for Museums
 and Monuments

London
British Council Collection
British Museum
National Portrait Gallery
The Royal Collection
Tate
Victoria and Albert Museum

Los Angeles
The J. Paul Getty Museum

Madrid
Museo Arqueológico Nacional
Museo Nacional del Prado

Malibu
The J. Paul Getty Museum,
 Villa Collection

The Mari-Cha Collection Ltd

Mazara del Vallo
Museo del Satiro

Minneapolis
Minneapolis Institute of Arts

Mougins
Musée d'Art Classique de Mougins

Munich
Bayerisches Nationalmuseum

Naples
Soprintendenza Speciale per i Beni
 Archeologici di Napoli e Pompei

New York
Asia Society
The Metropolitan Museum of Art

Nuremberg
Museen der Stadt Nürnberg, Gemälde-
 und Skulpturensammlung

Oxford
The Ashmolean Museum

Palermo
Museo Archeologico Regionale

Paris
Bibliothèque nationale de France
Musée du Louvre
Musée National des Arts Asiatiques
 Guimet
Musée d'Orsay

Tom Phillips CBE RA

Phnom Penh
National Museum of Cambodia

Famille Germaine Richier

Rome
Museo Nazionale Etrusco de Villa Giulia
Museo Nazionale Romano

Rotterdam
Bodhimanda Foundation/
 Wereldmuseum
Ger Eenens Collection/Wereldmuseum

The Raymond and Beverly Sackler
 Collection

The Robert H. Smith Collection

Sofia
National Institute of Archaeology
 with Museum, Bulgarian Academy
 of Sciences

Stockholm
Nationalmuseum

Stoke-on-Trent
The Italian Gardens at the Trentham
 Estate

Mr and Mrs J. Tomilson Hill

Turin
Fondazione Museo delle Antichità Egizie

Vienna-Vaduz
The Princely Collections

Volterra
Museo Etrusco Guarnacci

Washington DC
Corcoran Gallery of Art

Zurich
Museum Rietberg

and others who wish to remain
anonymous

Photographic Acknowledgements

All works of art are reproduced by kind permission of their owners. Every effort has been made to trace photographers of works reproduced. Specific acknowledgements are as follows:

Aachen, Domschatzkammer: fig.65
Amsterdam, Collection Rijksmuseum: cats 84.1–6
Amsterdam, © Van Gogh Museum: cat.133
Angers, © Cliché musées d'Angers, photo P. David: fig.90
Barcelona, Photoaisa/Iberfoto: figs 66, 69
Berlin, Asian Art Museum, South, Southeast and Central Asian Collections, National Museums in Berlin: cat.47
Berlin, © bpk, Ethnologisches Museum, SMB: cats 75, 103
Berlin, © Staatliche Museen zu Berlin – Preußischer Kulturbesitz, Skulpturensammlung und Museum für Byzantinische Kunst, J. P. Anders, Berlin: cat.82
© Francesca G. Bewer: figs 12–13; fig.16 (by permission, President and Fellows of Harvard College)
Birmingham, © Birmingham Museums: fig.51
Bologna, © Museo Civico Medievale: cat.121
Boston, Photograph © 2012 Museum of Fine Arts, Boston: cat.71
© Louise Bourgeois Trust: cat.155 (photo by Peter Bellamy)
Braunschweig, Herzog Anton Ulrich-Museum, Kunstmuseum des Landes Niedersachsen, Museumsfotograf: fig.70
Cagliari, Museo Archeologico Nazionale di Cagliari: cat.18
© D. Cambell: cats 53, 59–60
Cambridge, © The Fitzwilliam Museum, Cambridge: cats 12–13, 33, 115; cat.152 (Reproduced by permission of The Henry Moore Foundation)
Cleveland, © The Cleveland Museum of Art: cat.55
Cologne, © Rheinisches Bildarchiv, Köln: cat.8 (rba_c010541); cat.10 (rba_c010558); cat.153 (rba_c005078/© Jasper Johns/VAGA, New York/DACS, London 2012)
Copenhagen, The David Collection: cat.66 (p.159; detail, p.281)
Copenhagen, Roberto Fortuna & Kira Ursem, The National Museum of Denmark: cat.7
Courtesy of Tony Cragg: cat.158 (photo by Charles Duprat/© DACS 2012)
Dresden, Skulpturensammlung, Staatliche Kunstsammlungen: fig.87
Durham, used by permission of the Chapter of Durham Cathedral, Michele Allan: cat.65
Edinburgh, © National Museums Scotland: fig.63

Erfurt, www.kunstverlag-peda.de: fig.10
Florence, Alinari Archives, Florence. Reproduced with the permission of Ministero per i Beni e le Attività Culturali: fig.11 (Serge Domingue), figs 18, 43 (George Tatge)
Florence, © Antonio Quattrone: cats 23, 38, 46 (Museo Archeologico Nazionale di Firenze, su concessione della Soprintendenza per i Beni Archeologici della Toscana); cat.112 (Musei Civici Fiorentini); cat.80; cat.88 (Opera di Santa Maria del Fiore)
Florence, © 2012 Photo Scala: figs 7, 17, 67, 72.1–4, 73, 75, 79–80; fig.20 (© DeA Picture Library/Ara Guler/Art Resource, NY); fig.54 (Kimbell Art Museum, Fort Worth, Texas/Art Resource, NY); figs 21, 23, 49, 52 (The Metropolitan Museum of Art/Art Resource, NY); figs 77–78 (courtesy of the Ministero per i Beni e le Attività Culturali, Florence); fig.47 (Museo Archeologico, Naples); fig.94 (The Museum of Modern Art, New York/© Succession Picasso/DACS, London 2012); fig.58 (National Museum, Lagos); fig.59 (National Museum of Ife); figs 5–6 (Vanni/Art Resource, NY); cats 50, 69 (The Metropolitan Museum of Art/Art Resource, NY); cats 70, 72–74, 91, 102 (National Commission for Museums and Monuments, Abuja, Nigeria); cats 81, 96, 99, 107, 111 (courtesy of the Ministero Beni e Attività Culturali)
Geneva, © The George Ortiz Collection. Yoram Lehmann, Jerusalem: figs 26, 35
Ger Eenens Collection, Wereldmuseum, Rotterdam: cat.137
© Succession Alberto Giacometti (Fondation Alberto et Annette Giacometti, Paris and ADAGP, Paris), licensed by ACS and DACS, London, 2012: cat.151
© John Gollings: figs 48, 57
Goslar, Fotostudio Volker Schadach: cat.89
Graz, © Universalmuseum Joanneum, Alte Galerie, Graz, Austria: cat.89
Graz, Universalmuseum Joanneum, Archaeology Museum: cat.22 (p.118–19; detail, p.6–7)
Halle, © Landesamt für Denkmalpflege und Archäologie Sachsen-Anhalt, Juraj Lipták: fig.4
Innsbruck, Hofkirche: fig.81
Jakarta, Museum Nasional Indonesia Collection/Photo Feri Latief: cat.51
Jerusalem, © The Israel Museum, Elie Posner: cats 1–5
Kassel, Museumslandschaft Hessen Kassel, Sammlung Angewandte Kunst: cat.116
Knoxville, © 2012 Frank H. McClung Museum, The University of Tennessee: fig.24
London, © akg-images: fig.27; fig.3 (album); fig.76 (Cameraphoto); figs 29, 42, 46, 82, 89 (Erich Lessing);

figs 44, 74–75 (Rabatti–Domingie); cat.136
London, The Art Archive/Gianni Dagli Orti: figs 9, 36, 40, 84
London, The Bridgeman Art Library: fig.30; fig.93 (© National Museum Wales); fig.85 (Santa Maria della Concezione, Rome/Alinari); cat.42 (© Christie's Images), cat.148 (© Christie's Images/© ADAGP, Paris and DACS, London 2012)
London, British Council Collection: cat.147 (© Bowness, Hepworth Estate)
London, © Getty Images/Paula Bronstein: fig.25
London, © Monika Wengraf-Hewitt: fig.62
London, Photograph Ida Kar © National Portrait Gallery: fig.95 (collection National Galleries of Scotland): cat.130
London, collection Tom and Fiona Phillips, Heini Schneebeli: cats 126.1–9
London, Private collection: cat.44 (courtesy of Rupert Wace Ancient Art); cat.77 (courtesy of Rossi & Rossi Ltd); cat.87 (Victoria and Albert Museum, London); cat.101 (courtesy of Sotheby's); cat.118 (courtesy of Pyms Gallery, London); cats 64, 138
London, Royal Academy of Arts, Roy Fox: cats 109, 117.1–2 (Private collection); cat.124 (Houghton Hall, Norfolk); cat.156 (© Collection of the artist)
London, supplied by the Royal Collection Trust: cat.108 (© HM Queen Elizabeth II 2012)
London, Skanda Trust: cat.52
London, Photo: © Tate 2012: cats 142.1–4 (© Succession H.Matisse/DACS 2012); cats 143 (p.238), © ADAGP, Paris and DACS, London 2012; detail p.10); cat.144 (© ADAGP, Paris and DACS, London 2012); cat.145
London, © The Trustees of the British Museum: figs 19, 31, 60–61 (top half); cats 6, 9, 15–17, 20, 24, 27, 31, 37, 67, 79; cat.41 (Royal Collection Trust/© HM Queen Elizabeth II 2012)
London, Victoria and Albert Museum: figs 50, 92; cats 61, 78, 85, 94, 105, 123, 134; cat.86 (© H. E. Sheikh Saoud Bin Mohammed Bin Ali Al-Thani, Victoria and Albert Museum, London)
Los Angeles, The J. Paul Getty Museum: cat.21 (Villa Collection); cat.120
Madrid, © Museo Arqueologico Nacional: cat.83
Madrid, Photographic Archive. Museo Nacional del Prado: fig.83; cat.129
Courtesy of Dr K. Mankodi, Mumbai: fig.53
The Mari-Cha Collection Ltd: cat.62
Minneapolis Institute of Arts. Gift of funds from the John Cowles Foundation, 55.45: cat.146 (© Succession Picasso/DACS, London 2012)

Moscow, © The State Hermitage Museum. Photo by Svetlana Suetova: fig.33
Mougins, Vieux Village de Mougins, © Musée d'Art Classique de Mougins: cat.43
Munich, © Bayerisches Nationalmuseum, Walter Haberland: cat.113
Naples, © Soprintendenza Speciale per i Beni Archeologici di Napoli, Luigi Spina: cats 35, 40
Nara City Sightseeing Information Center, by permission: fig.2
New York, Art Resource/Vanni: figs 1, 8, 71; cat.45
New York, courtesy of Asia Society: cats 48, 57
New York, JPMorgan Chase Art Collection: cat.154 (© Jeff Koons)
New York, The Pierpont Morgan Library. MLC 2628: fig.22
New York, Private collection: cat.14 (photo by Benjamin Watkins); cat.149 (photo by Jerry Thompson/© Estate of David Smith/DACS, London/VAGA, New York 2012)
New York, photograph courtesy of Sotheby's, Inc. © 2008: cat.104
New York, collection of Mr and Mrs J. Tomilson Hill: cat.92 (photo by Maggie Nimkin), cat.150
Nuremberg, Museen der Stadt Nürnberg, Gemälde- und Skulpturensammlung: cat.98
Oxford, Ashmolean Museum, University of Oxford: fig.91; cat.19
Paris, Bibliothèque nationale de France: cat.34
Paris, © Centre de recherche et de restauration des musées de France – RMN/Thierry Borel: fig.14
Paris, courtesy EFEO (L'Ecole française d'Extrême-Orient: fig.56
Paris, © RMN: fig.88 (Château de Versailles/René-Gabriel Ojéda); figs 32, 68 (Musée du Louvre. Droits réservés); fig.34 (Musée du Louvre/Christian Larrieu); fig.28 (Musée du Louvre/Franck Raux); cats 12, 49 (Musée Guimet, Paris/Thierry Ollivier); cat.93 (Musée national de la Renaissance/Hervé Lewandowski); cats 95, 106 (Musée national de la Renaissance/Gérard Blot); cats 97, 131, 140 (Musée d'Orsay, Paris/Réné-Gabriel Ojéda); cat.141 (The Metropolitan Museum of Art, Dist. RMN-GP, image of the MMA)
Private collection: cats 68.1–2, 110; cat.157 (photo by Dave Morgan, Private collection © Anish Kapoor)
A private European collection: cat.56
Courtesy John Rawson: fig.39
Rome, Museo Nazionale Romano: cat.36
Rome, SSPSAE e per il Polo Museale della città di Roma: fig.86

Rome, Soprintendenza Speciale per i Beni Archeologici dell'Etruria Meridionale: cat.29
Rotterdam, Collection Bodhimanda Foundation, Wereldmuseum: cat.76 (p.168, © Studio R. Asselberghs – Frédéric Dehaen, Brussels, detail p.9)
The Raymond and Beverly Sackler collection: cat.30 (Alan Zindman, NYC)
Sicily, Regione Siciliana – Assessorato Regionale dei Beni Culturali e dell'Identità Siciliana – Dipartimento dei Beni Culturali e dell'Identità Siciliana – Servizio Museo interdisciplinare Regionale "A. Pepoli" Trapani/© 2012 Photo Scala, Florence: cat.28
Sofia, National Institute of Archaeology with Museum – Bulgarian Academy of Sciences: cat.26
Stockholm, © The Nationalmuseum: cats 119, 122
Stoke-on-Trent, The Trentham Estate, Staffordshire, photo by Deborah McPeake: cat.132
Courtesy Donna Strahan: fig.15
Trier, Dom-Information Trier, photographer: Sebastian Schritt: fig.64
Turin, Fondazione Museo delle Antichità Egizie: cat.39
Vienna, © Kunsthistorischesmuseum Vienna with MVK and OETM: fig.61 (bottom half)
Vienna, © Liechtenstein. The Princely Collections, Vaduz-Vienna: cats 92, 100, 114, 127–28
Volterra, Guarnacci Etruscan Museum, City of Volterra: cat.32
Washington DC, Corcoran Gallery of Art: cat.139
Washington, National Geographic Stock/O. Louis Mazzatenta: figs 41, 45
Zurich, The Alice and Pierre Uldry Collection: cat.25
Zurich, The Khalili Collections: cat.135

Index

All references are to page numbers; those in **bold** type indicate catalogue plates, and those in *italic* type indicate essay illustrations